THE NEW MODERNIS

THE NEW MODERNIST STUDIES READER

AN ANTHOLOGY OF ESSENTIAL CRITICISM

Edited by Sean Latham and Gayle Rogers

BLOOMSBURY ACADEMIC

LONDON · NEW YORK · OXFORD · NEW DELHI · SYDNEY

BLOOMSBURY ACADEMIC
Bloomsbury Publishing Plc
50 Bedford Square, London, WC1B 3DP, UK
1385 Broadway, New York, NY 10018, USA
29 Earlsfort Terrace, Dublin 2, Ireland

BLOOMSBURY, BLOOMSBURY ACADEMIC and the Diana logo are trademarks of
Bloomsbury Publishing Plc

First published in Great Britain 2021

Cover design: Namkwan Cho
Cover image © Dan McCoy / Getty Images

A catalogue record for this book is available from the British Library.

A catalog record for this book is available from the Library of Congress.

ISBN: HB: 978-1-3501-0626-0
PB: 978-1-3501-0625-3
ePDF: 978-1-3501-0628-4
eBook: 978-1-3501-0627-7

Typeset by Deanta Global Publishing Services, Chennai, India
Printed and bound in Great Britain

To find out more about our authors and books visit www.bloomsbury.com and
sign up for our newsletters.

CONTENTS

Contents

ACKNOWLEDGMENTS

This anthology stands at the end of a project that we began in 2014 at the invitation of David Avital. He helped guide the New Modernisms series as a whole as well as the ten volumes it now includes. That work has given us the opportunity to collaborate with an outstanding collection of authors who have, in turn, expanded our own view of modernism's complications, provocations, and opportunities. As the series neared completion, it became clear that we needed an anthology like this, and we are grateful to David, Lucy Brown, Ben Doyle, and the other sharp editors at Bloomsbury who have kept faith with this project.

We also owe a real debt of gratitude to Layne Farmen, a graduate assistant at the University of Tulsa who helped us gather the works collected here from their various sources, and then helped us work through the complicated process of securing permissions. We are similarly grateful to the contributors themselves, who responded enthusiastically to our proposal. Journals and academic presses themselves provided us access to the materials. The chapters and essays reproduced here do not contain the images that were present in some of the originals; to see those, please consult the originals, which also contain a wealth of further reading.

We are grateful to the Richard D. and Mary Jane Edwards Endowed Publication Fund in the Dietrich School of Arts and Sciences at the University of Pittsburgh, which provided essential financial assistance.

INTRODUCTION

Sean Latham and Gayle Rogers

Where is the New Modernist Studies? That may seem like an odd question, especially when so few scholars agree on *what* the New Modernist Studies is, but it points to a problem that this anthology attempts to address. Scholarly movements and fields come into being and are renovated in a great variety of spaces: journals, monographs, conferences, classrooms, anthologies, lectures, even hallway conversations. No effort at recovering their full history could ever be complete—that is not the goal here—but, quite startlingly, there has not yet been a single, go-to collection that gathers the major publications that animated the New Modernist Studies. Accounts of the field and its emergence are not hard to find: some are celebratory, others critical, and others still simply descriptive. But teachers, researchers, and students alike often go on long journeys through bibliographies and critical sources to track down the pieces that recur in discussions of how and why the field has been so thoroughly transformed over the past quarter century.

This volume collects a coherent, readable set of articles and book chapters that helped give the New Modernist Studies its current shape. These touchstones are familiar to many, but sometimes difficult to find. We present them together as a sourcebook. Before proceeding any further though, we need to make two important disclaimers. The first is that we have no intention of imposing an artificial sense of order on a wide-ranging set of debates, so we have chosen simply to arrange the contents of this book in chronological order. We are not, therefore, suggesting a developmental narrative arc. (For those interested in such a narrative, we try to give one in the final chapter of our book, *Modernism: Evolution of an Idea* [2015], just as several essays included here do.) Many publications do refer to others that preceded them, whether by a few years or a number of years, while others were clearly composed simultaneously. They also refer to a host of publications in far-flung fields, and to once-rare archival sources that have since become readily accessible and familiar. A chronological presentation, we believe, will allow curious readers to draw their own connections and conclusions while working—or skipping—through this book.

The second disclaimer is that we do not wish to create an all-encompassing anthology. This book is meant to be portable and digestible, and that desire—along with the typical limitations of permissions fees and production costs—meant that we had to make painful exclusions when assembling the contents. Nor did we have the space to include a number of earlier, transitional pieces that laid a foundation for the works that articulated the New Modernist Studies. We hope, instead, that readers will find here both a cogent grouping and a map for further exploration. We stand behind the pieces we chose; we think that, while every reader can and will debate what we had to *exclude*, few could question the merits of what we *include*. These were (and remain) formative interventions, and, whether gauged through quantitative metrics like the number of citations or through qualitative forms of influence in opening new lines of inquiry or archival resources, they qualify as demonstrably important for the chapters in the field's history that followed them.

In making our selections, we focused on publications that engage with the generative problem of modernism itself. *Modernism* has always been a complex and contested term, and that remains true even amid the shift to what initially seemed like the much more capacious New Modernist Studies, whose history has been marked by disagreement, factionalism, and expansion rather than intellectual alignment and rigid canonization. This rebranding of the field did not take place in a vacuum, but instead was part of a much broader shift in the academy toward the reorganization of literary and historical fields to accommodate both the effective end of a narrow version of canonicity

and the consequent inclusion of new texts, new archives, and new theoretical approaches. Such conceptual engagements with modernism have been successful because they so often brought to bear methodologies, chronologies, and techniques from other fields. This collection therefore includes scholarship from the spheres of law, feminism, sociology, economics, media studies, translation studies, and the global histories of empire, as well as more traditional meditations on aesthetics and literary innovation. It ranges, too, from attempts at consolidating what the New Modernist Studies *is* to attempts at disrupting the very processes and ideals of consolidation itself.

What makes each of these publications perennially fresh and germane, as opposed to dated and worn out, is not simply the changing terrain of the New Modernist Studies, whether in the 1990s or in the present. It's also the broader cultural context of the work that academics do. A common gripe about professors is that we only produce jargon-filled, abstruse studies of historical minutiae. But in most every piece presented here, one can see and feel the dynamism of a movement like feminism, for example, as it undergoes dramatic changes between the political landscapes of the 1980s and post-2016 United States. The questions of racial appropriation in Michael North's and Brent Hayes Edwards's chapters have only grown in salience, while the urgent concerns with copyright, digital reproduction, and patterns of consumption that cut across at least four of these texts have only been magnified by technological advances. The changes to syllabi and to our senses of a shared cultural past cannot be separated, just as the issues of originality and remediation remain as fiercely debated today as they did in 1920s London and São Paulo.

For those who want to think critically about how culture operates, and thus how fields of study approach culture per se, this collection offers some of the most vivid, engaged work to be found. We hope, in the end, that this collection will be a useful starting point for those of you who will write the next chapters in the histories that these texts represent. It's probable that the New Modernist Studies does not need more narrative accounts of its rise and history—not right now, at least. It's even more probable that there are lines of inquiry that remain insufficiently pursued, yet are hiding in plain sight for the canny scholar who can connect some apparently disparate dots contained in these rich, robust scholarly works. We invite our readers to carry forward that process.

CHAPTER 1
EXCERPT FROM *AFTER THE GREAT DIVIDE*
MODERNISM, MASS CULTURE, POSTMODERNISM
Andreas Huyssen[*]

The New Modernist Studies emerged in response to intellectual, critical, and institutional pressures that threatened to marginalize early twentieth-century work that had once been considered revolutionary. Postmodernism, in particular, sought to differentiate itself—as both a literary-historical period and a school of critical thought—by focusing on popular culture, semiotics, and the deconstruction of value hierarchies. In doing so, it effectively began to reduce modernism to a collection of antique formalisms that were both elitist and premised on the exclusion of women, people of color, and almost all of mass culture.

Andreas Huyssen helped set the terms of this debate in 1987 with the publication of *After the Great Divide: Modernism, Mass Culture, Postmodernism*, which drew on the cultural criticism of Frankfurt School critics like Theodor Adorno. He argued that modernism had successfully carved out a distinctive place for itself by creating and then vigorously enforcing a strict boundary between its own carefully cultivated practices and the explosive growth of popular culture. Thanks to the interlocking effects of mass literacy, the availability of leisure time, and the creation of technologies like cinema, entirely new cultural industries took shape. These typically catered to broad yet carefully segmented audiences whose ever-changing standards of taste, judgment, and pleasure often diverged from those of elite critics and practitioners. This, Huyssen argued, led to the growing sense of a "great divide" between highbrow art on the one side and mass culture on the other.

We open this anthology with a pair of chapters from Huyssen's book precisely because it helped constitute fully the transformative debates that would lead to the demand for a "new" modernist studies freed from the narrow corner in which postmodern theorists tried to confine it. "The Hidden Dialectic" argues that twentieth-century media technologies contributed simultaneously to the rise of both mass culture and to the radical new artistic practices associated with modernism. This produced a powerful paradox: the same technologies that seemed to be producing an increasingly homogenous art for mass audiences were also enabling the creation of increasingly revolutionary practices like montage. These twin revolutions served to disrupt the cultural authority of art itself as an autonomous reservoir of cultural, ethical, and national value.

Modernism consequently arose, Huyssen argues, by carefully distancing itself from radical attacks on the idea of art as such (associated with the avant-garde) as well as from the dull homogeneity of mass culture. And it did so through a misogynist gender politics in which male artists and writers pitted themselves against popular art forms they associated with women viewers and consumers. This produced a "powerful masculinist mystique" that helped canonize writers like Joyce, Pound, Eliot, and Flaubert, turning their commercial failure and lack of wide popularity into a paradoxical sign of their success as artists able to resist the presumed depredations of mass culture.

[*]From Andreas Huyssen, *After the Great Divide: Modernism, Mass Culture, Postmodernism*. Indiana University Press, ©1986. Reproduced here with permission.

After the Great Divide is a foundational pivot between the old and new modernist studies. Although the book goes on to explore how postmodernism sought to reactivate the revolutionary potential of the avant-garde, its incisive critique of modernism's collapse into a husk of masculinist elitism launched a fundamental reassessment of the early twentieth century. In some ways, the myriad attempts to resist Huyssen's influential arguments have become the groundwork for much of the work included in this anthology, ranging from the media-centric pieces by Goble and Pressman to the pieces focused on gender (Felski), the marketplace (Rainey), and theory (Saint-Amour). Although the "great divide" might still persist as a heuristic for thinking about high modernism and mass culture, the New Modernist Studies developed largely as an attempt to explore the complexity of a revolutionary era that could not be so easily divided against itself.

Historical materialism wishes to retain that image of the past which unexpectedly appears to man singled out by history at a moment of danger. The danger affects both the content of the tradition and its receivers. The same threat hangs over both: that of becoming a tool of the ruling classes. In every era the attempt must be made anew to wrest tradition away from conformism that is about to overpower it.

<div align="right">Walter Benjamin, Theses on the Philosophy of History</div>

THE HIDDEN DIALECTIC: AVANTGARDE! TECHNOLOGY! MASS CULTURE

I

When Walter Benjamin, one of the foremost theoreticians of avantgarde art and literature, wrote these sentences in 1940 he certainly did not have the avantgarde in mind at all. It had not yet become part of that tradition which Benjamin was bent on salvaging. Nor could Benjamin have foreseen to what extent conformism would eventually overpower the tradition of avantgardism, both in advanced capitalist societies and, more recently, in East European societies as well. Like a parasitic growth, conformism has all but obliterated the original iconoclastic and subversive thrust of the historical avantgarde[1] of the first three or four decades of this century. This conformism is manifest in the vast depoliticization of post–World War II art and its institutionalization as administered culture,[2] as well as in academic interpretations which, by canonizing the historical avantgarde, modernism and postmodernism, have methodologically severed the vital dialectic between the avantgarde and mass culture in industrial civilization. In most academic criticism the avantgarde has been ossified into an elite enterprise beyond politics and beyond everyday life, though their transformation was once a central project of the historical avantgarde.

In light of the tendency to project the post-1945 depoliticization of culture back onto the earlier avantgarde movements, it is crucial to recover a sense of the cultural politics of the historical avantgarde. Only then can we raise meaningful questions about the relationship between the historical avantgarde and the neo-avantgarde, modernism and post-modernism, as well as about the aporias of the avantgarde and the consciousness industry (Hans Magnus Enzensberger), the tradition of the new (Harold Rosenberg) and the death of the avant-garde (Leslie Fiedler). For if discussions of the avantgarde do not break with the oppressive mechanisms of hierarchical discourse (high vs. popular, the new new vs. the old new, art vs. politics, truth vs. ideology), and

if the question of today's literary and artistic avantgarde is not placed in a larger socio-historical framework, the prophets of the new will remain locked in futile battle with the sirens of cultural decline—a battle which by now only results in a sense of dèjà vu.

II

Historically the concept of the avantgarde, which until the 1930s was not limited to art but always referred to political radicalism as well,[3] assumed prominence in the decades following the French Revolution. Henri de Saint Simon's *Opinions littéraires, philosophiques et industrielles* (1825) ascribed a vanguard role to the artist in the construction of the ideal state and the new golden age of the future,[4] and since then the concept of an avantgarde has remained inextricably bound to the idea of progress in industrial and technological civilization. In Saint Simon's messianic scheme, art, science, and industry were to generate and guarantee the progress of the emerging technical-industrial bourgeois world, the world of the city and the masses, capital and culture. The avantgarde, then, only makes sense if it remains dialectically related to that for which it serves as the vanguard—speaking narrowly, to the older modes of artistic expression, speaking broadly, to the life of the masses which Saint Simon's avantgarde scientists, engineers, and artists were to lead into the golden age of bourgeois prosperity.

Throughout the 19th century the idea of the avantgarde remained linked to political radicalism. Through the mediation of the Utopian socialist Charles Fourier, it found its way into socialist anarchism and eventually into substantial segments of the bohemian subcultures of the turn of the century.[5] It is certainly no coincidence that the impact of anarchism on artists and writers reached its peak precisely when the historical avantgarde was in a crucial stage of its formation. The attraction of artists and intellectuals to anarchism at that time can be attributed to two major factors: artists and anarchists alike rejected bourgeois society and its stagnating cultural conservatism, and both anarchists and left-leaning bohemians fought the economic and technological determinism and scientism of Second International Marxism, which they saw as the theoretical and practical mirror image of the bourgeois world.[6] Thus, when the bourgeoisie had fully established its domination of the state and industry, science and culture, the avant-gardist was not at all in the forefront of the kind of struggle Saint Simon had envisioned. On the contrary, he found himself on the margins of the very industrial civilization which he was opposing and which, according to Saint Simon, he was to prophesy and bring about. In terms of understanding the later condemnations of avantgarde art and literature both by the right (*entartete Kunst*) and by the left (bourgeois decadence), it is important to recognize that as early as the 1890s the avantgarde's insistence on cultural revolt clashed with the bourgeoisie's need for cultural legitimation, as well as with the preference of the Second International's cultural politics for the classical bourgeois heritage.[7]

Neither Marx nor Engels ever attributed major importance to culture (let alone avantgarde art and literature) in the working-class struggles, although it can be argued that the link between cultural and political-economic revolution is indeed implicit in their early works, especially in Marx's Parisian Manuscripts and the *Communist Manifesto*. Nor did Marx or Engels ever posit the Party as the avantgarde of the working class. Rather, it was Lenin who institutionalized the Party as the vanguard of the revolution in *What Is to Be Done* (1902) and soon after, in his article "Party Organization and Party Literature" (1905), severed the vital dialectic between the political and cultural avantgarde, subordinating the latter to the Party. Declaring the artistic avantgarde to be a mere instrument of the political vanguard, "a cog and screw of one single great Social Democratic mechanism set in motion by the entire politically conscious avantgarde of the entire working

class,"[8] Lenin thus helped pave the way for the later suppression and liquidation of the Russian artistic avantgarde which began in the early 1920s and culminated with the official adoption of the doctrine of socialist realism in 1934.[9]

In the West, the historical avantgarde died a slower death, and the reasons for its demise vary from country to country. The German avantgarde of the 1920s was abruptly terminated when Hitler came to power in 1933, and the development of the West European avantgarde was interrupted by the war and the German occupation of Europe. Later, during the cold war, especially after the notion of the end of ideology took hold, the political thrust of the historical avantgarde was lost and the center of artistic innovation shifted from Europe to the United States. To some extent, of course, the lack of political perspective in art movements such as abstract expressionism and Pop art was a function of the altogether different relationship between avantgarde art and cultural tradition in the United States, where the iconoclastic rebellion against a bourgeois cultural heritage would have made neither artistic nor political sense. In the United States, the literary and artistic heritage never played as central a role in legitimizing bourgeois domination as it did in Europe. But these explanations for the death of the historical avantgarde in the West at a certain time, although critical, are not exhaustive. The loss of potency of the historical avantgarde may be related more fundamentally to a broad cultural change in the West in the 20th century: it may be argued that the rise of the Western culture industry, which paralleled the decline of the historical avant-garde, has made the avantgarde's enterprise itself obsolete.

To summarize: since Saint Simon, the avantgardes of Europe had been characterized by a precarious balance of art and politics, but since the 1930s the cultural and political avantgardes have gone their separate ways. In the two major systems of domination in the contemporary world, the avantgarde has lost its cultural and political explosiveness and has itself become a tool of legitimation. In the United States, a depoliticized cultural avantgarde has produced largely affirmative culture, most visibly in pop art where the commodity fetish often reigns supreme. In the Soviet Union and in Eastern Europe, the historical avantgarde was first strangled by the iron hand of Stalin's cultural henchman Zhdanov and then revived as part of the cultural heritage, thus providing legitimacy to regimes which face growing cultural and political dissent.

Both politically and aesthetically, today it is important to retain that image of the now lost unity of the political and artistic avantgarde, which may help us forge a new unity of politics and culture adequate to our own times. Since it has become more difficult to share the historical avantgarde's belief that art can be crucial to a transformation of society, the point is not simply to revive the avantgarde. Any such attempt would be doomed, especially in a country such as the United States where the European avantgarde failed to take roots precisely because no belief existed in the power of art to change the world. Nor, however, is it enough to cast a melancholy glance backwards and indulge in nostalgia for the time when the affinity of art to revolution could be taken for granted. The point is rather to take up the historical avant-garde's insistence on the cultural transformation of everyday life and from there to develop strategies for today's cultural and political context.

III

The notion that culture is a potentially explosive force and a threat to advanced capitalism (and to bureaucratized socialism, for that matter) has a long history within Western Marxism from the early Lukács up through Habermas's *Legitimation Crisis* and Negt/Kluge's *Öffentlichkeit und Erfahrung.*[10] It even underlies, if only by its conspicuous absence, Adorno's seemingly dualistic theory of a monolithically manipulative culture industry and an avantgarde locked into negativity. Peter Bürger, a recent theoretician of the avantgarde, draws extensively on this critical Marxist

tradition, especially on Benjamin and Adorno. He argues convincingly that the major goal of art movements such as Dada, surrealism, and the post-1917 Russian avantgarde was the reintegration of art into life praxis, the closing of the gap separating art from reality. Bürger interprets the widening gap between art and life, which had become all but unbridgeable in late 19th century aestheticism, as a logical development of art within bourgeois society. In its attempt to close the gap, the avantgarde had to destroy what Bürger calls "institution art," a term for the institutional framework in which art was produced, distributed, and received in bourgeois society, a framework which rested on Kant's and Schiller's aesthetic of the necessary autonomy of all artistic creation. During the 19th century the increasingly categorical separation of art from reality and the insistence on the autonomy of art, which had once freed art from the fetters of church and state, had worked to push art and artists to the margins of society. In the art for art's sake movement, the break with society—the society of imperialism—had led into a dead end, a fact painfully clear to the best representatives of aestheticism. Thus, the historical avantgarde attempted to transform l'art pour l'art's isolation from reality—which reflected as much opposition to bourgeois society as Zola's *j'accuse*—into an active rebellion that would make art productive for social change. In the historical avantgarde, Bürger argues, bourgeois art reached the stage of self-criticism; it no longer only criticized previous art *qua* art, but also critiqued the very "institution art" as it had developed in bourgeois society since the 18th century.[11]

Of course, the use of the Marxian categories of criticism and self-criticism implies that the negation and sublation (*Aufhebung*) of the bourgeois "institution art" is bound to the transformation of bourgeois society itself. Since such a transformation did not take place, the avantgarde's attempt to integrate art and life almost had to fail. This failure, later often labelled the death of the avantgarde, is Bürger's starting point and his reason for calling the avantgarde "historical." And yet, the failure of the avantgarde to reorganize a new life praxis through art and politics resulted in precisely those historical phenomena which make any revival of the avantgarde's project today highly problematic, if not impossible: namely, the false sublations of the art/life dichotomy in fascism with its aesthetization of politics,[12] in Western mass culture with its fictionalization of reality, and in socialist realism with its claims of reality status for its fictions.

If we agree with the thesis that the avantgarde's revolt was directed against the totality of bourgeois culture and its psycho-social mechanisms of domination and control and if we then make it our task to salvage the historical avantgarde from the conformism which has obscured its political thrust, then it becomes crucial to answer a number of questions which go beyond Bürger's concern with the "institution art" and the formal structure of the avantgarde art work. How precisely did the dadaists, surrealists, futurists, constructivists, and productivists attempt to overcome the art/life dichotomy? How did they conceptualize and put into practice the radical transformation of the conditions of producing, distributing, and consuming art? What exactly was their place within the political spectrum of those decades and what concrete political possibilities were open to them in specific countries? In what way did the conjunction of political and cultural revolt inform their art and to what extent did that art become part of the revolt itself? Answers to these questions will vary depending on whether one focuses on Bolshevik Russia, France after Versailles, or Germany, doubly beaten by World War I and a failed revolution. Moreover, even within these countries and the various artistic movements, differentiations have to be made. It is fairly obvious that a montage by Schwitters differs aesthetically and politically from a photomontage by John Heartfield, that Dada Zurich and Dada Paris developed an artistic and political sensibility which differed substantially from that of Dada Berlin, that Mayakovsky and revolutionary futurism cannot be equated with the productivism of Arvatov or Gastev. And yet, as Bürger has convincingly suggested, all these phenomena can legitimately be subsumed under the notion of the historical avantgarde.

IV

I will not attempt here to answer all these questions, but will focus instead on uncovering the hidden dialectic of avantgarde and mass culture, thereby casting new light on the objective historical conditions of avantgarde art, as well as on the socio-political subtext of its inevitable decline and the simultaneous rise of mass culture.

Mass culture as we know it in the West is unthinkable without 20th century technology—media techniques as well as technologies of transportation (public and private), the household, and leisure. Mass culture depends on technologies of mass production and mass reproduction and thus on the homogenization of difference. While it is generally recognized that these technologies have substantially transformed everyday life in the 20th century, it is much less widely acknowledged that technology and the experience of an increasingly technologized life world have also radically transformed art. Indeed, technology played a crucial, if not *the* crucial, role in the avantgarde's attempt to overcome the art/life dichotomy and make art productive in the transformation of everyday life. Bürger has argued correctly that from Dada on the avantgarde movements distinguish themselves from preceding movements such as impressionism, naturalism, and cubism not only in their attack on the "institution art" as such, but also in their radical break with the referential mimetic aesthetic and its notion of the autonomous and organic work of art. I would go further: no other single factor has influenced the emergence of the new avantgarde art as much as technology, which not only fueled the artists' imagination (dynamism, machine cult, beauty of technics, constructivist and productivist attitudes), but penetrated to the core of the work itself. The invasion of the very fabric of the art object by technology and what one may loosely call the technological imagination can best be grasped in artistic practices such as collage, assemblage, montage and photomontage; it finds its ultimate fulfillment in photography and film, art forms which can not only be reproduced, but are in fact designed for mechanical reproducibility. It was Walter Benjamin who, in his famous essay "The Work of Art in the Age of Mechanical Reproduction," first made the point that it is precisely this mechanical reproducibility which has radically changed the nature of art in the 20th century, transforming the conditions of producing, distributing, and receiving/consuming art. In the context of social and cultural theory Benjamin conceptualized what Marcel Duchamp had already shown in 1919 in *L.H.O.O.Q.* By iconoclastically altering a reproduction of the *Mona Lisa* and, to use another example, by exhibiting a mass-produced urinal as a fountain sculpture, Marcel Duchamp succeeded in destroying what Benjamin called the traditional art work's aura, that aura of authenticity and uniqueness that constituted the work's distance from life and that required contemplation and immersion on the part of the spectator. In another essay, Benjamin himself acknowledged that the intention to destroy this aura was already inherent in the artistic practices of Dada.[13] The destruction of the aura, of seemingly natural and organic beauty, already characterized the works of artists who still created individual rather than mass-reproducible art objects. The decay of the aura, then, was not as immediately dependent on techniques of mechanical reproduction as Benjamin had argued in the Reproduction essay. It is indeed important to avoid such reductive analogies between industrial and artistic techniques and not to collapse, say, montage technique in art or film with industrial montage.[14]

It may actually have been a new experience of technology that sparked the avantgarde rather than just the immanent development of the artistic forces of production. The two poles of this new experience of technology can be described as the aesthetization of technics since the late 19th century (world expos, garden cities, the *cité industrielle* of Tony Garnier, the *Città Nuova* of Antonio Sant'Elia, the *Werkbund*, etc.) on the one hand and the horror of technics inspired by the awesome war machinery of World War I on the other. And this horror of technics can itself be regarded as a logical and historical outgrowth of the critique of technology and the positivist

ideology of progress articulated earlier by the late 19th-century cultural radicals who in turn were strongly influenced by Nietzsche's critique of bourgeois society. Only the post-1910 avantgarde, however, succeeded in giving artistic expression to this bipolar experience of technology in the bourgeois world by integrating technology and the technological imagination in the production of art.

The experience of technology at the root of the dadaist revolt was the highly technologized battlefield of World War I—that war which the Italian futurists glorified as total liberation and which the dadaists condemned as a manifestation of the ultimate insanity of the European bourgeoisie. While technology revealed its destructive power in the big *Materialschlachten* of the war, the dadaists projected technology's destructivism into art and turned it aggressively against the sanctified sphere of bourgeois high culture whose representatives, on the whole, had enthusiastically welcomed the war in 1914. Dada's radical and disruptive moment becomes even clearer if we remember that bourgeois ideology had lived off the separation of the cultural from industrial and economic reality, which of course was the primary sphere of technology. Instrumental reason, technological expansion, and profit maximization were held to be diametrically opposed to the *schöner Schein* (beautiful appearance) and *interesseloses Wohlgefalien* (disinterested pleasure) dominant in the sphere of high culture.

In its attempt to reintegrate art and life, the avantgarde of course did not want to unite the bourgeois concept of reality with the equally bourgeois notion of high, autonomous culture. To use Marcuse's terms, they did not want to weld the reality principle to affirmative culture, since these two principles constituted each other precisely in their separation. On the contrary, by incorporating technology into art, the avantgarde liberated technology from its instrumental aspects and thus undermined both bourgeois notions of technology as progress and art as "natural," "autonomous," and "organic." On a more traditional representational level, which was never entirely abandoned, the avantgarde's radical critique of the principles of bourgeois enlightenment and its glorification of progress and technology were manifested in scores of paintings, drawings, sculptures, and other art objects in which humans are presented as machines and automatons, puppets and mannequins, often faceless, with hollow heads, blind or staring into space. The fact that these presentations did not aim at some abstract "human condition," but rather critiqued the invasion of capitalism's technological instrumentality into the fabric of everyday life, even into the human body, is perhaps most evident in the works of Dada Berlin, the most politicized wing of the Dada movement. While only Dada Berlin integrated its artistic activities with the working-class struggles in the Weimar Republic, it would be reductive to deny Dada Zurich or Dada Paris any political importance and to decree that their project was "only aesthetic," "only cultural." Such an interpretation falls victim to the same reified dichotomy of culture and politics which the historical avantgarde had tried to explode.

V

In Dada, technology mainly functioned to ridicule and dismantle bourgeois high culture and its ideology, and thus was ascribed an iconoclastic value in accord with Dada's anarchistic thrust. Technology took an entirely different meaning in the post-1917 Russian avant-garde—in futurism, constructivism, productivism, and the proletcult.

The Russian avantgarde had already completed its break with tradition when it turned openly political after the revolution. Artists organized themselves and took an active part in the political struggles, many of them by joining Lunacharsky's NARKOMPROS, the Commissariat for Education. Many artists automatically assumed a correspondence and potential parallel between the artistic

and political revolution, and their foremost aim became to weld the disruptive power of avantgarde art to the revolution. The avantgarde's goal to forge a new unity of art and life by creating a new art and a new life seemed about to be realized in revolutionary Russia.

This conjunction of political and cultural revolution with the new view of technology became most evident in the LEF group, the productivist movement, and the proletcult. As a matter of fact, these left artists, writers, and critics adhered to a cult of technology which to any contemporary radical in the West must have seemed next to inexplicable, particularly since it expressed itself in such familiar capitalist concepts as standardization, Americanization, and even taylorization. In the mid-1920s, when a similar enthusiasm for technification, Americanism, and functionalism had taken hold among liberals of the Weimar Republic, George Grosz and Wieland Herzfelde tried to explain this Russian cult of technology as emerging from the specific conditions of a backward agrarian country on the brink of industrialization and rejected it for the art of an already highly industrialized West: "In Russia this constructivist romanticism has a much deeper meaning and is in a more substantial way socially conditioned than in Western Europe. There constructivism is partially a natural reflection of the powerful technological offensive of the beginning industrialization."[15] And yet, originally the technology cult was more than just a reflection of industrialization, or, as Grosz and Herzfelde also suggest, a propagandistic device. The hope that artists such as Tatlin, Rodchenko, Lissitzky, Meyerhold, Tretyakov, Brik, Gastev, Arvatov, Eisenstein, Vertov, and others invested in technology was closely tied to the revolutionary hopes of 1917. With Marx they insisted on the qualitative difference between bourgeois and proletarian revolutions. Marx had subsumed artistic creation under the general concept of human labor, and he had argued that human self-fulfillment would only be possible once the productive forces were freed from oppressive production and class relations. Given the Russian situation of 1917, it follows almost logically that the productivists, left futurists, and constructivists would place their artistic activities within the horizon of a socialized industrial production: art and labor, freed for the first time in history from oppressive production relations, were to enter into a new relationship. Perhaps the best example of this tendency is the work of the Central Institute of Labor (CIT), which, under the leadership of Alexey Gastev, attempted to introduce the scientific organization of labor (NOT) into art and aesthetics.[16] The goal of these artists was not the technological development of the Russian economy at any cost—as it was for the Party from the NEP period on, and as it is manifest in scores of later socialist realist works with their fetishization of industry and technology. Their goal was the liberation of everyday life from all its material, ideological, and cultural restrictions. The artificial barriers between work and leisure, production and culture were to be eliminated. These artists did not want a merely decorative art which would lend its illusory glow to an increasingly instrumentalized everyday life. They aimed at an art which would intervene in everyday life by being both useful and beautiful, an art of mass demonstrations and mass festivities, an activating art of objects and attitudes, of living and dressing, of speaking and writing. Briefly, they did not want what Marcuse has called affirmative art, but rather a revolutionary culture, an art of life. They insisted on the psycho-physical unity of human life and understood that the political revolution could only be successful if it were accompanied by a revolution of everyday life.

VI

In this insistence on the necessary "organization of emotion and thought" (Bogdanov), we can actually trace a similarity between late 19th-century cultural radicals and the Russian post-1917 avantgarde, except that now the role ascribed to technology has been totally reversed. It is precisely

this similarity, however, which points to interesting differences between the Russian and the German avantgarde of the 1920s, represented by Grosz, Heartfield, and Brecht among others.

Despite his closeness to Tretyakov's notions of art as production and the artist as operator, Brecht never would have subscribed to Tretyakov's demand that art be used as a means of the emotional organization of the psyche.[17] Rather than describing the artist as an engineer of the psyche, as a psycho-constructor,[18] Brecht might have called the artist an engineer of reason. His dramatic technique of *Verfremdungseffekt* relies substantially on the emancipatory power of reason and on rational ideology critique, principles of the bourgeois enlightenment which Brecht hoped to turn effectively against bourgeois cultural hegemony. Today we cannot fail to see that Brecht, by trying to use the enlightenment dialectically, was unable to shed the vestiges of instrumental reason and thus remained caught in that other dialectic of enlightenment which Adorno and Horkheimer have exposed.[19] Brecht, and to some extent also the later Benjamin, tended toward fetishizing technique, science, and production in art, hoping that modern technologies could be used to build a socialist mass culture. Their trust that capitalism's power to modernize would eventually lead to its breakdown was rooted in a theory of economic crisis and revolution which, by the 1930s, had already become obsolete. But even there, the differences between Brecht and Benjamin are more interesting than the similarities. Brecht does not make his notion of artistic technique as exclusively dependent on the development of productive forces as Benjamin did in his Reproduction essay. Benjamin, on the other hand, never trusted the emancipatory power of reason and the *Verfremdungseffekt* as exclusively as Brecht did. Brecht also never shared Benjamin's messianism or his notion of history as an object of construction.[20] But it was especially Benjamin's emphatic notion of experience (*Erfahrung*) and profane illumination that separated him from Brecht's enlightened trust in ideology critique and pointed to a definite affinity between Benjamin and the Russian avantgarde. Just as Tretyakov, in his futurist poetic strategy, relied on shock to alter the psyche of the recipient of art, Benjamin, too, saw shock as a key to changing the mode of reception of art and to disrupting the dismal and catastrophic continuity of everyday life. In this respect, both Benjamin and Tretyakov differ from Brecht: the shock achieved by Brecht's *Verfremdungseffekt* does not carry its function in itself but remains instrumentally bound to a rational explanation of social relations which are to be revealed as mystified second nature. Tretyakov and Benjamin, however, saw shock as essential to disrupting the frozen patterns of sensory perception, not only those of rational discourse. They held that this disruption is a prerequisite for any revolutionary reorganization of everyday life. As a matter of fact, one of Benjamin's most interesting and yet undeveloped ideas concerns the possibility of a historical change in sensory perception, which he links to a change in reproduction techniques in art, a change in everyday life in the big cities, and the changing nature of commodity fetishism in 20th-century capitalism. It is highly significant that just as the Russian avantgarde aimed at creating a socialist mass culture, Benjamin developed his major concepts concerning sense perception (decay of aura, shock, distraction, experience, etc.) in essays on mass culture and media as well as in studies on Baudelaire and French surrealism. It is in Benjamin's work of the 1930s that the hidden dialectic between avantgarde art and the Utopian hope for an emancipatory mass culture can be grasped alive for the last time. After World War II, at the latest, discussions about the avantgarde congealed into the reified two-track system of high vs. low, elite vs. popular, which itself is the historical expression of the avantgarde's failure and of continued bourgeois domination.

VII

Today, the obsolescence of avantgarde shock techniques, whether dadaist, constructivist, or surrealist, is evident enough. One need only think of the exploitation of shock in Hollywood

productions such as *Jaws* or *Close Encounters of the Third Kind* in order to understand that shock can be exploited to reaffirm perception rather than change it. The same holds true for a Brechtian type of ideology critique. In an age saturated with information, including critical information, the *Verfremdungseffekt* has lost its demystifying power. Too much information, critical or not, becomes noise. Not only is the historical avantgarde a thing of the past, but it is also useless to try to revive it under any guise. Its artistic inventions and techniques have been absorbed and co-opted by Western mass mediated culture in all its manifestations from Hollywood film, television, advertising, industrial design, and architecture to the aesthetization of technology and commodity aesthetics. The legitimate place of a cultural avantgarde which once carried with it the Utopian hope for an emancipatory mass culture under socialism has been preempted by the rise of mass mediated culture and its supporting industries and institutions.

Ironically, technology helped initiate the avantgarde artwork and its radical break with tradition, but then deprived the avantgarde of its necessary living space in everyday life. It was the culture industry, not the avantgarde, which succeeded in transforming everyday life in the 20th century. And yet—the Utopian hopes of the historical avantgarde are preserved, even though in distorted form, in this system of secondary exploitation euphemistically called mass culture. To some, it may therefore seem preferable today to address the contradictions of technologized mass culture rather than pondering over the products and performances of the various neo-avantgardes, which, more often than not, derive their originality from social and aesthetic amnesia. Today the best hopes of the historical avantgarde may not be embodied in art works at all, but in decentered movements which work toward the transformation of everyday life. The point then would be to retain the avantgarde's attempt to address those human experiences which either have not yet been subsumed under capital, or which are stimulated but not fulfilled by it. Aesthetic experience in particular must have its place in this transformation of everyday life, since it is uniquely apt to organize fantasy, emotions, and sensuality against that repressive desublimation which is so characteristic of capitalist culture since the 1960s.

Notes

1. The term "historical avantgarde" has been introduced by Peter Bürger in his *Theory of the Avant-Garde*, trans. Michael Shaw (Minneapolis: University of Minnesota Press, 1984). It includes mainly dadaism, surrealism and the post-revolutionary Russian avantgarde.

2. Cf. Theodor W. Adorno, "Culture and Administration," *Telos*, 37 (Fall 1978), 93–111.

3. See Donald Drew Egbert, *Social Radicalism and the Arts: Western Europe* (New York: Alfred A. Knopf, 1970).

4. On the authorship of relevant sections of the *Opinions*, see Matei Calinescu, *Faces of Modernity: Avantgarde, Decadence, Kitsch* (Bloomington: Indiana University Press, 1977), p. 101f.

5. See Egbert, *Social Radicalism and the Arts*; on bohemian subcultures, see Helmut Kreuzer, *Die Boheme* (Stuttgart: Metzler, 1971).

6. See David Bathrick and Paul Breines, "Marx und/oder Nietzsche: Anmerkungen zur Krise des Marxismus," in *Karl Marx und Friedrich Nietzsche*, ed. R. Grimm and J. Hermand (Königstein/Ts.: Athenäum, 1978).

7. See Andreas Huyssen, "Nochmals zu Naturalismus-Debatte und Links-opposition," in *Naturalismus-Ästhetizismus*, ed. Christa Bürger, Peter Bürger, and Jochen Schulte-Sasse (Frankfurt am Main: Suhrkamp, 1979).

8. V. I. Lenin, "*The Re-Organization of the Party*" and "*Party Organization and Party Literature*" (London: IMG Publications, 1972), p. 17.

9. See Hans-Jürgen Schmidt and Godehard Schramm, eds., *Sozialistische Realismuskonzeptionen: Dokumente zum 1. Allunionskongress der Sowjetschriftsteller* (Frankfurt am Main: Suhrkamp, 1974).

10. Jürgen Habermas, *Legitimation Crisis*, trans. Thomas McCarthy (Boston: Beacon Press, 1975); Oskar Negt and Alexander Kluge, *Öffentlichkeit und Erfahrung* (Frankfurt am Main: Suhrkamp, 1972).

11. See Bürger, *Theory of the Avant-Garde*, esp. chapter 1.

12. See Rainer Stollmann, "Fascist Politics as a Total Work of Art: Tendencies of the Aesthetization of Political Life in National Socialism," *New German Critique*, 14 (Spring 1978), 41–60.

13. See Walter Benjamin, "The Author as Producer," in *Understanding Brecht*, trans. Anna Bostock (London: New Left Books, 1973), p. 94.

14. See Burkhardt Lindner and Hans Burkhard Schlichting, "Die Dekonstruktion der Bilder: Differenzierungen im Montagebegriff," *Alternative*, 122/123 (Oct./Dec. 1978), 218–21.

15. George Grosz and Wieland Herzfelde, "Die Kunst ist in Gefahr. Ein Orientierungsversuch" (1925), cited in Diether Schmidt, ed., *Manifeste—Manifeste Schriften deutscher Künstler des 20.Jahrhunderts*, I (Dresden, n.d.), pp. 345–46.

16. See Karla Hielscher, "Futurismus und Kulturmontage," *Alternative*, 122/123 (Oct./Dec. 1978), 226–35.

17. Sergej Tretjakov, *Die Arbeit des Schriftstellers: Aufsätze, Reportage, Porträts* (Reinbek: Rowohlt, 1972), p. 87.

18. Ibid., p. 88.

19. Max Horkheimer and Theodor W. Adorno, *Dialectic of Enlightenment*, trans. John Cumming (New York: Herder & Herder, 1972).

20. See Walter Benjamin, "Theses on the Philosophy of History," in *Illuminations*, ed. Hannah Arendt (New York: Schocken Books, 1969).

MASS CULTURE AS WOMAN: MODERNISM'S OTHER

I

One of the founding texts of modernism, if there ever was one, is Flaubert's *Madame Bovary*. Emma Bovary, whose temperament was, in the narrator's words, "more sentimental than artistic," loved to read romances.[1] In his detached, ironic style, Flaubert describes Emma's reading matter: "They [the novels] were full of love and lovers, persecuted damsels swooning in deserted pavilions, postillions slaughtered at every turn, horses ridden to death on every page, gloomy forests, romantic intrigue, vows, sobs, embraces and tears, moonlit crossings, nightingales in woodland groves, noblemen brave as lions, gentle as lambs, impossibly virtuous, always well dressed, and who wept like fountains on all occasions."[2] Of course, it is well known that Flaubert himself was caught by the craze for romantic novels during his student days in the College at Rouen, and Emma Bovary's readings at the convent have to be read against this backdrop of Flaubert's life history—a point which critics rarely fail to make. However, there is ample reason to wonder if the adolescent Flaubert read these novels in the same way Emma Bovary would have, had she actually lived—or, for that matter, as real women at the time read them. Perhaps the answer to such a query will have to remain speculative. What is beyond speculation, however, is the fact that Emma Bovary became known, among other things, as the female reader caught between the delusions of the trivial romantic narrative and the realities of French provincial life during the July monarchy, a woman who tried to live the illusions of aristocratic sensual romance and was shipwrecked on the banality of bourgeois everyday life. Flaubert, on the other hand, came to be known as one of the fathers of modernism, one of the paradigmatic master voices of an aesthetic based on the uncompromising repudiation of what Emma Bovary loved to read.

As to Flaubert's famous claim: "Madame Bovary, c'est moi," we can assume that he knew what he was saying, and critics have gone to great lengths to show what Flaubert had in common with Emma Bovary—mostly in order to show how he transcended aesthetically the dilemma on which she foundered in "real life." In such arguments the question of gender usually remains submerged, thereby asserting itself all the more powerfully. Sartre, however, in his monumental *L'Idiot de la Famille*, has analyzed the social and familial conditions of Flaubert's "objective neurosis" underlying his fantasy of himself as woman. Sartre has indeed succeeded in showing how Flaubert fetishized his own imaginary femininity while simultaneously sharing his period's hostility toward real women, participating in a pattern of the imagination and of behavior all too common in the history of modernism.[3]

That such masculine identification with woman, such imaginary femininity in the male writer, is itself historically determined is clear enough. Apart from the subjective conditions of neurosis in Flaubert's case, the phenomenon has a lot to do with the increasingly marginal position of literature and the arts in a society in which masculinity is identified with action, enterprise, and progress—with the realms of business, industry, science, and law. At the same time, it has also become clear that the imaginary femininity of male authors, which often grounds their oppositional stance vis-à-vis bourgeois society, can easily go hand in hand with the exclusion of real women from the literary enterprise and with the misogyny of bourgeois patriarchy itself. Against the paradigmatic "Madame Bovary, c'est moi," we therefore have to insist that there is a difference. Christa Wolf, in her critical and fictional reflections on the question "who was Cassandra before anyone wrote about her?," put it this way:

> We have admired this remark [Flaubert's "Madame Bovary, c'est moi"] for more than a hundred years. We also admire the tears Flaubert shed when he had to let Madame Bovary die, and the crystal-clear calculation of his wonderful novel, which he was able to write despite his tears; and we should not and will not stop admiring him. But Flaubert was *not* Madame Bovary; we cannot completely ignore that fact in the end, despite all our good will and what we know of the secret relationship between an author and a figure created by art.[4]

One aspect of the difference that is important to my argument about the gender inscriptions in the mass culture debate is that woman (Madame Bovary) is positioned as reader of inferior literature—subjective, emotional and passive—while man (Flaubert) emerges as writer of genuine, authentic literature—objective, ironic, and in control of his aesthetic means. Of course, such positioning of woman as avid consumer of pulp, which I take to be paradigmatic, also affects the woman writer who has the same kind of ambition as the "great (male) modernist." Wolf cites Ingeborg Bachmann's tortured novel trilogy *Todesarten* (Ways of Dying) as a counterexample to Flaubert: "Ingeborg Bachmann *is* that nameless woman in *Molina*, she *is* the woman Franza in the novel fragment *The Franza Case* who simply cannot get a grip on her life, cannot give it a form; who simply cannot manage to make her experience into a presentable story, cannot produce it out of herself as an artistic product."[5]

In one of her own novels, *The Quest for Christa T*, Wolf herself foregrounded the "difficulty of saying I" for the woman who writes. The problematic nature of saying "I" in the literary text—more often than not held to be a lapse into subjectivity or kitsch—is of course one of the central difficulties of the postromantic, modernist writer. Having first created the determining conditions for a certain historically specific type of subjectivity (the Cartesian cogito and the epistemological subject in Kant, as well as the bourgeois entrepreneur and the modern scientist), modernity itself has increasingly hollowed out such subjectivity and rendered its articulation highly problematic. Most modern artists, male or female, know that. But we only need to think

of the striking contrast between Flaubert's confident personal confession, "Madame Bovary, c'est moi," and the famed "impassibilité" of the novel's style to know that there is a difference. Given the fundamentally differing social and psychological constitution and validation of male and female subjectivity in modern bourgeois society, the difficulty of saying "I" must of necessity be different for a woman writer, who may not find "impassibilité" and the concomitant reification of self in the aesthetic product quite as attractive and compelling an ideal as the male writer. The male, after all, can easily deny his own subjectivity for the benefit of a higher aesthetic goal, as long as he can take it for granted on an experiential level in everyday life. Thus Christa Wolf concludes, with some hesitation and yet forcefully enough: "Aesthetics, I say, like philosophy and science, is invented not so much to enable us to get closer to reality as for the purpose of warding it off, of protecting against it."[6] Warding something off, protecting against something out there seems indeed to be a basic gesture of the modernist aesthetic, from Flaubert to Roland Barthes and other poststructuralists. What Christa Wolf calls reality would certainly have to include Emma Bovary's romances (the books *and* the love affairs), for the repudiation of *Trivialliteratur* has always been one of the constitutive features of a modernist aesthetic intent on distancing itself and its products from the trivialities and banalities of everyday life. Contrary to the claims of champions of the autonomy of art, contrary also to the ideologists of textuality, the realities of modern life and the ominous expansion of mass culture throughout the social realm are always already inscribed into the articulation of aesthetic modernism. Mass culture has always been the hidden subtext of the modernist project.

II

What especially interests me here is the notion which gained ground during the 19th century that mass culture is somehow associated with woman while real, authentic culture remains the prerogative of men. The tradition of women's exclusion from the realm of "high art" does not of course originate in the 19th century, but it does take on new connotations in the age of the industrial revolution and cultural modernization. Stuart Hall is perfectly right to point out that the hidden subject of the mass culture debate is precisely "the masses"—their political and cultural aspirations, their struggles and their pacification via cultural institutions.[7] But when the 19th and early 20th centuries conjured up the threat of the masses "rattling at the gate," to quote Hall, and lamented the concomitant decline of culture and civilization (which mass culture was invariably accused of causing), there was yet another hidden subject. In the age of nascent socialism *and* the first major women's movement in Europe, the masses knocking at the gate were also women, knocking at the gate of a male-dominated culture. It is indeed striking to observe how the political, psychological, and aesthetic discourse around the turn of the century consistently and obsessively genders mass culture and the masses as feminine, while high culture, whether traditional or modern, clearly remains the privileged realm of male activities.

To be sure, a number of critics have since abandoned the notion of *mass* culture in order to "exclude from the outset the interpretation agreeable to its advocates: that it is a matter of something like a culture that arises spontaneously from the masses themselves, the contemporary form of popular art."[8] Thus Adorno and Horkheimer coined the term culture industry; Enzensberger gave it another twist by calling it the consciousness industry; in the United States, Herbert Schiller speaks of mind managers, and Michael Real uses the term mass-mediated culture. The critical intention behind these changes in terminology is clear: they all mean to suggest that modern mass culture is administered and imposed from above and that the threat it represents resides not in the masses but in those who run the industry. While such an interpretation may serve as a welcome corrective

to the naive notion that mass culture is identical with traditional forms of popular art, rising spontaneously from the masses, it nevertheless erases a whole web of gender connotations which, as I shall show, the older terminology "mass culture" carried with it—i.e., connotations of mass culture as essentially feminine which were clearly also "imposed from above," in a gender-specific sense, and which remain central to understanding the historical and rhetorical determinations of the modernism/mass culture dichotomy.

It might be argued that the terminological shift away from the term "mass culture" actually reflects changes in critical thinking about "the masses." Indeed, mass culture theories since the 1920s—for instance, those of the Frankfurt School—have by and large abandoned the explicit gendering of mass culture as feminine. Instead they emphasize features of mass culture such as streamlining, technological reproduction, administration, and Sachlichkeit—features which popular psychology would ascribe to the realm of masculinity rather than femininity. Yet the older mode of thinking surfaces time and again in the language, if not in the argument. Thus Adorno and Horkheimer argue that mass culture "cannot renounce the threat of castration,"[9] and they feminize it explicitly, as the evil queen of the fairy tale when they claim that "mass culture, in her mirror, is always the most beautiful in the land."[10] Similarly, Siegfried Kracauer, in his seminal essay on the mass ornament, begins his discussion by bringing the legs of the Tiller Girls into the reader's view, even though the argument then focuses primarily on aspects of rationalization and standardization.[11] Examples such as these show that the inscription of the feminine on the notion of mass culture, which seems to have its primary place in the late 19th century, did not relinquish its hold, even among those critics who did much to overcome the 19th century mystification of mass culture as woman.

The recovery of such gender stereotypes in the theorizing of mass culture may also have some bearing on the current debate about the alleged femininity of modernist/avant-gardist writing. Thus the observation that, in some basic register, the traditional mass culture/modernism dichotomy has been gendered since the mid-19th century as female/male would seem to make recent attempts by French critics to claim the space of modernist and avant-garde writing as predominantly feminine highly questionable. Of course this approach, which is perhaps best embodied in Kristeva's work, focuses on the Mallarmé-Lautréamont-Joyce axis of modernism rather than, say, on the Flaubert-Thomas Mann-Eliot axis which I emphasize in my argument here. Nevertheless, its claims remain problematic even there. Apart from the fact that such a view would threaten to render invisible a whole tradition of women's writing, its main theoretical assumption—"that 'the feminine' is what cannot be inscribed in common language"[12]—remains problematically close to that whole history of an imaginary male femininity which has become prominent in literature since the late 18th century.[13] This view becomes possible only if Madame Bovary's "natural" association with pulp—i.e., the discourse that persistently associated women with mass culture—is simply ignored, and if a paragon of male misogyny like Nietzsche is said to be speaking from the position of woman. Teresa de Lauretis has recently criticized this Derridean appropriation of the feminine by arguing that the position of woman from which Nietzsche and Derrida speak is vacant in the first place, and cannot be claimed by women.[14] Indeed, more than a hundred years after Flaubert and Nietzsche, we are facing yet another version of an imaginary male femininity, and it is no coincidence that the advocates of such theories (who also include major women theoreticians) take great pains to distance themselves from any form of political feminism. Even though the French readings of modernism's "feminine" side have opened up fascinating questions about gender and sexuality which can be turned critically against more dominant accounts of modernism, it seems fairly obvious that the wholesale theorization of modernist writing as feminine simply ignores the powerful masculinist and misogynist current within the trajectory of modernism, a current which time and again openly states its contempt

for women and for the masses and which had Nietzsche as its most eloquent and influential representative.

Here, then, some remarks about the history of the perception of mass culture as feminine. Time and again documents from the late 19th century ascribe pejorative feminine characteristics to mass culture—and by mass culture here I mean serialized feuilleton novels, popular and family magazines, the stuff of lending libraries, fictional bestsellers and the like—not, however, working-class culture or residual forms of older popular or folk cultures. A few examples will have to suffice. In the preface to their novel *Germinie Lacerteux* (1865), which is usually regarded as the first naturalist manifesto, the Goncourt brothers attack what they call the false novel. They describe it as those "spicy little works, memoirs of street-walkers, bedroom confessions, erotic smuttiness, scandals that hitch up their skirts in pictures in bookshop windows." The true novel (*le roman vrai*) by contrast is called "severe and pure." It is said to be characterized by its scientificity, and rather than sentiment it offers what the authors call "a clinical picture of love" (*une clinique de l'amour*).[15] Twenty years later, in the editorial of the first issue of Michael Georg Conrad's journal *Die Gesellschaft* (1885), which marks the beginning of "die Moderne" in Germany, the editor states his intention to emancipate literature and criticism from the "tyranny of well-bred debutantes and old wives of both sexes," and from the empty and pompous rhetoric of "old wives criticism." And he goes on to polemicize against the then popular literary family magazines: "The literary and artistic kitchen personnel has achieved absolute mastery in the art of economizing and imitating the famous potato banquet. . . . It consists of twelve courses each of which offers the potato in a different guise."[16] Once the kitchen has been described metaphorically as the site of mass cultural production, we are not surprised to hear Conrad call for the reestablishment of an "*arg gefärdete Mannhaftigkeit*" (seriously threatened manliness) and for the restoration of bravery and courage (*Tapferkeit*) in thought, poetry, and criticism.

It is easy to see how such statements rely on the traditional notion that women's aesthetic and artistic abilities are inferior to those of men. Women as providers of inspiration for the artist, yes, but otherwise *Berufsverbot* for the muses,[17] unless of course they content themselves with the lower genres (painting flowers and animals) and the decorative arts. At any rate, the gendering of an inferior mass culture as feminine goes hand in hand with the emergence of a male mystique in modernism (especially in painting), which has been documented thoroughly by feminist scholarship.[18] What is interesting in the second half of the 19th century, however, is a certain chain effect of signification: from the obsessively argued inferiority of woman as artist (classically argued by Karl Scheffler in *Die Fran und die Kunst*, 1908) to the association of woman with mass culture (witness Hawthorne's "the damned mob of scribbling women") to the identification of woman with the masses as political threat.

This line of argument invariably leads back to Nietzsche. Significantly, Nietzsche's ascription of feminine characteristics to the masses is always tied to his aesthetic vision of the artist-philosopher-hero, the suffering loner who stands in irreconcilable opposition to modern democracy and its inauthentic culture. Fairly typical examples of this nexus can be found in Nietzsche's polemic against Wagner, who becomes for him the paradigm of the decline of genuine culture in the dawning age of the masses and the feminization of culture: "The danger for artists, for geniuses . . . is woman: adoring women confront them with corruption. Hardly any of them have character enough not to be corrupted—or 'redeemed'—when they find themselves treated like gods: soon they condescend to the level of the women."[19] Wagner, it is implied, has succumbed to the adoring women by transforming music into mere spectacle, theater, delusion:

I have explained where Wagner belongs—*not* in the history of music. What does he signify nevertheless in that history? *The emergence of the actor in music.* . . . One can grasp it with

one's very hands: great success, success with the masses no longer sides with those who are authentic—one has to be an actor to achieve that. Victor Hugo and Richard Wagner—they signify the same thing: in declining cultures, wherever the decision comes to rest with the masses, authenticity becomes superfluous, disadvantageous, a liability. Only the actor still arouses *great* enthusiasm.[20]

And then Wagner, the theater, the mass, woman—all become a web of signification outside of, and in opposition to, true art: "No one brings along the finest senses of his art to the theater, least of all the artist who works for the theater—solitude is lacking; whatever is perfect suffers no witnesses. In the theater one becomes people, herd, female, pharisee, voting cattle, patron, idiot—*Wagnerian*."[21] What Nietzsche articulates here is of course not an attack on the drama or the tragedy, which to him remain some of the highest manifestations of culture. When Nietzsche calls theater a "revolt of the masses"[22] he anticipates what the situationists would later elaborate as the society of the spectacle and what Baudrillard chastises as the simulacrum. At the same time, it is no coincidence that the philosopher blames theatricality for the decline of culture. After all, the theater in bourgeois society was one of the few spaces which allowed women a prime place in the arts, precisely because acting was seen as imitative and reproductive rather than original and productive. Thus, in Nietzsche's attack on what he perceives as Wagner's feminization of music, his "infinite melody"—"one walks into the sea, gradually loses one's secure footing, and finally surrenders oneself to the elements without reservation"[23]—an extremely perceptive critique of the mechanisms of bourgeois culture goes hand in hand with an exhibition of that culture's sexist biases and prejudices.

III

The fact that the identification of woman with mass has major political implications is easily recognized. Thus Mallarmé's quip about "*reportage universel*" (i.e., mass culture), with its not so subtle allusion to "*suffrage universel*" is more than just a clever pun. The problem goes far beyond questions of art and literature. In the late 19th century, a specific traditional male image of woman served as a receptacle for all kinds of projections, displaced fears, and anxieties (both personal and political), which were brought about by modernization and the new social conflicts, as well as by specific historical events such as the 1848 revolution, the 1870 Commune, and the rise of reactionary mass movements which, as in Austria, threatened the liberal order.[24] An examination of the magazines and the newspapers of the period will show that the proletarian and petit-bourgeois masses were persistently described in terms of a feminine threat. Images of the raging mob as hysterical, of the engulfing floods of revolt and revolution, of the swamp of big city life, of the spreading ooze of massification, of the figure of the red whore at the barricades—all of these pervade the writing of the mainstream media, as well as that of right-wing ideologues of the late 19th and early 20th centuries whose social psychology Klaus Theweleit has perceptively analyzed in his study *Male Phantasies*.[25] The fear of the masses in this age of declining liberalism is always also a fear of woman, a fear of nature out of control, a fear of the unconscious, of sexuality, of the loss of identity and stable ego boundaries in the mass.

This kind of thinking is exemplified by Gustave Le Bon's enormously influential *The Crowd* (*La Psychologie des foules*, 1895), which as Freud observed in his own *Mass Psychology and Ego Analysis* (1921) merely summarizes arguments pervasive in Europe at the time. In Le Bon's study, the male fear of woman and the bourgeois fear of the masses become indistinguishable: "Crowds are everywhere distinguished by feminine characteristics."[26] And: "The simplicity and exaggeration

of the sentiments of crowds have for result that a throng knows neither doubt nor uncertainty. Like women, it goes at once to extremes. . . . A commencement of antipathy or disapprobation, which in the case of an isolated individual would not gain strength, becomes at once furious hatred in the case of an individual in a crowd."[27] And then he summarizes his fears with a reference to that icon which perhaps more than any other in the 19th century—more even than the Judiths and Salomes so often portrayed on symbolist canvases—stood for the feminine threat to civilization: "Crowds are somewhat like the sphinx of ancient fable: it is necessary to arrive at a solution of the problems offered by their psychology or to resign ourselves to being devoured by them."[28] Male fears of an engulfing femininity are here projected onto the metropolitan masses, who did indeed represent a threat to the rational bourgeois order. The haunting specter of a loss of power combines with fear of losing one's fortified and stable ego boundaries, which represent the *sine qua non* of male psychology in that bourgeois order. We may want to relate Le Bon's social psychology of the masses back to modernism's own fears of being sphinxed. Thus the nightmare of being devoured by mass culture through co-option, commodification, and the "wrong" kind of success is the constant fear of the modernist artist, who tries to stake out his territory by fortifying the boundaries between genuine art and inauthentic mass culture. Again, the problem is not the desire to differentiate between forms of high art and depraved forms of mass culture and its co-options. The problem is rather the persistent gendering as feminine of that which is devalued.

IV

Seen in relation to this kind of paranoid view of mass culture and the masses, the modernist aesthetic itself—at least in one of its basic registers—begins to look more and more like a reaction formation rather than like the heroic feat steeled in the fires of the modern experience. At the risk of oversimplifying, I would suggest that one can identify something like a core of the modernist aesthetic which has held sway over many decades, which manifests itself (with variations due to respective media) in literature, music, architecture, and the visual arts, and which has had an enormous impact on the history of criticism and cultural ideology. If we were to construct an ideal type notion of what the modernist artwork has become as a result of successive canonizations—and I will exclude here the poststructuralist archeology of modernism which has shifted the grounds of the debate—it would probably look somewhat like this:

— The work is autonomous and totally separate from the realms of mass culture and everyday life.
— It is self-referential, self-conscious, frequently ironic, ambiguous, and rigorously experimental.
— It is the expression of a purely individual consciousness rather than of a Zeitgeist or a collective state of mind.
— Its experimental nature makes it analogous to science, and like science it produces and carries knowledge.
— Modernist literature since Flaubert is a persistent exploration of and encounter with language. Modernist painting since Manet is an equally persistent elaboration of the medium itself: the flatness of the canvas, the structuring of notation, paint and brushwork, the problem of the frame.

— The major premise of the modernist art work is the rejection of all classical systems of representation, the effacement of "content," the erasure of subjectivity and authorial voice, the repudiation of likeness and verisimilitude, the exorcism of any demand for realism of whatever kind.

— Only by fortifying its boundaries, by maintaining its purity and autonomy, and by avoiding any contamination with mass culture and with the signifying systems of everyday life can the art work maintain its adversary stance: adversary to the bourgeois culture of everyday life as well as adversary to mass culture and entertainment which are seen as the primary forms of bourgeois cultural articulation.

One of the first examples of this aesthetic would be Flaubert's famous "impassibilité" and his desire to write "a book about nothing, a book without external attachments which would hold together by itself through the internal force of its style." Flaubert can be said to ground modernism in literature, both for its champions (from Nietzsche to Roland Barthes) and for its detractors (such as Georg Lukacs). Other historical forms of this modernist aesthetic would be the clinical, dissecting gaze of the naturalist;[29] the doctrine of art for art's sake in its various classicist or romantic guises since the late 19th century; the insistence on the art-life dichotomy so frequently found at the turn of the century, with its inscription of art on the side of death and masculinity and its evaluation of life as inferior and feminine; and finally the absolutist claims of abstraction, from Kandinsky to the New York School.

But it was only in the 1940s and 1950s that the modernism gospel and the concomitant condemnation of kitsch became something like the equivalent of the one-party state in the realm of aesthetics. And it is still an open question to what extent current poststructuralist notions of language and writing and of sexuality and the unconscious are a postmodern departure toward entirely new cultural horizons; or whether, despite their powerful critique of older notions of modernism, they do not rather represent another mutation of modernism itself.

My point here is not to reduce the complex history of modernism to an abstraction. Obviously, the various layers and components of the ideal modernist work would have to be read in and through specific works in specific historical and cultural constellations. The notion of autonomy, for instance, has quite different historical determinations for Kant, who first articulated it in his *Kritik der Urteilskraft*, than for Flaubert in the 1850s, for Adorno during World War II, or again for Frank Stella today. My point is rather that the champions of modernism themselves were the ones who made that complex history into a schematic paradigm, the main purpose of which often seemed to be the justification of current aesthetic practice rather than the richest possible reading of the past in relation to the present.

My point is also not to say that there is only one, male, sexual politics to modernism, against which women would have to find their own voices, their own language, their own feminine aesthetic. What I am saying is that the powerful masculinist mystique which is explicit in modernists such as Marinetti, Jünger, Benn, Wyndham Lewis, Celine et al. (not to speak of Marx, Nietzsche, and Freud), and implicit in many others, has to be somehow related to the persistent gendering of mass culture as feminine and inferior—even if, as a result, the heroism of the moderns won't look quite as heroic any more. The autonomy of the modernist art work, after all, is always the result of a resistance, an abstention, and a suppression—resistance to the seductive lure of mass culture, abstention from the pleasure of trying to please a larger audience, suppression of everything that might be threatening to the rigorous demands of being modern and at the edge of time. There seem to be fairly obvious homologies between this modernist insistence on purity and autonomy in art, Freud's privileging of the ego over the id and his insistence on stable, if flexible, ego boundaries, and Marx's privileging of production over consumption. The lure of

mass culture, after all, has traditionally been described as the threat of losing oneself in dreams and delusions and of merely consuming rather than producing.[30] Thus, despite its undeniable adversary stance toward bourgeois society, the modernist aesthetic and its rigorous work ethic as described here seem in some fundamental way to be located also on the side of that society's reality principle, rather than on that of the pleasure principle. It is to this fact that we owe some of the greatest works of modernism, but the greatness of these works cannot be separated from the often one-dimensional gender inscriptions inherent in their very constitution as autonomous masterworks of modernity.

V

The deeper problem at stake here pertains to the relationship of modernism to the matrix of modernization which gave birth to it and nurtured it through its various stages. In less suggestive terms, the question is why, despite the obvious heterogeneity of the modernist project, a certain universalizing account of the modern has been able to hold sway for so long in literary and art criticism, and why even today it is far from having been decisively displaced from its position of hegemony in cultural institutions. What has to be put in question is the presumably adversary relationship of the modernist aesthetic to the myth and ideology of modernization and progress, which it ostensibly rejects in its fixation upon the eternal and timeless power of the poetic word. From the vantage point of our postmodern age, which has begun in a variety of discourses to question seriously the belief in unhampered progress and in the blessings of modernity, it becomes clear how modernism, even in its most adversary, anti-bourgeois manifestations, is deeply implicated in the processes and pressures of the same mundane modernization it so ostensibly repudiates. It is especially in light of the ecological and environmental critique of industrial and postindustrial capitalism, and of the different yet concomitant feminist critique of bourgeois patriarchy, that the subterranean collusion of modernism with the myth of modernization becomes visible.

I want to show this briefly for two of the most influential and by now classical accounts of the historical trajectory of modernism—the accounts of Clement Greenberg in painting and of Theodor W. Adorno in music and literature. For both critics, mass culture remains the other of modernism, the specter that haunts it, the threat against which high art has to shore up its terrain. And even though mass culture is no longer imagined as primarily feminine, both critics remain under the sway of the old paradigm in their conceptualization of modernism.

Indeed, both Greenberg and Adorno are often taken to be the last ditch defenders of the purity of the modernist aesthetic, and they have become known since the late 1930s as uncompromising enemies of modern mass culture. (Mass culture had by then of course become an effective tool of totalitarian domination in a number of countries, which all banished modernism as degenerate or decadent.) While there are major differences between the two men, both in temperament and in the scope of their analyses, they both share a notion of the inevitability of the evolution of modern art. To put it bluntly, they believe in progress—if not in society, then certainly in art. The metaphors of linear evolution and of a teleology of art are conspicuous in their work. I quote Greenberg: "It has been in search of the absolute that the avant-garde has arrived at 'abstract' or 'nonobjective' art—and poetry, too."[31] It is well known how Greenberg constructs the story of modernist painting as a single-minded trajectory, from the first French modernist avant-garde of the 1860s to the New York School of abstract expressionism—his moment of truth.

Similarly, Adorno sees a historical logic at work in the move from late romantic music to Wagner and ultimately to Schonberg and the second school of Vienna, which represent *his* moment of

truth. To be sure, both critics acknowledge retarding elements in these trajectories—Stravinsky in Adorno's account, surrealism in Greenberg's—but the logic of history, or rather the logic of aesthetic evolution, prevails, giving a certain rigidity to Greenberg's and Adorno's theorizing. Obstacles and detours, it seems, only highlight the dramatic and inevitable path of modernism toward its telos, whether this telos is described as triumph as in Greenberg or as pure negativity as in Adorno. In the work of both critics, the theory of modernism appears as a theory of modernization displaced to the aesthetic realm; this is precisely its historical strength, and what makes it different from the mere academic formalism of which it is so often accused. Adorno and Greenberg further share a notion of decline that they see as following on the climax of development in high modernism. Adorno wrote about "Das Altern der Neuen Musik," and Greenberg unleashed his wrath on the reappearance of representation in painting since the advent of Pop Art.

At the same time, both Adorno and Greenberg were quite aware of the costs of modernization, and they both understood that it was the ever increasing pace of commodification and colonization of cultural space which actually propelled modernism forward, or, better, pushed it toward the outer margins of the cultural terrain. Adorno especially never lost sight of the fact that, ever since their simultaneous emergence in the mid-19th century, modernism and mass culture have been engaged in a compulsive *pas de deux*. To him, autonomy was a relational phenomenon, not a mechanism to justify formalist amnesia. His analysis of the transition in music from Wagner to Schönberg makes it clear that Adorno never saw modernism as anything other than a reaction formation to mass culture and commodification, a reaction formation which operated on the level of form and artistic material. The same awareness that mass culture, on some basic level, determined the shape and course of modernism is pervasive in Clement Greenberg's essays of the late 1930s. To a large extent, it is by the distance we have traveled from this "great divide" between mass culture and modernism that we can measure our own cultural postmodernity. And yet, I still know of no better aphorism about the imaginary adversaries, modernism and mass culture, than that which Adorno articulated in a letter to Walter Benjamin: "Both [modernist art and mass culture] bear the scars of capitalism, both contain elements of change. Both are torn halves of freedom to which, however, they do not add up."[32]

But the discussion cannot end here. The postmodern crisis of high modernism and its classical accounts has to be seen as a crisis both of capitalist modernization itself and of the deeply patriarchal structures that support it. The traditional dichotomy, in which mass culture appears as monolithic, engulfing, totalitarian, and on the side of regression and the feminine ("Totalitarianism appeals to the desire to return to the womb," said T. S. Eliot[33]) and modernism appears as progressive, dynamic, and indicative of male superiority in culture, has been challenged empirically and theoretically in a variety of ways in the past twenty years or so. New versions of the history of modern culture, the nature of language, and artistic autonomy have been elaborated, and new theoretical questions have been brought to bear on mass culture and modernism; most of us would probably share the sense that the ideology of modernism, as I have sketched it here, is a thing of the past, even if it still occupies major bastions in cultural institutions such as the museum or the academy. The attacks on high modernism, waged in the name of the postmodern since the late 1950s, have left their mark on our culture, and we are still trying to figure out the gains and the losses which this shift has brought about.

VI

What then of the relationship of postmodernism to mass culture, and what of its gender inscriptions? What of postmodernism's relationship to the myth of modernization? After all, if the

masculinist inscriptions in the modernist aesthetic are somehow subliminally linked to the history of modernization, with its insistence on instrumental rationality, teleological progress, fortified ego boundaries, discipline, and self-control; if, furthermore, both modernism and modernization are ever more emphatically subjected to critique in the name of the postmodern—then we must ask to what extent postmodernism offers possibilities for genuine cultural change, or to what extent the postmodern raiders of a lost past produce only simulacra, a fast-image culture that makes the latest thrust of modernization more palatable by covering up its economic and social dislocations. I think that postmodernism does both, but I will focus here only on some of the signs of promising cultural change.

A few somewhat tentative reflections will have to suffice, as the amorphous and politically volatile nature of postmodernism makes the phenomenon itself remarkably elusive, and the definition of its boundaries exceedingly difficult, if not per se impossible. Furthermore, one critic's postmodernism is another critic's modernism (or variant thereof), while certain vigorously new forms of contemporary culture (such as the emergence into a broader public's view of distinct minority cultures and of a wide variety of feminist work in literature and the arts) have so far rarely been discussed *as* postmodern, even though these phenomena have manifestly affected both the culture at large and the ways in which we approach the politics of the aesthetic today. In some sense it is the very existence of these phenomena which challenges the traditional belief in the necessary advances of modernism and the avantgarde. If postmodernism is to be more than just another revolt of the modern against itself, then it would certainly have to be defined in terms of this challenge to the constitutive forward thrust of avantgardism.

I do not intend here to add yet another definition of what the postmodern *really* is, but it seems clear to me that both mass culture and women's (feminist) art are emphatically implicated in any attempt to map the specificity of contemporary culture and thus to gauge this culture's distance from high modernism. Whether one uses the term "postmodernism" or not, there cannot be any question about the fact that the position of women in contemporary culture and society, and their effect on that culture, is fundamentally different from what it used to be in the period of high modernism and the historical avant-garde. It also seems clear that the uses high art makes of certain forms of mass culture (and vice versa) have increasingly blurred the boundaries between the two; where modernism's great wall once kept the barbarians out and safeguarded the culture within, there is now only slippery ground which may prove fertile for some and treacherous for others.

At stake in this debate about the postmodern is the great divide between modern art and mass culture, which the art movements of the 1960s intentionally began to dismantle in their practical critique of the high modernist canon and which the cultural neo-conservatives are trying to re-erect today.[34] One of the few widely agreed upon features of postmodernism is its attempt to negotiate forms of high art with certain forms and genres of mass culture and the culture of everyday life.[35] I suspect that it is probably no coincidence that such merger attempts occurred more or less simultaneously with the emergence of feminism and women as major forces in the arts, and with the concomitant reevaluation of formerly devalued forms and genres of cultural expression (e.g., the decorative arts, autobiographic texts, letters, etc.).

However, the original impetus to merge high art and popular culture—for example, say in Pop Art in the early 1960s—did not yet have anything to do with the later feminist critique of modernism. It was, rather, indebted to the historical avantgarde—art movements such as Dada, constructivism, and surrealism—which had aimed, unsuccessfully, at freeing art from its aestheticist ghetto and reintegrating art and life.[36] Indeed, the early American postmodernists' attempts to open up the realm of high art to the imagery of everyday life and American mass culture are in some ways reminiscent of the historical avantgarde's attempt to work in the interstices of high

art and mass culture. In retrospect, it thus seems quite significant that major artists of the 1920s used precisely the then wide-spread "Americanism" (associated with jazz, sports, cars, technology, movies, and photography) in order to overcome bourgeois aestheticism and its separateness from "life." Brecht is the paradigmatic example here, and he was in turn strongly influenced by the post-revolutionary Russian avantgarde and its daydream of creating a revolutionary avantgarde culture for the masses. It seems that the European Americanism of the 1920s then returned to America in the 1960s, fueling the fight of the early postmodernists against the high-culture doctrines of Anglo-American modernism. The difference is that the historical avantgarde—even where it rejected Leninist vanguard politics as oppressive to the artist—always negotiated its political *Selbstverständnis* in relation to the revolutionary claims for a new society which would be the *sine qua non* of the new art. Between 1916—the "outbreak" of Dada in Zurich—and 1933/34—the liquidation of the historical avantgarde by German fascism and Stalinism—many major artists took the claim inherent in the avantgarde's name very seriously: namely, to lead the whole of society toward new horizons of culture, and to create an avantgarde art for the masses. This ethos of a symbiosis between revolutionary art and revolutionary politics certainly vanished after World War II; not just because of McCarthyism, but even more because of what Stalin's henchmen had done to the left aesthetic avantgarde of the 1920s. Yet the attempt by the American postmodernists of the 1960s to renegotiate the relationship between high art and mass culture gained its own political momentum in the context of the emerging new social movements of those years—among which feminism has perhaps had the most lasting effects on our culture, as it cuts across class, race, and gender.

In relation to gender and sexuality, though, the historical avantgarde was by and large as patriarchal, misogynist, and masculinist as the major trends of modernism. One needs only to look at the metaphors in Marinetti's "Futurist Manifesto," or to read Marie Luise Fleisser's trenchant description of her relationship to Bertolt Brecht in a prose text entitled "Avantgarde"— in which the gullible, literarily ambitious young woman from the Bavarian province becomes a guinea pig in the machinations of the notorious metropolitan author. Or, again, one may think of how the Russian avantgarde fetishized production, machines, and science, and of how the writings and paintings of the French surrealists treated women primarily as objects of male phantasy and desire.

There is not much evidence that things were very different with the American postmodernists of the late 1950s and early 1960s. However, the avantgarde's attack on the autonomy aesthetic, its politically motivated critique of the highness of high art, and its urge to validate other, formerly neglected or ostracized forms of cultural expression created an aesthetic climate in which the political aesthetic of feminism could thrive and develop its critique of patriarchal gazing and penmanship. The aesthetic transgressions of the happenings, actions, and performances of the 1960s were clearly inspired by Dada, Informel, and action painting; and with few exceptions— the work of Valie Export, Charlotte Moorman, and Carolee Schneemann—these forms did not transport feminist sensibilities or experiences. But it seems historically significant that women artists increasingly used these forms in order to give voice to their experiences.[37] The road from the avantgarde's experiments to contemporary women's art seems to have been shorter, less tortuous, and ultimately more productive than the less frequently traveled road from high modernism. Looking at the contemporary art scene, one may well want to ask the hypothetical question whether performance and "body art" would have remained so dominant during the 1970s had it not been for the vitality of feminism in the arts and the ways in which women artists articulated experiences of the body and of performance in gender-specific terms. I only mention the work of Yvonne Rainer and Laurie Anderson. Similarly, in literature the re-emergence of the concern with perception and identification, with sensual experience and subjectivity in relation to gender and

sexuality would hardly have gained the foreground in aesthetic debates (against even the powerful poststructuralist argument about the death of the subject and the Derridean expropriation of the feminine) had it not been for the social and political presence of a women's movement and women's insistence that male notions of perception and subjectivity (or the lack thereof) did not really apply to them. Thus the turn toward problems of "subjectivity" in the German prose of the 1970s was initiated not just by Peter Schneider's *Lenz* (1973), as is so often claimed, but even more so by Karin Struck's *Klassenliebe* (also 1973) and, in retrospect, by Ingeborg Bachmann's *Malina* (1971).

However one answers the question of the extent to which women's art and literature have affected the course of postmodernism, it seems clear that feminism's radical questioning of patriarchal structures in society and in the various discourses of art, literature, science, and philosophy must be one of the measures by which we gauge the specificity of contemporary culture as well as its distance from modernism and its mystique of mass culture as feminine. Mass culture and the masses as feminine threat—such notions belong to another age, Jean Baudrillard's recent ascription of femininity to the masses notwithstanding. Of course, Baudrillard gives the old dichotomy a new twist by applauding the femininity of the masses rather than denigrating it, but his move may be no more than yet another Nietzschean simulacrum.[38] After the feminist critique of the multilayered sexism in television, Hollywood, advertising, and rock 'n' roll, the lure of the old rhetoric simply does not work any longer. The claim that the threats (or, for that matter, the benefits) of mass culture are somehow "feminine" has finally lost its persuasive power. If anything, a kind of reverse statement would make more sense: certain forms of mass culture with their obsession with gendered violence are more of a threat to women than to men. After all, it has always been men rather than women who have had real control over the productions of mass culture.

In conclusion, then, it seems clear that the gendering of mass culture as feminine and inferior has its primary historical place in the late 19th century, even though the underlying dichotomy did not lose its power until quite recently. It also seems evident that the decline of this pattern of thought coincides historically with the decline of modernism itself. But I would submit that it is primarily the visible and public presence of women artists in *high* art, as well as the emergence of new kinds of women performers and producers in mass culture, which make the old gendering device obsolete. The universalizing ascription of femininity to mass culture always depended on the very real exclusion of women from high culture and its institutions. Such exclusions are, for the time being, a thing of the past. Thus, the old rhetoric has lost its persuasive power because the realities have changed.

Notes

1. Gustave Flaubert, *Madame Bovary*, trans. Merloyd Lawrence (Boston: Houghton Mifflin, 1969), p. 29.

2. Flaubert, p. 30.

3. Cf. Gertrud Koch, "Zwitter-Schwestern: Weiblichkeitswahn und Frauenhass—Jean-Paul Sartres Thesen von der androgynen Kunst," in *Sartres Flaubert lesen: Essays zu Der Idiot der Familie*, ed. Traugott König (Rowohlt: Reinbek, 1980), pp. 44–59.

4. Christa Wolf, *Cassandra: A Novel and Four Essays* (New York: Farrar, Straus, Giroux, 1984), p. 300f.

5. Wolf, *Cassandra*, p. 301.

6. Wolf, *Cassandra*, p. 300.

7. Stuart Hall, paper given at the conference on mass culture at the Center for Twentieth Century Studies, Spring 1984.

8. Theodor W. Adorno, "Culture Industry Reconsidered," *New German Critique*, 6 (Fall 1975), 12.

9. Max Horkheimer and Theodor W. Adorno, *Dialectic of Enlightenment* (New York: Continuum, 1982), p. 141.

10. Max Horkheimer and Theodor W. Adorno, "Das Schema der Massenkultur," in Adorno, *Gesammelte Schriften,* 3 (Frankfurt am Main: Suhrkamp, 1981), p. 305.

11. Siegfried Kracauer, "The Mass Ornament," *New German Critique*, 5 (Spring 1975), pp. 67–76.

12. Sandra M. Gilbert and Susan Gubar, "Sexual Linguistics: Gender, Language, Sexuality," *New Literary History*, 16, no. 3 (Spring 1985), 516.

13. For an excellent study of male images of femininity since the 18th century see Silvia Bovenschen, *Die imaginierte Weiblichkeit* (Frankfurt am Main: Suhrkamp, 1979).

14. Teresa de Lauretis, "The Violence of Rhetoric: Considerations on Representation and Gender," *Semiotica* (Spring 1985), special issue on the Rhetoric of Violence.

15. Edmond and Jules de Goncourt, *Germinie Lacerteux,* trans. Leonard Tancock (Harmondsworth: Penguin, 1984), p. 15.

16. *Die Gesellschaft*, 1, no. 1 (January 1885).

17. Cf. Cäcilia Rentmeister, "Berufsverbot für Musen," *Ästhetik und Kommunikation*, 25 (September 1976), 92–113.

18. Cf., for instance, the essays by Carol Duncan and Norma Broude in *Feminism and Art History*, ed. Norma Broude and Mary D. Garrard (New York: Harper & Row, 1982) or the documentation of relevant quotes by Valerie Jaudon and Joyce Kozloff, "'Art Hysterical Notions' of Progress and Culture," *Heresies*, 1, no. 4 (Winter 1978), 38–42.

19. Friedrich Nietzsche, *The Case of Wagner*, in *The Birth of Tragedy and the Case of Wagner*, trans. Walter Kaufmann (New York: Random House, 1967), p. 161.

20. Nietzsche, *The Case of Wagner*, p. 179.

21. Friedrich Nietzsche, *Nietzsche Contra Wagner*, in *The Portable Nietzsche*, ed. and trans. Walter Kaufmann (Harmondworth and New York: Penguin, 1976), pp. 665f.

22. Nietzsche, *The Case of Wagner*, p. 183.

23. Nietzsche, *Nietzsche Contra Wagner*, p. 666.

24. For a recent discussion of semantic shifts in the political and sociological discourse of masses, elites, and leaders from the late 19th century to fascism see Helmuth Berking, "Mythos und Politik: Zur historischen Semantik des Massenbegriffs," *Ästhetik und Kommunikation*, 56 (November 1984), 35–42.

25. An English translation of the two-volume work will soon be published by the University of Minnesota Press.

26. Gustave Le Bon, *The Crowd* (Harmondworth and New York: Penguin, 1981), p. 39.

27. Le Bon, p. 50.

28. Le Bon, p. 102.

29. Naturalism is not always included in the history of modernism because of its close relationship to realistic description, but it clearly belongs to this context as Georg Lukacs never ceased to point out.

30. On the relationship of the production/consumption paradigm to the mass culture debate see Tania Modleski, "Femininity as Mas(s)querade: A Feminist Approach to Mass Culture," forthcoming in Colin MacCabe, ed., *High Theory, Low Culture*, University of Manchester Press.

31. Clement Greenberg, "Avant-Garde and Kitsch," in *Art and Culture: Critical Essays* (Boston: Beacon Press, 1961), p. 5f.

32. Letter of March 18, 1936, in Walter Benjamin, *Gesammelte Schriften*, 1, 3 (Frankfurt am Main: Suhrkamp, 1974), p. 1003.

33. T. S. Eliot, *Notes towards the Definition of Culture*, published with *The Idea of a Christian Society* as *Christianity and Culture* (New York: Harcourt, Brace, 1968), p. 142.

34. For a discussion of the neo-conservatives' hostility toward postmodernism see the essay "Mapping the Postmodern."

35. While critics seem to agree on this point in theory, there is a dearth of specific readings of texts or art works in which such a merger has been attempted. Much more concrete analysis has to be done to assess the results of this new constellation. There is no doubt in my mind that there are as many failures as there are successful attempts by artists, and sometimes success and failure reside side by side in the work of one and the same artist.

36. On this distinction between late 19th-century modernism and the historical avantgarde see Peter Bürger, *Theory of the Avant-Garde* (Minneapolis: University of Minnesota Press, 1984).

37. Cf. Gislind Nabakowski, Helke Sander, and Peter Gorsen, *Frauen in der Kunst*, 2 volumes (Frankfurt am Main: Suhrkamp, 1980), especially the contributions by Valie Export and Gislind Nabakowski in volume 1.

38. I owe this critical reference to Baudrillard to Tania Modleski's essay "Femininity as Mas(s)querade."

CHAPTER 2
INTRODUCTION TO *THE GENDER OF MODERNISM*
*Bonnie Kime Scott**

A landmark anthology in the history of modernist studies, Bonnie Kime Scott's *The Gender of Modernism* brought together a vast array of overlooked and underread source texts in order to redirect a field of study that had been "gendered masculine" for decades. The reasons why modernism had been formulated in such a way are readily apparent now, from the mythology of the Men of 1914 to the portraits of mass culture as feminine and weak. Scott harnesses the energies of feminist and women's studies and brings them to bear on a field that, perhaps more than any other, had denied the contributions of non-male figures. Indeed, even notable exceptions like Woolf and Stein confirmed the rule, since they were allowed into the modernist canon precisely because their works were said to share formal, non-gender specific aesthetic qualities with those of their already-codified male counterparts.

Operating with a belief that "in relation to gender, modernism has a great deal of unassessed vitality in form and content, with its own intricate and varied theory," Scott allows her anthology to perform recuperative recovery work while simultaneously reckoning with the effects of a male-dominated canon—a canon that, by that point, had been both venerated and castigated. A crucial effect of this synthesis of 1970s and 1980s feminist criticism with early twentieth-century women's texts was to reframe a number of modernist figures—Woolf and Stein, certainly, but also Djuna Barnes, Zora Neale Hurston, Mina Loy, Rebecca West, and many others—as engaged in diverse projects of first-wave feminism. *The Gender of Modernism* revealed both vivid continuities and telling disjunctures between the work of suffragettes and women's studies founders in the academy, for instance.

More broadly, explorations of écriture feminine now could more fully consider modernist writing, while women who were known less for their works and more for their patronage, editorship, and publishing became more than enabling figures in the background of male modernists' achievements. Finally, Scott includes an image, "A Tangled Mesh of Modernists," that became a staple of modernist literature courses in universities, and that has been reproduced countless times in a variety of publications (including in our own book, *Modernism: Evolution of an Idea*). The image connects both men and women in endlessly crisscrossing circuits, furthering the point that gender in modernism is not an issue that can be treated apart from considerations of modernism writ large. Misogynists like Pound are only degrees apart from both men who explored women's intellectual and embodied worlds sympathetically (like Joyce, and arguably Lawrence), and from women who were at the forefront of gender-based activism. Theorists of women's writing stand next to household names and overlooked figures alike. *The Gender of Modernism* may well have done more than any other text in modernist studies not only to recast a broad-based understanding of the field, but also to reshape syllabi, whether in introductory courses or graduate seminars. The archive of modernism that seemed so restricted and ossified to Huyssen was now connecting even more nodes than Scott's image could capture.

*From Bonnie Kime Scott, *The Gender of Modernism: A Critical Anthology*. Indiana University Press, ©1990. Reproduced here with permission.

Was it wisdom? Was it knowledge? Was it, once more, the deceptiveness of beauty, so that all one's perceptions, half way to truth, were tangled in a golden mesh? or did she lock up within her some secret which certainly Lily Briscoe believed people must have for the world to go on at all? . . . She imagined how in the chambers of the mind and heart of the woman who was, physically, touching her, were stood, like the treasures in the tombs of kings, tablets bearing sacred inscriptions, which if one could spell them out, would teach one everything, but they would never be offered openly, never made public. What art was there, known to love or cunning, by which one pressed through into those secret chambers?

—Virginia Woolf, *To the Lighthouse 78–79*

1. Toward a Gendered Reading of Modernism

While Virginia Woolf certainly did not intend to provide a parable for a modernist anthology in this evocation of a woman artist's desire, she might be describing the experience of archival explorers of the late twentieth century as they relocate lost and neglected textual treasures and draw connections between them. Modernism as we were taught it at midcentury was perhaps halfway to truth. It was unconsciously gendered masculine. The inscriptions of mothers and women, and more broadly of sexuality and gender, were not adequately decoded, if detected at all. Though some of the aesthetic and political pronouncements of women writers had been offered in public, they had not circulated widely and were rarely collected for academic recirculation. Deliberate or not, this is an example of the politics of gender. Typically, both the authors of original manifestos and the literary historians of modernism took as their norm a small set of its male participants, who were quoted, anthologized, taught, and consecrated as geniuses. Much of what even these select men had to say about the crisis in gender identification that underlies much of modernist literature was left out or read from a limited perspective. Women writers were often deemed old-fashioned or of merely anecdotal interest. Similar limiting norms developed in the contemporaneous Harlem Renaissance, which enters the scope of modernism as presented in this anthology.

What is the "art . . . , known to love and cunning," with which we press into forgotten modernist territory? Since the late 1920s, when Woolf sent Lily Briscoe searching through the pages of *To the Lighthouse* and supplied us with her own study of gender and women writers, *A Room of One's Own*, we have been offered new theories to use in the art of feminist criticism. These theories come from many disciplines, including psychoanalysis, psychology, linguistics, anthropology, sociology, and history, and have been reconceptualized and combined across the disciplines through feminist perspectives.[1] Since the early 1970s, scholars in women's studies have been investigating the marginalized archive of women writers and have made the case for women's having a literary tradition (or traditions) of their own. The supply of women's texts has brought into question the adequacy of the previous canon, disrupting it and questioning canon formation itself. In the 1980s, without abandoning the project of recovering women writers, women's studies gained theoretical range and depth by turning to the concept of gender.

Gender is a category constructed through cultural and social systems. Unlike sex, it is not a biological fact determined at conception. Sociology has long discussed sex roles, the term *roles* calling attention to the assigned rather than determined nature of gender. The latter term is gradually and appropriately replacing *sex* in the designation (see Anderson, listed in the Selected Bibliography). Gender is more fluid, flexible, and multiple in its options than the (so far) unchanging biological binary of male and female. In history, across cultures, and in the lifetime development of the individual, there are variations in what it means to be masculine, or feminine, in the availability of identifications such as asexual and androgynous, and in the social implications of lesbian,

homosexual, and heterosexual orientations. French feminist theories make constant reference to gender as they study the position of the psychoanalytic subject in relation to family romance and related theories of language and difference. In moving on from the Freudian emphasis on masculine, Oedipal norms and events in the family, there has been increased attention to a maternal, pre-Oedipal stage of identification. In language the semiotic category related to the maternal body and babble now commands attention as the pre-text for symbolic language associated with the phallus and the law of the father (see Kristeva, Cixous).

Gender coexists and interacts with other categories. Its interaction with sexual orientation has already been suggested. Additional implicated categories are class, race, nation, economic stature, and family type. Hence we cannot properly deal with gender in isolation but should see it as one of many layers of identification. By using gender as a theoretical category, we are also encouraged to think about the structure of categorical systems, the number of variable positions they entertain, and the permeability of boundaries within and between them.

Gender is not a mask for feminist or woman, though they are inextricable from it. Both men and women participate in the social and cultural systems of gender, but women write about it more, perhaps because gender is more imposed upon them, more disqualifying, or more intriguing and stimulating to their creativity. The present predominance of women theorists and women's writing in gender studies does not undermine the gender concept; it is better seen as historical, built upon patterns of gender asymmetry. The gender of modernism in this anthology may seem to be feminine, but the real intent of the text is to demonstrate that modernism was inflected, in ways we can only now begin to appreciate, by gender.

Our critical generation did not invent gender as a literary concept. Essays included in this anthology demonstrate that modernists themselves attached labels such as "virile" and "feminine" to the new writing as they reviewed it, attributing different meanings and values to the terms. The practice is as old as literary criticism in English, which dates back to the eighteenth century. The Victorians certainly worked with paradigms of gender, and there are excellent studies of gender in Victorian myth (Nina Auerbach, *The Woman and the Demon*) and of its effects on the identity of the woman writer (Sandra Gilbert and Susan Gubar, *The Madwoman in the Attic*). Women writers of the nineteenth century have been granted eminence in one genre (the novel), which their twentieth-century sisters have not. To date, critical considerations of gender in the moderns have emphasized malady and violence. Elaine Showalter (A *Literature of Their Own*) has seen Virginia Woolf as a writer in psychological retreat, and sex war is a dominant scenario in Gilbert and Gubar's *No Man's Land*.[2] This anthology is assembled in the belief that, in relation to gender, modernism has a great deal of unassessed vitality in form and content, with its own intricate and varied theory.

When we turn in our research from a few masters and movers of modernism to its forgotten, gender-inflected territories, we may suspect, like Lily Briscoe, that we are tangled in a "golden mesh." The connecting strands of association between modernists are more numerous than we suspected; they vibrate with sexual energies and anxieties. We read neglected genres, encounter uncertain quests for gender identity, and find confusing content that was not previously analyzed— and perhaps not even detected, since it was encoded at its conception to pass the censors of self and society. Gender, layered with other revised conceptual categories such as race and class, challenges our former sense of the power structures of literary production. We suspect that modernism is not the aesthetic, directed, monological sort of phenomenon sought in their own ways by authors of now-famous manifestos—F. T. Marinetti (futurism), Ezra Pound (imagism and vorticism), T. E. Hulme (classicism), Wyndham Lewis (vorticism), T. S. Eliot ("Tradition and the Individual Talent"), and Eugene Jolas (the "revolution of the word")—and perpetuated in new critical-formalist criticism through the 1960s.[3] Modernism as caught in the mesh of gender is polyphonic, mobile, interactive, sexually charged; it has wide appeal, constituting a historic shift in parameters.

2. Toward a New Scope for Modernism

While the word *modernism* appears in the title of this book, the editors involved in this project have worked restively with it, and introductions to specific authors repeatedly manipulate the term.[4] The "experimental, audience challenging, and language-focused" writing that used to be regarded as modernism becomes for some of our editors a gendered subcategory—"early male modernism" (Lilienfeld, section 2), for example, or "masculinist modernism" (Schenck, 15). None of the editors is particularly interested in fitting neglected figures into what is now seen as a limited definition, though there are discussions of the ways in which Djuna Barnes, Mina Loy, and Marianne Moore were admitted to the "male" category to the neglect of important feminine or feminist elements in their work (Broe, 1; Burke, 11; Brownstein, 16).

Virginia Woolf suggested another subcategory of modernism in the 1930s' "outsider's society" of *Three Guineas* (see Silver, 26), a group that relates to the female writers who predominate in this anthology but also speaks to the marginalities of class, economics, and exile. The existence of her term and the presence of *society* in it suggest rudimentary group identification and organization that combine or cross categories of identification.

Black writers, though seldom discussed by the "makers" of modernism, were involved in the movement. As we overlap the concept of the "New Negro" with traditional descriptions of modernism, it is possible to see that women writers could be excluded by definition from both groups. For example, Jessie Redmon Fauset might be rejected from modernism because her style is perceived as old-fashioned and from the "New Negro" group defined by Alain Locke because she had northern, urban origins (see Wall, 6). Black writers experience their own systems of geographic difference, linguistic definition, and affiliation to literary predecessors and movements, and these systems have striking parallels to traditional modernism. White writers also contribute to the modernist treatment of race. H. D. writes about the social dynamics of crossing the borderlines of race, particularly in sexual encounters, in describing *Borderline*, a film she made with Paul Robeson. Nancy Cunard writes about her mother's racial prejudice against her intimate friend, black jazz pianist Henry Crowder (see "Black Man and White Ladyship"). Fascination with blacks alternates with self-confessed racism in a letter from Ezra Pound to Marianne Moore.

Another set of writers have doubly marginal status as colonials. Katherine Mansfield, Jean Rhys, and Anna Wickham may have been quite interested in new literary endeavors, but they had their own special problems connecting with the literary establishment and deciding when (and if) native content should enter their texts. The issue takes on increased importance when we consider modernist interest in anthropology and the "primitive."

The consideration of a nonexperimental group of writers, alongside the more traditional experimental canon, challenges language-centered interpretations of modernism favored in the canonization process from Ezra Pound to Julia Kristeva (see Schenck, 15). Their presence helps us detect other breaks with tradition, such as the treatment of lesbian sexuality and women's critiques of fascism and war.

The volume's limitation to English-language texts, British and American writers, and the period roughly from 1910 to 1940 is a practical matter. We are aware that this narrowing excludes contemporary Europeans, later Latin American writers, and authors writing in French, such as Natalie Barney and Renee Vivien. Translations of French, Latin, Greek, and Oriental texts—expert ones by Sylvia Beach and Maria Jolas, for example, as well as the Chinese and Japanese translations by Ezra Pound—lie beyond our present range and analysis. The categories of nationality and literary period invoked here are arguably the products of patriarchy. Several anthologized authors were already struggling with national identity and modern period; they reported their perceptions of difference in Italy, Spain, Vienna, Berlin, or Harlem, saw the world sink twice into major wars

among nations, and found themselves as Americans and colonials alienated and in exile from home or tradition.

Periodization has been challenged as an organizational concept by feminist theory. If we can question whether the Renaissance was a renaissance for women or suggest (as Woolf did) that the advent of the middle-class woman writer was a revolution (*A Room of One's Own* 68), we can also rethink the supposed liberations of modernism or the relation of the Great War to literature. Did the formal innovations advanced by modernism and the phallic metaphors used to express them suit women writers as well as they did men? Did the supposed sexual freedom and newly won political franchise allow women power and creative dimension in the literary field? Or did they create burdensome, reactionary resistances or limited assignments in the publishing world? How did the Great War, which has generally been seen as a deep influence on modernist views of the world, have different effects on men and women writers? Men who went to the front, some experiencing injury and death, such as Rupert Brooke, Siegfried Sassoon, Ernest Hemingway, and Ford Madox Ford, became the canonized authors on the war. As noncombatants, women went into munitions factories and battlefield hospital units, both as workers and as reporters; they brooded on the home front, both experiencing and writing dream fantasies of traversing blood-sodden battlefields and losing their own limbs. But the journalism, stories, and poems on war and pacifism by such writers as Antonia White, Rose Macaulay, and Rebecca West have been neglected. D. H. Lawrence's reactions to women's postwar behavior (in "Cocksure Women and Hensure Men") give another gender-inflected view of the home front in this period.

The 1920s are represented in many of the texts included here as a time of excitement and new freedoms, particularly for women. There were communities of writers who met in Sylvia Beach's bookshop or Gertrude Stein's rooms in Paris, in the vicinity of Washington Square in Greenwich Village or Seventh Avenue in Harlem; there were predominantly women's communities such as Natalie Barney's salon on Rue Jacob and Peggy Guggenheim's Hayford Hall in England, places where lesbian and gay sexuality was tolerated, sometimes celebrated, and often textualized (see Benstock, *Women of the Left Bank*). The international set of cities associated with modernism offered mobility in class, variety in living arrangements (often at cheap prices for expatriates), and access to publication. Nella Larsen's upbeat, urban, "modern woman" image (see Davis, 9) might be applied to many of the women writers and their female characters in this collection—Djuna Barnes, Nancy Cunard, Jessie Redmon Fauset, Zora Neale Hurston, Mina Loy, Katherine Mansfield, Rebecca West. But accounts of Mansfield in Eliot's letters or Woolf's diaries suggest that what went as bold feminine modernity could be met with contempt. The glamour of Cunard, Barnes, and West (which they helped create) attracted more attention in the press than their literary work did. Long periods of literary silence, laborious rewriting, and isolation are more representative of the lives of Barnes and Jean Rhys than the bright life of the 1920s.

The year 1940 has served as a typical terminal date for studies of modernism (some end with 1930). By that time, the major experimental works, such as *The Waste Land*, *Tender Buttons*, *The Waves*, and *Finnegans Wake*, had appeared and death had claimed Lawrence, Mansfield, and Yeats; Woolf and Joyce were dead by early 1941. The world changed again sharply with World War II. Letters continued to circulate, assessing the times the writers had shared, our most poignant example being Cunard's 1946 letter to Ezra Pound. Rhys, Barnes, and Warner resurfaced with late, much-revised work, as attested in this anthology. West never stopped publishing, though she lost her visibility with American audiences and turned away from her early radicalism. She allows us to imagine what the changes in culture might have done to other modernists had they lived into the 1980s. She has long-distance perspective on the importance given to modernist organizers such as Pound ("Spinster to the Rescue"). Interrupted careers, like interrupted influence, tell us a great deal about the politics of literary production, a politics we enter in our recovery work.

3. Issues of the Canon

This volume deliberately features women writers, without strictly limiting itself to them—a decision in line with the current profile of gender studies. In their critique of culture, modernist women persistently bring up issues of gender, whereas men assert that the masculine is what should be advanced, whoever writes it (see Burke, 11), and are not particularly interested in seeing this attitude as gender-conditioned. The separatist treatment of women that flourished in the 1970s remains defensible. It is useful when one is hypothesizing a women's tradition (see Showalter, *A Literature of Their Own*) or attempting to release women's creativity from male influences (see Cixous, "The Laugh of Medusa"). It responds to the opposite tendency in traditional anthologies and studies of modernism. It was the "men of 1914" (T. S. Eliot, James Joyce, Ezra Pound, and Wyndham Lewis) whom Lewis proclaimed in the revolutionary manifestos of *Blast* and its successors, and Pound for whom Hugh Kenner named the modernist era (*The Pound Era*). In 1965, to provide backgrounds for their students' study of the moderns, Richard Ellmann and Charles Feidelson assembled *The Modern Tradition*. Of its 948 pages, fewer than nine were allotted to women writers (George Eliot and Virginia Woolf). In a contemporary review of the volume, Frank Kermode was surprised to find "amazingly little sex (which might have had a section of its own)" (68). While Kermode does not elaborate on what he means by "sex," if social relations between the sexes are included, his comment relates to our concern to write gender into modernism. While modernist studies are rolling off the presses at an unprecedented rate, a surprising number still find interest only in canonized males.[5]

By including five male figures intricately involved in writing with women or on gender, we resist both determinism by sex and reversed neglect. There are brief selections from Eliot, Joyce, and Lawrence in the anthology, and they document personal and cultural constructions of femininity and masculinity. Pound has an extensive section, as is appropriate to the complexity of his involvement in forms and politics of gender, including his male genital models of creativity and his initial sponsoring of numerous women's writing careers (see Bush, 17). Hugh MacDiarmid has had his own problems with marginal omission from the canon and with the English language as a medium for Scottish experience—a pattern offering parallels with female marginality (Gish, 13). By featuring twenty-one women writers we are saying that the presence of women in modernism has been vastly underestimated. And the process of writing women into modernism must go on from here.

A compensation for the fact that we had to limit the number of authors given sections in the anthology is that those included are often connected to someone omitted by an anthologized letter or review or by a comparison offered in an introduction. Richard Wright appears in Hurston's reference to his abusive review of her own *Their Eyes Are Watching God* and in her review of his *Uncle Tom's Children*. As a literary editor of the *Crisis*, Jessie Fauset draws our attention to Langston Hughes, Arna Bontemps, and Jean Toomer, whose careers she fostered, and to Georgia Douglas Johnson and Anne Spencer, who were ranked among the best in an anthology she was reviewing. Amy Lowell comes to us through her correspondence with Marianne Moore and Lawrence. We meet Bryher and Elizabeth Bishop through Moore. Editors of influential reviews, who were frequently writers as well, are cited (often for several authors) in introductory essays and letters: Ford Madox Ford (*English Review, transatlantic review*), Dora Marsden and Harriet Shaw Weaver (*Freewoman, Egoist*), John Middleton Murry (*Athenaeum, Adelphi*), Harriet Monroe (*Poetry*), and Margaret Anderson (*Little Review*). As in most anthologies, some of our gaps are due to prohibitive permissions costs and other restrictions. Poetry and uncollected manuscripts destined for "complete works" projects presented special problems. Ironically, the welcome reprinting of the works of modernist women writers in recent years has added to the cost of anthologies in the field. *The Gender of Modernism* does not pretend to have reached and opened all of modernism's "secret chambers," but it tests

important terms and provides basic textual resources for ongoing explorations and reconceptions of this revolutionary set of writings.[6]

4. Feminist Collaboration

Each section of this volume is edited and introduced by a scholar familiar with the author presented therein, accustomed to doing archival study, and interested in pursuing feminist criticism. The contributing editors have chosen the primary texts to be included. They were encouraged to select and discuss works that offer women writers' theories of writing or illuminate neglected dynamics and concepts of gender in literary forms and production. Contributing editors did some reshaping of the original guidelines, noting that some authors are much more willing than others to embrace feminism or to engage in theoretical construction and debate.

Selected authors are not limited to feminist activists and theoreticians. There is a preponderance of what could be considered marginal genres—essays, book reviews, interviews, letters, diaries, sketches, even notebooks. Autobiographical entries by White and Rhys contribute to a feminist reinterpretation of that genre, and we recover forgotten plays by Barnes. The volume thus offers a shift in emphasis from the privileged genres of the novel and—particularly in modernist definition—poetry. It makes our offerings very different from those included in the modernist section of Sandra Gilbert and Susan Gubar's very useful *Norton Anthology of Literature by Women*.

Contributing editors argued that some authors were not in a position to write reviews or that their most relevant and revolutionary statements on gender and writing were accessible through their fiction and poetry, hence the appearance of gender-laden excerpts from novels and selected poetry. In the case of Rhys, we offer a fatal version of an abortion story (*Voyage in the Dark*, the original of part 4; see Howells, 18) that was suppressed by Rhys's male publisher. The suppression of elements of the confession of Dr. O'Connor, the bisexual, transvestite hero of Barnes's *Nightwood*, by T. S. Eliot, who sponsored it in his publishing house, comes under discussion (Gish, 5). The volume also compensates for the failure of H. D's prose (*Notes on Thought and Vision*) to see print until the early 1980s, despite the welcome her more programmatic imagist poetry received (see Friedman, 4).

Our nineteen scholars offer feminist theoretical diversity and attend to varied presences of gender in a broad spectrum of modernist writers. Feminist theoretical approaches are entertained in each introduction, often tailored to the writer in question (e.g., Hanson's discussion of "greatness" in Mansfield, 14; Squier's attention to women writers and pacifism in her introduction to Macaulay, 12; Gish's discussion of gender and vernacular in relation to MacDiarmid, 13; Marcus's contrast of the Catholic experience of confession in White and Joyce, 24). With quite a few authors, it is possible to trace historical attitudes toward gender both in their writing and in the criticism of it (see, for example, DeKoven on Stein, 21, and my introductions to Joyce, 8, and Lawrence, 10). The nature of the project—its organization by author and its attention to archives—encourages empirical, experiential, biographical, historical methodologies often identified with Anglo-American critics.[7] Yet once contributing editors get to their introductions of primary texts, the semiotics and psychoanalytic paradigms often associated with French feminist approaches come into use (see, for example, Hanson on Mansfield, 14, and Brownstein on Moore, 16).

5. Connections

The value of literary connections, for anything from creative stimulation to contact with publishers, seems indisputable. Having assembled texts on and by twenty-six authors related to problems

of gender and modernism, it seems worthwhile to explore the connections that emerge among them. In the accompanying figure, the names of authors treated in sections of this anthology were arranged in alphabetical order counterclockwise in a circle (a shape and sequence chosen to discourage hierarchical thinking). Each time an important connection was made in an introduction or a primary work in the anthology, a line was drawn between the writers. The resulting figure calls to mind Woolf's "golden mesh," a web, or a ball of yarn. It offers a table of contents at a glance and reminds us of the pluralistic interest and cooperative format of this volume. Authors and editors who were not assigned their own section of the volume but whose names occur in several introductions or primary texts have their names printed in lower case. Appearing like a surrounding aura, placed for minimal confusion close to their connected authors, they merit an anthology of their own.

This mesh or web can be followed or read in numerous ways. One could count how many strands emerge from a given author as a gauge of "importance," though this can lead to conservative results. Predictably, such a count favors Pound, the supremely active formulator and talent hunter of modernism; Joyce, whose *Ulysses* was considered by many the central text of modernism; Eliot, institutionalizer of modernism; and Woolf, who probably satisfies more traditional definitions of modernism than any other woman writer in the mesh. These patterns indicate in part that this study takes off from inherited formulations, where both authors and scholars have lived in patriarchy.[8] But there are surprises, such as the extraordinary number of connections to Marianne Moore. There are other revelations. One pattern readily apparent is that women writers took a great deal of interest in one another: a strand quite regularly indicates an appreciative review (West—Woolf, H. D.—Moore, Larsen—Fauset) or an attempt to define contemporary writing through a female writer (Richardson, Sinclair). Not all strands lead to Eliot, Pound, and Joyce. May Sinclair provides introductions to Richardson and H. D. that stand up well to anything written to the present day. A strand from Moore to another woman writer may indicate a different manner of review than she would have written for a man (see Brownstein, 16). The H. D. and Marianne Moore sections let us sample the network of significant correspondence among modernist women writers. Other important female relationships go beyond the sensitivity of the figure. These include Moore's very close identification with her mother and her choice of celibacy, Cunard's repudiation of her mother's racism and class, and Barnes's rapport with a woman (Helen Westley) in the context of an interview.

Connection between a female and a male figure may mean several things. Mansfield seems to have perceived a need for male protection from sexual exploitation, in addition to the access men provided to publication (Hanson, 14). Evidence of sexual exploitation comes in the public image constructed for Barnes, Mansfield, Loy, and West, who are noted for beauty or sensuousness in contemporary reviews and letters. Cunard lashes out at the press for its sexist, racist sensationalizing of her relationship with Henry Crowder ("Black Man and White Ladyship"). The tendency to sensationalize the biography of women writers rather than to explore their works with care is pointed out in the introduction to Stein (De Koven, 21); it is a problem shared by West and Mansfield.

There is a more positive side to women's connections to men. Female modernists did write defenses of men and their literary movements (Sinclair and Moore on Eliot and Pound; Richardson and Loy on Joyce). In the case of Nella Larsen, there is a list of modern male writers, admired in her reading, which she uses to defend the style of her important male mentor, Walter White. These writings remind us of the attacks modernist men sustained from conservative reviewers and the alliance experimental women writers could feel with them.

There are also critiques and appreciations of a slightly older generation of male writers (H. D.—Yeats, Richardson—Wells, Woolf—Bennett, Galsworthy, Wells). Parodies of prominent modernist men such as Eliot and Hemingway are offered by Macaulay, Stein, and Woolf. Points of departure are declared in Loy's own brand of futurism, where she emphasizes amplitude of consciousness that Marinetti did not consider (Burke, 11), and in Cunard's diatribe against what Pound had become with his connection to Italian fascism. The Fascist leanings of major male modernists come in for

scrutiny (Friedman, 4). It is important to review the careers of Pound and Lawrence by periods, for both their relations to women writers and their actual gendered imagery alter over time (Bush, 17; Scott, 8). Finally, women as editors and subeditors published male writers (Cunard—Pound and men of the Harlem Renaissance; Margaret Anderson, Sylvia Beach, and Dora Marsden—Joyce; Lowell—Lawrence; Moore—William Carlos Williams). The individualist, vitalist theory of Marsden was attuned to the contemporary projects of Pound and Joyce (Bush, 17).

Some writers have relatively few connections, suggesting a position of layered marginality discussed in numerous introductions to authors, including Rhys and Cather. The existence of a few links between black and white writers (Cunard—Hurston, H. D.—Paul Robeson, Larsen—Van Vechten, Fauset in Paris) is certainly a pattern worth pursuing, both in the anthology and beyond (see Friedman on Cunard, 3). Isolation and selection by sexual orientation and social class can also be read in the mesh. The tangled intricacy of the connections visible in the small sample of interactions available in this anthology suggests that our understanding of modernism depends on an inadequate number of sources and is accordingly sketchy and oversimplified.

6. Modernist Form

A major goal of this anthology is that neglected viewpoints of modernists on their own aesthetic projects should now be known and taken up. The terms *modernist* and *modernism* are used in the complex analyses of H. D. and Mina Loy. H. D. offers us a critical history of imagism, including Pound's maneuverings in and out of the practice. The anthology contains theoretical texts by Gertrude Stein which, though they demand attention, are quite readable. One of them was first addressed to an American student audience. Stein finds in Moore an image that is both frail and absolutely hard, this alloy outlasting the girders and skyscrapers one might associate with the formulas of Pound, Lewis, and the futurists. There are two classic essays ("Modern Fiction" and "Mr. Bennett and Mrs. Brown") in which Virginia Woolf declares the modern departure from Edwardian "materialists" and liberation from an enslavement of the author to conventions. May Sinclair writes excellent introductions to the techniques of psychological novelists. She provides the term *stream of consciousness* for analysis of Dorothy Richardson's narrative. Woolf offers a countertheory of tradition, toppling the priesthood of critics suggested in the criticism of T. S. Eliot (Silver, 26), and Rebecca West questions the authority of Eliot's criticism as too dependent on sober manner and repeated formulas.

Genre and the relation of writing to other arts are among the most interesting topics that can be pursued with the evidence of this anthology. Marginality by genre afflicted Rose Macaulay and Katherine Mansfield as writers of the short story and essay (see Squier, 12, and Hanson, 14). Rebecca West wrote in forms that combined so many genres (travel literature, history, psychobiography, crime reportage) that they fell between the critical cracks (see Scott, 123), though she appreciated the poetry of the modernist prose of Woolf ("High Fountain of Genius"). H. D. was discouraged in her attempts to find her own form of essay prose-poem ("Notes on Thought and Vision") by Pound and sexologist Havelock Ellis (Friedman, 4); these same essays seem very advanced today. Hurston and Cunard had as much interest in folklore as in literature. Richardson and H. D. were remarkable reviewers of film, as shown in work that originally appeared in the journal *Close Up*. The film frame became a means of talking about literary technique for Stein and Woolf, and Richardson assigned the silent film to a feminine order of "being," as opposed to the spoken domain of "The Film Gone Male." Numerous authors worked beyond the boundaries of writing. Loy, Lawrence, and Barnes were artist-writers. Fauset and Cunard promoted illustrators' work in the volumes they edited. Stein, Woolf, and Cunard had significant art collections and contacts with artists (Stein—Pablo Picasso; Woolf—Roger Fry, the Bells and post-impressionism;

Cunard—African art). Music and dance were important to Joyce, Hurston, Pound, Richardson, and Cunard. Since modernism found expression in many arts, it is useful to follow literary authors into them. This is possible in the anthologized selection of Barnes's drawings, all rich in their interpretation of gender.

One striking aspect of H. D., Mansfield, Loy, Moore, Stein, and Woolf is their feminist critical thinking on language, the unconscious, and realistic representation. They anticipate French feminist psychoanalytic and linguistic approaches and offer texts that write the erotics of the female body. H. D. and Pound assign gendered metaphors to the creative process. The feminine to Pound is chaos; to H. D., the womb, dung, and jellyfish are feminine sources of creativity. While gender lay deeply encoded in H. D.'s early imagist work, she moved on to female voiced and perceived rewritings of classical myths and self-reflexive psychological studies that turned writing into self-healing (Friedman, 4). Nella Larsen uses restless travel, racial "passing," and psychological doubles to explore the bewildering array of shifting possibilities for modern women (see Davis, 9). As for constructs of the mind, Mina Loy focuses on the capacity of consciousness and calls the unconscious "a rubbish heap of race tradition." H. D. offers a construct of body, mind, and overmind (a state of "super-feeling" comparable to the reach of jellyfish tentacles). Loy discusses Joyce's *Ulysses* in terms of phallus and "sanguine introspection of the womb," anticipating Lacanian terminology. D. H. Lawrence deals in the assignment of separate spheres and considers, with vastly different conclusions than those of West and Richardson, the impact of women on the world of work (and vice versa). The question of whether there is a feminine style of writing interests authors as diverse as MacDiarmid, Richardson, Mansfield, and Eliot—a discussion where punctuation is frequently at issue; Richardson allows Joyce's Molly Bloom to testify.

Character is an important theoretical topic that divided Virginia Woolf and the Edwardians ("Mr. Bennett and Mrs. Brown"). One recurrent consideration with special reference to gender is the author's attitude toward "woman consciousness," to use Richardson's term. A view of the greatness of feminine modes and experiences is expressed by Mansfield and shared in Woolf's definition of life ("Modern Fiction" and "Mr. Bennett and Mrs. Brown"). Richardson resists the man-trained woman, as in effect does Lawrence; on the other extreme, Richardson would rather have woman taken as a fellow pilgrim than as mother nature or queen of heaven. H. D. and Jean Rhys have very different attitudes toward female victimization, the former resisting it as an image of Joan of Arc. As Coral Howells points out, Rhys repeats it in her stories of women falling victim to their own and male romantic fantasies. Diane Gillespie notes that Sinclair brings psychological, philosophical, and mystical considerations to a study of ways that people, and particularly women, fail to reach their potential in society

When it comes to the much-discussed question of modernist language, the anthologized authors have different attitudes toward words. Stein declares a "words period," seeks the exact word, and is commended by Loy for offering "the word in and of itself." "Lively words" is the phrase used to articulate her style (DeKoven, 21). Repetition of words is essential to her writing. Rhythmic repetition shows up again in H. D.'s review of Dreyer. Pound assigns Moore and Loy to a type of poetry concerned with language, logopoeia (discussed by Bush, Brownstein, and Burke). In contrast to the imagist impulse to pare down to hard exactness, in her nonapologetic explanation of "Negro Expression," Hurston introduces an aesthetic of adornment, with its most literary manifestation being rich use of metaphor. MacDiarmid presents a clash between English and Scots dialects—the latter associated with a masculinity that breaks down amid its own declamations (Gish, 13). This interest in languages other than standard English, in lively language, can be related to the prodigious word play of Joyce and Stein. Such play has been the subject of considerable attention from poststructuralist critics, but usually in male writers, even by feminist analysts.

7. Cultural Critiques

Radical critiques of the patriarchal family focus on maternal relationships, and alternate familial forms are important themes for modernist authors in our selections. Incest and mother-daughter relationships are treated by Cather, who encodes them as the more acceptable politics of master-slave relationships (Lilienfeld, 2). Barnes encodes sexual molestation, even in her graphics (Broe, 1). Lawrence's solution for emasculation of the father in the modern family is to free children from the influence of the mother, a Utopian plan in which Rebecca West finds numerous practical oversights ("Reply to 'Good Boy Husbands'"). A young James Joyce expresses skepticism about the whole system of the conventional family and guilt over his mother's early death to the young woman who was to become his life companion (Letter to Nora Barnacle). Patriarchal critique lies encoded in Sylvia Townsend Warner's "Bluebeard's Daughter" (see Marcus, 22). On a more positive note, close family dynamics are preserved and extended to a literary community in the round-robin form of correspondence Marianne Moore learned from her mother (Brownstein, 16). Women degraded and alienated by family structures are given voice in the poetry of Charlotte Mew (Schenck, 15). While one woman may compete for a man with Hurston's protagonist-narrator, a more powerful woman, "Big Sweet," uses her expertise in the codes of the community to protect the narrator from violence and to expedite her anthropological research.

Many of the authors' texts and editors' introductions show a high level of sensitivity to the politics of author-reader relations. On the conventional side, Eliot defends Moore's aristocratic language as the sort of aristocracy where the rulers are of the same blood as the ruled. A democratic construction of the readers' relation to the author is offered by Woolf ("Anon" and "The Reader") and Stein ("Americans"). Loy suggests that modernism demands creativity of the audience, and Stein finds that having an audience alters the lecturer's sense of her own words. Hurston tells us that everything done among the people she represents assumes an audience. Mansfield is critical of Richardson, charging that she writes for self rather than audience, producing a "killing pace" for the reader. Sinclair's defense of the sort of obscurity that serves to evoke feeling also relates to audience involvement. Counter to what is traditionally expected from modernism, aloof indecipherability is not much valued among the writers contained in this volume.

8. Wars and Visions

The politics of gender and war interest numerous writers. The social impact of World War I on women's roles in society threw Lawrence into a state of alarm. Macaulay, Warner, White, and Wickham demonstrate the difficulty of the role of noncombatant—male or especially female. The most haunting fantasy of a noncom's war may be Antonia White's "The House of Clouds," in which a woman descending into madness fantasizes that she has become the medium of communication for soldiers dead in the war. Canonical war poetry has battlefield conventions that exclude the war poems of women (Squier, 12), and we are only now recovering them. Woolf makes an "evangelical appeal" for "spirituality" to her audience (Henke, 26). She is increasingly invested in social commentary and attentive to the threat to civilization embedded in a patriarchal system determined on dominance, hierarchy, and war (Silver, 26). On the related subject of violence, Hurston hypothesizes that the lavish interracial, sexually related killing available in Richard Wright's fiction appeals to male black readers.

There are several versions of how the world, and consequently art, changed for writers in the early twentieth century. Stein proposes a synchronic paradigm that annihilates nineteenth-century realism. Sinclair suggests that subject-object relations were altered, an insight that relates to her careful defining of image and imagery in her excellent analysis of H. D.'s poetry. Loy proclaims,

"Today is the crisis in consciousness." Woolf's attack on Edwardian materialism is echoed in Willa Cather's resistance to material accumulation and comes over even into Lawrence's "meaningless reiterations of the physical senses." Cather resists things that are named but not created ("The Novel Démeublé"). Other prophecies follow World War I. Mansfield cannot see how "after the war men could pick up the old threads as though it had never been" (Letter, 16 November 1919), and she resists representation: "the subject to the artist is the *unlikeness* to what we accept as reality" (Journal, 1921). Lawrence assigns hope to a religion recovered in male forgathering. Antonia White works out an alternate subject position, returning Catholic confession to a public domain (Marcus, 24). Rebecca West suggests that Christ "damned" the world through his passion on the cross, "accustoming it to the sight of pain" ("Trees of Gold"). H. D. turns to female renovating deities and is less interested in deconstruction than in reconstruction. Larsen, in her reconstructive vision, finds life and spirit in the black race, as opposed to a white race "doomed to destruction by its own mechanical gods." Lawrence dreads the same gods and turns to the pagan spirituality of rituals attuned to natural cycles. We have noted H. D.'s use of basic natural beings like the jellyfish to describe elements of the psyche that must be incorporated. Despite their reference back to nature, some writers record an energizing effect from the modern city (Fauset, Larsen, Joyce, Woolf, West). In the epigraph to this introduction, Woolf's Lily Briscoe seeks in feminine territory "some secret which . . . people must have for the world to go on at all"; this is an aim shared with many modernists. Lily Briscoe too was just beginning her effort to articulate the things she had to comprehend, including the Victorian mother-woman and the old association of treasures with kings.

Virginia Woolf complained of a lack of perspective in her famous essay "Modern Fiction": "It is for the historian of literature to decide . . . if we are now beginning or ending or standing in the middle of a great period of prose fiction, for down in the plain little is visible." Stein pondered the ugliness of the struggle away from old things into new ones, saying that what is ugly settles like sediment over time ("Transatlantic Interview"). After fifty years we may have enough distance and sedimentation time, along with adequate theoretical perspective, to take in more than was visible to the modernists themselves or to the early critics of modernism. If they followed Pound's dictum to "make it new,"[9] we still must work on identifying the process and the pronoun. The making, the formal experiment, no longer seems to suffice as a definition. Mind, body, sexuality, family, reality, culture, religion, and history were all reconstrued. In settling for a small set of white male modernists and a limited number of texts and genres, we may have paused upon a conservative, anxious, male strain of modernism, however valuable and lasting those texts. The politics and aesthetics of gender may lie at the heart of a comprehensive understanding of early twentieth-century literature and its full array of literary treasures. This collection attests that a great deal of energy and creativity was subtracted out by gender from modernism. In acknowledging this, and in putting it back, we may be discovering how modernism can continue to "make it new."

Notes

1. It is not within the scope of this introduction to provide a summary of these important theoretical developments. The Selected Bibliography contains relevant items. On psychological development and language acquisition, including roles and paradigms of the father and mother as related to signifying processes, see Culler, Derrida, Eco, Garner et al., Gilligan, Jardine, Kristeva, Lacan, and Irigaray. For post-Freudian theory relating to family romance, see Gallop, Gilligan, Mitchell, and Yalom. On history, see Douglas, Foucault, Lerner, and Joan Scott. Foucault's study of the "archive" is particularly relevant to this enterprise, as it deals with the rules that govern acceptable discourse in a society at a given time. For summaries of the impact of feminist perspectives on the academy, see Aiken et al.

2. In *No Man's Land*, vol. 1, Gilbert and Gubar treat male as well as female modernists. Their central thesis leads to the selection of texts that offer scenarios of sex war, a pattern which they extend into

male appropriation of feminine language. They also suggest a pattern of affiliation that permits women writers to select and control literary mothers. They do not offer to any great extent a theory of gender apart from sex.

3. For a critique of monological thinking, see Bakhtin and Irigaray. Jane Marcus, in reconsidering this anthology as a finished unit, suggested that

 we may wish as well to interrogate the idea of the avant garde, and the similarity between the critical definitions of modern and the postmodern. What values did theorists and aestheticians of modernism from Adorno to Benjamin espouse and why did they exclude gender? How would modernism look if viewed from Africa or India or Japan? What is the patriarchal component of Eurocentrism?

4. See Sultan 96–101 for a history of the term's usage and a summary of various arguments for and against its validity.

5. See Bergonzi, Bradbury and MacFarlane, Dasenbrock, Faulkner, Levenson, Meisel, Moore, Quinones, Schwartz, Spender, Stead, Symons, Tindall, and Wilson. For a handy collection of (mainly male-authored) manifestos on modernism, see Faulkner's *Modernist Reader*. It should be supplemented with Marinetti's futurist manifestos.

6. In responding to the final collection, Jane Marcus generated a series of questions and modernist subgenres that would lead to new collecting. In the category of a possible Marxist modernism, she names Christina Stead's *The Man Who Loved Children* and *The House of All Nations*. In a category of feminist antifascism, she suggests Katharine Burdekin's 1937 dystopia, *Swastika Night*. In a category of the feminist historical novel, she suggests Laura Riding's *A Trojan Ending* and *Lives of Wives* and Ford Madox Ford's *The Fifth Queen*, as well as *Parade's End*. She would collect the essays and pamphlets of women peace activists, from Crystal Eastman to Emma Goldman, and the pacifist books banned under the Defense of the Realm Act in England. She calls attention to additional scripts of female madness in Emily Holmes Coleman's *The Shutter of Snow*, Anna Kavan's *Asylum Piece*, and Radclyffe Hall's banned lesbian novel, *The Well of Loneliness*. She cites Ivy Compton-Burnett as a Bakhtinian dialogic novelist in *Manservant and Maidservant* and *A Father and His Fate* and considers Barbara Comyns's *Sisters by a River* an example of Kristevan female semiotic. She lists additional women writers who have been assigned to a "conventional" category: Elizabeth Bowen, Rosamund Lehmann, M. J. Farrell (Molly Keane), Mary Webb, and Mary Butts.

7. Readers unfamiliar with the debates among various feminisms might wish to consult the following works, listed in the Selected Bibliography: *Yale French Studies* special number, Jacobus, Marks and de Courtivron, Miller's *Poetics of Gender*, Moi, and Showalter's *New Feminist Criticism*.

8. For a provocative discussion of where feminist study takes off from, see Jehlen.

9. Pound used this injunction as the title for a 1934 collection of his essays. It also appears in Canto LIII (Kenner 448, Sultan 100).

CHAPTER 3
AGAINST THE STANDARD
LINGUISTIC IMITATION, RACIAL MASQUERADE, AND THE MODERNIST REBELLION
*Michael North**

Clement Greenberg began his famous essay "Avant-Garde and Kitsch" (1939) with the claim that "one and the same civilization produces simultaneously two such different things as a poem by T. S. Eliot and a Tin Pan Alley song." Michael North takes Greenberg's concern with form across high and low media in a different direction by focusing on how modernists moved language itself across learned and vernacular registers. Modernist writers had branded themselves as linguistic innovators by bending, plying, and reshaping multiple tongues to suit their aesthetic purposes. Hugh Kenner had influentially characterized modernists as preoccupied with the "invention of language" in an era marked by the consolidation of "standard" English, as epitomized by the *Oxford English Dictionary* project, and by the renewed scholarly interest in ur-languages like Sanskrit, which Eliot used to conclude *The Waste Land* (1922). But of course, this standardization was the direct product of English's many contacts with foreign languages all around the word and across deep history. Thus, Pound rhymed words across English, Greek, and French, while Joyce created what seemed like an entirely new language out of thousands of heteroglossic portmanteaus in *Finnegans Wake* (1939).

But North shows that modernist writers were less "inventors" of language and more mimickers and masqueraders of nonwhite dialects (often cast as "low" and vulgar demotics) from their own backyards. North's insight allows him to connect a familiar set of elite high modernists to their contemporaries like Al Jolson, whose signature scene in *The Jazz Singer* (1927) features him "blacking up" and performing minstrel tunes. North traces an astounding "pattern of rebellion through racial ventriloquism," culminating in readings of Eliot—the poet presumed by many (including Huyssen) to have nothing but contempt for putatively low cultures. To be sure, Eliot's later-discovered "King Bolo" poems are full of offensive stereotypes of Blackness and vulgar wordplay on African American vernacular English. North follows the dialectic through Eliot's works and, in the process, reads them alongside the emergence of the Harlem Renaissance and its equally dualistic figures, like Carl Van Vechten. He shows that this generation of African American writers had hoped for sympathy and collaboration from their white peers because of their interest in Black dialects, but ultimately, they found a level of "white interest" that was "more dangerous than indifference."

In North's archivally omnivorous exploration of the "equivocal role" of dialect writing in many contexts, G. B. Shaw's experiments with Cockney dialect rub shoulders with Joel

*From Michael North, *The Dialect of Modernism: Race, Language, and Twentieth-Century Literature*. Oxford University Press, ©1994. Reproduced here with permission.

Chandler Harris's Uncle Remus stories, and attempts at linguistic standardization often undermine and undo themselves in fascinating ways for a host of modernist figures. North not only expands the canon of modernism, but also offers an account of why the Harlem Renaissance remained on the sidelines of most scholarly visions of modernist writing for so long. The promise that Langston Hughes and Alain Locke saw in distinctively Black aesthetic forms was more a wellspring for white poetic experimentation for their counterparts; the parallels in the English context with colonial linguistic encounters, as North shows, are impossible to ignore. With elements of ethnic studies, linguistics, formalism, media archaeology, and cultural politics, North's chapter here demonstrates the consequences of a new collision course on which multiple modernisms seemed to be heading in the early 1990s.

I

In the preface to *Pygmalion* George Bernard Shaw reassures his readers, some of whom might be daunted by the dazzling success of Eliza Doolittle, that she is but an example of the "many thousands of men and women who have sloughed off their native dialects and acquired a new tongue." Sounding a bit like Dale Carnegie, who began his self-help empire at about this time, Shaw promises those who follow Eliza a world of social harmony based on proper phonetics, a world in which words cannot be mispronounced, in which men and women will no longer be divided by differences of speech. "It's filling up the deepest gulf that separates class from class and soul from soul," as Henry Higgins crows in the play itself.[1] The American musical *My Fair Lady* expands on Shaw's expansiveness by staging Eliza's final elocution lesson as a triumphant tango: when "the rine in Spine" finally becomes "the rain in Spain," the three principals drop all decorum and dance.

The same subject is handled rather differently in another famous American musical, one whose slapdash colloquial title, *Singin' in the Rain*, would have made Henry Higgins cringe. In this elocution lesson, Don Lockwood, famous silent movie actor, receives instruction from a prissy professorial type in string tie and thick glasses. Don's lesson also ends in dance, but in this case the student and his sidekick transform the professor's tongue twister into a tap extravaganza, in which the professor himself is merely a dumb prop. They untie his tie, muss his hair, put a lampshade on his head, throw his papers in the air, and end by belting out a perfectly harmonized *a*, the same *a*, incidentally, that Eliza finally masters in *her* triumphant elocution scene. But what a difference! Don and his friend Cosmo dance to demonstrate their utter indifference to verbal exactitude. Taking the tongue twister into tap shows how American verve and creativity triumph over empty formality, American individuality over conformity and authoritarianism. What else would you expect from a movie whose very title drops its *g*'s?[2]

Yet this movie, seemingly so breezy and informal, contains within it a tangle of feelings about speech and language that makes Shaw seem almost as shallow as Dale Carnegie. The elocution scene is but a part of the larger story of the arrival of the talkies, an arrival that *Singin' in the Rain* portrays, on one level at least, as an unmasking. Lina Lamont, silent movie star and Don Lockwood's longtime screen companion, seems sweet and refined. Her voice, which is carefully kept out of the first few scenes of the movie so as to heighten its impact, reveals the fact that she is not. Her coarse screeching is contrasted throughout to the calm, low voice of the newcomer Kathy Selden, who *is* sweet and also genuine, which is much better than being refined. Thus the whole movie is structured around the contrast between Kathy and Lina: their names, their clothes, their faces, their hairstyles, their personalities. Kathy enters the movie as a critic of the trumped-up,

hokey acting of the silent era, and her progress from obscurity to stardom is an allegory of the emergence of movies like *Singin' in the Rain*. Don's screen love scene with Lina involves powdered wigs, heavy brocade, and stilted language on the title cards; for his first love scene with Kathy, he sets up the most ostentatiously simple stage set ever filmed and then croons straight from the heart.

The big difference, of course, is sound, which frees movies from the dodges, exaggerations, and falsehoods of the past and allows them to sing. On the other hand, sound puts film actors to the test, and those, like Lina, whose talent is shallow and unnatural are exposed. But sound brings to the movies not just singing but also another, more equivocal, art: dubbing. The studio's answer to Lina's vocal limitations is not to replace her with Kathy, but just to replace her voice with Kathy's. It is historically true that dubbing was born with the talkies: Warner Oland's "Kol Nidre" was dubbed in *The Jazz Singer*; Alfred Hitchcock's *Blackmail* was completely reshot as a talkie, with Hitchcock's script girl crouching under tables and behind doors to provide a voice for the thickly accented leading lady.[3] But the possibilities of dubbing threaten the whole structure of *Singin' in the Rain*, based as it is on the idea that voice reveals the true measure of one's talent and character.

There is actually a good deal of unacknowledged dubbing in *Singin' in the Rain*. Because Debbie Reynolds, who played Kathy Selden, wasn't a very strong singer or dancer, her high notes and taps were dubbed throughout the movie. Beyond this, two entire songs were dubbed by Betty Noyes, one of them the very song Kathy Selden sings to cover up Lina's vocal limitations. If this seems to smudge the message of the movie somewhat, it's as nothing compared with the scene in which Kathy dubs Lina's spoken voice. Here Reynolds is actually dubbed by Jean Hagen, who played Lina. In other words, Hagen is dubbing Reynolds dubbing Hagen. The reason for this last sleight of hand is that Reynolds had what director Stanley Donen considered a "midwestern" accent, while Hagen, beneath the screech she affected for her role as Lina, actually had just the sort of smooth, cultured voice the scene demanded.[4] One wonders why they didn't just give Reynolds elocution lessons.

Behind its assured surface, therefore, *Singin' in the Rain* reveals the mixed emotions that most Americans have about the national speech. Despite its pose of insouciant nonconformity, the movie is just as prescriptive as Henry Higgins, with the same linguistic hypersensitivity that Americans have always harbored along with their colloquial freedom. And yet hypocrisy is just one element of this complex situation, for while the movie is furtive about its own dubbing, it is quite open about the dubbing of "The Duelling Cavalier," the movie within the movie. When Cosmo Brown comes up with the idea of dubbing, everyone cheers him as a genius, though they promise to use the technique "just this once," as if it were a powerfully seductive drug. The deception is finally revealed to the opening-night audience when Kathy is exposed singing behind the miming Lina, but their reaction is not outrage or confusion but laughter and applause. As Ronald Haver points out in his audio essay on the movie, the audience realizes at once what is happening, though dubbing is so new it should be unrecognizable to them.

Such knowing enjoyment is an actual component of audience reaction to films like *My Fair Lady*, since everyone has known from the very beginning that Audrey Hepburn is not actually singing in the scene that celebrates Eliza's discovery of her new voice. Though Eliza may labor long and hard to sound like a proper lady, Audrey Hepburn can sing like Marni Nixon virtually at the touch of a button. What's really being celebrated in such scenes is not vocal authenticity but rather the technical wizardy that can make anyone sound like anyone else. The real American retort to linguistic authoritarianism is dubbing, carefully manipulated falsehood, and not the naturalism of Don Lockwood's love song to Kathy. If *Singin' in the Rain* is about the entry of the movies into modernity, then that condition is represented as one in which technology sets the whole concept of vocal authenticity aside as irrelevant and is applauded for doing so.

In one of the most peculiar scenes in this movie, the camera follows Don and Cosmo as they cross a vast stage set on which four or five movies are being filmed simultaneously. As they pause

near the "African" set, a white extra in blackface and elaborate feathers reads them a notice from *Variety* announcing *The Jazz Singer*. This scene provides the pretext for everything else that happens in the movie, since it is the success of *The Jazz Singer* that motivates the changes in the film studio, and at the same time it reveals an important missing element in this, one of the most lily-white musicals ever made: race.[5]

Except for this one element, *Singin' in the Rain* is a very faithful retelling of *The Jazz Singer*. Rebellion against Old World authority through jazz is also the essence of the earlier movie, as is revealed at the very beginning when old Mr. Yudelson catches Jakie Rabinowitz, the cantor's son, down at the beer garden, singing "Waiting for the Robert E. Lee" and "shufflin'," when he should be practicing the "Kol Nidre" with his father.[6] Later, as an adult, Jakie, become Jack Robin the jazz singer, has an archetypal American argument with his father: "[Y]ou're of the old world! Tradition is all right, but this is another day! I'll live my life as I see fit!"[7] Finally, just as his career is about to take off, Jack is once again summoned to sing the "Kol Nidre," this time as his aged father lies on his deathbed. Like *Singin' in the Rain*, *The Jazz Singer* tells this story partly to reflect and applaud its own technical accomplishments. Jack succeeds as a singer because he sings from the heart; his voice "has that tear in it."[8] The growth to self-realization of such a career could only be told in sound, by a process like the one Vitaphone was introducing with elaborate fanfare in *The Jazz Singer*, so that Jakie's acquisition and defense of his own personal voice recapitulates the advance of movies into the talking era.

On the other hand, *The Jazz Singer* raises the same questions about technical wizardry that *Singin' in the Rain* does: Is a movie with sound more realistic than one without, or is it merely the producer of newer and more powerful illusions? When Jakie becomes Jack and sings his own songs is he unmasked, revealed as himself at last, or is he wearing a new mask instead? These questions, which are posed by the use of dubbing in *Singin' in the Rain*, are presented visually as well as vocally in *The Jazz Singer* by Jolson's blackface makeup. Mr. Yudelson puts it with crude succinctness upon discovering Jack in his dressing room: "It talks like Jakie, but it looks like a nigger."[9] Yet, for the most part, "it" doesn't even sound like Jakie: the music that represents his youthful self-assertion is mostly black music, from the minstrel shuffle he does as a youngster to "Mammy" at the very end. How can Jakie become Jack, become himself, as it were, by donning a disguise? More fundamentally, how can *The Jazz Singer* enter the modern era of talking pictures by recapitulating a minstrel show routine at least a hundred years old?[10] Why should the latest technical accomplishment, one that claimed to provide a new fidelity to nature, rely on such an old-fashioned and painfully obvious masquerade?

Like *Singin' in the Rain*, once again, *The Jazz Singer* keeps these questions out in the open. The later musical makes dubbing not only a major subject but, in fact, the fulcrum of the plot, as if in blissful ignorance of the peril this technique poses to the movie's central message of wholesome naturalness. The earlier movie does the same by pulling its star, Al Jolson, back and forth across the racial boundary. It shows him making up, juxtaposes scenes in the synagogue with those on stage, and, at one point, does a mirror dissolve from his face with black makeup to that of a cantor singing. All this suggests conflict and tension, but it also suggests that the black mask is less important than the process of masking. The alternative to Old World tradition with all its rigidity is not blackface per se but the ability to change identity that blackface implies.

There is a kind of vocal blackface too, a mimicry of "black" speech patterns that serves to cover up what Sampson Raphaelson, author of the story on which *The Jazz Singer* was based, called the "richly filthy East Side *argot*."[11] But visual and vocal blackface don't always coincide in *The Jazz Singer*, and the black makeup is often weirdly incidental to Jolson's performances. He can "sing it jazzy," without his makeup, as he does when singing "Blue Skies" to his mother,[12] and he can sing a sentimental number of his own like "Mother of Mine, I Still Have You" as if he were an Irish tenor,

despite wearing blackface. What all of this emphasizes is that blackface is a role, a creation, into which and out of which Jack can slip at will.

It is only partially accurate, therefore, to portray Jakie's transformation into the Jazz Singer as his achievement of a free, authentic personality, an American personality untrammeled by outmoded conventions. For the modern American personality Jakie acquires is free precisely to the extent that it is inauthentic, free to don and change masks at will. The grotesque exaggeration of blackface makeup had always been meant at least in part to emphasize the fact that the wearer was *not* black; in the 1920s Jolson made this old tactic breezy and up-to-date by publicly joking about the inauthenticity of his role. In 1925 *Vanity Fair* published his account of a trip to the South under the tide "Maaaaam-my! Maaaaam-my! The Famous Mammy-Singer Explores His Native (?) Sunny Southland." For the purposes of this article, Jolson pretends to believe the clichés he has been purveying about the South, and he reacts with mock horror as the actual South repeatedly fails to conform to the clichés. Finally, he hopes at the very least to find "the southern darky—the banjo strummer whose wit is famous wherever minstrel shows have been played," but when he does find a promising specimen the man tells Jolson one of his own jokes, a joke he had been using on the stage for years.[13]

Jolson does not draw the obvious conclusion from this episode, that he is himself the "southern darky" he is looking for, he and white performers like him the only fleshly reality of this very old stereotype. But neither does he flinch at the contradiction between such knowing self-mockery and the maudlin sentiment of films like *The Jazz Singer*. One does not undermine the other, because the film insists equally on both. On one hand, the black persona carries all the connotations of natural, unspoiled authenticity that Europe has attached to other cultures at least since Montesquieu, and thus Jakie can throw off convention to become himself by becoming "black." On the other hand, blackface declares itself openly as a mask, unfixes identity, and frees the actor in a world of self-creation.[14]

We seem to have come a long way from Eliza Doolittle's masquerade as a lady, and yet all of our masquerades tell the same story, or parts of the same story. *Singin' in the Rain* shows how variously Americans respond to the linguistic and cultural prescriptiveness of experts like Henry Higgins. A single movie can accommodate Stanley Donen's nervous conventionality, Don Lockwood's brash freedom, and Cosmo Brown's technical wizardry, which allows the movie to have both convention and nature by erasing all the boundaries between them. This is what makes *Singin' in the Rain* such a faithfully American movie, its utterly genuine combination of cultural innocence and technological cynicism. But *Singin' in the Rain* is less than faithful to the moment it pretends to portray, the modernist moment of the 1920s, in that it omits any mention of race. The new voice that American culture acquired in the 1920s, the decade of jazz, stage musicals, talking pictures, and aesthetic modernism, was very largely a black one. In music, on stage, and in film, white artists dubbed in a black voice and often wore, as Jolson did, a black mask. Because this mask, and the voice that issued from it, already embodied white America's quite various feelings about nature and convention, it became an integral part of the cultural and technical innovation of the 1920s. The story that both *Singin' in the Rain* and *The Jazz Singer* tell, the story of modernity's triumphant rebellion against the restrictions of the past, can hardly be told without it.

II

In January 1922, about the time that T. S. Eliot returned from his rest cure in Lausanne with a certain nineteen-page poem in his suitcase, Sampson Raphaelson published "The Day of Atonement" in *Everybody's Magazine*. This is the story of a young Jewish American so taken with "the plaintive

blare of 'Alexander's Ragtime Band'" that he becomes a "blackface comedian," a story later made into a play and then the movie *The Jazz Singer*.[15] This protagonist's route to modernity may seem quite different from the one Eliot was about to chart, and yet the story Raphaelson tells of becoming modern by acting black was to be retold over and over in the next decade. It is, in fact, this story that links the transatlantic modernism Eliot and Joyce inaugurated in 1922 with the Harlem Renaissance mat began, with Claude McKay's *Harlem Shadows*, at exactly the same time.

At the height of the Harlem Renaissance, in the year of *The Jazz Singer*, Rudolf Fisher reported wryly that all his favorite Harlem haunts had been taken over by whites "playing Negro games. . . . They camel and fish-tail and turkey, they geche and black-bottom and scronch, they skate and buzzard and mess-around—and they do them all better than I!"[16] In the same year Charles S. Johnson published in his anthology *Ebony and Topaz* a story that goes one step further, for the title character of "The Negro of the Jazz Band" is, despite his seemingly black skin and extraordinary sense of rhythm, white.[17] Though the story is meant to be a kind of fantasy, there were at this time many fashionable whites who purposely skirted the racial line, and at least a few who temporarily crossed it. Carl Van Vechten, who was famously caricatured in blackface by Miguel Covarrubias, had first passed for black as an undergraduate. Waldo Frank, author of the racial melodrama *Holiday*, also posed as black when traveling in the South with Jean Toomer.[18]

One might include in this company a number of white writers without Van Vechten's obvious connection to Harlem. Long before the Harlem Renaissance, Wallace Stevens signed himself "Sambo" in a letter to his fiancée, and long after it Ezra Pound was still calling Eliot "de Possum" and using what he imagined was black dialect in his letters.[19] It was in London that Eliot signed himself "Tar Baby," in Paris that Gertrude Stein casually used "dey" and "dem."[20] William Carlos Williams imagined himself as a black musician in the 1940s, and as late as 1959 John Berryman could go back to the very source by dedicating one of his first *Dream Songs* to Daddy Rice, who "jumped 'Jim Crow' in 1828."[21] In "The Day of Atonement," then, Raphaelson tells a rather common story of white rebellion and escape by means of racial cross-identification, a story Nathan Huggins sums up in three phrases: "They defected, became apostates; they became Negroes."[22]

What ragtime promised Raphaelson's protagonist, what the minstrel show promised Berryman almost two generations later, was a voice. In 1923 Sherwood Anderson wrote to Jean Toomer about listening to some black dockworkers sing, held back from speaking to them by a reluctance he did not quite understand: "Perhaps I did not know how much I wanted a voice from them."[23] The heroine of *HERmione*, H. D.'s autobiographical novel, feels the same sort of vocal magnetism, in her case amounting almost to mesmerism, in talking to her family's black cook: "Her fell into the rhythm of Mandy's speech, the moment she began to speak to Mandy."[24] Though H. D. never let this rhythm pass into her published work, Alice Corbin, one of the early coeditors of *Poetry* magazine, did, in the appropriately named "Mandy's Religion," as did a number of other contributors to the journals of the early modernist avant-garde, including Carl Sandburg, Malcolm Cowley, Mina Loy and, perhaps most famously, Vachel Lindsay.[25] Eliot, Pound, and Stein fell into the same rhythm, in published work and in their letters, where it was often saved for private allusions and in-jokes, as if there were some secrets only a black voice could conceal.

The whole pattern of rebellion through racial ventriloquism is best illustrated by someone who might seem the least likely example: T. S. Eliot. As unlike Jakie as he might seem, as distant as he was front the Hester Street synagogue and from ragtime, Eliot did nonetheless resemble Jakie in defying his father's ancestral expectations to follow a more modern art. Instead of finishing his dissertation and joining the Harvard faculty, as his father had requested, Eliot remained in England to become a poet and free-lance man of letters, and he was very much saddened when his father died apparently thinking his son a failure.[26] Even before he abandoned his dissertation, however, Eliot produced a long-running parody of the kind of scholarship to which he was supposed to devote

his life. In 1914 he sent to Conrad Aiken one of the infamous King Bolo poems, an obscene screed about "King Bolo's big black queen," carefully and cruelly annotated: "See Krapp: STREITSCHRIFT GEGEN HASENPFEFFER. 1.xvii §367, also Hasenpfeffer: POLEMISCHES GEGEN KRAPP I.II. 368ff. 490ff." Obscene doggerel is obviously a safety valve for this student sick of scholarly trivia, and eye dialect of a very crude sort becomes an alternative to the cramped language of references and citations: "King Bolo's big black bassturd kween/Her taste was kalm and klassic. . . ."[27] Thus Eliot rejects his family's traditional expectations and becomes a "blackface comedian," a role to which Ezra Pound gave the name "de Possum."

As the comic alternative to the serious scholarship expected by his family, doggerel in dialect becomes the prototype of the audacious poetry Eliot was to write instead of academic philosophy. As early as 1915 he wrote a play with a blackface role, the "REV. HAMMOND AIGS comic negro minister, of the 'come breddern' type."[28] Although the play was little more than an extended joke to entertain his Cambridge friend Eleanor Hinkley, it did suggest close knowledge of the prevailing dramatic stereotypes. So fond was Eliot of these particular clichés that Clive Bell sarcastically suggested in 1921 that Eliot's "agonizing labours seem to have been eased somewhat by the comfortable ministrations of a black and grinning muse."[29] Bell declined to be more specific, but at the time Eliot was laboring to put his knowledge of black music to work in *The Waste Land*, which contained at one time references to a number of rags and minstrel songs. These were finally removed from the final text, so that Eliot's "black and grinning muse" did not emerge in print until the fragments of *Sweeney Agonistes* were published in 1926–27.[30] The climax of this unfinished play is a minstrel show rendition of the Johnson-Cole-Johnson hit "Under the Bamboo Tree," a sensation during the St. Louis World's Fair of 1904, which Eliot attended with his family. Eliot called *Sweeney* a "Comic Minstrelsy" and a "jazz play."[31] It is, in fact, his version of *The Jazz Singer*, which was released that same year, his way of breaking with the very respectability he had so recently achieved.

For Eliot, as for a large number of other writers who were to make transatlantic modernism the dominant movement of the 1920s, the story *of The Jazz Singer* seems paradigmatic.[32] For another modern movement struggling to emerge at the same time, however, the story had a very different import. In 1927 James Weldon Johnson, lyricist of "Under the Bamboo Tree," published *God's Trombones*, which carefully avoided the very voice Eliot, Anderson, H. D., and the others envied to the point of mimicry. Johnson says in his preface that "practically no poetry is being written in dialect by the colored poets of today."[33] Dialect is impossible for a serious black poet of the 1920s because it is "based upon the minstrel traditions of Negro life," on "a happy-go-lucky, singing, shuffling, banjo-picking being," the very being, that is to say, that Jolson became in *The Jazz Singer*.[34]

When Alain Locke, instigator and editor of the landmark anthology *The New Negro*, wanted an example of "the newer motive" in African-American literature, he turned to "The Creation," the first of Johnson's sermons to be published. In this "interesting experiment," says Locke, is to be seen one of the "modernistic styles of expression" coming into being in the 1920s.[35] "The Creation" hardly seems "modernistic" in comparison to its exact contemporary *Sweeney Agonistes*: it has no contemporary references, no stylistic tricks, nothing overtly "experimental." But it could seem modern in the context of *The New Negro* simply by avoiding certain nearly inescapable stereotypes suggested by its subject, stereotypes Eliot had naturally drawn upon for his character the Reverend Hammond Aigs. As Van Vechten put it, "The Creation" was the poem that "broke the chain of dialect which bound Paul Laurence Dunbar and freed the younger generation from this dangerous restraint."[36]

Van Vechten's metaphor tells the whole story of the difference between these two modernisms. Linguistic imitation and racial masquerade are so important to transatlantic modernism because they allow the writer to play at self-fashioning. Jazz means freedom to Jakie Rabinowitz partly

because it is fast and rhythmically unrestrained but also because it is not ancestrally his: to sing it is to make a choice of self, to do his own dubbing, as it were. For African-American poets of this generation, however, dialect is a "chain." In the version created by the white minstrel tradition, it is a constant reminder of the literal unfreedom of slavery and of the political and cultural repression that followed emancipation. Both symbol and actuality, it stands for a most intimate invasion whereby the dominant actually attempts to create the thoughts of the subordinate by providing it speech.[37]

Even more ironically, when a younger generation of African-American writers attempted to renew dialect writing by freeing it from the clichés Johnson criticized, fashionable white usage of the same language stood in their way as a disabling example.[38] Locke hoped that the interest of certain white modernists in plain and unvarnished language would help to make a wider audience for writers like Langston Hughes, Jean Toomer, and Claude McKay. At one point, he actually envisioned an alliance between an indigenous American modernism and the younger Harlem writers, to be based on a mutual interest in the language of the folk.[39] But these hopes were to be disappointed, and the younger writers found, as Johnson had, that white interest in African-American language and culture was, if anything, more dangerous than indifference.

Thus two different modernisms, tightly linked by their different stakes in the same language, emerge between 1922 and 1927. Houston Baker, Jr., has argued that Anglo-American modernism is dangerously irrelevant to the movement that was born at about the same time in Harlem.[40] In another sense, Anglo-American modernism is dangerous in its very relevance to the Harlem Renaissance because its strategies of linguistic rebellion depended so heavily on a kind of language that writers like Johnson rejected. For this reason, however, it is impossible to understand either modernism without reference to the other, without reference to the language they so uncomfortably shared, and to the political and cultural forces that were constricting that language at the very moment modern writers of both races were attempting in dramatically different ways to free it.

III

The publication of the *Oxford English Dictionary* (OED), the most important event in the stabilization of the English language, took more than forty years—coincidentally from the 1880s, when most of the transatlantic modernists were born, to the 1920s, when their most important works were published. Hugh Kenner has suggested that this is an important coincidence, that the OED shaped the way modernism looked at language.[41] But the OED, even in all its massiveness, is just one element in a whole complex of tense and tangled relationships within the language, all of which had their effect on the modernisms of the period.

In the beginning, the whole purpose of the OED was to deny the possibility of tense and tangled relationships within the language. To have any hope of success within the lifetime of humankind, the compilers of the dictionary needed to set some limit to the number of words to be defined. The 1858 proposal for the dictionary, therefore, rules out of consideration dialect words more recent than the Reformation, and, in doing so, provides what the OED itself cites as the first recorded use of the phrase "standard language."[42] This phrase was such a useful one that it became more and more common as the century went on. Shaw, for example, claimed that the whole purpose of *Pygmalion* was to dramatize the need for a "standard English."[43] The real danger, of course, is not simply that guttersnipes like Eliza will continue to wallow in linguistic filth, but that perfectly respectable girls like Clara Eynsford Hill will adopt it and make it fashionable. If Henry Higgins does not set the standard, then Eliza and her like will, and the whole country will end up talking a "quaint slavey lingo."[44]

Demands for linguistic standardization had been made from the earliest days of printing, which made variations more obvious by distributing them more widely, and became particularly insistent in the eighteenth century, when decorum of all kinds was highly prized.[45] But there was a distinct increase in volume in the years encompassed by the publication of the OED. It was in the 1880s that criticism of linguistic faults became a "thriving industry." Kenneth Cmiel's tabulation shows forty-one editions of works of verbal criticism or linguistic self-help between 1881 and 1885 and twenty-nine more between 1886 and 1890, almost twice as many as any other decade after 1860.[46] Popular magazines reflected this interest as well, with whole series of articles on standardization and usage in *Harper's*, *Lippincott's*, *Scribner's*, *Appleton's*, and the *Galaxy*.[47] This was also the heyday of spelling reform, Shaw's own hobbyhorse.[48]

There was a change of tone as well as volume. Standardization of the kind advocated after 1880 is different from the process by which one dialect gradually acquires power and prestige and so comes to dominate its rivals, as West Saxon crowded out other dialects to become Old English. What the flood of books and articles published in the 1880s called for was "a process of more or less conscious, planned and centralized regulation of language" in which "new elements threatening to enter the language are limited, and . . . variants within the language are hierarchized, and sometimes eliminated."[49] This program brought with it a moralistic tone and an almost evangelical fervor that made relatively minor infractions seem matters of cultural life or death.

During this period a number of organizations were formed to monitor such infractions. One of these was, of course, the OED itself, although on publication it turned out to be far too inclusive to serve as the mighty bulwark many had hoped for.[50] More stringent was the Society for Pure English (SPE), whose founder, Robert Bridges, was one of Shaw's models for Henry Higgins. The SPE was originally conceived in 1913 to "preserve the richness of differentiation in our vocabulary" and to oppose "whatever is slipshod and careless, and all blurring of hard-won distinctions." It began by objecting to artificial standards, even those promulgated by the new pronouncing dictionaries of the era, and it included among its members writers such as Thomas Hardy and Arnold Bennett, whose novels often included language that was more genuine than correct. Before long, however, the tracts of the SPE became little more than a testing ground for the little articles on "*shall* versus *will*" and the split infinitive that H. W. Fowler was to consolidate in his *Modern English Usage*.[51] Though Robert Graves's accusation that the SPE was "the literary equivalent of political fascism" seems a bit extreme, its tracts did devote a remarkable amount of space to issues, such as the proper use of the hyphen, of greater symbolic social value than linguistic significance.[52]

The SPE allowed Bridges to play Higgins on a larger stage, which grew even larger when he chaired the first BBC Advisory Committee on Spoken English.[53] Some members of the SPE also served on the commission chaired by Sir Henry Newbolt that examined the role of language and literature in the English educational system. The Newbolt Report, or *The Teaching of English in England* as it was properly titled, called unequivocally for "correct pronunciation and clear articulation" of "standard English" as the bedrock of education in all subjects.[54] This report, as well as Bridges's role with the BBC, shows how the pressure for standardization suffused the country by the 1920s.

An American equivalent of these groups was the American Academy of Arts and Letters, which received a grant in 1916 to "determine its duty regarding both the preservation of the English language in its beauty and integrity, and its cautious enrichment by such terms as grow out of modern conditions."[55] By the early 1920s, however, this modest program had become a full-fledged cultural crusade. In a national radio broadcast Nicholas Murray Butler proclaimed, "The preservation of our English speech in its purity is for the Academy a matter of high concern." Thus the academy established a Medal for Good Diction on the Stage and assigned Hamlin Garland to monitor the progress it would encourage.[56]

Garland thus joined the swelling ranks of the linguistic watchdogs, Englishmen like George Sampson, whose *English for the English* warned that the country was "torn with dialects," and Americans like Adams Sherman Hill, who decried in *Our English* the "'local color' and local dialects which jaded minds demand nowadays."[57] So pervasive and so inescapable was the conviction that language was in peril that even in deepest Africa H. Rider Haggard's She complained that the savages among whom she lived had "debased and defiled" the pure Arabic of the past.[58]

The stage was crowded in these years with individuals volunteering to serve as "linguistic conscience" to the nation.[59] In a book that had gone through eighteen editions by 1889, Richard Grant White attempted to enlist his readers in "a sort of linguistic detective police."[60] Noses to the ground, decoder rings at the ready, members of White's club would find and, apparently, punish those variations that so many writers of the time seemed to find disloyal. In fact, what was new and peculiar to the period was not linguistic difference and variation, which had been even more promiscuous in the past, but demands for its elimination. Leonard Forster dramatizes this change by noting that when William Beckford wrote *Vathek* in French in 1784 it excited little comment, but when Oscar Wilde wrote *Salome* in French in 1894 it caused a scandal. What makes the difference is a concept of "language loyalty" relatively new in history and, John Joseph points out, peculiar to Europe.[61]

The whole idea that language is something to which one must remain loyal, the idea that empowers White's detective police as they search the countryside, is a popularized application of Romantic philology.[62] When Leibniz declared that "tongues differ as profoundly as do nations," he suggested an equation that was to be crucial for Herder, who taught that each language is a spiritual individuality like a nation, and for Humboldt, who took the next and, for our purposes, most crucial step, by maintaining that language is "an accurate index to the grade of intellectual comprehension attained by" a people.[63] Thus language becomes the cornerstone of national identity and an index of cultural health. Over and over, the linguistic conscience tells its captive audience that linguistic unity is not just crucial to national unity but actually synonymous with it. English, according to the Newbolt Report, is not just a medium: "It is itself the English mind." Thus, according to George Sampson, "The one common basis of a common culture is the common tongue." And finally, linguistic nonconformists must be admonished, as American immigrants were in 1916, that "a cleavage in the language now would mean to us a cleavage of the nation in its most vulnerable if not its most essential part."[64]

As powerful, and as powerfully seductive, as these ideas are, they are haunted by a crucial weakness, a self-destructiveness in the very notion of racial, national, or linguistic purity. Étienne Balibar maintains that a "pure race" can never, by definition, coincide with the totality of a national population, so that racism always works in reverse, creating a nation by taking its distance from the rejected.[65] The same is true of languages, which can never be pure despite the best efforts of the SPE. Thus the most shopworn commonplace in all the propaganda for standardization is that the standard language cannot be defined or even adequately described: "We do not expect to hear it, as a matter of course, in any given place where men congregate; when we do hear it, we know it for what it is."[66] This is the infallible, if somewhat mysterious, test: "[W]e all know when we are reading good English and when we are reading bad English. That is the conclusion of common sense. . . ."[67]

Despite these bland assertions, it turns out that, more commonly, we know only when we hear *bad* English. Sampson's second thoughts on the subject are revealing: "There is no need to define Standard English speech. We know what it is, and there's an end on't. Or, to put it another way, we know what is *not* standard English, and that is a sufficiently practical guide."[68] This explains why the campaign for standardization became a chorus of complaint and censure, why, even today, virtually all popular linguistic criticism focuses obsessively on minor errors and why grammar, in the popular mind, consists entirely of prohibitions. Over a hundred years ago, Henry Alford,

Dean of Canterbury, condensed the entire tradition into one elegantly self-evident maxim: "Avoid all oddity of expression."[69] Yet this puts the poor speaker in the plight of the person who is ordered not to think of a brown bear. This situation is especially painful because the errors that are most stigmatized are, of course, the most common. The final turn in this paradoxical situation comes when we realize that "a particular usage is not attacked as non-standard until it has become very general and widespread."[70] The standard is not standard, that is to say, but rather the very opposite. Critics willing to play with numbers speculate that perhaps 3 to 4 percent of the population of England speaks standard English,[71] but the truth is that no one speaks standard English because that language is simply whatever shapeless thing is left when all the most common errors are removed.

If standard English is chimerical, however, the social forces that stand behind it are not, and the theoretical weakness of the standard language movement was precisely what gave it such great social strength. The period covered by the publication of the OED was one of great immigration and urban centralization: between 1871 and 1901 the number of towns in England with more than fifty thousand inhabitants doubled, and in the same period there was mass emigration from southern and eastern Europe and Russia at the greatest rate in history. At the same time, European imperialism attained a new pace so feverish it was commonly called a "scramble."[72] If anything, these vast social changes tended to favor linguistic uniformity, and linguists such as Otto Jespersen suggested that dialects were in the process of dying out worldwide.[73] Yet this process was hardly a painless or impersonal one.

Urbanization and mass emigration brought together all sorts of languages, dialects, and idiolects previously separated by space and social difference. The flood of linguistic criticism after 1880 was part of an attempt to sort out these competing languages and arrange them in order of prestige. At the same time, this concentration on linguistic propriety concealed concern for another kind of purity. Defense of the language became an indirect and intellectually respectable way of defending the borders, those outlying borders crossed by foreigners and those closer, less tangible, but even more sensitive borders crossed by a growing urban working class.[74] At the same time, the linguistic thought police struggled against one of the ironies of empire: extending the borders meant including millions of new speakers who might in time exert more influence over English than it could exert over them.

The first consideration given for the creation of the SPE was, therefore, the spread of the English language throughout the world.[75] Originally such anxiety had been directed at the United States. Americanisms had been decried as early as the 1740s, and in the generally unfriendly spirit of the 1860s Alford drew a direct connection between "the process of deterioration which our Queen's English has undergone at the hands of the Americans" and the debasement of the American nation in general.[76] Bridges had chiefly the Americans in mind when he decried "this most obnoxious condition, namely, that wherever our countrymen are settled abroad there are alongside of them communities of other-speaking races, who, maintaining among themselves their native speech, learn yet enough of ours to mutilate it, and establishing among themselves all kinds of blundering corruptions, through habitual intercourse infect therewith the neighbouring English."[77] The racism inherent in such attacks could be surprisingly indiscriminate. In 1927 an anonymous contributor to the *New Statesman* denounced the outrageous idea that "our language belongs to everybody who uses it—including negroes and Middle-Westerners and Americanised Poles and Italians."[78]

If the American experience excited such anxiety about "other-speaking races," the great expansion of empire in the nineteenth century made linguistic critics almost giddy. In 1886 T. L. Kington-Oliphant had serenely decreed that in recompense for all she borrowed, England provided to the empire "her own staple, namely the speech of free political life."[79] Looking back in 1926, however, A. Lloyd James, secretary to the BBC Advisory Committee on Spoken English, took it for granted that the influence had been all in the other direction: "[T]his territorial expansion of our

language sowed the seeds of its disintegration. . . ."[80] Between these two dates, "the immense area over which the language now extends" is routinely cited as one of the most important factors in its decline from purity.[81] The language that was to have symbolized England's cultural preeminence over the world, thus justifying its political and economic domination, became instead a symbol of English vulnerability, and defense of the language became a way of defending England against the cultural consequences of the implosion of the empire.

American concerns of the time about the purity of the language were in part defensive reactions to English prejudice. Richard Grant White batted back Dean Alford's slur on American speech by claiming that the British were even worse. John Hay took another tack by praising the vigor and power of American speech.[82] But Americans also had imperial anxieties quite similar to those of the English. In 1887 William Fowler worried that as "our countrymen are spreading westward across the continent, and are brought into contact with other races, and adopt new modes of thought, there is some danger that, in the use of their liberty, they may break loose from the laws of the English language. . . ."[83] Announcing the dedication of the American Academy of Arts and Letters to language issues thirty years later, Paul Elmer More spoke as if this dangerous process were nearly complete, the language "no longer the possession of the people alone who had created it, but . . . spoken and written over a vast territory among many peoples separated from the main stem by political and other traditions."[84] American expansion westward implied the same danger of linguistic contamination for Americans "from the main stem" that the English had feared from America itself.

Worse yet, in this view, was the threat that American English faced even if it stayed put: the threat of immigration. The boom in linguistic criticism in the United States coincided with the increased immigration of the 1880s and was one manifestation of the reaction against it. The "wild motley throng" that crowds in through the "unguarded gates" of Thomas Bailey Aldrich's 1895 poem of the same name bring with them a disturbing cacophony:

> In street and alley what strange tongues are loud,
> Accents of menace alien to our air,
> Voices that once the Tower of Babel knew.[85]

Thus, in a book that had gone through twenty-one editions by 1892, William Mathews declared that since "unity of speech is essential to the unity of a people" even so much as "a daily newspaper with an Irish, German, or French prefix, or in a foreign language, is a perpetual breeder of national animosities."[86] More dangerous yet was the possibility that foreign languages might corrupt English itself, so that Joseph Fitzgerald urged his readers to treat foreign loanwords "as aliens, and to agitate for an exclusion act against them."[87]

This was not merely a jingoistic campaign carried on by xenophobic know-nothings; it was in large part the work of established writers and intellectuals, men like Barrett Wendell, Brooks Adams, and Francis Parkman. For example, when Henry James returned to the United States in 1905, after his own immigration to England, he was appalled to find that he had forgotten to lock the door behind him. In his outrage James felt the presence of newly emigrated speakers of English quite literally as the invasion of a burglar:

> All the while we sleep the vast contingent of aliens whom we make welcome, and whose main contention, as I say, is that, from the moment of their arrival, they have just as much property in our speech as we have . . . all the while we sleep the innumerable aliens are sitting up (*they don't sleep!*) to work their will on their new inheritance and prove to us that they are without any finer feeling or more conservative instinct of consideration for it . . . than they may have on the subject of so many yards of freely figured oilcloth, from the shop. . . .

James's other metaphor for this linguistic violation is even more intimate:

> [T]o the American Dutchman and Dago, as the voice of the people describes them, we have simply handed over our property—not exactly bound hand and foot, I admit, like Andromeda awaiting her Perseus, but at least distracted, dishevelled, despoiled, divested of mat beautiful and becoming drapery of native atmosphere and circumstance. . . .[88]

James's choice of allusion may have made the graduating class of Bryn Mawr, to whom he directed this hysterical outburst, uncomfortable in ways that he did not intend, but it struck a sympathetic chord in Paul Shorey, who told the American Academy a few years later:

> [W]e are all hearing every day and many of us are reading and writing not instinctively right and sound English but the English of German American and Swedish American, Italian American, Russian American, Yiddish American speakers, pigeon [sic] English, Japanese schoolboy English, Hans Breitmann English, doctors' dissertation English, pedagogical seminary English, babu English.[89]

The verbal excessiveness of these defenses, like a squid shooting ink, suggests that both Shorey and James were so concerned they were willing to destroy the language in order to save it.[90]

It should be clear by now, however, that language is simply a convenient symbol of resistance to social change. The same processes that took the English to the far corners of the world and the Americans to the western shore, that brought emigrants from all over Europe to the United States, tended to erase the most visible means of distinguishing between different classes and nationalities. One of the wry messages of *Pygmalion* is that clothes make the lady, and, as manufacturing made dress more uniform, the leap from flower girl to lady became less extreme. But it is far easier to dress Eliza up in borrowed finery than it is to change her speech. Shaw's play is, therefore, a demonstration of the way that speech came to play the role of chief social discriminator as other means became less effective.[91] Between the 1880s and the 1920s, linguistic criticism became a way of checking social mobility and racial progress without overt illiberalism. Even today, criticism of speech is often, if not always, a way of expressing other social prejudices that polite discourse overtly disavows.[92] Thus the theoretical weakness of Romantic linguistic nationalism, its ghostly, parasitic dependence on that which it would expel, is the source of its social utility. The standard language movement did not need to define the standard language in order to succeed, because its real purpose was to focus attention on the alien, both foreign and domestic, and to provide a means of discriminating where other methods were beginning to fail.

IV

In these years during which dialect words were excluded from the pages of the OED, dialect was, of course, routinely stigmatized. The inconveniences arising "from the existence of local dialects" are, in the opinion of G. P. Marsh, "Very serious obstacles to national progress, to the growth of a comprehensive and enlightened patriotism, to the creation of a popular literature, and to the diffusion of general culture."[93] The two great myths of linguistic decline, the Hellenizing of Greece and the fall of Rome, tended to associate the division of a language into varieties with cultural collapse. Thus Paul Elmer More warned the American Academy that English had entered its "Englistic" period, beyond which the future seemed pretty dim.[94]

Yet, in the same set of addresses, Shorey reminded his listeners that it was "the scholarly Lowell who composed poems in a Yankee dialect."[95] And it was the scholarly Bridges who lamented "our

perishing dialects" in the tracts of a society devoted by tide at least to the preservation of pure English. In fact, the SPE was sometimes seen, from within and without, as a kind of junior branch of the English Dialect Society. In the 1918 *Cambridge History of American Literature* C. Alphonso Smith treated the SPE as if it were a conservator of dialect differences, and Walter Raleigh joined the SPE, by one account, because he thought it would offer opportunities to "coin words, and use dialect, and rap out forcible native idioms."[96] This paradox was hardly limited to the SPE. The Newbolt Report contained an opinion, submitted by the Committee on Adult Education, that dialect literature should be encouraged because "dialect, where it still lives, is the natural speech of emotion, and therefore of poetry and drama."[97]

There seems to be some indecision here, even in this very opinionated propaganda, about which English is really pure. The Newbolt Report was forthright about the need for instruction in standard English, especially if this required the abandonment of dialect, and the tracts of the SPE devoted many pages to monitoring niggling distinctions.[98] And yet there was some suspicion even here that the standard language was a fiction, an artificial convention, and that a mere convention could hardly play the role in the English ethos assigned to the national language. After all, the popular linguist Max Müller had taught since the middle of the century that the standard written languages were mere confections: "The real and natural life of language is in its [spoken] dialects."[99]

In fact, there was a marked increase in English dialect writing at this time, including works by Hardy, Stevenson, Kipling, Barnes, and the writers of the Irish Revival, as well as writers such as Henley and Davidson, who were aggressively vernacular in style.[100] The conflict between dialect, idiolect, and the standard language began to appear as a plot element in literature of the period, but not all writers agreed with Mr. Alfred Yule of Gissing's *New Grub Street*, who was given such exquisite pain by his wife's uneducated speech he never invited guests to his home. Bi-dialectal shifters such as poor Mrs. Yule, who live in two distinct speech communities, begin to appear in a sympathetic light and then in a favorable one, a process that can be traced from *Tess of the d'Urbervilles* to *Lady Chatterley's Lover*.[101]

Dialect writing was pursued even in an atmosphere of linguistic censoriousness because of the hope that it might be "the prince in disguise . . . an original and unique literary medium of expression."[102] Dialect, it was often argued about this time, was "purer" than the standard written language because it was less affected by printing, education, and "elocution masters."[103] If the real culprit in the degeneration of language is education, or the newspapers, or science, or modern slang, as Alford, James, and other watchdogs variously claimed, then perhaps the good old rural dialects of England were the "pure" alternative.[104] This is one way of understanding the enlistment in the SPE of Thomas Hardy, though he was perhaps the leading practitioner of dialect writing at the time.

Times of verbal nicety in England have often coincided with romantic rediscoveries of dialect, a coincidence best exemplified by the careers of Scott and Austen. The sort of recourse to dialect represented by Scott is easy enough to understand, but what of C. M. Doughty's claim that he traveled into Arabia "to redeem English from the slough into which it has fallen."[105] How could a sojourn among the heathen possibly redeem English? Of course, if distance from education, newspapers, science, and modern slang makes for authenticity and pure language, then maybe Arabia is just the place to find it. Or perhaps Africa, as Andrew Lang suggested when he said that "the natural man in me, the survival of some blue-painted Briton" responds best to "a *true* Zulu love story."[106] Or perhaps South America, where Roger Casement found a language so old, so elemental and untouched, no one even knew the meaning of it.[107] The shape of the paradox, at any rate, begins to emerge. On one hand, the standard language movement has as its central purpose the protection of England from other races. Yet, insofar as it recoils from what Henry James called "the high modernism of the condition,"[108] the more it is thrown into the kind of primitivism that contributed to another great trend of the period: the colonial

adventure story. Perhaps it is not so odd, then, that when Rider Haggard's heroes Holly and Vincy finally reach the heart of darkest Africa and complete their search for the mysterious She, they find a linguistic critic.

The situation in America is even more complex, since it develops in the shadow of England's authority. American defiance of this authority can take two forms: a claim that Americans are in fact more proper in their speech than the English, or a claim that Americans speak a more vital, natural speech than their decadent co-linguists. Thus American linguistic critics are even more apt than their English colleagues to splay themselves across this paradox. Even Shorey, as pinched an authoritarian as ever addressed the American Academy, praised the "crisp concise verbiage" of popular America because it "unites us in a fellowship of democratic revolt against the pedant" and "differentiates us from the supercilious and slow-witted Englishman who cannot understand it."[109] Both Brander Matthews, another Academician, and Gilbert Tucker wrote to the SPE to alert it to the fact that American English still had all the pith and vividness the SPE was searching for in England.[110]

However true this may have been, it ran against another cherished notion that America had no dialects, at least in the sense of provincial variations. Visitors to the United States in the late eighteenth and early nineteenth centuries reported an amazing uniformity of speech, on which the Americans sometimes plumed themselves when it seemed to contrast favorably with the divisiveness of English provincialisms.[111] There was, of course, one significant exception to this general uniformity: "Dialect in general is there less prevalent than in Britain, except among the poor slaves."[112] In fact, there grew up a theory that was to enjoy an extremely long life, that the English dialect variations were preserved in America only in the untutored speech of the slaves. Joel Chandler Harris, for example, claimed that the language he used in the Uncle Remus stories was simply white English three hundred years out-of-date. In the 1920s, George Philip Krapp made this claim into a full-fledged scientific theory, one which enjoyed a certain popularity in the black press of the time perhaps because it seemed to rescue black speech from the worst prejudices against it.[113]

If the slaves had preserved the "good old Elizabethan pronunciation," as R. Emmett Kennedy put it, then did it not follow that theirs was the purest English? Kennedy followed the SPE line of reasoning perfectly: the true index of a race or nation is found in its "native melodies and folk literature," preserved as much as possible from "the artificialities of civilization." Yet this authentic national voice belonged only to the unlettered folk "who have not lost the gracious charm of being natural." Ambrose Gonzales, like Kennedy a white dialect writer of the 1920s, said much the same thing: "The peasantry, the lower classes generally, are the conservators of speech."[114] As an anonymous critic observed in an 1889 review of Harris, such ideas fit perfectly within the confines of Romantic philology, except that "Putnam County . . . becomes like the Central Plateau of the Hindu-Kush Mountains—'east of the moon and west of the sun'—so dear to the myth-mongers and philologists of the Müller school."[115]

And yet, on the other hand, black English had long been considered not just corrupt in itself but also the cause of corruption in others. As early as 1740, dire notice was taken of the way that a colonial speaker who regularly consorts with slaves "acquires their broken way of talking."[116] In the next century, Dickens noticed with disapproval that "women who have been bred in the slave States speak more or less like negroes, from having been constantly in their childhood with black nurses."[117] Writers like Kennedy and Gonzales do not disavow such notions: the black speakers in their works are abundantly provided with the sort of malapropisms that have always characterized literary representations of "broken English." Somehow the language included in works like Kennedy's *Black Cameos* and Gonzales's *Black Border* is both broken and pure, twisted and authentic. And yet perhaps it is this very inconsistency that explains why the 1880s, the decade in which the standard language movement became a "thriving industry," also marked the beginning of another, seemingly quite different, industry: dialect literature.

From the hint given by Irwin Russell's "Christmas Night in the Quarters" in 1878, Joel Chandler Harris and Thomas Nelson Page developed a style of writing that was soon to dominate American magazines to such an extent it provoked pleas for relief.[118] In 1897 T. C. De Leon called it "a sort of craze." Even Page himself admitted that the result of Harris's success with Uncle Remus was "a deluge of what are called 'dialect-stories,' until the public, surfeited by them has begun almost to shudder at the very name." Prominent magazines such as *Harper's*, the *Atlantic*, *Scribner's*, the *North American Review*, and *Century* ran hundreds of stories and vignettes in dialect in this period.[119] At first this may seem to be a realization of the standardized worst fear, that popular language would be determined from below and not from above. On the other hand, however, it may be that these stories in dialect are simply another way of managing the social pressures behind the standard language movement.

C. Alphonso Smith did not consider it especially peculiar that his survey of "Negro Dialect" in the 1918 *Cambridge History of American Literature* was almost totally devoted to white writers. Smith dismisses Booker T. Washington and W. E. B. Du Bois not because they did not write in dialect but because they were not of "unmixed negro blood," and he ignores Charles W. Chesnutt altogether.[120] Here Smith simply reflects the fact that the dialect movement was almost exclusively a matter of white mimicry and role-playing. Harris may have been the most successful such writer because he had the greatest psychological investment in the role. Painfully shy and a stutterer, Harris preferred to appear before his public, and sometimes even before personal friends, as Uncle Remus. Like Jakie Rabinowitz forty years later, it seems that Harris could not find a voice until he found a black one.[121]

On the other hand, Harris was an accomplished editorialist for the Atlanta *Constitution*, where he helped Henry W. Grady define the New South that was to follow the demise of Reconstruction.[122] Harris's dual role is more than a psychological curiosity: it expresses the duplicity of the whole dialect movement. It is no accident that this movement coincides with the dismantling of Reconstruction and the birth of Jim Crow, with a legal retrenchment that began in 1883 with the overthrow of the Civil Rights Act and culminated in *Plessy v. Ferguson* in 1896, and with an increase in racist propaganda and hate crimes.[123] For the comic stories of the dialect movement firmly establish in the minds of the white readership a picture of the freed slaves as hapless, childlike, and eager for paternalistic protection.

The essential conceit on which these works are based is that their subject is fast disappearing. Over and over, it is said that Harris caught Uncle Remus at the moment he and his kind had ceased to exist.[124] Oddly enough, such figures continued to disappear for at least the next thirty years, at which time E. K. Means congratulated himself for preserving in print a new generation of vanishing Negroes.[125] The central trope of the movement, the "disappearing Negro," was serviceable on several levels. It functioned as wish fulfillment, revealing the barely submerged hope that the freed slaves would simply die off. It served as a metaphor of the temporal reversal of the post-Reconstruction period, taking readers imaginatively back in time as the South was being taken politically back in time. And it fed nostalgia for a time when racial relationships had been simple and happy, as least for whites, suggesting that they might be simple and happy again if southern whites were simply left alone to resolve things themselves.[126]

What was really vanishing, in other words, was a racial relationship that Jim Crow laws were meant to recreate. The black of the dialect stories was little more than a metaphor for the antebellum way of life. As Page put it, "It has been very often suggested that I was writing up the darkey; but my real intention has been to write up the South and its social life, using the darkey as a medium. . . ."[127] Yet Page seems unaware of the full implications of this metaphorical identification, as Julia Peterkin certainly was when she ingenuously rephrased it: "I shall never write of white people; to me their lives are not so colorful. If the South is going to write, what is it they are going to write about—the Negro, of course."[128] If the South has no subject but the Negro, as Harris had no voice but that of

Uncle Remus, then the region has come to be defined entirely in terms of that which it hates and fears. The freed slaves are submerged, expelled, and expanded until they become coterminous with the region itself.

In the same way, black speech is mocked as deviant and at the same time announced as the only true voice of the South. This has the effect of affirming the standard about which the standardizers were so concerned while simultaneously creating an escape from it. Smith claims that "the American passion for a standardized average of correctness" has checked the use of dialect among whites, but he does not suspect that the "Negro dialect" to which he devotes his article *is* white dialect in that it stands in for that which has apparently been abandoned.[129] Bad grammar has long been the privilege of the upper classes, who demonstrate their superiority to social constraints by slipshod speech. The dialect tradition extended this privilege to the entire white race, which could pay homage to and in the same breath demonstrate its independence from the standard language.

The difficulties this created for African-American writers of the time are indicated by the absence of Charles W. Chesnutt from Smith's encyclopedic article. Chesnutt himself included a sort of allegory of this situation in his novel *The Marrow of Tradition*, in which Tom Delamere, "a type of the degenerate aristocrat," excels in "cakewalk or 'coon' impersonations, for which he was in large social demand." Delamere's talent turns to crime when he robs and kills his own aunt while disguised as the faithful black houseservant Sandy, who is nearly lynched for the crime.[130] The way that Delamere goes free while Sandy is confined and almost executed represents the unequal effects of the racial mimicry of the dialect tradition, which represented imaginative license for its white practitioners but quite literal imprisonment for blacks. These effects impinged in the same way on the most noted African-American poet of the period, Paul Laurence Dunbar, who complained that praise of his dialect verse had become a trap because readers would pay attention to nothing else.[131] This is the very "chain of dialect" that Johnson had to break in the 1920s, while another young aristocrat named Tom practiced his "coon impersonations."

In the generation between *The Marrow of Tradition* and *God's Trombones* the chain became, if anything, even tighter. According to Thomas Gossett, the widespread race riots of 1919 marked an intensification of American racism that lasted throughout the 1920s: "[B]ooks and articles expounding the transcendent importance of race as a key to civilization poured from the presses in the 1920's." There was an increase in racial violence, in overt discrimination, and in prejudices about language: in 1919 fifteen states passed laws requiring that all instruction, public and private, be in English.[132] At the same time, there was a second boom in dialect writing, even larger, if anything, than the first. So strong was the "vogue" that Edgar Billups feared that the field would be given over to mere "faddists." Julia Peterkin complained that her Gullah stories were ignored because so many of the potential reviewers wrote dialect stories of their own.[133] These might have included Irvin Cobb, Hugh Wiley, T. S. Stribling, Robert McBlair, Gertrude Sanborn, Ada Jack Carver, John Trotwood Moore, Marcellus Whaley, E. C. L. Adams, Roark Bradford, John B. Sales, and many others. In addition to the magazines and journals that had been publishing dialect since the 1880s, *The Saturday Evening Post* began to make it a particular speciality.[134]

By the 1920s, then, dialect was solidly established in a quite equivocal role: it reflected increasingly shrill demands for adherence to a chimerical standard and at the same time defied those demands. As "broken English," dialect was the opposite without which "pure English" could not exist. In fact, "pure English" could never adequately be represented except by implication, so that dialect, slang, and other forms of linguistic slovenliness had to be kept in currency to keep "pure English" alive. At the same time, however, dialect served as the "natural" form of "pure English," its unmarked counterpart, to which even the strictest schoolmaster had to pay lip service at times. Finally, dialect preserved an escape from all the social pressures implied by the standard language movement: "black" dialect was white dialect in hiding. This is not to say that there was no actual black speech

with its own order and rules, only that the acted, sung, and published versions of this language were almost always white products, no matter how much they may have resembled their black prototypes. Black dialect was a resort freely open only to whites, and thus its popularity matched and in fact reflected the influence of the standard language movement so inimical to non-European cultures and languages.

V

Born in the 1870s and 1880s, modernists such as Eliot, Pound, Stein, H. D., Williams, and Stevens grew up at a time when the English language was being pulled apart by competing political and social forces. Schoolchildren, both white and black, "were taught that the speech of their fathers was not proper English speech. They were encouraged to leave behind their dialects and regional and ethnic idioms."[135] This, for many, was a rather more difficult process than Shaw supposes when he speaks of the "many thousands of men and women who have sloughed off their native dialects and acquired a new tongue." At the same time, however, youngsters like Ezra Pound were presented with a romanticized alternative in the stories of Uncle Remus and the dialect tradition of the popular magazines.[136]

When their movement climaxed with *The Waste Land* in 1922, the modernists' linguistic horizon also enclosed "The Day of Atonement," the Newbolt Report, *The Book of American Negro Poetry*, *Harlem Shadows*, Clement Wood's *Nigger*, and Wittgenstein's *Tractatus*, all of which were published in the same year. And though it may seem that these various linguistic productions have little to do with one another, they are in fact joined by a rather dense network. Brander Matthews, a member of the American Academy and a contributor to the tracts of the SPE, introduced James Weldon Johnson's dialect poetry to the nation.[137] C. K. Ogden, inventor of Basic English and translator of the *Tractatus*, published two dozen poems by Claude McKay in the same issue of the *Cambridge Magazine* that included "The Linguistic Conscience."[138] Eliot stole from Johnson; Johnson advised Van Vechten; Van Vechten introduced Gertrude Stein to Harlem by quoting her in *Nigger Heaven*.[139]

The position of literary modernism in this network of linguistic relationships is almost necessarily equivocal. In a 1926 comment in the *Dial*, Marianne Moore welcomed the SPE because she found its tracts "persuasively fastidious." Though she admitted that "perfect diction" is less to be found in America than mastery of slang, she did find enough of it to mention James, Poe, Whistler, Stevens, Pound, and Cummings as examples. Moore was clearly entranced by the possibilities for fine distinction presented by the articles of the SPE, which she saw as the ally of poets interested in the infinite variousness of words.[140] On her own side of the Atlantic, however, the forces of linguistic criticism had chosen Moore herself for attack. One of the papers published by the American Academy in 1925, Robert Underwood Johnson's "Glory of Words," is in fact an extended attack on literary modernism: on free verse, on contemporary subject matter, on colloquial diction, on Eliot, Conrad Aiken, Carl Sandburg, Amy Lowell, and on Marianne Moore. Quoting a stanza from "Those Various Scalpels," Johnson asks, "What is the remedy for this disease?" The answer is "to dwell upon the glory of words in our inexhaustible and imperishable treasures of great poetry," which is probably about what Moore thought she was doing.[141]

The irony reveals how variously modernism might be defined as bringing greater precision to language or as destroying just those rules and usages that made precision possible. But there is another, more specific, twist in this relationship as well. Moore declares a "fascinated interest" in the variability of American pronunciation, "when in New York seabirds are *seaboids*, when as in the Negro vernacular, the tenth becomes the *tent*, certainly is *certainy*, and Paris is *Parus*."[142] Moore's examples are fairly weak, and one is apparently a piece of eye dialect, but the message is

clear: vernacular and dialect distortions of the language are a resource to be mined. Eliot praised Moore in the pages of the *Dial* precisely for her ability to exploit this resource, "the jargon of the laboratory and the slang of the comic strip."[143] But in Johnson's ears this same mixture of sounds causes exquisite pain. "The free verse of today," he says, "disdains the lute, the harp, the oboe, and the 'cello and is content with the tom-tom, the triangle, and the banjo."[144] The racial implications of Johnson's musical examples are fairly clear: modernism disdains great literature for black minstrelsy. Its rebellion against pure English and the great literature written in it is figured as racial treason.

Johnson may have had in mind Vachel Lindsay's poem "The Congo" or Carl Sandburg's "Jazz Fantasia." He might well have trained his sights on two plays not published until two years after his talk, *Sweeney Agonistes* and E. E. Cummings's *Him*, both of which use minstrel instrumentation. Cummings's play, which Moore admired so much she arranged to have parts of it published in the *Dial*, aims to give offense in exactly the quarter defended by Johnson.[145] Perhaps this is what endeared it to Moore, because the play is an unruly compendium of variant Englishes from drunken slurs to soap box oratory to advertisement slogans to vaudeville to medicine show barking.

Cummings tends to arrange these languages in competing pairs. A drunken Englishman who asks to have his "topper" replaced on his "nut" is met by an American policeman who says things like "Lissun. Wutchuhgut dare." An Ethiopian who claims "Ah ain goin nowhere" meets some suspicious centurions. A "gentleman" whose hypercorrectness of speech leads him to misuse the word *infer* meets a shapeless mob. The climax, in a way, of this fairly shapeless bit of modernist vaudeville is the confrontation between six "coalblack figures" in full minstrel regalia, singing to an invisible jazz band, and John Rutter, "President pro tem of the Society for the Contraception of Vice." Rutter spins out an enormously bloated indictment of "harmful titillation provocation or excitation complete or incomplete of the human or inhuman mind or body" whether it "be oral graphic neither or both and including with the written and spoken words the unwritten and unspoken word or any inscription sign or mark." Rutter is, in brief, one of the "linguistic thought police" let loose by Richard Grant White and egged on by Robert Underwood Johnson. Meanwhile the minstrel singers say things like "Gway yoh poor whytrash."[146]

The confrontation between linguistic authoritarianism and American dialects is but one version of a more general conflict between repression and freedom, which Cummings dramatizes by having the minstrels confront Rutter with "something which suggests a banana in size and shape and which is carefully wrapped in a bloody napkin."[147] This object symbolizes what Rutter, despite his name, does not have, what he fears, and what his language in all its convoluted Latinate obscurity attempts to hide. The ultimate affront to Rutter and his ilk would obviously be actual obscenity, and yet Cummings shrinks from this final outrage, letting black speech and jazz innuendo suggest what he is too squeamish to say.

Johnson is perfectly right, then, to associate the modernist affront with minstrel instruments. Minstrel dialect is for Cummings one of the languages of rebellion, and the rebellion against stifling linguistic authoritarianism that it makes possible is the type of a much broader rebellion against repression and standardization of all kinds. In the year of *The Jazz Singer* and *Sweeney Agonistes*, Cummings also breaks away from the fathers, from the Robert Underwood Johnsons, by donning a minstrel disguise. Thus the terms of *The Jazz Singer* are recapitulated, with Robert Underwood Johnson in the role of the outraged father who shouts, "Singing nigger songs in a beer garden! You bummer! You no good lowlife!"[148] and E. E. Cummings as the cheeky lad who demands the right to express himself by putting shoeblack on his face.

Thus the generational conflict between the older critics clustered behind the American Academy's walls and the younger writers outside was fought over the body of a third figure, a black one. When Sherwood Anderson wanted to express his fear about creeping standardization and linguistic intolerance, he drew on the old metaphor of the vanishing Negro: "Will the love of words

be lost? Success, standardization, big editions, money rolling in. . . . Words goin the way of the black, of song and dance." It is no accident that Anderson actually begins to speak in dialect here, because he implicitly aligns the free language of the modern artist with the despised dialect of African America. In this analysis only the standard language is actually "white." Artistic language is, by virtue of its deviation from that standard, black: "In the end they will make factory hands of us writers too. The whites will get us. They win."[149]

Because the American Academy had long associated immigration with linguistic decline, it also viewed the conflict over language as a racial one. Modernism became another form of mongrelization, another impurity stirred into the terrifying mixture that America was becoming. Like Johnson, Stuart Sherman attacked the younger generation as if its literary experiments had introduced some sort of alien bacillus into the bloodstream of the republic. Such young people, he charged, were in league "against virtue and decorum and even against the grammar and idiom of English speech." This league might never have gathered, Sherman suggests darkly, if not for a group of leaders "whose blood and breeding are as hostile to the English strain as a cat to water." Sherman's metaphor for these "alien-minded" writers is peculiarly inappropriate: he calls them "Mohawks," as if American Indians were somehow more alien to America than the English immigrants of the 1660s. But his point is clear nonetheless: writers who tamper with the English language are, ipso facto, racial aliens.[150]

The figure in the midst of all this, the racial alien, is, of course, a cipher, and yet it actually represents the one point of agreement in the battle of literary generations. Both sides tend to see this figure as natural, primitive, life-affirming, and impatient of restraint. This unspoken agreement shows how little threat was actually posed to the reigning order by plays like *Him*. Despite the outrage of Robert Underwood Johnson, such plays merely offered the sort of escape that confirmed authority by confirming its categories, no matter how thoroughly they may have reversed the value judgments attached to those categories. When Cummings or Anderson romanticize dialect as a natural and spontaneous alternative to a restrictive standard, they merely repeat what Johnson has already said, albeit in a different tonality. And yet *Him* shares something else with *The Jazz Singer*: a tendency to undermine its own oppositions. The jumble of competing languages in Cummings's play makes it very difficult to nominate one as the most "natural." Cummings's vaudevillian ventriloquism is so indiscriminate it undermines the status of dialect itself, leveling all language. This is the real threat it poses to the forces of standardization.

VI

The third member of the linguistic ménage à trois at the center of *Pygmalion* is Colonel Pickering, author of *Spoken Sanscrit*, who comes home to England especially to meet Henry Higgins. One of Higgins's real-life prototypes, Henry Sweet, had predicted Pickering, in a way, when he argued that the widening of the Empire would provide linguists with innumerable useful and exotic examples, of which Sanskrit was only the first. Studying Sanskrit in India, Sir William Jones had proposed the notion of a common ancestor behind it and most of the European languages, an ancestor that came to be called Indo-European. Jones's suggestion gave rise to a kind of "unified field theory" of language, with a new etymological principle of human universality to replace that once provided in a narrower sphere by Latin grammar.[151]

Eliza's education is in part an experiment to test this theory, which she corroborates by ably learning a whole panoply of languages besides standard English, including African dialects and "Hottentot clicks."[152] Higgins's ability to teach and Eliza's to learn these quite different languages suggests a common substratum and therefore a brotherhood among them. Given enough time

and study, perhaps all languages could be arranged around a single standard, a possibility that would assuage all the anxieties of the Society for Pure English by transforming it into the Society for Pure Language. But this is just what troubled the opponents of the Indo-European theory. If there is a common substratum linking English and Sanskrit, then there is a fundamental cultural commonality linking the English and what Muller called "the black inhabitants of India," and if there is such a commonality then it seems impossible to maintain the superiority on which the empire depended.[153]

The ironic result of the "unified field theory," as Linda Dowling points out, is that, instead of affording linguists a standard by which they could construct some vast pecking order of world languages, it reduced all languages to the same plane.[154] In this way the ethnographic appetite of imperialist Europe led in the end to the very opposite of the vast order once envisioned; it led to contemporary cultural and linguistic relativism. The very gesture that extended European intellectual sway over all the globe undermined the pretensions of European thought and language. Thus professional linguists have been utterly at odds with the standard language movement since its beginnings, because they tend to look at language as purely conventional and relative.[155]

In part this relativism grew naturally out of the linguistic difficulties faced by the earliest ethnographers. Franz Boas, attempting to deal with the basic ethnographic problem of linguistic transcription, realized that it was impossible to treat a European language, no matter how "scientific," as a neutral container for other languages. Trapped inside his own linguistic system, the European observer could only approximate what he heard. Thus there was no way to rank or hierarchize languages; they were simply different sound systems, mutually incompatible.[156] The same was true for Bronislaw Malinowski, who claimed that ethnographic research had "driven" him away from the idea of language as a stable repository of meaning toward a new theory he called "the principle of Symbolic Relativity." This theory, which held that each language is governed by a "pragmatic world vision," frees us, Malinowski says, "from logical shackles and grammatical barrenness."[157] It also made the whole notion of a standard language a philosophical incoherence.[158]

This dual development, this link between ethnographic interests and linguistic relativism, was recapitulated within the international modernism that grew up at the same time. In some cases the connection between ethnography and artistic experiment was remarkably direct. The American painter Max Weber, for example, sat down in the American Museum of Natural History one day in 1911 and began to write free verse. Weber began with a piece called "To Xochipilli, Lord of Flowers," inspired by a pre-Columbian sculpture in the museum's collection, and finished fifteen years later with a book called *Primitives: Poems and Woodcuts*, which included poems like "Congo Form" and "Bampense Kasai," which was written about an African mask.[159] For the most part, however, the influence of ethnographic collections was mediated through scholars like Wilhelm Worringer and Lucien Lévy-Bruhl. In both cases ethnography fed the desire George Steiner identifies particularly with the avant-garde of the period 1870–1900, the desire to investigate—through destructive experimentation if necessary—the very bases of language.[160]

The writers who felt this necessity most keenly all seem to have been polyglot cosmopolitans: Pound, Kandinsky, Cendrars, Tzara, Apollinaire. Richard Huelsenbeck's 1917 dada manifesto "The New Man" describes this miscellaneous group as "saturated, stuffed full to the point of disgust with the experience of all outcasts, the dehumanized beings of Europe, the Africans, the Polynesians, all kinds. . . ."[161] Peculiarly, Africans and Polynesians come to stand for all outcasts, and their languages, or imaginary versions of their languages, for the new speech of the new man. Pound declared that "the artist recognises his life in the terms of the Tahitian savage," and he sat for a portrait bust that made him look like an Easter Island idol.[162] And when Huelsenbeck appeared at the first of many evenings at the Cabaret Voltaire, he recited "some Negro poems that I had made up myself."[163]

These poems were the first of many "chants negres" to grace a dada evening at the Cabaret Voltaire, where the entertainment also often included Huelsenbeck's drumming and "African"

masks by Marcel Janco.[164] Dada poetry of the period depended heavily on "pseudo-African" languages made up of nonsense syllables like the "umba umba" that graced Huelsenbeck's first essay in the genre. At its extreme, such poetry went beyond nonsense syllables to the very letter itself, as in Huelsenbeck's "Chorus Sanctus":

> aao a ei iii oii
> ou ou o ou ou e ou ie a ai
> ha dzk drrr br obu br bouss boum
> ha haha hi hi hi l i l i l i leïomen[165]

Using an ersatz African language as a wedge, Huelsenbeck pries language loose, letter by letter, from sense and meaning.

In this the dadaists came closer than they realized to one of the oldest and most traditional of all American entertainments. The original minstrel shows themselves were somewhat dadaistic. Dan Emmett, composer of "Dixie," also became famous for something called "Machine Poetry," "a babble on a single tone, fizzling out into prose."[166] And this history shows how deeply conventional the association between black speech and nonsense was. Yet dada pushed the disintegrating power of nonsense so far as to upset the easy dichotomy that kept the alinguistic safely in Africa or in the slave quarters of the plantation.

In 1926, for example, Hannah Hoch produced the visual counterpart of a dada poem with her series of photocollages entitled *From an Ethnographical Museum*.[167] These mix African images with bits and pieces of conventional European beauty: lips, eyes, seductive female legs. The mixture disrupts conventional European notions of beauty by putting cover girl lips on an African mask and high-heeled legs beneath a sculptured African torso. It also disrupts the dichotomy that places only African images in ethnographic museums. Here the ethnographic gaze is all-encompassing, and it has the dadaistic effect of reducing every cultural icon to the same level, making nonsense of all. The collages are an exact visual equivalent of the effect that ethnography had on European linguistics, relativizing the European by including it in the same frame of analysis as the foreign, and they also reflect the reversal of values that lurked in the heart of the avant-garde poetry of this period that used African models.

Blaise Cendrars, to take an even more significant example, was an amateur ethnographer of some popular importance, since the *Anthologie nègre* that he published in 1920 became widely known in Europe and the United States.[168] Though Cendrars was not himself a dadaist, selections from the anthology were in fact used at a 1919 "Fête nègre" in Paris that very much resembled the goings-on at the Cabaret Voltaire.[169] Cendrars, who was born Frédéric Louis Sauser in Switzerland and was a relentless traveler, agreed with Huelsenbeck that there was some essential correspondence between this condition of modern statelessness and the life of "le sauvage": "Quand le poète a voulu exprimer le monde moderne, 'il a souvent employé le langage du sauvage. C'était une nécessité.'" The poet faces the modern world "pauvre et démuni comme un sauvage armé de pierres devant les bêtes de la brousse."[170] Thus it was that one of the great themes of Cendrars's life was "le renouvellement du langage poétique par l'imitation de certaines caractéristiques des langues archaïques."[171]

This process produces certain poems, such as "Mee Too Buggi," that reproduce in poetry the relativizing effect of Höch's collages. "Mee Too Buggi" is, in fact, a collage, a tissue of quotations from a nineteenth-century English ethnographic work. Since this work depends on quotation itself, the words of Cendrars's poem sometimes have three or four competing resonances. "Mee Too Buggi" is, it turns out, the name of a Tongan dance, apparently rendered from the indigenous language into pidgin English and then imported by way of French translation into the text of Cendrars's poem. Though one American translator twisted the line into "Me too boogie," the circle cannot be

closed that easily. The competing interests of Tongan, English, and French cancel one another out, producing a nonsense term that has no secure home in any language.[172]

As Jean-Pierre Goldenstein points out, this use of a language unintelligible to virtually all readers of the poem "crée un effet d'étrangeté et d'illisibilité."[173] "Mee too buggi," "fango fango," "Mee low folia" become mere signs torn loose from any signification. Thus Cendrars uses the ethnographic material in collage to reproduce the effect achieved by artists like Höch and, on a grander scale, Picasso, who used the clash between European and African materials to create an effect of cultural disorientation that would finally expose the pretensions of the sign to natural signification. "Mee Too Buggi" also juxtaposes "Bolotoo" and "Papalangi," as if these were two remote and unknown places, but "Papalangi," it turns out, was a Tongan word for Europe.[174] The European reader, in almost certain ignorance, looks back at himself or herself as at a foreigner from a distant country with a funny, nonsensical name. This effect is, for the most part, a private joke, but the poem makes the same point frequently on the surface. At the beginning of the poem, the poet takes up his sacred lyre and touches it to his nose. The whole production of literature, of history, of poetry ("Rimes et mesures dépourvues"), is reduced to slapstick ("L'homme qui se coupa lui-meme la jambe ruississait dans le genre simple et gai") and low pidgin ("Mee low folla").[175] The mockery reduces the privilege of poetry, of language itself, to nothing.

Unlike Cummings, who resorts to racial models so as to find an authentic language, a natural one to counterpose to the artificial languages of authority, Cendrars mixes pidgin in with French to emphasize the artificiality of both. His nearest counterpart in English is perhaps Joyce, especially the Joyce of *Finnegans Wake*, but also the Joyce of "Oxen of the Sun," which ends its history of English prose styles with a "frightful jumble" of "Pidgin English, nigger English, Cockney, Irish, Bowery slang and broken doggerel. . . ."[176] This mélange may represent drunkenness or moral chaos, but it may also represent the present as an era without a dominant linguistic standard, one in which pidgin can replace Macaulay at the center of power. It is as if Joyce offers this as the language of modernism, of the modern condition in which dialect and idiolect take the place of standard English as the rightful language of literature.

Cendrars may find other counterparts among the transatlantic modernists, other expatriates such as Conrad or Stein, or writers who lived in the United States all their lives in a condition of linguistic disaffinity, like Williams. Such writers see their own language, once taken for granted, as a distinct and arbitrary set of conventions. According to Seamus Heaney, this is a condition that afflicts more and more poets in this century: "Many contemporaries writing in English have been displaced from an old at-homeness in their mother tongue and its hitherto world-defining heritage."[177] This is like the condition Marianna Torgovnick has discussed under Lukacs's term "transcendental homelessness," but it is rather more specifically linguistic and political than transcendental. And it is a global condition that affects millions beyond the literate elite.[178] The forces behind the linguistic conflicts of the last hundred years are so vast as "to convert what had been an experience of small minorities to what, at certain levels, and especially in its most active sites and most notably in the United States, could be offered as a definition of modernity itself."[179]

As Torgovnick shows, primitivism seems necessarily to accompany a condition of exile, as the exile searches man's primeval past for another home.[180] But racial primitivism provides a home only for some exiles; for others, like Cendrars, it calls into question the whole notion of "at-homeness," especially if that condition goes along with a heritage once thought to be "world-defining." What "The Negro of the Jazz Band" finally learns by passing for black is that "everyone disguises his own personality. . . . The world is a marketplace of falsefaces."[181] This is the revelation that waits at the heart of *The Jazz Singer*, that there is no true voice at all, only a shuttling back and forth made possible by makeup.

Of course, this sort of restless relativism contains its own possibilities of romantic primitivism. Stephen Greenblatt maintains that the elemental cultural sin of the European colonizers was

their refusal to grant "opacity" to the other peoples they encountered. Nowadays, as Sara Suleri has complained, such opacity is virtually enforced, as the "unreadability" of the colonial other becomes fetishized.[182] Thus the romantic nomadism of Deleuze and Guattari depends quite unself-consciously on the racial other as the type of the asignifying sign, and on dialect as the prototype of a nomadic language: "To be a foreigner, but in one's own tongue, not only when speaking a language other than one's own. To be bilingual, multilingual, but in one and the same language, without even a dialect or a patois. To be a bastard, a half breed, but through a purification of race. That is when style becomes a language." This is what might be called postmodern primitivism, and it differs from the older modernist variety only in romanticizing the relativity and opacity of language instead of its concreteness.[183] Thus the new aesthetic may look a great deal like the old, as Pasolini's African romanticism looks like Eliot's:

> I have been rational and I have been
> irrational: right to the end.
> And now . . . ah, the desert deafened
> by the wind, the wonderful and filthy
> sun of africa that illuminates the world.
>
> Africa! My only
> alternative . . .[184]

That such lines could be written by a postmodern hero as late as 1960 suggests that some things will never change, no matter how much the categories may be shuffled. On the other hand, the notion of linguistic and cultural relativism brought about by the dislocations of the late nineteenth and twentieth centuries does make possible a reversal of terms, of points of view, very useful to writers who have never before been able to feel "at home" in English.

Something like this is suggested, at any rate, in Salman Rushdie's *Satanic Verses* by the character of Saladin Chamcha, the Man of a Thousand Voices and a Voice. Chamcha makes his money doing voice-overs: "On the radio he could convince an audience that he was Russian, Chinese, Sicilian, the President of the United States."[185] Chamcha's placelessness is thus played for laughs, but the humor is mostly at the expense of his listeners, who have no idea they are docilely listening to a man they might refuse to sit next to in the subway. What Rushdie is dramatizing here is a global reversal of the situation of *The Jazz Singer*, a fundamental contravention of the old law that mimicry meant freedom only for the European.

Like *The Jazz Singer*, *The Satanic Verses* is also self-reflexive, for Chamcha's voice-overs dramatize a situation of which Rushdie himself is one of the best examples:

> What seems to me to be happening is that those peoples who were once colonized by the language are now rapidly remaking it, domesticating it, becoming more and more relaxed about the way they use it—assisted by the English language's enormous flexibility and size, they are carving out large territories for themselves within its frontiers.[186]

Rushdie's final metaphor precisely reverses the standard imperialist language, as his whole statement represents his own hopeful reversal of the standardizes' worst fear. *The Satanic Verses* "rejoices in mongrelization and fears the absolutism of the Pure."[187] Across the century, Henry James and Rushdie agree that this is "the high modernism of the condition," that the movement and mixture of peoples and their languages, dialects, and vernaculars is the defining condition of the literature of our time. How we get from James's shudder of rejection to Rushdie's celebration, and from the racial mimicry of T. S. Eliot to that of Saladin Chamcha, is one of the most important stories that modern literature has to tell.

Notes

1. Bernard Shaw, "Preface: A Professor of Phonetics," *Collected Plays with Their Prefaces*, 7 vols. (New York: Dodd, Mead, 1975), 4:664, 734. In a fragment included in this edition, Shaw claims that he wrote the play purely to publicize phonetics as a way of achieving a standard English pronunciation (p. 800). See also Shaw's "Plea for Speech Nationalisation," in *The English Language: Essays by Linguists and Men of Letters, 1858-1964*, 2 vols., ed. W. F. Bolton and D. Crystal (Cambridge: Cambridge University Press, 1966–1969), 2:80–85.

2. Compare this scene to a famous episode in American advertising. To counter protests about the grammatical error in its slogan claiming that its brand "tastes good like a cigarette should," the company ran another ad defiantly asking, "What do you want, good grammar or good taste?" Dennis Baron calls this "the glorious defeat of artificial grammatical prescriptions by the democratic representatives of realistic language." See his *Grammar and Good Taste: Reforming the American Language* (New Haven, Conn.: Yale University Press, 1982), p. 169.

3. Robert L. Carringer, *The Jazz Singer* (Madison: University of Wisconsin Press, 1979), p. 140; Ronald Haver, audio essay, *Singin' in the Rain* (Criterion, 1988, laserdisc).

4. All the details in this paragraph are included in Havers's audio essay, included on one track of the 1988 Criterion laserdisc reissue *of Singin' in the Rain*.

5. In fact, this scene is itself frequently omitted from televised versions of *Singin' in the Rain*.

6. *The Jazz Singer* (Warner Bros./Vitaphone, 1927). The title cards refer to him as "Ragtime Jakie." Carringer, p. 143.

7. *The Jazz Singer*, title cards. The corresponding scene in the screenplay is much milder and lacks the generational rebelliousness. Carringer, pp. 98–99.

8. The movie retains a useful ambiguity about this "tear." Is it a function of Jack's Jewishness or sorrow at separation from his heritage and family? Yudelson says, "[T]hat's Jakie—with the cry in the voice, just like in the temple." Carringer, p. 122.

9. Carringer, p. 120. In the film itself this becomes, "He talks like Jakie—but he looks like his shadow."

10. For a penetrating discussion of these questions, to which I am greatly indebted, see Michael Rogin, "Blackface, White Noise: The Jewish Jazz Singer Finds His Voice," *Critical Inquiry* 18 (Spring 1992): 417–53, esp. pp. 429, 430–431. *The Jazz Singer* was hardly unique in bringing these old routines to the screen. In fact, what is remarkable about this period is the prevalence of blackface routines in film, onstage, and even on radio. Within a year of the premiere of *The Jazz Singer*, the following productions appeared, each with significant blackface roles (all page citations are to William Torbert Leonard, *Masquerade in Black* [Metuchen, N. J.: Scarecrow Press, 1986]): Carl Laemmle's lavish film version of *Uncle Tom's Cabin* (pp. 186–89); D. W. Griffith's comic version of the same story, *Topsy and Eva* (p. 192); Eddie Cantor's feature film debut in *Kid Boots* (p. 241); Moran and Mack (a.k.a. "Two Black Crows") in *Two Flaming Youths*, with W. C. Fields (p. 278); First National's *An Octoroon* (p. 372); and MGM's *Heart of Maryland* with a large white cast in blackface (pp. 370–71). Onstage there were premieres as different as Oscar Hammerstein's extravaganza *Golden Dawn* (pp. 203, 206–7); Jay C. Flippen in *Padlocks of 1927* (p. 250); David Belasco's *Lulu Belle* (p. 322); Maxwell Anderson and Laurence Stallings's *Deep River* (pp. 331–32); and the return of McIntyre and Heath to vaudeville after their "retirement" (p. 275). At the same time, Amos 'n' Andy, then known as Sam 'n' Henry, made their radio debut (pp. 234–37).

11. Carringer, p. 148.

12. Ibid., p. 145. Jolson ad-libbed most of the extended sound sequences in the film. These are transcribed and printed in Carringer.

13. Al Jolson, "Maaaaam-my! Maaaaam-my! The Famous Mammy-Singer Explores His Native(?) Sunny Southland," *Vanity Fair* 24 (April 1925): 42, 98. This kind of interchange of material did actually take place, however. Shelton Brooks, a black composer, wrote at least two songs for Jolson, and Garland Anderson, a black bellhop who had written a play, took it to Jolson, who arranged to have it performed. The result, *Appearances*, was the first full-length Broadway production of the work of a black playwright. As a kind of ultimate reversal, John Mason, a black performer, was made up to look like Jolson in blackface for the 1929 *Deep Harlem*. Bruce Kellner, *The Harlem Renaissance: An Historical Dictionary for the Era* (1984; rpt. New York/London: Methuen/Routledge & Kegan Paul, 1987), pp. 54, 14, 111.

14. Another way of putting this would use the terminology advanced by Werner Sollors, who focuses on "the conflict between contractual and hereditary, self-made and ancestral, definitions of American identity—between *consent* and *descent*." See his *Beyond Ethnicity: Consent and Descent in American Culture* (New York: Oxford University Press, 1986), pp. 5–6. In *The Jazz Singer* Jakie Rabinowitz seems to move from an ethnicity defined by descent to a citizenship defined by consent. And yet the use of another ethnicity, another form of descent, to manage this transition shows how complexly the two modes are intertwined, at least in the modern period.

15. Raphaelson's story is reprinted in Carringer, pp. 147–67. *Pygmalion* made its first American appearance in the same magazine in 1914.

16. Rudolf Fisher, "The Caucasian Storms Harlem," *The American Mercury* 11 (August 1927): 398.

17. Jose M. Salaverria, "The Negro of the Jazz Band," trans. Dorothy R. Peterson, in *Ebony and Topaz: A Collectanea*, ed. Charles S.Johnson (1927; rpt. Freeport, N. Y.: Books for Libraries Press, 1971), pp. 65–66.

18. Carl Van Vechten, *"Keep A-Inchin' Along": Selected Writings of Carl Van Vechten About Black Art and Letters*, ed. Bruce Kellner (Westport, Conn.: Greenwood Press, 1979), pp. 4–5, 69; John R. Cooley, *Savages and Naturals: Black Portraits by White Writers in Modern American Literature* (Newark: University of Delaware Press/London and Toronto: Associated University Presses, 1982), p. 73. There is a letter preserved in the Jean Toomer papers that records Frank's decision to travel as black, if Toomer were going to do the same. Waldo Frank to Jean Toomer, nd (1922?), Jean Toomer papers, box 2, folder 83, James Weldon Johnson Collection of Negro Literature and Art, Beinecke Rare Book and Manuscript Library, Yale University.

19. Holly Stevens, *Souvenirs and Prophecies: The Young Wallace Stevens* (New York: Knopf, 1977), p. 199; Ezra Pound, *The Selected Letters of Ezra Pound, 1907-1941*, ed. D. D. Paige (1950; rpt. New York: New Directions, 1971), p. 294.

20. *The Letters of T S. Eliot*, ed. Valerie Eliot (New York: Harcourt, Brace, 1988), p. 350; James R. Mellow, *Charmed Circle: Gertrude Stein and Company* (New York: Praeger, 1974), pp. 64, 69, 77.

21. John Berryman, *The Dream Songs* (New York: Farrar, Straus & Giroux, 1969), p. v. For a discussion of Berryman and a number of the other writers mentioned here see Aldon L. Nielsen, *Reading Race: White American Poets and the Racial Discourse in the Twentieth Century* (Athens: University of Georgia Press, 1988).

22. Nathan Irvin Huggins, *Harlem Renaissance* (New York: Oxford University Press, 1971), p. 93.

23. Sherwood Anderson to Jean Toomer, January 3, 1924, Jean Toomer papers, box 1, folder 8, James Weldon Johnson Collection of Negro Literature and Art, Beinecke Rare Book and Manuscript Library, Yale University. The whole correspondence is of the greatest interest. See Darwin T. Turner, "An Intersection of Paths: Correspondence Between Jean Toomer and Sherwood Anderson," *in Jean Toomer: A Critical Evaluation*, ed. Therman B. O'Daniel (Washington, D.C.: Howard University Press, 1988), pp. 99–110; and Mark Helbling, "Sherwood Anderson and Jean Toomer," in O'Daniel, ed., pp. 111–20.

24. H. D., *HERmione* (New York: New Directions, 1981), p. 26. For a discussion of this passage and the whole issue of racial crossidentification in H. D., see Susan Stanford Friedman, "Modernism of the 'Scattered Remnant': Race and Politics in the Development of H. D.'s Modernist Vision," in *H.D.: Woman and Poet*, ed. Michael King (Orono: University of Maine Press/National Poetry Foundation, 1986), pp. 99–116.

25. Alice Corbin, "Mandy's Religion," *Seven Arts* 2 (September 1917): 600; Carl Sandburg, "Jazz Fantasia," *Dial* 68 (March 1920): 294; Malcolm Cowley, "Farewell Blues," in *The American Caravan*, ed. Van Wyck Brooks et al. (New York: Literary Guild, 1927), pp. 57–58; Mina Loy, "The Widow's Jazz," *Pagany* 2 (Spring 1931): 68–70. Lindsay's most famous contribution to this genre is, of course, "The Congo." See as well "Booker Washington Trilogy," *Poetry* 8 (June 1916): 109–21; and "Notes on the Booker Washington Trilogy," *Poetry* 8 June 1916): 146–48.

26. Peter Ackroyd, *T. S. Eliot: A Life* (New York: Simon & Schuster, 1984), pp. 65, 91. Just before his father's death, Eliot wrote to John Quinn about the importance of having a book published soon: "You see I settled over here in the face of strong family opposition, on the claim that I found the environment more favourable to the production of literature. This book is all I have to show for my claim—it would go toward making my parents contented with conditions—and towards satisfying them that I have not made a mess of my life, as they are inclined to believe." *Letters*, p. 266.

27. Eliot, *Letters*, pp. 42–43, 125. Aiken called these poems "a cynical counterpoint to the study of Sanskrit and the treatise on epistemology." Conrad Aiken, "King Bolo and Others," in *T. S. Eliot: A Symposium*, ed. Richard March and Tambimuttu (1949; rpt. Freeport, N.Y.: Books for Libraries Press, 1968), p. 21.

28. Eliot, *Letters*, p. 77. For discussions of other early literary treatments of racial subjects see Robert Crawford, *The Savage and the City in the Work of T. S. Eliot* (Oxford: Clarendon Press, 1987), pp. 83–85.

29. Clive Bell, *Since Cezanne* (New York: Harcourt, Brace, 1922), p. 222. "Plus de Jazz," the essay from which this comment is quoted, is dated 1921.

30. For a full discussion of the role of minstrel songs in the *Waste Land* drafts, see chapter 4 in the present study.

31. Michael J. Sidnell, *Dances of Death: The Group Theatre of London in the Thirties* (London: Faber, 1984), pp. 263–65; Arnold Bennett, *The Journals of Arnold Bennett*, ed. Newman Flower (London: Cassell, 1933), 3:52.

32. At the same time, racial masquerade was becoming an accepted part of ordinary white middle-class American life. Books such as Herbert Preston Powell's *World's Best Book of Minstrelsy* (Philadelphia: Penn Publishing, 1926) were published to guide churches, charitable organizations, schools, and fraternal organizations in producing their own authentic minstrel shows.

33. James Weldon Johnson, *God's Trombones: Seven Negro Sermons in Verse* (1927; rpt. New York: Penguin, 1990), p. 8.

34. James Weldon Johnson, ed., *The Book of American Negro Poetry*, 2nd ed. (1931; rpt. New York: Harcourt, Brace & World, 1969), pp. 4, 41. Johnson quoted from this preface in the preface to *God's Trombones*.

35. Alain Locke, "Negro Youth Speaks," in *The New Negro*, ed. Alain Locke (1925; rpt. New York: Atheneum, 1968), p. 51.

36. Van Vechten, p. 59. For other comments about "the chain of dialect" see: Locke, pp. 5, 48; Walter M. Brasch, *Black English and the Mass Media* (Amherst: University of Massachusetts Press, 1981), p. 149; and Henry Louis Gates, Jr., *The Signifying Monkey: A Theory of African-American Literary Criticism* (New York: Oxford University Press, 1988), pp. 176–78.

37. Racial masquerade, that is to say, is allowable only for whites. As James Weldon Johnson said, it is deemed "quite seemly for a white person to represent a Negro on the stage, but a violation of some inner code for a Negro to represent a white person." *Black Manhattan* (1930; rpt. New York: Atheneum, 1969), p. 191.

38. By 1931 Johnson had modified his opinion of dialect somewhat under the influence of Langston Hughes and Sterling Brown. See his "Preface to the Revised Edition," *Book of American Negro Poetry*, p. 4. For a more complete discussion, see chapter 6 in the present study. It is interesting that Johnson and Locke both felt a resemblance between their linguistic situation and that of Irish writers like Synge: "What the colored poet in the United States needs to do is something like what Synge did for the Irish . . ." (*Book of American Negro Poetry*, p. 41). It is also ironic that Synge should have seemed a successful model, when, in fact, he was attacked in Ireland for perpetuating the clichés of the stage Irishman, in many ways a British equivalent of the black minstrel. For a fuller discussion of such correspondences, see C. L. Innes, *The Devil's Own Mirror: The Irishman and the African in Modern Literature* (Washington, D.C.: Three Continents Press, 1990).

39. For the details of this anticipated alliance, see chapter 6 in the present study.

40. Houston A. Baker, Jr., *Modernism and the Harlem Renaissance* (Chicago: University of Chicago Press, 1987), pp. 1–8. For another opinion, one that that stresses the similarity between the linguistic tactics of Anglo-American modernism and African-American writers, see Clyde Taylor, "Salt Peanuts," *Callaloo* 5 (1982): 1–11.

41. Hugh Kenner, *The Pound Era* (Berkeley: University of California Press, 1971), pp. 94–103.

42. "Proposal for the Publication of a New English Dictionary by the Philological Society," in *Proper English? Readings in Language, History and Cultural Identity*, ed. Tony Crowley (London: Routledge, 1981), p. 154. Crowley has since discovered a usage of the term dating back to 1844. See Roy Harris, "Murray, Moore and the Myth," in *Linguistic Thought in England, 1914-1945*, ed. Roy Harris (London: Duckworth, 1988), p. 20. It still remains significant that the OED dated the term to its own first circulars.

43. Shaw, *Collected Plays*, 4:800. For the increasing popularity of the phrase "standard language," see John Earl Joseph, *Eloquence arid Power: The Rise of Language Standards and Standard Languages* (London: Frances Pinter, 1987), pp. 3–5.

44. Shaw, "A Plea for Speech Nationalisation," p. 84. Linda Dowling finds irony in the fact that Clara Hill mistakes Eliza's "bloody" as the newest fashionable slang. See her *Language and Decadence in the Victorian Fin deSiecle* (Princeton, N. J.: Princeton University Press, 1986), p. 95.

45. James Milroy and Leslie Milroy, *Authority in Language: Investigating Language Prescription and Standardisation*, 2nd ed., (London: Routledge, 1991), p. 36; Edward Finegan, *Attitudes Toward English Usage: The History of a War of Words* (New York: Teacher's College of Columbia University Press, 1980), p. 20. As Richard Bailey shows, such demands were often countered by another line of reasoning, that English was especially strong and vital because it was various. See his *Images of English: A Cultural History of the Language* (Ann Arbor: University of Michigan Press, 1991), pp. 32–59.

46. Kenneth Cmiel, *Democratic Eloquence: The Fight Over Popular Speech in Nineteenth-Century America* (New York: William Morrow, 1990), pp. 123, 263–65.

47. Elsa Nettels, *Language, Race, and Social Class in Howells's America* (Lexington: University Press of Kentucky, 1988), pp. 8–9.

48. Baron, p. 82; Bailey, p. 210.

49. Joseph, pp. 14, 109.

50. Tony Crowley, *Standard English and the Politics of Language* (Urbana: University of Illinois Press, 1989), pp. 107–24.

51. Society for Pure English, Tract No. 1 (1919), p. 6; Tract No. 2 (1919), pp. 37–39; Tract No. 4 (1921), pp. 14–19; Tract No. 9 (1922), pp. 24–26. See Bailey, pp. 206–8.

52. Robert Graves, *Impenetrability, or The Proper Habit of English* (London: Hogarth, 1926), pp. 30–31. In 1921 Graves had written to the society to protest its doctrine of "one word, one meaning." See Tract No. 4 (1921), pp. 22–26.

53. Shaw, *Collected Plays*, 4:663; John Honey, *Does Accent Matter? The Pygmalion Factor* (London: Faber & Faber, 1989), p. 31.

54. *The Teaching of English in England* (London: His Majesty's Stationery Office, 1921), p. 19. See Crowley, *Standard English*, pp. 236–49.

55. Paul Elmer More et al., *Academy Papers: Addresses on Language Problems by Members of the American Academy of Arts and Letters* (New York: Scribner's, 1925), p. v.

56. Charles A. Fenton, "The American Academy of Arts vs. All Comers: Literary Rags and Riches in the 1920's," *South Atlantic Quarterly* 58 (1959): 575. This campaign will be discussed in greater detail in chapter 6 of the present study.

57. George Sampson, *English for the English: A Chapter in National Education* (1921; rpt. Cambridge: Cambridge University Press, 1952), p. 47; Adams Sherman Hill, *Our English* (New York: American Book Co., 1888), p. 113. Hill was Boylston Professor of Rhetoric and Oratory at Harvard and was instrumental in introducing the first English composition courses there.

58. H. Rider Haggard, *The Annotated She*, ed. Norman Etherington (Bloomington: Indiana University Press, 1991), p. 99.

59. "The Linguistic Conscience," *Cambridge Magazine* 10 (Summer 1920): 31. The broadside is unsigned, but W. Terence Gordon reports that it was written by C. K. Ogden, who edited the magazine. See his *C. K. Ogden: A Bio-Bibliographic Study* (Metuchen, N. J.: Scarecrow Press, 1990), pp. 9–10.

60. Richard Grant White, *Words and Their Uses, Past and Present* (Boston: Houghton Mifflin, 1889), p. 423.

61. Leonard Forster, *The Poet's Tongues: Multilingualism in Literature* (Cambridge: Cambridge University Press, 1970), pp. 54–55; Joseph, p. x. Forster uses the phrase "language loyalty" on p. 19. For a rather different account of the growth of linguistic nationalism, see Benedict Anderson, *Imagined Communities: Reflections on the Origin and Spread of Nationalism*, rev. ed. (London: Verso, 1991). Of particular interest here is Anderson's account of the way that linguistic nationalism passes to the Third World (pp. 113–40).

62. Linda Dowling, "Victorian Oxford and the Science of Language," *PMLA* 97 (March 1982): 163.

63. George Steiner, *After Babel: Aspects of Language and Translation* (London: Oxford University Press, 1975), pp. 75, 78–81; Dowling, *Language and Decadence*, p. 35.

64. Edward Steiner, quoted in Shirley Brice Heath, "Standard English: Biography of a Symbol," in *Standards and Dialects of English*, ed. Timothy Shopen and Joseph M. Williams (Cambridge, Mass.: Winthrop, 1980), p. 29.

65. Etienne Balibar, "Paradoxes of Universality," in *Anatomy of Racism*, ed. David Theo Goldberg (Minneapolis: University of Minnesota Press, 1990), pp. 285–86.

66. R. W. Chapman, quoted in Bailey, p. 8. See the entire introduction, pp. 1–16.

67. Paul Elmer More, *Academy Papers*, p. 23. For a progressive demolition of all possible standards for theorizing the standard, see Crowley, *Standard English*, chaps. 3, 4, and 5.

68. Sampson, pp. 47–48.

69. Henry Alford, *A Plea for the Queen's English*, 2nd ed. (London: A. Strahan, 1869), p. 279.

70. Milroy and Milroy, p. 21.

71. Bailey, p. 11.

72. Crowley, *Standard English*, p. 156; E.J. Hobsbawm, *The Age of Empire, 1875-1914* (New York: Pantheon, 1987), pp. 36–37, 56–73.

73. Otto Jespersen, *Mankind, Nation and Individual from a Linguistic Point of View* (1925; rpt. London: George Allen & Unwin, 1946), pp. 44–45. See also Cmiel, pp. 142–46.

74. Bailey, pp. 114–15; Crowley, *Standard English*, pp. 207–57.

75. Robert Bridges, "The Society's Work," Society for Pure English, Tract No. 21 (1925), p. 4.

76. Bailey, p. 123; Alford, p. 6. This attack, occasioned by the slaughter of the Civil War, was removed from later editions.

77. Bridges, p. 5. Bailey reports that Bridges scuttled plans for cooperation with an American version of the SPE (p. 207).

78. Quoted in Bailey, p. 157.

79. T. L. Kington-Oliphant, *The New English*, 2 vols. (London: Macmillan, 1886), 2:230.

80. A. Lloyd James, "Broadcast English," in Bolton and Crystal, eds., p. 100.

81. Henry Reeve, quoted in Bailey, p. 242; Dowling, "Victorian Oxford," pp. 171–72. See also Sampson, p. 51, and Dowling, *Language and Decadence*, p. 87.

82. White, p. 44; Williams Roscoe Thayer, quoted in Allen Walker Read, "Amphi-Atlantic English," *English Studies* 17 (1935): 174. Read's article is a rich compendium of statements about the tension between English and American English. See also Bailey, pp. 124–25.

83. William Fowler, *English Gramma* (1887), quoted in Heath, pp. 28–29.

84. More, *Academy Papers*, p. 10. See the dissent by another American Academy member, Brander Matthews, *Academy Papers*, pp. 63–93, and *Essays on English* (New York: Scribner's, 1922), pp. 4–6.

85. Quoted in Thomas F. Gossett, *Race: The History of an Idea in America* (1963; rpt. New York: Schocken, 1965), p. 306. For a discussion of the anti-immigration agitation of the time, and especially the role played in it by writers and intellectuals, see pp. 134–43, 287–309.

86. William Mathews, *Words; their use and abuse* (Chicago: Griggs, 1892), pp. 47–48.

87. Quoted in Nettels, p. 19.

88. Henry James, *The Question of Our Speech* (Boston: Houghton Mifflin, 1905), pp. 44–45, 41.

89. Paul Shorey, "The American Language," in *Academy Papers*, p. 161. Shorey praises James's address on page 129.

90. See Michael Taussig, *Shamanism, Colonialism, and the Wild Man: A Study in Terror and Healing* (Chicago: University of Chicago Press, 1987), for the "deformation of good speech" that is a necessary component of the defense of colonialism (p. 70).

91. For a discussion of this process in an American context, see Cmiel, p. 38.

92. Milroy and Milroy, pp. 98–103.

93. Quoted in Heath, pp. 23–24. See also Crowley, *Standard English*, p. 67.

94. More, *Academy Papers*, p. 9. See also Crowley, *Standard English*, p. 126.

95. Shorey, *Academy Papers*, p. 135.

96. Bridges, Society for Pure English, Tract No. 9 (1922), p. 21; C. Alphonso Smith, "Dialect Writers," in *The Cambridge History of American Literature*, 4 vols., ed. W. P. Trent et al. (New York: Putnam, 1918), 2:361; Logan Pearsall Smith, "Robert Bridges: Recollections," Society for Pure English, Tract No. 35 (1931): 487. In *The Dialect of the Tribe*, Margery Sabin uses Smith's *Words and Idioms* as an example of

English taste for the concrete and idiomatic, apparently unaware that much of this material originally appeared as Tract No. 12 of the SPE. Its appearance there illustrates the point to be made, that the SPE accommodated those like Smith who defended "the idiomatic loopholes in rational language" and those like Fowler who spent long hours attempting to close them. See Logan Pearsall Smith, "English Idioms," *Society for Pure English*, Tract No. 12 (1923); and Margery Sabin, *The Dialect of the Tribe: Speech and Community in Modern Fiction* (New York: Oxford University Press, 1987), p. 18.

97. *Teaching of English in England*, p. 275.

98. Ibid., p. 65. There was some controversy on this point within the commission, with some sentiment for the idea that dialect speakers should simply become bilingual (p. 67).

99. Dowling, "Victorian Oxford," p. 169. See also Dowling, *Language and Decadence*, p. 83.

100. N. F. Blake, *Non-Standard Language in English Literature* (London: Deutsch, 1981), p. 166; Dowling, *Language and Decadence*, pp. 182, 214, 226–30; Crowley, *Standard English*, pp. 160–61.

101. Norman Page, *Speech in the English Novel*, 2nd ed. (London: Macmillan, 1988), pp. 75–76; Sabin, p. 17.

102. George Philip Krapp, *The English Language in America* (1925; rpt. New York: Frederick Ungar, 1960), p. 225.

103. Crowley, *Standard English*, p. 140.

104. Alford, p. 245; James, pp. 40–41. See also Blake, p. 160.

105. Graves, p. 42.

106. Patrick Brantlinger, *Rule of Darkness: British Literature and Imperialism, 1830–1914* (Ithaca, N.Y.: Cornell University Press, 1988), pp. 231–32.

107. Taussig, p. 87.

108. James, p. 40.

109. Shorey, *Academy Papers*, pp. 152–53.

110. Society for Pure English, Tract No. 4 (1921), p. 42; and Tract No. 6 (1921), p. 28.

111. Baron, pp. 21–24; Read, pp. 161, 167.

112. James Adams (1799), quoted in Read, p. 161.

113. Joel Chandler Harris, quoted in Brasch, p. 86. Krapp, p. 251. See also Annie Weston Whitney, "Negro American Dialects," *The Independent* 53 (August 22, 1901, and August 29, 1901): 1981, 2039. For discussions in the black press see "Negro Dialect," *Opportunity* 2 (September 1924): 260; and Edwin D. Johnson, "The Speech of the American Negro Folk," *Opportunity* 5 (July 1927): 196. J. L. Dillard has attacked Krapp's theory with such vehemence it seems necessary to observe that it may have had a certain strategic usefulness at the time it was offered.

114. R. Emmett Kennedy, *Black Cameos* (New York: Albert & Charles Boni, 1924), pp. x, xii; Ambrose E. Gonzales, *The Black Border* (Columbia, S. C.: State Printing Co., 1922), p. 12. The same sort of thing had been said in England about the rural peasantry since at least the beginning of the nineteenth century. See Page, *Speech in the English Novel*, p. 60.

115. "Daddy Jake the Runaway," in *Critical Essays on Joel Chandler Harris*, ed. R. Bruce Bickley (Boston: G. K. Hall, 1981), p. 17.

116. Bailey, p. 130; Brasch, p. 4.

117. Quoted in Baron, p. 26.

118. Smith dates the dialect boom to Russell's poem (*Cambridge History*, p. 353), as do Page and A. C. Gordon in their collection *Befo' de War: Echoes in Negro Dialect* (1888; rpt. New York: Scribner's, 1906), which was dedicated to "Irwin Russell Who Awoke the First Echo." Harris's *Uncle Remus: His Songs and Sayings* was first published in 1880. Page says that the idea for "Marse Chan," his first dialect story, came to him in the same year. *The Novels, Stories, Sketches and Poems of Thomas Nelson Page*, 12 vols. (New York: Scribner's, 1906), 1:ix–x.

119. T. C. De Leon, "The Day of Dialect," *Lippincott's Magazine* 60 (November 1897): 680; Thomas Nelson Page, "The Immortal Uncle Remus," *Book Buyer 1* (December 1895): 642–45, reprinted in Bickley, p. 56; Joseph Boskin, *Sambo: The Rise and Demise of an American Jester* (New York: Oxford University Press, 1986), p. 108; Rayford W. Logan, *The Negro in American Life and Thought: The Nadir, 1877–1901* (New York: Dial Press, 1954), pp. 239–74; Bruce Jackson, ed., *The Negro and His Folklore in Nineteenth-Century Periodicals* (Austin: University of Texas Press, 1967), p. 211. See also Brasch, pp. 114–17; and Nettels, pp. 65–66.

120. Smith, *Cambridge History*, p. 351. Smith is hardly alone in this. The extensive article by J. A. Harrison on "Negro English," *Anglia* (1884), is indebted to the writings of white writers like Harris, Macon, and Sherwood Bonner. See *Perspectives on Black English*, ed. J. L. Dillard (The Hague: Mouton, 1975), pp. 143–95.

121. Boskin, pp. 101–2; Bernard Wolfe, "Uncle Remus and the Malevolent Rabbit," *Commentary* 8 (July 1949): 31–41, reprinted in Bickley, pp. 82–83.

122. Gossett, pp. 264–65. See the long and finely nuanced discussion of Harris in Eric J. Sundquist, *To Wake the Nations: Race in the Making of American Literature* (Cambridge, Mass.: Harvard University Press/ Belknap Press, 1993), pp. 323–59.

123. Gossett, pp. 274–75, 280–81.

124. Smith, *Cambridge History*, p. 354; Page, "The Immortal Uncle Remus," p. 56. The former slave pining for the old plantation had been a staple of the minstrel show since the 1850s. See Hans Nathan, *Dan Emmett and the Rise of Negro Minstrelsy* (Norman: University of Oklahoma Press, 1962), p. 243.

125. E. K. Means, *E. K. Means: Is this a title? It is the name of a writer of negro stories, who has made himself so completely* the *writer of negro stories that his book needs no title.* (New York: Putnam's, 1918), pp. vi–vii. This book was of particular importance to William Carlos Williams. See chapter 7 of the present study.

126. See Page, "The Immortal Uncle Remus," p. 56; Jackson, p. xxiii; and George M. Fredrickson, *The Black Image in the White Mind: The Debate on Afro-American Character and Destiny, 1817-1914* (New York: Harper & Row, 1971), pp. 208, 211.

127. Quoted in Edgar P. Billups, "Some Principles for the Representation of Negro Dialect in Fiction," *Texas Review* 8 (January 1923): 100.

128. Quoted in Alain Locke, "Our Little Renaissance," in Johnson, ed., *Ebony and Topaz*, p. 117.

129. Smith, *Cambridge History*, p. 361.

130. Charles W. Chesnutt, *The Marrow of Tradition* (Boston: Houghton Mifflin, 1901), pp. 95, 96. See Sundquist's massive contextualization of this novel in *To Wake the Nations*, pp. 271–454.

131. "The Poet," in *The Complete Poems of Paul Laurence Dunbar* (New York: Dodd, Mead, 1913), p. 191. See the discussion in Brasch, pp. 126–35.

132. Gossett, pp. 390, 371.

133. Billups, p. 101; Brasch, p. 171. See also "Negro Dialect," *Opportunity* 2 (September 1924): 259.

134. As distorted and demeaning as most of this work now seems, it actually established a threshold for the Harlem Renaissance. In 1927, when Alain Locke looked for evidence that "Our Little Renaissance" had made a difference, he actually began by citing Peterkin and Du Bose Heyward. Charles Johnson's introduction to *Ebony and Topaz* mentions Peterkin, Heyward, Paul Green, and Guy Johnson, all of whom except Heyward contributed to the volume themselves. Locke, "Our Little Renaissance," in Johnson, ed., *Ebony and Topaz*, p. 117; Johnson, "Introduction," in Johnson, ed., *Ebony and Topaz*, p. 12. Dorothy Scarborough, author of *In the Land of Cotton*, was invited to the banquet for Jessie Fauset from which the Harlem Renaissance is sometimes dated, and she also served, along with Clement Wood, author of *Nigger*, as judge for the *Opportunity* literary awards. *Opportunity* 2 (May 1924): 144; and 2 (September 1924): 277.

135. Huggins, p. 63. Huggins specifically includes the modernist generation in this description.

136. For the impact of Uncle Remus on Pound, see Humphrey Carpenter, *A Serious Character: The Life of Ezra Pound* (London: Faber, 1988), pp. 22, 414. Vachel Lindsay was also strongly affected by early reading from Uncle Remus (Cooley, p. 51). The first poetry read aloud to William Carlos Williams was that of Paul Laurence Dunbar, which was also very popular at the time. See *The Autobiography of William Carlos Williams* (New York: New Directions, 1951), p. 15. Nor was the dialect fad limited to America. In 1926 Henry Newbolt reported, with some satisfaction, that the popularity of O. Henry, Mark Twain, and Bret Harte, which had swept through English schools like "a prairie fire," was now as dead as "Uncle Remus." "The Future of the English Language," in *Studies in Green and Gray* (London: Thomas Nelson, 1926), p. 232.

137. James Weldon Johnson, *Fifty Years and Other Poems* (Boston: Cornhill, 1917), pp. xi–xiv. For a discussion of Johnson's long association with Matthews, see Lawrence J. Oliver, *Brander Matthews, Theodore Roosevelt, and the Politics of American Literature, 1880-1920* (Knoxville: University of Tennessee Press, 1992), pp. 47–62.

138. *Cambridge Magazine* 10 (Summer 1920): 55–59. The headnote, presumably by Ogden, claims that McKay's almost severely conventional poems display "some of those peculiar qualities which rendered the visit of the Southern Syncopated Orchestra so memorable last Autumn. . . ."

139. Carl Van Vechten, *Nigger Heaven* (1926; rpt. New York: Octagon, 1980), p. 57. In Johnson's correspondence there is a brief letter from Stein that, in a trivial sense, completes this circle. She thanks him for sending her a copy of *God's Trombones*, which, she says, she is reading with great interest. James Weldon Johnson correspondence, series I, folder 459, James Weldon Johnson Collection of Negro Literature and Art, Beinecke Rare Book and Manuscript Library, Yale University.

140. *The Complete Prose of Marianne Moore*, ed. Patricia C. Willis (New York: Viking, 1986), p. 167. Moore was also responsible for publishing two or three of the last published writings of Jean Toomer in the *Dial*.

141. Robert Underwood Johnson, "The Glory of Words," in More et al., pp. 276–77.

142. Moore, p. 167.

143. T. S. Eliot, "Marianne Moore," *Dial* 75 (1923): 596. A few lines in "Black Earth," a poem originally published in the *Egoist* in 1918 and in *Others for 1919*, apparently convinced Pound that Moore might herself be black: "And are you a jet black Ethiopian Othello-hued, or was that line in one of your *Egoist* poems but part of your general elaboration and allegory and designed to differentiate your colour from that of the surrounding menageria?" *Selected Letters*, p. 143.

144. Johnson, "The Glory of Words," pp. 265–66. See Nathan, pp. 147, 154, for the role of the triangle in early minstrel shows.

145. Richard S. Kennedy, *Dreams in the Mirror: A Biography of E. E. Cummings* (New York: Liveright, 1980), p. 294. *Sweeney Agonistes* will be discussed in greater detail in chapter 4 of the present study.

146. E. E. Cummings, *Three Plays and a Ballet*, ed. George J. Firmage (London: Peter Owen, 1968), pp. 45–46, 52, 58, 43–44.

147. Cummings, p. 44.

148. Carringer, p. 63.

149. Sherwood Anderson, *Sherwood Anderson's Notebooks* (New York: Boni & Liveright, 1926), p. 135. Quoted in Helbling, "Sherwood Anderson and Jean Toomer," pp. 119–20.

150. Stuart P. Sherman, *Americans* (New York: Charles Scribner's Sons, 1922), pp. 20, 316–17.

151. Dowling, "Victorian Oxford," p. 162; idem, *Language and Decadence*, p. 14.

152. Shaw, *Collected Plays*, 4:735–36.

153. Dowling, "Victorian Oxford," p. 165.

154. Ibid., p. 169; idem, *Language and Decadence*, pp. 101–2.

155. Cmiel, pp. 150–66.

156. Franz Boas, "On Alternating Sounds," *American Anthropologist* 2 (January 1889): 47–53; reprinted in *The Shaping of American Anthropology, 1883–1911: A Franz Boas Reader*, ed. George W. Stocking, Jr. (New York: Basic Books, 1974), pp. 72–77. The implications of this idea for the different varieties of the American language are worked out in Sundquist.

157. Bronislaw Malinowski, "The Problem of Meaning in Primitive Languages," supplement to *The Meaning of Meaning*, by C. K. Ogden and I. A. Richards, 10th ed. (London: Routledge & Kegan Paul, 1949), pp. 299, 309, 328.

158. For other discussions of the way that ethnography and linguistic and cultural relativism have grown up together, see Steiner, p. 87; Dowling, "Victorian Oxford," p. 169; and, most especially, James Clifford, *The Predicament of Culture: Twentieth-Century Ethnography, Literature, and Art* (Cambridge, Mass.: Harvard University Press, 1988).

159. Gail Levin, "American art," in *"Primitivism" in 20th century Art: Affinities of the Tribal and the Modern*, ed. William Rubin, 2 vols. (New York: Museum of Modern Art, 1984), 2:454–55.

160. Steiner, pp. 176–87. For the influence of Worringer on the primitivism of English avant-garde art, see Richard Cork, *Vorticism and Abstract Art in the First Machine Age* (Berkeley: University of California Press, 1976), pp. 115, 175. For his influence on the primitivism of English writers of the period, see Michael North, *The Final Sculpture: Public Monuments and Modern Poets* (Ithaca, N.Y.: Cornell University Press, 1985), pp. 111–21. For the influence of Levy-Bruhl on Eliot, see Crawford, pp. 87–92;

for his influence on the French avant-garde, see Evan Maurer, "Dada and Surrealism," in Rubin, *"Primitivism" in 20th Century Art*, 2:542.

161. Richard Huelsenbeck, *Memoirs of a Dada Drummer*, ed. Hans J. Kleinschmidt, trans. Joachim Neugroschel (New York: Viking, 1974), p. xxxi.

162. Ezra Pound, *Ezra Pound and the Visual Arts*, ed. Harriet Zinnes (New York: New Directions, 1980), p. 181.

163. Huelsenbeck, p. 9.

164. Maurer, 2:536–41.

165. Richard Huelsenbeck, "Chorus Sanctus," *Little Review* 10 (Spring 1924): 20.

166. Nathan, p. 217.

167. Maurer, 2:538–39. The collages date to 1926.

168. Blaise Cendrars, *The African Saga*, trans. Margery Bianco (New York: Payson & Clarke, 1927). The importance of this work in American racial politics is signified by the introduction of Arthur Spingarn. See also Alain Locke, "A Note on African Art," *Opportunity* 2 (May 1924): 137. Cendrars's actual qualifications in the 591 languages supposedly represented in the anthology have been pretty thoroughly debunked. See Jean-Claude Blachère, *Le Modèle nègre: Aspects littéraires du my the primitiviste au XXe siècle chez Apollinaire-Cendrars-Tzara* (Dakar: Nouvelles Editions Africaines, 1981), pp. 76–77; and Jay Bochner, *Blaise Cendrars: Discovery and Re-creation* (Toronto: University of Toronto Press, 1978), pp. 66–67.

169. Jean-Louis Paudrat, "From Paris," in Rubin, *"Primitivism" in 20th Century Art*, 1:158. Though Cendrars was not a dadaist, a number of his early poems, including "Mee Too Buggi," to be discussed later, were published in dada journals such as Hugo Ball's *Cabaret Voltaire*. See Bochner, pp. 61, 124.

170. Blachère, p. 112.

171. Ibid., p. 19. See also the excellent discussion of Cendrars in Marjorie Perloff, *The Futurist Moment: Avant-Garde, Avant Guerre, and the Language of Rupture* (Chicago: University of Chicago Press, 1986), pp. 2–43.

172. Jean-Pierre Goldenstein, *Dix-neuf poèmes élastiques de Blaise Cendrars: édition critique et commenté* (Paris: Méridiens Klincksieck, 1986), pp. 98–100, 146. Goldenstein reprints the French translation— *Histoire des Naturels des îles Tonga on des Mais, situées dans l'Ocean Pacifique depitis leur découverte par le capitaine Cook* (1817)—of the English book from which virtually every word of the poem has been taken.

173. Goldenstein, p. 146.

174. Ibid., pp. 99, 148.

175. "Mee Too Buggi" (1914) is also reprinted and discussed in Blachere, pp. 75–76, 210–11. Its sources are discussed in Monique Chefdor, *Blaise Cendrars* (Boston: Twayne, 1980), p. 51. On its nature as collage see Bochner, pp. 126–27, 137.

176. James Joyce to Frank Budgen, *Letters*, ed. Stuart Gilbert and Richard Ellmann, 3 vols. (New York: Vintage, 1966) 1:139–40.

177. Seamus Heaney, *The Government of the Tongue* (New York: Noonday/Farrar, Straus & Giroux, 1988), p. 40.

178. Edward Said makes this point in "Reflections on Exile," *Granta* 13 (Autumn 1984): 159–72.

179. Raymond Williams, *The Politics of Modernism* (London: Verso, 1989), pp. 78–79.

180. Marianna Torgovnick, *Gone Primitive: Savage Intellects, Modern Lives* (Chicago: University of Chicago Press, 1990), pp. 188, 193.

181. Johnson, ed., *Ebony and Topaz*, pp. 65–66.

182. Stephen J. Greenblatt, *Learning to Curse: Essays in Early Modern Culture* (New York: Routledge, 1990), p. 32; Sara Suleri, *The Rhetoric of English India* (Chicago: University of Chicago Press, 1992).

183. In fact, even this version of the romance of the foreign has its roots in modernism, as is shown by an outburst in the *Anti-Oedipus*: "Strange Anglo-American literature: from Thomas Hardy, from D. H. Lawrence to Malcolm Lowry, from Henry Miller to Allen Ginsberg and Jack Kerouac, men who knew how to leave, to scramble the codes. . . . They overcome a limit, they shatter a wall, the capitalist barrier. And of course they fail to complete the process, they never cease failing to do so." This is postmodernism

looking back at modernism, and making of its restless cultural peregrinations a new aesthetic. Gilles Deleuze and Felix Guattari, *A Thousand Plateaus*, trans. Brian Massumi (Minneapolis: University of Minnesota Press, 1987), pp. 379, 98; idem, *Anti-Oedipus*, trans. Robert Hurley, Mark Seem, and Helen R. Lane (Minneapolis: University of Minnesota Press, 1983), pp. 132–33.

184. From "Frammento alia morte" (1960), quoted in Chris Bongie, *Exotic Memories: Literature, Colonialism, and the Fin de Siecle* (Stanford, Calif.: Stanford University Press, 1991), p. 201.

185. Salman Rushdie, *The Satanic Verses* (New York: Viking, 1989), p. 60.

186. Salman Rushdie, *Imaginary Homelands, Essays and Criticism, 1981–1991* (New York: Viking, 1991), p. 64. Rushdie's optimism might be contrasted here with the far sterner conclusion of Ngugi wa Thiong'o, who has maintained in a number of publications over the last twenty years that African writers can never write honestly in English.

187. Rushdie, *Imaginary Homelands*, p. 394.

CHAPTER 4
MODERNITY AND FEMINISM
*Rita Felski**

The early drive of the New Modernist Studies to expand the range of texts that could be somehow counted as modernist initially took shape within the still recognizable contours of a canon. That is, critics like Bonnie Kime Scott and Michael North sought to show how the kinds of radical textual innovation once associated with a small coterie of largely male writers could also be found in work by women and people of color. Crucially, however, these arguments did little to unsettle the idea of modernism as such and sought instead to preserve it as an aesthetically bounded category defined by experimentation, craft, and disruption.

In her groundbreaking book *The Gender of Modernity*, Rita Felski helped fashion what would become some of the guiding methodologies of the New Modernist Studies. By drawing explicitly on key concepts within feminist theory and literary sociology, she offered a new way to think in richer, more expansive ways about modernism as only one of many cultural formations within the larger horizon of modernity. In the chapter included here, she contrasts various theories of modernity and sharply critiques what she calls postmodernism's attempt to produce a "totalizing critique of totalization." Modernity, she insists, is not a monolith, but is instead shot through with differences generated by race, gender, language, sexuality, and history, all of which overlap and even contradict one another at times. Focusing on writing both by and about women, she argues, enables us to map such contradictions because women were both symbols of the modern (like Flaubert's Madame Bovary) and its agents (like the first-wave feminists who led global suffragist movements). Alternative experiences of a de-totalized modernity, she contends here, can be found not just in a handful of difficult works, but in other kinds of cultural formations like melodrama, cosmetics, shopping, motherhood, and fashion.

Although plainly expansive in nature, Felski's work does not seek to transform all cultural production from the early twentieth century into complex art worthy of the same attention lavished on works like *Ulysses*. Instead, she proposes using work by and about women to ask how the elitist practices we associate with modernism formed, gained value, policed their boundaries, and managed to exclude mass culture. "Modernism," she insists, "is only one aspect of the culture of women's modernity." *The Gender of Modernity* thus aims to bring its other aspects more clearly into view and thus to insist that "modernity contains a number of . . . logics which may often work in contradiction as well as collusion." The chapter included here carefully spells out both this rich new conception of modernity while also articulating many of the core methodological practices that now define the New Modernist Studies.

I prefer to study . . . the everyday, the so-called banal, the supposedly un-or non-experimental, asking not "why does it fall short of modernism?" but "how do classical theories of modernism fall short of women's modernity?"

Meaghan Morris, "Things to Do with Shopping Centres"

Even the most cursory survey of the vast body of writing about the modern reveals a cacophony of different and often dissenting voices. Modernity arises out of a culture of "stability, coherence, discipline and world-mastery";[1] alternatively it points to a "discontinuous experience of time, space and causality as transitory, fleeting and fortuitous."[2] For some writers it is a "culture of rupture," marked by historical relativism and ambiguity;[3] for others it involves a "rational, autonomous subject" and an "absolutist, unitary conception of truth."[4] To be modern is to be on the side of progress, reason, and democracy or, by contrast to align oneself with "disorder, despair and anarchy."[5] Indeed, to be modern is often paradoxically to be antimodern, to define oneself in explicit opposition to the prevailing norms and values of one's own time.[6]

Clearly, there is no magical means of resolving this semantic confusion, which derives from the complicated and many-faceted aspects of modern development. Yet it is possible to identify certain key factors which contribute to this bewildering diversity of definitions. For example, the different understandings of the modern across national cultures and traditions lead to potential difficulties of translation when texts circulate within a global intellectual economy. Thus for Jüirgen Habermas "die Moderne" comprises an irreversible historical process that includes not only the repressive forces of bureaucratic and capitalist domination but also the emergence of a potentially emancipatory, because self-critical, ethics of communicative reason. Here Hegel emerges as a key figure, in whose philosophy the theoretical self-consciousness of modernity receives its first systematic articulation.[7] Vincent Descombes, by contrast, takes Habermas to task for such an unproblematic equation of modernity with idealist philosophy, a move which is, he argues, so closely rooted in the specific history and sociology of German culture that it remains "impossible" for those trained in French thought. For Descombes, it is the realm of poetics rather than philosophy and above all the figure of Baudelaire that define the parameters of a French *modernité* characterized by ambiguity, discontinuity, and a blurring rather than separation of art and life.[8] In this terminological dispute we can see a clear instance of one of the defining and recurring ambiguities of the modern: its use by some writers as more or less synonymous with the Enlightenment tradition and by others as antithetical to it.

This brings me to the related question of the influence of particular disciplinary traditions on the construction and circulation of theoretical concepts. The work of Michel Foucault in particular has sharpened our awareness of the ways in which structures of knowledge help to form our sense of the very objects they claim to analyze. Thus modernity can mean something very different in the work of political theorists, literary critics, sociologists, and philosophers, to take just a few random instances. This ambiguity relates not just to conflicting estimations of the nature and value of the modern but also to disagreements as to its actual location in historical time. Whereas a political theorist may situate the origins of modernity in the seventeenth century and in the work of Hobbes, a literary critic is just as likely to claim that modernity has its birth in the mid or late nineteenth century. Rather than a precise historical periodization, modernity thus comprises a constantly shifting set of temporal coordinates. As Lawrence Cahoone points out, "the historical starting point is impossible to fix; any century from the sixteenth through the nineteenth could be, and has been, named as the first 'modern' century. The Copernican system, for example, arguably a cornerstone of modernity, dates from the sixteenth century, while democratic government, which can claim to be the essence of modern politics, did not become the dominant Western political form until very recently."[9]

Cahoone's statement allows us to see that modernity is not a homogeneous Zeitgeist which was born at a particular moment in history, but rather that it comprises a collection of interlocking institutional, cultural, and philosophical strands which emerge and develop at different times and which are often only defined as "modern" retrospectively. In attempting to distinguish between these different strands, it is helpful to begin by clarifying the "family of terms" associated with the modern.[10] *Modernization* is usually taken to denote the complex constellation of socioeconomic phenomena which originated in the context of Western development but which have since manifested themselves around the globe in various forms: scientific and technological innovation, the industrialization of production, rapid urbanization, an ever expanding capitalist market, the development of the nation-state, and so on. *Modernism*, by contrast, defines a specific form of artistic production, serving as an umbrella term for a mélange of artistic schools and styles which first arose in late-nineteenth-century Europe and America. Characterized by such features as aesthetic self-consciousness, stylistic fragmentation, and a questioning of representation, modernist texts bore a highly ambivalent and often critical relationship to processes of modernization. The French term *modernité*, while also concerned with a distinctively modern sense of dislocation and ambiguity, locates it in the more general experience of the aestheticization of everyday life, as exemplified in the ephemeral and transitory qualities of an urban culture shaped by the imperatives of fashion, consumerism, and constant innovation.[11] Finally, *modernity* is often used as an overarching periodizing term to denote a historical era which may encompass any or all of the above features. This epochal meaning of the term typically includes a general philosophical distinction between traditional societies, which are structured around the omnipresence of divine authority, and a modern secularized universe predicated upon an individuated and self-conscious subjectivity.[12]

The factual ambiguity implicit in the idea of the modern is, however, combined with a distinctive rhetorical power. Modernity differs from other kinds of periodization in possessing a normative as well as a descriptive dimension—one can be "for" or "against" modernity in a way that one cannot be for or against the Renaissance, for example. The symbolic force of the term lies in its enunciation of a process of differentiation, an act of separation from the past. Thus the famous Querelle des Anciens et des Modernes in late-seventeenth-century Europe turned on the challenge to the authority of classical texts as ultimate cultural reference points and bearers of timeless truths. Matei Calinescu notes that while both sides in the dispute retained a certain unquestioning adherence to neoclassical ideals, it was here that the idea of the modern first acquired an explicit polemical edge as a rejection of the dead weight of history and tradition. Increasingly, "modern" was to become synonymous with the repudiation of the past and a commitment to change and the values of the future.[13]

It is easy to see that the politics of such an ideal are inherently double-edged. On the one hand, the appeal to the modern could serve as a means of legitimating rebellion against hierarchical social structures and prevailing modes of thought by challenging the authority of tradition, custom, and the status quo. Such historical events as the French Revolution are often identified as key moments in the articulation of distinctively modern notions of autonomy and equality, grounded in the belief that there exists no authority beyond that of a critical, and self-critical, human reason. On the other hand, the idea of the modern was deeply implicated from its beginnings with a project of domination over those seen to lack this capacity for reflective reasoning. In the discourses of colonialism, for example, the historical distinction between the modern present and the primitive past was mapped onto the spatial relations between Western and non-Western societies. Thus the technological advances of modern nation-states could be cited as a justification for imperialist invasion, as the traditions and customs of indigenous peoples were forced to give way to the inexorable path of historical progress.[14] Similarly, the modern brought with it an ideal of equality grounded in fraternity that effectively excluded women from many forms of political life. Thus

Joan Landes comments that "from the standpoint of women and their interests, enlightenment looks suspiciously like counter-enlightenment and revolution like counterrevolution."[15] Tracing the history of women's roles in the French Revolution, Landes shows how the discourse of modern rights and republican virtues effectively served to silence women through a recurring identification of the human with the masculine.

Appeals to the modern and the new could, however, also be appropriated and articulated anew by dissident or disenfranchised groups to formulate their own resistance to the status quo. Thus in the early twentieth century the figure of the New Woman was to become a resonant symbol of emancipation, whose modernity signaled not an endorsement of an existing present but rather a bold imagining of an alternative future. In rather different ways, modernist and avant-garde movements sought to disrupt taken-for-granted assumptions and dogmatic complacencies, refashioning the idea of the modern to signify ambiguity, uncertainty, and crisis rather than an uncritical ascription to a teleology of Western progress and an ideal of reason. The "old new" of dominant bourgeois values was thus regularly challenged by diverse groups who defined themselves as "authentically new" and who drew on and revitalized the promise of innovation as liberating transformation implicit in the idea of the modern to forge an array of critical and oppositional identities.

Appeals to modernity have, in other words, been used to further a multifarious range of political and cultural interests. Rather than identifying a stable referent or set of attributes, "modern" acts as a mobile and shifting category of classification that serves to structure, legitimize, and valorize varied and often competing perspectives. My analysis thus begins with the assumption that modernity embraces a multidimensional array of historical phenomena that cannot be prematurely synthesized into a unified Zeitgeist. Hence I am skeptical of those writings which equate the entire modern period with a particular and narrowly defined tradition of intellectual thought stretching from Kant to Marx (as if several centuries of history could be reduced to the writings of a handful of philosophers!) in order to celebrate the emergence of postmodern ambiguity and difference against modern homogeneity and rationality. Such a purported critique of totalization is itself vastly totalizing, doing interpretive violence to the complex and heterogeneous strands of modern culture, which cannot be reduced to exemplifications of a monolithic world-view in this way. Within the specific context of late-nineteenth-century Europe, for example, appeals to science, rationality, and material progress coexisted with Romantic invocations of emotion, intuition, and authenticity as well as alongside self-conscious explorations of the performative and artificial status of identity and the inescapable metaphoricity of language. Rather than inscribing a homogeneous cultural consensus, the discourses of modernity reveal multiple and conflicting responses to processes of social change.

My intent here is not to claim that modern and postmodern are interchangeable signifiers; clearly, our own fin de siècle differs in crucial and fundamental ways from its predecessor, even as it also reveals some intriguing parallels. (Thus many of the topoi and catchphrases often seen as quintessentially postmodern—simulation, pastiche, consumption, nostalgia, cyborgs, cross-dressing—are suggestively foreshadowed in a number of nineteenth-century texts.) Nevertheless, feminist theory surely needs to question rather than uncritically endorse an opposition between a repressive modernity and a subversive postmodernity which has become de rigeur in certain areas of contemporary theory. As Gianni Vattimo has emphasized, such a view of the postmodern typically repeats the gesture of overcoming and futurity that is fundamental to the modern, naively re-enacting the very logic of history as progress that it claims to renounce.[16]

My own analysis is motivated by the desire to question existing theories of literary and cultural history in order to reveal their blindness to issues of gender. In this sense, I am in sympathy with feminist critics who argue that theories of both the modern and the postmodern have been organized around a masculine norm and pay insufficient attention to the specificity of women's lives and experiences. Yet I do not seek to demonstrate the illusory nature of the modern in order to position women and feminist concerns outside its logic. Such acts of attempted demystification are

necessarily problematic because they fail to acknowledge their own inevitable enmeshment within the categories that they seek to transcend. Thus I hope to show that feminism, which has been highly critical of the concept of the modern, has also been deeply influenced by it, and that struggles for women's emancipation are complexly interwoven with processes of modernization. If women's interests cannot be unproblematically aligned with dominant conceptions of the modern, neither can they simply be placed outside of them.

"Heroines of Modernity"

The claim that most contemporary theories of the modern are male-centered will not, I imagine, come as a great surprise to most readers of this book. It is a constant feature that links together a range of otherwise very disparate texts. I have already cited Berman's richly textured, but in this sense frustratingly monological, account; within the area of literary and cultural studies alone one could easily list many other critical works which claim to offer a general theory of modernity but base themselves exclusively on writings by men and textual representations of masculinity. The issue is even more straightforward within the field of social and political theory, where the equation of modernity with particular public and institutional structures governed by men has led to an almost total elision of the lives, concerns, and perspectives of women.[17]

The identification of modernity with masculinity is not, of course, simply an invention of contemporary theorists. Many of the key symbols of the modern in the nineteenth century—the public sphere, the man of the crowd, the stranger, the dandy, the flâneur—were indeed explicitly gendered. There could for example, be no direct female equivalent of the flâneur, given that any woman who loitered in the streets of the nineteenth-century metropolis was likely to be taken for a prostitute.[18] Thus a recurring identification of the modern with the public was largely responsible for the belief that women were situated outside processes of history and social change. In the texts of early Romanticism one finds some of the most explicitly nostalgic representations of femininity as a redemptive refuge from the constraints of civilization. Seen to be less specialized and differentiated than man, located within the household and an intimate web of familial relations, more closely linked to nature through her reproductive capacity, woman embodied a sphere of atemporal authenticity seemingly untouched by the alienation and fragmentation of modern life.

This view of femininity has retained much of its rhetorical power, resurfacing in the work of numerous contemporary writers. Thus part of the common sense of much mainstream feminist thought has been a belief that such phenomena as industry, consumerism, the modern city, the mass media, and technology are in some sense fundamentally masculine, and that feminine values of intimacy and authenticity remain outside the dehumanizing and alienating logic of modernity. These assumptions received explicit articulation in works of cultural feminism which embraced a Romantic ideal of femininity as an enclave of natural self-presence in the face of the tyrannical onslaught of technocratic rationality. More recent feminist work has drawn upon psychoanalytic and poststructuralist theory to pitch a broadly similar critique at a more abstract level, arguing that the founding concepts and structures of modern thought are by nature phallocentric. In a recent book, for example, Juliet MacCannell claims that modernity is predicated on the elimination of woman and sexual difference. According to MacCannell, modern society no longer exemplifies the law of the father, but rather represents the regime of the brother, as the traditional and unquestioned authority of the patriarchal God or king gives way to a modern Enlightenment logic of equality, fraternity, and identity. Yet for women, this historical development brings with it more oppressive, because concealed, regimes of domination; the modern is predicated on the absence of the Other and the erasure of feminine agency and desire.[19]

Aspects of MacCannell's thesis are suggestive, and her reading of the modern through the lens of psychoanalytic theory usefully destabilizes the rational/irrational dichotomy by exposing the fantasmic and narcissistic dimensions of Enlightenment thought. Yet the difficulty with all such theories of the modern lies in the relentless generality of their claims. It is one thing to argue that particular institutional and cultural phenomena arising out of processes of modernization have been historically structured around a male norm, as does Joan Landes in her careful discussion of the symbolic politics of the eighteenth-century public sphere or Griselda Pollock in her account of the sexual topography of the nineteenth-century city.[20] It is quite another to claim that an extended historical period can be reduced to the manifestation of a single, unified, masculine principle. Such an absolute critique fails to account for the contradictory and conflictual impulses shaping the logic— or rather logics—of modern development. It does not allow for the possibility that certain aspects of modernity may have been or could potentially be beneficial for women. Instead, it engenders a dichotomy between an alienated modern past and an authentic (postmodern?) feminine future which can provide no account of the possible mechanisms of transition from one condition to the other.[21] Furthermore, such a view of the essentially masculine nature of modernity effectively writes women out of history by ignoring their active and varied negotiations with different aspects of their social environment. Accepting at face value an equation of the modern with certain abstract philosophical ideals and a male-dominated public life, it fails to consider the specific and distinctive features of women's modernity.

There also exists, however, a body of feminist work on the modern which has significantly influenced the arguments in this book. As well as drawing upon recent rewritings of the literary history of the fin de siècle by Elaine Showalter and Sandra Gilbert and Susan Gubar, I have found recent works by Elizabeth Wilson, Christine Buci-Glucksmann, Rachel Bowlby, Nancy Armstrong, Andreas Huyssen, and Patrice Petro to be enormously useful.[22] What these critics share is a self-conscious recognition of the complex intersections between woman and modernity, of the mutual imbrication as well as points of contradiction between these two categories. Rather than espousing either a progress narrative which assumes that modernization brought with it an unambiguous improvement in women's lives or else a counter-myth of nostalgia for an edenic, nonalienated, golden past, their writings offer a sustained engagement with the shifting complexities of the modern in relation to gender politics.

Thus on the one hand, as many feminist writers have noted, the nineteenth century saw the establishment of increasingly rigid boundaries between private and public selves, so that gender differences solidified into apparently natural and immutable traits. The distinction between a striving, competitive masculinity and a nurturant, domestic femininity, while a feasible ideal only for a minority of middle-class households, nevertheless became a guiding rubric within which various aspects of culture were subsumed. Mary Poovey notes that "the model of a binary opposition between the sexes, which was socially realized in separate but supposedly equal 'spheres,' underwrote an entire system of institutional practices and conventions at midcentury, ranging from a sexual division of labor to a sexual division of economic and political rights."[23] These material and institutional realities both shaped and were themselves shaped by dominant conceptions of women's relationship to history and progress, as spatial categories of private and public were mapped onto temporal distinctions between past and present. By being positioned outside the dehumanizing structures of the capitalist economy as well as the rigorous demands of public life, woman became a symbol of nonalienated, and hence nonmodern, identity. A proliferating body of scientific, literary, and philosophical texts sought to prove that women were less differentiated and less self-conscious than men and more rooted in an elemental unity. As a result, for a range of female as well as male thinkers, women could enter modernity only by taking on the attributes that had been traditionally classified as masculine.

On the other hand, however, a close consideration of nineteenth-century texts suggests that the divisions between public and private, masculine and feminine, modern and antimodern were

not as fixed as they may have appeared. Or rather, they were unmade and remade in new ways. Christine Buci-Glucksmann refers to a "symbolic redistribution of relations between feminine and masculine," which she sees as a prevailing countertendency within nineteenth-century urban life.[24] Thus the ideology of separate spheres was undercut by the movement of working-class women into mass production and industrial labor, causing numbers of writers to express their fears that the workplace would become sexualized through the dangerous proximity of male and female bodies. The expansion of consumerism in the latter half of the century further blurred public/private distinctions, as middle-class women moved out into the public spaces of the department store and the world of mass-produced goods in turn invaded the interiority of the home. Finally, late-nineteenth-century feminists and social reformers provided one of the most visible and overtly political challenges to existing gender hierarchies. Asserting their rights to political and legal equality with men, they simultaneously appealed to a distinctively feminine moral authority as a justification for their occupation of the public sphere. Increasingly, images of femininity were to play a central role in prevailing anxieties, fears, and hopeful imaginings about the distinctive features of the "modern age."

In this context a number of critics have commented upon the significance of the prostitute in the nineteenth-century social imaginary and her emblematic status in the literature and art of the period.[25] Both seller and commodity, the prostitute was the ultimate symbol of the commodification of eros, a disturbing example of the ambiguous boundaries separating economics and sexuality, the rational and irrational, the instrumental and the aesthetic. Her body yielded to a number of conflicting interpretations; seen by some contemporary writers to exemplify the tyranny of commerce and the universal domination of the cash nexus, it was read by others as representing the dark abyss of a dangerous female sexuality linked to contamination, disease, and the breakdown of social hierarchies in the modern city. Subjected to increasing forms of government regulation, documentation, and surveillance, the prostitute was an insistently visible reminder of the potential anonymity of women in the modern city and the loosening of sexuality from familial and communal bonds. Like the prostitute, the actress could also be seen as a "figure of public pleasure," whose deployment of cosmetics and costume bore witness to the artificial and commodified forms of contemporary female sexuality.[26] This motif of the female performer easily lent itself to appropriation as a symptom of the pervasiveness of illusion and spectacle in the generation of modern forms of desire. Positioned on the margins of respectable society, yet graphically embodying its structuring logic of commodity aesthetics, the prostitute and the actress fascinated nineteenth-century cultural critics preoccupied with the decadent and artificial nature of modern life.

The changing status of women under conditions of urbanization and industrialization further expressed itself in a metaphorical linking of women with technology and mass production. No longer placed in simple opposition to the rationalizing logic of the modern, women were now also seen to be constructed through it. The image of the machine-woman is another recurring theme in the modern, explored in such texts as Philippe Auguste Villiers de L'Isle Adam's novel *Tomorrow's Eve*.[27] As Andreas Huyssen notes, this image comes to crystallize in condensed form a simultaneous fascination and revulsion with the powers of technology. Like the work of art, woman in the age of technological reproduction is deprived of her aura; the effects of industry and technology thus help to demystify the myth of femininity as a last remaining site of redemptive nature. In this sense modernity serves to denaturalize and hence to destabilize the notion of an essential, God-given, femaleness. Yet this figure of the woman as machine can also be read as the reaffirmation of a patriarchal desire for technological mastery over woman, expressed in the fantasy of a compliant female automaton and in the dream of creation without the mother through processes of artificial reproduction. There is a crucial ambiguity in the figure of the woman-as-machine—does she point to a subversion or rather a reinforcement of gender hierarchies?—which continues to mark her most recent reincarnation in Donna Haraway's cyborg manifesto.[28]

The prostitute, the actress, the mechanical woman—it is such *female* figures that crystallize the ambivalent responses to capitalism and technology which permeated nineteenth-century culture. The list can easily be extended. The figure of the lesbian, for example, came to serve as an evocative symbol of a feminized modernity in the work of a number of nineteenth-century male French writers who depicted her as an avatar of perversity and decadence, exemplifying the mobility and ambiguity of modern forms of desire. As Walter Benjamin notes in his discussion of Baudelaire, the lesbian's status as heroine of the modern derived from her perceived defiance of traditional gender roles through a subversion of "natural" heterosexuality and the imperatives of biological reproduction. Lilian Faderman and more recently Thais Morgan have explored some of the manifestations of this cult of lesbian exoticism as it shaped the texts of the nineteenth-century male avant-garde. As Morgan notes, the figure of the lesbian came to function as an emblem of chic transgression, allowing artists and writers to explore an enlarged range of pleasures and subjectivities without necessarily challenging the traditional assumptions and privileges of masculinity.[29]

As this example indicates, many prevailing representations of modern feminity are shaped by the preoccupations of masculine fantasy and cannot simply be read as accurate representations of women's experience. Yet this is not to argue for a counter-realm of authentic femininity that awaits discovery outside such representations and the textual and institutional logics of the modern. On the contrary, I hope to show that the nostalgia for such a nonalienated plenitude is itself a product of modern dualistic schemas which positioned woman as an ineffable Other beyond the bounds of a masculine social and symbolic order. Rather than pursuing the chimera of an autonomous feminity, I wish to explore some of the different ways in which women drew upon, contested, or reformulated dominant representations of gender and modernity in making sense of their own positioning within society and history. Women's experience cannot be seen as a pre-given ontology that precedes its expression, but is constituted through a number of often contradictory, albeit connected strands, which are not simply reflected but are constructed through the "technologies of gender" of particular cultures and periods.[30] Such an understanding of history as *enactment* situates femininity in its multiple, diverse, but determinate articulations, which are themselves crisscrossed by other cultural logics and hierarchies of power. Gender is continually in process, an identity that is performed and actualized over time within given social constraints.

To acknowledge the social determination of femininity is not, therefore, to advocate a logic of identity which assumes that women's experiences of modernity can simply be assimilated to those of men. To be sure, women's lives have been radically transformed by such quintessentially modern phenomena as industrialization, urbanization, the advent of the nuclear family, new forms of time-space regulation, and the development of the mass media. In this sense, there can be no separate sphere of women's history outside the prevailing structures and logics of modernity. At the same time, women have experienced these changes in gender-specific ways that have been further fractured, not only by the oft-cited hierarchies of class, race, and sexuality but by their various and overlapping identities and practices as consumers, mothers, workers, artists, lovers, activists, readers, and so on. It is these distinctively feminine encounters with the various facets of the modern that have been largely ignored by cultural and social meta-theories oblivious to the gendering of historical processes. Thus an approach to literary and cultural history which focuses on texts by and/or about women may result in a somewhat different set of perspectives on the nature and meaning of historical processes. Those dimensions of culture either ignored, trivialized, or seen as regressive rather than authentically modern—feelings, romantic novels, shopping, motherhood, fashion—gain dramatically in importance, whereas themes previously considered central to the sociocultural analysis of modernity become less significant or recede into the background. As a result, our sense of what counts as meaningful history is subtly yet profoundly altered as the landscape of the modern acquires a different, less familiar set of contours. Yet the feminist critic also runs the risk of reinforcing gender stereotypes if she devotes all her attention to the uncovering of

a distinctive "women's culture." Many nineteenth-century women sought to question such a notion by crossing traditional male/female boundaries, whether in overtly political or in more muted and less visible ways. It is equally important to acknowledge the female presence within those spheres often seen as the exclusive province of men, such as the realm of public politics or avant-garde art. By appropriating such traditionally masculine discourses, women helped to reveal the potential instability of traditional gender divides, even as their versions of these discourses often reveal suggestive and interesting differences. Rather than reading such strategies as pathological signs of women's subsumption into an all-embracing phallocentrism, I am interested in exploring the hybrid and often contradictory identities which ensued. If gender politics played a central role in shaping processes of modernization, these same processes in turn helped to initiate an ongoing refashioning and reimagining of gender.

Modernist Aesthetics and Women's Modernity

Among the various terms associated with the modern, modernism is the one that is most familiar within the field of literary studies. Unlike modernity, it can be situated in historical time with a relative degree of precision; most critics locate the high point of modernist literature and art between about 1890 and 1940, while agreeing that modernist features can be found in texts both preceding and following this period. The emergence of modernism in continental Europe is often linked to the appearance of symbolism in France and aestheticism in fin-de-siècle Vienna, whereas in England and America modernist tendencies are usually supposed to have manifested themselves somewhat later, from around the time of the First World War.

While modernist literature comprises a broad and heterogeneous range of styles rather than a unified school, it is nevertheless possible to list some of its most important identifying features. According to Eugene Lunn's useful summary, these include aesthetic self-consciousness; simultaneity, juxtaposition, and montage; paradox, ambiguity, and uncertainty; and the dehumanization of the subject.[31] These aesthetic features are conventionally explained with reference to the crisis of language, history, and the subject which shaped the birth of the twentieth century and left an indelible mark on the literature and art of the period. Thus Malcolm Bradbury and James McFarlane note that modernism "is the art consequent on the disestablishing of communal reality and conventional notions of causality, on the destruction of traditional notions of the wholeness of individual character, on the linguistic chaos that ensues when public notions of language have been discredited and when all realities have become subjective fictions."[32]

There is, however, much less agreement regarding the sociopolitical consequences of modernist innovation in the sphere of literature and art. Within such European countries as France, Germany, Italy, and Russia, the formal experimentation of late-nineteenth- and early-twentieth-century artistic movements was frequently linked to an explicit social agenda by both practitioners and critics: radical aesthetics was intimately intertwined with avant-garde politics. A crucial notion here was that of *ostranenie*, or defamiliarization, used by the Russian Formalist school to describe literature's capacity to disrupt automatized perceptions and draw attention to the materiality of language as a set of signifiers. For a variety of avant-gardes, this defamiliarizing potential allowed artistic innovation to acquire an integral connection to social change. Modernism was the art most suited to challenging political complacencies and ideological dogmas by disrupting the mimetic illusions of realist and naturalist traditions and articulating through its very form the radical contradictions and ambiguities which characterized modern life.

Within the Anglo-American context, modernism has been read rather differently, a fact at least partly due to the lack of a substantive avant-garde tradition in England and America and the more openly conservative and quietist politics of many of its key practitioners. As a result, modernism

has often been defined in opposition to sociopolitical concerns, as critics have invoked the subtleties of modernist experimentation to defend an ideal of the autonomous, self-referential art object. Thus an elective affinity established itself between the often rarefied aesthetic concerns of writers such as T. S. Eliot and Ezra Pound and the formalist and antireferential emphasis of New Criticism as an institutional practice and technology of reading. Marianne DeKoven writes that "the triumph of New-Critical Modernism has made it appear blunt, banal, even gauche to discuss modernist writing as a critique of twentieth-century culture—to approach it, in fact, as anything other than the altar of linguistic and intellectual complexity in search of transcendent formal unity."[33] DeKoven's perceived need to legitimate and defend her own sociopolitical interpretation of Joseph Conrad and Virginia Woolf underlines the entrenched nature of such assumptions and the marked differences in this respect between Anglo-American and European modernist traditions.

Both of these traditions, nevertheless, are united in their largely uncritical reproduction of a masculine—and often overtly masculinist—literary lineage that has come under scrutiny from feminist scholars. Some critics have drawn attention to a machismo aesthetic characterizing the work of male modernists that is predicated upon an exclusion of everything associated with the feminine. Here modernism's emphasis on a rigorously experimental, self-conscious, and ironic aesthetic is interpreted as embodying a hostile and defensive response to the seductive lures of emotion, desire, and the body. Other feminists have pursued a different line of argument, noting that many of the key features of modernist experimentation suggestively coincide with the feminist critique of phallogocentrism. Suzette Henke, for example, draws on the work of Julia Kristeva to read the work of James Joyce as a subversive challenge to the structures of phallocentric discourse, unleashing a plurality of signifiers that articulate the ambiguities of a libidinal desire aligned with the maternal body. The polysemic nature of modernist art is thus reappropriated for the feminist project through its radical unsettling of the fixity of gender hierarchy.[34]

Besides producing such revisionist readings of the male modernist canon, feminist critics are also bringing women to the fore as key practitioners and theorists of modernism. As well as rereading such well-known writers as Virginia Woolf and Gertrude Stein, they are beginning to recover a less well-known tradition of female modernists and hence to reshape and redefine the contours of literary history. Distancing itself from the more reductive, content-based analyses of early feminist criticism, this recent work is often at pains to acknowledge the subtleties and complexities of modernist writing through careful attention to its tropes, metaphors, wordplays, and textual rhythms.[35] Clearly, there are institutional grounds for such interventions and for attempting to bring more women into existing literary canons by drawing attention to the innovative and formally sophisticated nature of their art. Yet it is also evident that some of the women's texts discussed in such surveys are less informed by the credo of modernist experimentalism than by alternative literary traditions such as realism or melodrama. In this context, Celeste Schenk advocates a "polemic for the dismantling of a monolithic 'Modernism' defined by its iconoclastic irreverence for convention and form, a difference which has contributed to the marginalization of women poets during the period."[36] Rather than simply arguing for the inclusion of a few more women in the modernist canon, Schenk suggests that a sustained challenge to the fetish of avant-gardism and an expansion of the term "modernism" to cover all the texts written within a given period might help to counteract the marginal status of women and open up the critical gaze to the variety of styles of writing circulating within a given historical era.

The issue at stake here is that of the benefits and dangers residing in particular forms of categorization. While I am in overall sympathy with Schenk's concerns, her suggestion that modernism be expanded to include "anything written between 1910 and 1940" seems unsatisfactory for obvious reasons. If modernism is no longer defined by any distinctive stylistic or formal features, the dates that she advocates in turn become completely arbitrary; why locate the inception of modernism in 1910, rather than 1880, or 1850, or 1830, all periods which saw themselves as

"modern" in important ways? To dissolve the specificity of "modernism" in this way is to render an already vague term effectively useless by robbing it of any meaningful referent. It is surely more useful to retain the term as a designation for those texts which display the formally self-conscious, experimental, antimimetic features described earlier, while simultaneously questioning the assumption that such texts are necessarily the most important or representative works of the modern period. Modernism is only one aspect of the culture of women's modernity.

In other words, the feminist critique of literary history is best achieved not by denying the existence of formal and aesthetic distinctions between texts, but rather by questioning and rethinking the meanings that are frequently assigned to these distinctions. These range from the liberal humanist celebration of the great male modernist as the heroic spokesman of his time to the belief, shared by various poststructuralist, neo-Marxist, and feminist critics, that experimental art exemplifies the most authentically radical challenge to the authority of dominant ideological systems. This isolation of the modernist text as a privileged site of cultural radicalism relies upon certain taken-for-granted assumptions about the uniquely privileged status of literary discourse that have become increasingly tenuous in critical theory. The first of these positions can be loosely described as a form of mimeticism; while purportedly rejecting the reflectionist frame of a realist aesthetic, it nevertheless assumes that modernism in some sense offers a truthful representation of the radically indeterminate and fragmentary nature of the social. In this sense, the modernist text becomes the privileged bearer of epistemological authority, crystallizing in its very structure the underlying fissures that the realist text glosses over. Modernism is elevated over realism paradoxically because it is a truer realism; going beyond the superficial stability of surface literary conventions, it reveals that reality *is* fluidity, fragmentation, indeterminacy.[37]

A psychologist position, by contrast, places greater emphasis on the proximity of the modernist text to the fragmented and incoherent workings of the unconscious. Here the fascination of many modernist writers with the subterranean workings of the psyche coincides with the renewed impact of psychoanalysis on recent literary theory. Thus feminist critics have drawn heavily upon psycholinguistic theories of meaning to interpret the fissures and contradictions within modernist texts as eruptions of a libidinal desire that threaten to disrupt the fixed structures of a phallocentric system. Modernism's disruption of hierarchical syntax and of linear time and plot, its decentering of the knowing and rational subject, its fascination with the aural and rhythmic qualities of language, are seen to provide the basis for a subversively other feminine aesthetic linked to the impulses of the unconscious.[38]

Both of these positions assume in different ways that the modernist work bears a privileged relationship to a nonlinguistic reality which forms the basis of its transgressive potential. Through its articulation of repressed truths, the fractured text in some sense challenges, undermines, or otherwise calls into question the mystificatory discourses of a bourgeois/patriarchal order. The modernist text thus becomes the ultimate expression of the real contradictions of modernity. Yet I have already noted that the question of what modernity *is* is by no means as self-evident as such theories sometimes assume. Whereas Marxist theorists, for example, have tended to emphasize the crisis-driven logics of capitalist production, other writers have pointed out that cultural practices do not necessarily harmonize with economic development in any straightforward way. Alain Corbin, for example, notes the relative stability of religion, custom, and traditional networks of kinship and affiliation in nineteenth-century Paris, suggesting that claims for the radical transformation of social life under capitalism are often exaggerated.[39] If one accepts the legitimacy of such critiques of totalizing models of periodization, it becomes less easy to identify a single kind of text, whether the realist or high modernist work of art, as embodying the truth of the modern Zeitgeist in a uniquely representative way. In fact, any attempt to specify a single work as an authoritative index of an entire culture problematic (modernity, women) is revealed as a methodologically fraught enterprise in its positing of an isomorphic relationship between a literary text and the real. Rather, the idea of the modern

fractures into a range of often contradictory, if connected, strands which were not simply reflected but were in part constructed through the different discourses of a particular period. Thus our own sense of the modern as a period of radical instability and constant change is itself at least partly indebted to the prominence of iconoclastic modernist artworks in received histories of twentieth-century culture; a reading of other kinds of texts may in turn engender a rather different view of the relationship between stability and change within the modern period.

The epistemological problems inherent in appeals to the essence of modernity bear directly on the textual politics of modernism, suggesting that generalized claims for the subversive nature of experimental forms need to be replaced by more contextually specific analyses of the relations between particular discourses and different axes of power. Much of the avant-garde art of the turn of the century, for example, expressed a profound antipathy toward dominant ideologies and world-views on the part of marginalized artistic and intellectual elites. In articulating this alienation at the level of artistic form, such avant-gardes espoused a critical and contestatory aesthetic that sought to explode the complacent certainties of bourgeois attitudes. Yet a feminist reading often reveals striking lines of continuity between dominant discourse and aesthetic counterdiscourse in terms of a shared valorization of Oedipal models of competitive masculinity and an overt disdain for the "womanly" sphere of emotion, sentiment, and feeling. As a result, the introduction of gender politics radically complicates an existing opposition between what Matei Calinescu has termed the "two modernities" of bourgeois rationalization and radical art, fracturing and reconfiguring existing lines of power.[40] A text which may appear subversive and destabilizing from one political perspective becomes a bearer of dominant ideologies when read in the context of another. In this context the anxious pursuit of the authentically transgressive text within recent literary and cultural theory is revealed as a singularly unproductive and uninteresting enterprise.

This argument in turn has significant implications for feminism's own choice of methodology, indicating the problems inherent in trying to encapsulate the essence of women's modernity through the close reading of one or two exemplary canonical texts. The works of Woolf or Stein, for example, may reveal much more about the specific context of the aristocratic-bohemian female subcultures of Bloomsbury and the Left Bank in the 1920s than about some repressed and exemplary Ur-femininity. Such writings offer us elegant and ironic explorations of the fragility of linguistic and sexual norms, articulating an intellectual and artistic world-view that was shaped by the impact of Freudianism and feminism, of linguistic philosophies and artistic manifestoes. However, they tell us much less about those aspects of modernity that shaped the lives of other kinds of women: the modernity of department stores and factories, of popular romances and women's magazines, of mass political movements and bureaucratic constructions of femininity. Such concerns are not of course completely absent from modernism, but they are typically mediated and refracted through an aesthetic lens of irony, defamiliarization, and montage specific to an artistic and intellectual—though not necessarily political—elite of the period. The connection of such an aesthetic to the discourses, images, and representations of the modern shaping the lives of other classes and groups of women is by no means self-evident. As Martin Pumphrey notes, "Any adequate reading of the modern period . . . must take account of the fact that the debates over women's public freedom, over fashion and femininity, cosmetics and home cleaning were as essential to the fabrication of modernity as cubism, Dada or futurism, as symbolism, fragmented form or the stream-of-consciousness narrative."[41]

If epistemological claims for the truth of modernist writing may be in need of some modification, so too are political ones. Thus writers such as Gertrude Stein are often singled out for attention by feminist critics because of their defiance of linguistic and social conventions and their transgressive questioning of femininity. Such a reclamation of a female avant-garde tradition undoubtedly forms an important part of the feminist rewriting of literary history through its creation of a pantheon of major, inspiratory women artists. Yet it also often perpetuates an unfortunate dichotomy of literary and political value which identifies formal experimentation as the most authentically

resistive practice, with a consequent stigma attached both to representational art forms and to the regressive, sentimental texts of mass culture. Such a future-oriented, progressivist rhetoric, I would suggest, may provide an insufficiently nuanced way of approaching the gender politics of cultural texts within the uneven histories of the modern. Thus a central aspect of feminist scholarship has been its concern with the everyday and the mundane, and its consequent recuperation of those areas of women's lives often dismissed as trivial or insignificant. In this context to equate modernity with modernism, to assume that experimental art is necessarily the privileged cultural vehicle of a gender politics, is surely to ignore the implications of the feminist critique not just for methods but for objects of analysis.

Here feminist scholarship enters into a productive relationship with semiotic theories, which have broken down rigid oppositions between art and society by demonstrating the sign-laden nature of the entire cultural domain. To argue that the world is textual in this sense is not to deny its political, institutional, and power-determined realities, but to recognize that these realities are concretized through a diversity of semiotically complex artifacts and activities. Such an expanded understanding of the cultural text can contribute significantly toward retheorizing the modern by breaking down traditional distinctions between a radical avant-gardism (often codified as masculine) and a mass culture that has often been depicted as sentimental, feminine, and regressive. In particular, recent feminist work in the area of popular culture and cultural studies has paved the way for a rethinking of women's modernity that can include a consideration of the politics of experimental art but that can go beyond the isolated hypostatization of the modernist text.[42] Such a culturally based reading of modernity may usefully supplement and rearticulate the existing but somewhat moribund discourses of modernization and modernism within sociology and literary criticism, respectively.

The Politics of Method

I have thus chosen to approach the issue of gender and modernity via an array of texts that span the factual/fictional as well as the high/popular divide. The particular forms of writing examined in the following chapters are drawn from a spectrum of genres, including sociological theory, realist and naturalist novels, popular melodrama, political tracts and speeches, and works of early modernism. All of these forms articulate in different ways an awareness of and response to the problematic of the modern that is crucially intertwined with their representation of the feminine. By linking together forms of writing which are often kept apart, I wish to scrutinize the metaphorical and narrative dimensions of sociological and political writing while simultaneously situating the self-conscious literariness of early modernist experimentation within particular sociopolitical contexts. If the establishment of New Historicism has helped to pave the way for such cross-generic readings, my argument is equally indebted to cultural studies for having irrevocably problematized the opposition between a "high" literature assumed to be inherently ambiguous and self-critical and a mass culture equated with the reproduction of a monolithic ideological standpoint. The meanings of all texts, it has become increasingly clear, are produced through complex webs of intertextual relationships, and even the most conciliatory and apparently monological of texts may show evidence of dissonance, ambiguity, and contradiction rather than simply reinscribing conformism.

To displace oppositions, however, is not to argue for identities. While it is important to identify images and clusters of ideas that migrate across texts, it is equally necessary to give careful consideration to the distinctive conventions and logics governing particular discourses and kinds of texts as well as to the specific contexts in which they operate. I thus wish, in Ludmilla Jordanova's words, "to draw attention to the intricate transformations and multiple meanings of fundamental ideas in our cultural traditions," to explore the various ways in which concepts and images are taken

up and concretized within particular forms and genres of writing.[43] These "intricate transformations" are immediately apparent when one begins to track the figure of the feminine, whose meanings blur and change, sometimes dramatically, sometimes almost imperceptibly, as one moves across different regimes of discourse and traditions of representation. Gender, as Jordanova points out, contains many sedimented layers of meaning; it is a composite whose boundaries are unstable and constantly shifting, even as it also reveals significant elements of continuity across the differentials of period and context.

With one or two exceptions, my corpus of texts is drawn from the period 1880–1914. The fin de siècle was a period in which conflicting attitudes to the modern were staged with particular clarity, where invocations of decadence and malaise were regularly interspersed with the rhetoric of progress and the exhilarating sense of the birth of a new age. In this sense, of course, it is a time which invites inevitable parallels with our own. It was also a period which saw an increasing differentiation of discursive fields, as art became increasingly self-conscious and aware of its own status as art at the same time as such disciplines as sociology, psychology, and anthropology sought to establish themselves as autonomous disciplines and scientific accounts of reality. As a result, it was in the late nineteenth century that many competing accounts of the modern received their first systematic articulation. Caught between the still-powerful evolutionary and historicist models of the nineteenth century and the emergent crises of language and subjectivity which would shape the experimental art of the twentieth, the turn of the century provides a rich textual field for tracking the ambiguities of the modern.

The first half of the book is devoted to a detailed reading of some recurring representations of the gender of modernity as they manifest themselves in the texts of male writers of the fin de siècle. I begin by identifying what is still perhaps the most common view of woman as existing outside the modern, examining the ways in which this view is expressed and legitimated in early sociological theory through its equation of modernity with a masculine sphere of rationalization and production. In the following chapter, I analyze what appears to be an antithetical view, the association of modernity with the realm of irrationality, aesthetics, and libidinal excess, as exemplified in the figure of the voracious female consumer. Why, I ask, are representations of modernity increasingly feminized and demonized, and what does this reveal about the relationship between the logics of capitalism and patriarchy in an emerging culture of consumption? Finally, I consider the migration of the trope of the feminine from the body of woman to avant-garde aesthetics, examining the emergence of a still-influential notion of literary modernity as linked to the feminization of (men's) writing. In these three ideational clusters, the metaphor of woman undergoes some striking transmutations as well as revealing significant continuities of emphasis.

The second half of the book, by contrast, centers upon women's own representation of the relationship between modernity and femininity, as manifested not simply in the content but in the styles and techniques of their writing. I ask: how did women position themselves in relation to the logics of temporality and the social, political, and aesthetic values associated with the modern? I begin with a discussion of the popular romance, a form often considered to be regressive and anachronistic but whose nostalgic yearning for an indeterminate "elsewhere" is, I suggest, a foundational trope within the modern itself. I follow this with an excavation of the philosophies of history evident in the speeches and tracts of first-wave feminists, focusing on their deployment of metaphors of evolution and revolution as markers of a particular experience of historical consciousness and sense of temporality. Finally, I contrast this politico-philosophical discourse of modernity with the literary modernity of the French decadent writer Rachilde (Marguerite Eymery), whose stylized explorations of the links between sexual perversion and the aestheticization of identity uncannily foreshadow some central concerns of contemporary cultural theory. By contrasting these very different genres—sentimental romance, political rhetoric, avant-garde aesthetics—I seek to highlight some of the very different imaginings of and responses to the modern among women writers of the fin de siècle.

My own analysis of these differing views makes certain claims to representativeness, as does any argument by definition. However, these claims do not rely on the presumed capacity of a single text to crystallize the underlying features of a social totality, to articulate the repressed feminine Other of the patriarchal logos or even to encapsulate *the* dominant ideology of the modern period. Rather, I aim to pinpoint and to analyze some of the most pervasive representations of women and modernity that recur within, and sometimes across, particular cultural boundaries and discursive fields, and whose traces extend well beyond the nineteenth century into our own. It is here that a comparative approach may prove useful, by highlighting different conceptualizations of the modern within particular cultural traditions, as well as allowing for a recognition of affinities that cross national boundaries. I have tried to select texts which illuminate such recurring themes with particular clarity, though the present selection is by no means a necessary or inevitable one. Similar arguments could easily be developed in relation to very different materials, though with obvious differences of emphasis.

While my approach has clearly been influenced by the new forms of cultural history as well as the more traditional discipline of the history of ideas, it retains an explicitly feminist interest in establishing connections between discourses and ideas on the one hand and systems of power on the other. I remain committed to the analytical value of positing broad systemic logics (hence my continuing and unembarrassed use of terms such as patriarchy and capitalism), while also believing that modernity contains a number of such logics which may often work in contradiction as well as collusion. Here I have found Nancy Fraser's notion of "axes of power" enormously useful; it has the merit of avoiding totalizing and functionalist models of society by highlighting the interactions and potential contradictions between different power hierarchies without, however, dissolving and dispersing the notion of power completely.[44] Such a model in turn yields a specific understanding of the politics of texts; rather than simply existing either in the center or at the margins, individual texts may possess different and often contradictory meanings in relation to particular power axes. My argument assumes, in other words, that the political meanings of particular discourses, images, and clusters of representation are not given for all time, but may vary significantly depending on the conditions of enunciation and the contexts in which they appear.

The following discussion also distances itself from an epistemological dualism which assumes that men's writing must invariably distort female experience whereas women's writing provides true access to it. Instead, it presumes that all knowledge of female (or male) experience—however intimate or seemingly private—is mediated by intersubjective frameworks and systems of meaning, but that these frameworks are heterogeneous rather than unified, and often are in conflict. The relationship of such discourses to the empirical fact of an author's gender is complex and variable rather than constant; one cannot predict the potential truth value or otherwise of a specific text simply from a knowledge of the author's sex. Thus the representation of femininity in works such as *Nana* and *Madame Bovary*, for example, interconnects in suggestive ways with recent feminist discussions of performance, desire, and consumerism; it is for this reason that I draw on these novels in my critical discussion of the sexual politics of modernity. Yet other aspects of these novels are misogynistic and otherwise problematic, invoking a critical rather than assenting response from this feminist reader. In other words, I am interested in pursuing the partial illuminations offered by particular texts rather than attributing to them a uniform essence of truth or falsehood grounded in authorial gender; these partial illuminations in turn derive from the points of correspondence and connection between the critical perspectives opened up by feminist theory and the ideologies operative within particular forms of nineteenth-century writing.

Such an oscillation between illumination and critique necessarily shapes my reading of texts by women as well as men; there is no unbroken substratum of communal identity which binds women together across history and culture. From the standpoint of the present, the texts of nineteenth-century women writers reveal their inevitable enmeshment within the ideologies and world-views

of their time, so that their voices speak to us across a chasm of historical difference. This is true not only of self-identified conservatives such as the romance writer Marie Corelli, but also of those fin-de-siècle feminist writers and activists whose commitment to social change is deeply intertwined with what now seem anachronistic, and often overtly racist, Darwinian or Malthusian beliefs. The feminist desire to reclaim women's writing can surely only ground itself in a political commitment to recover the lost voices of women rather than in an epistemological claim for the necessary truth that is spoken by such voices. It is for this reason that my discussion retains a distinction between men's and women's texts—not because women's views of modernity are invariably more accurate than those of men, but because feminist criticism is in my view committed to giving at least equal weight to such views and to paying careful attention to the specific features of women's writing. This specificity, it should be emphasized, should not be seen as simply internal to a text; rather, it is fundamentally shaped by the particular meanings and effects which accrue to discourses publicly authored by women. The gender of authorship is a crucial factor influencing the circulation and reception of textual meaning.

I need only to conclude by noting my own investment in this project and the methodological implications of such an investment. I make no attempt to occupy a position of neutrality by limiting myself to a purely antiquarian recording of late-nineteenth-century discourses; rather, my analysis is an ideologically interested one which seeks to establish points of connection between the texts of the past and the feminist politics of the present. In this sense, it is a work of cultural theory as well as cultural history; if the value of "history" lies in drawing attention to the particularity of events, that of "theory" lies in the ability to make meaningful connections across these discrete particulars. From such a standpoint, the selective nature of interpretation is not just inevitable but desirable, given that social processes can only be constituted as meaningful objects of analysis in relation to a particular viewpoint and set of concerns. I thus subscribe to a belief in the inevitable hermeneutic dimension of any act of writing and the necessary construction of the past from the standpoint of the present. At the same time, however, I have tried as far as possible to avoid the obvious anachronisms which may result from an unreflecting projection of present-day truths onto the texts of the past in order to find them lacking. Instead, my discussion aims to retain an awareness of the discursive possibilities that were available at a given historical moment and to assess the political implications of particular representations of women and modernity in that light. This historical tightrope of empathy and critique is a difficult one to negotiate skillfully: it remains for the reader to decide how successfully this negotiation has been achieved.

Notes

Epigraph: Meaghan Morris, "Things to Do with Shopping Centres," in *Grafts: Feminist Cultural Criticism*, cd. Susan Sheridan (London: Verso, 1988), p. 202.

1. Bryan S. Turner, "The Rationalization of the Body: Reflections on Modernity and Discipline," in *Max Weber: Rationality and Modernity*, ed. Sam Whimster and Scott Lash (London: Allen and Unwin, 1987), p. 223.
2. David Frisby, *Fragments of Modernity* (Cambridge: MIT Press, 1986), p. 4.
3. Matei Calinescu, *Five Faces of Modernity: Modernism, Avant-Garde, Decadence, Kitsch, Postmodernism* (Durham: Duke University Press, 1987), p. 91.
4. Susan J. Hekman, *Gender and Knowledge: Elements of a Postmodern Feminism* (Cambridge: Polity Press, 1990), p. 188.
5. *Modernism, 1890–1930*, ed. Malcolm Bradbury and James McFarlane (Harmond-sworth: Penguin, 1976), p. 41.
6. Marshall Berman, *All That Is Solid Melts into Air: The Experience of Modernity* (London: Verso, 1983), p. 14.

7. See Jürgen Habermas, *The Philosophical Discourse of Modernity* (Cambridge: Polity Press, 1987), and *Habermas and Modernity*, ed. Richard J. Bernstein (Cambridge: Polity Press, 1985).

8. Vincent Descombes, "Le Beau Moderne," *Modern Language Notes*, 104, 4 (1989): 787–803.

9. Lawrence E. Cahoone, *The Dilemma of Modernity: Philosophy, Culture, and Anti-Culture* (Albany: State University of New York Press, 1988), p. 1.

10. My discussion here draws on Mike Featherstone's helpful gloss, "In Pursuit of the Postmodern," *Theory, Culture, and Society*, 5, 2/3 (1988): 195–215.

11. See Frisby, *Fragments of Modernity*, and Mike Featherstone, "Postmodernism and the Aestheticization of Everyday Life," in *Modernity and Identity*, ed. Scott Lash and Jonathan Friedman (Oxford: Basil Blackwell, 1992).

12. See, e.g., Charles Taylor, *Sources of the Self: The Making of the Modern Identity* (Cambridge: Harvard University Press, 1989).

13. Calinescu, *Five Faces of Modernity*, pp. 23–35.

14. On the complicity of Western notions of history and modernity with the legacy of imperialism, see, e.g., Robert Young, *White Mythologies: Writing History and the West* (London: Routledge, 1990).

15. Joan B. Landes, *Women and the Public Sphere in the Age of the French Revolution* (Ithaca: Cornell University Press, 1988), p. 204.

16. Gianni Vattimo, *The End of Modernity: Nihilism and Hermeneutics in a Post-Modern Culture* (Baltimore: The Johns Hopkins University Press, 1988), p. 4.

17. See, e.g., Carole Pateman, *The Disorder of Women: Democracy, Feminism, and Political Theory* (Stanford: Stanford University Press, 1989); *Feminist Interpretation and Political Theory*, ed. Mary Lyndon Stanley and Carole Pateman (Cambridge: Polity Press, 1991); R. A. Sydie, *Natural Women, Cultured Men: A Feminist Perspective on Sociological Theory* (Milton Keynes: Open University Press, 1987); T. R. Kandal, *The Woman Question in Classical Sociological Theory* (Miami: Florida International University Press, 1988).

18. Susan Buck-Morss, "The Flâneur, the Sandwichman, and the Whore: The Politics of Loitering," *New German Critique*, 39 (1986): 119. The flâneur has emerged as a key figure in recent feminist accounts of modernity, though opinions vary as to the possibility of a female flâneur. See Janet Wolff, "The Invisible Flâaneuse: Women and the Literature of Modernity," *Theory, Culture, and Society*, 2, 3 (1985): 37–46; Griselda Pollock, "Modernity and the Spaces of Femininity," in her *Vision and Difference: Femininity, Feminism and the Histories of Art* (New York: Routledge, 1988); Deborah Epstein Nord, "The Urban Peripatetic: Spectator, Streetwalker, Woman Writer," *Nineteenth-Century Literature*, 46, 3 (1991): 351–375; and Elizabeth Wilson, "The Invisible Flâneur," *New Left Review*, 191 (1992): 90–110.

19. Juliet Flower MacCannell, *The Regime of the Brother: After the Patriarchy* (London: Routledge, 1991). On fraternity, see also Carole Pateman, *The Sexual Contract* (Stanford: Stanford University Press, 1988).

20. Landes, *Women and the Public Sphere*, and Pollock, "Modernity and the Spaces of Femininity."

21. See Iris Marion Young, "The Ideal of Community and the Politics of Difference," in *Feminism/Postmodernism*, ed. Linda Nicholson (New York: Routledge, 1990).

22. Elaine Showalter, *Sexual Anarchy: Gender and Culture at the Fin de Siècle* (New York: Viking Penguin, 1990); Sandra M. Gilbert and Susan Gubar, *No Man's Land: The Place of the Woman Writer in the Twentieth Century*, vol. 1: *The War of the Words* (New Haven: Yale University Press, 1988), and *No Man's Land*, vol. 2: *Scxchanges* (New Haven: Yale University Press, 1989); Elizabeth Wilson, *Adorned in Dreams: Fashion and Modernity* (Berkeley: University of California Press, 1987), and *The Sphinx in the City: Urban Life, the Control of Disorder, and Women* (London: Virago, 1991); Christine Buci-Glucksmann, *La raison baroque: de Baudelaire a Benjamin* (Paris: Editions Galilee, 1984); Rachel Bowlby, *Just Looking: Consumer Culture in Dreiser, Gissing, and Zola* (Methuen: New York, 1985); Nancy Armstrong, *Desire and Domestic Fiction: A Political History of the Novel* (Oxford: Oxford University Press, 1987); Andreas Huyssen, "Mass Culture as Woman: Modernism's Other" and "The Vamp and the Machine: Fritz Lang's *Metropolis*," in his *After the Great Divide: Modernism, Mass Culture, and Postmodernism* (Bloomington: Indiana University Press, 1986); Patrice Petro, *Joyless Streets: Women and Melodramatic Representation in Weimar Germany* (Princeton: Princeton University Press, 1989).

23. Mary Poovey, *Uneven Developments: The Ideological Work of Gender in Mid-Victorian England* (Chicago: University of Chicago Press, 1988), p. 8.

24. Christine Buci-Glucksmann, "Catastrophic Utopia: The Feminine as Allegory of the Modern," *Representations*, 14 (1986): 222.

25. Recent discussions of the prostitute as a symbol of modernity influenced by the work of Walter Benjamin include Buck-Morss, "The Flâneur, the Sandwichman, and the Whore," and Angelika Rauch, "The *Trauerspiel* of the Prostituted Body or Woman as Allegory of Modernity," *Cultural Critique*, 10 (1989): 77–88. See also T. J. Clark, *The Painting of Modern Life* (Princeton: Princeton University Press, 1984), ch. 2; Charles Bernheimer, *Figures of Ill-Repute: Representing Prostitution in Nineteenth-Century France* (Cambridge: Harvard University Press, 1989); Alain Corbin, *Women for Hire: Prostitution and Sexuality in France after 1850* (Cambridge: Harvard University Press, 1990); Lynda Nead, *Myths of Sexuality: Representations of Women in Victorian Britain* (Oxford: Basil Blackwell, 1988); and Judith Walkowitz, *Prostitution and Victorian Society: Women, Class, and the State* (Cambridge: Cambridge University Press, 1980), and *City of Dreadful Delight: Narratives of Sexual Danger in Late-Victorian London* (Chicago: University of Chicago Press, 1992).

26. Charles Baudelaire, *The Painter of Modern Life and Other Essays* (London: Phaidon Press, 1984), p. 36.

27. Philippe Auguste Villiers de L'Isle Adam, *Tomorrow's Eve*, trans. Robert Martin Adams (Urbana: University of Illinois Press, 1982). See also, e.g., Mary Ann Doane, "Technophilia: Technology, Representation, and the Feminine," in *Body/Politics: Women and the Discourse of Science*, ed. Mary Jacobus, Evelyn Fox Keller, and Sally Shuttleworth (New York: Routledge, 1990); Annette Michelson, "On the Eve of the Future: The Reasonable Facsimile and the Philosophical Toy," in *October: The First Decade, 1976–1986*, ed. Annette Michelson et al. (Cambridge: MIT Press, 1987); Rodolphe Gasche, "The Stelliferous Fold: On Villiers de L'Isle-Adam's *L'Eve future*," *Studies in Romanticism*, 22 (1983): 293–327; Peter Gendolla, *Die lebenden Maschinen: Zur Geschichte der Maschinen-menschen hei Jean Paul, E.T.A. Hoffmann, und Villiers de L'Isle Adam* (Marburg: Guttandin und Hoppe, 1980).

28. My discussion of the mechanical woman is indebted to Huyssen's "The Vamp and the Machine." For the cyborg, see Donna Haraway, "A Manifesto for Cyborgs: Science, Technology, and Socialist Feminism in the 1980s," in her *Simians, Cyborgs, and Women* (New York: Routledge, 1991).

29. Thais E. Morgan, "Male Lesbian Bodies: The Construction of Alternative Masculinities in Courbet, Baudelaire, and Swinburne," *Genders*, 15 (1992): 41. See also Walter Benjamin, *Charles Baudelaire: A Lyric Poet in the Era of High Capitalism* (London: New Left Books, 1973), pp. 89–93, and Lillian Faderman, *Surpassing the Love of Men: Romantic Friendships and Love between Women from the Renaissance to the Present* (London: Junction Books, 1981), pp. 254–276.

30. Teresa de Lauretis, *Technologies of Gender* (Bloomington: Indiana University Press, 1987).

31. Eugene Lunn, *Marxism and Modernism* (London: Verso, 1985), pp. 33–37.

32. Malcolm Bradbury and James McFarlane, "The Name and Nature of Modernism," in Bradbury and McFarlane, *Modernism*, p. 27.

33. Marianne DeKoven, *Rich and Strange: Gender, History, Modernism* (Princeton: Princeton University Press, 1991), p. 12.

34. Suzette Henke, *James Joyce and the Politics of Desire* (London: Routledge, 1990).

35. See, e.g., Shari Benstock, *Women of the Left Bank: Paris, 1900–1940* (Austin: University of Texas Press, 1986); Gillian Hanscombe and Virginia L. Smyers, *Writing for Their Lives: The Modernist Women, 1910–1940* (London: Women's Press, 1987); and *The Gender of Modernism: A Critical Anthology*, ed. Bonnie Kime Scott (Bloomington: Indiana University Press, 1990).

36. Celeste Schenk, "Charlotte Mew," in *The Gender of Modernism*, p. 320, note 1.

37. Laura Marcus, "Feminist Aesthetics and the New Realism," in *New Feminist Discourses*, ed. Isobel Armstrong (London: Routledge, 1992), p. 14. For a detailed discussion of the mimetic claims implicit in much modernist aesthetic theory, see Astradur Eysteinsson, *The Concept of Modernism* (Ithaca: Cornell University Press, 1990).

38. DeKoven, *Rich and Strange*, p. 8.

39. Alain Corbin, "Backstage," in *A History of Private Life*, vol. 4: *From the Fires of Revolution to the Great War*, ed. Michelle Perrot (Cambridge: Harvard University Press, 1990), p. 503.

40. Calinescu, *Five Faces of Modernity*, p. 43.

41. Martin Pumphrey, "The Flapper, the Housewife, and the Making of Modernity," *Cultural Studies*, 1, 2 (1987): 181.

42. Here I am thinking of the above-mentioned texts by Petro, Huyssen, and Wilson, but also of such landmark works in feminist cultural studies as Tania Modleski, *Loving with a Vengeance: Mass-Produced Fantasies for Women* (New York: Methuen, 1984); Ien Ang, *Watching Dallas* (New York: Methuen, 1985); and Janice Radway, *Reading the Romance: Women, Patriarchy, and Popular Literature* (Chapel Hill: University of North Carolina Press, 1984).

43. Ludmilla Jordanova, *Sexual Visions: Images of Gender in Science and Medicine between the Eighteenth and Twentieth Centuries* (New York: Harvester Wheatsheaf, 1989), p. 2.

44. Nancy Fraser, *Unruly Practices: Power, Discourse, and Gender in Contemporary Social Theory* (Minneapolis: University of Minnesota Press, 1989).

CHAPTER 5
CONSUMING INVESTMENTS
JOYCE'S *ULYSSES*

Lawrence Rainey*

Like Andreas Huyssen, Lawrence Rainey also sought to redefine modernism by locating it within a vast and ever-expanding cultural marketplace. He did not see a great divide between modernism and mass culture, however; instead he treats the experimental literature of the early twentieth century as a carefully designed set of commercial practices. Put another way, he suggests that modernism became a brand and thus a surprising source of profit for artists, collectors, and publishers. *Institutions of Modernism* laid the foundation for this new focus on the material aspects of literary production by exploring marketing campaigns alongside other strategies authors used to advertise themselves as geniuses. This book focuses on consumption, investment, and speculation by calling our attention to wealthy patrons who collected artwork, paid for fellowships, and purchased manuscripts from struggling artists. These figures freed the creators from the punishing demands of the mass marketplace only to then transform them into lucrative personal investments. Modernism, this influential work argues, did not operate in a closed aesthetic sphere somehow apart from the literary marketplace; instead it opened a new and potentially rewarding place within it.

Rainey's work synthesizes economics, sociology, literary history, and archival research as an alternative to the formalism that defined the "old" modernist studies. The book controversially begins by urging critics to turn away, at least temporarily, from a close reading of words, symbols, and images, which he calls the "scholastic scrutiny of linguistic minutiae." Instead, Rainey proposes the technique of "not-reading," a form of interpretation by contextualization that focuses on the material object of the book itself and on the complicated pathways it travels through our markets and our culture.

The chapter included here employs this innovative method to offer an alternative account of how Joyce's *Ulysses* came to be seen as the iconic modernist novel. Rainey begins by recounting the book's infamous legal troubles that led to its being banned in the United States. He argues that Joyce and his publisher, Sylvia Beach, cleverly played on this scandal to market the author as a genius and the rare first editions of *Ulysses* as collector's items. As the chapter's title playfully suggests, the book was marketed as an investment opportunity—one that indeed paid off handsomely for those who purchased the steeply priced first edition. This decision to cater to elite consumers helped create new marketing channels for other writers who could aim their often difficult or scandalous books not at the mass market, but at a richer, more discerning audience willing to invest in an author's potential fame.

Rainey's book remains an essential point of departure for the New Modernist Studies since it provided a way to link elitist art to mass culture by carefully segmenting the literary marketplace into its different audiences. His insistence on a material approach to culture as an alternative to New Critical formalism simultaneously connected to the field's explosive

*From Lawrence Rainey, *Institutions of Modernism: Literary Elites and Public Culture*. Yale University Press, ©1998. Reproduced here with permission.

interest in media and publishing technologies. This is not to say that Rainey divested himself fully from the idea of a modernist canon, and the book met serious criticism thanks to its treatment of H.D. and other women writers from the era. In urging scholars to practice "not reading," however, it enabled critics to treat modernism not just as a style, but as a commercial brand deeply integrated into the larger cultural marketplace.

Seventy-five years ago, at seven o'clock in the morning on 2 February 1922, Sylvia Beach waited at the Gare de Lyon in Paris to greet the morning express train from Dijon. As it slowed beside the platform, she later recalled, a conductor stepped down and handed her a small bundle that contained two copies of the first edition of *Ulysses*. Beach, the proprietor of Shakespeare and Company, an English-language bookshop in Paris, had just become the publisher of what would become the most celebrated novel of the century. Elated, she hastened to the hotel where Joyce was residing and handed him his copy, a present for his fortieth birthday; then she hurried back to her store and ceremoniously placed the second copy in the window. Soon a small crowd of onlookers gathered to admire the volume's handsome blue cover and celebrate the august event.[1]

This, Beach's account, confirms our most common assumptions about the publication of *Ulysses*, and hence about literary modernism. Joyce and Beach are cast as heroic figures who have succeeded despite a benighted legal system, philistine publishers, and a hostile or indifferent public; and their efforts are readily appreciated by a small yet discerning circle of readers whose insight, in the course of many years, is gradually corroborated by critics and scholars, as the book achieves canonical status. Those readers' names appear and reappear in every account of *Ulysses*'s first publication. One critic, describing a record book in which Sylvia Beach entered the names of buyers from the United Kingdom, writes: "The ledger book . . . was slowly filling with familiar names: Bennett, two Huxleys, three Sitwells, Woolf, Churchill, Wells, Walpole, and Yeats (who would receive the Nobel prize in literature in 1923)."[2] Another, commenting on the order forms that buyers had to fill out, elaborates: "André Gide was the first French subscriber. Other forms . . . are signed by W. B. Yeats, Sherwood Anderson, John McCormack, Hart Crane, Djuna Barnes, and William Carlos Williams."[3] Variations are confined to alterations of sequence or increases in catalogue length: "The many subscriptions . . . include such luminaries as André Gide, W. B. Yeats, Sherwood Anderson, Hart Crane, William Carlos Williams, Virgil Thomson, Ronald Firbank, John Dos Passos, Burton Rascoe, William van Wyck, Jo Davidson, Otto Kahn, Peggy Guggenheim, Marsden Hartley, and many others."[4] Yet there is something unsatisfying about such lists, which never extend to more than fifteen names.[5] On one hand, they conspicuously neglect to tell us who purchased the other 985 copies of the 1,000 that made up the first edition. On the other, they possess a liturgical, mantra-like quality, as if the series of names could invoke a magical power to ward off something forbidden, something to be excluded by this very act of repetitive naming. Arranged in an orderly row, like so many stylized saints standing beside one another in a Byzantine mosaic, the readers' names acquire a similar uniformity: they have been removed from the world of historical contingency and have entered a timeless realm that is free of accident, devoid of change, and impervious to the mutations of mundane life. The ritual of naming has transformed a historic event into a timeless pageant, a static sequence of grand figures. And just as the mosaic background makes each figure stand discrete and isolated against a white emptiness, so the catalogue of names furnishes a blank conceptual and historical field in which the heroism of the private individual is outlined all the more strongly for not having been explicitly mentioned. It reinforces, all the more subtly, the received narrative of *Ulysses*'s first publication, that familiar story that recounts "The Battle of *Ulysses*" lauds the "heroic efforts by Miss Beach," celebrates the "remarkable dedication of Miss Beach, [the printer] Darantiere and Joyce himself," or sings the salutary virtues that "broke the modern Odyssey into print" despite the legal obstructions and public indifference.[6] Meanwhile, the

social and historical contexts are silently cast outside the purview of examination, deemed unworthy of serious attention, and rejected in favor of the generic list, an academic variant of the epic catalogue that is implicitly connected to a narrative focused on the epic efforts of grand individuals.

The first edition of *Ulysses*, it has been said, marked "not only a historic literary event but a landmark in the annals of publication history."[7] It did indeed. It signaled the decisive entry of modernism into the public sphere via an identifiable process of commodification, via its transformation into a product whose value could now be assayed within the framework of several overlapping institutions, an institutional context whose shape and structure have been left largely unexamined. My point is not to urge a revisionary account that impugns the morals or motivations of Beach or Joyce—though I suspect these were more complex than might be gleaned from our received narratives—but to situate their decisions and actions within the context of a body of institutions, a corpus of collecting, marketing, and discursive practices that constituted a composite social space. That space was intricately connected with other institutional spheres yet was also extremely malleable, responsive both to intervention from individuals and to interaction with other sectors of the public sphere. The first publication and sale of *Ulysses*, precisely because that social space was so fragile in character, happened in ways that none of the protagonists had foreseen.

In reality, individual readers played a limited role in shaping the success that greeted the first edition of *Ulysses*. Their importance was decidedly minor when compared with the influence wielded by a quite different group of buyers—the dealers and speculators in the rare book trade who bought the overwhelming majority of copies of the first edition. That was one feature that characterized publication and sale of the first edition: it brought to the fore a conflict between the interests of individual readers (viewed as a group) and professional booksellers, export agents, and dealers in rare books (viewed as another group), as both competed to obtain the same scarce resource, the one thousand copies of the limited edition. But more than simple conflict was involved. In part the marketing of the first edition became an unintended experiment in the transformation of the common reader, an experiment in which readers were solicited to take on a mélange of functions—to assume the roles of collectors, patrons, or even investors—that overlapped in complex ways with their function as consumers. The first edition of *Ulysses* should be viewed, in part, as an attempt to realize an ideal mode of cultural production of the same sort that was being theorized in the contemporaneous Bel Esprit project launched by Ezra Pound, which proposed that thirty people agree to guarantee ten pounds per year to T. S. Eliot. Both projects, however, were ultimately troubled by unresolved ambiguities in their assumptions about art, the assessment of value, and their respective roles in a market economy and the public sphere, questions that passed unnoticed in both contemporary and subsequent assessments of the *Ulysses* edition. Although most observers have viewed the first edition as an unqualified success, the issues it left unanswered may have turned it into something that more nearly resembles a Pyrrhic victory. To recognize this can tell us much about some of the crucial ironies of the modernist enterprise, ironies that continue to vex our debates about the arts and their audiences, culture and its consumption, even today.

Although the events that culminated in the book publication of *Ulysses* on 2 February 1922 have been recounted in numerous biographies and specialized studies of Joyce, most of them have offered anecdotal narratives that avoid analytical and critical evaluation.[8] I rehearse them here partly to help readers bring them to mind and, more important, to situate them within a contextual description that differs sharply from received accounts. Before Joyce's agreement with Beach, three very different plans had been considered for the book publication of *Ulysses*—plans developed by Harriet Shaw Weaver, John Rodker, and Ben Huebsch. Though all were ultimately rejected, the dynamics that had been set in motion when they were under consideration continued to influence the way Beach's edition was conceived and executed.

Plans for the book publication of *Ulysses* began to take shape almost as soon as Joyce had completed his famous move from Trieste to Paris, where he arrived on 9 July 1920. Until then it had been tacitly assumed that the completed work would be published in the same way as Joyces previous novel. *A Portrait of the Artist as a Young Man* had first been issued in December 1916 by the American publisher Huebsch, who then sent overseas the unbound sheets for the English edition that was issued a few weeks later by Weaver, owner and director of the Egoist Press. (The Egoist Ltd. had published the *Egoist*, a monthly journal, from 1913 through December 1919 and in 1916 had created a book-publishing wing, the Egoist Press.) No one had especially worried over the question of precedence, whether the English or American edition would appear first; that was a pragmatic issue to be resolved in the light of circumstances. From the English viewpoint, it depended on finding a printer, for British law holds not just the publisher but also the printer liable for legal actions arising from publication, and on those grounds several printers had previously objected to specific passages and refused to print them without alterations when *Ulysses* was being published serially in the *Egoist* (from March 1918 on). In the spring of 1919, however, Weaver finally found the Pelican Press, a firm that would soon print the concluding issues of the *Egoist* (from July to December 1919). The firm's manager, she reported, was "a Roman Catholic Irishman" who "had been much interested" by *A Portrait*. He now read the first ten episodes of *Ulysses* and pronounced himself "willing" to undertake the novel.[9] Weaver, after bringing the *Egoist* to a close with the final issue of December 1919, thought that she had finally resolved the problem of *Ulysses*. She had not calculated on Joyce's move to Paris.

This move was executed under the aegis of Pound, who stayed in the city with Joyce for some two weeks (9 July to 21 July, from the day of Joyce's arrival to the date of his own return to London) in order to help him get settled. It was a hectic period during which Joyce was introduced to nearly everyone whom Pound knew. Among them was Rodker, a minor poet whose poems, prose sketches, and criticism—including an essay on Joyce's *Exiles*—had appeared in the *Little Review* during Pound's tenure as foreign editor from 1917 to 1919.[10] When Pound resigned in early 1919, Rodker succeeded him; a few months later, he launched a private press and publishing firm, the Ovid Press.[11] When he left London for Paris in May 1922, Rodker told Wallace Stevens that he was "going to France for two or three months' holiday. I've been sweating very hard at the press, doing all the printing myself."[12] There he was introduced to Joyce, undoubtedly by Pound. On 27 July, he and his wife, the author Mary Butts, took Joyce and his family to dinner.[13] The next morning Rodker hastened back to London to check on his business affairs. He was greeted by a disaster. Writing a brief note to accompany a copy of *Hugh Selwyn Mauberley* for Stevens, one of his best clients and a well-known book collector, he explained his situation: "These last books are I think the Swan Song of the Press. I have come back to find more bills than I could possibly have imagined to exist."[14]

Rodker returned two days later to Paris, where he continued to see Joyce on an occasional basis. By mid-August, despite his increasingly straitened financial circumstances, he presented Joyce with a plan to publish *Ulysses*. On 16 August, Joyce wrote to Weaver, who by now had assumed the role of his agent and factotum, asking her to confirm her prior report that the Pelican Press was willing to print all of *Ulysses*, so that he could know how to reply to Rodker. Weaver promptly checked with the firm, then informed Joyce that it had reluctantly but firmly declined to print the novel.[15] Joyce now assumed that Rodker would undertake the book, perhaps publishing it from Paris.[16] But when Rodker finally saw "Nausicaa" and "Oxen of the Sun," which were still only episodes 13 and 14 of a work that promised to grow much longer, he realized that his artisanal handpress was no match for so vast a project and that his lack of capital probably ruled out the question altogether.[17] Though Rodker's plan came to nothing, it is important because it was the first to raise the possibility of a limited and deluxe edition; in doing so, it planted a seed that would come to fruition in the famous first edition issued by Beach—but only after it had been assimilated to a quite different project.

In September 1920, when an unsolicited copy of the *Little Review* that contained the infamous "Nausicaa" episode was sent to the daughter of a prominent New York attorney, it set off a chain

of events that led John Sumner, secretary of the New York Society for the Suppression of Vice, to file an official complaint. A warrant was sworn out against the Washington Square Bookshop, where Sumner had purchased several copies, and American postal authorities, now alerted to the case, announced that they would hold up mailing of the issue pending the outcome of a hearing scheduled for 4 October.[18] The defense was entrusted to John Quinn, a prominent corporate attorney and noted cultural patron who had earlier organized much of the financing that supported the *Little Review*, largely because of his loyalties to Joyce and Pound. Quinn managed to get the case against the Washington Square Bookshop dropped, then to postpone the hearing for the *Little Review* until 18 October. At that hearing (finally held on 21 October), the magistrate decided to hold the defendants over for trial in Special Sessions, where the case would be heard by three judges. From the start, Quinn was convinced that Special Sessions would rule against the *Little Review*; therefore, he aimed not at winning the case but at adjourning it as long as he could. He planned to follow two strategies: first, to obtain a series of modest postponements by pleading the press of previous engagements in court; then, to move that the trial's venue be changed from Special Sessions, where "conviction would be certain," to the Court of General Sessions, where it would be tried by jury.[19] Even if he still lost the case before a jury, he would have gained enough time to get the book in print.

Quinn was also certain just what kind of edition was required—a private edition. He even cited specific examples of the sort that he had in mind: James Huneker's novel, *Painted Veils*, which had been published a few months earlier by the American firm Boni and Liveright; two novels by George Moore, *The Story-Teller's Holiday* and *Avowals*, issued several years earlier by the British publisher William Heinemann; and D. H. Lawrence's *Women in Love*, released by the American house Thomas Seltzer, also in 1920.[20] "Private edition," as used here by Quinn, was a technical term that had recently acquired a highly particular meaning. It did not refer, as it usually did then and still does today, to an edition that was privately printed in an extremely small print run (one hundred to two hundred copies), with the intention that copies circulate as gifts among friends and acquaintances of the author. Instead it was a ploy that 5 several publishers had recently devised to evade the laws on obscenity that prevailed in both the United States and England. The first firm to use it had been William Heinemann, which published all of Moore's later novels with the simple phrase "privately printed" displayed on the title page. Instead of distributing the volume through normal retail outlets, Heinemann announced that it was available only "by subscription" directly from the publisher. In this way, it could argue that the book was not for sale in the public realm, hence could not be charged with harming public morals. It also hoped to increase earnings. Prices for the "private edition" were raised to five times the average price for a new novel; by selling the book directly to readers, thereby eliminating the 30 to 35 percent of the price that would normally go to the bookseller, the firm earned still more. Indeed, the publisher could even increase its royalties to the author and still have better than average profits. Heinemann's practice was noticed almost immediately by Thomas R. Smith, an omnivorous collector of erotica, who was also the chief editor at the firm of Boni and Liveright. It was at Smith's instigation that Liveright published Huneker's *Painted Veils*, the story of a Wagnerian soprano named Ishtar who deliberately debauches a student of theology. The price was $10.00 (at a time when the average book cost between $1.50 and $2.50), and the book was available only "by subscription." Quinn was only too familiar with the novel; he had read it in manuscript form at the beginning of 1920 when Huneker had given it to him to solicit his legal advice.[21] Huebsch, Joyce's American publisher, was, no doubt, familiar with it as well.

Quinn, then, planned to have *Ulysses* published as a "private edition" in the strict sense that this term had acquired in the United States in 1920. If he could defer the trial long enough for this to occur, he believed, the work as a whole would amply demonstrate that Joyce's intentions were neither obscene nor pornographic, while Joyce might earn income enough to bridge the gap until an ordinary edition could be published. But Joyce was far from having completed the novel, and Huebsch was frightened by the potential legal imbroglio. He temporized, as did Quinn, who succeeded in postponing the

trial first to December, then to February. On 14 and 21 February 1921, the case finally went to court: the three judges of Special Sessions rejected Quinn's motion for a trial by jury, ruled that *Ulysses* was obscene, and pronounced the editors of the *Little Review* guilty of publishing obscenity. They were fined fifty dollars each, and it was understood that they would publish no further episodes of *Ulysses*. These events precipitated the collapse of all plans for an American edition. Five weeks later, on 24 March, Huebsch informed Quinn, who was also acting as Joyce's counsel and representative in the United States, that he would be unable to publish *Ulysses* without excisions and alterations in the test. Quinn refused, on Joyce's behalf, and on 5 April Huebsch formally declined the manuscript, sending a letter to Weaver, Joyce's patron and unofficial agent in London.

Joyce, residing in Paris, was left uninformed about the trials outcome or its implications for *Ulysses*. When the *Little Review* trial was still pending, Quinn was suddenly overwhelmed by work resulting from the stock market crash that struck in November 1920. He had been unable to find time to write "any book or art letters or letters to personal friends" for seven months, as he explained to Pound in May 1921.[22] Thus, Joyce was left to discover news about the trial on his own. On Thursday, 31 March 1921, Joyce stopped by Beach's bookstore and was given a press cutting from the *New York Tribune* that reported the trial's outcome. Shocked, he hurried to an "American bank" where he "bribed the porter to let me look up the files of all the papers they had." He returned "the next day" as well and "copied out another from the *Sun* and the Boston *Transcript*." Two days later on Sunday, 3 April 1921, he wrote to report the news to Weaver.[23] Despite what might have seemed an unprecedented disaster, Joyce was not disconsolate, for between his discovery of Thursday and his letter of Sunday, another event had intervened.

Joyce, it can be safely inferred, stopped for his daily visit to Shakespeare and Company on Friday, 1 April, for when Beach wrote a letter to her mother on the same date, she described the prospects for her store thus: "Mother dear its more of a success every day and soon you may hear of us as a reglar [*sic*] Publishers and of the most important book of the age . . . shuuuuuuuu . . . it's a secret, all to be revealed to you in my next letter and its going to make us famous rah rah!" (Beach's ellipses). Evidently Beach did not post her letter immediately but continued to add a paragraph here and there as time permitted. Perhaps as much as a week later (8 April?), she concluded with a triumphant postscript: "P.S. Its decided. I'm going to publish 'Ulysses' . . . in October . . . !!! Ulysses means thousands of dollars of publicity for me. Subscriptions to be sent to Shakespeare and Company at once."[24] Joyce and Beach had reached their fateful agreement. On 10 April, Joyce announced their arrangement to Weaver. Referring to his having definitively ended discussions with Huebsch, Joyce went on:

> The next day I arranged for a Paris publication to replace the American one—or rather I accepted a proposal made to me by *Shakespeare and Co*, a bookseller's here, at the instance of Mr Larbaud.
>
> The proposal is to publish here in October an edition (complete) of the book so made up:
> 100 copies on Holland handmade paper at 350 frs
> (signed)
> 150 copies on verge d'arches at 250 frs
> 750 copies on linen at 150 frs
> that is, 1000 copies with 20 copies extra for libraries and press. A prospectus will be sent out next week inviting subscriptions. There are many already in advance with shops here, I am told. They offer me 66% of the net profit. . . . The actual printing will begin as soon as the number of orders covers approximately the cost of printing.[25]

Within a week, as he had anticipated, Beach and Joyce devised a four-page prospectus that was sent to potential subscribers.

Joyce's agreement with Beach marked a radical change in the kind of edition that was now proposed, a change that was largely due to the influence of Adrienne Monnier, the proprietor of a French bookstore located near Beach's. Monnier, who saw her shop as "half convent" and herself as a "nun of other times," had already acquired experience in publishing several deluxe editions, and it was she, as Beach later recalled, who now "initiated me into the mysteries of limited editions."[26] The "special" or "private" edition that had been previously discussed by Quinn and Huebsch was essentially an ordinary edition in disguise; it was still addressed to a relatively wide readership and was described as "private" only to reduce the risk of prosecution and to mask an increase in prices and profits. What Beach proposed was something quite different—a genuine deluxe edition. The difference was apparent in every feature: price, royalties, discount structure, audience, and authorial control. The Huebsch-Quinn private edition had been expected to sell at £2; Beach's edition would sell at three different prices, the lowest of which stood at £3 3s. (nearly 60 percent higher), the highest at £7 7s. (more than 350 percent higher).[27] No less marked were change in royalties. An ordinary edition would have given Joyce royalties of 15 to 20 percent on gross sales; the Huebsch-Quinn edition would have given him a higher figure, perhaps 25 to 30 percent, with the increase coming largely from alterations in the discount structure as described below. The royalties on a deluxe edition, though, were much bigger, typically 50 percent, and Beach herself proposed that Joyce receive 66 percent of the net profits. Equally marked were differences in the discount structure and venues of sale. An ordinary edition was normally offered to booksellers at a discount of roughly 33 percent. The American "private edition" eliminated the discount structure altogether, requiring individual readers to purchase the book directly from the publisher as "subscribers." A deluxe edition, in contrast, had an extremely modest discount, typically around 10 percent. The small discount was a direct function of another, much more important difference—a change in audience. An ordinary edition, or even a "private edition" of the American sort, was addressed primarily to individual readers. A deluxe edition, instead, was directed partly to a small corpus of well-to-do collectors but principally to the dealers and speculators who sold to collectors—which is to say, to dealers themselves, who alternated between selling some copies to clients and holding others until the edition was exhausted and its value on the collectors' market had doubled or tripled. Thus, when Joyce informed Weaver that Beach's edition would "replace the American one," he was describing the project only as seen from his viewpoint; for him the Beach edition would indeed "replace the American one," or so he hoped. But his remarks concealed the extent of the change that was taking place. It was a decision to reconceive the very notion of audience and readership: to transform the reader into a collector, an investor, or even a speculator. Moreover, the particular royalty structure of Beach's edition, which guaranteed Joyce the unprecedented figure of 66 percent of net sales, had the effect of turning every purchaser of the edition into a quasi-patron, someone directly supporting the artist himself.

The full extent of the change that took place with the agreement between Joyce and Beach may also have gone unnoticed because of "Weaver's continued belief that she was going to publish the ordinary English edition that she had been planning since 1919. True, Weaver had been disappointed when the Pelican Press declined to print the novel in August 1920, but the subsequent withdrawal of Rodker had left her free to assume that she would publish *Ulysses* anyway, proceeding as she had previously done with *A Portrait*, when she purchased extra sheets from the American publisher Huebsch and then had them bound herself. The Huebsch-Quinn plan for a "private edition"—and it is unlikely that Weaver even understood what the term meant—had left this assumption unaltered. Indeed, so firm were Weaver's plans that already in late 1920 she had sent out announcements of her ordinary English edition, and by January 1921, she had received preliminary orders for some 150 copies. The new project formulated by Joyce and Beach would also have no effect on her plans, she assumed, for the Beach edition was meant only to "replace the American one" that had been abandoned by Huebsch, as Joyce had put it. As late as 12 May 1921, therefore, when Weaver generously assembled "a list . . . of bookshops to whom I shall send the circulars" that would

announce Beach's edition, she still excluded English shops from the list, "as I take it that you would not be sending to them."[28] She would soon be disabused of that notion.

Weaver's continued belief in the imminent publication of an ordinary English edition was also a function of her inexperience; she had no idea what a deluxe or limited edition was. Yet the tensions between the incompatible conceptions that animated these two projects could only be deferred, not evaded, as soon became apparent in the correspondence between Weaver and Beach about the question of the bookseller's discounts. Weaver, we should recall, was herself a publisher. She had begun in 1915 with the *Poets' Translations* series, six small pamphlets priced at not more than sixpence each, published between September 1915 and February 1916, and over the next four years, she issued seven books: Joyce's *A Portrait* (February 1917), Eliot's *Prufrock and Other Observations* (June 1917), Pound's *Dialogues of Fontanelle* (October 1917), Wyndham Lewis's *Tarr* (July 1918), Pounds *Quia Pauper Amavi* (October1919), Lewis's *The Caliph's Design* (October 1919), and Richard Aldington's *Images* (November 1919). These she issued in relatively small editions ranging from five hundred (*Prufrock*) to one thousand copies (*Tarr* and *The Caliph's Design*).[29] Despite their modest print runs, all had been conceived as ordinary editions—available for sale to a general public of common readers. Weaver, as one might expect, was quite conversant with the standard discount offered to shops—her own was ordinarily 33 percent—and her extensive experience with the marketing of her own books had made her acquainted with a goodly number of booksellers. Further, since American bookshops had shown a steady interest in several of her titles, she had also become familiar with exporting agents who catered to the American market. On 21 April, eleven days after Joyce had informed her of the new plans, Weaver wrote to Beach to discuss the question of bookshops: "I have had a number of orders from shops, English and American. Will you kindly tell me whether you propose to give any discount to shops; and, if so, how much? Of course the shops ordering from us were expecting an ordinary edition, but some of them might probably obtain orders for your special edition." The reply from Beach left her deeply disconcerted, and on 27 April she registered her consternation: "I have had no experience of limited expensive editions and it had not occurred to me that booksellers make a practice of buying copies to hold up and sell at double or treble the original price. In these circumstances I quite agree with you that a discount of 10 per cent is sufficient for them."[30] Weaver's consternation is telling, for it indicates that the distinction between the ordinary and the limited edition resided not in the number of copies but in the institutional structure into which the copies were integrated, the channels of distribution through which they passed. Weaver herself had published three editions that were substantially smaller (500, 600, and 750 copies) than Beach's, but they had all been directed toward a general public, however indifferent it may have proved. Beach's edition was directed primarily toward dealers, toward speculators. The reason to buy a book published by Weaver was to read it; the reason to buy the edition proposed by Beach was quite different—to be able to sell it again, perhaps at a significant profit if all went well. Here was the final and consummate paradox of modernism. Though we tend to associate modernism with the emergence of the New Criticism and the triumph of close reading, the effect of modernism was not so much to encourage reading as to render it superfluous. What modernism required was not the individual reader but a new and uneasy amalgam of the investor, the collector, and the patron.

The ordinary edition and the limited edition entailed antithetical and incompatible understandings of production, audience, and market dynamics. They could not coexist. The persistence of Weavers plan for an ordinary edition posed an insuperable problem for Beach's project. No one, after all, would want to pay the hefty price of the deluxe edition when a few months' wait would procure the same book at one-fifth the price. To resolve this question, Beach and Weaver had to reach agreement—a sticky question, since Weaver was also Joyce's patron, furnishing him with his only steady income. It was Robert McAlmon, the young American writer who resided in Paris but regularly traveled to London to visit his wife's wealthy family, whom Beach entrusted with the delicate task of persuading Weaver to announce that the English edition would be deferred indefinitely. McAlmon's visit to Weaver was

followed by a letter from Beach. On 8 July, Weaver told Beach exactly what she wanted to hear: "I am much concerned at hearing, first from Mr. McAlmon and then from you, that the announcement of the cheaper English ordinary edition of *Ulysses* has been affecting adversely the chances of the Paris limited edition." "The cheaper prospective edition," Weaver now conceded, "is doing harm," and to redress it she would "send out to all shops on our lists (and to any people I hear of who are waiting for the cheaper edition) the notice" that the English edition was postponed "indefinitely."[31] Beach promptly thanked her—and well she might have. The deluxe edition was inherently monopolistic; it presupposed that one could exploit a market by manipulating the ratio of supply and demand; to succeed, it required that supply be issued from only one source. Having eliminated the Weaver project, Beach could now turn to the other side of the equation, increasing demand.

To generate demand required publicity. Beach, in fact, was fascinated by the operations of modern public relations: her sister Cyprian was planning to become a film actress, and as Beach explained to her other sister, Holly, their mother had "had a great deal of expenses getting Cyprian equipped as a rising star." A month later, she reported to Holly: "Cyprian did some filming in the city the other day and there were crowds of star-gazers you may believe."[32] In the case of Joyce, much of Beach's task had already been accomplished for her by newspaper coverage of the *Ulysses* trial, which had been unusually extensive, including stories in the *New York Times*, *Chicago Herald Examiner*, *New York Tribune*, *Boston Transcript*, *New York Sun*, *New York World*, *New York Herald*, *New York Daily News*, and *New Age* in London.[33] Beach was deeply interested in the question of publicizing the novel, both for Joyce's sake and for her own. When she announced her agreement with Joyce to her mother, she wrote (as previously noted), "it's going to make us famous rah rah! . . . Ulysses means thousands of dollars of publicity for me." Writing to Holly Beach several weeks later, she stressed the same motif: "Ulysses is going to make my place famous. Already the publicity is beginning and swarms of people visit the shop on hearing the news."[34] In a letter to Holly the next month, she reiterated the theme: "It's all owing to your help and publicity work for Shakespeare and Company that I've been able to make such a success out of the thing! And YOU know it. The Tribune sent around their Miss Rosemary Carr to interview me for a writeup which will appear ere very long."[35] The "writeup" appeared two weeks later, covering nearly a full column and including a photograph of Beach with a caption that described her as "a Maecenas for Paris writers, poets, and bookworms."[36] No less important was another brief notice that had appeared a few weeks earlier in a London newspaper, the *Observer*. Although it consisted of only a single paragraph, it encapsulated motifs that would prove central to the publication of *Ulysses*.

For Britons, the *Observer* is still a part of everyday culture, but for most Americans it remains little known. Although founded in 1791, its modern history begins in 1905, when it was purchased by Alfred Harmsworth, Baron Northcliffe, the newspaper magnate who in 1896 had created the *Daily Mail*, often considered the first newspaper for a mass public. Three years later, Harmsworth appointed as the *Observer's* chief editor James L. Garvin, who would hold the post until 1942. Within a year, Garvin had increased weekly circulation from 20,000 to 57,000 readers; by 1914, the figure had risen to 170,000 and by 1915 to nearly 200,000, the level at which it would remain throughout 1915–1930. The newspaper's success was due partly to Garvin's genuine writing and editorial gifts, partly to a larger change in British society and culture. As one writer shrewdly expressed it, "The Victorian Sabbath was giving place to the Edwardian weekend."[37] The *Observer* was a Sunday newspaper, and in the years before the rise of radio or television it became a focus for relaxation and reflection. Garvin devoted pages 4 and 5 of the newspaper to books, music, and the countryside, and he oversaw a staff of gifted journalists. Not least among these was Sisley Huddleston, who became the *Observer's* Paris correspondent, covering both diplomatic and cultural affairs, the latter in his "Paris Week by Week." Only seven days after Joyce wrote to Weaver announcing his agreement with Beach, Huddleston included a notice under the subtitle "James Joyce." It reported the result of the New York trial in February, then concluded:

James Joyce was almost in despair when an American girl, Sylvia Beach, who courageously founded a little library of English books in the Quartier Latin, at the sign of Shakespeare and Company, came to the rescue. She has undertaken to have printed in France and to publish privately the big and strange volume. Whatever may be thought of the work, it is going to attract almost sensational attention.[38]

Two points need to be made concerning Huddleston's feature. One concerns its rhetoric: Huddleston was plainly using the language of cinematic melodrama (the author was "in despair," until "an American girl . . . came to the rescue"), and yet this vocabulary has furnished the lexicon that recurs in discussions of the first edition down to the present. In her 1959 memoir, *Shakespeare and Company*, Beach recounted her decision to publish the first edition, naming the chapter "Shakespeare and Company to the Rescue"; when a scholarly critic narrated the same event in 1988, he concurred: "Miss Beach . . . came immediately to the rescue."[39] Even before the book was published, the narrative of its publication had been established. The other point concerns the notice's practical consequences. In May, Weaver advised Beach: "The enterprising manager of Messrs. Jones and Evans [a prominent bookstore] wrote to me for your address after seeing a notice in the *Observer*. I am glad to hear he has ordered three copies of each edition."[40] Weaver's report testifies to the power of the newspaper as a medium, and that of the *Observer* in particular. When the *Observer* later published Huddleston's review of *Ulysses* on 5 March 1922, four weeks after the book's release, it was only two days later that Beach received almost 150 orders for the book. Yet when ordinary readers responded to Huddleston's review, they were inevitably brought into an uneasy relationship with more professional booksellers and speculators. Or to put it in more practical terms, when they read Huddleston's review and attempted to purchase *Ulysses*, they discovered that many copies were already in the hands of the anonymous but "enterprising manager of Messrs. Jones and Evans." The anonymous manager, or the type that he represents, never figures among the lists of heroic readers that scholars have traditionally offered in discussing the first edition of *Ulysses*—but he may have been the most significant protagonist of them all. Briefly appeased by Beach's explanation about the discount proposed for bookshops, Weaver soon pressed for a larger discount for export agents and wholesalers. Citing the American firm Stevens and Brown, she wrote:

They are not the kind of firm which would be likely to buy copies to hold up and sell at an advanced price. For wholesale and export agents such as this firm I think it will be necessary to offer 12 1/2% or 15% to induce them to try to get orders. Would you agree to 15% in cases such as this? This firm said that it was scarcely worth their while to take any trouble over the book at a discount of 10% because their customers, being booksellers, they will themselves have to allow some discount.[41]

Two months later, Weaver raised the point anew: "Some of the shops here (Messrs. Jones and Evans for one) say that even 15% is not sufficient inducement to them to order more than a very few copies." All bookshops, she added sympathetically, were "suffering from the general trade depression in this country."[42] Her letter arrived in late July when the first surge of orders that had greeted announcement of the edition was beginning to flag. Partly in the hope of inducing more sales, partly in response to Weaver's pleas, Beach decided to offer a discount of 20 percent to all bookstores, export agents, and rare book dealers.[43] (She also extended the discount to members of the trade or other publishers and to members of the press, the latter in a bid for favorable reportage.) Her decision had a paradoxical effect: it made the edition more accessible to a wider audience, enabling a modest number of bookstores to place orders on behalf of individual readers, but it also made the edition more attractive to speculative booksellers, who could now rest assured of a small profit even if they charged only the published price, rather than holding the edition in the hope of greater profits.

Orders from dealers and agents soon mounted, and the London firm of William Jackson is highly representative of the trend that emerged. On 7 July 1921, the firm ordered eight copies.[44] On 16 August, its order was increased to twenty copies, with a note from Jackson adding, "I shall probably want more yet." On 21 September the order was increased again to thirty-five copies, and on 3 January 1922 it was changed to seventy copies. As more than six months had elapsed since the firm first placed its order, Jackson wrote on 19 January to inquire "when the book will be ready." Four days later, having been advised that copies would be available in a matter of weeks, he increased his order to eighty copies. Finally, on 1 February, he raised his order to one hundred copies. It is an astounding figure, accounting for 10 percent of the entire edition and for 13 percent of the issue at 150 francs. Of the cheaper copies that were most likely to be purchased by ordinary readers, more than one in seven was bought by one dealer alone. To be sure the size of Jackson's purchase was unusual, and it constituted the largest single order that Beach received. But it suggests the influence that the dealers wielded as a group. If we glance only at the purchases (in francs) of the eighteen shops, dealers, and agents who placed orders that totaled more than 1,000 francs, we can sense the extent of their role in the first edition.

The Galignani Library 224, rue de Rivoli, Paris	1,080
Hodges & Figgis 20 Naussau Street, Dublin	1,160
Mitchell Kennerly 489 Park Avenue, New York	1,200
Brentano's 37, avenue de l'Opéra, Paris	1,600
Mitchell's Bookstore Buenos Aires	1,600
Washington Square Bookshop 28 West Eighth Street, New York	1,620
T. S. Mercer 4 Tufton Street, Westminster, London SW1	1,680
Birrell & Garnett 19 Taviston Street, Gordon Square, London	1,880
The Irish Book Shop 45 Dawson Street, Dublin	2,240
W. H. Smith & Son 248, rue de Rivoli, Paris	2,760
Gordon & Gotch 10 St. Bride Street, London EC4	3,000
B. F. Stevens & Brown 4 Trafalgar Square, London WC2	3,040
The Sunwise Turn 51 East Forty-fourth Street, New York	3,040
John Clark, Exporrer 12 Ludgate Square, Ludgate Hill, London EC4	3,200
Librairie Emile Terquem I, rue Scribe, Paris	4,680
Agence Generate de Librairie 7, rue de Lille, Paris	5,160
The Chelsea Book Club 65 Cheyne Walk, London SW$_3$	5,280
William Jackson, Export Bookseller 16 Tooks Court, Cursitor Street, Chancery Lane, London	11,600

Taken together, these dealers alone accounted for 55,280 francs, nearly 40 percent of the 142,000 francs in gross sales that Beach took in for *Ulysses*.[45] When shops and dealers that placed smaller orders are also taken into account, excluding those who placed orders on behalf of individual readers—and in their correspondence they took pains to cite their clients' names when doing so—the total comes to nearly 60 percent of the gross sales. (Individual readers, in contrast, account for slightly more than 40 percent, though this figure shrinks to 36 percent if we exclude the journalists and reviewers who received press discounts.)

Dealers, shops, and export agents consumed a surprisingly large share of the edition, but not all of it. If one were obliged to identify a single moment at which the first edition can be said to have entered the public sphere, becoming genuinely available to a substantial public, it would be Sunday, 5 March 1922, when Huddleston's review of *Ulysses* appeared in the *Observer*, reaching its readership of roughly two hundred thousand people. Huddleston firmly expressed his admiration for the book, declaring it a work of genius. Joyce's style(s) he praised without reserve, saying that his phrases were "as perfect as these things can be" and that "a single just-right sentence" could concentrate "a great sweep of meaning." He even offered a brief primer in how to read what was then being called "the interior monologue," and by addressing the educated reader in a frank and easygoing manner, he effectively communicated his regard for Joyce's achievement.[46] The response was immediate. Two days later, on 7 March, as Pound explained to his father, "Observer review brought in orders for 136 copies of Ulysses, last Tuesday; 136 in one day at 15 bones the copy."[47] Nine days later, the last of the 150-franc copies had been sold, and Beach was advising buyers that they would have to purchase the more expensive issues. Many, quite simply, could not afford them.[48]

The plight of the ordinary reader is epitomized in a letter written by R. C. Armilt, a resident of Kilmarnock, who, in response to Huddleston's review, wrote directly to Joyce himself. He had, he explained, deeply admired *A Portrait*.

> Some time ago I read your "Portrait of the Artist." I admired it. I recognized it as a fine, unusual piece of work. It was a new note in our literature with I know not what incalculable influence in the future.
>
> I desired to read more of you, to hear more of you. Now I see that you have published another book privately. . . . Doubtless there is good reason for this procedure. Possibly you are not to blame. It may be no right of people like myself to have the fine and beautiful literature of our day. But what am I to do?
>
> I am not a rich man.

Armilt concluded, almost pleading, "am I to be denied the joy of reading one more work which is not for this time alone?" Armilt turned out to be lucky: his letter arrived on the last day that cheaper copies were still available. Others were less fortunate.

Yet to pose a straightforward opposition between common readers and speculative dealers is to lose sight of the multiplicity of functions that accrued to the role of the reader-buyer as a consequence of the deluxe edition, especially as it had evolved under Beach's direction. To understand this better, however, we must briefly consider the question of the edition's cost: what did it mean, in everyday terms, to buy a copy of the first edition of *Ulysses* in 1921–1922? Answering that question requires a glance at prevailing exchange rates. Because purchasers of *Ulysses* paid for their copies when they were ready from the printer, the relevant period is a span of five months, from 2 February 1922, when the first copies reached Beach, to roughly 1 July, when the edition was exhausted. Throughout this time, the franc was fairly stable. On 2 February, the dollar stood at 11.925 francs on the Paris Bourse, while on 30 June, it stood at 11.995 francs, and in the intervening months it fluctuated little. The situation was no different on other exchanges: in New York, on 1 February, the dollar was trading at 11.97 francs, while on 1 July it was trading at 11.94 francs. Similar stability prevailed in the ratio of the franc to the pound, which stood at 52.725 on 2 February and 51.395 on 1 July.[49] The book's prices in each currency were as follows:

Copies 1–100	350 francs	£7 7s.	$30
Copies 101–250	250 francs	£5 5s.	$22
Copies 251–1,000	150 francs	£3 3s.	$14

To compare the cost of living from one era to another is a notoriously hazardous undertaking, and it would be unwise to lay claim to more than a rough approximation. Still, anecdotal evidence can give at least some indication of what such sums could buy in Paris, London, or New York. For example, Morrill Cody, a young American journalist who moved to Paris in 1921, later recalled:

> Living in Paris in the early twenties was cheap. . . . Then one could manage to live in Paris for less than twenty-five dollars a month. Soon after my return [in 1921] I got a job on the European edition of Colonel McCormick's *Chicago Tribune*. It paid only fifteen dollars a week, but it was enough for a small hotel room and food and occasional drink at the Select or one of the other popular cafes in the neighborhood. Some of my friends with incomes of one hundred dollars a month lived very well, indeed, with their wife or partner.[50]

Cody was young, single, and without responsibilities, and quite plainly he was tolerant of spartan conditions. More typical was the case of Ezra Pound and his wife, Dorothy. They moved to Paris in early April of 1921, and in October, they rented a fairly spacious studio at 70, bis rue Notre-Dame-des-Champs. The rent was three hundred francs a month.[51] Pound's salary at this time was an average of twenty-five dollars per month, though his income was supplemented by occasional royalties, payments for publications, and gifts of ten to twenty dollars from his parents. Altogether he earned some forty dollars a month, somewhat more than the twenty-five recommended by Cody, yet Pound also found it difficult to make ends meet.

Pound was fortunate, however, in one respect. His British wife had her own income, receiving from her parents two hundred pounds per year, or just under four pounds per week.[52] Her family evidently preferred not to support Pound, and their estimate of her needs was meant to correspond with a modest living wage in England. In 1924, "the average man at full work . . . obtained 60s' a week," or three pounds. In 1924, it was also estimated that the annual "income from wages per house" was "£210 [$1,050] if there was no unemployment or absence owing to sickness during the year," a figure that amounts to just over four pounds a week.[53] Anecdotal evidence reinforces that figure. In May 1922, the future mystery writer Dorothy L. Sayers, who was twenty-nine years old and a graduate of Oxford, took a job as a copywriter with the advertising firm of S. H. Benson: her salary was four pounds (twenty dollars) a week.[54]

The cost of living was slightly higher in the United States at this time. Cody thought his weekly salary of fifteen dollars rather low in 1921, but in 1919, Robert Sherwood was hired for twenty-five dollars a week to be on the staff of *Vanity Fair* in New York, and a year later, when Jeanne Ballot became executive secretary to the magazine's editor, she received twenty-two dollars a week. Margaret Case Harriman, who also worked on the editorial staff of *Vanity Fair*, received thirty-five dollars a week in 1922.[55] While such figures give only an approximate idea of how much the first edition of *Ulysses* cost, they make clear that even the cheapest issue, priced at 150 francs (£3 3s., or $14.00), was not inexpensive. In Paris, it represented almost half a month's rent for a studio in a moderately priced part of the city; in England, it approached or exceeded the average weekly wage for a normal adult; and in New York, it was 50 to 67 percent of the weekly salary for editorial staff of the city's most prestigious magazine. To buy a copy of the first edition of *Ulysses*, in other words, was not an action that can be readily compared with the everyday purchase of a book; for those who were not wealthy, it required at least some deliberation, some consideration about disposable income and its allocation.

When private readers purchased copies of the first edition, they did not just buy a book, they also assumed some of the functions of patrons. Several features of the deluxe edition worked toward establishing a patron-client relationship. One was the contract between Joyce and Beach, which stipulated that he receive 66 percent of the net profits. To an extent that was without precedent in ordinary editions and unusual even among deluxe editions, money from individual readers went directly to the author. But this economic structure merely reflected a broader effort to restore a more direct, less mediated relationship between author and reader. The book was no longer an industrial product, a mere commodity shaped by the conventions of the publishing industry and produced by the machinery of the large publishing house. Every facet of its production was now associated with the author: he was asked to approve the paper, typeface, and page layout for each issue, as well as to choose the color for the cover and even to authorize the inks that would reproduce the color. The logic of this drive toward a more direct rapport between author and reader also shaped the editions pricing structure, which culminated in the issue priced at 350 francs (copies numbered 1–100), with each copy signed and dated by Joyce. Still, it may give pause that it should be only and precisely the highest-priced issue that to the greatest degree "restored" unmediated relations among author, work, and reader, for it suggests that this restoration was partly fictional, if not factitious: the deluxe edition could *seem to restore* those more direct relations insofar as it bracketed from consideration the larger world of industrial and financial relations that sustained the incomes of those who could afford it.

To ask that readers become patrons, that consumers become at least passive producers, that the artist work for an identifiable audience rather than a mass public, was a leitmotif of early-twentieth-century discussion about the social structure of the arts. Roger Fry's hope, expressed in 1912, that the new professional classes would become a significant force of patronage was typical of a broad movement that also included the German Expressionist artists gathered around die Brücke in Dresden, sustained by a group of "passive members"— professionals, businesspeople, and intellectuals who contributed a monthly sum for which they received a yearly graphics portfolio.[56] It is not an accident that another attempt of this sort was conceived in March 1922, just when sales of the first edition of *Ulysses* were at their height: Ezra Pound's Bel Esprit project, his proposal that thirty individuals each guarantee ten pounds (fifty dollars) per year to Eliot, providing him with an income of three hundred pounds. Bel Esprit, Pound explained in a contemporary essay, was needed "because the individual patron is nearly extinct." In effect, the Bel Esprit project would create a practical organizational structure that would institutionalize the community forged by the deluxe edition of *Ulysses*. It would be a deluxe edition in perpetuity, but now, instead of retrospective consumption, Pound urged, the "geographically scattered association" would engage in prospective patronage.[57]

The strands of patronage, consumption, collecting, and speculation were intricately interwoven in the emerging fabric of modernism. But perhaps nowhere can their complex interaction be better discerned than in an account of the Sunwise Turn, a New York bookstore that purchased eighteen copies of *Ulysses* for more than three thousand francs, enough to make it the sixth largest buyer of the first edition.[58] The firms existence virtually coincided with the rise, triumph, and assimilation of modernism (founded in 1916, it was sold to the Doubleday chain in 1927).[59] The shop was first opened by Madge Jenison and Mary Mowbray Clarke, and their plans for it combined an uneasy mixture of modernizing professionalism and primitivist vitalism. The store would offer "all that is related to modern life," doing so with "the professional spirit which puts its knowledge and integrity at the disposal of the community." But the store's name derived from an Irish agrarian expression describing farmers who prefer to "do everything daesal (sunwise)," a phrase that they thought expressed "one of the deepest feelings of primitive life, that when you go with the sun you

get all the beneficent and creative powers of the earth."[60] "The sunwise turn" suggested movement in a direction that would harmonize with primitive feeling and yet synchronize with modernity.[61] By "selling books in a more modem and civilized way," the shop would "carry them . . . into the stream of creative life of our generation."[62] The store's full name was "The Sunwise Turn: A Modern Bookshop."

The bookstore opened in 1916 on Thirty-first Street just east of Fifth Avenue, where it remained until 1919. "We were to conduct it like life, and it was to look like life," the owners felt. The decor was designed by Arthur Davies, a close friend of Quinn, who had been a principal organizer of the famous Armory Show in 1913. Davies colored the walls "a burning orange" and worked the other colors of the prism into the woodwork and detailing, and he entrusted the shop sign to Henry Fitch Taylor, another prominent organizer of the Armory Show. The shop was lavish in displaying "beautiful pieces of sculpture and textiles and paintings"; Mowbray Clarke's husband was a sculptor, and she hoped that the store might serve to attract patrons for him.[63] But the emphasis on display and exhibition also stemmed from less personal considerations. When planning the store, Jenison and Mowbray Clarke had borne in mind "that an art dealer needs only five patrons buying $2,000 a year to keep him afloat, and that if we could have fifty patrons who bought $500 worth of books a year, we would be safe." (They had originally planned to locate in some vacant rooms available in the building that still housed Alfred Stieglitz's studio and gallery at 291 Fifth Avenue.) But this attempt to assimilate the bookstore to the art gallery, to operate it on principles derived from art dealers, proved difficult in actual practice, for the two owners soon discovered "how few people there are, *except collectors*, who buy $500 worth of books a year."[64] The shop turned out to be a paradox; a store could not survive if it relied on only "fifty patrons," and yet it also could not survive by selling to a mass of undifferentiated buyers, since the profit margin on books was simply too small (roughly 30 percent at this time). To survive and succeed, the store had to sell other wares (such as stationery), goods with higher profit margins that would offset the low returns on books. "So you survive at bookselling by selling something else," as Jenison summarized her discovery. "You may sell old and rare books. Profits are always large on collector's items."[65] Thus Jenison discovered through experience that only collectors spend five hundred dollars on books each year and that rare books bring in larger profits; these larger margins were critical to a store's survival and success. The Sunwise Turn, in short, exhibited paintings, textiles, and sculptures for the same reason that it pursued an extensive trade in rare books and signed editions: profit margins on them supplemented the meager returns on ordinary books, and they attracted an elite of cultured and well-to-do clients whose every purchase was not only larger but more profitable.[66] To thrive, a bookstore needed not just readers but a core group of collector-patrons.

There was a second reason as well. The display of textiles and artworks also fostered a distinctive marketing profile: "Only give the world something with character to talk about and it will carry your name to the sunset. . . . It is the cachet of an imaginative personality that sells it." Every feature of the store—the decor, the stationery, even the bookwrappings—was marshaled to this end. "The sale of thousands of books strayed into our shop because we wrapped them in curious brilliant packages. Some artists who worked on the designs made them so deliriously lovely that it was difficult to make up one's mind ever to open them."[67] Yet the unremitting emphasis on display and image, as such remarks suggest, could lead to a paradoxical state of affairs, one in which active readers were slowly replaced with passive consumers, mere buyers who were less engaged with a books contents and more bedazzled by its wrappings. The attention given to rare books and artworks, the insistence on exhibition, display, ambience, packaging—all originally conceived as supplements to the core activity of bookselling—inexorably altered the relations among the store's functions. Buying was no longer a means to the experience of reading but an experience in its own right, an autonomous activity that threatened to over-shadow and replace the reading event that it was meant to facilitate.

After a lackluster beginning (in 1916, sales totaled $12,192; in 1917, $12,874), the store began to thrive (in 1918, sales reached $18,259; in 1919, $37,782). In autumn 1919, armed with more capital from a new partner, Harold Loeb, the shop moved into new quarters at 51 East Forty-fourth Street (part of the Yale Club building), where the decor of the previous location was painstakingly reconstructed. The next year, 1920, it posted more than $70,000 in sales. The new location was directly across from Grand Central Station, and the immediate vicinity housed four hotels and ten of the city's more prominent clubs. The space was more than double and the foot traffic triple that of the earlier location. The store launched a series of lectures and readings in combination with book signings; authors included Robert Frost, Amy Lowell, Lola Ridge, and Alfred Kreymborg. It also became a publisher, issuing volumes by Witter Bynner, Rainer Maria Rilke, Ananda Coomaraswamy, and Lord Edward John Dunsany, among others.[68]

The Sunwise Turn, it can be argued, also furnished consumers and personnel with training in the modernist culture of collecting and patronage. One example will suffice. The father of Loeb, the third partner, was a Wall Street broker in the influential house of Kuhn-Loeb, while his mother was a member of the prominent Guggenheim family. When Loeb's twenty-one-year-old cousin Peggy Guggenheim was looking for something to do, he suggested that she join the store's group of unpaid assistants for a while. As Jenison later recalled:

> They sold thousands of dollars worth of books for us. They filed invoices. They swept floors. They ran errands. I have sometimes secreted a smile behind a monogtaph to see . . . Peggy Guggenheim, in a moleskin coat to her heels and lined with pink chiffon, going out for electric-light bulbs and tacks and pickup orders at the publishers, and returning with a package large enough to make any footman shudder and a careful statement of moneys disbursed.[69]

Yet Loeb, who knew Guggenheim far better than Jenison, was more perceptive in assessing her experience at the Sunwise Turn. She "was one of the young people whom Mary Clarke affected," and it was this influence that later led her to "collect . . . the latest in experimental painting and [give] money and meals to poor artists and writers."[70] When Guggenheim left the store, she sailed to Europe, eventually settling in Paris; her first step as a patron-collector was taken a little later, on 15 February 1922, when she stopped in Beach's store and purchased, with "cash" as Beach duly recorded, a copy of the first edition of *Ulysses* numbered 339. (Guggenheim may have overestimated the attendant privileges: a few weeks later when Joyce found himself invited to a party celebrating her marriage to Laurence Vail, he confessed his bewilderment. "I scarcely know him," he wrote, speculating that someone in his family had "met him or her somewhere.")[71]

The Sunwise Turn, quite plainly, encouraged an ambiguous atmosphere, one in which motifs of advancing consumerism and cultural patronage joined in a brief, uneasy, and unstable embrace. The store itself was caught in the ambiguity. As Loeb recalled:

> For me, the "profit system" existed whether I liked it or not; and since it did, I accepted the first rule of business: to operate without loss. Other shops carried on without a subsidy, and I felt that ours should too. Mary, however, was against capitalism itself. To her the word "profit" had an evil connotation. She would have been willing to operate in the red, if someone would have picked up the tab and made up the loss. . . . I insisted that the shop be run so that it could continue without outside help.[72]

There was to be no resolution. Loeb finally sold his share of the shop in early 1921, and Mowbray Clarke struggled on until the store was purchased by a larger rival.

Guggenheim's subsequent career—her lifelong patronage of Djuna Barnes, her famous collection of paintings now in Venice—is readily understandable in light of her experiences at the Sunwise Turn. Many of the store's clients were collectors. Perhaps the most prominent was Alfred Knopf, the young publisher who had issued Pound's *Pavannes and Divisions* in 1918 and Eliot's *Poems* in 1920, both at the urging of Quinn. Knopf "used to come occasionally and buy royally"; he purchased two copies of *Ulysses* directly from Beach, availing himself of the 20 percent discount allowed to publishers, and added them to what eventually became one of the finest private book collections in the United States.[73] Another was Huebsch, the publisher whose plan to bring out *Ulysses* had collapsed in the aftermath of the *Little Review* trial; during especially busy evenings in the Christmas season, Huebsch "stopped in about eight and put on labels" for packages to be delivered the next day. Huebsch purchased three copies of *Ulysses* directly from Beach, also availing himself of the trade discount.[74] Yet another buyer was Leon Fleischmann, a senior editor for the publishing firm of Boni and Liveright, who had first met Loeb and Guggenheim when they were working at the Sunwise Turn. Fleischmann moved to Paris in 1921, where on 8 February 1922 he acquired numbered copy 254 of *Ulysses*.[75] (His wife, Helen, whose liaisons with other men he reportedly encouraged, would later marry Joyce's son, Giorgio.) Although they were not prominent collectors, Jane Heap and Margaret Anderson (the two editors of the *Little Review)* also frequented the Sunwise Turn, and evidently they even had discussions with Mowbray Clarke and Jenison about what to do with *Ulysses.* The Sunwise Turn was another agent within the same institutional space that housed Beach's Shakespeare and Company. As Mowbray Clarke informed Beach in a letter that accompanied the store's order for eighteen copies of *Ulysses,* "We thought of publishing it here but didn't have the money."[76]

Buyers of the first edition, by virtue of their participation in the economy of collecting, now became investors. This was plain enough to most *contemporaries*; hostile reviewers called its price "excessive" and "exaggerated."[77] One commented more extensively: "The volume is to be had by those who take the trouble to seek it out for about £3 10s., and most of those who are troubling to seek it out are buying it as an investment—they flatter themselves that a first edition of this remarkable author will bring them a handsome profit within a few years."[78] It took much less time than that. By September, when another reviewer noted that "the edition is limited and the price is rapidly ascending in the 'curious' market," he was guilty only of understatement.[79] Already on 27 March, scarcely seven weeks after the first copies had reached Beach in Paris, Quinn reported that copies of the lowest-priced issue of *Ulysses* were generally circulating in New York for $20 (£4, or 200 francs) with one having reached $50, almost 350 percent more than the original asking price.[80] In late June in Paris, only eight days after the edition had sold out, copies of the 150-franc issue were going for 500 francs (£10, or $50).[81,82] On 5 August, six weeks later, Mitchell Kennerley heard that copies in London were bringing £10 each, but a week later, on the basis of firsthand observation, he reported that copies in London were fetching £20.[83] In October, Joyce informed his aunt Josephine Murray: "The market price of the book now in London is £40 and copies signed are worth more. . . . In a few years copies of the first edition will probably be worth £100 each, so book experts say, and hence my remark."[84]

Participants followed the vertiginous success of the first edition with the intensity of stockbrokers, and everyone hastened to pronounce it a triumph. In the aftermath of Huddlestons review in March, Weaver hastened to offer Beach her congratulations: "I had a card from Mr. Joyce yesterday saying that the 150 franc edition is out of print already—much sooner than I had imagined it would be. Many congratulations on your success as a publisher!"[85] Pound was no less insistent in announcing the same news to Alice Corbin Henderson, the former associate editor at *Poetry* magazine: "'Ulysses' is as you probably know 'out' triumphantly and the edition probably sold by now. . . . Record sale for one day was 136 on last Tuesday. So that's that."[86] Indeed, the

edition's success seems almost to have blinded people to changes that it was bringing about in their own perceptions and conduct. By May 1922, Weaver, who had once found it inconceivable "that booksellers make a practice of buying copies to hold up and sell," was urging Beach to do just that: "In any case I should think it would be well worth your while to hold back a number of copies to sell at a fancy price when the edition becomes a collector's curiosity as it is certain to do."[87] The rhetoric of investment was so tenacious that even in the 1950s, when Beach was writing her memoirs, she remarked of Joyce, "As soon as *Ulysses* was off his hands, he lost interest in it as a book if not as an investment."[88]

Conservative critics who lamented the rise in the first edition's price may have been too literal-minded in their understanding of the investment being asked of readers. For readers less fortunate than Peggy Guggenheim, the substantial price of the first edition inevitably dictated a certain psychic investment, demanding assent to strong claims about the work's aesthetic or literary value, claims that could then, legitimately or not, be justified by being translated back into economic terms. That thinking, in turn, bore witness to a much broader social phenomenon, the collapse of shared confidence in the notion of aesthetic autonomy and the independent coherence of aesthetic value—a collapse precipitated partly by the theoretical and institutional onslaught of the avant-garde as codified in the writings of Futurists, Dadaists, and Surrealists, or perhaps as best epitomized in Marcel Duchamp's famous "Fountain"; and partly by the relentless and ever increasing penetration of capitalist relations into every dimension of life, including the aesthetic, penetration that increasingly eroded the boundaries between art and commerce. Readers, no longer confident that they could appeal to the public sphere in support of their assertions about the aesthetic value of *Ulysses*, turned to the workings of the market itself, taking its outcomes to be confirmations, even justifications, of their claims.

One sees this logic at work in Pound's remark written to his mother and father in mid-1921, just as they were approaching retirement and looking for good investments: "I don't, en passant, know any sounder investment (even commercially) than the first edition of Ulysses."[89] Pound's comment epitomizes what might be called the double order of values that was at stake in the first edition. When he first urges that the edition is a "sound investment," he is merely using the term in a weak sense as a metaphor for something else; "sound investment" can be translated as "genuine literary achievement," and his comment acquires a sardonic undertone from the knowledge, shared by his parents, that that is not the kind of investment they are seeking. But when he hastens to add "even commercially," he invokes a second order of values associated with investment in the more common or literal sense, as an outlaying of money for profit or gain; here the first edition is a sound investment because it will increase in monetary value. Pound does not articulate the nature of the connection between these two orders of value, between his aesthetic claim and his assertion about monetary value, but their juxtaposition works to elide the two into a single category or to suggest that the second justifies the first, that an increase in the monetary value of the first edition works to justify claims about the artistic or literary value of *Ulysses*. Pound was not, I think, being naive about the philosophical difficulties inherent in mediating between these orders; more likely, he was taking for granted that those difficulties were of no interest to his parents, whose everyday outlook assumed that the workings of the marketplace were essentially just and self-justifying, serving as a homogeneous guarantor of value. For his parents, as for society at large, an increase in monetary value would validate or justify claims about artistic value. Pound, in acceding to their assumptions, bore witness to the same crisis of aesthetic value that prompted participants in the first edition to think its success would also justify claims about the work's aesthetic value, that its fortunes would ratify assertions of cultural worth. "Where is the value?" asked one early reviewer after listing many traits of *Ulysses* that he thought would prove trying to readers. "Better to wait a few generations," he answered himself.[90] For the modernists, there was no time to wait.

At stake in the intensity of discussion about the first editions investment value was a gnawing anxiety about the nature of value and its justification in a market economy and an increasingly democratic society. For what set the avant-garde art market apart from other markets, after all, was precisely "an extreme ambiguity in the value of the objects that are sold."[91] Instead of being attributed on the basis of production costs, or even merchandising costs, value in this kind of market is largely discursive in nature, based on evaluations by experts, critical and journalistic opinion. Yet for a work such as *Ulysses*, little hope appeared in those quarters. That explains why participants in the planning of the edition pursued two strategies in attempting to market the edition. On one hand, they especially sought out purchasers with prominent and distinguished names, such as William Butler Yeats and George Bernard Shaw, in the same way that gallery owners attempt to place new paintings or sculptures with eminent collectors. Here was one alternative to critical and journalistic opinion, a potential source of discursive capital that would ratify the work's value. On the other hand, they turned to the workings of the market itself, taking its outcomes to be confirmations, even justifications, of their claims.

The modernists had already witnessed, within their lifetimes, the deepening penetration of capitalist relations into every feature of everyday life, including its increasing extension in the realm of cultural production. They were not especially optimistic about Utopian alternatives to a market economy (and the history of the twentieth century seems to have confirmed their skepticism), and they were certainly not going to wait until such alternatives were realized to test the validity of their claims. They were eager to demonstrate that their work could be successful now and to construe market success as a justification for their aesthetic and cultural claims.

In forfeiting demands for public sanction to the operations of the marketplace, the participants in the first edition of *Ulysses* encouraged a misunderstanding that has continued to reverberate in debate about the avant-garde and its public, art and its audience. For the marketplace is not, and never can be, free from systemic distortions of power, and its outcomes cannot be equated with undistorted participation in practices of justification, or with norms of equal and universal participation in discussions about cultural and aesthetic value. The operations of the market are not an adequate substitute for free agreement; indeed, they are not a substitute at all, insofar as they are operations of an entirely different order. (How different an order is fully evident at nearly every step in the proceedings that attended the first edition of *Ulysses*; for if we are to be honest and set aside our abiding affection for *Ulysses*, we will admit that the marketing practices for the first edition were essentially monopolistic manipulations of supply and demand, actions characteristic not of a free market, if such a thing exists, but of unconstrained cartels.) The invisible hand of Adam Smith is not a moral or rational agent, nor can it be an aesthetic agent. And it can never be a substitute for processes of mutual intelligibility and critical justification. Insofar as the first edition of *Ulysses* became the exemplary case for a substitution of exactly this sort, while simultaneously remaining an archetype of the modern encounter between difficult art and its public, its "success" served only to obscure the immense loss of faith in the integrity of the aesthetic that it entailed. The echoes of that success can still be heard today in arguments that museums should receive our support because they attract tourism, stimulate business, or expand the tax base, or that the National Endowment for the Arts should be encouraged on similar and equally dubious grounds.

Strangely, and yet appropriately, it was the person who first "initiated" Beach "into the mysteries of limited editions," Monnier, who alone among the original participants in the first edition of *Ulysses* came to perceive the immense tragedy that had occurred. Monnier was writing in 1938 and reflecting on the causes of what she now called "the scourge," the devastation that had followed when the fragile economy of patron-investors lay in ruins and the modernist experiment was past:

> I have said that the scourge was just and it is true that for several years, even the ones called the years of "prosperity," we all behaved ourselves rather badly. We made books objects of

speculation; we made or let be made a *stock exchange for* books. . . . Myself, did I not often propose books, saying that in a month the price would have at least doubled? And it was so easy to sell under those conditions. Now, repentance! Ah, it was well done![92]

Monnier's tone was perhaps unduly apocalyptic, derived from the religious vocabulary that so deeply appealed to her, but she was accurate in identifying characteristics that had helped shape the economy of literary modernism. It is a commonplace of cultural history that literary patronage gradually vanished in the eighteenth century due to changes in copyright laws, the spread of literacy, and the steady emergence of a popular market. Yet it is a fact that much of the literature that we now designate "modernist" was produced under the aegis of a revived patronage that flourished on a remarkable scale. For several reasons, however, the patronage of literary modernism was rarely the pure or disinterested support that we typically associate with patronage. The increasing penetration of capitalist relations into every facet of life, into the mind itself, meant that both writers and patrons were uneasy about an institution so clearly at odds with the work ethic, the meritocratic ethos that subtends market relations. As Robert Louis Stevenson had put it in 1881, he would agree to forgo writing popular fiction provided that someone "give me £1,000 . . . and at the same time effect such a change in my nature that I shall be content to take it from them instead of earning it."[93] John Quinn, to cite one example, quite plainly served as patron to Pound; yet he always arranged it so that Pound was receiving a salary for some editorial function, whether as foreign editor of the *Little Review* or correspondent and agent for the *Dial.* Patronage, as an essentially premodern form of social exchange, had to be disguised as something else if it were not to seem too at odds with the modern world.

One mask that it adopted was the concept of "investment." Patrons were not just giving away money in misguided sentimentalism about the arts, they were investing in something that would increase in value in the future. But for literature, the question remained: what *was* that something? In March 1922, only days after learning of the success that was greeting the first edition of *Ulysses*, Pound devised his Bel Esprit proposal to guarantee a healthy income to Eliot, "because the individual patron is nearly extinct." But although it was conceived as a replacement for patronage, Bel Esprit was not merely patronage in a new form, a point that Pound stressed to John Quinn:

> I can't come back too STRONGLY to the point that I do NOT consider this Eliot subsidy a pension. I am puke sick of the idea of pensions, taking care of old crocks.
>
> For me my £10 a year on Eliot is an investment. . . . I put this money into him as I would put it into a shoe factory if I wanted shoes. Better simile, into a shipping company, of say small pearl-fishing ships, some scheme where there was a great deal of risk but a chance of infinite profit.[94]

Yet the metaphor of investment was only partially applicable to literature: normally one's return on a successful investment results in an increase in one's own wealth or property; but because literary property remains the author's, investment could hardly characterize the process Pound wished to describe. To achieve more congruity between the metaphor of investment and the dilemmas posed by intellectual property, it was necessary to concretize the literary, to turn it into an object. Which is why the deluxe or limited edition acquired such prominence: it transformed literary property into a unique and fungible object, something that more nearly resembled a painting or an objet d'art, a "something" that could genuinely rise in value, at least on the collectors market.

Literary modernism constitutes a strange and perhaps unprecedented withdrawal from the public sphere of cultural production and debate, a retreat into a divided world of patronage, investment, and collecting. Uneasiness concerning the ethical legitimacy of patronage, corresponding efforts to assimilate patronage to concepts of investment and profit, and the concomitant attempt to objectify

literary value in the form of the rare book or deluxe edition—all these trace a profound change in the relations among authors, publishers, critics, and readerships. To a remarkable degree, modernist literature was an experiment in adopting exchange and market structures typical of the visual arts, a realm in which patronage and collecting can thrive because its artisanal mode of production is compatible with a limited submarket for luxury good. (Perhaps it is no accident that paintings repeatedly figure as metaphors for the literary work in this period, from *A Portrait of the Artist* to Lily Brisco's abstract portrait of Mrs. Ramsay in *To the Lighthouse*.) A submarket of this sort is extremely responsive to pressures from a small nucleus of patron-collectors: even a single figure or institution can alter its dynamics, as attested by the power of the Paul Getty Museum in the market for old masters. Modernism required not a mass of readers but just such a corps of patron-collectors, or patron-investors.

A famous photograph of Sylvia Beach and James Joyce, taken in mid-1922, shows them seated beneath a poster announcing "The Scandal of *Ulysses*," the title of a hostile review that appeared in the *Sporting Times*. Beach is seen turning toward Joyce, with the poster just above his head, while Joyce casts a distracted glance at some papers on the table. Their actions suggest Olympian indifference, evincing only contempt for the specter of mass culture lurking behind them. But as Harriet Shaw Weaver noted when she sent the placard to Beach in Paris: "I don't know how widely it figured in London. I should not have known of it had I not happened to go to the office of the paper."[95] The scandal of *Ulysses*, or at least of the first edition, did not consist in the philistine hostility of mass culture, as opposed to the discerning judgment of elite readers. The real scandal lay elsewhere, in that intangible yet perceptible social space where aesthetic value became confused with speculation, collecting, investment, and dealing, a space in which modernism and commodity culture were not implacable enemies but fraternal rivals.

Notes

1. Sylvia Beach, *Shakespeare and Company* (1956; reprint, Lincoln: University of Nebraska Press, 1980), 45–76, 84–98.

2. Noel Riley Fitch, *Sylvia Beach and The Lost Generation* (New York: W. W. Norton, 1983), 105.

3. Robert Bertholf, *"Ulysses" at Buffalo: A Centenary Exhibition* (Buffalo: State University of New York Press, 1982), n.p., s.v. "Case 2."

4. Melissa Banta and Oscar A. Silverman, eds., *James Joyce's Letters to Sylvia Beach: 1921–1940* (Bloomington: Indiana University Press, 1987), 211n.12.

5. Even so elegant a writer as Richard Ellmann must labor to instill a breath of life into so moribund a form: "André Gide brought in his subscription in person, Pound brought in the subscription of Yeats, Hemingway sent in his own enthusiastically. . . . Among those who replied [to the prospectus] were the son or nephew of Bela Kun, an Anglican bishop, a chief of the Irish revolutionary movement, and Winston Churchill." Ellmann, *James Joyce* (New York: Oxford University Press, 1982), 506.

6. "The Battle of *Ulysses*" is the title of the chapter that recounts the story of the first edition in Fitch, *Sylvia Beach*, 65–92; "heroic efforts" is from A. Walton Litz, "Foreword," in Banta and Silverman, eds., *James Joyce's Letters to Sylvia Beach*, viii; the other quotations are from Bertholf, "Introduction," *"Ulysses" at Buffalo*, [I].

7. Banta and Silverman, eds., *James Joyce's Letters to Sylvia Beach*, 4.

8. The principal accounts are Beach, *Shakespeare and Company*, 45–76, 84–98; Ellmann, *James Joyce*, 499–526; Fitch, *Sylvia Beach*, 65–92; and *DMW*, 167–220.

9. *DMW*, 173. The Complete Press had refused to print the "Telemachus" episode in March 1918; the firm then consented to print the "Nestor" episode for the *Egoist* issue dated January–February 1919, but insisted on cutting material from the "Proteus" episode for the issue of March–April 1919 and finally

refused to print any more. Weaver turned to the Pelican Press for subsequent issues, which contained parts of "Hades," "Scylla and Charybdis," and "Wandering Rocks," from July to December 1919. She then decided to close the *Egoist* as a serial. See *DMW*, 147, 155, 159, 163, 173–174.

10. John Rodker's nine publications in the *Little Review* were: "Night-Pieces," 4 (July 1917), 16–18; "Theatre Muet," 4 (August 1917), 12–15; "Incidents in the Life of a Poet," 4 (January 1918), 31–35; "Notes on Novelists," 5 (August 1918), 53–56; "Books," 5 (September 1918), 47–50; "List of Books," 5 (November 1918), 31–33; "'Exiles': A Discussion of James Joyces Play," 5 (January 1919), 20–22; "De Gourmont-Yank," 5 (March 1919), 29–32; and "A Barbarian," 6 (December 1919), 40–42.

11. Plans for the press were under way by 6 July 1919, when Ezra Pound wrote to John Quinn suggesting that "Joyce will perhaps have to be published by the Ovid Press. Thank God the press can at least publish the suppressed parts. It will mean a huge job for Rodker if he has to print the whole novel"; Pound, *SLPQ*, 177. Under the imprint of the Ovid Press, Rodker later issued three deluxe editions: Wyndham Lewis's portfolio *Fifteen Drawings* (January 1920), Eliot's *Am Vos Prec* (February 1920), and Pound's *Hugh Selwyn Mauberley* (June 1920), all in limited editions of 250, 264, and 250 copies, respectively. On the portfolio by Lewis, see Omar Pound and Philip Grover, *Wyndham Lewis: A Descriptive Bibliography* (Folkestone, Kent: William Dawson and Sons, 1978), 73–74; Bradford Morrow and Bernard Lafourcade, *A Bibliography of the Writings of Wyndham Lewis* (Santa Barbara, Calif: Black Sparrow Press, 1978), 38–39; and William Ransom, *Private Presses and Their Books* (New York: R. R. Bowker, 1929), 374. On the Eliot edition, see *TSEB*, 25–27; on the Pound edition, see *EPB*, 29–31. Rodker also reports, in his correspondence with Wallace Stevens, that he published an edition of his own poems. See Rodker to Stevens, 24 March 1920, Huntington Library, Wallace A. Stevens Collection, 1582.

12. Huntington Library, Stevens Collection, 1582.

13. James Joyce, *Letters of James Joyce*, vol. 3, ed. Richard Ellmann (New York: Viking Press, 1966), 12.

14. Rodker to Stevens, 28 July 1920, Huntington Library, Stevens Collection, 1583.

15. Joyce, *Letters of James Joyce*, vol. 3, 15; *DMW*, 174.

16. "Miss Weaver writes nobody will print it. So it will be printed, it seems, in Paris and bear Mr. John Rodker's imprint as English printer" (Joyce to Stanislaus Joyce, ibid., 17).

17. Rodker had still not seen the "Nausicaa" and "Oxen" episodes by 13 September 1920, when Joyce wrote to him in London, but at this point, the project for a complete edition of *Ulysses* may have changed into plans for a deluxe edition of only the "Nausicaa" and "Oxen" episodes, an edition that would be more manageable for Rodker and might earn money to tide Joyce over until a complete edition could be published in the future (see ibid., 21). Two weeks later, by 29 September, Rodker had finally read "Oxen" and written to Joyce in its praise. Joyce, in reply, promised to "speak . . . of your suggestion" to Huebsch, who was visiting Joyce in Paris (ibid., 23). The same day, after his meeting with Huebsch, Joyce wrote to Frank Budgen: "Huebsch my New York publisher is here. They say *Ulysses* will come out first in a private edition of 1000 copies at 150 frs each" (Joyce, *Letters of James Joyce,* vol. 1, ed. Stuart Gilbert [New York: Viking Press, 1957], 148). This is Joyce's first mention of the "private edition" discussed below, and it shows how easily the Rodker project was assimilated to the new plan.

18. For the events surrounding the case, I rely on Jackson R. Bryer, "Joyce, *Ulysses*, and the *Little Review*," *South Atlantic Quarterly* 66 (Spring 1967): 148–164; *MNY*, 441–457; and Ellmann, *James Joyce*, 502–504.

19. Quinn to Pound, 7 December 1920, BIUL, *PM.1:*

 I adjourned it to December 13th, and on December 13th it will, because of my legal engagements, be adjourned to January. In the meantime I will make a motion to have it taken away from Special Sessions, which means a trial by three judges with conviction certain, and have it transferred to General Sessions, which means (a) presentation to the Grand Jury, (b) indictment, (c) pleading, and (d) holding it for a trial before jury, which would hang it up for a year because it will then become a bail case and not a jail case, and jail cases are tried first. Meantime the book can be (a) finished by Joyce, (b) published by Huebsch, I hope, in a limited edition, (c) the entire edition sold, and then my interest in the matter will end and the Little Review can get some other lawyer and I will bow myself out.

20. Quinn cites these four books when discussing *Ulysses* in a letter to Pound, 12 December 1920, BIUL, *PM.1.*

21. For a cursory discussion of the so-called private editions and their adoption by Liveright, see Tom Dardis, *Firebrand: The Life of Horace Liveright* (New York: Random House, 1995) 156–158. For Quinn's reading of Huneker's manuscript, see *MNY*, 553.

22. Quinn to Pound, 1 May 1921, BIUL, *PM.1*:

 > Early in November a financial crash struck this country; prices dropped and a slow panic began. Enormous losses were made by banks and companies, firms and individuals; failure followed failure from unexpected quarters; men's nerves were drawn to the snapping point; hysteria and irritability and worry were common, and for the last five months, now nearly six months, I have been driven from morning to night and had to work evenings, Sundays and holidays, even Christmas day and New Year's day, all day and many nights. The strain has been dreadful at times. . . . I have only been able to go through with the work that crowded on me by sacrifice of all personal interests and the neglect of my personal affairs. . . . During that time I have gone nowhere, declined all invitations, have not been to the theatre and have not had a single complete day's rest or time for play. I have not answered any book or art letters or letters to personal friends.

23. Joyce, *Letters of James Joyce*, vol. 1, 165. The transcription that Joyce made from the article in the *New York Tribune*, which he sent to Harriet Shaw Weaver, is conserved in the Beinecke Library, Yale University, James Joyce Collection, Folder 325. The article itself, titled "Mr. Sumner's Glorious Victory," appeared in the *New York Tribune*, 22 February 1922, 10. Fitch assumes, as I do, that Joyce's reference to "a bookshop"—"I was given one day in a bookshop here a cutting which the owner had received by chance from New York"—in his letter to Weaver of 3 April 1921 means Shakespeare and Company. See Fitch, *Sylvia Beach*, 77.

24. Beach to Eleanor Orbison Beach, 1 April 1921, PUF, *BP*, Box 19, Folder 21. The letter is also quoted in A. Walton Litz, "Foreword," in Banta and Silverman, eds., *James Joyces Letters to Sylvia Beach*, viii, and in Fitch, *Sylvia Beach*, 78. Litz's and Fitch's transcriptions differ slightly; this one has been checked against the original.

25. Joyce, *Letters of James Joyce*, vol. 1, 162.

26. On Adrienne Monnier's "essentially religious" sense of vocation and her own writings articulating this, see Richard McDougall, ed. and trans., *The Very Rich Hours of Adrienne Monnier* (New York: Charles Scribner's Sons, 1976), 13. Beach's recollection is from *Shakespeare and Company*, 49.

27. The price of the private edition proposed by Quinn and Huebsch, two pounds, is mentioned in a letter from Joyce to Frank Budgen (Joyce, *Letters of James Joyce*, vol. 1, 144).

28. On Weaver's projected edition and the 150 subscribers, see *DMW*, 176; Weaver to Beach, 12 May 1921, PUF, *BP*, Box 232, Folder 2.

29. A list of Weaver's publications is given in *DMW*, 464–465. For the publications by Eliot, Joyce, and Pound, see *TSEB* and *EPB*.

30. Weaver to Beach, 21 April 1921, 27 April 1921, both PUF, *BP*, Box 232, Folder 2.

31. Weaver to Beach, 8 July 1921, PUF, *BP*, Box 232, Folder 2.

32. Beach to Holly Beach, 22 September 1921, 24 October 1921, both PUF, *BP*, Box 19, Folder 19.

33. See "Little Review in Court," *New York Times*, 15 February 1921, 4; "Greenwich Girl Editors in Court," *Chicago Herald Examiner*, 15 February 1921; "Improper Novel Costs Women $100," *New York Times*, 22 February 1921, 13; "Ulysses Finds Court Hostile as Neptune," *New York World*, 22 February 1921, 24; "'Ulysses' Adjudged 'Indecent'; Review Editors Are Fined," *New York Tribune*, 22 February 1921, 6; "Women Editors Fined for Obscene Article," *New York Daily News*, 22 February 1921, 3; "Greenwich Village Editoresses Fined: Literary Effusion in Their Review Is Cause," *New York Herald*, 22 February 1921, 8; "Taste, Nor Morals Violated," *New York Times*, 23 February 1921, 12; "Mr. Sumner's Glorious Victory," *New York Tribune*, 23 February 1921, 10; and "Suppressing an Unread Book," *New York World*, 23 February 1921, 10. Robert Deming claims that "Joyce's reputation among men of letters was greatly increased by the suppression of the *Little Review* for publishing *Ulysses*," in Robert Deming, ed., *James Joyce: The Critical Heritage* (London: Routledge and Kegan Paul, 1970), vol. 1, 17–18.

34. Beach to Holly Beach, 23 April 1921, PUF, *BP*, Box 19, Folder 2b.

35. Beach to Holly Beach, 14 May 1921, PUF, *BP*, Box 19, Folder 2b.

36. [Rosemary Carr], "Literary Adventurer. American Girl Conducts Novel Bookstore Here," *Chicago Tribune*, 28 May 1921, Paris edition, 3.

37. All circulation figures, except for the 1915 data, are from David Ayerst, *Garvin of the Observer* (London: Croom Helm, 1985), 70, 128, and 229. The 1915 data are taken from David Griffiths, ed., *Encyclopaedia of the British Press* (London: Macmillan, 1992), 444. "The Victorian Sabbath" is from Ayerst, *Garvin of the Observer*, 70.

38. [Sisley Huddleston], "Paris Week by Week," *Observer*, 17 April 1921. The essay is attributed to Huddleston by Beach in a letter to Holly Beach, 23 April 1921, PUF, *BP*, Box 19, Folder 2b: "I'm sending [you] a copy of the London Observer with a word by Sisley Huddleston on Ulysses."

39. Beach, *Shakespeare and Company*, 45–48; Banta and Silverman, eds., *James Joyces Letters to Sylvia Beach*, viii.

40. Weaver to Beach, 12 May 1921, PUF, *BP*, Box 232, Folder 2.

41. Weaver to Beach, 24 May 1921, PUF, *BP*, Box 232, Folder 2.

42. Weaver to Beach, 19 July 1921, PUF, *BP*, Box 232, Folder 2.

43. Oddly, Beach did not inform Weaver of her change in policy, and Weaver did not learn about it until March 1922. See Weaver to Beach, 10 March 1922, PUF, *BP*, Box 133, Folder 6.

44. William Jackson's orders are in PUF, *BP*, Box 132, Folder 12.

45. Beach's sales records for *Ulysses* form an immense and extremely complex body of documentation, because each transaction typically required numerous letters between Beach and a buyer: (1) a buyer would write to Beach and inquire about the edition's cost; (2) Beach would reply by sending off a prospectus that described the edition and included an order blank; (3) buyers then returned the order blank, indicating which issue they preferred; (4) Beach then sent off a postcard advising the buyer that his or her copy was ready and would be shipped upon receipt of remittance; (5) buyers sent in their payment, often with letters speculating about the appropriate rate of exchange if they were not residing in Paris; (6) Beach at last sent off the copy. Beach tried to register the transaction's status at every point in the ongoing exchange and, though imperfectly maintained, her elaborate system provided so many points of cross-reference that she could almost always pinpoint an order's status, even if she had to check in several different places. Most of the correspondence and the order forms are now housed in PUF, *BP*, Boxes 132–133, but a small group of order forms (fifty-seven of them) are at the State University of New York at Buffalo, Capen Library, Poetry Collection, Sylvia Beach Papers, folder "Ulysses Subscriptions, 1st Edition." In addition to these materials, Beach kept four different record books (now located in PUF, *BP*, Box 63). One contains preliminary records of all orders up to around January 1922. Around that date, Beach created the other three record books, organized by geography or by the location where the book would have to be sent (the United States, the United Kingdom, and France and the Continent). Here Beach was careful to record payments, for she had no intention of shipping copies that had not been paid for. Finally, Beach also kept the "Calepin de vente d'*Ulysses*," a running record of the first edition's sales, which she gave to Maurice Saillet, upon whose death in 1992 it was acquired by the Harry Ransom Center for Research in the Humanities, University of Texas, Austin, where it is among the Carlton Lake Collection. In the "Calepin de vente" Beach kept two more lists: one that recorded each sale when it was finally completed and a copy was sent off, in chronological order; and another that registered the name of the buyer and the copy number the buyer received, from 1 to 1,000. The list registering the names of the buyers has been published in *James Joyce: Books and Manuscripts* (New York: Glenn Horowitz Bookseller, 1996), 113–134. In short, I have collated the materials at Princeton, Buffalo, and Austin, and the foregoing remarks on sales derive from these collations.

46. Huddleston, "Ulysses," *Observer*, 5 March 1922; reprinted in Huddleston, *Articles de Paris* (London: Methuen, 1928), 40–47; also reprinted in Deming, ed., *James Joyce*, vol. 1, 213–216.

47. Pound to Homer Pound, 10 March 1922, NHYB, *PP*, Box 52, Folder 1967.

48. R. C. Armilt to James Joyce, PUF, *BP*, Box 133, Folder 2. An anonymous letter to Joyce, dated 7 March 1922 (in the same folder), reads: "I have seen a long review of your Ulysses in The Observer. Would it be possible for me to get a copy of the book by subscription. If the book is not too expensive."

49. The franc had fluctuated between 10.715 (20 April) and 12.06 to the dollar (26 June), a range of only 1.35 francs. Exchange rates for the franc and the dollar on the Paris Bourse are from Eleanor Lansing Dulles, *The French Franc, 1914–1928: The Facts and Their Interpretation* (New York: Macmillan Publishers, 1929), 463. Figures for the New York Stock Exchange are taken from the *New York Times*, 2 February 1922, 24, and 1 July 1922, 19. Figures for the London exchange are from the *Times* (London), 2 February 1922, 15, and 1 July 1922, 17.

50. Morrill Cody, *The Women of Montparnasse* (Ctanbury, N. J.: Cornwall Books, 1984), 8–9.

51. Pound to John Quinn, 19 December 1921, NYPL, *QP*; the letter is omitted in *SLPQ*.

52. Pound's regular income came from the *Dial*, which paid him fifty dollars for his "Paris Letter" every other month; see *Dial Papers*, Beinecke Library, Yale University, Payment Records. Dorothy Pound's income is

reported in Pound to Quinn, 4–5 July 1921, NYPL, *QP*, which is transcribed in *SLPQ*, 209–214, especially 210. In the same letter, Pound recalls his difficulties in the winter of 1921–1922, telling Quinn, "and you know how damn near a squeak I have had more than once, and even so recently as last winter" (211). He had requested that Quinn loan him $250 on 22 October 1921; see *MNY*, 492.

53. Arthur L. Bowley and Josiah Stamp, *The National Income, 1924* (Oxford: Oxford University Press, 1927), 30. The figure for income from wages per house presumes that more than one household member was at work.

54. Barbara Reynolds, *Dorothy L. Sayers: A Biography* (1993; New York: St. Martin's Griffin, 1997), 106. One might add that Inspector Parker, a fictional bachelor who aids Lord Peter Wimsey in Sayers's 1923 mystery *Whose Body?* pays one pound a week for "a Georgian but inconvenient flat at No. 12A Great Ormond Street" (Dorothy L. Sayers, *Whose Body?* [New York: Harper & Row, 1987], 54).

55. Martha Colin Cooper, "Frank Crowninshield and *Vanity Fair*" (Ph.D. diss., University of North Carolina at Chapel Hill, 1976), 48.

56. See Roger Fry, "Art and Socialism," in his *Vision and Design*, ed. J. Bullen (Oxford: Oxford University Press, 1981), 39–54, especially his discussion on 43. On the organization of die Brücke, see Jill Lloyd, *German Expressionism: Primitivism and Modernity* (New Haven: Yale University Press, 1991), 16–18. For other discussions of the question by contemporaries, see A. Halbe, "Gedanken und Vorschlage zur Durchführung einer wirtschaftlichen Organisation der Kunstlerschaft," *Werkstatt der Kunst* 38 (1913): 523–525, and in the English context, see the unsigned essay "The Angels Club," *New Freewoman*, 1 October 1913. The essay is ascribed to Pound by *DMW*, 98, but her attribution has not been accepted by others. For Pound's own views, see his interview with John Cournos, "Bad Poetry Due to Lack of Money. Ezra Pound, Idaho Singer, Calls for Subsidies, and a Wandering Minstrelsy Life," *Boston Evening Transcript*, 6 September 1913, sec. 3, 6, cols. 3–5.

57. Useful overviews of the Bel Esprit project are given by Humphrey Carpenter, *A Serious Character: The life of Ezra Pound* (Boston: Houghton Mifflin, 1988), 409–412, and *SLPQ*, 8–10. All quotations are from Pound, "Paris Letter," *Dial* 73 (November 1922): 549–554, reprinted in *EPPP*, 4:261.

58. Beach's records of her transactions with the Sunwise Turn are in PUF, *BP*, Box 132, Folder 2, and Box 133, Folder 3.

59. The principal sources for the history of the Sunwise Turn are Madge Jenison, *The Sunwise Turn: A Human Comedy of Bookselling* (New York: E. P. Dutton, 1923); Harold Loeb, *The Way It Was* (New York: Criterion Books, 1959), especially chapters 2 and 3; and "Obituary Notes: Madge Jenison," *Publisher's Weekly* 178 (4 July i960): 167–168.

60. Jenison, *The Sunwise Turn*, 19.

61. "Oxen of the Sun" opens with a triple invocation for luck and fertility, beginning with this Gaelic word: "Deshil Holies Eamus. Deshil Holies Eamus. Deshil Holies Eamus" (Joyce, *Ulysses*, ed. Hans Walter Gabler et al. [New York and London: Garland Publishing, 1984], episode 14, line 1). Don Gifford, with Robert J. Seidman, writes, "'Deshil' after the Irish *deasil, deisiol*: turning to the right, clockwise, sunwise; a ritual gesture to attract good fortune, and an act of consecration when repeated three times" *("Ulysses" Annotated: Notes for James Joyces "Ulysses,"* rev. ed. [Berkeley: University of California Press, 1988], 408).

62. Jenison, *The Sunwise Turn*, 19–20.

63. "We were to conduct," ibid., 19; "a burning orange," ibid., 17, 24; "beautiful pieces," ibid., 21.

64. "We would be safe," ibid., 8; "How few people there are," ibid., 8–9 (emphasis added).

65. Ibid., 158.

66. Rodker advised Stevens that the owners of the Sunwise Turn "are good customers . . . and they are interested in what I am doing" (Rodker to Stevens, 24 March 1920, Huntington Library, Stevens Collection, 1582). Loeb recounts his journey to London and Dublin for the purpose "of replenishing our stock of rarities," especially signed first editions, in *The Way It Was*, 41.

67. Jenison, *The Sunwise Turn*, 84–85.

68. Sales figures, ibid., 35; new location, ibid., 139–140; space more than double, Loeb, *The Way It Was*, 34; foot traffic triple, Jenison, *The Sunwise Turn*, 140; volumes issued, Loeb, *The Way it Was*, 34–35.

69. Jenison, *The Sunwise Turn*, 46.

70. Loeb, *The Was It Was*, 36.

71. Joyce, *Letters of James Joyce*, vol. 1, 144.

72. Loeb, *The Way It Was*, 52–53.

73. Knopf "used to come ocasionally and buy royally," Jenison, *The Sunwise Turn*, 53. Alfred Knopf's collection is preserved in its entirety at the University of Texas at Austin, Harry Ransom Humanities Research Center, and his copy of *Ulysses* (numbered 454) is part of the Alfred Knopf Collection. But Beach's record books show that he purchased two copies, the second of which is not identified. See PUF, *BP*, Box 63, Record Books: record book entitled "United States," s.v. "K." Also at the back of this volume, see two loose-leaf pages labeled "PAID USA," which record that Knopf had paid 240 francs, or the price of two copies (at a 20 percent discount for "members of the trade"). See also the record book entitled "England, Ireland, Scotland," with a loose-leaf page labeled "Copies to be Sent to U.S.A.," which also shows that Knopf purchased 2 copies.

74. "Stopped about eight," Jenison, *The Sunwise Turn*, 111. Huebsch purchases: PUF, *BP*, Box 63, Record Book: "United Kingdom." See the loose-leaf page labeled "Send to Braver-man," which records that three copies of the 150-franc edition were to be sent to Huebsch. Also in the Box 63 record book entitled "U.S.A." is a notation that three copies were to be sent to Huebsch and that his payment by check was received on 28 February. The untitled record book in Box 63 shows that Huebsch had earlier been "notified" that his copies were ready. Huebsch's name is recorded in the day-to-day sales list of the daybook in the University of Texas collection, though not in the copy-by-copy list, which makes it impossible to identify which copies he received.

75. Loeb records his first meeting with Leon Fleischmann in *The Way It Was*, 42. Fleischmann's order form is in the PUF, *BP* Box 132, Folder 7, and it indicates that he was living at 38, rue de Penthievre, Paris; in the Record Book entitled "France" (Box 63), Fleischmann is reported to have "paid Feb. 8" and to have received copy number 254. His purchase is also recorded in the "Calepin de vente" at the University of Texas.

76. Mary Mowbray Clarke to Beach, undated letter accompanying a check dated 8 February 1922, PUF, *BP* Box 133, Folder 3.

77. See Shane Leslie, "Ulysses," *Quarterly Review* 238 (October 1922), 219–234; partially reprinted in Deming, ed., *James Joyce*, vol. 1, 206, 210.

78. See "A New Ulysses," *Evening News* (London), 8 April 1922, 4; reprinted in Deming, ed., *James Joyce*, vol. 1, 193.

79. "Domini Canis" [Shane Leslie], "Ulysses," *Dublin Review* 171 (September 1922), 112; reprinted in Deming, ed., *James Joyce*, vol. 1, 201.

80. John Quinn to Beach, 27 March 1922, Capen Library, Poetry Collection, Beach Papers, Folder "Ulysses Subscriptions, 1st Edition."

81. "'Ulysses' is sold out" (Beach to Harriet Shaw Weaver, 18 June 1922, British Library, Harriet Shaw Weaver Papers).

82. "But Adrienne Monnier ('La Maison des Amis des Livres,' 7, rue de l'Odéon) took over a number [of copies] and is beginning to sell them at Fr 500 (edition at Fr 150)" (Beach to Weaver, 26 June 1922, British Library, Harriet Shaw Weaver Papers).

83. On the early August price, see Mitchell Kennerley to Beach, 4 August 1922, PUF, *BR* Box 132, Folder 5; the London price on 12 August is in Kennedy to Quinn, reported in *MNY*, 533.

84. Joyce, *Letters of James Joyce*, vol. 1, 190.

85. Weaver to Beach, 17 March 1922, PUF, *BR* Box 232, Folder 3.

86. Pound to Alice Corbin Henderson, 12 March 1922, in Ira B. Nadel, ed., *The Letters of Ezra Pound to Alice Corbin Henderson* (Austin: University of Texas Press, 1993), 224.

87. Weaver to Beach, 20 May 1922, PUF, *BR* Box 232, Folder 3. Weaver urges this still more insistently in another letter, on 16 June 1922, held in the same location. Five weeks later, Beach replied: "I did not hold back any copies for speculation for fear that the public might misinterpret it. But Adrienne Monnier ('La Maison des Amis des Livres,' 7, rue de l'Odéon) took over a number [of copies] and is beginning to sell them at Fr 500 (edition at Fr 150) and will give the proceeds to Mr. Joyce. Perhaps you will give that address to people who inquire where they can obtain 'Ulysses.' I always tell them that Adrienne Monnier among other booksellers subscribed for a good many copies and might have some left" (Beach to Weaver, 26 June 1922, British Library, Harriet Shaw Weaver Papers).

88. Beach, *Shakespeare and Company*, 183.

89. Pound to Homer and Isabel Pound, 11 May 1921, NHYB, *PR* Box 52, Folder 1966.

90. George Rehm, "Review of *Ulysses*," *Chicago Tribune*, 13 February 1922, Paris edition, 2; reprinted in Deming, ed., James Joyce, vol. 1, 213.

91. Diana Crane, *The Transformations of the Avant-Garde: The New York Art World, 1940–1985* (Chicago: University of Chicago Press, 1987), 112.

92. Monnier in McDougall, ed. and trans., *The Very Rich Hours of Adrienne Monnier*, 141.

93. Robert Louis Stevenson, quoted in Jenni Calder, *Robert Louis Stevenson: A Life Study* (Oxford: Oxford University Press, 1980), 172.

94. Pound to Quinn, 4–5 July 1922, in *SLPQ*, 213.

95. Weaver to Beach, 11 April 1922, PUF, *BR* Box 232, Folder 3.

CHAPTER 6

THE MASS PRODUCTION OF THE SENSES

CLASSICAL CINEMA AS VERNACULAR MODERNISM

Miriam Bratu Hansen *

In the late 1990s, the burgeoning New Modernist Studies built its revision of early twentieth-century cultural studies around feminist studies, book history, media theory, African American historiography, postcolonial studies, and more. One of its most essential intellectual influences, however, emerged from a group of loosely affiliated thinkers from the 1930s known as the Frankfurt School. This included cultural critics like Walter Benjamin, Siegfried Kracauer, and Theodor Adorno who crafted powerful meditations from within the modernity they saw growing up around them. Although they disagreed (often intensely) on the value of mass culture, they nevertheless shared an interest in the intersection of art and technology as a site of potential human liberation.

Their focus on critical social thought provided a dense, sometimes elliptical language that sought to connect the fledgling study of film to more traditional media like literature and music, all of which they subsumed under the larger category of mass modernity. Miriam Bratu Hansen played a key role in interpreting the work of these early Frankfurt School thinkers for a new generation of largely English-speaking scholars who were looking for ways to rethink modernism. She had studied with Adorno in Frankfurt and drew on his ideas to critique the formalism of French and American film. After publishing a landmark study titled *Babel and Babylon: Spectatorship in American Silent Film* (1991), she went on to found and direct the influential Department of Cinema and Media Studies at the University of Chicago.

In "The Mass Production of the Senses," Hansen lays the foundation for a new approach to film that connects it directly to the radical expansiveness of the New Modernist Studies. Modernism, she contends, is not a specific set of formal experiments in the arts, but instead a broad array of cultural and aesthetic responses to the rise of a modernity now defined and interpreted through mass culture. She then makes the case for what she influentially calls a "vernacular modernism," one that took shape not simply in Eliot's poetry or on Picasso's canvases, but rather in a "whole range of cultural and artistic practices that register, respond to, and reflect upon processes of modernization and the experience of modernity, including a paradigmatic transformation of the conditions under which art is produced, transmitted, and consumed." Like Rita Felski, she believes that the same contradictions and contours of emotion can be found in an experimental poem *and* the cut of a dress. For Hansen, the most expressive and influential of these vernacular forms was classical Hollywood cinema: those films that emerged from the American studio system and circulated to venues around the world. They provided, she argues, "a powerful matrix for modernity's liberatory impulses— its moments of abundance, play, and radical possibility, its glimpses of collectivity and gender

`From *Modernism/modernity*, v. 6, no. 2, pp. 59–77. Johns Hopkins University Press, ©1999. Reproduced here with permission.

equality." These are particularly evident, she contends, in its plots, characters, and even modes of distribution. Hollywood cinema offered the world a look at the first mass cultural society, which then used the new technology of film to examine itself. With its melodramatic plots, fast-talking women, and romantic conventions, this tradition, Hansen finds, voices the same utopian desires that earlier critics like Benjamin had identified in department stores and mass spectacles.

The Frankfurt School approach Hansen so artfully deploys in this essay became a model for other scholars also trying to think across modernity's many media forms and thus to break away from the glorious isolation of the old formalisms. Where Clement Greenberg and Hugh Kenner had once defined modernism as the deep exploration of a single medium like paint or language, Hansen now opened up a path toward comparison and synthesis. The influence of her work is everywhere evident in the New Modernist Studies and vividly on display in the next generation of media critics like Goble and Pressman, whose work appears later in this collection.

In this essay, I wish to reassess the juncture of cinema and modernism, and I will do so by moving from the example of early Soviet cinema to a seemingly less likely case, that of the classical Hollywood film. My inquiry is inspired by two complementary sets of questions: one pertaining to what cinema studies can contribute to our understanding of modernism and modernity; the other aimed at whether and how the perspective of modernist aesthetics may help us to elucidate and reframe the history and theory of cinema. The juncture of cinema and modernism has been explored in a number of ways, ranging from research on early cinema's interrelations with the industrial-technological modernity of the late nineteenth century, through an emphasis on the international art cinemas of both interwar and new wave periods, to speculations on the cinema's implication in the distinction between the modern and the postmodern.[1] My focus here will be more squarely on mid-twentieth-century modernity, roughly from the 1920s through the 1950s—the modernity of mass production, mass consumption, and mass annihilation—and the contemporaneity of a particular kind of cinema, mainstream Hollywood, with what has variously been labelled "high" or "hegemonic modernism."

Whether or not one agrees with the postmodernist challenge to modernism and modernity at large, it did open up a space for understanding modernism as a much wider, more diverse phenomenon, eluding any single-logic genealogy that runs, say, from Cubism to Abstract Expressionism, from T. S. Eliot, Ezra Pound, James Joyce, and Franz Kafka to Samuel Beckett and Alain Robbe-Grillet, from Arnold Schönberg to Karlheinz Stockhausen. For more than a decade now scholars have been dislodging that genealogy and delineating alternative forms of modernism, both in the West and in other parts of the world, that vary according to their social and geopolitical locations, often configured along the axis of post/coloniality, and according to the specific subcultural and indigenous traditions to which they responded.[2] In addition to opening up the modernist canon, these studies assume a notion of modernism that is "more than a repertory of artistic styles," more than sets of ideas pursued by groups of artists and intellectuals.[3] Rather, modernism encompasses a whole range of cultural and artistic practices that register, respond to, and reflect upon processes of modernization and the experience of modernity, including a paradigmatic transformation of the conditions under which art is produced, transmitted, and consumed. In other words, just as modernist aesthetics are not reducible to the category of style, they tend to blur the boundaries of the institution of art in its traditional, eighteenth- and nineteenth-century incarnation that turns on the ideal of aesthetic autonomy and the distinction of "high" vs. "low," of autonomous art vs. popular and mass culture.[4]

Focusing on the nexus between modernism and modernity, then, also implies a wider notion of the aesthetic, one that situates artistic practices within a larger history and economy of sensory perception that Walter Benjamin for one saw as the decisive battleground for the meaning and fate of modernity.[5] While the spread of urban-industrial technology, the large-scale disembedding of social (and gender) relations, and the shift to mass consumption entailed processes of real destruction and loss, there also emerged new modes of organizing vision and sensory perception, a new relationship with "things," different forms of mimetic experience and expression, of affectivity, temporality, and reflexivity, a changing fabric of everyday life, sociability, and leisure. From this perspective, I take the study of modernist aesthetics to encompass cultural practices that both articulated and mediated the experience of modernity, such as the mass-produced and mass-consumed phenomena of fashion, design, advertising, architecture and urban environment, of photography, radio, and cinema. I am referring to this kind of modernism as "vernacular" (and avoiding the ideologically overdetermined term "popular") because the term vernacular combines the dimension of the quotidian, of everyday usage, with connotations of discourse, idiom, and dialect, with circulation, promiscuity, and translatability. In the latter sense, finally, this essay will also address the vexed issue of Americanism, the question of why and how an aesthetic idiom developed in one country could achieve transnational and global currency, and how this account might add to and modify our understanding of classical cinema.

I begin with an example that takes us back to one standard paradigm of twentieth-century modernism: Soviet cinema and the context of Soviet avant-garde aesthetics. At the 1996 festival of silent film in Pordenone, the featured program was a selection of early Soviet films made between 1918–1924, that is, before the great era of montage cinema, before the canonical works of Sergei Eisenstein, V. I. Pudovkin, Dziga Vertov, and Alexandr Dovzhenko. The question that guided the viewing of these films was, of course, how Russian cinema got from the Old to the New within a rather short span of time; how the sophisticated mise-en-scene cinema of the Czarist era, epitomized by the work of Yevgenij Bauer, was displaced by Soviet montage aesthetics. Many of the films shown confirmed what film historians, following Lev Kuleshov, had vaguely assumed before: that this transformation was mediated, to a significant degree, by the impact of Hollywood. American films began to dominate Russian screens as early as 1915 and by 1916 had become the main foreign import. Films made during the years following 1917, even as they stage revolutionary plots for "agit" purposes, may display interesting thematic continuities with Czarist cinema (in particular a strong critique of patriarchy) and still contain amazing compositions in depth.[6] Increasingly, however, the mise-en-scene is broken down according to classical American principles of continuity editing, spatio-temporal coherence, and narrative causality. A famous case in point is Kuleshov's 1918 directorial debut, *Engineer Prait's Project*, a film that employed Hollywood-style continuity guidelines in a polemical break with the slow pace of Russian "quality pictures."[7] But the "American accent" in Soviet film—a faster cutting rate, closer framing, and the breakdown of diegetic space—was more pervasive and can be found as well, in varying degrees of consistency, in the work of other directors (Vladimir Gardin, Ceslav Sabinskij, Ivan Perestiani). Hyperbolically speaking, one might say that Russian cinema became Soviet cinema by going through a process of Americanization.

To be sure, Soviet montage aesthetics did not emerge full blown from the encounter with Hollywood-style continuity editing; it is unthinkable without the new avant-garde movements in art and theater, without Constructivism, Suprematism, Productivism, Futurism—unthinkable without a politics of radical transformation. Nor was continuity editing perceived as neutral, as simply the most "efficient" way of telling a story. It was part and parcel of the complex of "Americanism" (or, as Kuleshov referred to it, "Americanitis") that catalyzed debates on modernity and modernist movements in Russia as it did in other countries.[8] As elsewhere, the enthusiasm for things American, tempered by a critique of capitalism, took on a variety of meanings, forms, and functions. Discussing the impact of American on Soviet cinema, Yuri Tsivian distinguishes

between two kinds of Americanism: one, stylistic borrowings of the classical kind described above ("American montage," "American foreground"), and two, a fascination with the "lower genres," with adventure serials, detective thrillers, and slapstick comedies that, Tsivian argues, were actually more influential during the transitional years. If the former kind of Americanism aspired to formal standards of narrative efficiency, coherence, and motivation, the latter was concerned with external appearance, the sensual, material surface of American films; their use of exterior locations; their focus on action and thrills, physical stunts and attractions; their tempo, directness, and flatness; their eccentricity and excess of situations over plot.[9]

Tsivian analyzes the Americanism of the "lower" genres as an intellectual fashion or taste. Discerning "something of a slumming mentality" in Eisenstein's or FEKS' fascination with "serial queen" melodramas, he situates the preference of Soviet filmmakers for "cinematic pulp fiction" (Victor Shklovsky) in the context of the leftist avant-garde's attack on high art, cultural pretensions, and western ideals of naturalism ("BON," 43).[10] What interests me in this account is less the intellectual and artistic intertext than the connection it suggests, *across* the distinction, between the two faces of American cinema: the classical norm, as an emergent form that was to dominate domestic as well as foreign markets for decades to come, and the seemingly nonclassical, or less classical, undercurrent of genres that thrive on something other than or, at the very least, oblique to the classical norm. What also interests me in the dynamics of Americanism and Soviet film is the way they urge us to reconsider the relationship between classical cinema and modernism, a relationship that within cinema studies has habitually been thought of as an opposition, as one of fundamentally incompatible registers.

The opposition between classicism and modernism has a venerable history in literature, art, and philosophy, with classicism linked to the model of tradition and modernism to the rhetoric of a break with precisely that tradition.[11] In that general sense, there would be no problem with importing this opposition into the field of cinema and film history, with classical cinema falling on the side of tradition and alternative film practices on the side of modernism. If, however, we consider the cinema as part of the historical formation of modernity, as a larger set of cultural and aesthetic, technological, economic, social, and political transformations, the opposition of classical cinema and modernism, the latter understood as a discourse articulating and responding to modernity, becomes a more complicated issue.

I am using "classical cinema" here as a technical term that has played a crucial part in the formation of cinema studies as an academic discipline. The term came to serve as a foundational concept in the analysis of the dominant form of narrative cinema, epitomized by Hollywood during the studio era. In that endeavor, "classical cinema" referred to roughly the same thing whether you were doing semiotics, psychoanalytic film theory, neoformalist poetics, or revisionist film history. This is not to say that it *meant* the same thing, and just a brief glimpse at its key moments will illustrate the transvaluations and disjunctures of the term.

Not coincidentally, the reference to Hollywood products as "classical" has a French pedigree. As early as 1926, Jean Renoir uses the phrase "cinematic classicism" (in this case referring to Charlie Chaplin and Ernst Lubitsch).[12] A more specific usage of the term occurs in Robert Brasillach and Maurice Bardèche's *Histoire de cinéma*, in particular in the second edition of 1943, revised with a collaborationist bent, where the authors refer to the style evolved in American sound film of 1933-1939 as the "classicism of the 'talkie.'"[13] After the Occupation, critics, notably André Bazin, began to speak of Hollywood filmmaking as "a classical art." By the 1950s, Bazin would celebrate John Ford's *Stagecoach* (1939) as "the ideal example of the maturity of a style brought to classic perfection," comparing the film to "a wheel, so perfectly made that it remains in equilibrium on its axis in any position."[14] This classical quality of American film, to quote Bazin's well-known statement, is due not to individual talent but to "the genius of the system, the richness of its ever-vigorous tradition, and its fertility when it comes into contact with new elements."[15]

The first major transvaluation of the concept of classical cinema came with post-1968 film theory, in the all-round critique of ideology directed against the very system celebrated by Bazin. In this critique, formulated along Althusserian and Lacanian lines and from marxist and later feminist positions, classical Hollywood cinema was analyzed as a mode of representation that masks the process and fact of production, turns discourse into diegesis, history into story and myth; as an apparatus that sutures the subject in an illusory coherence and identity; and as a system of stylistic strategies that weld pleasure and meaning to reproduce dominant social and sexual hierarchies.[16] The notion of classical cinema elaborated in the pages of *Cahiers du Cinéma, Cinéthique, Screen, Camera Obscura* and elsewhere was less indebted to a neoclassicist ideal, as it still was for Bazin and Rohmer, than to the writings of Roland Barthes, in particular *S/Z* (1970), which attached the label of a "classic," "readerly," ostensibly transparent text to the nineteenth-century realist novel.[17]

Another turn in the conception of classical cinema entails the rejection of any evaluative usage of the term, whether celebratory or critical, in favor of a more descriptive, presumably value-free and scientifically valid account. This project has found its most comprehensive realization to date in David Bordwell, Janet Staiger, and Kristin Thompson's monumental and impressive study, *The Classical Hollywood Cinema: Film Style and Mode of Production to 1960* (1985). The authors conceive of classical cinema as an integral, coherent system, a system that interrelates a specific mode of production (based on Fordist principles of industrial organization) and a set of interdependent stylistic norms that were elaborated by 1917 and remained more or less in place until about 1960. The underlying notion of classical film style, rooted in neoformalist poetics and cognitive psychology, overlaps in part with the account of the classical paradigm in 1970s film theory, particularly with regard to principles of narrative dominance, linear and unobtrusive narration centering on the psychology and agency of individual characters, and continuity editing. But where psychoanalytic-semiotic theorists pinpoint unconscious mechanisms of identification and the ideological effects of "realism," Bordwell and Thompson stress thorough motivation and coherence of causality, space, and time; clarity and redundancy in guiding the viewer's mental operations; formal patterns of repetition and variation, rhyming, balance, and symmetry; and overall compositional unity and closure.[18] In Bordwell's formulation, "the principles which Hollywood claims as its own rely on notions of decorum, proportion, formal harmony, respect for tradition, mimesis, self-effacing craftsmanship, and cool control of the perceiver's response—canons which critics in any medium usually call 'classical'" (*CHC*, 3–4).

Such a definition is not just generally "classical" but more specifically recalls neoclassicist standards, from seventeenth-century neo-Aristotelian theories of drama to eighteenth-century ideals in music, architecture, and aesthetic theory.[19] (I do not wish to equate eighteenth-century aesthetics at large with the neoclassicist tradition, nor with an ahistorical reduction to neoformalist principles; the eighteenth century was at least as much concerned with affect and effect, with theatricality and sensation, passion and sentiment, as with the balance of form and function.) As in literary and aesthetic antecedents that invoke classical antiquity as a model—recall Stendhal's definition of classicism as a style that "gives the greatest possible pleasure to an audience's ancestors"[20]—the temporal dynamics of the term classical as applied to the cinema is retrospective; the emphasis is on tradition and continuity rather than newness as difference, disruption, and change.

I can see a certain revisionist pleasure in asserting the power and persistence of classical standards in the face of a popular image of Hollywood as anything but decorous, harmonious, traditional, and cool. But how does this help us account for the appeal of films as diverse as *Lonesome, Liberty, Freaks, Gold Diggers of 1933, Stella Dallas, Fallen Angel, Kiss Me Deadly, Bigger Than Life, Rock-a-Bye Baby* (add your own examples)? And even if we succeeded in showing these films to be constructed on classical principles—which I'm sure can be done—what have we demonstrated? To repeat Rick Altman's question in an essay that challenges Bordwell, Thompson, and Staiger's model: "How

classical was classical narrative?"[21] Attempts to answer that rhetorical question have focused on what is left out, marginalized or repressed, in the totalizing account of classical cinema—in particular, the strong substratum of theatrical melodrama with its uses of spectacle and coincidence but also genres like comedy, horror, and pornography that involve the viewer's body and sensory-affective responses in ways that may not exactly conform to classical ideals.[22] Also minimized is the role of genre in general, specifically the affective-aesthetic division of labor among genres in structuring the consumption of Hollywood films. An even lesser role is granted to stars and stardom, which cannot be reduced to the narrative function of character and, like genre but even more so, involve the spheres of distribution, exhibition practices, and reception. *The Classical Hollywood Cinema* explicitly and, it should be said, with self-imposed consistency, brackets the history of reception and film culture—along with the cinema's interrelations with American culture at large.

It is not my intention to contest the achievement of Bordwell, Staiger, and Thompson's work; the book does illuminate crucial aspects of how Hollywood cinema works and goes a long way toward accounting for the stability and persistence of this particular cultural form. My interest is rather in two questions that the book does *not* address, or addresses only to close off. One question pertains to the historicity of classical cinema, in particular its contemporaneity with twentieth-century modernisms and modern culture; the other question is to what extent and how the concept can be used to account for Hollywood's worldwide hegemony. To begin with, I am interested in the anachronism involved in asserting the priority of stylistic principles modelled on seventeenth- and eighteenth-century neoclassicism. We are dealing with a cultural formation that was, after all, perceived as the incarnation of *the modern*, an aesthetic medium up-to-date with Fordist-Taylorist methods of industrial production and mass consumption, with drastic changes in social, sexual, and gender relations, in the material fabric of everyday life, in the organization of sensory perception and experience. For contemporaries, Hollywood at its presumably most classical figured as the very symbol of contemporaneity, the present, modern times: "this our period," as Gertrude Stein famously put it, "was undoubtedly the period of the cinema and series production."[23] And it held that appeal not only for avant-garde artists and intellectuals in the United States and the modernizing capitals of the world (Berlin, Paris, Moscow, Shanghai, Tokyo, Sao Paulo, Sydney, Bombay) but also for emerging mass publics both at home and abroad. Whatever the economic and ideological conditions of its hegemony—and I wish by no means to discount them—classical Hollywood cinema could be imagined as a cultural practice on a par with the experience of modernity, as an industrially-produced, mass-based, vernacular modernism.

In cinema studies, the juncture of the classical and the modern has, for the most part, been written as a bifurcated history. The critique of classical cinema in 1970s film theory took over a structuralist legacy of binarisms, such as Barthes's opposition between the "readerly" and "writerly," which translated into the binary conception of film practice as either "classical-idealist," that is, ideological, or "modernist-materialist," that is, self-reflexive and progressive. This is particularly the case for the theory and practice of "counter cinema" that David Rodowick has dubbed "political modernism"—from Jean-Luc Godard and Peter Gidal through Noel Burch, Peter Wollen, Stephen Heath, Laura Mulvey and others—that owes much to the revival or belated reception of the 1920s and 1930s leftist avant-garde, notably Bertolt Brecht.[24] Moreover, the polarization of classical cinema and modernism seemed sufficiently warranted by skepticism vis-à-vis Hollywood's self-promotion as "international modern," considering how much the celebration of American cinema's contemporaneity, youth, vitality, and directness was part of the industry's own mythology deployed to legitimate cutthroat business practices and the relentless expansion of economic power worldwide.

While Bordwell and Thompson's neoformalist approach is to some extent indebted to the political-modernist tradition, *The Classical Hollywood Cinema* recasts the binarism of classicism and modernism in two ways.[25] At the level of industrial organization, the modernity of Hollywood's

mode of production (Fordism) is subsumed under the goal of maintaining the stability of the system as a whole; thus major technological and economic changes, such as the transition to sound, are discussed in terms of a search for "functional equivalents" by which the institution ensures the overall continuity of the paradigm (*CHC*, 304). In a similar vein, any stylistic deviations of the modernist kind *within* classical cinema—whether imports from European avant-garde and art films, native films noir, or work of idiosyncratic auteurs like Orson Welles, Alfred Hitchcock, and Otto Preminger—are cited as proof of the system's amazing appropriative flexibility: "So powerful is the classical paradigm that it regulates what may violate it" (*CHC*, 81).[26]

To be sure, there is ample precedent outside film history for the assimilation of the modern to classical or neoclassicist standards; after all, art historians speak of "classical modernism" (Picasso, de Chirico, Leger, Picabia) and there were related tendencies in music (Reger, Stravinsky, Poulenc, de Faya, to name just a few).[27] In modern architecture (LeCorbusier, Gropius, the Bauhaus), we can see the wedding of machine aesthetics to a notion of presumably natural functions, and in literary modernism, we have self-proclaimed neoclassicists such as T. E. Hulme, Wyndham Lewis, Ernst Jünger, and Jean Cocteau. In the genealogy of film theory, one of the founding manifestos of classical cinema is Hugo Münsterberg's *The Psychology of the Photoplay* (1916), a treatise in neo-Kantian aesthetics applied to the cinema. Its author was actually better known for books on psychology and industrial efficiency that became standard works for modern advertising and management. Yet, these examples should be all the more reason for the historian to step back and consider the implications of these junctures that reveal themselves as increasingly less disjunctive with the passing of modernity, the disintegration of hegemonic or high modernism, and the emergence of alternative modernisms from the perspective of postmodernity.

A key problem seems to lie in the very concept of the "classical"—as a historical category that implies the transcendence of mere historicity, as a hegemonic form that claims transcultural appeal and universality. Already in its seventeenth- and eighteenth-century usages, the neoclassicist recourse to tradition, in whatever way it may misread or invent a prior original, does not take us through history, but instead to a transhistorical ideal, a timeless sense of beauty, proportion, harmony, and balance derived from *nature.* It is no coincidence that the neoformalist account of classical cinema is linked and elaborated in Bordwell's work to the project of grounding film studies in the framework of cognitive psychology.[28] *The Classical Hollywood Cinema* offers an impressive account of a particular historical formation of the institution of American cinema, tracking its emergence in terms of the evolution of film style (Thompson) and mode of production (Staiger). But once "the system" is in place (from about 1917 on), its ingenuity and stability are attributed to the optimal engagement of *mental* structures and perceptual capacities that are, in Bordwell's words, "biologically hard-wired" and have been so for tens of thousands of years.[29] Classical narration ultimately amounts to a method of optimally guiding the viewer's attention and maximizing his or her response by way of more intricate plots and emotional tensions. The attempt to account for the efficacy of classical stylistic principles with recourse to cognitive psychology coincides with the effort to expand the reign of classical objectives to types of film practice outside Hollywood that had hitherto been perceived as alternative (most recently in Bordwell's work on Feuillade and other European traditions of staging-in-depth) as well as beyond the historical period demarcated in the book (that is, up to 1960).[30]

How can we restore historical specificity to the concept of classical Hollywood cinema? How can we make the anachronistic tension in the combination of neoclassicist style and Fordist mass culture productive for an understanding of both classical Hollywood cinema and mass-mediated modernity? How do we distinguish, within the category of the classical, between natural norm, canonical cultural form, and a rhetorical strategy that perhaps enabled the articulation of something radically new and different under the guise of a continuity with tradition? Can there be an account of classicality that does not unwittingly reproduce, at the level of academic discourse, the universalist

norms mobilized not least for purposes of profit, expansion, and ideological containment? Or wouldn't we do better to abandon the concept of classical cinema altogether and instead, as Philip Rosen and others have opted to do, use the more neutral term "mainstream cinema"?[31]

For one thing, I don't think that the term "mainstream" is necessarily clearer, let alone neutral or innocent; in addition to the connotation of a quasi-natural flow, it suggests a homogeneity that locates side streams and countercurrents on the outside or margins rather than addressing the ways in which they at once become part of the institution and blur its boundaries. For another, I would argue that, for the time being, classical cinema is still a more precise term because it names a regime of productivity and intelligibility that is both historically and culturally specific, much as it gets passed off as timeless and natural (and the efforts to do so are part of its history). In that sense, however, I take the term to refer less to a system of functionally interrelated norms and a corresponding set of empirical objects than to a scaffold, matrix, or web that allows for a wide range of aesthetic effects and experiences—that is, for cultural configurations that are more complex and dynamic than the most accurate account of their function within any single system may convey and that require more open-ended, promiscuous, and imaginative types of inquiry.[32]

From this perspective, one might argue that it would be more appropriate to consider classical Hollywood cinema within the framework of "American national cinema." Such a reframing would allow us, among other things, to include independent film practices outside and against the pull of Hollywood, such as "race films," regional, subcultural, and avant-garde film practices. While this strategy is important, especially for teaching American cinema, the issue of Hollywood's role in defining and negotiating American nationality strikes me as more complicated. If we wish to "provincialize Hollywood," to invoke Dipesh Chakrabarty's injunction to "provincialize" European accounts of modernity, it is not enough to consider American cinema on a par with any other national cinema—inasmuch as that very category in many cases describes defensive formations shaped in competition with and resistance to Hollywood products.[33] In other words, the issue of classicality is bound up with the question of what constituted the hegemony of American movies worldwide and what assured them the historic impact they had, for better or for worse, within a wide range of different local contexts and diverse national cinemas.

The question of what constitutes Hollywood's power on a global scale returns us to the phenomenon of Americanism discussed earlier in connection with Soviet film. I am concerned with Americanism here less as a question of exceptionalism, consensus ideology, or crude economic power, though none of these aspects can be ignored, than as a practice of cultural circulation and hegemony. Victoria de Grazia has argued that Americanism still awaits analysis, beyond the polarized labels of, respectively, cultural imperialism and a worldwide spreading of the American Dream, as "the historical process by which the American experience was transformed into a universal model of business society based on advanced technology and promising formal equality and unlimited mass consumption."[34] However ideological these promises may, or may not, turn out to be, de Grazia observes that, unlike earlier imperial practices of colonial dumping, American cultural exports "were designed to go as far as the market would take them, starting at home." In other words, "cultural exports shared the basic features of American mass culture, intending by that term not only the cultural artifacts and associated forms, but also the civic values and social relations of the first capitalist mass society."[35]

Regarding classical cinema, one could take this argument to suggest that the hegemonic mechanisms by which Hollywood succeeded in amalgamating a diversity of competing traditions, discourses, and interests on the *domestic* level may have accounted for at least some of the generalized appeal and robustness of Hollywood products *abroad* (a success in which the diasporic, relatively cosmopolitan profile of the Hollywood community no doubt played a part as well). In other words, by forging a mass market out of an ethnically and culturally heterogeneous society, if often at the expense of racial others, American classical cinema had developed an idiom, or idioms, that

travelled more easily than its national-popular rivals. I do not wish to resuscitate the myth of film as a new "universal language" whose early promoters included D. W. Griffith and Carl Laemmle, founder of the Universal Film Company, nor do I mean to gloss over the business practices by which the American film industry secured the dominance of its products on foreign markets, in particular through control of distribution and exhibition venues.[36] But I do think that, whether we like it or not, American movies of the classical period offered something like the first global vernacular. If this vernacular had a transnational and translatable resonance, it was not just because of its optimal mobilization of biologically hardwired structures and universal narrative templates but, more important, because it played a key role in mediating competing cultural discourses on modernity and modernization, because it articulated, multiplied, and globalized a particular historical experience.

If classical Hollywood cinema succeeded as an international modernist idiom on a mass basis, it did so not because of its presumably universal narrative form but because it meant different things to different people and publics, both at home and abroad. We must not forget that these films, along with other mass-cultural exports, were consumed in locally quite specific, and unequally developed, contexts and conditions of *reception*; that they not only had a levelling impact on indigenous cultures but also challenged prevailing social and sexual arrangements and advanced new possibilities of social identity and cultural styles; and that the films were also changed in that process. Many films were literally changed, both for particular export markets (e.g., the conversion of American happy endings into tragic endings for Russian release) and by censorship, marketing, and programming practices in the countries in which they were distributed, not to mention practices of dubbing and subtitling.[37] As systematic as the effort to conquer foreign markets undoubtedly was, the actual reception of Hollywood films was likely a much more haphazard and eclectic process depending on a variety of factors.[38] How were the films programmed in the context of local film cultures, in particular conventions of exhibition and reception? Which genres were preferred in which places (for instance, slapstick in European and African countries, musical and historical costume dramas in India), and how were American genres dissolved and assimilated into different generic traditions, different concepts of genre? And how did American imports figure within the public horizon of reception that might have included both indigenous products and films from other foreign countries? To write the international history of classical American cinema, therefore, is a matter of tracing not just its mechanisms of standardization and hegemony but also the diversity of ways in which this cinema was translated and reconfigured in both local and translocal contexts of reception.

Americanism, notwithstanding Antonio Gramsci (as well as recent critiques of Gramsci and left Fordism), cannot simply be reduced to a regime of mechanized production, an ideological veneer for discipline, abstraction, reification, for new hierarchies and routes of power. Nor can it be reduced to the machine aesthetics of intellectual and high modernism.[39] We cannot understand the appeal of Americanism unless we take seriously the promises of mass consumption and the dreams of a mass culture often in excess of and in conflict with the regime of production that spawned that mass culture (a phenomenon that has been dubbed "Americanization from below").[40] In other words, we have to understand the material, sensory conditions under which American mass culture, including Hollywood, was received and could have functioned as a powerful matrix for modernity's liberatory impulses—its moments of abundance, play, and radical possibility, its glimpses of collectivity and gender equality (the latter signalled by its opponents' excoriation of Americanism as a "new matriarchy").[41]

The juncture of classical cinema and modernity reminds us, finally, that the cinema was not only part and symptom of modernity's experience and perception of crisis and upheaval; it was also, most importantly, the single most inclusive cultural horizon in which the traumatic effects of modernity were reflected, rejected or disavowed, transmuted or negotiated. That the cinema was capable of a

reflexive relation with modernity and modernization was registered by contemporaries early on, and I read Benjamin's and Siegfried Kracauer's writings of the 1920s and 1930s as, among other things, an effort to theorize this relation as a new mode of reflexivity.[42] Neither simply a medium for realistic representation (in the sense of marxist notions of reflection or *Widerspiegelung*), nor particularly concerned with formalist self-reflexivity, commercial cinema appeared to realize Johann Gottlieb Fichte's troping of reflection as "seeing with an added eye" in an almost literal sense, and it did so not just on the level of individual, philosophical cognition but on a mass scale.[43] I am also drawing on more recent sociological debates on "reflexive modernization" (Ulrich Beck, Anthony Giddens, Scott Lash), a concept deployed to distinguish the risk-conscious phase of current post- or second modernity from a presumably more single-minded, orthodox, and simple first modernity. However, I would argue (although I cannot do so in detail here) that modernization inevitably provokes the need for reflexivity and that, if sociologists considered the cinema in aesthetic and sensorial terms rather than as just another medium of information and communication, they would find ample evidence in both American and other cinemas of the interwar period of an at once modernist and vernacular reflexivity.[44]

This dimension of reflexivity is key to the claim that the cinema not only represented a specifically modern type of public sphere, the public here understood as a "social horizon of experience," but also that this new mass public could have functioned as a discursive form in which individual experience could be articulated and find recognition by both subjects and others, including strangers.[45] Kracauer, in his more utopian moments, understood the cinema as an alternative public sphere—alternative to both bourgeois institutions of art, education, and culture, and the traditional arenas of politics—an imaginative horizon in which, however compromised by its capitalist foundations, something like an actual democratization of culture seemed to be taking shape, in his words, a "self-representation of the masses subject to the process of mechanization."[46] The cinema suggested this possibility not only because it attracted and made visible to itself and society an emerging, heterogeneous mass public ignored and despised by dominant culture. The new medium also offered an alternative because it engaged the contradictions of modernity at the level of the senses, the level at which the impact of modern technology on human experience was most palpable and irreversible. In other words, the cinema not only traded in the mass production of the senses but also provided an aesthetic horizon for the experience of industrial mass society.

While Kracauer's observations were based on moviegoing in Weimar Germany, he attributed this sensory reflexivity more often than not to American film, in particular slapstick comedy with its well-choreographed orgies of demolition and clashes between people and things. The logic he discerned in slapstick films pointed up a disjuncture within Fordist mass culture, the possibility of an anarchic supplement generated on the same principles: "One has to hand this to the Americans: with slapstick films they have created a form that offers a counterweight to their reality. If in that reality they subject the world to an often unbearable discipline, the film in turn dismantles this self-imposed order quite forcefully."[47] The reflexive potential of slapstick comedy can be, and has been, argued on a number of counts, at the levels of plot, performance, and mise-en-scene, and depending on the particular inflection of the genre. In addition to articulating and playing games with the violence of technological regimes, mechanization and clock time, slapstick films also specialized in deflating the terror of consumption, of a new culture of status and distinction.[48] Likewise, the genre was a vital site for engaging the conflicts and pressures of a multiethnic society (think of the many Jewish performers who thematized the discrepancies between diasporic identity and upward mobility, from Larry Semon through Max Davidson and George Sydney). And, not least, slapstick comedy allowed for a playful and physical expression of anxieties over changed gender roles and new forms of sexuality and intimacy.

But what about other genres? And what about popular narrative films that conform more closely to classical norms? Once we begin looking at Hollywood films as both a provincial response to modernization and a vernacular for different, diverse, yet also comparable experiences, we may find that genres such as the musical, horror, or melodrama may offer just as much reflexive potential as slapstick comedy, with appeals specific to those genres and specific resonances in different contexts of reception. This is to suggest that reflexivity can take different forms and different affective directions, both in individual films and directorial oeuvres and in the aesthetic division of labor among Hollywood genres, and that reflexivity does not always have to be critical or unequivocal. On the contrary, the reflexive dimension of these films may consist precisely in the ways in which they allow their viewers to confront the constitutive ambivalence of modernity.

The reflexive dimension of Hollywood films in relation to modernity may take cognitive, discursive, and narrativized forms, but it is crucially anchored in sensory experience and sensational affect, in processes of mimetic identification that are more often than not partial and excessive in relation to narrative comprehension. Benjamin, writing about the elimination of distance in the new perceptual regimes of advertising and cinema, sees in the giant billboards that present things in new proportions and colors a backdrop for a "sentimentality . . . restored to health and liberated in American style," just as in the cinema "people whom nothing moves or touches any longer learn to cry again."[49] The reason slapstick comedy hit home and flourished worldwide was not critical reason but the films' propulsion of their viewers' bodies into laughter. And adventure serials succeeded because they conveyed a new immediacy, energy, and sexual economy, not only in Soviet Russia and not only among avant-garde intellectuals. Again and again, writings on the American cinema of the interwar period stress the new physicality, the exterior surface or "outer skin" of things (Antonin Artaud), the material presence of the quotidian, as Louis Aragon put it, "really common objects, everything that celebrates life, not some artificial convention that excludes corned beef and tins of polish."[50] I take such statements to suggest that the reflexive, modernist dimension of American cinema does not necessarily require that we demonstrate a cognitive, compensatory, or therapeutic function in relation to the experience of modernity but that, in a very basic sense, even the most ordinary commercial films were involved in producing a new sensory culture.

Hollywood did not just circulate images and sounds; it produced and globalized a new sensorium; it constituted, or tried to constitute, new subjectivities and subjects. The mass appeal of these films resided as much in their ability to engage viewers at the narrative-cognitive level or in their providing models of identification for being modern as it did in the register of what Benjamin troped as the "optical unconscious."[51] It was not just *what* these films showed, what they brought into optical consciousness, as it were, but the way they opened up hitherto unperceived modes of sensory perception and experience, their ability to suggest a different organization of the daily world. Whether this new visuality took the shape of dreams or of nightmares, it marked an aesthetic mode that was decidedly not classical—at least not if we literalize that term and reduce it to neoclassicist formal and stylistic principles. Yet, if we understand the classical in American cinema as a metaphor of a global sensory vernacular rather than a universal narrative idiom, then it might be possible to imagine the two Americanisms operating in the development of Soviet cinema—the modernist fascination with the "low," sensational, attractionist genres and the classicist ideal of formal and narrative efficiency—as two vectors of the same phenomenon, both contributing to the hegemony of Hollywood film. This may well be a fantasy: the fantasy of a cinema that could help its viewers negotiate the tension between reification and the aesthetic, strongly understood, the possibilities, anxieties, and costs of an expanded sensory and experiential horizon—the fantasy, in other words, of a mass-mediated public sphere capable of responding to modernity and its failed promises. Now that postmodern media culture is busy recycling the ruins of both classical cinema and modernity, we may be in a better position to see the residues of a dreamworld of mass culture that is no longer ours—and yet to some extent still is.

Notes

This essay appears here with the permission of Edward Arnold, publishers, and, along with the essays by Andreas Huyssen and Ann Douglas in *Modernism/Modernity* 5, no. 3, derive from papers delivered at the conference "Modern Culture and Modernity Today" held at Brown University, 14-15 March 1997, organized by Professor Robert Scholes and sponsored by the Malcolm S. Forbes Center, the Department of Modern Culture and Media at Brown University, and *Modernism/Modernity*. Our gratitude to Professor Scholes and Mark Gaipa for their collaboration.—editors' note

For critical readings, research, and suggestions I wish to thank Paula Amad, Dudley Andrew, Bill Brown, Susan Buck-Morss, Jean Comaroff, Michael Geyer, Tom Gunning, Lesley Stern, Yuri Tsivian, and Martha Ward, as well as inspiring audiences and commentators in various places where I presented versions of this paper.

1. See, for instance, Leo Charney and Vanessa R. Schwartz, eds., *Cinema and the Invention of Modern Life* (Berkeley: University of California Press, 1995); John Orr, *Cinema and Modernity* (Cambridge: Polity Press, 1993); and Anne Friedberg, *Window Shopping: Cinema and the Postmodern* (Berkeley: University of California Press, 1993). In addition, of course, there have been numerous studies on the impact of cinema on experimentation in other media, especially fiction, painting, and theater.

2. See, for instance, Marshall Berman, *All That Is Solid Melts into Air: The Experience of Modernity* (New York: Simon and Schuster, 1982); Andreas Huyssen, *After the Great Divide: Modernism, Mass Culture, Postmodernism* (Bloomington: Indiana University Press, 1986); Peter Wollen, "Out of the Past: Fashion/Orientalism/The Body" (1987), in *Raiding the Icebox: Reflections on Twentieth-Century Culture* (Bloomington: Indiana University Press, 1993); Richard Taruskin, "A Myth of the Twentieth Century: *The Rite of Spring*, the Tradition of the New, and 'Music Itself,'" *Modernism/Modernity* 2, no. 1 (January 1995): 1–26; Rosalind Krauss, *The Originality of the Avant-Garde and Other Modernist Myths* (Cambridge, Mass.: MIT Press, 1985); Griselda Pollock, "Modernity and the Spaces of Femininity," in Pollock, *Vision and Difference* (London: Routledge, 1988), 50–90; Molly Nesbit, "The Rat's Ass," *October* 56 (spring 1991): 6–20; Matthew Teitelbaum, ed., *Montage and Modern Life 1919-1942* (Cambridge, Mass.: MIT Press, 1992); Houston A. Baker, Jr., *Modernism and the Harlem Renaissance* (Chicago: University of Chicago Press, 1987); Michael North, *The Dialect of Modernism* (New York: Oxford University Press, 1994); Paul Gilroy, *The Black Atlantic: Modernity and Double Consciousness* (Cambridge, Mass.: Harvard University Press, 1993); Homi Bhabha, *The Location of Culture* (New York: Routledge, 1994), ch. 12; Tejaswini Niranjana, P. Sudhir, Vivek Dhareshwar, eds., *Interrogating Modernity: Culture and Colonialism in India* (Calcutta: Seagull Books, 1993); Arjun Appadurai, *Modernity at Large: Cultural Dimensions of Globalization* (Minneapolis: University of Minnesota Press, 1996); Néstor García Canclini, "Latin American Contradictions: Modernism without Modernization?" in *Hybrid Cultures: Strategies for Entering and Leaving Modernity,* trans. C. L. Chiappari and S. L. Lopez (Minneapolis: University of Minnesota Press, 1995), 41–65; and Sharan A. Minichiello, ed., *Japan's Competing Modernities: Issues in Culture and Democracy 1900-1930* (Honolulu: University of Hawai'i Press, 1998).

3. Lawrence Rainey and Robert von Hallberg, "Editorial/Introduction," *Modernism/Modernity* 1, no. 1 (January 1994): 1.

4. Peter Bürger, following Adorno, asserts that the very category of "style" is rendered problematic by the advanced commodification of art in the twentieth century and considers the refusal to develop a coherent style (as in dada and surrealism) a salient feature of avant-gardist, as distinct from modernist, aesthetics; see Bürger, *Theory of the Avant-Garde*, trans. Michael Shaw (Minneapolis: University of Minnesota Press, 1984), esp. ch. 2, "The Historicity of Aesthetic Categories." The opening up of both modernist and avant-garde canons, however, shows a great overlap between the two, just as the effort on the part of particular modernist artists and movements to *restore* the institutional status of art may well go along with avant-gardist modes of behavior and publicity; see my *Ezra Pounds frühe Poetik zwischen Aufklärung und Avantgarde* (Stuttgart: Metzler, 1979). See also Huyssen, *After the Great Divide*, esp. ch. 2, "Adorno in Reverse: From Hollywood to Richard Wagner."

5. In the second version of his famous essay, "The Work of Art in the Age of Mechanical Reproduction" (1935), Benjamin wrote of the "the theory [*die Lehre*] of perception that the Greeks called aesthetics" (*Gesammelte Schriften*, ed. Rolf Tiedemann and Hermann Schweppenhäuser [Frankfurt A. M.: Suhrkamp, 1989], 7:381; my translation). He conceived of the politics of this essay very much as an effort to confront the aesthetic tradition narrowly understood, in particular the persistence of aestheticism in

contemporary literature and art, with the changes wrought upon the human sensorium by industrial and military technology. See Susan Buck-Morss, "Aesthetics and Anaesthetics: Walter Benjamin's Artwork Essay Reconsidered," *October* 62 (fall 1992): 3–41; see also my "Benjamin and Cinema: Not a One-Way Street," *Critical Inquiry* 25, no. 2 (winter 1999): 306–43.

6. On the cinema of the Czarist period, see Yuri Tsivian, "Some Preparatory Remarks on Russian Cinema," in *Testimoni silenziosi: Filmi russi 1908-1919/Silent Witnesses: Russian Films 1908-1919*, ed. Paolo Cherchi Usai et al. (Pordenone, London: British Film Institute, 1989); idem, *Early Cinema in Russia and Its Cultural Reception* (1991), trans. Alan Bodger (1994; Chicago: University of Chicago Press, 1998); also see the contributions of Paolo Cherchi Usai, Mary Ann Doane, Heide Schlüpmann, and myself to two special issues of the journal *Cinefocus* 2, no. 1 (fall 1991) and 2, no. 2 (spring 1992).

7. See Yuri Tsivian, "Between the Old and the New: Soviet Film Culture in 1918-1924," *Griffithiana* 55/56 (1996): 15–63; hereafter abbreviated "BON"; idem, "Cutting and Framing in Bauer's and Kuleshov's Films," *Kintop: Jahrbuch zur Erforschung des frühen Films* 1 (1992): 103–13; and Kristin Thompson, David Bordwell, *Film History: An Introduction* (New York: McGraw-Hill, 1994), 130.

8. See, for instance, *The Weimar Republic Sourcebook*, ed. Anton Kaes, Martin Jay, and Edward Dimendberg (Berkeley: University of California Press, 1994), section 15; and Antonio Gramsci's famous essay, "Americanism and Fordism," in *Selections from the Prison Notebooks* [1929–1935], ed. and trans. Quintin Hoare and Geoffrey Nowell Smith (New York: International Publishers, 1971), 277–318. See also Mary Nolan, *Visions of Modernity: American Business and the Modernization of Germany* (New York: Oxford University Press, 1994); Thomas J. Saunders, *Hollywood in Berlin: American Cinema and Weimar Germany* (Berkeley: University of California Press, 1994), esp. chs. 4 and 5; Alf Lüdtke, Inge Marßolek, Adelheid von Saldern, eds., *Amerikanisierung: Traum und Alptraum im Deutschland des 20. Jahrhunderts* (Stuttgart: Franz Steiner, 1996); and Jean-Louis Cohen and Humbert Damisch, eds., *Américanisme et modernité: L'idéal américain dans l'architecture* (Paris: EHESS, Flammarion, 1993).

9. See "BON," 39–45.

10. A related recruiting of "low" popular culture for the programmatic attack on the institution of art can be found in western European avant-garde movements, in particular dada and surrealism.

11. See Robert B. Pippin, *Modernism as a Philosophical Problem* (London: Blackwell, 1991), 4.

12. See Thomas Elsaesser, "What Makes Hollywood Run?" *American Film* 10, no. 7 (May 1985): 52–5, 68; Renoir quoted on 52.

13. Robert Brasillach and Maurice Bardèche, *Histoire du cinéma*, 2nd ed. (Paris: Denoël, 1943), 369, quoted in David Bordwell, *On the History of Film Style* (Cambridge, Mass.: Harvard University Press, 1997), 47. With regard to the earlier edition (1935), which bestows the term "classic" on international silent film of the period 1924–1929, Bordwell remarks that the invocation of the term recalls "the common art-historical conception of classicism as a dynamic stability in which innovations submit to an overall balance of form and function." (40) On the political stance of the authors, in particular Brasillach, see Alice Kaplan, *Reproductions of Banality: Fascism, Literature, and French Intellectual Life* (Minneapolis: University of Minnesota Press, 1986), chs. 6 and 7, and Bordwell, ibid., 38–41.

14. André Bazin, "The Evolution of the Western," in *What Is Cinema?* sel. and ed. Hugh Gray (Berkeley: University of California Press, 1971), 2:149. In "The Western: Or the American Film Par Excellence," Bazin invokes Corneille to describe the "simplicity" of western scripts as a quality that both lends them "naive greatness" and makes them a subject for parody (2:147). Also see Bazin, "The Evolution of the Language of Cinema," in *What Is Cinema?* 1:29. Dudley Andrew has drawn my attention to Eric Rohmer who during the same period developed a notion of cinematic classicism that more broadly linked "modern" cinema to the eighteenth-century tradition. See Rohmer, *Le Gout de la beauté*, ed. Jean Narboni (Paris: Editions de l'Etoile, 1984), esp. "L'Age classique de cinéma," 25–99; see also Bordwell, *History of Film Style*, 77.

15. André Bazin, "La Politique des auteurs," in *The New Wave*, ed. Peter Graham (New York: Doubleday, 1968), 143, 154.

16. See, for example, Jean-Louis Comolli and Jean Narboni, "Cinema/Ideology/Criticism," in *Screen Reader 1* (London: SEFT, 1977); Janet Bergstrom, "Enunciation and Sexual Difference (Part I)," *Camera Obscura* 3-4 (1979); as well as writings by Comolli, Jean-Louis Baudry, Christian Metz, Raymond Bellour, Stephen Heath, Laura Mulvey, and Colin MacCabe in *Narrative, Apparatus, Ideology: A Film Theory Reader*, ed. Philip Rosen (New York: Columbia University Press, 1986).

17. See Judith Mayne, "*S/Z* and Film Theory," *Jump Cut* 12–13 (December 1976): 41–5. A notable exception to this tendency is Raymond Bellour who stresses the formal and stylistic principles at work in classical cinema (patterns of repetition-resolution, rhyming, symmetry, redundancy, interlacing of micro- and macrostructures) by which classical films produce their conscious and unconscious meanings and effects. See Bellour, *L'Analyse du Film* (Paris: Editions Albatros, 1979), which includes the texts translated as "Segmenting/Analyzing" and "The Obvious and the Code," in *Narrative, Apparatus, Ideology*, 66–92, 93–101.

18. See David Bordwell, Janet Staiger, Kristin Thompson, *The Classical Hollywood Cinema: Film Style and Mode of Production to 1960* (New York: Columbia University Press, 1985); hereafter abbreviated *CHC*. In *The Classical Hollywood Cinema*, "realism" is equated with verisimilitude and, as such, figures as one of four types of narrative motivation—compositional, realistic, intertextual, artistic (*CHC*, 19). While this qualification seems appropriate vis-à-vis the diversity of Hollywood genres (think of the musical, for instance), it does not make the issue of cinematic "realism" go away, whether as rhetorical claim, ideological fiction, or aesthetic possibility. In this context, see Christine Gledhill's interesting attempt to understand "realism" as American cinema's way of facilitating the "modernization of melodrama" (Gledhill, "Between Melodrama and Realism: Anthony Asquith's *Underground* and King Vidor's *The Crowd*," in *Classical Hollywood Narrative: The Paradigm Wars*, ed. Jane Gaines [Durham, N.C.: Duke University Press, 1992], 131).

19. See Rick Altman, "Dickens, Griffith, and Film Theory Today," in *Classical Hollywood Narrative*, 15–17, discusses the problematic relationship of Bordwell's concept of cinematic classicism with its French literary antecedents.

20. Stendhal, quoted in *CHC*, 367–8.

21. Altman, "Dickens, Griffith, and Film Theory Today," 14.

22. The debate on melodrama in cinema studies is extensive; for an exemplary collection see Christine Gledhill, ed., *Home is Where the Heart Is: Studies in Melodrama and the Woman's Film* (London: British Film Institute, 1987), especially Gledhill's introduction, "The Melodramatic Field: An Investigation," 5–39; Gledhill, "Between Melodrama and Realism: Anthony Asquith's *Underground* and King Vidor's *The Crowd*," in *Classical Hollywood Narrative*; and Linda Williams, "Melodrama Revised," in *Refiguring American Film Genres: Theory and History*, ed. Nick Browne (Berkeley: University of California Press, 1998). On genres that involve the body in nonclassical ways, see Linda Williams, "Film Bodies: Gender, Genre, and Excess," *Film Quarterly* 44, no. 4 (summer 1991): 2–13. On the mutually competing aesthetics of slapstick comedy, see Donald Crafton, "Pie and Chase: Gag, Spectacle and Narrative in Slapstick Comedy," in *Classical Hollywood Comedy*, ed. Kristine Brunovska Karnick and Henry Jenkins (New York: Routledge, 1994), 106–119; see also William Paul, *Laughing Screaming: Modern Hollywood Horror and Comedy* (New York: Columbia University Press, 1994).

23. Gertrude Stein, "Portraits and Repetition," in *Lectures in America* (New York: Random House, 1935), 177. For a critical account of the industrial, political, and cultural dimensions of Fordism, see Terry Smith, *Making the Modern: Industry, Art, and Design in America* (Chicago: University of Chicago Press, 1993).

24. See D. N. Rodowick, *The Crisis of Political Modernism: Criticism and Ideology in Contemporary Film Theory* (Urbana: University of Illinois Press, 1988); see also Sylvia Harvey, *May '68 and Film Culture* (London: British Film Institute, 1978), ch. 2; and Martin Walsh, *The Brechtian Aspects of Radical Cinema*, ed. Keith M. Griffiths (London: British Film Institute, 1981). For an example of the binary construction of this approach, see Peter Wollen, "Godard and Counter-Cinema: *Vent d'est*" (1972), in *Narrative, Apparatus, Ideology*, 120–9.

25. See, for instance, Kristin Thompson and David Bordwell, "Space and Narrative in the Films of Ozu," *Screen* 17, no. 2 (summer 1976): 41–73; Thompson, *Breaking the Glass Armor: Neoformalist Film Analysis* (Princeton: Princeton University Press, 1988), part 6; and Bordwell, *Narration in the Fiction Film* (Madison: University of Wisconsin Press, 1985), ch. 12.

26. Such statements bear an uncanny similarity with Max Horkheimer and Theodor W. Adorno's analysis of the "Culture Industry" as an all-absorbing totality in *Dialectic of Enlightenment* (1944/47), though obviously without the despair and pessimism that prompted that analysis.

27. The Basel Kunstmuseum mounted an impressive exhibition of classicist modernism in music and the arts; see the catalogue, *Canto d'Amore: Klassizistische Moderne in Musik und bildender Kunst 1914-1935*, ed. Gottfried Boehm, Ulrich Mosch, and Katharina Schmidt (Basel: Kunstmuseum, 1996); and the collection of essays and sources accompanying the concurrent concert series, *Klassizistische Moderne*, ed. Felix Meyer (Winterthur: Amadeus Verlag, 1996).

28. See *CHC*, 7–9, 58–9; Bordwell, *Narration in the Fiction Film*, ch. 3 and passim; and idem, "A Case for Cognitivism," *Iris* 5, no. 2 (1989): 11–40. See also Dudley Andrew's introduction to this issue of *Iris*, devoted to "Cinema and Cognitive Psychology," 1–10; and the continuation of the debate between Bordwell and Andrew in *Iris* 6, no. 2 (summer 1990): 107–16. In the effort to make cognitivism a central paradigm in film studies, Bordwell is joined by, among others, Noël Carroll; see Bordwell and Carroll, eds., *Post-Theory: Reconstructing Film Studies* (Madison: University of Wisconsin Press, 1996), 37–70; and Carroll, *Theorizing the Moving Image* (Cambridge: Cambridge University Press, 1996).

29. Bordwell, "*La Nouvelle Mission de Feuillade*; or, What Was Mise-en-Scène?," *The Velvet Light Trap* 37 (spring 1996): 23; see also idem, *On the History of Film Style*, 142; and idem, "Convention, Construction, and Cinematic Vision," in *Post-Theory*, 87–107.

30. See Bordwell, "*La Nouvelle Mission de Feuillade*"; *On the History of Film Style*, ch. 6; and *Classical Hollywood Cinema*, ch. 30. Kristin Thompson's new study is concerned with the persistence of classical principles past 1960, see her "Storytelling in the New Hollywood: The Case of *Groundhog Day*," paper presented at the Chicago Film Seminar, 3 October 1996.

31. Rosen, *Narrative, Apparatus, Ideology*, 8.

32. Patrice Petro, drawing on the work of Karsten Witte and Eric Rentschler, contrasts this centrifugal quality of Hollywood cinema with the literalization of classical norms in Nazi cinema: "The Nazi cinema [in its strategies of visual enticement and simultaneous narrative containment] represents the theory (of classical Hollywood narrative) put into practice rather than the practice (of Hollywood filmmaking) put into theory" (Petro, "Nazi Cinema at the Intersection of the Classical and the Popular," *New German Critique* 74 [spring-summer 1998]: 54).

33. Dipesh Chakrabarty, "Postcoloniality and the Artifice of History: Who Speaks for 'Indian' Pasts?" *Representations* 37 (winter 1992): 20.

34. Victoria de Grazia, "Americanism for Export," *Wedge* 7–8 (winter-spring 1985): 73. See also de Grazia, "Mass Culture and Sovereignty: The American Challenge to European Cinemas, 1920-1960," *Journal of Modern History* 61, no. 1 (March 1989): 53–87.

35. De Grazia, "Americanism for Export," 77. Mica Nava, "The Cosmopolitanism of Commerce and the Allure of Difference: Selfridges, the Russian Ballet and the Tango 1911-1914," *International Journal of Cultural Studies* 1, no. 2 (August 1998): 163–96, argues for a similar distinction, that is, between a commercial culture of cosmopolitan modernism shaped in the United States and the cultural imperialism of colonial regimes.

36. On the role of foreign markets for the American film industry, see Kristin Thompson, *Exporting Entertainment* (London: British Film Institute, 1985); Ian Jarvie, *Hollywood's Overseas Campaign: The North Atlantic Movie Trade, 1920-1950* (New York: Cambridge University Press, 1992); David W. Ellwood and Rob Kroes, eds., *Hollywood in Europe: Experiences of a Cultural Hegemony* (Amsterdam: VU University Press, 1994); and Ruth Vasey, *The World According to Hollywood, 1918-1939* (Madison: University of Wisconsin Press, 1997). On the celebration of film as a new "universal language" during the 1910s, see my *Babel and Babylon: Spectatorship in American Silent Film* (Cambridge, Mass.: Harvard University Press, 1991), 76–81, 183–7.

37. On the practice of converting happy endings of American films into "Russian endings," see Yuri Tsivian, "Some Preparatory Remarks on Russian Cinema," *Silent Witnesses*, 24; see also Mary Ann Doane, "Melodrama, Temporality, Recognition: American and Russian Silent Cinema," *Cinefocus* 2, no. 1 (fall 1991): 13–26.

38. See, for instance, Rosie Thomas, "Indian Cinema: Pleasures and Popularity," *Screen* 26, no. 1 (January-February 1985): 116–31; Sara Dickey, *Cinema and the Urban Poor in South India* (New York: Cambridge University Press, 1993); Stephen Putnam Hughes, "'Is There Anyone out There?': Exhibition and the Formation of Silent Film Audiences in South India," Ph.D. diss., University of Chicago, 1996; Onookome Okome and Jonathan Haynes, *Cinema and Social Change in West Africa* (Jos, Nigeria: Nigerian Film Corporation, 1995), ch. 6; see also Hamid Naficy, "Theorizing 'Third World' Film Spectatorship," *Wide Angle* 18, no. 4 (October 1996): 3–26.

39. For an example of such a critique, see Peter Wollen, "Modern Times: Cinema/ Americanism/The Robot" (1988), in *Raiding the Icebox*, 35–71.

40. The phrase "Americanization from below" is used by Kaspar Maase in his study of West-German youth culture of the 1950s, *BRAVO Amerika: Erkundungen zur Jugendkultur der Bundesrepublik in den fünfziger Jahren* (Hamburg: Junius, 1992), 19.

41. On the different economy of gender relations connoted by American culture in Weimar Germany, see Nolan, *Visions of Modernity*, 120–7; and Eve Rosenhaft, "Lesewut, Kinosucht, Radiotismus: Zur (geschlechter-)politischen Relevanz neuer Massenmedien in den 1920er Jahren," in Lüdtke, Marßolek, von Saldern, eds., *Amerikanisierung*, 119–43.

42. See my essays "Benjamin and Cinema," and "America, Paris, the Alps: Kracauer (and Benjamin) on Cinema and Modernity," in Charney and Schwartz, eds. *Cinema and the Invention of Modern Life*, 362–402.

43. J. G. Fichte, quoted in Ulrich Beck, Anthony Giddens, Scott Lash, *Reflexive Modernization: Politics, Tradition and Aesthetics in the Modern Social Order* (Stanford: Stanford University Press, 1994), 175.

44. See Beck, Giddens, Lash, *Reflexive Modernization*; see also Giddens, *Modernity and Self-Identity* (Stanford: Stanford University Press, 1991). Lash, "Reflexive Modernization: The Aesthetic Dimension," *Theory, Culture and Society* 10, no. 1 (1993): 1–23, criticizes his coauthors for both the notion of a "high" or "simple" modernity and for their neglect of the "aesthetic dimension," but he does not develop the latter in terms of changes in the institution of art and the new regimes of sensory perception emerging with mass-mediated modernity.

45. This is not to say that the cinema was unique or original in forging a modern type of publicness. It was part of, and borrowed from, a whole array of institutions—department stores, world fairs, tourism, amusement parks, vaudeville, etc.—that involved new regimes of sensory perception and new forms of sociability. At the same time, the cinema represented, multiplied, and deterritorialized these new experiential regimes. My understanding of the public sphere as a general, social "horizon of experience" is indebted to Oskar Negt and Alexander Kluge, *The Public Sphere and Experience* (1972), trans. Peter Labanyi, Jamie Daniel, Assenka Oksiloff, intr. Miriam Hansen (Minneapolis: University of Minnesota Press, 1993).

46. [Siegfried Kracauer], "Berliner Nebeneinander: Kara-Iki—Scala-Ball im Savoy—Menschen im Hotel," *Frankfurter Zeitung* 17 February 1933, my translation; see also "Cult of Distraction" (1926) and other essays in: Kracauer, *The Mass Ornament: Weimar Essays*, trans., ed., and intr. by Thomas Y. Levin (Cambridge, Mass.: Harvard University Press, 1995).

47. [Siegfried Kracauer], "Artistisches und Amerikanisches," *Frankfurter Zeitung*, 29 January 1926, my translation.

48. See, for instance, Eileen Bowser, "Subverting the Conventions: Slapstick as Genre," in *The Slapstick Symposium*, ed. Bowser (Brussels: Féderation Internationale des Archives du Film, 1988) 13–17; Crafton, "Pie and Chase"; and Charles Musser, "Work, Ideology and Chaplin's Tramp," *Radical History* 41 (April 1988): 37–66.

49. Benjamin, "One-Way Street" (1928), trans. Edmund Jephcott, in *Selected Writings*, ed. Marcus Bullock and Michael W. Jennings (Cambridge, Mass.: Harvard University Press, 1996), 476 (translation modified).

50. Antonin Artaud, "The Shell and the Clergyman: Film Scenario," *transition* 29–30 (June 1930): 65, quoted in Siegfried Kracauer, *Theory of Film* (1960; Princeton, N.J.: Princeton University Press, 1997), 189; Louis Aragon, "On Decor" (1918) in *French Film Theory and Criticism: A History/Anthology, 1907-1939*, ed. Richard Abel (Princeton, N.J.: Princeton University Press, 1988), 1:165. See also Colette, "Cinema: *The Cheat*"; Louis Delluc, "Beauty in the Cinema" (1917) and "From *Orestes* to *Rio Jim*" (1921); Blaise Cendrars, "The Modern: A New Art, the Cinema" (1919); and Jean Epstein, "Magnification" (1921) in ibid. See also "*Bonjour cinéma* and Other Writings by Jean Epstein," trans. Tom Milne, *Afterimage*, 10 [n.d.], esp. 9–16; and Philippe Soupault, "Cinema U.S.A." (1924), in *The Shadow and Its Shadow: Surrealist Writings on Cinema*, ed. Paul Hammond (London: British Film Institute, 1978), 32–3.

51. Benjamin develops the notion of an "optical unconscious" in "A Short History of Photography" (1931), trans. Stanley Mitchell, *Screen* 13 (spring 1972): 7–8; and in his famous essay, "The Work of Art in the Age of Mechanical Reproduction" (1936), in *Illuminations*, ed. Hannah Arendt, trans. Harry Zohn (New York: Schocken, 1969), 235–7. See also his defense of *Battleship Potemkin*, "A Discussion of Russian Filmic Art and Collectivist Art in General" (1927), in Kaes, Jay, Dimendberg, eds., *Weimar Republic Sourcebook*, 627.

CHAPTER 7
YOUTH IN PUBLIC

THE *LITTLE REVIEW* AND COMMERCIAL CULTURE IN CHICAGO

*Mark S. Morrisson**

As the New Modernist Studies began to change what could be counted as modernist and thus implicitly authenticated for serious study and teaching, scholars began to look ever more deeply into the archives. Institutions like Yale, the University of Texas, and the University of Buffalo had already acquired sprawling collections of manuscripts, correspondence, and other writing by major twentieth-century figures, but such materials were often still subject to copyright and, in some cases, tightly controlled by estates and trusts. (For more on this, see Chapter 16 in this volume.) As a result, scholars often had difficulty accessing key materials that might have allowed for the kind of radical expansion Walkowitz and Mao proposed.

Such challenges, however, actually opened up the possibility for a new kind of work that would grow to into its own thriving subfield called modern periodical studies. "Modernism," Robert Scholes wrote, "began in the magazines." Indeed, the early twentieth century was a golden age of periodicals: authors typically serialized their work first in magazines and often saw book publication as only secondary (and often less lucrative). Most of the major publishing firms of the era operated their own periodicals and these were distributed across expansive global networks. The rise of advertising and new technologies for printing and papermaking, furthermore, made it easy even for amateurs to start new publications, leading to an explosion of "little magazines" that led wave after wave of radical innovations in literature, art, and culture.

Mark Morrisson helped direct critics and scholars into this rich trove of archival material with the publication of *The Public Face of Modernism* in 2001. This book explores the ways in which art and literature magazines in the early twentieth century tried initially to carve out a space for popular innovation. Far from withdrawing into the rarified air on the far side of Huyssen's "great divide" between high and popular culture, these magazines initially tried to build a bridge by marketing modernism to a mass readership. That experiment initially failed, but the New Modernist Studies found in these magazines a rich new set of connections among art, advertising, and audiences that helped fundamentally upset established views of modernism's presumed autonomy.

In the chapter excerpted here, Morrisson focuses on the *Little Review*, perhaps the most famous of the era's little magazines. Initially based in Chicago and then in New York, it published Joyce's *Ulysses* in a series of installments from 1918 to 1920. This eventually led its two daring editors—Margaret Anderson and Jane Heap—into a New York courtroom, where they faced criminal charges for violating obscenity laws and helped make Joyce himself a star. Morrisson first takes us back to the magazine's early years to explore how Anderson

*From Mark S. Morrisson, *The Public Face of Modernism: Little Magazines, Audiences, and Reception, 1905-1920*. University of Wisconsin Press, ©2001. Reproduced here with permission.

built it around a newfound fascination with the freedom and liberation of youth culture in America. In its articles, advertisements, and politics, he argues, we see no evidence of artists "turning their backs on audiences and publishing for the select few." Instead, "the *Little Review* promoted modernism as a youth movement" and it was finally banned, he concludes, for publishing a portion of *Ulysses* in which a young Irish woman uses magazine stories and ads to create a fantasy of both pleasure and escape that shocked the American censors.

Morrisson himself helped found the Modernist Studies Association and was a co-organizer of its first conference, an event that served as a milestone in the transformation of the field. He later co-founded the *Journal of Modern Periodical Studies*, which continues to focus on the richness of the magazine archive and the many surprises it still yields.

In 1908, a fashionable young woman—"as chic as any of the girls who model . . . for the fashion magazines"—wearied of her stifling Indiana home life and complained of it in a letter to "The Perfect Comrade" an advice column in *Good Housekeeping* for girls and young women. The columnist, Clara Laughlin, invited her correspondent to Chicago for a visit and soon urged her to move to the city to interview stage celebrities for magazines. The eighteen-year-old and her sister relocated to Chicago, and she reviewed books for Laughlin in a popular Presbyterian magazine, the *Interior* (later the *Continent*), supported by Cyrus McCormick. She also began reviewing for the *Friday Literary Review* of the *Chicago Evening Post*. Ironically, this ultra-American tale of youth moving from the small town to the big city, to begin a career in the growing mass publishing world, was the story of Margaret Anderson, the founder and editor of the *Little Review*—whose profession to "make no compromise with the public taste" and willingness to publish everything from imagism, *Ulysses*, and French avant-gardism to anarchist diatribes made it the quintessential modernist little magazine.[1] This story of the origin of one of the most important avant-garde magazines highlights a significant and overlooked aspect of the emergence of American modernism before the war: the imbrication of commercial mass culture with the public self-fashioning of modernism. And playing a central role in the story of Margaret Anderson, the *Little Review*, and American modernism was the newly emerging "cult of youth"—a source of great cultural anxiety in early twentieth-century America.

The *Little Review* had much in common with transatlantic counterpart, the *Egoist*. Neither conforms to the commonplace understanding of modernist little magazines as turning their backs on audiences and publishing for the select few as coterie organs. The *Egoist* used mass-advertising techniques (mediated by radical counterpublic spheres) to seek an urban mass audience; the *Little Review* likewise attempted to reach large audiences, but it also borrowed *directly* from mass market publications and advertising rhetoric to style a popular periodical that would differ from mass market magazines only in that mass appeal would not serve as the basis of its editorial decisions. Like *Blast*, the *Little Review* turned to the energies of a vibrant advertising culture to help bring modernism into the public sphere, but, of course, the differences between London and Chicago ensured that the *Little Review* would follow a different path than *Blast* did.

Commercial mass culture greatly influenced the self-fashioning of early American modernism and the Chicago Renaissance. Indeed, as youth became increasingly important to American commercial culture, the *Little Review* promoted modernism as a youth movement. European avant-garde groups (like the Italian futurists) that promoted a cult of youth are not adequate contexts for understanding this phenomenon in Chicago. Instead, we must turn to two facets of American commercial culture: the development of the marketing potential of adolescence and a tentatively emerging "public sphere of youth" sustained by youth forums and columns in commercial

magazines. While mass market institutions crafted positive images of youth, characterized by abandon and consumerism, American culture paradoxically also attempted to regulate youth's relation to commercial culture, to prevent the rhetorical abandon of consumerism from becoming actual moral abandon. Youth columns in mass market magazines negotiated these social misgivings by constructing a carefully contained "open forum" to discuss issues important to youth. Thus when the *Little Review* actually tried to create an *unregulated* public organ for youth—an avant-garde magazine whose aesthetic, social, and political radicalism was pervaded by a new ideology, setting the freedoms of youth in public against constraining and authoritarian domesticity—it collided head on with the law and the Society for the Suppression of Vice.

Whereas mass advertising techniques had influenced the promotion of the *Egoist* and its predecessors, the commercial publishing industry that brought Margaret Anderson to Chicago (and sustained her before the founding of the *Little Review*) greatly influenced both the marketing and the form of the *Little Review*. The quotations from various authors scattered throughout its pages mirrored those in the "New Books" section of the *Continent*, and the *Little Review*'s large critical section, including the "Sentence Reviews," also reflected the short book notices commonly found in mass market newspapers and magazines like the *Continent*. As with most commercial publications, the "Sentence Reviews" covered a wide range of works: serious intellectual studies and novels, music and art discussions, gardening, travel, reference works, poetry, and radical political works as well as romances and sentimental novels. Models for the "New York Letter" and "London Letter" that the *Little Review* regularly featured during its Chicago years could be found in the *Chicago Evening Post*. Furthermore, the lists of "Best Sellers" in the Chicago area prominently displayed in the April and May 1914 issues spoke to a broader audience than a tiny elitist coterie organ would desire and included the latest romances and even a Zane Grey western.[2]

In spite of modernism's rhetorical lack of concern for audiences, Anderson clearly intended to augment the circulation of the *Little Review*. By July 1914, only the fifth issue, she took a further step toward reaching the broad audiences of the mass market magazines by announcing a reduction of the cover price from 25 cents to 15 cents a copy and the subscription price from $2.50 to $1.50 per year—the price of the mass market monthlies like *Munsey's*, *McClure's*, *Good Housekeeping*, and *Ladies' Home Journal*. In "A Change of Price," Anderson proclaimed: "We have discovered that a great many of the people whom we wish to reach cannot afford to pay $2.50 a year for a magazine. It happens that we are very emphatic about wanting these people in our audience, and we believe they are as sincerely interested in *The Little Review* as we are stimulated by having them among our readers. Therefore we are going to become more accessible." Because recent mass market magazines had significantly boosted their circulations by lowering their prices,[3] it seemed to Anderson that price, rather than the nature of the content, was the major obstacle to a wide circulation. The *Little Review* was in the black and boasted of "a subscription list that acts like a live thing!" but, Anderson added, "we want more!"[4] She announced a campaign by which anyone sending in three yearly subscriptions could get one free, or might make a 33 1/3 percent commission on each subscription, and, like other magazine editors, she tried to enlist college students as canvassers for the magazine.[5] A later issue ran a notice about commissions on subscriptions: "We want circulation solicitors in every city in the country. Liberal commissions. For particulars address William Saphier, circulation manager" (Oct. 1914, 63). Anderson had ambitions for the *Little Review* to reach a nationwide circulation, and she prominently displayed lists of bookstores that sold the magazine in thirty-six cities in twenty states across the country (June 1914, 55–56).

Notwithstanding its nonmainstream literary content, the *Little Review* during its Chicago years was almost uniquely successful among little magazines in attracting advertising to its pages, due to its similarities to mass market publications. *Diane of the Green Van*, a novel that had won a "$10,000

Prize Novel" contest and sat at the top of the *Little Review*'s best-sellers list, was publicized with several full-page advertisements in 1914 which boasted that more than 75,000 copies had been sold in advance publication. Assuming that the *Little Review*'s audience was not just social radicals, the advertisers assured that "It is not a 'problem' or 'sex' novel; it does not deal with woman suffrage; it does not argue. Diane of the Green Van is frankly a story for entertainment" (Mar. 1914, 64). Most of the seventeen pages of advertisements in the first issue and in succeeding issues were for major American publishing houses; unlike book advertisements in the *Egoist*, they publicized not only "problem" or "sex" novels and political works, but also a full range of mass market publications, including fiction and coffee-table travel books.[6] Lucian Gary, literary editor of the *Friday Literary Review* of the *Chicago Evening Post*, praised the contents of the "astonishing" new review, but especially noted that "The contributions, more than forty pages of them, were followed by seventeen more pages of advertising!" (Mar. 20, 1914, 1).

The *Little Review* also attracted advertisements for nonliterary products. A long-running series of lavishly illustrated advertisements for Goodyear tires, along with those for Mason & Hamlin pianos and the "Carola Inner-Player," were interspersed with book and magazine advertisements. This combination—intellectual and political books, mass market novels, and other commercial goods—suggests that American companies saw little "highbrow"–"lowbrow" distinction between this little magazine of modernist literature and art and more obviously mass market publications. The *Little Review*, which could not rival the huge circulation of magazines like *Munsey's* or the *Ladies' Home Journal*, simply charged companies less for advertising space.

Commodity Advertising and the Cult of Youth

But the intersection with commercial mass culture that most defined the early *Little Review*'s fashioning of modernism—and the Chicago Renaissance—was the cult of youth. Our current idea of adolescence as a period between childhood and mature adult life did not fully exist before the last two decades of the nineteenth century, or even the first decade of the twentieth (Davis ix; Demos and Demos 209–221). Large-scale demographic changes, especially the nineteenth-century movement from farm to city, caused shifts in familial relations. From the increasingly lengthy period between childhood and full adulthood emerged a youth culture.[7] The concept of adolescence became common American currency only around the turn of the century, with the writings of G. Stanley Hall, the president of Clark University and a professor of psychology and pedagogy (Davis xii; Demos and Demos 214). Hall's systematic "child study" movement, coupled with his keen interest in Darwinism, produced not only the first "scientific" concept of adolescence, but also an important role for it in his "theory of recapitulation"—the idea that the development of the child recapitulates the development of the race. His 1904 magnum opus—*Adolescence: Its Psychology, and Its Relations to Physiology, Anthropology, Sociology, Sex, Crime, Religion, and Education*—suggested that adolescence, which he charted between fourteen and twenty-four years of age, was especially important in that it "recapitulated" the most recent of mankind's developmental leaps, and even for a short time advanced man beyond the present stage of civilization. Hall wrote, "Adolescence is a new birth, for the higher and more completely human traits are now born. The qualities of body and soul that now emerge are far newer. The child comes from and harks back to a remoter past; the adolescent is neo-atavistic, and in him the later acquisitions of the race slowly become prepotent" (xiii). Hall associated youth with "vigor, enthusiasm, and courage" (xviii) and felt that the sense of newness and the intellectual and emotional curiosity and aspirations of adolescence marked their great potential but also opened them up to great temptation to succumb to the dangers of urban life (xv). But he was hopeful that education could augment this precious social commodity: "Youth needs repose, leisure, art, legends, romance, idealization, and in a word humanism, if it is to enter

the kingdom of man well equipped for man's highest work in the world" (xvii). Hall's influence on American culture can hardly be overstated, and his work drew wide attention, including that of Margaret Anderson, who had taken over Laughlin's position as the literary editor of the *Continent*.[8]

Many books of the period exemplified the newly popular infatuation with youth and adolescence, and Anderson tracked some of these in her *Continent* columns. In a signed review she called Randolph Bourne's *Youth and Life* "one of the significant and interesting publications of the current literary season" and she affirmed Bourne's claim that "It is the glory of the present age that in it one can be young." She continued: "One dares to be young in this day and age because the potentiality of youth has been discovered, and on every side tribute is being paid to it. To have youth is to have about the best thing God invents" ("The Glory of Present-Day Youth"). Bourne argued that "The younger generation is coming very seriously to doubt both the practicability and worth of [the] rational ideal. They do not find that the complex affairs of either the world or the soul work according to the laws of reason" (230). He advocated substituting for the rational ideal the "experimental ideal": "Life is not a campaign of battle, but a laboratory where its possibilities for the enhancement of happiness and realization of ideals are to be tested and observed" (232–233). In his understanding of youth as idealistic, vigorous, and free to experiment with new life-styles and ideas, Bourne follows Hall's notion of the potential of adolescence to advance the race. Bourne's characterization of the youthful "experimental life" was echoed throughout the *Little Review* a few years later. Using a promotional tactic she would adopt widely in discussing writers for the *Little Review*, Anderson boasted of Bourne's own youth: "[He] confesses to just 25 years."

Many writers shared this positive characterization of youth. But many also shared Hall's warnings about the dangers posed to adolescents by modernity, especially the commercial exploitation of youth culture. Perhaps the most significant was Jane Addams's popular study of youth culture in Chicago, *The Spirit of Youth and the City Streets* (1909), parts of which reached millions of readers in the *Ladies' Home Journal* in October and November 1909. Addams's book documents the shabby and stunted life of working-class youth in the industrial city, complaining that the youthful impulse to play knew no positive outlet in the modern city. Addams blamed modern commercial culture, arguing that young men and women had only gin palaces, dance halls, and movie theaters to entertain them: "Apparently the modern city sees in these girls only two possibilities, both of them commercial: first, a chance to utilize by day their new and tender labor power in its factories and shops, and then another chance in the evening to extract from them their petty wages by pandering to their love of pleasure" (7–8).[9]

Indeed, two manifestations of this commodification of youth helped to shape the *Little Review* as an organ of modernism and modernity in Chicago: images and discourses of youth in advertising, and the youth forums and advice columns in commercial magazines. As the concept of adolescence spread widely through popular discourse, the burgeoning commodity culture helped to solidify the importance of "youth" in America by commercializing it, and, I suggest, by turning the rhetoric of youthful spontaneity, experiment, exuberance, and ardor into a rhetoric of consumption. Images of youthfulness were part of what I have previously discussed as product-symbol strategies for advertising—advertising that associates the buyer with a desirable life-style or a personal characteristic rather than explaining the merits or uses of a product (see chap. 3). Companies hoping to sell to all ages (especially those producing appearance-related products like clothing or health and beauty aids) used images of youth to help promote their product.[10] These national campaigns also reinforced a heightened social preoccupation with youth, one that manifested itself in the business world with the spread of compulsory retirement policies during the first quarter of the century, and with changing medical definitions of aging, which by 1890 began to view senility as a normal result of aging, itself described as a process of loss. The modern American corporate world privileged the mental quickness of youth over the wisdom of experience and age (Lears 168–169).

Youth also became an important target of segmentation advertising during the first quarter of the twentieth century, because manufacturers and merchants quickly realized that young people were more susceptible to the mass marketing of fashion than their parents, and, most important, that they had begun to lead their elders in the choice of commodities.[11] In addition, an emerging marketing theory suggested that the young were important future consumers: they formed their buying habits between their late teens and late twenties (mirroring Hall's parameters for adolescence), and remained loyal in later life to products they chose during their youth (Hollander and Germain 17–18). *Printer's Ink*, the advertising trade journal, noted the importance of advertising to the college market, even awarding a prize to a Wanamaker's advertisement directed at college men.[12] The magazine spotlighted a cigarette company's scheme of hiring college students to devise advertisements that would help the company compete with other tobacco advertisers in the college magazines. One such advertisement proclaimed, "From the time you enter as a Freshman—Slide along the line and get the sheepskin—go on out into the Great Wide—and come back to Reunion—It's FATIMA all along the Line!" (reproduced in *Printer's Ink* Mar. 11, 1915, 25). The *University of Chicago Magazine*, whose pages were filled with images promoting new fashions and local hotels and restaurants catering to college men and women, boasted, "The University of Chicago Magazine carries more advertising than any other publication of its kind in the United States. . . . Say 'University of Chicago Magazine' to the advertisers" (Feb. 8909, 1).

Chicago stores also targeted the young with special fashions and departments, using these newly prominent rhetorics about youthful character. Connecting youth to fashion (and equating both with revolution), The Hub, a Loop clothing store, proclaimed, "Young men's clothes are treated with but moderate consideration in most stores—the idea that a *young* man is only a *small sized* man still remains their policy [hardly the case by the teens]. We've revolutionized things here—created a special young men's store, assembled special young men's styles. Youth, vigor, vim, life and 'pep' characterize our displays—they're as full of 'life' and 'go' as the most ardent admirer of young men's styles could desire" (*Chicago Evening Post*, Apr. 3, 1914, 3). Another Chicago department store, Mandel Brothers, which frequently targeted "girls and flappers" and young men in its advertisements, and had its motto, "The store that keeps step with youth" (*Chicago Evening Post*, Oct. 11, 1915, 14). These advertisements pictured young people dressed in the latest fashions—though never in a family context—and portrayed them as the vanguard of the new (a strategy that greatly appealed to young modernists in the *Little Review*).

Youth, Advertising, and the *Little Review*

The importance of images of youth in promotional culture could not have been overlooked by Margaret Anderson and other writers for the *Little Review*, many of whom had long been involved or interested in the world of advertising. Sherwood Anderson (who moved back to Chicago in 1913 and began to publish early stories and episodes from *Winesburg, Ohio* in the magazine) had worked for years in an advertising firm, and had written articles for a trade journal, *Agricultural Advertising*. Ben Hecht, whose early "Dregs" stories, in the *Review* described the adventures of a "young dramatist" in the streets of Chicago, worked for an advertising agency and advised Anderson and Jane Heap on ways to increase their circulation.[13] John Gould Fletcher, whose "Green Symphony" and other early poems appeared in the *Review*, contributed an article entitled "Vers Libre and Advertising" in which he explained that "in the main I have found American advertisements refreshingly readable" (29). Half tongue-in-cheek, but also half-seriously, Fletcher compared some vigorous advertising texts to "the insipid tinklings of the lyrists who feebly strum in pathetically threadbare meters throughout the pages of most magazines" (29). Aligning advertising with literary modernism, he admonished the "gentlemen of the poets' profession": "How can you expect to find readers by lazily sticking to your antiquated formulas, when even the advertisement writers in the very magazines you do your work for

are getting quite up-to-date?" (30). Jane Heap even consulted with James Howard Kehler, a prominent Chicago advertising agent, about plans to market the *Little Review* as it moved to New York.[14]

An awareness of youth's advertising value, I suggest, led writers for the *Little Review* to package and promote their modernist experiments in writing and living with neoromantic tropes of youth. Advertising strategies put forward an ideal of youth as able to remake itself through fashion and consumption. This understanding of youth appealed to writers, artists, and social thinkers who wished not to build on the traditions of their parents but to effect a radical rupture with tradition. In the first issue of the *Little Review*, Sherwood Anderson discussed "the new note in the craft of writing" in terms of youth and age: "Already a cult of the new has sprung up, and doddering old fellows, yellow with their sins, run here and there crying out that they are true prophets of the new, just as, following last year's exhibit, every age-sick American painter began hastily to inject into his own work something clutched out of the seething mass of new forms and new effects scrawled upon the canvases by the living young cubists and futurists" ("The New Note"). Anderson proclaimed, "It is the voice of the new man, come into a new world, proclaiming his right to speak out of the body and soul of youth, rather than through the bodies and souls of the master craftsmen who are gone." He adds: "In the craft of writing there can be no such thing as age in the souls of the young poets and novelists who demand for themselves the right to stand up and be counted among the soldiers of the new. That there are such youths is brother to the fact that there are ardent young cubists and futurists, anarchists, socialists, and feminists; it is the promise of a perpetual sweet new birth of the world; it is as a strong wind come out of the virgin west." Anderson synthesizes ideas of psychologists and cultural critics like Hall and Bourne, the corporate world's emphasis on youthful intelligence over the experience of age, and advertising images of ardent and brave new youth in a new world and a "new" city, to unite modernist writers, artists, and social radicals around an ideal of fresh youth remaking the world.

Ben Hecht likewise portrayed the *Little Review* as a magazine of youth: "I understand The Little Review to be an embodiment of inspired opinion, an abandonment of mental emotion—Youth," and he praised the review for being "young and idiotic and given to unnecessary emotions and so forth" ("Slobberdom, Sneerdom, and Boredom" 22–25). Again, it is against the entrenched, safe mediocrity of maturity that the *Sturm und Drang* of adolescence refreshingly renews. Other authors followed the lead of advertising in connecting youth to America as a young modern nation. Amy Lowell complained of America's mediocre traditionalism, "That the United States of America is young is a truism which needs no stating, and unfortunately its youth is hopelessly fettered in the strings of tradition" ("Miss Columbia: An Old-Fashioned Girl" 36). But, employing a commercial term, she expressed her hope that the dances of youth culture would help generate American art: "Do you realize that [the turkey trot] is America's first original contribution to the arts! Low or high, that is not the point; it is America's own *product*" (emphasis mine). She echoes Hall's evolutionary understanding of adolescence: "I am told by those who know, that dancing is the first art practiced by primitive peoples. I believe that in our 'turkey-trotting' and 'rag-time' we have the earliest artistic groupings of a new race" (37).

The rhetoric of youth was often susceptible to the hyperbole we associate with avant-garde manifestos. One writer flung defiance at "pedantic," "didactic," and "foolish" old age, and boldly proclaimed: "There is no wisdom but youth. There is no vision but the unafraid impulse of unfettered nerves. The follies of youth are the enduring expressions of art. Man loses his Ego at thirty and becomes conceited" (A. E. D. 37). The idea that youth, while susceptible to chaotic emotional excess ("Youth that laughs at tears and weeps at laughter"), gestured toward future civilization echoes Hall's understanding of adolescence. But the young person's arrogance and disregard for the wisdom of age made him or her the ideal consumer, and, in a connection A. E. D. added to the equation, the ideal artist: "There is no beauty but youth. There is no beauty in age. Ho! you doddering banality with the superior tolerance in your stutter, you are decomposing on your feet. . . . Blessed are the young in heart for they shall be God" (38). This kind of youthful bravado, of course, resembles the manifestos of the Italian futurists, of whom the *Little Review* contributors were aware,[15] but

American modernists did not need the Italian futurists as inspiration to fashion themselves as a youth movement. The socio-cultural developments I have discussed led one American author in 1913 to complain that "We are today under the tyranny of the special cult of adolescence"[16]

Margaret Anderson explicitly and repeatedly made the connection between modernist art and literature and youth, and she tapped into the cult of youth to advertise the magazine. Like product advertisements that offered youthfulness to all ages, a circular promoting the magazine after it moved to New York proclaimed "THE LITTLE REVIEW IS IMMORTAL / surpasses ALL includes ALL outlives ALL / ISMS . . . / cubism, impressionism, futurism, unanism, neo-classicism, ultraism, imagism, vorlicism, dadaism, simulateneism, expressionism—all." Using modern advertising's playful variation of font sizes and typefaces, this circular proclaimed the review's uniquely wide range of interests, including mass cultural topics. It identified the *Little Review* as "A Review of painting, sculpture, design, architecture, prose, poetry, music, dance, drama, notes on the theatre, music-hall, cinema, circus, sports, books and on the triumphs, experiments, crimes of the modern art world— / The Little Review Cannot be imitated." But it also included the rhetoric of youth among the "7 reasons why you should subscribe": "If you are tired of the imbecile, dogmatic pretense of the old magazines," for example, and "If you want to keep eternally young." Like an advertisement for a health or beauty product, a product-symbol strategy is here used to urge the subscriber to identify with eternal youth as opposed to both fleeting fashions and dogmatic old age and tradition. In an earlier subscription promotion in the *Review*, Anderson invoked an image of immortal youth familiar to Chicago theatergoers from a recent performance, asking readers to identify with the boy who never wants to enter the stodgy world of adulthood in J. M. Barrie's *Peter Pan*: "We are sending out this card to the four thousand people who have expressed an interest in THE LITTLE REVIEW. . . . Will you please help? THE LITTLE REVIEW *must* live! To let it die now for want of asking—much as we hate to do it—seems to us too stupid to consider. We feel much as Peter Pan did when he rushed to the footlights with his 'Oh, do you believe in fairies?' But—we do believe!" ("THE LITTLE REVIEW Asks Some Help!").

Within the *Little Review* itself, Anderson promoted the magazine as unabashedly youthful. As she had a year earlier in her review of Randolph Bourne's *Youth and Life*, she repeatedly boasted of the young age of the "new poets" her magazine was promoting: Charles Ashleigh was only twenty-five (Anderson noted in "Our New Poet"): "We look for big things from this young man" and Maxwell Bodenheim only twenty-two ("Our Third New Poet"). In the editorial of the second issue of the magazine, she explicitly compared the *Little Review* to the Pre-Raphaelite magazine the *Germ*. She praised the "astounding" *Germ* and noted that the ages of the founders ranged between nineteen and twenty-two. She explained that "All this came to our mind the other day when some one accused us of being 'juvenile.' What hideous stigma was thereby put upon us? The only grievous thing about juvenility is its unwillingness to be frank; it usually tries to appear very, very old and very, very wise" ("The Germ" 1–2). She admitted that the *Germ* was "frankly young," as shown by its interest in death poetry, but "*The Germ* might have been even more 'juvenile' and so avoided some of the heavy, sumptuous sentences in that Browning review. It would have gained in readableness without any possible sacrifice of beauty or truth. In their poetry the Pre-Raphaelites were as simple and spontaneous as children; in their criticism they were rhetorical. Our sympathy is somehow very strongly with the spontaneity—whatever dark juvenile crimes it may be guilty of—in the eyes of those who merely look but do not see" (2). In her February 1915 editorial, "Our First Year," Anderson noted that "We have been uncritical, indiscriminate, juvenile, exuberant, chaotic, amateurish, emotional, tiresomely enthusiastic, and a lot of other things which I can't remember now—all the things that are usually said about faulty new undertakings. The encouraging thing is that they are said most strongly about promising ones" (1).

In addition to lending a new vocabulary to commodity advertising, youth culture had invaded and given nuances to public space in two important ways, both of which affected the development of

the *Little Review.* Chicago, whose downtown area had been almost entirely destroyed in the Great Fire of 1871, had become a center for architectural experiment and was home to the first proliferation of skyscrapers.[17] Sherwood Anderson's "new birth of the world" and "strong wind come out of the virgin west" described a city of new, intensely public modern architecture. And, as Margaret Anderson and modernist authors in the *Little Review* would do, Chicago advertisers associated images of youth culture with the public spaces and architecture of this young and rapidly expanding urban skyline.

In its 1902 promotional pamphlet, entitled "Progressive Chicago," the Washington Shirt Company used drawings and photographs to connect its quick rise to prominence to the growth of the city of Chicago.[18] But this growth of both city and company was figured as a change not from childhood to adulthood, but rather from childhood to a vibrant youth. A drawing of the old wooden post office in early Chicago precedes photos of the enormous new stone Post Office and Federal Building and of the Washington Shirt Company's Loop stores. The text parallels Hall's vision of an atavistic childhood recapitulating the unevolved primitive—here figured as the "slimy, soggy marshes by the water's edge" of early Chicago—and then giving way to a "neo-atavistic" adolescence, gesturing toward the future of civilization: "To-day the broad avenues, beautiful boulevards, and crowded business districts of Chicago are continually beautified and improved by the noble structures that point to continued growth and expansion as well as results achieved. The erection of the new Post Office and Federal Building by the United States Government in the very heart of the city already indicates the definite business center of the metropolis." Like Hall's adolescents, both company and city were portrayed as an apotheosis of some future stage of modernity—potential in the act of realization, vigorous and capable, idealistic and still growing.

The Washington Shirt Company emphasized the alacrity and idealism of youth: "The service provided for customers is that of 'quick action,' and it is well known that 'you don't have to *wait* at The Washington Shirt Company.' . . . For the most part young men comprise the working force, and all enter heartily into the work of the firm. With good-natured loyalty they join in supplying the needs of 'His Majesty the American Citizen.'" It also connected the advertising rhetoric of Chicago's public space and the "youthful" company itself with an ideal of modernity: "[Visitors] will see stores combining the most modern features of mercantile establishments as well as the most recent dictations of fashion in the dress details of a modern man." Modern man, in a modern city—modernity itself—was figured as fashion and consumption, and the consumer was explicitly also portrayed as a youth. "His Majesty the American Citizen" was depicted in a drawing that the company continued to use for at least a decade, of a well-dressed but casual and very young, even adolescent-looking, man. The customer has youthful features and no facial hair. He smokes a cigarette, leaning back in a chair with an American flag draped over it, propping himself up with his foot on a crown. The evocation of the Yankee youth, brazen, almost smug-looking, flouting the authority of old traditions (just as America had thrown off the paternal shackles of monarchical Britain), urged customers to identify with a young and growing city and work force. The company brochure paralleled Bourne's understanding of the "experimental life" by proclaiming that the secret to the growth of this young work force was the motto: "Never fear a mistake, but *fear to repeat one.*"

Similar visual images and text were used to extol a vision of the youth and growth of both company and city. Fort Dearborn National Bank juxtaposed its logo drawing of the old wooden Fort Dearborn (the original site of Chicago) with the modern brick skyscraper bank building.[19] The text asserted "One of Chicago's foremost banks. It typifies the spirit of the city for strength, security and steady growth." (This "modern bank" reached out to the young with special accounts as well.) Many advertisements used images of youth in the amazing new urban architecture of Chicago. Local hotels and dance halls advertised with illustrations of young men and women in the new buildings. The glamour of the young was paralleled by the glamour of such new public spaces as the Auditorium Annex and its restaurants, bars, and corridors.[20]

Jane Addams had complained about the way in which youths had entered the public spaces of Chicago—wandering the streets and spending their money in the dance halls, gin palaces, and movie theaters. But Margaret Anderson and other *Little Review* authors were more captivated by Chicago as a city in which youth could transform public space. The *Little Review* serves as a document of this modernist fascination with the unexpected charged moments of urban public experience. While Addams lamented the commercialism, Anderson and others saw the possibility for such spaces to generate art in spite of themselves. Anderson wrote about discovering a young German violinist who had been a child prodigy in Europe, playing in the very epitome of the modern mercantile economy, the department store: "In one of Chicago's big department stores of the cheaper type you may—provided you're something of a poet—walk straight into the heart of a musical adventure, it is that amazing, resentful, and very satisfying adventure of discovering genius at work, under the by no means unique condition of being unrecognized" ("Nur Wer die Sehn-sucht Kennt," 34). She discovers the great violinist in the lunch room, surrounded by people who clamor for more "tawdry" fare: "In the midst of it the waitresses rush back and forth, the patrons eat their food with interest, only pausing to applaud when some tawdry vaudevillian sings a particularly vulgar song. The dishes clang, some one upsets a tray with a great crash, and at intervals there is a tango outrage by a couple who know nothing about dancing. Underneath it all the violin throbs its deep accompaniment" (35). The tastes of the majority of shoppers in the Loop may be "vulgar," but for the appreciative, Chicago provided public space for a young performer (or for a young magazine).[21]

Anderson played on the connections among advertising, the public spaces created by department stores, and the readers of the *Little Review*. In the June–July 1915 issue, as advertising had fallen off—largely due to the *Little Review* writers' strident affirmation of Emma Goldman and anarchism (Bryer 119)—Anderson, always with a taste for the eyecatching, set aside seven full pages of the issue, inserting only a small box of type in the center of each. The first offered $5.00 to anyone who secured a full-page advertisement for the magazine, and then noted, "On the following pages you will find the 'ads' we might have had in this issue, but haven't" (56). These included advertising advice and potential "ads" for Chicago Loop stores—Mandel Brothers, Marshall Field's, Carson Pirie Scott, McClurg, the Cable Piano Company—and for the New York publisher, Mitchell Kennerley, who had regularly advertised in the *Little Review* in the past.

In addition to the cleverness of the sales pitch, these "ads" connected the *Little Review* with the consumption and fashion advocated by modern corporate America. Anderson suggested to Mandel Brothers how they might promote themselves to her readers as "the most original and artistic store in Chicago" and she concluded: "If they should advertise those things here I have no doubt the 1,000 Chicago subscribers to The Little Review would overflow their store" (57). The public space created by the shopping district could appeal to readers as both consumers and artists. She derided Carson Pirie Scott's sense of fashion as lagging behind that of the magazine: "The Carson-Pirie attitude toward change of any sort is well-known—I think they resent even having to keep pace with the change in fashions" (59). Yet, in addition to the Radical Book Shop and other bookstores, both McClurg's and Carson Pirie Scott's bookstores carried the *Little Review*.

So the *Little Review* clad itself in the mantle of youth and, as the Washington Shirt Company would put it, reached out to Progressive Chicago and the rest of the country. Though it frequently struggled financially, the *Little Review* maintained a fairly large readership by the standards of little magazines, unlike its transatlantic counterpart, the *Egoist*. It seems to have ranged between 2,000 and 3,000 subscribers.[22] When the review became more a part of the international modern art world, it even opened a Little Review Gallery in New York that sold books and art and mounted several major exhibitions during the twenties—the Machine Age Exposition, the International Exposition of New Systems of Architecture, and the International Theatre Exposition.

As Margaret Anderson and other *Little Review* writers discussed the magazine using tropes of youth, its readers received it as the young voice of social and aesthetic progress. Like the *Freewoman*,

New Freewoman, and *Egoist*, the *Little Review* had a lively correspondence section that created a discursive public space for its readers to discuss the issues the magazine raised. The section's title, "The Reader Critic," ascribed an equal status to correspondents and primary authors alike, and (like the Freewoman Discussion Circles in London) this lively public arena, at the suggestion of readers, soon spilled over into organized public meetings at the Fine Arts Building on Michigan Avenue— in many ways the center of the Chicago Renaissance, as it was the home of the *Little Review*, the *Dial*, Browne's Bookstore (designed by Frank Lloyd Wright and managed by the editor of the *Dial*), and the experimental Little Theater.[23] As Anderson put it, "An attempt to influence the art, music, literature, and life of Chicago is an exciting and worthy one, and should have its opportunity of expression" ("To Serve an Idea").

Many of the readers who wrote to the *Little Review* understood the magazine in terms of youth. One Chicago reader wrote that "It is just into terrible inertia—this every day and *every* day humdrum conservatistic acceptance of things as they are—that THE LITTLE REVIEW comes with its laughter of the gods; it is so joyous, so fearless, so sure of its purpose, and hurls itself against it with its vital young blood and its burning young heart" (M. Lyon). Youthful "enthusiasm" was often associated with the review. Another reader noted, "If I do not always agree with it I at least have the sense of arguing with a friend whose intellect I respect—never did I feel that for any other publication. And I love freshness and freedom and enthusiasm as I love youth itself—they're the qualities that promise growth" (Smith). Another acknowledged that "as an elderly gentleman with a large family I bow to the superknowledge and exuberance of your youth, and freely admit you are giving full value for the money" (Weedon). Another reader from Chicago proclaimed that "*The Little Review* bubbles over with enthusiasm and love of life" and contrasted its spirit to that of her wasted childhood in the slums, during which she tried to escape the bareness of strict duties, quarreling, and poverty (Interested Reader 56).

Youth and the Public Sphere

Beyond the images of youth remaking itself anew that corporate America and the *Little Review* propagated is the other important aspect of the ideology of youth I have been sketching—its *public* nature. The vision of youth in public, away from the control of the family in domestic space, was perhaps the most controversial aspect of the cult of youth. So the cultural anxiety created by commercial culture, central to my analysis of the *Little Review* as an organ of youth, involved the relation of youth to the public and domestic spheres. Just as the *Little Review* was packaged and received as the embodiment of the cult of youth, it also was a forum for the discussion of youth in relation to traditional social, cultural, and political institutions—chief among them, the family. Anderson and her contributors frequently rehashed and discussed what was essentially Anderson's founding tale of her own independence in the modern city. If youth or adolescence was to live up to the high expectations that both intellectuals and advertisers had provided for it, it would require freedom from stifling institutions. Anderson explained: "The average girl of twenty in a conventional home hates to be told that she must not read Havelock Ellis or make friends with those dreadful persons known vaguely as 'socialists,' or that she must not work when she happens to believe that work is a beautiful thing. She is submerged in the ghastly sentimentalities of a tradition-soaked atmosphere—and heaven knows that sentimentalities of that type are difficult to break away from."[24]

Ben Hecht's sketch of "The American Family" likewise portrayed a daughter whose spirit of rebellion is crystallized by a book, or a friend, or a man: "There is an awakened mental curiosity, a perceptible inclination to break from the oppressiveness of the surrounding dead. In the night the daughter wonders and doubts. She would like 'to get away'—to go forth free of certain fiercely

applied restrictions and meet a different kind of folk, a different kind of thought" (I). But, he goes on, "Revolt is for souls still living, and the living are weaker than the dead. The living soul is a lone, individual force, its yearnings are ephemeral and undefined. The mother knows what they are. The dead always know what it is they have lost" (I). So the mother (like Margaret Anderson's own mother) binds the daughter to oppressive family life, with discussions of the duty of children to parents and of proper behavior. In Sherwood Anderson's story "Sister," the narrator explains: "[My sister] became a devout student and made such rapid strides in her classes that my mother— who to tell the truth is fat and uninteresting—spent the days worrying. My sister, she declared, would end by having brain fever" (3). But the fifteen-year-old girl tries to emancipate herself sexually and is dragged into the stables by her father and beaten with the carriage whip. Many of the contributions to the early *Little Review* touch on this theme of youth trying to free itself from the stifling death-grip of the conventional "mature" adult world, and, of course, the fashion and product advertisements aimed at youth helped promote images of youth away from the confines of family life. At this level, the avant-garde and the world of commercial advertising were walking hand in hand.

This interest in the plight of youth seeking intellectual nourishment, excitement, and freedom from the domestic sphere accompanied an interest among *Little Review* writers and readers in the education of both adolescents and children. In "The Renaissance of Parenthood," Anderson, who saw herself as still "of the age that must classify as 'daughter,'" wrote of the necessity of reforming the way parents relate to their children and published a letter from a young woman to her mother. Anderson explains that the woman "was in her early twenties; she had a sister two or three years younger, and both of them had reached at least a sort of economic independence. She had come to the conclusion, after a good many years of rebellion, that the whole fabric of their family life was wrong; and since it was impossible to talk the thing out sensibly—because, as in all families where the children grow up without being given the necessary revaluations, real talk is no more possible than it is between uncongenial strangers—she had decided to discuss it in a letter" (6–7). The letter suggested an equal stature for the mother and her two daughters and the elimination of the authoritative and sentimentalized role of motherhood. Anderson notes her own use of such tactics with her father at home. But the situation of the letter writer, who is not named, and the suggestions in the letter are so much like those of Margaret Anderson that I suspect the letter she quotes was her own to her mother. In any case, she uses the article to talk about current theories of childhood education by Shaw, Ellen Key, and Charlotte Perkins Oilman, concluding: "The new home is a recognition that the child is not the only factor in society that needs educating. It assumes that no one's education is finished just because he's been made a parent. It means that we can all go on being educated together" (14).

Other contributors elaborated in more detail some of the issues surrounding the education of children and adolescents. Dr. Rudolf von Lie-bich called for a "Ferrer" or "Modern" school in Chicago that emphasized a secular and "natural" education in ethics, science, and other knowledges, "free from the noxious taint of authority, superstition, or respectability" (55). Von Liebich invited interested parties to notify the *Little Review* and other organizers. Many articles addressed other contemporary writings on education theory and emphasized the importance of avoiding superstition and stifling authoritarianism with children.[25]

This packaging of the *Little Review* as a youthful journal, its frequent examination of issues of the freedom of youth, and, perhaps above all, the open forum of "The Reader Critic" correspondence section quickly attracted young or adolescent readers to the review.[26] In the September 1914 issue "A boy reader" from Chicago wrote, much as Margaret Anderson had written to the "The Perfect Comrade," to chronicle the intellectual deadness, the lack of personal freedom, and the superstitious religious attitudes of his family life. He mentions Shaw plays and prefaces that caused him to reassess his own family life, and, just like Anderson and other readers, he resorted to writing letters to his

parents about domestic problems: "Of course when I presented my case to my parents I was met with that attitude always displayed toward youthful self-assertion. To make my case clear to their somewhat bewildered minds I drew up a list of grievances: there were thirty-three concrete faults in the existing order that must be stamped out or radically changed" (Boy Reader 57).

In a later issue "A Boy" in Chicago wrote: "I am a boy sixteen years old, and one could not expect me to know much about poetry—especially free verse. But I have heard of your magazine as a magazine that was ready to print what all kinds of people thought. So I have written a little verse—it is not a poem—telling you something about what is going on inside my mind, for these matters trouble every boy's mind, although you may think that we are light-minded at my age" (Boy, letter and poem, 38). The "Boy's" poem, "Blindness," chronicled his wanderings through Chicago streets seeing the "deformed and sick and hungry," but noting that he cannot heal the sick or make the streets cleaner:

> So I just think of other things.
> Of my books at home, or the tennis courts in the park,
> Or my pretty sister or anything.
> There is nothing wrong in my own world.
> I am happy. I like my school well enough,
> I have my boy friends, and they are healthy athletic boys.
> All the girls I know are good girls,
> With charming and high minds.
> And yet it is true that many boys lie and steal,
> And girls run away and are dragged into lives of shame.
> Why do I not see it? Why do I not do anything?
> Why am I so helpless, if I have any duty to others?

Regardless of the merits of this verse, the salient point here is that a sixteen-year-old student not only was reading the *Little Review*, picking up on its social agenda, and even making the connection to free verse as the poetic of modernity, but also decided, like the earlier "Boy Reader," to make his complaint public and to question the complacency that marked youth's traditional place in society.

In the next issue, Arthur Davison Ficke, a frequent contributor, wrote in: "Tell your 'sixteen year old boy' that his poem is damn interesting—but to cut out the 'only sixteen' and 'one could not expect me to know much about poetry' stuff. At sixteen most of us had read all the poetry in existence, and were busy writing epics that were to re-make the world. Tell him to stop being a sixteen-year-old worm, and to get up on his hind legs and bite the stars. Tell him to write arrogantly of this 'charming' world he sees. It's time enough to be humble when one is old." Ficke thus affirmed youth as exuberant, arrogant, and, above all, the voice of progress and renewal in the modern world. The correspondence continued in the next issue, as the "boy" sent in a free-verse poem, "Impressions of the Loop," about a boy walking through the streets of the mercantile district of Chicago's downtown, watching the women judging each other's fashions and wearing brand-name perfumes, while miserable, sick men and women sat begging on every corner, uncared for by the rich.

The *Little Review* and Youth Columns

Thus not only was modern youth in the public spaces of the new city a persistent theme in the *Little Review*, but the magazine also provided a public forum for the discussion of "youth issues" and young people's thoughts and feelings. This forum closely resembled a widely popular institution

of commercial journalism—letter and advice columns for youth in newspapers and magazines. Throughout the nineteenth century, there had been an increase in the number and popularity of "young people's" magazines, but these were primarily children's magazines like *Youth's Companion* (which hit a circulation of around a half million or more between the 1890s and World War I), *American Boy*, and *St. Nicholas* (Peterson 158–162). Family magazines like the *Continent* also had children's sections, "Young America" and "Young People's Service." But women's and family magazines in the late nineteenth and early twentieth centuries also featured write-in columns for people whom Hall would categorize as "adolescents."

These columns often took the form of advice departments. The adolescent or young adult could write to Annie Laurie's "Advice to Girls" in the *Chicago Evening Post*, to *Good Housekeeping*'s "The Perfect Comrade" (to whom Anderson herself had written), or to the numerous departments in the *Ladies' Home Journal*. In 1883, Cyrus Curtis and Louisa Knapp Curtis turned their newspaper column for women into a new magazine, *Ladies' Home Journal*. This magazine became a forum for the discussion of gender issues, as it took letters from readers and published general articles and advice on aspects of women's lives (Damon-Moore 37). By 1889 the magazine's offices in New York, Chicago, and Philadelphia employed seven to ten people a day just to open letters (Damon-Moore 27). *Ladies' Home Journal* and other women's magazines, like *McCall's*, *Woman's Home Companion*, and *Good Housekeeping*, were predicated on the recognition of women as consumers, and, as Damon-Moore suggests, they were a gold mine for advertisers and the publishers alike as they helped explicitly to identify women with commodity consumption (24–25). However, by the 1890s the new *Ladies' Home Journal* editor, Edward Bok, had realized that not just women read the magazine. He began to pursue men and adolescents of both sexes with new departments. "Side Talks with Girls," aimed at sixteen- to twenty-five-year-old women, was followed by "Side Talks with Boys" in 1891, "Problems of Young Men" in 1894, and "What Men Are Asking" in 1897 (Damon-Moore 73–75). As the *Little Review* began publishing, *Ladies' Home Journal* included advice departments for every concern, as well as regular columns like Margaret E. Sangster's "My Girls," Mrs. Burton Kingsland's "The Prevailing Etiquette for Young Men," and "The Girls' Club" to which young readers could write.

Given the close tie between targeted audiences and commercial advertising in journals like *Ladies' Home Journal*, as youth or adolescence became a part of the consumer culture, the mass market publishing industry created special forums to appeal to young audiences. But whether such forums can legitimately be considered institutions of a "public sphere of youth" is debatable. Habermas sees such intertwinings of the content of a magazine and the interests of its advertisers as a debasement of the public sphere: "Ever since the marketing of the editorial section became interdependent with that of the advertising section, the press (until then an institution of private people insofar as they constituted a public) became an institution of certain participants in the public sphere in their capacity as private individuals; that is, it became the gate through which privileged private interests invaded the public sphere" (*Structural* 185). Visions like this, and like those of Ford and, in a different way, Monro, presuppose some idealized public sphere located in the past that then is understood to decline as the press becomes increasingly commercial. Clearly the commercial market opened up new tools and spaces for a number of different kinds of journals—from the avant-garde to the most explicitly profit-motivated—so Habermas's sense that the increasing capitalization of the media precludes public deliberation cannot wholly be true. But, for reasons that Habermas does not address, we must consider the effect of cultural anxieties about youth upon the public nature of these columns.

Not only were youth columns thoroughly structured by commercialism, but also, in the case of *Ladies' Home Journal*, they even ceased to print the letters from the young writers and only dispensed advice. Damon-Moore notes: "There was a genuine respect in Knapp's *Journal* for the opinions of readers, and there was a real give-and-take relationship between the magazine and

its audience. Bok's service departments, in contrast, came to focus more exclusively on answering reader questions" (69). They provided much useful information and advice on all issues interesting to their correspondents, but there was little sense of a public conversation taking place, such as the *Little Review* tried to foster.

In addition, and perhaps most important to the career of the *Little Review*, as the cult of youth arose and was crafted as one of consumption and abandon to fit the needs of commerce, a simultaneous attempt to regulate youth's actual self-gratification also emerged. Advice columns tended to be very normative in regard to social etiquette and personal behavior. Anderson wrote of Clara Laughlin's "The Perfect Comrade" column: "The advice seemed to prescribe none of the immobility usually urged upon the young, so I decided to ask Miss Laughlin how a perfectly nice but revolting girl could leave home" (Anderson, *Thirty Years'*, 12). The answer precipitated Anderson's move to Chicago, but "The Perfect Comrade" columns in general staunchly supported a normative patriarchal view of the family. In one "The Perfect Comrade" column about careers for young women, possibly the very column that so excited Anderson, Laughlin wrote that careers in the big city were good for young women, not only for young women's own self-fulfillment, but also because they prolonged the period between school and marriage and thus kept girls from too soon entering upon marriage to the wrong man (Feb. 1908, 152–153). But she was careful to note that the career should not be permanent but should be abandoned after marriage: "You say I seem to take it for granted that your careers will be brief? I certainly like to think so, for the women I've known with whom a career remained the chief business of life are not the happiest women among my friends" (153). Girls who have careers benefit from a greater chance of meeting eligible young men than those who stay at home with their mothers, and "it not infrequently happens that the girl of today learns in her brief pursuit of a career some things that help her to a finer comradeship with her husband than the famous housewife of bygone days was wont to enjoy" (153). While encouraging young women to move to urban areas and take on careers, and while soliciting responses and opinions from her youthful readership on the issues she raised, Laughlin nevertheless adamantly affirmed that all women should marry, and that their careers and independence should immediately be given up to perform domestic duties for their breadwinning husbands. Jane Addams might have objected that young women were not meeting the right sort of men in the cities, but Laughlin would merely have countered with more advice on how to live a proper life in the city.

Though many youth columns *seemed* an open forum for young people to discuss important issues publicly, the commercial character of the magazines fostering them ensured that only a range of opinions acceptable to advertisers and readers could be discussed seriously. Furthermore, the "parental" columnist served to regulate the discussion. These magazines promoted a vision of youth as independent consumers, as, for instance, *Ladies' Home Journal* even began a long-running "Girls' Club," whose motto was With One Idea: To Make Money. To earn "pin money" to spend on clothing, vacations, schooling, and long-desired merchandise, the club organized "girls" from their teen years through their twenties to sell subscriptions to the magazine, rewarding them with commissions and with jewelry, marriage chests, and other gifts bearing the club's symbol, the swastika. The Girls' Club, which even had its own magazine, the *Swastika*, had thousands of members and filled the Curtis publishing company's coffers. But it also connected youth to consumption and portrayed its members as independent consumers, free from the constraints of the family purse strings (which portrays the young woman alone behind the wheel of her own car on a vacation, with the club's seal of approval, the swastika, on the car). But when the manager of the Girls' Club was not simply promoting the consumer power of the club members, lauding high-sellers, she chose to print letters that also cautioned against excess. A "Girl" wrote to *Ladies' Home Journal* to warn about the peril caused by new fashions resembling the clothing worn by prostitutes: "Nowadays when we enter a restaurant and dance place it is hard to know who is who. We all know that the American women

and girls copy the fashions and the costumes that are made to attract and allure for the demimonde in Paris. Many American women who consider themselves *comme il faut* have their hair touched up, their faces and lips painted. That used to be the hallmark for a certain type of woman; it is not so now. Yet while the woman has changed outwardly many still cling to their old-fashioned ideas of class distinction." The letter gave examples of men and women who had mistaken respectable young followers of fashion for prostitutes.

These magazines negotiated cultural anxieties about the thin line between consumer abandon and moral abandon by using their "parental" authority to both legitimate and regulate these desires. Nowhere is this more evident than in discussions about clothing and fashion. As "The Perfect Comrade" explained, even invoking divine support for clothing fashions: "A Pretty girl in Ohio (I know she's pretty because she sent me her picture) writes to ask me if I think it's wrong for her to care about pretty clothes. Wrong? Why, bless her heart, it would be radically wrong if she didn't! Anything that God made that doesn't care how it looks, is not as God made it; the devil of 'don't care' has taken possession of it" (Laughlin, Oct. 1908, 433). This column, following a series of "Good Housekeeping Patterns," went into detail about appropriate clothing to purchase for various occasions. "The Perfect Comrade" explained that when she sees a woman in public who hasn't kept up her appearance, she assumes the woman to be a "'slack' wife and mother and citizen" (433).

However, the final paragraph of the article cautioned, "I don't suppose it is necessary to tell any girl in this circle of readers how worse than worthless are the clothes for which one pays ever so slightly in self-respect. Thousands of girls go to perdition every year, lured by a silk petticoat, a plumed hat. If I loved dress so well that I was willing to lose even the least little bit of my self-respect to get them, then indeed should I think it 'wrong for me to like pretty clothes.' . . . For, as I have said, one of the first things we must learn in this world, is to take just the right account of clothes and never to take too much" (435). Laughlin simultaneously justifies the mobilization of desire for consumption that *Good Housekeeping* and its advertisers espoused and limits that desire in youth, fending off any number of implied excesses—sexual impropriety, financial mismanagement, vanity, placing appearance as the mark of character, and so forth. This was the norm in columns aimed at youth. Letters, if printed at all, were carefully chosen; parental advice was carefully dispensed even while propagating a vision of independence and consumer freedom.

While the *Little Review* tried to create a public institution for youth to exchange ideas freely about the nature of modern life, there was not much of a precedent for this kind of freedom of thought for youth or for a noncommercial basis for the letters columns. And soon this lack of self-regulation led to complaint. After the first issue, "Sade Iverson" wrote to congratulate Anderson on the "insouciant little pagan paper" but patronizingly cautioned her: "You must not scoff at age, little bright eyes, for some day you, too, will know age; and you should not jeer at robustness of form, slim one, for the time may come when you, too, will find the burdens of flesh upon you. Above all, do not proclaim too loudly the substitution of Nietzsche for Jesus of the Little Town in the niche of your invisible temple, for when you are broken and forgotten there is no comfort in the Overman. One thing more: Restraint is sometimes better than expression."[27] Later in the same year, a Reverend A. D. R. in Chicago wrote in to complain that his daughter was exposed to the frequent discussions of Nietzsche: "I earnestly request you to discontinue sending your impertinent publication to my daughter who had the folly of undiscriminating youth to fall in the diabolical snare by joining the ungodly family of your subscribers. As for you, haughty young woman, may the Lord have mercy upon your sinful soul! Have you thought of the tremendous evil that your organ brings into American homes, breaking family ties, killing respect for authorities, sowing venomous seeds of Antichrist-Nietzsche-Foster, lauding such inhuman villains as Wilde and Verlaine, crowning with laurels

that blood-thirsty Daughter of Babylon, Emma Goldman, and committing similar atrocities? God hear my prayer and turn your wicked heart to repentance." But these early complaints about corrupting young readers were mild compared to the trouble the *Little Review* would soon experience as it moved to New York.

The *Little Review*, *Ulysses*, and Censorship: The Seaside Girl in America

Within the context of the publishing industry's greater attention to youth, and the *Little Review*'s attempts to address and reflect this "youth culture," one of the more notorious incidents in the history of Anglo-American modernism—the war against the *Little Review* waged by the post office and the New York Society for the Suppression of Vice—becomes more comprehensible. Ulf Boethius argues that popular culture has always been seen by some as a threat to the young, and that there have been periodic campaigns against popular culture—what sociologist Stanley Cohen calls "moral panics" (Boethius 41). One of the most intensive of these campaigns, begun in the 1870s by Anthony Comstock, targeted titillating mass market novels, photographs, and any other materials that threatened the morals of the young. Comstock created the New York Society for the Suppression of Vice in 1872, and by 1873 he had helped launch a law prohibiting materials considered obscene or harmful to youth from being carried by the postal service. The state appointed Comstock as special agent to ensure that the law was followed, and he oversaw postal censorship for four decades (Boethius 40).

The Society for the Suppression of Vice regulated young consumers even while the mass market culture and advertisers began to reach out to them. The first seizure by New York postal authorities of a *Little Review* issue was due to Wyndham Lewis's story "Cantleman's Spring-Mate" (Oct. 1917), which was held to violate the criminal code against "obscene, lewd, or lascivious publications" (Bryer 243–250). The *Little Review*'s reluctant lawyer and frequent patron, John Quinn, wrote Judge W. H. Lamar, the solicitor of the Post Office Department in Washington D. C., complaining that Lewis's story about the sexual exploitation of a village virgin by a young soldier did not violate federal statute. However, as Quinn later explained to Anderson, Lamar read the piece and "thought [it] unfit for innocent young minds," though Quinn had argued that the *Little Review*'s readership was really comprised of "mature and worldly minds."[28] The *Little Review* lost the case in New York. Setting the stage for the *Ulysses* trial soon to come, Judge Lamar had argued about the corruption of youth, and Anderson and Quinn had unsuccessfully tried to defend against this argument by claiming that the readership was a select circle of adults.

Again in 1919 and 1920 when the Society for the Suppression of Vice (now under John Sumner) was waging its campaign against the serial publication of *Ulysses*,[29] Quinn argued to Lamar that the magazine was not for or read by the young. He quoted to Lamar a statement by Anderson that the audience was "composed chiefly of artists, thinkers and men with a passionate belief in the need for an intellectual culture in America. . . . The general ruck of people would as soon read The Little Review as take a dose of castor oil." She asserted that young boys and girls of the "convent, young girls' seminary, young boys' Sunday school" age did not read it and would not understand it anyway.[30] However, given the early advertising of the *Little Review* in Chicago with images of youth, its attempts to market itself as a kind of youth forum, and the fact that teenage boys and girls did read it, the attacks on it as unfit for the young mind were perhaps not as irrelevant as Margaret Anderson tried to suggest.

Though the post office had incinerated three issues containing *Ulysses* chapters ("Lestrygonians" in Jan. 1919, "Scylla and Charybdis" in May 1919, and "Cyclops" in Jan. 1920), it is perhaps not surprising that the *Ulysses* episode that drew the ire of John Sumner's Society for the Suppression of Vice was the "Nausicaa" chapter in the July–August 1920 issue, which narrates the encounter on the

strand between Leopold Bloom and the young Gerty MacDowell (see Ellmann 502–503).[31] I believe that "Nausicaa" seemed particularly threatening largely because it touched so powerfully on all the American concerns about a consumer youth culture that I have been discussing in this chapter. It is perhaps the most famous modernist portrait of "youth in public," and its presence in the *Little Review* confirmed the mounting anxieties that the magazine sought out and corrupted youthful readers. (Appropriately enough, the "Nausicaa" publication in the *Little Review* drew the attention of New York's district attorney only when he found his daughter reading a copy of it [Leckie 78]!)

Much of the critical attention given to "Nausicaa" in recent years has considered the role of commodities and advertising in the thoughts of a young woman, Gerty MacDowell, as she sits on a rock on Sandymount Strand in Dublin, displaying herself for a mysterious onlooker (who turns out to be the masturbating Leopold Bloom). Even the most superficial reader of Joyce's chapter will be overwhelmed by the myriad allusions to consumer culture. Gerty's thoughts dwell on products like "white rose scent" (May–June 1920, 71), patent medicines like "iron jelloids" (Apr. 1920, 45), and a long list of clothing like "a neat blouse of electric blue, selftinted by dolly dyes, with a smart vee" combined with "the newest thing in footwear" (Apr. 1920, 47). These products were purchased at the new bastions of consumerism, department stores like Clery's, and were advertised in mass market magazines like the weekly *Princess's Novelettes*, whose columns and advertisements dominate Gerty's thoughts.[32] Indeed, the kinds of columns aimed at American adolescent girls and women (in magazines like *Good Housekeeping* and *Ladies' Home Journal*) similarly served as arbiters of appearance and decorum in Gerty's Irish adolescence.

The narrator, as is so often the case in Joyce's work, adopts the idiom of the narrated: Joyce parodies the styles of the sentimental texts that Gerty reads, like Maria Cummins's novel *The Lamplighter*, or poems that begin with lines like "Art thou real, my ideal?" that Gerty copies out of newspapers in "violet ink that she bought in Wisdom Hesly's [sic] (May–June 1920, 71). But he also fuses with this style the language of advertisements, fashion journalism, and youth magazine advice columns: "Time was when those brows were not so silkily seductive. It was Madame Vera Verity, directress of the Woman Beautiful page of the Princess Novelette, who had first advised her to try eyebrowleine which gave that haunting expression to the eyes, so becoming in leaders of fashion, and she had never regretted it" (Apr. 1920, 46).

Jennifer Wicke, Suzette Henke, Thomas Richards, Garry Leonard, and others have underscored the staggering frequency and complexity of allusion to the turn-of-the-century Irish consumer culture, and Richards and Leonard in particular have suggested that consumer advertising structures Bloom's "consumption" of Gerty. Richards explains that the phrase "queen of ointments"(Apr. 1920, 45), which appears in "Nausicaa," was the slogan for Beetham's "Larola" and that in the 1880s and 1890s, Beetham marketed ointments and lotions with a popular advertising formula, "the seaside girl" (226). Invoking these advertisements, and the popular song that Blazes Boylan sings, Bloom thinks about Gerty, "Didn't look back when she was going down the strand. Wouldn't give that satisfaction. Those girls, those girls, those lovely seaside girls" (July–Aug. 1920, 48). Even beyond the many specific allusions to advertising campaigns, department stores, and products that appear in her thoughts, Richards suggests that Gerty herself is meant to evoke this popular nineteenth-century advertising phenomenon and explains that the image of the seaside girl created an alluring vision of young carefree "nymphs" on view for men, an image that played on a rapidly growing youth culture, like the one I have discussed in America. Many health and beauty products advertised with this image, and seaside resorts used it to promote a contained and socially acceptable vision of sexual display on the beach: as Richards puts it, "The seaside girl displays an all-purpose allegiance that accommodates a violation of a sexual taboo just as easily as it promotes a white skin befitting the modest and the chaste" (234).

But Richards's admirable tracing of the context of the seaside girl and the myriad advertising images in the chapter leads him to a pretty bleak reading of young Gerty and of the commodity

culture that so dominates her thoughts. He argues that Joyce portrays advertising as "a coercive agent for invading and structuring human consciousness" (207) that makes human experience "generalized and impoverished" (211). Moreover, Richards argues that Gerty's self has been constituted by advertisers as a passive object of the male gaze: "Women were taught to identify with the seaside girl image while men were encouraged to desire it. These gendered variants are illustrated simply and directly in 'Nausicaa,' where Gerty consumes the seaside girl while Bloom consumes Gerty. . . . Male identity exists prior to and during the act of consumption; female identity gets effaced in the process. Bloom remains Bloom, but Gerty must become the seaside girl" (246).

Building on the work of Richards and others, Garry Leonard argues that Gerty "carefully advertises and packages her sexuality as a complex masquerade of femininity designed to attract a male consumer—in this case, Leopold Bloom. Far from being sexually naive and one-dimensional [as Richards portrays her], Gerty has a keener understanding of sexuality than Bloom does because she understands that the anatomical act of sex is as irrelevant as whatever is inside a carefully advertised package" (99). Leonard explores the ways in which Gerty "packages her body in a manner that advertises the culturally accepted norm of femininity" (99), not simply because she has been structured by advertising to think this way, as Richards argues, but rather because the demographics and economics of turn-of-the-century Ireland necessitated women turning themselves into commodities to get husbands, and to avoid that other kind of sexual commodification—streetwalking.[33]

Readings like those of Henke, Richards, and Leonard locate "Nausicaa" in the consumer culture of Britain and Ireland and interpret the role of that consumer culture in Gerty's relationship to Bloom. But the text may be resituated in the American context of the *Little Review* and American commercialized youth culture. As a result of publishing "Nausicaa," Margaret Anderson and Jane Heap were found guilty in the *Little Review* obscenity trial and were forced to pay a $50 fine each and to stop publishing *Ulysses*. As Ellmann explains, John Quinn "had to certify that the *Nausicaa* episode was the worst in the book to save his clients from being sent to prison" (503); given American cultural anxieties about youth culture, "Nausicaa" actually *was*, in fact, the "worst chapter" in the book. Of course, if the *Little Review* had been able to continue publishing *Ulysses*, "Circe" would, no doubt, have been confiscated for its graphic portrayal of sado-masochistic sex in a brothel, and the John Sumners of America would have squirmed at Molly's monologue in "Penelope," but Gerty MacDowell was especially problematic.

As editors of a magazine of youth—and of youth in a modern, liberated world of consumption and experiment—Margaret Anderson and Jean Heap's motivations for serializing *Ulysses* in the *Little Review* are not hard to imagine. Beyond the incredible vitality of Joyce's experimental prose style, the wandering artist persona of young Stephen Dedalus—who rejects the constraining philistinism of family, country, and religion for a world of aesthetic, spiritual, and sexual freedom in *Portrait of the Artist* (an example of the *Bildungsroman* genre that so enticed readers and writers of the *Little Review*)—would have made *Ulysses* attractive to many of the magazine's readers. Upon reading the third of Stephen's initial chapters in *Ulysses*, "Proteus," Margaret Anderson exclaimed, "This is the most beautiful thing we'll ever have. We'll print it if it's the last effort of our lives" (in Ellmann 421).

But Gerty MacDowell, more than Stephen Dedalus, seems to exemplify everything that concerned Americans about the new commercialized youth culture. John Sumner and the judges and prosecutors considered the chapter both obscene and corrupting of youth. The defense witnesses Quinn called to speak to the merits of the chapter tried to avert what was obviously at stake in the trial—a sense that youth needed the protection of censorship against the sexual corruption that was feared to accompany the new consumer culture. John Cowper Powys testified that *Ulysses* was "a beautiful piece of work in no way capable of corrupting the minds of young girls," and, after provoking the wrath of the prosecutors, Quinn argued triumphantly, "That's what

Ulysses does. It makes people angry. . . . But it doesn't tend to drive them to the arms of some siren" (in Ellmann 503).

Jane Heap herself put her finger on the problem in the nature of the charge against the magazine. "The present case is rather ironical," she wrote in "Art and the Law." "We are being prosecuted for printing the thoughts in a young girl's mind. Her thoughts and actions and the meditations which they produced in the mind of the sensitive Mr. Bloom. If the young girl corrupts, can she also be corrupted? Mr. Joyce's young girl is an innocent, simple, childish girl who tends children . . . she hasn't had the advantages of the dances, cabarets, motor trips open to the young girls of this more pure and free country" (6). Heap questioned, then, whether the fears that young girls might be corrupted by Gerty's example were being conflated in the trial with the greater fear that the new "girl" of the consumer age might herself be dangerous to adult men. Were the lawyers concerned about Gerty, or about Bloom? Moreover, Heap points out that Gerty might seem simple, and perhaps even naive, in comparison to the youth culture that already existed in America, in which, quite positively Heap would conclude, girls were far more mobile both literally and figuratively in their social lives. Rather than needing the protection of a paternalistic court, the young girls of America were quite active and powerful on their own; as Heap concluded, with a tongue-in-cheek flourish, "If there is anything I really fear it is the mind of the young girl" (6).

What set off alarm bells when the seaside girl appeared in the *Little Review*, I believe, was that Gerty had publicly crossed, quite knowingly, that carefully drawn but ever-shifting line that advice columns like those in *Good Housekeeping* and *Ladies' Home Journal* had tried so hard to maintain between a healthy interest in consumption and fashionable self-presentation, and morally dangerous sexual abandon. If "girls" must be urged to follow fashion, dress up, and be attractive to men, they must, at the same time, be warned about compromising themselves sexually, as Clara Laughlin feared they might. If they must be warned that the newest fashions might be misconstrued as the bold styles of prostitutes (as "The Girls' Club" column assumed), then Gerty MacDowell has been both a good consumer and a too-good consumer.

This American context, then, suggests a reading in which Joyce's Gerty MacDowell is much more threateningly active than either Richards's, or even Leonard's, interpretation of Gerty as a self-commodified object for the active consumption of Leopold Bloom allows her to be. If Bloom can fantasize about, and thus "consume," Gerty as his seaside girl—the image she has created for herself—she, in turn, can fantasize about and "consume" him as the "manly man," the "gravefaced gentleman" with a "passionate nature" (May–June 1920, 68), the dark stranger, and even act on that fantasy. Though, of course, these roles can be seen as constructed for both Bloom and Gerty (though Bloom himself is adept at understanding the nuances of advertising images since he is an advertising canvasser), both sides can be seen to choose these roles actively for their own sexual advantage. Gerty makes herself a liberated, active, consumer, as "The Girls' Club" urged, by shopping frugally and finding "what she wanted at Clery's summer sales" (Apr. 1920, 47) to complete her "look." But she also becomes a liberated and active participant in sexuality in a way that makes the unashamed return of Stephen's gaze by the seaside "bird girl" in chapter 4 of *Portrait* look quite tame. Rather than emptying her sexual moment of any "authenticity," as Richards implies, the commodity terms in which she experiences the moment are actively sexualized by her. Phrases like "silkily seductive," which are probably product slogans, used hints of sexuality as part of their appeal; in Gerty's encounter with Bloom, though, they become explicitly erotic—not because Gerty is a passive creature constructed by advertisers, as Richards argues, or a passive object for male consumption, as Leonard imagines her, but because she herself takes such an active role in parlaying her public display into a sexual encounter that works for her and for Bloom. Gerty uses her "silkily seductive" brows for active sexual seduction, for sexual gratification in the "real" world.

Notably, after the *Little Review* / *Ulysses* trial focusing on these passages, Joyce augmented the already pervasive allusions to consumer culture, adding references (in the typescript overlay of 1921 and in

the proofs of the first book edition of *Ulysses*)[34] to additional mass market magazines—*Lady's Pictorial* and *Pearson's Weekly*—and to patent medicines and "Widow Welch's female pills," among others. And he also augmented the very connection that so worried the Society for the Suppression of Vice—the linkage of the new commodity culture to youth sexuality.

In the following passage, for example, Joyce adds to the *Little Review* version of the masturbatory moment a reference to another phrase that is almost certainly a product slogan, "the fabric that caresses the skin." Ironically, Gerty actively makes Bloom function as the fabric that caresses her skin, just as he caresses his own, taking sexual pleasure from his view:

> and he could see her other things too, nainsook knickers, [the fabric that caresses the skin, better than those pettiwidth, the green,] four and eleven, on account of being white and she let him and she saw that he saw and then it went so high it went out of sight a moment and she was trembling in every limb from being bent so far back that he could see [had a full view] high up above her knee where no-one ever not even on the swing or wading and she wasn't ashamed and he wasn't either to look in that immodest way like that because he couldn't resist the sight [of the wondrous revealment half offered] like those skirtdancers behaving so immodest before gentlemen looking and he kept on looking, looking. She would fain have cried to him chokingly, held out her snowy slender arms to him to come, to feel his lips laid on her white brow. (July–Aug. 1920, 43; bracketed passages added beginning 1921, Gabler 787–789)

Gerty's fantasy chastely climaxes in Bloom kissing her "white brow"—a white brow emphasized by the dark eyebrows, the "silkily seductive" brows, acquired through Madame Vera Verity's advice, and the help of "eyebrowleine." But the consumer abandon advocated by *Princess's Novelettes* has now become explicitly sexual. Even the "modest" and "chaste" component of the seaside girl spectacle has been replaced by the "immodest" way Bloom is looking at Gerty, and the "immodest" way Gerty is displaying herself before him.

While such an active flaunting of sexual propriety and the desire to use that fashion instinct to its full advantage were positioned by the writers and readers of the *Little Review* as a refreshing cry for the freedom of youth, "Nausicaa" was clearly seen as horrifying by those segments of American culture who feared that the consumption-driven "cult of youth" was only sowing the seeds of promiscuity. This fear is represented by the father in Sherwood Anderson's *Little Review* story "Sister," who beats his daughter for trying to liberate herself sexually; Gerty MacDowell is symbolically beaten by the American judicial system and the censorship of the Society for the Suppression of Vice. Youth in public, they argued, must be tightly reined in, at the seaside or in the pages of a magazine that was thought to corrupt youth.

As with the emergence of modernism in Britain, American modernists looked optimistically to the institutions of modern commercial culture to provide them with the cultural influence obtained through a broad readership, and they envisioned a public sphere of free expression that would be enlivened by aesthetic modernism. The *Little Review*, born out of the journalistic milieu of a quickly modernizing commercial city, turned (like its transatlantic counterpart, the *Egoist*) to the strategies and forms of an expanding mass market publishing world in hopes of reaching a mass urban audience without changing its content to appeal to mass taste. Of course the cultural landscape of America was different from that of Britain, and the nuances of American modernists' attempt to incorporate aspects of commercial mass culture into their self-promotion differed from those of London editors. The permeability of the "great divide" in America, and a greater willingness to borrow directly from commercial culture led American modernists to focus on the new cult of youth in American promotional and corporate culture.

Though the *Little Review* ultimately had more success than the *Egoist* in attracting a steady readership, the attempt by its writers and editor to create a public sphere of youth—without the mechanism that at once propagated images of youth as consumers and tried to contain any actual abandonment of moral and social traditions—brought the *Little Review* up against the regulatory wall of the postal service and the Society for the Suppression of Vice. As in Britain, the commercial dynamics of mass market publishing ensured that any dream of widespread mass appeal and influence for a modernist magazine would ultimately be Utopian, but American commercial culture clearly helped shape the form of one of America's most avant-garde little magazines. The increasingly commercialized mass press seemed to offer new opportunities to modernist authors to become part of public discourse, but the same cultural anxieties that caused the commercial press to regulate itself also constrained the ability of an organ of open public discussion to shape that discourse on aesthetics, politics, or sociocultural norms. Though the *Little Review* was published until the end of the twenties, its appearance became increasingly sporadic, and it never achieved the wide readership Margaret Anderson had desired during its Chicago years. Yet during its first several years, while under the influence influenced of the commercial youth culture, the *Little Review* offered something that is always hard to come by, even in this age of the Internet—a truly free voice.

Notes

1. M. Anderson's version of her move to Chicago can be found in her *My Thirty Years' War* (12–20). Bryer fills in the details omitted in Anderson's account in the only full-length study of the *Little Review* (5–8). The comparison of Anderson to a magazine model is Hecht's from *A Child of the Century* (in Bryer 30).

2. Ohmann explains that the publishing industry in the 1890s began to concentrate its energies on producing the best-seller. The *Bookman* began the first regular publication of regional best-seller lists in 1895 and national best-seller lists in 1897 (Ohmann 24).

3. The strategy of English publishers like Harmsworth, Newnes, and Pearson of lowering the price of a newspaper or magazine even below its cost, thus increasing circulation, and then taking profits from increased advertising revenues (discussed in chap. 3) had its counterpart in late nineteenth-century America. Frank Munsey and S. S. McClure reached unheard-of circulation figures and advertising revenues by pandering to mass audiences. The popular religious weeklies (like the *Continent*), the favorite medium for advertisers during the nineteenth century, lost ground to the new mass market general magazines like *Ladies' Home Journal, Cosmopolitan, Cottier's, Delineator, McCall's, McClure's, and Munsey's* (see Peterson 7–21).

4. M. Anderson gloated that "As for our practical friends who warned us against starting a literary magazine, even their dark prophecies of debt and a speedy demise have had to dissolve before our statements that we have paid our bills with what *The Little Review* has earned in its six months of existence, that we are free of debt, that we even have money in the bank" ("A Change of Price").

5. M. Anderson explained: "College girls ought to find the field a very workable one during their summer vacations. Every ten subscriptions will mean $5.00 to the energetic young woman who pursues her friends with accounts of *The Little Review's* value and charm." See "A Voting Contest for Scholarships," which discusses a subscription campaign by the weekly *Republican* which enlisted student advertising and subscription canvassers through a scholarship contest.

6. Advertisers included Henry Holt, Houghton Mifflin, Charles Scribner, Putnam, Appleton, Lippincott, Dodd Mead, Doran, B. W Huebsch, John Lane, Forbes, Yale, and many other publishers large and small.

7. Demos and Demos trace the effects of urbanization on American families. Agricultural children worked alongside adults on the farm and then continued their work as they became adults, whereas industrial city children either did not have a significant economic function within the family or, as in poor factor laboring children, performed work often quite different from that of their parents. Urban children also had closer contact with other children in urban neighborhoods. Over the nineteenth century, these shifts led to a more complete distinction between children and adults, and to a youth culture. The high rate of social change and the plurality of alternatives regarding careers, life-styles, and moral codes, and, in cities

like Chicago, the disparity between the goals and ideals of immigrants and those of their children, led finally to the growth of adolescence as an observable fact (young people in distress or in rebellion against their parents) and finally to adolescence as a concept (Demos and Demos 216–218).

8. Bryer explains that M. Anderson had been reviewing since 1908 for the *Interior,* which became the *Continent* in 1910, and probably became the editor of the books section in mid-1912 (12). The lead article in the January 2, 1913, "New Books" section, "G. Stanley Hall on Modern Education," praised Hall's new book, *Educational Problems,* and noted, "Dr. Hall's presentation tends to be somewhat popular in tone and always practical in aim rather than merely pedagogic" ([M. Anderson] 21).

9. Using terms like "ardor" and "enthusiasm" (which frequently appeared in the *Little Review*), Addams hoped that youth could play a positive role in reforming modernity: "It is because the ardor of youth has not been attracted to the long effort to modify the ruthlessness of industry by humane enactments, that we sadly miss their resourceful enthusiasm and that at the same time groups of young people who hunger and thirst after social righteousness are breaking their hearts because the social reform is so long delayed and an unsympathetic and hard hearted society frustrates all this hope" (151–152). Political leaders, she suggested, should use these youthful "stores of enthusiasm" to work at practical contemporary efforts to improve society (152).

10. Hollander and Germain note that "Ciuett-Peabody Co. was responsible for one of the best known pre-World War I advertising campaigns—a long-running campaign based upon the incredibly handsome, if somewhat priggish looking, Arrow Collar Man" (36) and that the "Jantzen Girl," the central image of another major youth-based campaign for swimwear, by 1928 had become the seventh best known trademark in the United States (37).

11. Ewen and Ewen 222–223, They suggest that "The implicit logic, which extended beyond clothing to almost all areas of life, was that the 'first duty of the citizen is to be a good consumer. This was the modern patriotic wisdom of David Cohn, a former Sears executive, and a chronicler of 'morals and manners' in the consumer age. It was a patriotic wisdom that assumed the triumph of youth over age, of the *new* over the *durable*" (224). See also Hollander and Germaine on early twentieth-century budget studies that showed that daughters over age fifteen, followed next by young men over fifteen, were responsible for the highest proportion of family expenditure on clothing, regardless of the family's income (13).

12. The award winning ad was for the "Mashie." Text beside a drawing of a young man wearing the hat proclaimed: "Our New Stetson Soft Hat for Young Men . . . designed by us for young men—college men particularly" (*Printer's Ink,* Mar. 23, 1904, 42).

13. Hecht letter to Anderson, on letterhead of National Campaign Service in Chicago with Hecht's name at top. Hecht suggests circularizing every woman belonging to every woman's club in the country and sending out stories to newspapers across the country. He urges her to "operate a publicity campaign and a circularizing campaign simultaneously. The Little Review has a vastly greater appeal to the obfuscated and yearning spinster than the Philistine ever had. It can be placed in every 'liberal's' home. It can be made a National magazine without changing its content an iota. In fact because of this content it can be developed. It possesses the vital asset of 'strangeness.' I am serious about this." He goes on to suggest a fund-raising dinner in Chicago to launch the campaign with his firm: "I swear that in 6 months the Little Review can be given a circulation of 50,000." Like Anderson, and also like Marsden and her circle in London, Hecht felt that some kind of segmentation advertising could bring a mass audience to a modernist little magazine without having to compromise its content.

14. Kehler wrote to Heap: "I am very much interested in the new plans of The Little Review. In fact, I have always been more than usually interested in Miss Anderson's plucky fight to publish a magazine." He gave her the names of several corporate contacts and advertising agents in New York, though he noted, "You understand, of course, that the advertising agent is not particularly friendly to small circulations . . . I am trying to give you a little inside on a few things that I think of at the moment; and your real object, of course, is to win these men to a *personal* interest in your efforts. Your publication isn't big enough to have much of an appeal to the average advertising man, but you can get business for it from certain types of men, if you can get them interested in your success. This is largely a question of personality, and as you and Miss Anderson have plenty of it, I am sure you will succeed.

"I do not know you so well except through hearsay, but I know Miss Anderson and her work. She is an intellectual asset to the country, and she ought to be supported as such. If you can get that point of view over, you will win in cases where you could not win on the strict advertising merits of your publication" (Kehler letter to Heap). Other correspondence during the mid-twenties suggest similar attempts to involve advertising and publicity agents in the *Little Review.*

15. Marinetti's manifesto, "War, the Only Hygiene of the World," appeared in translation in the November 1914 issue.

16. Demos and Demos (215) quote this from Frank O. Beck's *Marching Man-ward* (1913).

17. Chicago rapidly began rebuilding, and, in addition to monumental neoclassical civic architecture, more daring innovators in modernist architecture used innovations in iron and then steel frames to build ever-higher and more ornate skyscrapers. John Wellborn Root, Daniel Burnham, William Le Baron Jenney, Dankmar Adler, Louis Sullivan, William Holabird, and Martin Roche all contributed to a new and growing skyline. By 1890 more than $300 million had already been spent on reconstruction, and a quarter acre in the Loop was selling for $900,000. See Lowe 123–129. These new architects not only revolutionized the engineering and aesthetics of the tall building, but they also frequently saw a public social function to the spaces they created. In his essay "The Tall Office Building Artistically Considered," Sullivan called for "a natural and satisfying art, an architecture that will soon become a fine art in the true, the best sense of the word, an art that will live because it will be of the people, for the people, and by the people" (in Lowe 123). Lowe notes of the "Chicago School" that "It is significant that the consummate expressions of the School were to be office buildings, hotels, concert halls, cafes, beer gardens, and theaters. It was to be a supremely public architecture, an enhancement of places where the people gathered" (125).

18. The Washington Shirt Company had three stores in the Loop after a decade of business and claimed to have sold a million collars in one year. This pamphlet is in the Department of Special Collections, University of Chicago Library.

19. Advertisement on a playbill for "On Trial" by Elmer L. Reizenstein, commencing December 27, 1914, at George M. Cohan's Grand Opera House. Fort Dearborn National Bank advertising appeared in many playbills for Chicago theaters during the 1914/1915 season. Playbill Collection, Special Collections, University of Chicago.

20. Many of the playbills in the University of Chicago collection contain advertisements for Loop dance halls (the very sites Addams lamented) and for hotels with their own dance halls and cabarets, like the New Morrison Hotel and the Congress Hotel and Annex, formerly the Auditorium Annex, with images depicting the young eating in the Pompeian Grill Room or walking down the beautiful halls after the theater performances.

 Anderson herself did much writing in the public spaces of the Auditorium Hotel, one of the crowning glories of Adler and Sullivan's architectural careers, and some early notes assessing her own relationship to anarchism are even written on Auditorium Hotel letterhead. As with many *Little Review* writers, she related her political and aesthetic questions to the story of her escape from the oppressiveness of childhood with traditional parents. "Can the government give you a happy childhood," she asked. "Anarchist/He will refuse to stay in a family. If everyone would begin here. . . . Most radicals don't have kind of reaction you had in leaving family. Most radicals can't react this way. An artist always does" (M. Anderson notes). The young Anderson, now a disciple of Emma Goldman, writing in the halls of the Auditorium Hotel, related her personal familial narrative to her self-conception of modernism as anarchism and art synthesized.

21. M. Anderson expressed the wish several times in her article that she were an imagist poet who could capture the "right word" to describe the experience, and this inspired poets in later issues to submit poems about the young violinist. See Bodenheim and Soule.

22. The "Peter Pan" plea for subscribers in the December 1914 issue of the *Little Review* had claimed "four thousand people who have expressed an interest in THE LITTLE REVIEW," and the "ad" aimed at procuring advertising from Mandel Brothers claimed a thousand Chicago readers (June–July 1915, 57). In the April 1916 issue Anderson claimed the review had 2,000 subscribers (25). When the October 1917 issue was confiscated by the post office over Lewis's story "Cantleman's Spring Mate," John Quinn mentioned that the mailing had been of "some three thousand copies" (Quinn letter to Lamar).

23. Because of the great interest in Russian literature, which was frequently discussed by the *Little Review*, and the *Little Review*'s Russian writers, a group also formed to study Russian literature and language at the Fine Arts Building. See October 1915, 45.

24. "To the Innermost" 4. A year later, M. Anderson lamented: "What do you call this fantastic place where age that is weak rules youth that is strong?/Where parents prescribe life for children they cannot understand" ("Reversals" 2).

25. See, for instance, M. H. P.'s article berating Agnes Repplier's disciplinarian emphasis in her essays in the *Atlantic* ("Agnes Repplier on Popular Education"), and M. H. P.'s article "The Education of Girls," again

addressing an article in the *Atlantic*, and reflecting on the relative importance of practical domestic skills education to knowledge of the classics and languages for women. Saphier reviewed *The Education of Karl Witte*, relating it to contemporary issues, while Schuchert went on to give a full review to Ellen Key's *The Younger Generation*, discussing her "Charter for Children," and Comfort even reflected on what could be learned from children.

26. The *Little Review* even gained one of its employees from the ranks of adolescent readers. M. Anderson relates a phone call she received shortly after the first number: "My name is Charles Zwaska. I think your *Little Review* is wonderful and I want to help you in any way I can. I've broken away from conventional schooling and my time is free. Couldn't I be the office boy or something?" (M. Anderson, *Thirty Years*, 50–51). The seventeen-year-old Zwaska worked in the office of the magazine for years and wrote for it occasionally, though he always insisted on calling himself "the office boy."

27. "Sade Iverson" turned out to be Elia Peettie, a reviewer for the Chicago *Tribune* whose reviews M. Anderson detested. She sent in a series of poems about a young milliner with which she intended to parody the *Little Review*'s imagist poetry. An unsuspecting Anderson published many of them, and her readers seemed to love them and take them at face value (Bryer 68).

28. Quinn letter to Anderson.

29. E. Pound had sent M. Anderson and Heap the first three chapters of *Ulysses* in February 1918, and they began publishing the novel in the March 1918 issue of the *Little Review*.

30. Quinn letter to Lamar.

31. "Nausicaa" ran in the issues of April 1920 and May–June 1920, concluding in the July–August 1920 issue. "Oxen of the Sun" began running in the September–December 1920 issue, which was the last issue of the *Little Review* to contain *Ulysses*.

32. Girford explains that *The Princess's Novelette* was published in London and ran from 1886 to 1904, and that "The magazine's beauty and fashion pages were characterized by thinly disguised plugs for the magazine's advertisers and their products in prose of the sort Gerty echoes" (385–386).

33. Arguing with Henke's claim that "the aim of Madame Verity's cosmetic art is not truth, as her name would imply, but a simpering obfuscation of reality" (Henke 135), Leonard adds, "I would like to suggest the opposite; although Madame Verity's prose style appears to be an 'obfuscation,' its economic message is quite direct: without this product, your eyebrows will fail to attract male attention, and you will be left on the shelf in the sexual marketplace" (120).

34. See Gabler's synoptic edition, to which parenthetical citations to the text of *Ulysses* outside of the *Little Review* refer. It is also interesting that, almost nine years later, Gilbert explains in his diary that Joyce "collects girl's papers, Poppy's (?) paper, Peg's Journal etc. Has a wild idea of getting *A.L.P.* [the "Anna Livia Plurabelle" section of *Finnegans Wake*] published in one complete number of these. Impossible, I think, but one never knows" (14), and Staley reminds us that "In his research for *Finnegans Wake*, Joyce read various periodicals from popular culture, such as *Popply's Paper*, *The Baker and Confectioner*, *Boy's Cinema*, *The Furniture Record*, *The Schoolgirl's Own*, *Woman*, *Woman's Friend*, *Justice of the Peace*, and *The Hairdresser's Weekly* (Gilbert 14 n. 27).

CHAPTER 8
VARIATIONS ON A PREFACE
Brent Hayes Edwards[*]

As we have seen, the pressures on the ideas at the center of modernist studies were rarely singular: one could not consider gender and modernism without thinking about high and low cultures, for instance, nor could one discuss linguistic innovation without discussing race. Brent Hayes Edwards's book *The Practice of Diaspora* (2003) channeled a startling number of such pressures, and even while not treating the concept of modernism centrally, it managed to exert significant new force upon the field of modernist studies. In the background of Edwards's book were several currents. One was the work of a generation of scholars of African American modernism, including Houston Baker, Henry Louis Gates, and George Hutchinson. Another was the work of scholars of African diasporic cultures—most notably Paul Gilroy—who were less concerned with "modernism" per se and more concerned with rethinking notions of Blackness that presumed to hold together several constellated fields. And perhaps most important was a legacy of poststructuralist and postcolonial thought, here most closely identified with Jacques Derrida, Gayatri Chakravorty Spivak, and Édouard Glissant, that aimed to unpack and interrogate foundational concepts in Western thought and languages.

Edwards finds a through-line among all of these scholars and thinkers by way of the politics of Black internationalism in the early part of the twentieth century. Here, writers like Hughes, McKay, Locke, and Du Bois—newly and belatedly canonized as "modernist"—are important less for their original literary productions and more for their participation in leftist (often communist) diasporic networks of translation, reception, and commentary. For Edwards, these writers theorized and attempted to create solidarities among Black peoples around the world, all the while acknowledging that the nature of diaspora is that gaps of time, place, and language often make such solidarities difficult to achieve. Nowhere was this more visible than in the project of attempting to translate the works of major African diaspora writers during the interwar period. As Edwards shows, even a linguistic "slippage" as apparently small as the gap between the French terms *nègre* and *noir* exhibits a broader problem: the internal variations of a single language make translation—and the kind of transparent, equivalent communication that it promises—impossible from the start.

Such impossibilities affected the careers of Black modernists around the world, and thus we find Edwards treating some familiar themes of modernism, such as expatriatism and exile, hetero-linguistic invention and formal experimentation, collections and anthologies, and the effects of the Great War and of empire, from entirely new perspectives. Edwards also shows modernists from a variety of ethnic and political backgrounds to be engaged in the processes of characterizing and selling their works and those of their coteries, but this time with very different aims—namely, with political intentions that often went unfulfilled. In this

[*]From Brent Hayes Edwards, *The Practice of Diaspora: Literature, Translation, and the Rise of Black Internationalism*. Harvard University Press, ©2003 by the President and Fellows of Harvard College. Reproduced here with permission.

chapter of *The Practice of Diaspora*, he opens up new archives, such as Black Francophone modernist literature, that have since been explored at length. Here, the Anglophone African American literature that had dominated treatments of modernism and Blackness is recontextualized through the multilingual and multiethnic circuits from which it emerged. Edwards meanwhile initiates a new mode of treating modernism's geopolitics that continues to unfold in the present, as scholars seek to understand "modernism" more as an unreliable but nonetheless powerful glue for a host of international movements long considered to be on its periphery.

In December 1927, a Martinican student in classics at the Sorbonne named Jane Nardal wrote to Dr. Alain Locke at Howard University in Washington, D.C., requesting permission to translate his 1925 collection *The New Negro* into French, She had proposed the project to the Parisian publisher Payot and noted that her sister Paulette (who held a degree in English from the Sorbonne) would be assisting her in the preparation of the volume. The publisher and the Nardals had already agreed that *The New Negro* would have to be abridged for a French edition. She adds, "As an Afro-Latin [*en ma qualité" d'Afro-Latine*], I was well positioned to tell him, on his request, the excerpts that might interest the French public, generally so out of touch with what is happening outside of France."[1] The letter asks Locke for advice about these choices, commenting optimistically: "For a book written by American Negroes to be translated by French Negroes, wouldn't that be an obvious sign of the workings of that Negro internationalism [*cet internationalisme noir en marche*] that Mr. Burghardt Du Bois speaks about so prophetically in his masterful exposé, 'Worlds of Color'?" Nardal is alluding to the essay that concludes *The New Negro*, "The Negro Mind Reaches Out," in which Du Bois sketches the possibility of an alliance of intellectuals of African descent that might "shadow" and speak against the creeping domination of European imperialism around the world. "Led by American Negroes," Du Bois writes, "the Negroes of the world are reaching out hands toward each other to know, to sympathize, to inquire."[2]

Locke responded favorably, offering to compose a new introduction for the French version. He adds that he would "gladly rewrite the whole thing in a connected story of the new movement of the American Negro Renaissance, using excerpts of poetry, short stories, and several folk tales. And I send this as a counter proposal to you and M. Payot." In the meantime, he suggests, the Nardals might start—perhaps with the assistance of the Martinican novelist René Maran, with whom Locke had been corresponding for years—translating his prefatory essays in *The New Negro*, as well as some of the poems and Du Bois's piece, since all would "undoubtedly be included either in an abbreviated translation . . . or in what I would rewrite as a new book on this movement."[3]

Jane Nardal mentions in her letter that she would be able to publicize the translation through her connections to a number of Parisian newspapers, including *Le Soir* and *La Dépêche africaine*, a new periodical founded by a Guadeloupean named Maurice Satineau. In fact, she says, she has just written an essay for the latter's inaugural issue. But she neglects to inform Locke that her contribution to Satineau's paper—whose masthead trumpeted the subtitle "grande organe républicain indépendant de correspondance entre les Noirs" ("major independent republican journal of correspondence among Negroes")—was in fact the source of the phrase she used in describing Du Bois. Nardals essay "L'internationalisme noir" appeared in February 1928, opening with a forceful invocation of the world-straddling political ambitions that emerged after World War I:

L'on abaisse ou plutôt l'on tente d'abaisser en cet après-guerre les barrières qui existent entre les pays. Les frontières, les douanes, les préjugés, les moeurs, les religions, les langues

diverses permettront-ils jamais de réaliser ce projet? Nous voulons l'espérer, nous autres qui constatons la naissance dans le même temps d'un mouvement qui ne s'oppose nullement au premier. Des noirs de toutes origines, de nationalités, de mœurs, de religions différentes sentent vaguement qu ils appartiennent malgré tout à une seule et même race.

In this postwar period, the barriers that exist between countries are being lowered, or are being pulled down. Will the diversity of frontiers, tariffs, prejudices, customs, religions, and languages ever allow the realization of this project? We would like to hope so, we who affirm the birth at the same time of another movement which *is* in no way opposed to the first. Negroes of all origins and nationalities, with different customs and religions, vaguely sense that they belong in spite of everything to a single and same race.[4]

Whereas previously, there had been only mutual miscomprehension—with the "more favored" populations in the Americas looking down on Africans as savages, and the Africans themselves thinking of New World blacks as no more than slaves, subjugated "cattle" (*bétail*)—in the 1920s another kind of consciousness began to become possible, Nardal claims, largely due to transnational circuits of expressive culture: the advent of the *vogue nègre* in France and the increasing popularity of the spirituals, jazz, and African art. She concludes her summary history with an espousal of the "birth of racial spirit" in the metropolitan Negro intellectual: "Dorénavant, il y aurait quelque intétêt, quelque originalité, quelque fierté à être nègre, à, se retourner vers l'Afrique, berceau des nègres, à se souvenir d'une commune origine. Le nègre aurait peut-être à faire sa partie dans le concert des races où jusqu'à présent, faible et intimidé, il se taisait" ("From now on, there will be a certain interest, a certain originality, a certain pride in being black, in turning back toward Africa, cradle of the blacks, in recalling a common origin. The Negro will perhaps have to do his part in the concert of races, where until now, weak and intimidated, he has been silent").

In theorizing this *internationalisme noir*, however, Nardal is not willing to turn to a rhetoric of rootless racial belonging that would deny her background and upbringing—what her sister Paulette elsewhere termed her "Latin education" (*formation latine*).[5] And thus Jane Nardal turns to a neologism:

A idées nouvelles, mots nouveaux, d'où la création significative des vocables: Afro-Américains, Afro-Latins. Ils confirment notre thèse tout en jetant une lueur nouvelle sur la nature de cet internationalisme noir. Si le nègre veut être lui-même, affirmer sa personnalité, ne pas être la copie de tel ou tel type d'une autre race (ce qui lui vaut souvent mépris et railleries) il ne s'ensuit pourtant pas qu'il devienne résolument hostile à tout apport d'une autre race. Il lui faut, au contraire, profiter de l'expérience acquise, des richesses intellectuelles, par d'autres, mais pour mieux se connaître, et affirmer sa personnalité. Etre Afro-Americain, être Afro-Latin, cela veut dire être un encouragement, un réconfort, un exemple pour les noirs d'Afrique en leur montrant que certains bienfaits de la civilisation blanche ne conduisent pas forcément à renier sa race.

For new ideas, new words are required, and thus the meaningful creation of terms: Afro-Americans, Afro-Latins. These confirm our thesis while throwing a new light on the nature of this Negro internationalism. If the black wants to be himself, to affirm his personality, not to be the copy of some type of another race (as often brings him resentment and mockery), it still does not follow that he becomes resolutely hostile to any element from another race. On the contrary, he must profit from acquired experience, from intellectual riches, through others, but in order to better understand himself, to assert his own personality. To be Afro-American, to be Afro-Latin, means to be an encouragement, a comfort, an example for the Negroes of Africa by showing them that certain benefits of white civilization do not necessarily drive them to deny their race.

One notes the ingenuity of the term "Afro-Latin," which strikes an intriguing parallel to "Afro-American." The neologism is not a direct profession of loyalty to a nation-state or empire, but instead an appropriation of a wider cultural heritage of which republican France is a part. Oddly, though, it implies that "American" and "Latin" are parallel terms—apparently, as simultaneously regional and cultural distinctions within a broader Western space. Nardal does not espouse biological assimilation or miscegenation ("Afro-Americans" and "Afro-Latins" share a "racial" identity as *nègres*) but one of acculturation within a context of colony-metropole migration ("certain benefits of white civilization do not necessarily drive them to deny their race"). Although Jane Nardal was not a colonial apologist, as were many of the other contributors to *La Dépêche africaine*, her invention of "Afro-Latin" gives voice to a political moderation that she shared with the circle around Satineau's organization. She shies away from anything approaching Du Bois's fierce condemnation of colonial exploitation and racism, his flat pronouncement that "modern imperialism and modern industrialism are one and the same system."[6] As one might expect, Nardal's brand of *intemationalisme noir* may be most closely attuned to the internationalist thread in the writings of Alain Locke—above all, in its emphasis on cultural exchange and in its persistent New World Negro vanguardism.

I open with Nardal's initiative not because it was successful. Although *The New Negro* in its original edition remained a touchstone text for Francophone intellectuals in the late 1920s and early 1930s, a full translation never appeared in French. In 1931, the leftist journal *Europe* finally published a version of Locke's introductory essay, now translated by Louis and Renée Guilloux, under the title "Le Nègre nouveau."[7] What I want to highlight is precisely the semantic shifts in this bilingual flood of racial appellations and adjectives, the transformations enacted through what Nardal terms "la création significative des vocables." Not a linear chain, but a field through which are carried signifiers of "racial identity": *New Negro, inter-nationalisme noir, Afro-Latin, noirs américains, nègres, Afro-American, nègre nouveau.* I emphasize the multiplicity of this field to point out that in this regard, the practice of translation is indispensable to the pursuit of any project of internationalism, any "correspondence" that would connect intellectuals or populations of African descent around the world. If translation is a "poietic social practice that institutes a relation at the site of incommensurability," then reading the specifics of that practice are the only way to gauge the ensuing "relation" that is articulated across *décalage.*[8] This is also to point out that translation is not just the arena of any possible institutionalization of internationalism, but also the arena of ideological argument over its particular contours and applications.

To read this field, one must come to terms with the heterological slippage among vocables such as *nègre* and *noir.* What difference does it make to translate *The New Negro* as *Le Nègre nouveau* instead of *Le Nouveau noir?* Of course, a term such as *Negro* is already contested in English alone. Thus critics such as Henry Louis Gates, Jr., and Lawrence Levine have identified a struggle around the political valence of *New Negro* among U.S. black intellectuals in the 1920s: the socialist journal the *Messenger* espoused A. Philip Randolph's vision of an irrepressible, militant New Negro, while the journal *Opportunity* came to adopt a very different version of that phrase in the image of Alain Locke's cultural sophisticate.[9] But both these competing formations simultaneously insist on inflecting their differing definitions of the *New Negro* toward internationalism—whether the *Messenger's* socialist anticolonialism or *Opportunity's* "Talented Tenth" cosmopolitanism. In other words, to comprehend the internationalist aspirations among intellectuals of African descent after World War I, it is necessary to read evocations of *Negro* in the U.S. context next to the simultaneous debates around the applications and connotations of terms such as *nègre* in French. The space of any possible *intemationalisme noir* is the place these (and other) contexts come into contact: in discrete if variable instances of translation.

To undertake such an inquiry is in part to follow the suggestions of Raymond Williams in the introduction to *Keywords* regarding one of the limitations of that work. Except in a few cases (as with the terms *alienation* and *culture*), Williams's book does not offer any comparative linguistic

analysis of the "vocabulary" it sketches, what he calls the "shared body of words and meaning in our most general discussions, in English, of the practices and institutions which we group as *culture* and *society*." Such comparative studies would be helpful, he admits, since "many of the most important words that I have worked on either developed key meanings in languages other than English, or went through a complicated and interactive development in a number of major languages."[10]

Characteristically, Williams lets that "we" drift, effectively allowing the contours of his envisioned community of vocabulary sharers to remain assumed, undefined, and uncontested. *Keywords* opens with another characteristic gesture: the invocation of Williams's "working class family in Wales," his service in the army, and his years studying at Cambridge. The common phrase "we just don't speak the same language" becomes in this field of experience the key to a consideration of the social dynamics of what might be termed the heteroglossia of "Englishness":

> When we come to say "we just don't speak the same language" we mean something more general: that we have different immediate values or different kinds of valuation, or that we are aware, often intangibly, of different formations and distributions of energy and interest, In such a case, each group is speaking its native language, but its uses are significantly different, and especially when strong feelings or important ideas are in question. No single group is "wrong" by any linguistic criterion, though a temporarily dominant group may try to enforce its own uses as "correct."[11]

But what if "we just don't speak the same language" is the literal—instead of the figurative—ground of heteroglossia? It is to encounter a situation where, indeed, "no single group is wrong by any linguistic standard" but any alliance across those differences (of values, of formations, of energy, of interest, and of language itself) will be skewed by the peculiarities of interaction. It is to ask about the ramifications of semantic transformations in such a situation, since as Williams comments elsewhere, pursuing such an issue "across language" would demonstrate that "certain shifts of meaning indicate very interesting periods of confusion and contradiction of outcome, latencies in decision, and other processes of a real social history, which can be located rather precisely in this other way, and put alongside more familiar kinds of evidence."[12]

The discontinuities and disjunctures in any translation, the unavoidable skewing in any institutionalization of *internationalisme noir*, might be best described not as predetermined failure but as the rich complexity of a modern cultural practice characterized above all by what Edouard Glissant calls "detour," He suggests that populations formed through forced exportation and exploitation are traumatically wrenched away from their habitual social forms and into a specific kind of colonial context: not one formed by hostile incursion into a homeland, but one of "uprooting" *(déracinement)*. Glissant contrasts *retour* and *détour* as two strategic cultural responses to such uprooting. "Return," he writes, "is the obsession with the One: one must not alter being, To return is to consecrate permanence, non-relation."[13] Detour, on the other hand, is a turning away first of all from such an obsession with roots and singular genealogy. In Glissant's words:

> Detour is the ultimate resort of a population whose domination by an Other is concealed: it then must search *elsewhere* for the principle of domination, which is not evident in the country itself: because the mode of domination (assimilation) is the best of camouflages, because the materiality of the domination (which is not only exploitation, which is not only poverty, which is not only underdevelopment, but actually the complete eradication of the economic entity) is not directly visible. (32/20, modified)

The great utility of such a model is that it allows us to consider the work of figures such as Aimé Césaire and Frantz Fanon without recourse to simplistic models of expatriation and exile, working

instead with a paradigm in which indirection can be functional—can indeed be strategically necessary in certain conditions.

Thus detour is helpful in considering the complexities of internationalism, the sometimes "camouflaged" dynamics of formations in which two or more differently positioned populations attempt to counter a transnational "system of domination"—one thinks back to Du Bois's phrase: the incursions of "modern imperialism and modern industrialism" in the broadest sense—by organizing around a common "elsewhere," a shared logic of collaboration and coordination at a level beyond particular nation-states. For intellectuals such as Nardal, Locke, and Du Bois, black internationalism aims to translate "race" as the vehicle of that detour, as the shared and shifting ground of that "elsewhere." Unfortunately, Glissant's discussion of detour in *Le Discours antillais* tends to fall back on the nation-state and the national community as the final points of entanglement, the end of the road. Admittedly, he writes, it is necessary to come to terms with the African roots of Martinican culture. And familiar modern black transnational projects—he cites Marcus Garvey's Back-to-Africa movement and Négritude—exemplify the necessity in detour to "go somewhere," in the ways that they usefully "link a possible solution of the insoluble to the resolution other peoples have achieved" (35/23). Still, these examples are "singular" evidence of the difficulties of moving beyond borders; as Glissant notes with irony, intellectuals such as Césaire, Fanon, and the Trinidadian radical George Padmore are much better known in Africa than in their home countries in the Caribbean—in other words, their detours are "camouflaged or sublimated variants of the return to Africa" (35/24). It requires "an intense effort of generalization" for Africans and Antilleans to share the common ground of some internationalist project, with the result that a formation such as the Négritude movement remained abstract, ineffectual, unable to "take particular situations into account."

This dismissal of the "generalizing" drive of detour is unfortunate, because it defuses the term's capacity as a tool to theorize the position of populations undergoing "modes of domination" that exceed the nation-state—whether continuing and pervasive patterns of conflict-driven refugee movement (in contemporary Central Africa, for instance), economically compelled migration (in Mexico or Haiti), marginalization or eradication on national frontiers (as with the Kurds or the Basques), and involuntary exile (as with the Palestinians or Algerian secular intellectuals and feminists). Glissant's wariness of "generalization" relegates such diverse transnational or extranational flows of populations *to* the status of exceptions—or what he terms, in the case of Fanon, the "radical break" (*coupure radicale*) with the properly national context (36/25). Glissant is careful not to claim that intellectuals such as Césaire and Fanon are irresponsible or "abstract," but there appears to be little use to their "generalizing":

> The plans [*tracés*] of Négritude and the revolutionary theory of *The Wretched of the Earth* are generalizing, however. . . . They illustrate and demonstrate the landscape of a shared Elsewhere. One must return to the site [*Il faut revenir au lieu*]. Detour is not a useful ploy unless it is nourished by return: not a return to the dream of origin, to the immobile One of Being, but a return to the point of entanglement [*point d'intrication*], from which one was forcefully turned away; that is where it is ultimately necessary to set to work the elements of Relation, or perish. (36/26, modified)

What appears unthinkable in this conclusion is the possibility that detour may be the only strategy in certain situations: that the *point d'intrication* may in fact be "elsewhere" rather than in what Glissant refers to as the "pays natal," the native homeland.

In what follows, I take up the role of a particular set of "elsewheres" in the formulation and translation of black internationalist initiatives during the 1920s and 1930s. To take one, Paris represents a different detour for African Americans (whether soldiers, musicians, artists, or the

New Negro intelligentsia), for Antilleans, and for Africans. Traveling to Paris is obviously a detour for the African American, a voyage considered an escape (even if partial, even if temporary) from the outrages and frustrations of racism in the United States. But it must be considered another sort of detour even for the Francophone citizen or subject traveling from colony to metropole—if only because that move allows certain unpredictable kinds of boundary crossings and encounters. There is a multiple detour, in other words, in the way that, arguably more than anywhere in the world, Paris functions as a space of interaction among populations of African descent. In 1929, Franck Schoell argued in one of the first French-language overviews of the "Harlem Renaissance" that Paris had played a crucial role as transnational meeting ground:

> For it is France, it is England, it is Belgium that for a number of years have offered if not the first, then at least the most fruitful possibilities for real [*effectif*] contact among African blacks and American blacks [*Nègres d'Afrique et Nègres d'Amérique*]. If a Du Bois, a Langston Hughes has visited West Africa, it is through Europe that they passed to get there—in all the senses of the phrase. It is in the *quartier* of Pigalle and in the cafés of Montmartre, even in the cafés of Montparnasse, that the first encounters between Harlemites and Dahomeans were formed [*nouées*].[14]

Critics Tyler Stovall and Michel Fabre have more recently concurred that diasporic encounters possible in Paris were unparalleled in the interwar period.[15] Of course, some African Americans (including Du Bois and Hughes) went directly to West Africa in the 1920s, just as some Africans (Kwame Nkrumah and Kojo Tovalou Houenou, for example) went directly to the United States. Nevertheless, the European metropole was the privileged point of encounter, particularly in the small, ephemeral organizations and periodicals that sprung up throughout the interwar period in Paris and attempted to pursue internationalist alliances with similarly oriented groups in Harlem or in Kingston, in Fort-de-France or in Porto-Novo.

Translating the Word *Nègre*

If any *point d'intrication* is necessarily shared—necessarily also a crossroads, a point where linguistically and ideologically heterogeneous detours meet—then a consideration of the internationalist projects enabled in those meetings must begin by grappling with the semantic shifts and altered vocables they occasion. To gain a sense of the paleonomy of *Negro* and *nègre* in the context of American racism and European colonialism, one would have to turn to a work such as Jack Forbes's impressive study *Africans and Native Americans: The Language of Race and the Evolution of Red-Black Peoples*, a painstaking archival inquiry into the sedimentation of terms of racial designation through the period of slavery and colonization in the Americas.[16] Forbes's argument is far-reaching in its implications: after Columbus's nearly genocidal initial incursion, the process of re-populating the New World (especially throughout the Caribbean basin) was not characterized by the "replacement of Americans by Africans and African-European mixed-bloods" as has been often assumed, but instead by the incorporation of native Americans into the general slave population (269). This merging, Forbes argues, was concealed by the use of increasingly racialized terms of identity, which disenfranchised this "colored" labor force by imposing a "caste regime" system of social exclusion, thereby erasing what was in fact the highly varied background of populations throughout the Americas. Forbes informs us that he uses "the term 'American' for Indians in the colonial era and 'African' rather than 'negro' for presumably unmixed sub-Saharan Africans" (192); this basic premise must slowly but radically alter our sense of the phrase "African American" throughout his book.

Because *Africans and Native Americans* is structured around multi-linguistic etymological studies of the use of various racial terms (*negro, mulat(t)o, mestizo, pardo, loro, moor,* and *mustee*), the work is especially instructive about the historical relationship between *Negro* and *nègre*. In French, the first translations of African narratives of the early Spanish and Portuguese explorers and slave traders in the mid-sixteenth century almost exclusively used *noir* for the Spanish or Portuguese *negro* (meaning "black," the color), which was read as representing solely a color description. Only in the late 1500s and early 1600s did there begin to develop an understanding of *negro* that considered the term to represent a particular people and to mark their "difference." Other linguists including Simone Delesalle and Lucette Valensi have charted the way the word *nègre* came to be used in French to represent that specific alterity. As the French entered the slave trade (the Code Noir, the legal basis of the trade in France, was established in 1685), there developed an association between *nègre* and *esclave* ("slave") as synonyms, cemented in early dictionaries including Savary's *Dictionnaire universel de commerce* (1723), the work that single-handedly defined the French conception of Africans as a "race of slaves" in a phrasing copied in almost all the dictionaries of the next two hundred years.[17] Forbes argues that a crucial feature of the development of this logic of racialization was the invention of "miscegenation" terms such as *mulat(t)o, mestizo,* and *mulâtre,* which were used to extend the regime of exclusion and to control the access to civil rights and privileges (269). The spread of these terms over the next century served to impose racial difference as singular, distinguishing between only "black" Africans and "white" Europeans (125–130). The term *Negro* in English was adopted only relatively late from *negro* and *nègre* in Spanish and French, which were understood not as simple color designations but as variations on the term "slave" (84–85).[18]

Interestingly, in French the development of *nègre* had relatively little impact on the color designation *noir*, and thus we find French abolitionists adopting the latter term as a proper noun in the late eighteenth and early nineteenth century, attempting to invest it with connotations of humanity and citizenship. As Serge Daget notes, "With the word *Noir,* the abolitionist considered himself the master of a relatively new term, one which he would consider capable of introducing ideological substratums into his literature of combat."[19] This set of circumstances helps to explain the reasons black French citizens in the early twentieth century tended to describe themselves as "Noirs"—which indeed was second only to "hommes de couleur" as a self-designation among the elite. The connotations these terms held in the 1920s and 1930s has most famously been described by Frantz Fanon:

> The African, for his part, was in Africa the real representative of the black race [*la race nègre*]. As a matter of fact, when a boss made too great demands on a Martinican in a work situation, he would sometimes be told: "If it's a nigger [*nègre*] you want, go and look for him in Africa," meaning thereby that slaves and forced labor had to be recruited elsewhere. Over there, where the niggers [*nègres*] were.
>
> The African, on the other hand, apart from a few rare "evolved" [*évolués*] individuals, was looked down upon, despised, confined within the labyrinth of his epidermis. As we see, the positions were clear-cut: on the one hand, the black [*nègre*], the African; on the other, the European and the Antillean. The Antillean was a Negro [*noir*], but the black [*nègre*] was in Africa.[20]

In English, on the other hand, there is no such separation between *black* and *Negro*, both of which were taken after the Civil War to refer to a predominantly African-derived emancipated population, and both of which retained (in different degrees) the stereotypical baggage of *nègre* in French. In Forbes's account, this is due, again, to the pervasive "Africanization" of the slave population in the

United States. Toni Morrison has described this process in terms of the U.S. literary imagination with the neologism "American Africanism," a phrase which indicates the common invocation of a "real or fabricated Africanist presence" as a means to consolidate the "white" citizen-subject in American fiction.[21] For Forbes, moreover, the civil rights initiatives of African American intellectuals and activists in the modern period do not serve to challenge the core assumptions of linguistic racialization—on the contrary they risk buttressing and even, extending them (262). This is not to suggest that Forbes is consequently hostile to civil rights, but his work does make clear that the African American "legitimation by reversal"[22] of terms of racial designation during the 1920s and 1930s—one example is Du Bois's defense of the capitalized word "Negro" as a proper appellation—is a project fraught with risks.[23]

Let us return to the Francophone context after World War One. The very suggestion that the French word *nègre* translates English words such as *Negro* and *black* during the 1920s may seem odd, since one of the longstanding assumptions of Francophone literary criticism is that the noun *nègre* is not rehabilitated until much later. *Nègre* still had extremely negative connotations in the early 1920s, and a number of sympathetic French commentators refused to use the term at all. Thus Lucie Cousturier, who wrote a fascinating book about teaching French to West African soldiers stationed in Provence during the war, shudders at *nègre*, calling it an offensive word "that doesn't apply to real objects."[24] It is commonly supposed that Aimé Césaire is the first writer of African descent to claim the term *nègre* as a positive appellation: as one critic phrases it, Césaire "must be credited with being the first black intellectual outside Africa to have taken the humiliating term *nigger* and boldly transformed it into the proud term *black*"[25] However, notwithstanding the remarkable intervention of Cesaire's neologism "Négritude" on the eve of World War II, he is by no means the first to appropriate the noun *nègre*.

In January 1927, Lamine Senghor published an essay called "Le Mot 'Nègre'" (The word "Nègre") in the first issue of a newspaper call *La Voix des Nègres*, the organ of his group the Comité de Défense de la Race Nègre. Born on September 15, 1889, Senghor was the most charismatic and eloquent black Marxist of the interwar era during the few years that he was active in the metropole. He apparently volunteered for service among the West African recruits (*tirailleurs sénégalais*) in the French Army during World War I and was gassed in action at the front. Repatriated to Senegal, he moved again to France in 1921, working as a postal clerk and informally auditing classes at the Sorbonne. By the summer of 1924, he had joined the Union Intercoloniale, the unit of the French Communist Party that had been formed to sponsor rebellion throughout the French colonies (other members included the Antillean Max Clainville Bloncourt, the Haitian Camille Saint-Jacques, Samuel Stéphany from Madagascar, Jacques Barquisseau from the island of Reunion, the Algerian Hadj Ali Abdelkader, and a young Indochinese intellectual named Nguyen Ai Quoc, who would later be better known as Ho Chi Minh). Around this time, Senghor married a white Frenchwoman and had two children; although his family lived in Fréjus, in the south of France, he spent most of his time working for radical causes in the capital.

In March 1926, sensing like the other African and Antillean members of the Union Intercolonial that the Party was paying too much attention to the Riff war in Morocco and rebellions in Indochina, and too little to struggles in West Africa and the Caribbean, Senghor left the Communist Party to found the Comité de Défense de la Race Nègre (CDRN). *La Voix des Nègres* published only two issues in January and March 1927 before there occurred a split in the group between Senghor's supporters (the hardline activists and unbending anticolonialists committed to labor organizing) and a circle around Maurice Satineau, the Guadeloupean who would found *La Dépêche africaine* the next winter. Senghor and Tiemoko Garan Kouyaté brought together a new group called the Ligue de Défense de la Race Nègre, which founded a new periodical called *La Race nègre*. In February 1927, Senghor attended the inaugural congress in Brussels of the League Against Imperialism, organized by the German Marxist Willi Munzenberg (attendees included the Indian Jawaharlal

Nehru, the Algerian Messali Hadj, the Barbadian Richard B. Moore, and Max Clainville Bloncourt). There, Senghor gave a stunning, impassioned speech that was highly influential and widely reprinted.[26] Senghor was arrested in 1927 in Cannes for his agitation activities and imprisoned in Draguignan for part of the spring. His war injuries, already quite serious, were aggravated during the imprisonment, and he died in November 1927 at his home in Frejus.[27]

Senghor's "Le Mot 'Nègre'" is an extraordinary and scathing analysis of linguistic colonialism through the terminology of racialization in French.[28] The word *Nègre*, Senghor opens, "is the dirty word of our times; it is the word by which some of our race brothers no longer wish to be called." He continues:

> [t]he dominators of the peoples of the *race nègre*, those who divided up Africa for themselves under the pretext of civilizing the *nègres*, are employing an abominable divisive maneuver in order to better reign over them. In addition to the primitive division of caste, of tribes and religions, which they exploit in their favor in our lands, the imperialists are working to break the very unity of the race so as to keep us eternally in the state of slavery where we have been held by force for centuries.
>
> To accomplish this, they are extracting two new words out of the word *nègre*, in order to divide the race into three different categories, namely: "*bommes de couleur*," "*noirs*" — simply — and *Nègres*. The former are made to believe that they are "*bommes de couleur*" and neither *noirs* nor *nègres* (first category); the others are made to believe that they are "*noirs*" simply and not *nègres* (second category). As for the "leftovers" [*Quant aux "restes"*], they are *nègres* (third category).

There are a number of remarkable moves in this passage. First, rather than contesting or historicizing the term itself, Senghor starts by assuming *la race nègre* to be a valid descriptive. *Nègre* is in fact the unmarked category here, in linguistic terms. Thus "*bommes de couleur*" ("men of color") and "*noirs*" are marked off by quotation marks as colonial impositions, terms that "divide and conquer." The analysis understands these terms to be related in a socially imposed hierarchy that achieves through nominalized racialization what Forbes calls a "caste" system of exclusion "with each successive layer from top to bottom experiencing a greater degree of exclusion than the one above it."[29]

The essays schema breaks down the function of an imposed tripartite system of racialized designation in French colonization. In this sense, it is especially notable that Senghor does not dawdle in the then-current debates around assimilation. He refrains from an attack against collaborationist politicians such as the legislators Blaise Diagne and Gratien Candace—who commonly insisted they were "Black Frenchmen" (*noirs français*)—or reformist defenders of the empire such as Maurice Satineau (when he left the CDRN, Satineau founded a group significantly named the Comité de Défense des Intérêts de la Race Noire). Senghor instead wrenches open the chromaticism of "*bommes de couleur*" and "*noir*" *with* more than a little humor, not to squabble but to close ranks. He contends that even persons claiming to fall under those "extracted" categories are actually *nègres*:

> What does "*bommes de couleur*" mean? "We contend that this name designates all the men of the earth. The proof: there isn't a single man in the world who is not of one color or another. Thus, we cannot take for ourselves alone what belongs to all. And "*noir*"? We do not think that the word "*noir*" can serve to designate all the *nègres* in the world, given that all African *nègres* recognize with us that there exist, in various points of the continent, *nègres* as white as some European whites, *nègres* who have nothing *nègre* aside from their features and hair. We thus refuse to admit that only those who live in the depths of the Senegalese jungle, those who are exploited in the cotton fields of the Niger valley, the sugarcane cutters in the plantation fields

of Martinique and Guadeloupe, are *nègres*. Whereas one of our brothers holding a diploma from a European institution of higher learning would be a *homme de couleur*, and another who hasn't reached that level, but who works the same job as a white man and who adapts like white men to their life and their customs—the worker—would be simply a "*noir*."

No, Mr. Divide-and-Conquer!

Senghor closes with a clarion call to arms around exactly that term which had been the most derogatory designation for African diasporic populations under colonialism and slavery:

The youth of the Comité de Défense de la Race Nègre have made it their duty to take this name out of the mud where you are dragging it, so as to make of it a symbol. This name is the name of our race. Our lands, our rights and our liberty no longer ours, we cling to that which, along with the radiance of our skin color, is all that remains of the inheritance of our ancestors. . . . Yes, sirs, you have tried to use this word as a tool to divide. But we use it as a rallying cry: a torch! [*Nous, nous en servons comme mot d'ordre de ralliement: un flambeau!*] We do ourselves honor and glory by calling ourselves *Nègres*, with a capital N. It is our *race nègre* that we want to guide on the path of total liberation from its suffering under a yoke of enslavement. We want to demand the respect due to our race, as well as its equality with all the other races of the world, as is its right and our duty, and we call ourselves *Nègres!*

Christopher Miller has pointed out that in the way it reclaims *Nègre*, a word dragged in the mud of history, this argument is a "space-clearing gesture" that is "radical in the etymological sense: it attacks the roots of domination.[30] The strategy is not to undo the term's naturalized racialism (*Nègre* is still "the name of our race") but to "rally" and realign the term in the ideological "service" (*nous, nous en servons comme mot d'ordre de ralliement*) of a new anti-imperialist solidarity.

With a sense of the complexity of this field of signifiers, we are left with the question: how would we translate *Nègre* in Senghor's usage into English? Turning to contemporary literature in English, one thinks of Du Bois's propaganda campaign to capitalize *Negro*—but is this term then equivalent to Senghor's capitalized *Nègre*? One might also think of Carl Van Vechten's 1926 *Nigger Heaven* (translated into French as *Le Paradis des Nègres*), a novel that caused considerable controversy not only because its author was white, but also because of its title, with readers debating whether the phrase was simply an intentionally outrageous advertising ploy or an "honest" attempt to employ *nigger* as a "non-derogatory" appellation for African American urban characters.[31] Another work to note is U.S. Southern writer Roark Bradford's 1928 *Ol' Man Adam an' His Chillun*, a collection of folktales in which we encounter a seemingly similar three-tier typology of the African American population.[32] In the foreword to this "personal study of the black race," Bradford notes that he has somewhat informally "divided it into three general groups: The 'nigger,' the 'colored person,' and the Negro—upper case N."[33] Again, we are presented with a hierarchy, but here uncritically as a natural typology of the race—invested with all the familiar paternalistic baggage of stereotypes. So the "Negro" "is . . . a man of character and understanding who realizes that his people could not possibly have acquired in two hundred years the same particular brand of civilization that the white people built up in thousands of years," whereas the "colored person" is simply "tragic," "neither fish nor fowl."[34] The "nigger," as one might expect, interests Bradford "more than the rest," Rather than Senghor's biting etymology, we are offered an abstract litany of "traits": the "nigger" is uninterested in work but highly loyal, irresponsible but responsive to any stimuli, intuitively and endlessly creative within the confines of a fading rural folk culture.[35] Do the *niggers* in Van Vechten and Bradford (not necessarily the same figures, of course) jibe with Senghor's *Nègre*, a more or less rehabilitated term of derision?

It should be evident that it is difficult to match up any such hierarchy of social usage in the two contexts. I will risk constructing a shorthand, as follows: in the interwar period, the various

ideological accentuations of this group of signifiers share a ground-level connotation that *Negro* in English functions most like *noir* in French (both are adopted by assimilationists and civil rights activists; both aim at a certain "respectability" on the national front). At the same time, the function of *nègre* in French—while not unlike that of *nigger* in English—may be closest to the word *black*, a derogatory appellation in the 1920s (both are terms that populist radicals such as Lamine Senghor in French and Marcus Garvey in English were keen to rehabilitate in the service of a certain nationalism). The best "translation" of *nègre*, though, might not be a literal translation at all, but a linguistic nuance, an effect achieved in a particular nongeneralizable discursive instance. Consider this anecdote from Langston Hughes's autobiography *The Big Sea*, a hilarious recounting of his encounter with the woman who would replace him as an English teacher in Mexico:

> Professor Tovar had neglected to tell the new teacher that I was an *americano de color*, brown as a Mexican, and nineteen years old. So when she walked into the room with him, she kept looking around for the American teacher. No doubt she thought I was one of the students, chalk in hand, standing at the board. But when she was introduced to me, her mouth fell open, and she said: "Why, Ah-Ah thought you was an American."
>
> I said: "I am American!"
>
> She said: "Oh, Ah mean a white American!" Her voice had a southern drawl.
>
> I grinned.
>
> At the end of the first day, she said: "Ah never come across an educated Ne-gre before." (Southerners often make that word a slur between *nigger* and *Negro*.)
>
> I said: "They have a large state college for colored people in Arkansas, so there must be some educated ones there."
>
> She said: "Ah reckon so, but Ah just never saw one before." And she continued to gaze at me as her first example of an educated Negro.[36]

Hughes's cutting commentary on the woman's racism is coy and formalistic. His phonetic transcription of her accent simply relegates her first person singular to the level of a stammer ("Ah-Ah"), and that record of her idiocy defuses any derogatory force her slurred "Ne-gre" might have carried. But as an accentuation "between *nigger* and *Negro*" "Negre," as described by Hughes, places its nominal force close to that of *nègre* in French both phonetically and ideologically.

Some of the most intriguing moments in the interwar period occurred when these racialized terms were re-accentuated back toward what Forbes describes as their "originary" sense of "multiraciality," alluding to the mixture of disenfranchised populations in transatlantic patterns of dispersion. What is perhaps most suggestive about this occurrence is that it established a means of historicizing transnational formations, or as Gayatri Spivak puts it, "'inter-nationalizing' subalternist work from below."[37] Thus when Forbes cites the 1854 case where the California State Supreme Court "sought to bar all non-Caucasians from equal citizenship and rights" by creating a catchall term "Black," a designation designed to include not just all "Negroes" but also all the other "non-white" races as well, we should read this term in subtle resonance with the uses of "Black" to refer to Africans, Caribbeans, and Southeast Asians in post-World War II Britain—uses which have made possible at certain moments during the past twenty years a number of progressive "international" alliances there.[38] This historical etymology should also resonate when we attempt to come to terms with current usage in France, where interestingly enough, the chosen self-designation of the younger generation of Africans and Antilleans is sometimes *les Noirs*, but just as often *les blacks*—a term adopted from English in the past thirty years.

Likewise, there may be similar possibilities in the history of French usage of *nègre*, an epithet that at isolated moments during the history of the French Empire was applied liberally to a variety of populations. It should be clear that Lamine Senghor's claiming of the word *Nègre* is not an

argument for *return,* in Glissants terminology. It does not propose a usable originary blackness or a single African identity, but instead begins by accepting the historical fact of colonization and the contemporary racialized ideologies of exploitation in order to construct an appeal for solidarity. What's fascinating is that other Francophone radicals were at certain moments going even further; attempting to wrench the term *nègre* into the service of anti-imperialist alliances among what W. E. B. Du Bois called "the darker peoples of the world."

One instance is the contribution by Martinkan poet and schoolteacher Gilbert Gratiant to the single issue of the journal *L'Etudiant noir,* which appeared in March 1935. Apparently the young students who were assembling *L'Etudiant noir* (including Aimé Césaire and Léopold Sédar Senghor) asked Gratiant to write a response to the attacks that had been launched against him, especially in the predecessor student journal *Légitime Défense* (1932). His essay, "Mulâtres . . . pour le bien et le mal," is ultimately a defense of his unique political position and his own understanding of "creole" culture in the French Caribbean.[39] Gratiant clarifies that in writing about creole culture, he is not at all denying the African roots of the "black soul" (*âme nègre*) and the importance of African cultural forces in present-day Antillean life. He does argue, however, that the Caribbean is a mixed-race population from the beginning and that its cultural issues cannot be neatly packaged using inapplicable racialist dividing lines. The word *nègre,* Gratiant contends, has no "real" referent in some population linked by common roots. It can be employed only as a discursive strategy, an act of language to mark certain historical and material relations of domination and suffering. The position is significant, not least because Gratiant articulates it from a strong Marxist standpoint (specifically commending the work in Paris of the Communist Party—affiliated journal, *Le Cri des Nègres*). He advises conserving the use of *nègre* for that revolutionary context, which goes beyond a racial designation:

> [I]f the fact of proclaiming: *I am nègre!* [*je suis nègre!*] is the record of the limited historical fact I have tried to analyze, then I proclaim it, but that proclamation has no value elsewhere. If one wants to understand thereby that, recognizing that there subsists in me a *nègre* soul, in its creole form, or more vaguely in its unawakened forms, I am publicly paying tribute to that wonderful fact, I cry with a joyful wonder: *je suis nègre,* but the cry is not an exclusive one and my joy is just as deep at feeling myself a Martinican mulatto or just simply French in Vendômois, the Venddmois of the sweet Loire valley, that of my childhood, my friends, my brother's daughters. If, with this cry launched in defiance, one wants to understand a courageous and vehement support for the cause of the persecuted, my brothers in opprobrium whose skin is black, martyrs of race hatred, martyrs of villainous imperialisms: then I show my solidarity and shout: *je suis nègre!*[40]

In this limited sense, Gratiant accepts the word being brandished by the young students. But he refuses to take up what he sees as its racialist mystifications: even in underlining the survivals of African cultural forms in the French Caribbean, Gratiant insists on the other forces and factors that have shaped "creole" identity. But if the word *nègre* is a term of "solidarity" that is not essentialist, that is "not exclusive," then it allows something beyond a racial nationalism: for Gratiant, it is the lever of an anti-imperialist rallying cry that is articulated as an internationalism, a "support for the cause of the persecuted" in a more generalizable sense,

The Frame of Blackness

Claiming the term *nègre,* investing it with particular signifying content, and then deploying it as a link to another context (using it to translate *Negro,* for instance) are clearly practices with implications that go beyond the "simply" linguistic. In a larger sense, these are all *framing* gestures.

Thus the divergent interventions of Lamine Senghor and Gilbert Gratiant, for example, do not just *define* the word *nègre.* They also frame it: positioning, delimiting, or extending its range of application; articulating it in relation to a discursive field, to a variety of derived or opposed signifiers (*homme de couleur, noir*); fleshing out its history of use; and imagining its scope of implication, its uses, its "future." It is not coincidental that the interventions I have outlined so far take place in a particular limited range of sites within print culture, sites that imply a certain transitionality or instability if not rupture. Framing gestures work the edges, in other words: in the manifesto, in the impassioned response or open letter, in the broadside, in the editorial or position paper that stakes out ground in the inaugural issue of a newspaper. In the 1920s and 1930s, they emerge most emphatically in concerted efforts to "preface blackness" in all the senses of that phrase, particularly in introductions to books, collections, and anthologies.[41] As David Scott has recently noted, an introduction "*frames* a text by *placing* it in relation to its conditions of enunciability, and in relation to the system of discursivity that governs the production and organization of its statements. An introduction shows how a text occupies a certain space of problems, a particular context of questions, a distinctive domain of arguments. In short, it shows what the relations are to that background of knowledge—the archive—that sustains it."[42] Here I will briefly elaborate this broader sense of framing race, in order to argue that internationalist initiatives during the interwar period make recourse to certain strategies of literary formalism—and in particular, to certain practices of the preface.

Literary critics and historians including Robert Stepto, Henry Louis Gates, Jr., John Blassingame, and William Andrews have demonstrated in work on the slave narrative tradition in the nineteenth century that the emergence of African American narrative involves an inescapable grappling with the politics of literary form. Narratives by former slaves were a persistently *framed* mode of production: they are almost always supported and sometimes suffocated by a mass of documentary and verifying material serving to "authenticate" the Negro subject's discourse by positioning and explicating it. This material includes prefaces and postfaces from prominent abolitionists, the signature of the former slave on the frontispiece, photographs, avowed and unavowed editorial addendums and elisions, guarantees and testimonials to the former slave's upstanding character, ancillary tales or narratives, appended letters, and explanatory notes.[43] In particular, Stepto's 1979 study *From behind the Veil* argues convincingly that the representation of the black modern subject relies on the control over the framing apparatus even after the slave narratives, as works including Booker T. Washington's *Up from Slavery* (1901), Du Bois's *The Souls of Black Folk* (1903), James Weldon Johnson's *The Autobiography of an Ex-Colored Man* (1912), and Ralph Ellison's *Invisible Man* (1952) represent a variety of "archetypes" of black identity through the manipulation of framing structures and especially prefatory material.

On the one hand, Du Bois's *The Souls of Black Folk* attains this effect through a set of operations one might term "allegories of reading," which articulate the various levels of the text—their shifting, carefully calibrated points of entry to an "inside" marked as "Negro"—in a manner that stands in for social and epistemological access to the multiple layers and "deeper recesses" of the "world in which ten thousand thousand Americans live and strive." Thus it is on the textual border, in the book's "Forethought," that Du Bois announces that "herein lie buried many things which if read with patience may show the strange meaning of being black here in the dawning of the Twentieth Century."[44] At the same time, the book draws not just on formal strategies of the "authenticating frame" but also on the figurative rhetoric characteristic of the slave narratives. The most obvious example is the trope of the "veil." This trope does not commence with Du Bois but in fact recurs throughout the slave narrative tradition, in works by Frederick Douglass, Olaudah Equiano, Harriet Jacobs, and Mary Prince, usually deployed at moments of great narrative stress to mark the excesses of slavery that are in some sense "unspeakable." The veil is a metaphor for a particular kind of border, both rhetorical and moral. Toni Morrison, whose 1987 novel *Beloved* may indeed be read

as a more recent elaboration of this same inherited trope, has discussed the veil's prevalence and its implications as a particular kind of silence that shapes the tradition: "Over and over, the writers pull the narrative up short with a phrase such as, 'But let us drop a veil over these proceedings too terrible to relate.' In shaping the experience to make it palatable to those who were in a position to alleviate it, they were silent about many things, and they 'forgot' many things. There was a careful selection of the instances that they would record and a careful rendering of those that they chose to describe."[45]

The Souls of Black Folk rearticulates the trope of the veil to indicate the frontier of a black counterculture of modernity in a manner that allows the text to authenticate itself—to invest the narrator's first person with authority over that social and epistemological boundary. As the "Forethought" announces: "Leaving, then, the world of the white man, I have stepped within the Veil, raising it that you may view faintly its deeper recesses—the meaning of its religion, the passion of its human sorrow, and the struggle of its greater souls."[46] For Stepto, Du Bois's text not only puts pressure on its joints in this way, but also multiplies its framing gestures into an "orchestration" of every possible register.[47] Thus the "Forethought" and "Afterthought" are echoed at another level by the epigraphic structure of each chapter, where the prose is preceded by an ambiguous pairing of a quote from a European-language poem and a fragment of a musical score of a Negro spiritual (without the lyrics).[48] *The Souls of Black Folk*, which manipulates many kinds of data, facts, and evidence about blackness and which "weaves" together "varying modes of formal writing, including historiography, autobiography, eulogy, and . . . fiction," is a "new way of thinking about documentary writing and about what constitutes authenticating evidence."[49] The book continually shifts the epistemology of race through its complex layering of frames.

Many critics have noted the debts of James Weldon Johnson's 1912 *The Autobiography of an Ex-Colored Man* to Du Bois's work.[50] I would add that the importance of the novel is intimately linked to the ways it applies and revises the framing strategies of *The Souls of Black Folk*. *The Autobiography* is the "first sophisticated structural exploration," as Richard Yarborough has suggested, "of the generic fluidity underlying much of Afro-American autobiographical writing . . . and the first successful attempt to exploit this generic fluidity as an apt representation of the psychological tensions . . . inherent in the black experience."[51] One might push this insight even further and note that the novel explores this "generic fluidity" most prominently through a reformulation of the relation between preface and text.

Like the "Forethought" to *The Souls of Black Folk*, the preface to *The Autobiography* promises sociological facts and documentation to come in the text: it claims that the book will be a "human document," one which "shows in a dispassionate, though sympathetic, manner conditions as they actually exist between whites and blacks today."[52] It takes up the trope of the veil as well, marking a textual border as allegory: "In these pages it is as though a veil has been drawn aside: the reader is given a view of the inner life of the Negro in America, is initiated into the freemasonry, as it were, of the race" (xl). But this preface (written by Johnson, but signed "The Publishers")—combined with the novel's anonymous publication—signals a small but crucial shift of authority.[53] The Negro world is not a "prison-house" as it is described in *The Souls of Black Folk*, nor is "double consciousness" at once a gift and a deprivation that is conferred or imposed from without.[54] Instead, it is the white readership that is shut out, and which must by implication undergo a transformation, an initiation "into the freemasonry" of the Negro race, in order to cross what now seems to be a much more unsettling frontier. The sensationalism has been inverted, in other words—the book offers not the thrill of access to a "veiled" world, but the threat of incomprehension, of indistinguishable limits. So the preface here is not a door or frontier, but a kind of parodic "hinge" both opening and closing an "impossible text." As Aldon Nielsen describes it, *The Autobiography of an Ex-Colored Man* "produces the impossibility of a stable reading of its own narrative as exemplary of the instability, the impossibility, of American racial definition."[55] As in George Schuyler's 1931 novel *Black No*

More, sociology becomes a kind of joke on the reader, since the "color line" is exposed not as a tragic American fact but as the paradigmatic American fiction. When the narrator comments near the end of *The Autobiography* that he is "an ordinarily successful white man who has made a little money" (211), one realizes that Johnson's novel is less a revelation of "veiled" blackness than a critical exposure of normative American "whiteness." In the end, the narrative is nothing other than what Nielsen calls "the tale of the creation of an ordinary white man."[56]

It is sometimes overlooked that the rearticulation of framing strategies in *The Autobiography of an Ex-Colored Man* is anchored not just in the form of the novel but also by its transatlantic journey out of the nation-space. Although the preface promises a "vivid and startlingly new picture of conditions brought about by the race question in the United States" (xxxix), the unnamed narrator's most trenchant epiphany about race takes place during a trip to Europe with his wealthy patron. At the beginning of chapter 9, on the ocean liner to the old continent, the narrator comments that the ship "ran in close proximity to a large iceberg. I was curious enough to get up and look at it, and I was fully repaid for my pains. The sun was shining full upon it, and it glistened like a mammoth diamond, cut with a million facets. As we passed, it constantly changed its shape; at each different angle of vision it assumed new and astonishing forms of beauty" (126–127). It is as though the reader is being offered an optic image to replace the binarism and simplicity of the veil—a reminder that the "color line" must be comprehended in its subtle "facets" (and in international waters). It is a "constantly changing," "mammoth" whiteness at once beguiling and glisteningly treacherous. The so-called "Negro problem," as Johnson would later put it (taking his point of departure from *The Souls of Black Folk*'s famous rhetorical query, "How does it feel to be a problem?"), is "not a problem in the sense of being a fixed proposition involving certain invariable factors and waiting to be worked out according to certain defined rules. It is not a static condition; rather, it is and always has been a series of shifting interracial situations, never precisely the same."[57]

The Ex-Colored Man's epiphany about black popular music, inspired by a German pianist at a party in Berlin, is the same kind of realization:

> My millionaire planned, in the midst of the discussion on music, to have me play the "new American music" and astonish everybody present. The result was that I was more astonished than anyone else. I went to the piano and played the most intricate rag-time piece I knew. Before there was time for anybody to express an opinion on what I had done, a big bespectacled, bushy-headed man rushed over, and, shoving me out of the chair, exclaimed: "Get up! Get up!" He seated himself at the piano, and, taking the theme of my rag-time, played it through first in straight chords; then varied and developed it through every known musical form. I sat amazed. I had been turning classic music into rag-time, a comparatively easy task; and this man had taken rag-time and made it classic. The thought came across me like a flash—It can be done, why can't I do it? From that moment my mind was made up. (141–142)

The German brusquely pushes the narrator away from the piano to prove that musically, too, the "line" shifts, that it can be crossed both ways. The scene shows in microcosm what the novel as a whole achieves: the troubling, ambiguous framing of blackness, the performance of a "state of suspension between racial realms of cognition."[58]

But why does this scene need to be set in Berlin? In its staged syncretism, it is almost a kind of dramatization of the Germanic predilections of *The Souls of Black Folk*, in which Du Bois (who had himself studied in Berlin) quotes lyrics from Wagner's opera *Lohengrin*, or places a musical snippet from a Negro spiritual beneath a poem by Schiller. But even more pointedly, the contention in *The Autobiography of an Ex-Colored Man* is that a transnational foray is necessary to undo the "fixed" and "static" nature of the "Negro question" in the United States. The "flash" is predicated on

a confrontation, on the violence of a "shove" and a re-voicing of a "theme," on a "shifting interracial situation." The scene of two pianists in a party, jousting with improvised variations, is a scene where heterogeneous detours intersect at yet another *point d'intrication*—in this case the transnational circulation of African American music ("rag-time") in the European metropolis. In other words, the epiphany can be framed only as another sort of translation.

Race and the Modern Anthology

Gerald Early has recently made the provocative assertion that "the book that really kicked off the phase of the New Negro Movement known as the Harlem Renaissance—the phase that tried to produce a school or an identifiable discipline of black American letters—was not Jean Toomer's *Cane* (1923) or Claude McKay's *Spring in New Hampshire* (1922), it was James Weldon Johnson's 1922 anthology *The Book of American Negro Poetry*, the first collection of its type but surely not the last to display a considerable obsession in anthologizing the Negro."[59] The extension of formalist strategies from the slave narratives into African American literature in the twentieth century is evident not just in generically hybrid, subtly prefaced books by Du Bois, Johnson, and others. It is also, perhaps most importantly, evident in the Negro anthologies that seemed to be pouring out of publishing houses on both sides of the Atlantic in the early 1920s. For the first time—and in a rush that with hindsight is astonishing—there was great interest in researching, notating, transcribing, assembling, and packaging almost anything having to do with populations of African descent. Because the compulsively documentary New Negro movement coincides with the *vogue nègre* (the acquisition-minded European fascination with black performance and artifacts) and with the institutionalization of anthropology as a discipline, there appears to be an almost overnight explosion of textual collections after the war. It is possible to cite literally dozens and dozens of anthologies around black themes, from Blaise Cendrarss *Anthologie Nègre* (1921) in Paris and Johnson's *Book of American Negro Poetry* (1922) in New York all the way through the next decade.[60]

To note this flood of energy in modern print culture is to raise the question of the particular way an anthology frames race, the particular way it articulates an epistemology of blackness. As Theodore O. Mason, Jr., has pointed out in a smart treatment of the history of African American anthologizing efforts, it is also to highlight the perhaps surprising and perhaps ironic function that the anthology plays—not in confirming the canon, not in a backward-looking survey of the high points in a trajectory, but instead in founding and enabling the very tradition it documents, "at the beginning rather than the end of literary history making."[61] At the same time, it is crucial to place a text such as *The Book of American Negro Poetry* within this much wider, multilingual, Western rush to anthologize blackness, even if James Weldon Johnson's concerns and motivations are not at all consonant with the aims of V. F. Calverton, not to mention Cendrars, Maurice Delafosse, or Leo Frobenius. Such a juxtaposition makes clear the high stakes of framing the black subject in the 1920s, which is not just a national issue. The anthology is a means more broadly to grapple with *modernity* itself: the form serves to "mark time," whether for the purposes of racialist retrenchment (positioning the Negro as paradigmatically backward and primitive, innocent and unlettered, as in many of the European colonial and anthropological texts) or racialist vindication (positioning the Negro as paradigmatically modern and up to date, historical and literate, as in the anthologies that emerge during the Harlem Renaissance).

The anthology takes on such a central role in this period of "considerable obsession" with the Negro partly because the form is above all a way of accounting for a given cultural conjuncture. It delimits the borders of an expressive mode or field, determining its beginning and end points, its local or global resonance, its communities of participants and audiences. In doing so it necessarily

"presumes some idea of *difference*" (whether national, linguistic, generic, thematic, or identity-based) and aims to present the specific contours of that difference, in a way that both articulates it—makes it speak—and marks it off.[62] The anthology's expressive force is concentrated not just in the contents of a given collection or in its apparatus (its bibliography, its illustrations) or in its methodology (the sources it admits, the notational techniques it prefers, the way it limits its scope and pursues its assemblage). Most strikingly, the power of the anthology is concentrated in its discursive frame—in its preface, introduction, or opening statement. It should be no surprise that in a form so intimately concerned with framing, the preface becomes a point of great tension: the frame of the frame, as it were, the place where the collection itself is collected.

The allographic preface of the anthology "speaks before" (*prae-fatio*) what it collates.[63] A preface is always early or late, always a mask or a coda. It conditions the protocols of reception for the documents it presents. It purports to strike a path, to point the reader through a door or over a horizon, but paradoxically is usually written only after the text has been assembled. If the preface functions as a frame, we should recall that a frame in the etymological sense (as in the phrase "to frame an idea") refers both to the materiality of the limits or the edges of an object and to the interior force that gives it shape, that gives it life—not just the container but also the contained, not just the skin but also the blood or the skeleton. As a formal device, the preface speaks double in this way: it is outside, it marks what is not within the book, it precedes the book's "speaking," but it is also the very force that animates the book, that opens it for us and shows its contents. The preface therefore is a frame not always easily separable from the artifact itself, even as it rhetorically holds itself to be distinct from and prior to what it introduces.[64]

Let us consider in more detail James Weldon Johnson's anthology *The Book of American Negro Poetry*. The successful 1922 collection not only was the first gathering of Negro verse handled by a major U.S. publisher, but also was distinguished by its preface, a forty-two page essay on "The Creative Genius of the Negro" that, as Johnson put it a dozen years later, forcefully "called attention to the American Negro as a folk artist, and pointed out his vital contributions, as such, to our national culture."[65] Like Du Bois, Alain Locke, Charles S. Johnson, and Carter G. Woodson, Johnson hoped to provide overwhelming proof of the vitality, modernity, and historical depth of black expressive culture with the aim of reshaping the parameters of "the Negro question" in the United States. The famous declaration on the first page of the preface is characteristic: to varying degrees, these culture-framers shared Johnsons belief that nothing would accomplish more to change the "national mental attitude toward the race . . . than a demonstration of intellectual parity by the Negro through the production of literature and art."[66]

Johnson's effort to "demonstrate" parity through culture is above all a concern with the "universality" of black modernity. It is clear from the first page of the preface that *The Book of American Negro Poetry* aims to note how a black culture is distinctive, while at the same time lays claim to what Johnson terms black culture's "universal appeal." The rhetorical appeal to universality is by no means an unfamiliar strategy. Immanuel Wallerstein has pointed out that any project of cultural resistance necessarily must contest "the ideology of the system by appealing to antecedent, broader ideologies (that is, more 'universal' values)," which in effect accepts "the terms of the debate as defined by the dominant forces."[67] Johnson attempts to walk this tightrope when he begins the preface to *The Book of American Negro Poetry* with the oft-cited sweeping statement that "[a] people become great through many means, but there is only one measure by which its greatness is recognized and acknowledged. The final measure of the greatness of all people is the amount and standard of the literature and art they have produced. The world does not know that a people is great until that people produces great literature and art" (9). He takes on the parameters of culture as they have been defined by the very defenders of the Western high cultural tradition who would dismiss Negro American expression as formless or infantile.

But after these grand opening gestures, Johnson moves into a preface that seems at times to contradict this announcement about universality and "greatness." Ostensibly the preface frames black U.S. literature, but on the second page, Johnson indulges in an extended digression on the "creative genius of the Negro" *not* in terms of literature, not through the poetry collected in the anthology, but instead in terms of African American vernacular art: folklore ("the Uncle Remus stories"), music ("the 'spirituals' or slave songs"), dancing ("the Cakewalk"), and popular commercialized music ("ragtime") (10–20). If the goal is to argue the achievements of African Americans in "high art," then why does the preface commence with a passionate defense of the "vital spark" of "lower forms" (15, 17)? In the end, the preface is most remarkable in that it digresses precisely in order to contend that Negro expression is both constitutive of the American "cultural store" and excessive to it—what Paul Gilroy terms a "counterculture," but one that simultaneously defines the core of national culture.[68] Indeed, Johnson worries not that U.S. culture will absorb or consume African American culture, but in fact that the latter has so fully defined the national culture that its origins have gone unrecognized (13).

More specifically, Johnson argues that it is the Negro's "transfusive quality" that places black expression in a privileged relation to the "national spirit" as the predominant voice of "our common cultural store" (3). The Negro is "the creator of the only things artistic that have yet sprung from American soil and been universally acknowledged as distinctive American products" (10). But that "transfusive quality" is not a characteristic limited to the populations of African descent on U.S. territory. It is instead a "racial gift" that expresses itself wherever Negroes are found: "This power of the Negro to suck up the national spirit from the soil and create something artistic and original, which, at the same time, possesses the note of universal appeal, is due to a remarkable racial gift of adaptability; it is more than adaptability, it is a transfusive quality. And the Negro has exercised this transfusive quality not only here in America, where the race lives in large numbers, but in European countries, where the number has been almost infinitesimal" (20). With this move, Johnson is able to position black culture as the defining American culture without limiting black creativity to a national origin. It eludes the frame of the nation, even as it indelibly defines what is "universally recognized" as national.

When the preface finally does get to poetry, it goes "a little afield" again, this time geographically, discussing the literature as a phenomenon that straddles the entire hemisphere. Johnson includes Claude McKay (from Jamaica) and George Reginald Margetson (from St. Kitts) in the collection along with the many poets from the United States. In his autobiography, Johnson explains that his preface "went a little afield and mentioned some of the Negro poets of the West Indies and South America, giving most space to Plácido, the popular poet of Cuba. My selections for the anthology proper increased to three or four times the number I had originally planned for, but I felt that in the case of this particular book, there was more to be gained by being comprehensive than would be lost by not being exclusive."[69] It should be noted that this shift is enacted with a shift in terminology, another "creation of vocables." In the first pages of the preface, Johnson writes of the "Negro" or "American Negro poets." As he moves "afield" at the end of his discussion of Paul Laurence Dunbar, he introduces a new racial appellation: "Aframerican" (36). Although Dunbar "is the most outstanding figure in literature among the Aframericans of the United States, he does not stand alone among the Aframericans of the whole Western world. There are Plácido and Manzano in Cuba; Vieux and Durand in Haiti; Machado de Assis in Brazil, and others still that might be mentioned, who stand on a plane with or even above Dunbar" (37). This word is a transport term in that it allows Johnson to extend the definition of "American" in another fashion beyond the borders of the U.S. nation, for "Aframerican" designates, as he puts it, "Negroes of . . . North America, South America, or the West Indies."[70] Part of the accomplishment of the preface is making proper this expanded sense of racial identity; by the discussion of "Negro dialect" toward the end of the preface, it is no longer so striking that he defines black culture as exorbitant to the nation, with the result

that the nation is the subset of a larger regional space, as in references to "Aframerican poets in the United States" (42).

Functionally, a preface differs from an introduction in that the latter is unique, with "a more systematic, less historical, less circumstantial link with the logic of the book."[71] Prefaces "are multiplied from edition to edition and take into account a more empirical historicity," and so it is worth noting that in the preface to the revised 1931 edition of *The Book of American Negro Poetry*, Johnson seems to include the term "Aframerican" in his contention that, in the intervening decade, the claims of the preface to the first edition had been accepted as "facts," a matter of "historical data."[72] The second edition is often considered the more authoritative, because it includes the poetry of what Johnson calls the "World War group": the younger generation of talented New Negro poets who emerged in the mid-1920s including Langston Hughes, Sterling Brown, Helene Johnson, Arna Bontemps, Gwendolyn Bennett, Frank Home, and Waring Cuney—as well as Johnsons own experiments in vernacular poetry in his 1927 *God's Trombones*.[73] In the new edition's shorter preface, Johnson now uses "Aframerican" interchangeably with "Negro."

In the first edition, the term "Aframerican" allows the preface to frame Negro expressive culture as exceeding the U.S. nation in *yet* another, even more remarkable manner. Johnson concludes his move "afield" with an extraordinary subversive gesture that mobilizes the new word:

> In considering the Aframerican poets of the Latin languages I am impelled to think that, as up to this time the colored poets of greater universality have come out of the Latin-American countries rather than out of the United States, they will continue to do so for a good many years. . . . The colored poet in the United States labors within limitations which he cannot easily pass over. He is always on the defensive or the offensive. . . . I think it probable that the first world-acknowledged Aframerican poet will come out of Latin America. (39–40)

In an anthology titled *The Book of American Negro Poetry* that claims a certain "universality" for that poetry, this can only be called a startling departure. One might best characterize this move as what Jacques Derrida terms a "textual feint," a way of using the preface that undermines the very pretensions of the anthology form.[74] It is also of course still a certain framing of blackness, even if the frame here ends by undoing itself, by demonstrating the instability—even the impossibility—of framing within national bounds.

The Book of American Negro Poetry does not simply tip the scale the other way, of course. It is *not* an anthology of "Aframerican" poetry in the sense of an exhaustive, or even vaguely representative, collection of poetry by writers of African descent throughout the Americas. In fact, Johnson declines to abstract the generalizing drive of the term "Aframerican" and, on the contrary, emphasizes the differences between the placement of the Cuban poet Plácido and any of the black U.S. poets. "Over against the probability" that the first "world-acknowledged Aframerican" poet will emerge from Latin America, he thus writes, is "the great advantage possessed by the colored poet in the United States of writing in the world-conquering English language" (40). Johnson is looking for an uneasy balance here in which a racial generalization or internationalism will not trump American nationalism. The sooner that "Aframerican poets in the United States" write "*American* poetry spontaneously, the better," and the primary referent remains national even though the descriptive "American" is thrown into question or opened up suggestively.

In terms of its content, the anthology pursues this shuttling or ambivalence in the significance of "Aframerican" in at least two ways. The poetry in the body of the text is itself *geographically* transnational, as I have pointed out, due to the inclusion of Margetson and McKay from the Anglophone Caribbean, Although there are no foreign-language poets featured in the anthology, it demonstrates the *linguistic* diversity implied by "Aframerican" first by undercutting its interior (the section of work by Jessie Fauset includes her translation of "Oblivion," by the Haitian poet Massilon

Colcou [208]) and then by proliferating its edges: providing a single poem by Plácido not in the body of the text, but in an appendix to the book. The Spanish evidence of "Aframerican" writing sits at the back door, not quite counted in the body of *American Negro Poetry*, not quite exterior to it. Even this closing frame is itself split, for Johnson includes Plácido's original Spanish of "Despida a Mi Madre" followed by *two* quite different translations of the poem, one by William Cullen Bryant and another by Johnson himself (293–294). The anthology breaks and breaks again, as though to make *décalage* manifest in an open set of overlapping spaces. It invests in the signifier "Negro" and then extends it with "Aframerican"; it writes in English and then supplements it with Spanish; it carries the Spanish back to English and then translates it again. It is impossible to sew this fraying into some seamless space of common blackness. So if *The Book of American Negro Poetry* frames its particular motivating difference by overflowing the nation-state—even while defining national culture through a "racial gift"—the same framing overflows itself, extending and questioning the limits of its difference. The book splits its own binding.

Border Work

I do not mean to suggest that such strategies cannot be located in Francophone literary culture in the 1920s. The French black drive to document and anthologize was not comparable to the activities in Harlem, and not simply because the black presence in France (although vibrant and visible) was much smaller. Nor was the problem that Francophone intellectuals were unconcerned with collecting Negro culture (as we have already seen with Jane Nardal's approach to Alain Locke). Even in the midst of the *vogue nègre*, the circuits of financing and patronage that supported the Harlem intelligentsia until the onset of the Depression were never available in Paris. Still, black intellectuals in Paris were reading works such as *The Book of American Negro Poetry* and *The New Negro*, and it is possible to track—in other forms—a Francophone engagement with and reformulation of framing practices.

At times in Francophone periodical print culture, one might read instances of framing in effects of juxtaposition: departures from a context (whether translations, articles by an unlikely source, or pieces in a different tone) that are equally insertions into that context. I am thinking for instance of an exceptional document that was inserted into the first issue of *La Race nègre*, the newspaper that in June 1927 succeeded *La Voix des Nègres* as the organ of Lamine Senghor's Ligue de Défense de la Race Nègre. Titled "Réponse d'un ancient tirailleur sénégalais à M. Paul Boncour" (Response of a former African soldier to M. Paul Boncour), the piece is the testimony of a soldier from the Sudan named Baba Diarra concerning the harsh treatment of African recruits during the war. But unlike the pieces that surround it in the issue, Diarra's text is composed not in standard French but in a transcription of the version of French called *petit nègre,* which was spoken by many soldiers. It opens:

> 1912 moi ngasi volontaire partir la guerre Moroco pasqui mon commandant mon cercle li promi boucou bons quand moi y a bien travailler pour Lafranci tuer boucou Morocains. Moi venir 2e régiment Kati, Ayéyé-yéye! Mon boucou malore plus que esclave. Caporani y a frapper moi, sergent y a toujours manigolo . . . Y a pas bon, y a pas boucou manger . . . 1914, la guerre Lafrance avec bochi y a comenser, moi vinir encore . . . moi gagné gallon caporani. 1916 moi gagne sagent. Mais sagent ropéen parler moi comme lui y a parler tirailleur 2e classe. Gradé ropéens y a compter nous comme sauvasi, comme plus mauvais chien encore. Si nous faire clamison ficiers y a dire nous, vous pas droit, vous pas citouin francais, vous . . . ndigenes.[75]

In 1912 I volunteered to go to the war in Morocco because the commandant of my district promised great rewards if I worked well for France and killed many Moroccans. I came in the second Kati regiment [from Bamako], Ayéyé-yéyé! I suffered a great deal, more than a slave. The corporal hit me, the sergeant always had his cudgel. . . . It wasn't good, there wasn't much to eat . . . 1914, the war between France and the Germans started, and I came back again . . . I earned my corporal's stripes. But the European sergeant spoke to me like he spoke to a private second class. Europeans consider us savages, even worse than dogs. If we complain to the officers they tell us, you have no rights, you aren't a French citizen: you're . . . natives.

I have provided a relatively straightforward English translation of the passage, because there is no way to reproduce the effect the passage has in the original. In *La Race nègre*, Diarra's "response" is not introduced, explained, or translated in any manner, and it confronts a French reader with its unfamiliar syntax and vocabulary (*Ayéyé, manigolo, sauvasi, ficiers*).

Historian Philippe de Witte has noted that the inclusion of this document in *La Race nègre* attempts "to elevate a 'patois' to the rank of a language of communication" and that as a result "an infantilized, ridiculed, and humiliating language [*langue*] becomes . . . a popular language, rich and full of images."[76] Another critic who has considered the piece, Christopher Miller, is certainly correct to point out *that petit nègre* functions here as a "means of resistance."[77] But it is necessary to clarify that *petit nègre* is not precisely a patois, and—as Frantz Fanon recognized—nor is it a creole.[78] In fact, *petit nègre* is one of the strangest legacies of World War I: it was a simplified, deformed version of French that the military codified and deliberately *taught* to African soldiers as they came to fight in Europe, as a means both to infantilize them and to control their modes of interaction with their mainly white French commanding officers. It is no coincidence that the same issue of *La Race nègre* excerpts a passage from Lucie Cousturier's 1920 *Des Inconnus chez moi*, which is the first text in metropolitan France to take issue with the policy *of petit nègre* instruction in training camps:

The instructors were able to generalize an esperanto, or "*petit nègre*," proper to the fabrication and the delivery of soldiers through the quickest possible means. The instructors' role was restricted to this end; they did not at all anticipate that these soldiers might want to speak French in France. This is the proof of a military machine's perfection: not to make life easier, but . . . to destroy it.

Suppose that having to teach our language to an Englishman, we carefully took note of all the deformations his first attempts inflict on French pronunciation and syntax, and that from then on, we draw on them to present him with a French reduced to his English compatibilities.[79]

As de Witte comments, were Diarra's account "translated into Parisian French or into communist jargon, the indictment would have lost a good deal of its force."[80] But one might add that the text's "force" is located *in its form*: linguistically, *petit nègre* makes the same critique as the narrative itself. It implies that the proper mode of critique is a spoken vernacular (since *petit nègre* is not a written language, the text points to a certain orality, whether Diarra wrote it himself or whether it was transcribed from his speech). The text gains its "force" not only because it represents a populist gesture of inclusion in a black metropolitan periodical, but also because *petit nègre* is itself evidence—the framed documentation, confronting the reader—of the mistreatment of French West African soldiers during the war.

My second example is a singular novel published in 1924, the Guadeloupean Suzanne Lacascade's *Claire-Solange, âme africaine*. The story takes place in "that period of internationalism" just before World War I, as a successful colonial administrator named Etienne Hucquart arrives

in the metropole from Fort-de-France with his daughter Claire-Solange.[81] Set in Paris, the novel follows the unfolding of a love affair between the young *mulâtresse* (Claire-Solange is the product of Etienne's marriage to an Antillean woman) and Jacques Danzel, a distant cousin. The title character is one of the more remarkable characters in early Francophone fiction: impulsive, highly educated, and fiercely proud of her African ancestry. At one point, as the extended household is discussing the evils of prejudice in the modern world, an aunt asks Claire-Solange if she is anti-Semitic. She responds defiantly: "Papa has traveled around the world, fighting against prejudices; and how could I despise another oppressed race, I who am *nègre [moi qui suis nègre]*" (36). When her aunt, appalled at the word *nègre*, tries to dismiss this declaration as folly, Claire-Solange launches into a soliloquy:

> Look my frizzy hair. I couldn't smooth it down into tresses against my cheeks, like the Jews of Aden; I couldn't lift it up into a 1830 *chignon* bun. . . . My *nègre* hair must be separated with headbands, twisted for better or worse against the nape of my neck. . . . In order to deny my African origin, I would have to live under a veil, hiding both my eyes and my nose from view. . . . Come on, aunt, smile. Accept as she is a woman of color, who will give some variety to the family. (36–37)

Elsewhere she declares that her hobby *(marotte)* is to "protect and glorify the Negro race [*la race noire*]" "I am African," she proclaims, "African, through atavism and despite *my* paternal heritage!" offering a fanciful enumeration of the royal lineage of her African family line (65–66). Claire-Solange—whose mother perished when she caught a chill on a visit to Europe—even advances a sort of continental climatology, contending that her maternal "African" side is genetically far superior to her "cold," "artificial," "dull" European heritage.

Claire-Solange eventually falls in love with Jacques and, despite her abhorrence of the European winter, decides to stay with him in the metropole as the war breaks out, offering him the "unique love of an African woman" (220). Her choice to remain in Paris is both the result of Jacques "conquering" her "African pride" and the result of her own patriotism as a French citizen herself: "This city that I didn't love, this city is all of France, it's the honor of the country, it's you, it's my life. . . . My pride as an African woman [*orgueil d'Africaine*] has been conquered by you, Jacques, my pride as a Frenchwoman [*orgueil de Française*] remains intact" (170). As Maryse Condé has pointed out, this *dénouement* is an all-too-familiar stereotype of the "hot-blooded" Antillean woman surrendering as erotic object, even if for once she is rewarded with a French husband rather than a temporary colonial lover.[82] Still, *Claire-Solange*'s racialist rhetoric, its strong female characterization, and its rich portrait of Creole popular culture were apparently radical enough that the book aroused great indignation in the Caribbean, with the result that Lacascade was forced to leave Guadeloupe.[83]

Claire-Solange, âme africaine is particularly innovative in its depiction of Caribbean vernacular culture and music. The novel contains a great deal of Creole, which is usually explicated or contextualized in French although not always fully translated, in passages such as the one when an Antillean servant comes into the room where Claire-Solange and Jacques are talking; the servant, who was supposed to do Claire-Solange's hair, and has been looking for the young woman all over the house, complains, "*Man jouque croué ou bliez moin, titfille. . . . Je commence à croire que vous m' oubliez*" ("I'm starting to think that you're forgetting about me"). Claire-Solange chides her with a vulgarity, but then refuses to translate it for Jacques: "*Pas fais guiolle kiou poule, da ché. . . . Oh! Monsieur Danzel, je ne me risque pas à traduire. . . . Le Créole en ces mots brave l'honnêteté. . . . Il me faut vous quitter pour un étrange devoir. Je dois prêter ma tête à ma bonne*" ("*Pas fais guiolle kiou poule, da chè. . . .* Oh! Monsieur Danzel, I don't dare translate. . . . The Creole in these words defies respectability. . . . I have to leave you for a strange fate. I have to lend my head to my maid") (47).[84] Over and over, the text performs the edges of Caribbean vernacular culture, pointing at all that cannot be carried over. This is often a way of figuring Claire-Solange's "mixed" parentage, as in the amusing

scene when she sits down at the piano in the parlor to play Schumann's *Carnaval* and improvises away from the theme into "strange, nostalgic cadences, brief complaints, hoarse joys—a tam-tam of sorrowful drunkenness, whose syncopations tear the fevered soul: it is Ramadan, the African Carnival. Then the rhythm, starting to skip, creating a youthful gaiety, recalls a habanera." "*Le Mardi Gras à Fort-de-France*," Claire-Solange announces, and starts to sing a lyric in Creole (31). *Carnaval* is a significant choice, since Schumann's 1835 suite is already virtuosic and polyvocal, with each section of the suite designed to represent what the composer called the "many different mental states" brought about by his marriage (drawing on a coded musical tone sequence based on the letters of his wife's birthplace). Schumann sometimes referred to it as a *Maskentanz*, a masked ball, and the piece was inspired not just by what he considered to be the pieces of his personality (two sections are called *Florestan* and *Eusebius*, Schumann's imaginary names for the "two sides" of his nature), but also by the European improvisational tradition: many of the fragments are titled after characters in the *commedia del Parte* and other figures from the popular theater (*Pierrot, Arlequin, Pantalon et Colombine*).[85] So for Claire-Solange to play this particular piece "with originality" (31) and then to transport it across the Atlantic toward another Carnival tradition (*Le Mardi Gras à Fort-de-France*) is an excursion at least as suggestive as the epiphany in Johnson's *The Autobiography of an Ex-Colored Man*.

But if music figures mixed heritage through cultural transport in *Claire-Solange*, it also comes to mark a certain inaccessibility, a certain part of an African' heritage that remains elusive and unconquered. At one point, depressed on a cold, rainy day, Claire-Solange stays in the house, trying to soothe herself with music: "Anguish agitates her moving nostrils, makes her eyelids heavy, but the tears do not fall: Africans, you should know, conceal their impressions; if they cannot contain their suffering, they sing passionately. This is what the *muldâresse* did." There follows a short indented refrain:

> Tchah, béhoué, kika, kika
> Tchahj béhoué, kika!
> Krinon-no-no-no-no béhoué
> Ahah, béhoué, ahah (43)

The tune is described as "a tune of savage revolt, it cracks like the blow of the lash on the naked back of Negro slaves [*esclaves noirs*], it is repeated indefinitely . . ." (44). When her father, standing in the doorway (*sur le seuil*), says that he doesn't recognize it, she explains, "it's what that servant boy was singing in Zanzibar, on the N'Gamba bridge, the day when he stopped traffic with his contortions; no one dared to pass [*personne n'osait plus passer*], thinking that he was possessed."

Strikingly, this is a moment when the text multiplies its own thresholds *(seuils)*. The indented lyrics are footnoted with the following sentence: "L'auteur a entendu ces paroles dans des circonstances analogues à celle que relate Claire-Solange, mais personne n'a pu, ou n'a voulu lui en donner le sens" ("The author heard these words in circumstances analogous to those that Claire-Solange relates, but no one could, or would, give her their meaning") (43). The gesture is immediately reminiscent of W. E. B. Du Bois's repeated telling—in each of his four principal autobiographies—of a story about his "grandfather's grandmother," who used to sing an old Bantu song that no one could translate into English: *Do ba-na co-ba, ge-ne me, ge-ne me!/Ben d'nu-li, nu-li, nu-li, nu-li, den d'le.* It had been passed down through the generations, and "we sing it to our children," Du Bois writes, "knowing as little as our fathers what its words may mean, but knowing well the meaning of its music."[86] The song in *Claire-Solange* similarly figures a link to an African past. She tells her father, accepting his embrace, "Don't worry, I'm just going through a little bout of nostalgia [*Je traverse un petit accès de nostalgie*]" (44). However, this moment is slightly different in significance from Du Bois's familial anecdote. Claire-Solange's song is not an ancestral hand-me-down, representing both a possessed heritage and

that heritage's inherent distance in unfamiliar, untranslatable words. Hers is a personal memory of an individual past in a ambiguous position in Africa, as the daughter of a colonial administrator with some imagined "access" (*accès*) to an "African" identity, but with constant reminders of what separates her from the "natives." "No one could, or would, give her [the words'] meaning," as the footnote puts it. The footnote claims to provide a "documentary" source and confirms the song through the "analogue" of autobiography, although the note's insertion is both a way of indicating the entrance of an authorial voice into the text and at the same time a way of marking a distance between author and character (since the circumstances are "analogous" but not identical).

The explanatory footnote makes the text generically hybrid in another sense, since it confers an ethnographic rhetoric of citation around the song's use in the fiction. In fact, this rhetoric—what "the author heard" herself—is given a certain privilege as a recording, because it is distinguished from the pretensions of European colonial travel literature and anthropology. A few pages later, remarking that spring is arriving in Paris, Claire-Solange explains to Jacques, "I imagined the spring, and France itself, from your literature, yes, just as you imagine the colonies from the lying tales of explorers [*d'après les récits mensonges des explorateurs*]" (46). Lacascade's own artifact is apparently meant to convey knowledge about Africa in a mode different from the old *récits mensonges*— though intriguingly, it discovers that mode not in travel narrative or anthropology per se, but in a "mixed" form that appends or grafts a musical document into the "imagined" space of the novel. The footnote, in other words, attempts to articulate itself as a fact within a fiction, a framing that tells a certain truth about colonialism with the evidence of a recorded music of "savage revolt," a remembered music that is insistent and repeated in a manner that metaphorically represents "the blow of the lash on the naked back of Negro slaves." As with Du Bois, what makes the music powerful as evidence is precisely that it cannot be translated—that it marks a certain inaccessibility, a space of expression exterior to the colonial system, a certain resistance that "no one dares to pass."

Even as it is transcribed, even as it is "authenticated" by Lacascade's footnote, the song remains elusive. Perhaps it is truthful evidence about colonialism not just in that it represents African resistance through its own resistance to translation, but also in the sense that no one dares to pass it on—Lacascade transmits it to the reader only as something that *cannot* be transmitted as evidence in any disciplinary sense, as something that can appear only in this oblique, layered space in a fiction. This point is emphasized by a countergesture at the end of the book: Lacascade includes an appendix of "Trois Bel-Airs Des Antilles" (Three Tunes from the Antilles), handwritten manuscripts that the text indicates were harmonized by Joseph Salmon. The scores provide the lyrics, melody, and musical accompaniment of three songs that appear in the novel: "Le Clair Solange," "Dis-Moi Doudou," and "Mardi-Gras" (the tune *Le Mardi Gras à Fort-de-France* that Claire-Solange segues into during her performance of Schumann's *Carnavat*). There are other interwar examples of Francophone writers appending ethnographic data or texts to their fictions—one thinks for instance of Ousmane Soce's 1935 *Karim, roman sénégalais,* which includes a ninety-page appendix of nine "Contes et legendes d'Afrique noire" (Negro African tales and legends) at the end of the novel.[87] What's different about Lacascade's book, of course, is that the appendix does not include that strange, untranslatable, footnoted song sung by the servant boy in Zanzibar. If the appendix as a framing gesture represents a certain documentary impulse with regard to Antillean vernacular culture, it also closes *Claire-Solange, âme africaine* by pointing the reader to an impassable "record" of colonialism that remains outside the book's grasp.

A Blues Note

I close with one more variation, one more take on these framing strategies in yet another genre. It would be possible to devote an entire study to the uses of framing in Langston Hughes's oeuvre,

especially in his work as a translator and editor. If we should recall that both Aimé Césaire and Léopold Sédar Senghor published translations of African American poetry early in their careers, we should equally recognize that Hughes is the most prolific black poet-translator of the twentieth century (publishing versions of Léon-Gontran Damas, Jacques Roumain, Nicolás Guillén, Regino Pedroso, Gabriela Mistral, David Diop, and Jean-Joseph Rabéarivelo, among many others) and at the same time a prodigious and groundbreaking anthologist in his own right.[88] Here, however, I will focus solely on framing practices and translation aesthetics in Hughes's poetry itself. His second book, *Fine Clothes to the Jew* (1927), was one of the more controversial black publishing events of the second half of the decade, a lightning rod for impassioned reviews both positive and negative.[89] The *Pittsburgh Courier* judged that Hughes's new book was "trash," while the headline in the New York *Amsterdam News* proclaimed, "Langston Hughes—The Sewer Dweller." Another paper called him "the poet lowrate of Harlem," punning in derision of the writer who would later be fondly referred to as the "Negro poet laureate." Critic Benjamin Brawley averred that "it would have been just as well, perhaps better, if the book had never been published. No other ever issued reflects more fully the abandon and the vulgarity of its age."[90] Another array of intellectuals, including James Weidon Johnson, Margaret Larkin, and Alice Dunbar-Nelson attempted to argue for the book's significance. Howard Mumford Jones went so far as to contend that with his "blues poems," Hughes "has contributed a really new verse form to the English language," in an accomplishment reminiscent of the experiments with the spoken vernacular in the *Lyrical Ballads* composed by Wordsworth and Coleridge at the turn of the nineteenth century.[91] But it is only much more recently that critics have begun to come to terms with *Fine Clothes,* which Arnold Rampersad rightly calls Hughes's "finest achievement in language" and "one of the most astonishing books of verse ever published in the United States."[92]

The oft-noted innovation in Hughes's new poetry is that, in contrast to the rhetorical distancing in earlier efforts such as "The Weary Blues"—in which an ambivalently placed speaker reports that he "heard a Negro play" in Harlem "the other night," and then describes and quotes the lyrics of the singer's music—the poems in *Fine Clothes* are unmediated: blues lyrics recorded directly on the page with no intervening or exterior voice.[93] The lines are enjambed at the caesura, so that the A-A-B structure of the twelve-bar blues forms a six-line stanza, as in "Young Gal's Blues," which concludes as follows:

When love is gone what
Can a young gal do?
When love is gone, O,
What can a young gal do?
Keep on a-lovin me, daddy,
Cause I don't want to be blue.[94]

The blues poems allude to recording not just in their parallels to blues structure, but also in their length, which is always either three or four stanzas—just like the songs of Ma Rainey, Bessie Smith, and Ida Cox. As Martin Williams has noted, the limitations of the ten-inch record (which allowed a singer only about three minutes, enough time to sing four blues stanzas) were a crucial factor in the expressive possibilities of early blues recordings, and Hughes's blues poems operate within the constraints of the recorded form.[95]

The unmediated quality of the poems has an effect that is often stunning, especially since they are sung or spoken mainly in the voices of young black women. The reader encounters stark, unleavened voices of the black working class not just in the performance situations of the blues but also in everyday, domestic moments. The poem "Baby" is no more or less than the voice of a parent yelling at her child: "Albert!/Hey, Albert!/Don't you play in the road." The most radically minimalist

poem in this vein is "Shout," which in its entirety runs three lines: "Listen to yo' prophets,/Little Jesus!/Listen to yo' saints!"[96] These poems attain the economy of haiku, but the aesthetic is not so much concerned with observation and distillation as it is with what one might call the technologies of recording: capturing the varied and fragmented soundscape of black Memphis or Washington, D.C., in a roving aural sampling that includes sung blues as well as splintered, seemingly overheard exclamations and exchanges. What is striking is the implied proposition that the spoken black vernacular can provide the material of a modernist lyric poetics—without mediation, without elevation, without any of the rarefied quirks that are so often taken to connote "poetry."

This is not to say that *Fine Clothes* abandons framing devices. The book opens with a prefatory gesture, "A Note on the Blues" designed to instruct the reader in the peculiarities of the form:

> The first eight and the last nine poems in this book are written after the manner of the Negro folks-songs known as *Blues*. The *Blues,* unlike the *Spirituals,* have a strict poetic pattern: one long line repeated and a third line to rhyme with the first two. Sometimes the second line in repetition is slightly changed and sometimes, but very seldom, it is omitted. The mood of the *Blues* is almost always despondency, but when they are sung people laugh.

The preface announces the structure of the book to be itself framed by the blues poems it contains, a form whose "inescapable persistence" returns at the end of the volume.[97] This framing is itself doubled, since the first poem ("Hey!") and the last poem ("Hey! Hey!") in *Fine Clothes* are succinct companion pieces that frame the book within the temporal space of a single night: "Sun's a settin' . . . Wonder what the blues'll bring?" opens the first, whereas the second echoes, "Sun's a risin,/This is gonna be my song."[98] Since the unmediated blues poems imply a certain recording or transcription of a performance, it is important that the "Note" emphasizes that the poems are "written after the manner of" the blues—not ethnographic reproductions of a given blues context, but a written form that aims at the "mood" of that context in a way that may have a complex and even transformative relation to it. That is, if the blues poem suggests a transcription, it also suggests the graphic particularities of a musical score: a writing that precedes and structures a performance rather than follows and records it. One might add that the blues involves a split between affect and reception: its "mood" is sorrow—or more precisely melancholia, as Jahan Ramazani argues—but its performance triggers the release of laughter in the audience.[99]

In his autobiography *The Big Sea* (1940), Hughes explains that *Fine Clothes* was mainly about black working class culture: its voices are those of "workers, roustabouts, and singers, and job hunters on Lenox Avenue in New York, or Seventh Street in Washington or South State in Chicago— people up today and down tomorrow, working this week and fired the next, beaten and baffled, but determined not to be wholly beaten, buying furniture on the installment plan, filling the house with roomers to help pay the rent, hoping to get a new suit for Easter—and pawning that suit before the Fourth of July."[100] The book moves through five sections (titled "Blues," "Railroad Avenue," "Glory! Hallelujah!," "Beale Street Love," "From the Georgia Roads," "And Blues"), traveling through what Robert Stepto terms the "symbolic geography" of sacred and secular, urban and rural spaces in African American life in the first decades of the twentieth century. Even in this controlled progress, though, *Fine Clothes* jumps and skips at various points, shifting register, articulating a black symbolic geography in unexpected ways. Hughes would write elsewhere that the blues are paradigmatically "songs you sing alone."[101] But a number of the poems in the volume (including "Closing Time," "Brass Spittoons," and "Mulatto") depart from the single-voiced blues lyrics and experiment with many-voiced interwoven constructions.

On a larger scale, the individual poems are situated in a broader polyvocality precisely through their contrasts—the interpoem "conversations" the book performs in the way it is arranged. So

one of the most controversial pieces in the book, "Red Silk Stockings" (in which an unidentified speaker instructs, "Put on yo' red silk stockings,/Black gal/Go out an' let de white boys/Look at yo' legs/. . . An' tomorrow's chile'll/Be a high yaller") is undeniably inflammatory when taken as an isolated statement. But it is provocative in a different manner when it is read next to the poem that precedes it, "Mulatto" (with its repeated refrain—"*I am your son, white man!*"—interspersed with the father's rejection—"*You are my son!/Like hell!*"—and another gnawing, intermittent voice— "*What's the body of your mother?*"). And the confrontation in "Mulatto" is tempered in turn by the subtle ethics of the poem that comes before it, "Magnolia Flowers." There a speaker searches for "flowers" but instead finds "this corner/Full of ugliness." The description of the search for magnolias is interrupted by a repeated plea for forgiveness ("Sense me, I didn't mean to stump ma toe on you, lady") that seems to form—even as it interrupts, or "stumps its toe" on the body of the poem—a fragile model for ethical interaction in a context of gendered violence.[102] In other words, the dynamics of framing operate simultaneously at the level of the book (its prefaces and divisions), between poems (in contrast, juxtaposition, or echoing), and within poems (in carefully layered polyvocality).

These three poems all appear in the section of *Fine Clothes* called "From the Georgia Roads." The poem that follows "Red Silk Stockings" appears to break dramatically from that context, and indeed to break the frame of the book as a whole. Rather than the blues context of violence and labor in the U.S. South, we are offered "Jazz Band in a Parisian Cabaret":

Play that thing,
Jazz band!
Play it for the lords and ladies,
For the dukes and counts,
For the whores and gigolos,
For the American millionaires,
And the school teachers
Out for a spree.
Play it,
Jazz band!
You know that tune
That laughs and cries at the same time.
You know it.
 May I?
 Mais oui.
 Mein Gott!
 Parece una rumba.
Play it, jazz band!
You've got seven languages to speak in
And then some,
Even if you do come from Georgia.
 Can I go home wid yuh, sweetie?
 Sure.[103]

Apparently Hughes wrote the poem in early 1924, when he was a twenty-two year old expatriate scraping by in Paris working as a dishwasher at a club in Montmartre called Le Grand Duc. Founded three years earlier, Le Grand Duc had been purchased that winter by the African American boxer and sometimes drummer Eugene Bullard, who had joined the French Légion Etrangère to fight in

World War I (eventually becoming the only black pilot in the Lafayette Escadrille, a squadron of U.S. fighter pilots fighting for the French), and then stayed in Paris. When the headliner, African American singer Florence Embry Jones, left that spring to open a new club down the street called Chez Florence, Bullard hired a relative unknown from Harlem named Ada Smith, who would soon be one of the most famous entertainers in Paris, performing under a nickname that paid tribute to her red hair: "Bricktop." Le Grand Duc became known as an after-hours joint: "when all the other clubs were closed," Hughes explains, "the best of the musicians and entertainers from various other smart places would often drop into the Grand Duc, and there'd be a jam session until seven or eight in the morning—only in 1924 they had no such name for it."[104] The musicians included the trumpeter Cricket Smith, the drummer Buddy Gilmore, pianist Arthur "Dooley" Wilson, violinist Louis Jones, singers Mabel Mercer and Sophie Tucker, the dancer Louis Douglas, and pianist Palmer Jones (Florence's husband). The audiences at Le Grand Duc seemingly drew every celebrity in Paris: Mistinguett, Louis Aragon, the Prince of Wales, Fred Astaire, Charlie Chaplin, Fatty Arbuckle, Gloria Swanson, Nora Baynes, Fannie Ward, Nancy Cunard, Jimmy Walker, Ernest Hemingway, F. Scott Fitzgerald, Robert McAlmon, Cole Porter, Man Ray, Kiki, and Kojo Tovalou Houénou.[105]

"Jazz Band in a Parisian Cabaret" *is* a singular evocation of Hughes's expatriate experience. But what is it doing in *Fine Clothes*? First of all, the poem links jazz as a music—"that tune that laughs and cries at the same time"—to the doubled-edged description of blues in the books prefatory "Note." It reminds us that the two forms were not always easily distinguishable in the 1920s. Indeed, in recounting his months working in Le Grand Duc, Hughes's autobiography refers to the jazz musicians who played at the club, but calls their music *blues*:

> Blues in the rue Pigalle. Black and laughing, heartbreaking blues in the Paris dawn, pounding like a pulse-beat, moving like the Mississippi! . . .
> Play it, Mister Palmer Jones! Lawd! Lawd! Lawd! Play it, Buddy Gilmore! What you doin' to them drums? Man, you gonna bust your diamond studs in a minute![106]

The new word "jazz" pulls the blues poems of *Fine Clothes* out of their frame, out of the confines of black performance spaces in the United States. In other words, if poems such as "Railroad Avenue" and "Bound No'th Blues" articulate a migrancy particular to U.S. spaces, "Jazz Band in a Parisian Cabaret"—with its "new vocable" for the music—tugs that allusion to black modern mobility into another register, now transnational. The cabaret is an "amphibious space" of situational, temporary mobility in a number of senses: not only in nationality and language, but also class (allowing interaction and seduction among the European aristocracy, new American "millionaires," middle-class professionals "out for a spree," and the musicians themselves).[107] That mobility is at the same time a quality *in* the music as well, mirrored in jazz's ability to change its affective implications, to "laugh and cry at the same time."

The indented lines in four languages can be read on a number of levels. On the one hand, they are a recording:

> May I?
> Mais oui.
> Mein Gott!
> Parece una rumba.

Four voices in the audience of a cosmopolitan cabaret like Le Grand Duc—disparate responses, sounded: an English speaker inviting someone to dance or requesting a cigarette; a French speaker's affirmative reply; a German speakers exclamation of shock or surprise ("My God!"); an analysis

and re-contextualization in Spanish ("It sounds like a rumba"). This polyvocal strategy is one that Hughes experimented with in a few other poems around the same time, all in an effort to capture the particular aural overload of a club scene. The best known may be another poem evoking the late-night jam sessions in Le Grand Duc, "The Cat and the Saxophone (2 A.M.)," which appeared in Hughes's first book, *The Weary Blues* (1926). It interweaves the lyric transcription of a dialogue with lines from the 1924 song "Everybody Loves My Baby, But My Baby Don't Love Nobody But Me," written by Jack Palmer and Spencer Williams:

Say!
EVERYBODY
Yes?
WANTS MY BABY
I'm your
BUT MY BABY
sweetie, ain't I?
DON'T WANT NOBODY
Sure.[108]

But like the lines in "The Cat and the Saxophone," the multilingualism in "Jazz Band" may be an effort not just to capture a conversation, but also to *describe* the workings of the music itself. In this poetics, jazz is defined as "communication," as Hughes puts it elsewhere: the lyric draws on many languages to represent the music's dialogic qualities (thus, each language figures the specific intonation and expressive mode of a given instrument in the music's fabric).[109] The many languages in the poem are a means of apprehending a music so intimately concerned with dialogue and exchange among a group of performers and the audience that it can be approached only through a kind of critical multilingualism.[110] As Duke Ellington writes in his foreword to *The Encyclopedia of Jazz*: "I don't think there are enough words in the English language to do all of this right, and unless a man has a grasp of other languages it may be impossible for him to find the nuances and subtleties, the varying degrees of quality, in music."[111]

This is also a poetics of universality, to return to the terms of Johnson's preface to *The Book of American Negro Poetry*. Jazz "plays it" for a range of audiences that is wide, if not potentially unbounded: "You've got seven languages to speak in/And then some." Or as Hughes writes about the blues, the music has "something that goes beyond race or sectional limits, that appeals to the ear and heart of people everywhere."[112] At the same time, the music embodies the particular: if it speaks to everyone, it also always speaks for the place it "come[s] from." And that place inescapably carries certain connotations in the midst of what Bricktop called *le tumulte noir*, the exoticist craze in Paris for all things black. Thus the somewhat sneering tone to the qualifier that follows: "Even if you do come from Georgia." This is of course another sort of framing. (It may also be a way of moving from the figurative register back to the descriptive: the lines may be a reminder that Eugene Bullard himself was originally from Georgia—a reminder that the poem speaks to a particular context, *a* Parisian Cabaret and only one: Le Grand Duc. This may likewise be the reason that the next line is the only moment in the poem that implies a black Southern vernacular: "Can I go home *wid yuh*, sweetie?") But like the other framings I have elaborated, the poem undoes the very frame it sets up, since it places "Georgia" in Paris. It articulates the "blues in the rue Pigalle" that are "moving like the Mississippi." These imaginative shifts transform and expand the contours of the symbolic geography of black modern culture that *Fine Clothes* articulates.

Also indented, the last lines of the poem can be read as a recording, too. "Can I go home wid yuh, sweetie?/Sure": the transcription of two voices in a successful seduction, a mutual agreement

to "go home" together. But they are also an approach to the music, in a poem that is first of all an apostrophe—a form of lyric that calls out to the lyric, words that demand and beckon music ("Play it, jazz band"). The poem performs the intimacy, the erotics, of a sound that travels: what in the music takes you "home," and goes "home" with you. In other words, these last lines attempt to hold at least two things together in a fragile balance: on the one hand, an individual listener's affective connection to the music, and, on the other, the collectivity of listeners the music allows, the connections it fosters.

Does "Jazz Band in a Parisian Cabaret" imagine that collectivity in any broader sense? Does it represent anything that might approach Jane Nardal's *internationalisme noir*? To ask such a question, of course, is to suggest a complex articulation of the disparate instances of formalist strategies I have outlined here: to suggest a link among discursive practices that aim {at a wide variety of points in a transnational print culture) to frame blackness as an object of knowledge beyond the nation-state. Next to the polemics of Senghor and Johnson, the diasporic gestures of Lacascade and Hughes seem no more than whispers: a footnote in a novel, a few lines of a lyric. In "Jazz Band," one might say that the smallest frame is just a hint, even a mishearing: the possibility that in the first two indented lines of the poem ("May I?/Mais oui"), the English reader is asked to hallucinate the joint of collectivity in a bilingual pun. "May I?" might also ask us to mishear the next line, written in French, as its English homophone: *May we.* We are back where we started, with the complexities of linguistic difference. This effect would be the smallest hint of a broader coming together in the popular good-time spaces of the *vogue nègre*, in the guise of a corrective: don't ask for yourself alone ("May I?")—we're going to dance *together.* Even if the poem is written in many languages, this hint can be heard only by its primary readership: it is audible only for an English speaker because it is produced by *partage*, a nonsignifying difference between languages.[113] But for an English-speaking audience, in the "yes" *(oui)* there is at once a foreshadowing of community—the sound of the affirmation that brings "us" together, the articulation of a connection across difference—and also the kernel of what cannot be carried over: the sound of another tongue. At the smallest level, then, in the play of that productive ambivalence where "Jazz Band" breaks the book's frame to reach Paris "from the Georgia roads," the possibility of black internationalism is heard to be a matter of music.

Notes

1. Jane Nardal, letter to Alain Locke, December 27, 1927, Alain Locke Papers, box 164–74, folder 25, Moorland-Spingarn Manuscript Division, Howard University. Unless otherwise indicated, all translations are my own.

2. Du Bois, "The Negro Mind Reaches Out," *Foreign Affairs* 3, no. 3 (1924), collected in *The New Negro* (1925; reprint, New York: Atheneum, 1989), 412–413.

3. Alain Locke, letter to Jane Nardal, n.d., Alain Locke Papers.

4. Nardal, "L'internationalisme noir," *La Dépêche africaine* 1 (February 1928): 5.

5. Paulette Nardal, "Eveil de la conscience de race," *La Revue du monde noir* 6 (1932): 25.

6. Du Bois, "The Negro Mind Reaches Out," 386.

7. Locke, "Le Nègre nouveau," trans. Louis and Renée Guilloux, *Europe* 102 (June 15, 1931): 289–300.

8. Naoki Sakai, *Translation and Subjectivity: On "Japan" and Cultural Nationalism* (Minneapolis: University of Minnesota Press, 1997), 13.

9. Gates, "The Trope of a New Negro and the Reconstruction of the Image of the Black," *Representations* 24 (fall 1988): 129–157; Levine, "The Concept of the New Negro and the Realities of Black Culture," in *The Unpredictable Past: Explorations in American Cultural History* (New York: Oxford University Press, 1993), 86–106.

10. Williams, *Keywords: A Vocabulary of Culture and Society* (New York: Oxford University Press, 1976), 20, 15.

11. Ibid., 11.

12. Raymond Williams, "Keywords," in *Politics and Letters: Interviews with New Left Review* (London: New Left Books, 1979), 177.

13. Edouard Glissant, *Le Discours antillais* (Paris: Seuil, 1981), 30. A partial translation by J. Michael Dash has been published as *Caribbean Discourse: Selected Essays* (Charlottesville: University of Virginia Press, 1989), 16. Subsequent citations will be indicated with page numbers for the French and English editions (in that order) in parentheses in the text. I have modified many of the English translations.

14. Franck L. Schoell, "La 'Renaissance Nègre' aux Etats-Unis," *La Revue de Paris* (January 1, 1929): 158.

15. Stovall calls Paris a "Gateway to Africa" in *Paris Noir: African Americans in the City of Light* (Boston: Houghton Mifflin, 1996), 97.

16. Jack D. Forbes, *Africans and Native Americans: The Language of Race and the Evolution of Red-Black Peoples* (1988; reprint, Carbondale: University of Illinois Press, 1993). Page numbers for subsequent citations will be indicated in parentheses in the text.

17. See Simone Delesalle and Lucette Valensi, "Le Mot 'Nègre' dans les dictionnaires français d'Ancien Régime: histoire et lexicographic," *Langue Française* 15 (September 1972): 79–104.

18. See Lucette Valensi, "Nègre/Negro: recherches dans les dictionnaires français et anglais du XVTIème au XlXème siècles," in *L'Idée de race dans la pensée politique française contemporaine,* ed. Pierre Guiral and E. Temime (Paris: Editions du Centre National de la Recherche Scientifique, 1977), 157–170. Other comparative works focusing on the development of racial terminology in English include H. L. Mencken, "Designations for Colored Folk," *American Speech* (October 1944): 161–174; James W. Ivy, "Le fait d'être nègre dans les Amériques," *Presence africaine* 24–25 (February–May 1959): 123–131; Nathan Hare, "Rebels without a Name," *Phylon* 23, no. 3 (fall 1962): 271– 277; Harold R. Isaacs, "A Name to Go By," in *The New World of Negro Americans* (Cambridge: MIT Press, 1963), 62–72; Richard B. Moore, *The Name "Negro": Its Origin and Evil Use,* ed. W. Burghardt Turner and Joyce Moore Turner (1960; reprint, Baltimore: Black Classic Press, 1992).

19. Serge Daget, "Les mots *esclave, nègre, Noir,* et les jugements de valeur sur la traite négrière dans la littérature abolitionniste française de 1770 à 1845," *Revue française d'histoire d'outre-mer* 60 (1973): 518. Daget notes that this project was largely ineffectual in the abolitionist movement.

20. Fanon, "Antillais et Africains," in *Pour la revolution afiicaine* (Paris: Maspero, 1964), 26; translated by Haakon Chevalier as "West Indians and Africans," in *Toward the African Revolution: Political Essays* (New York: Grove Press, 1988), 21 (modified).

21. Toni Morrison, *Playing in the Dark: Whiteness and the Literary Imagination* (Cambridge, Mass.: Harvard University Press, 1992), 6.

22. The phrase "legitimation by reversal" is adopted from Gayatri Chakravorty Spivak, "Race before Racism and the Disappearance of the American: Jack D. Forbes' *Black Africans and Americans: Color, Race and Caste in the Evolution of Red-Black Peoples,*" *Plantation Society* 3, no. 2 (1993): 89.

23. With a certain amount of fanfare, the *New York Times* finally gave in to Du Bois's crusade and granted the word "Negro" a capital "N" in a patronizing Op-Ed—but only on March 15, 1930, much later than we might expect. See Isaacs, *The New World of Negro Americans,* 65. This came no less than nearly a hundred and fifty years after English sealed the link between "Negro" and "slave" precisely by removing that very capital "N"—early translations of the Spanish *negro* had been written as "Negro" in English from the mid-1500s until the end of the eighteenth century. (See Ivy, "Le fait d'être nègre dans les Amériques," 125.) For critics of *Negro* such as Richard B. Moore, however, the futility and inconsequentiality of such "petty" struggles to "fine-tune" or rehabilitate the designation represent a supreme irony.

24. Cousturier took it upon herself to tutor a number of the soldiers in French in her home, lamenting the abysmal quality of language instruction in the military. "The word *nègre* has not remained a simple vocable of practical usage," she writes, "and is not used for real objects *[ne saurait s'appliquer à des objets réels].* As poetically as the word 'dove' *[colombe],* which evokes white peace, innocence, divine love, for us the word 'nègre' effectively symbolizes inversely brutal frenzy, satanic ugliness and other nocturnal nightmares." As Cousturier saw it, her black pupils were ultimately just *des bommes* like any others. She

goes on to say that she thinks of the African soldiers as *inconnus,* "unknown," because they have been so consistently misnamed and misused. Cousturier, *Des Inconnus chez moi* (Paris: Editions la Sirène, 1920), 9.

25. A. James Arnold, *Modernism and Negritude: The Poetry and Poetics of Aimé Césaire* (Cambridge: Harvard University Press, 1981), 36.

26. On this congress and Senghor's speech, see Willi Munzenberg, "Pour une conférence coloniale," *La Correspondance internationale* 91, no. 6 (August 14, 1926): 1011; "La question nègre devant le Congrès de Bruxelles," *La Voix des Nègres* (March 1927): 1; "A Black Man's Protest," *Living Age* 332 (May 15, 1927): 866–868.

27. For more detail on Senghor's activities, see Philippe de Witte, *Les Mouvements nègres en France, 1919–1939* (Paris: L'Harmattan, 1985); J. Ayodele Langley, *Pan-Africanism and Nationalism in West Africa, 1900–1945* (London: Oxford University Press, 1973); J. S. Spiegler, *Aspects of Nationalist thought among French-Speaking West Africans, 1921—1939* (Ph.D. diss., Oxford University, 1968); *Lamine Senghor: vie et oeuvre* (Dakar: Front Culturel Sénégalais, 1979); Robert Cornevin, "Du Sénégal à la Provence: Lamine Senghor (1889–1927), pionnier de la négritude," *Provence historique* 25, no. 99 (January–March 1975): 69–77; Tiemoko Garan Kouyaté, "La ligue est en deuil: son très dévoué président Senghor Lamine est mort," *La Race nègre* 5 (May 1928); Brent Hayes Edwards, "The Shadow of Shadows," *Positions* (forthcoming winter 2003). I should note that Lamine Senghor was not related to Négritude founder Léopold Sédar Senghor.

28. Lamine Senghor, "Le mot 'Nègre,'" *La Voix des Nègres* 1 (January 1927): 1. Although the article is signed "Le Comité" of the Comité de Défense de la Race Nègre, it was written exclusively by Senghor, as it is nearly identical to an article called "Le réveil des Nègres" that he had previously published under his own name in *Le Paria* (The pariah), the journal of the French Communist branch of colonial radicals, the Union Intercoloniale. (See Senghor, "Le réveil des Nègres," *Le Paria* 38 [April 1926]: 1–2.) For other considerations of this essay, see Christopher Miller, "Involution and Revolution: African Paris in the 1920s," in *Nationalists and Nomads: Essays on Francophone African Literature and Culture* (Chicago: University of Chicago Press, 1998), 30–37; Philippe de Witte, *Les Mouvements nègres en France, 1919–1939* (Paris: L'Harmattan, 1985), 143–146.

29. Jack D. Forbes, "The Manipulation of Race, Caste and Identity: Classifying Afroamericans, Native Americans and Red-Black People" *The Journal of Ethnic Studies* 17, no. 4 (winter 1990): 5. In her review, Gayatri Spivak is somewhat critical of the application of "caste" to this context. See Spivak, "Race before Racism and the Disappearance of the American," 87.

30. Miller, "Involution and Revolution," 36–37.

31. At the time, a segregated balcony in a theater was called "nigger heaven." The phrase also figuratively depicts the way Harlem "hangs" out over the rest of Manhattan. Carl Van Vechten, *Nigger Heaven* (New York: Knopf, 1926), translated as *Le Paradis des Nègres* (Paris: Editions Kra, 1927). For two sides of the U.S. response, see W. E. B. Du Bois's caustic review in "Books," *Crisis* 33 (1926): 81–82; and James Weldon Johnson's more positive "Romance and Tragedy in Harlem—A Review," *Opportunity A* (1926): 316–317, 330. For commentary on this controversy, see George Hutchinson, *The Harlem Renaissance in Black and White* (Cambridge: Harvard University Press, 1995), 166–167; David Levering Lewis, *When Harlem Was in Vogue* (New York: Oxford University Press, 1981), 182–189.

32. Roark Bradford, *Ol' Man Adam an His Chillun, Being the Tales They Tell about the Time When the Lord Walked the Earth Like a Natural Man* (New York: Harper and Brothers, 1928). I would like to thank Robert O'Meally for drawing my attention to this collection.

33. Ibid., x.

34. Ibid., x–xi.

35. Ibid., xii.

36. Langston Hughes, *The Big Sea* (1940; reprint, New York: Thunder's Mouth, 1986), 78–79.

37. Spivak, "Race before Racism," 84, 85.

38. See Winston James, "Migration, Racism and Identity: The Caribbean Experience in Britain," *New Left Review* 193 (May–June 1992): 49–55.

39. Gratiant, "Mulâtres . . . pour le bien et le mal," *L'Etudiant noir* 1 (March 1935): 5–7. This essay has been reprinted in Gratiant, *Fables Créoles et autres écrits,* ed. Isabelle Gratiant et al. (Paris: Stock, 1996), 701–710.

40. Ibid., 7.

41. See Henry Louis Gates, Jr., "Preface to Blackness: Text and Pretext," in *Afro-American Literature: The Reconstruction of Instruction,* ed. Dexter Fisher and Robert Stepto (New York: Modern Language Association, 1978), 44–69.

42. David Scott, preface to "The Archaeology of Black Memory: An Interview with Robert A. Hill," *Small Axe* 5 (March 1999): 83.

43. See William L. Andrews, *To Tell a Free Story: The First Century of Afro-American Autobiography, 1769–1865* (Urbana: University of Illinois Press, 1986).

44. Du Bois, "Forethought," *The Souls of Black Folk,* in Du Bois, *Writings* (New York: Library of America, 1986), 359. Here I am adopting the title phrase of Paul de Man's *Allegories of Reading: Figural Language in Rousseau, Nietzsche, Rilke, and Proust* (New Haven: Yale University Press, 1979).

45. Toni Morrison, "The Site of Memory," in *Inventing the Truth: The Art and Craft of Memoir,* ed. William Zinsser (Boston: Houghton Mifflin, 1987), 109–110.

46. Du Bois, 359.

47. Robert Stepto, *From behind the Veil: A Study of Afro-American Narrative* (Urbana: University of Illinois Press, 1979), 52.

48. On the epigraphs to *The Souls of Black Folk,* see Eric Sundquist, *To Wake the Nations: Race in the Making of American Literature* (Cambridge: Harvard University Press, 1993), 490–493.

49. Stepto, 62.

50. See for example the sections on the novel in Stepto, *From behind the Veil* and Sundquist, *To Wake the Nations;* and also Aldon Nielsen's "James Weldon Johnson's Impossible Text: *The Autobiography of an Ex-Colored Man,*" in *Writing between the Lines: Race and Intertextuality* (Athens: University of Georgia Press, 1994), 172–184. Houston Baker, Jr., goes so far as to claim that "in a sense, *The Autobiography of an Ex-Colored Man* is a fictional rendering of *The Souls of Black Folk.*" Baker, *Singers of Daybreak: Studies in Black American Literature* (Washington, D.C.: Howard University Press, 1974), 22.

51. Richard Yarborough, "The First-Person in Afro-American Fiction," in *Afro-American Literary Study in the 1990's,* ed. Houston A. Baker and P. Redmond (Chicago: University of Chicago Press, 1989), 118.

52. James Weldon Johnson, *The Autobiography of an Ex-Colored Man* (1927; reprint, New York: Vintage, 1989), xxxix. Page numbers of subsequent citations will be indicated parenthetically in the text.

53. Interestingly, the book was received as a valid autobiographical document, and Johnson did not officially claim authorship until 1915. See Eugene Levy, *James Weldon Johnson: Black Leader, Black Voice* (Chicago: University of Chicago Press, 1973), 161.

54. Du Bois, 364, 365.

55. Nielsen, 173–174.

56. Nielsen, 178.

57. Johnson, "Race Prejudice and the Negro Artist," *Harper's Magazine* 157 (1928), reprinted in *The Selected Writings of James Weldon Johnson, vol. 2: Social, Political and Literary Essays,* ed. Sondra Kathryn Wilson (New York: Oxford University Press, 1995), 397.

58. Nielsen, 173.

59. Gerald Early, "Introduction" *My Soul's High Song: The Collective Writings of Countee Cullen, Voice of the Harlem Renaissance* (New York: Doubleday, 1991), 33.

60. Here is an inexhaustive, chronological sampling of the unprecedented explosion of anthologies and collections of "Negro materials" in English, French, and German after World War I. To give a sense of the breadth of this activity, I have included popular, literary, anthropological, musicological, and historical works (some collections would fall under more than one of these categories). *Anthologie nègre,* ed. Blaise Cendrars (Paris: Editions de la Sirene, 1921); *Petits Contes nègres pour les enfants des blancs,* ed. Cendrars (Paris: Denoël, 1921); *Atlantis: Volksmärchen und Volksdichtungen afrikans,* 12 volumes, ed. Leo Frobenius (Jena: E. Diederichs, 1921–1928); *Afrikanische Märchen,* ed. C. Meinhof (Jena: E. Diederichs, 1921); *The Book of American Negro Poetry,* ed. James Weldon Johnson (New York: Harcourt Brace, 1922); *Negro Folk Rhymes, Wise and Otherwise,* ed. Thomas Talley (New York: Macmillan, 1922); *L'Ame nègre,* ed. Maurice Delafosse (Paris: Payot, 1922); *La Poésie chez les primitifs,*

ed. E. Hurel (Brussels: Goemaere, 1922); *Negro Poets and Their Poems,* ed. Robert Kerlin (Washington, D.C.: Associated Press, 1923); *Congo Life and Jungle Stories,* ed. J. H. Weeks (London: Religious Tract Society, 1923); *An Anthology of Verse by American Negroes,* ed. Newman Ivey White and Walter Clinton Jackson (Durham, N.C.: Trinity College Press, 1924); Fernando Ortiz, *Glosario des Afronegrismos* (Havana: El Siglo, 1924); *The New Negro,* ed. Alain Locke (New York: Albert and Charles Boni, 1925); *Negro Orators and Their Orations,* ed. Carter G. Woodson (Washington, D.C.: Associated Publishers, 1925); *The Negro and His Songs,* ed. Howard W Odum and Guy B. Johnson (Chapel Hill: University of North Carolina Press, 1925); *On the Trail of Negro Folk Songs,* ed. Dorothy Scarborough (Cambridge: Harvard University Press, 1925); *The Book of American Negro Spirituals,* ed. James Weldon Johnson and J. Rosamond Johnson (New York: Viking, 1925); *Die Schilluk: Geschichte, Religion und Leben eines Niloten-Stammes,* ed. Wilhelm Hofmayr (Mödling bei Wien: Verlag der Administration des Anthropos, 1925); *The Mind of the Negro, as Reflected in Letters Written during the Crisis, 1800–1860,* ed. Carter G. Woodson (Washington, D.C.: Association for the Study of Negro Life and History, 1926); *The Blues—An Anthology,* ed. W. C. Handy and Abbe Niles (New York: Albert and Charles Boni, 1926); *Negro Workaday Songs,* ed. Odum and Johnson (Chapel Hill: University of North Carolina Press, 1926); *Primitive Negro Sculpture,* ed. Paul Guillaume and Thomas Munro (1926; reprint, New York: Hacker Art Books, 1968); *Among the Bantu Nomads,* ed. J. T. Brown (London: Seeley, Service and Co., 1926); *Four Negro Poets,* ed. Locke (New York: Simon and Schuster, 1927); *Caroling Dusk: An Anthology of Verse by Negro Poets,* ed. Countee Cullen (New York: Harper and Brothers, 1927); *Ebony and Topaz: A Collectanea,* ed. Charles S. Johnson (New York: Opportunity, 1927); *L'Art nègre: l'art animiste des noirs d'Afrique,* ed. Georges Hardy (Paris: H. Laurens, 1927); *La Littérature populaire à la côte des esclaves: contes, proverbes, devinettes,* ed. R. Trautmann (Paris: Institut d'Ethnologie, 1927); *A Decade of Negro Self Expression,* ed. Locke (Charlottesville: John F. Slater Fund, 1928); *Le Nègre qui chante,* ed. Eugène Jolas (Paris: Cahiers Libres, 1928); *Anthology of American Negro Literature,* ed. V. F. Calverton (New York: Modern Library, 1929); *Neue Märchen aus Afiika,* ed. A. Mislich (Leipzig: R. Voigtländers, 1929); *Akan-Ashanti Folk-Tales,* ed. R. S. Rattray (Oxford: Clarendon Press, 1930); *African Stories,* ed. A. D. Helser (New York: Fleming H. Revell, 1930); *Diaeli, le livre de la sagesse noire,* ed. André Demaison (Paris: H. Piazza, 1931); *Proverbes et maximes peuls et toucouleurs traduits, expliqués et annotés,* ed. H. Gaden (Paris: Institut d'Ethnologie, 1931); *Ce que content les Noirs,* ed. O. de Bouveignes (Paris: P. Lethielleux, 1935); *Negro: An Anthology,* ed. Nancy Cunard (1934; reprint, New York: Negro Universities Press, 1969).

Regarding the history of anthologies in African American literature, see John S. Lash, "The Anthologist and the Negro Author," *Phylon* 7, no. 1 (1947): 68–76; Kenneth Kinnamon, "Anthologies," in *The Oxford Companion to African American Literature,* ed. William L. Andrews, Frances Smith Foster, and Trudier Harris (New York: Oxford University Press, 1997), 22–28; Theodore O. Mason, Jr., "The African-American Anthology: Mapping the Territory, Taking the National Census, Building the Museum," *American Literary History* 10, no. 1 (1998): 185–198.

61. Mason, "The African-American Anthology," 187.

62. Ibid., 192.

63. The phrase "allographic preface" is adopted from Gerard Genette, *Paratexts: Thresholds of Interpretation,* trans. Jane E. Lewin (Cambridge: Cambrige University Press, 1997), 161,263–275.

64. See Gayatri Chakravorty Spivak, "Translator's Preface," in Jacques Derrida, *Of Grammatology* (Baltimore: Johns Hopkins University Press, 1976), ix-xiii.

65. James Weldon Johnson, *Along This Way: The Autobiography of James Weldon Johnson* (1933; reprint, New York: Penguin, 1990), 374–375. On the publication of *The Book of American Negro Poetry,* see *Levy, James Weldon Johnson,* 304–305.

66. "Preface to the First Edition," *The Book of American Negro Poetry* (rev. 2nd ed., New York: Harcourt Brace Jovanovich, 1931), 9. Page numbers for subsequent references will be indicated parenthetically in the text.

67. Immanuel Wallerstein, "The National and the Universal: Can There Be Such a Thing as World Culture?" in *Culture, Globalization and the World-System: Contemporary Conditions for the Representation of Identity,* ed. Anthony D. King (Minneapolis: University of Minnesota, 1997), 100.

68. Paul Gilroy, *The Black Atlantic: Modernity and Double Consciousness* (Cambridge: Harvard University Press, 1993), 36. Interestingly, Gilroy takes this phrase without comment from a context that inflects it rather differently, Zygmunt Bauman's "The Left as the Counterculture of Modernity," *Telos* 70 (winter 1986–1987): 81–93.

69. Johnson, *Along This Way,* 375.

70. Ibid., 375. He notes that "the word was coined, so far as I know, by Sir Harry H. Johnston," and says that it acquired a "slightly derisive sense" in the 1920s when it was adopted by H. L. Mencken.

71. Jacques Derrida, *Dissemination,* trans. Barbara Johnson (Chicago: University of Chicago Press, 1981), 17.

72. Johnson, "Preface to the Revised Edition," *The Book of American Negro Poetry,* 3.

73. Ibid., 5. On Johnson's prefaces to *God's Trombones* and *The Book of American Negro Spirituals* and his arguments about "Negro dialect," see Brent Hayes Edwards, "The Seemingly Eclipsed Window of Form: James Weldon Johnson's Prefaces," in *The Jazz Cadence of American Culture,* ed. Robert O'Meally (New York: Columbia University Press, 1997), 580–601.

74. Derrida, *Dissemination,* 36.

75. Baba Diana, "Réponse d'un ancien tirailleur sénégalais à M. Paul Boncour," *La Race nègre* 1 (June 1927): 158.

76. Philippe de Witte, *Les Mouvements nègres en France,* 157.

77. Miller, "Involution and Revolution," 44.

78. Fanon writes for instance that the Antillean "knows that what the poets call *divine crooning* [*roucoulement divin*] (that is: Creole) is only a middle term between pidgin-nigger [*petit-nègre*] and French." Fanon, "The Negro and Language," in *Black Skin, White Masks,* trans. Charles Lam Markmann (New York: Grove, 1967), 20 (modified). The original is "Le noir et le langage," in *Peau noire, masques blancs* (Paris: Seuil, 1952), 15.

79. Cousturier, *Des biconnus chez moi,* 103. The excerpt in the paper is "Notre page littéraire: un général sauvage, de Lucie Cousturier," *La Race nègre* 1 (June 1927): 3. On *petit nègre,* see also Myron Echenberg, *Colonial Conscripts: The Tirailleur Sénégalais in French West Africa, 1857–1960* (Portsmouth, N.H.: Heinemann, 1991), 15, 115–116. The *petit nègre* instruction manual used during the war was the sublimely titled *Le Francais tel que le parlent nos tirailleurs sénégalais* (French as our African soldiers speak it) (1916).

80. De Witte, *Les Mouvements nègres en France,* 158.

81. Lacascade, *Claire-Solange, âme africaine* (Paris: Eugène Figuière, 1924), 95. Page numbers of subsequent quotes will be indicated parenthetically in the text.

82. Maryse Condé, *La Parole des femmes, essai sur les romanciers des Antilles de langue francaise* (Paris: L'Harmattan, 1979), 28–31.

83. See Jack Corzani, *La Litterature des Antilles-Guyane francaises, vol. 3: la Négritude* (Fort-de-France: Editions Desormeaux, 1978), 211–213. I have located no information on Lacascade aside from this anecdote.

84. *Pas fais guiolle kioupoule, da chè* translated literally means "Don't make a face like a hen's ass, my dear."

85. See Peter Ostwald, *Schumann: The Inner Voices of a Musical Genius* (Boston: Northeastern University Press, 1985), 115; Frederick Niecks, *Robert Schumann* (London: J. M. Dent, 1925), 176.

86. Du Bois, "The Sorrow Songs," *The Souls of Black Folk,* 538–539. Other slightly different versions of this anecdote are "The Shadow of Years," chapter 1 in *Darkwater: Voices from within the Veil* (1920; reprint, New York: Dover, 1999), 3; "The Concept of Race," chapter 5 in *Dusk of Dawn: An Essay toward an Autobiography of a Race Concept* (1940), in *Writings* (New York: Library of America, 1986), 638; and *The Autobiography of W. E. B. Du Bois: A Soliloquy on Viewing My Life from the Last Decade of Its First Century* (New York: International Publishers, 1968), 62.

87. Ousmane Socé, *Karim, roman sénégalais* (1935; reprint, Paris: Nouvelles Editions Latines, 1948).

88. For the often overlooked translations by the fathers of Négritude, see Sterling Brown, "Les Hommes Forts" (Strong Men), trans. Aimé Césaire, *Charpentes* 1 (June 1939): 52–53 [the issue features poetry from around the world, although there is no U.S. rubric: the translation of Brown's poem is listed along with poems by Senghor and Léon-Gontran Damas under "Afrique noire"]; Léopold Sédar Senghor, "Trois poètes négro-américains," *Poésie 45* 23 (February-March 1945): 32–44 [the selection offers translations and the English originals of Jean Toomer, "Song of the Sun" and "Georgia Dusk"; Langston Hughes, "Our Land," "An Earth Song," and "Minstrel Man"; and Countee Cullen, "Heritage"]. On Hughes's own work as translator, see Alfred J. Guillaume, Jr., "And Bid Him Translate: Langston Hughes'

Translations of Poetry from French," *The Langston Hughes Review* 4, no. 2 (fall 1985): 1–23; John F. Matheus, "Langston Hughes as Translator," in *Langston Hughes: Black Genius,* ed. Therman B. O'Daniel (New York: William Morrow, 1971), 157–170.

89. Langston Hughes, *Fine Clothes to the Jew* (New York: Knopf, 1927).

90. Regarding reviews of *Fine Clothes to the Jew,* see *Langston Hughes: Critical Perspectives Past and Present,* ed. Henry Louis Gates, Jr., and K. A. Appiah (New York: Amistad, 1993); and Hughes, *The Big Sea: An Autobiography* (1940; reprint, New York: Thunder's Mouth Press, 1986), 264.

91. Howard Mumford Jones, *Chicago Daily News* (June 29, 1927), in *Langston Hughes: Critical Perspectives,* 67.

92. Arnold Rampersad, *The Life of Langston Hughes, vol. 1: I, Too, Sing America* (New York: Oxford University Press, 1986), 141.

93. Hughes, "The Weary Blues," *The Weary Blues* (1926), collected in *The Collected Poems of Langston Hughes,* ed. Arnold Rampersad (New York: Knopf, 1994), 50.

94. Hughes, "Young Gal's Blues," in *Fine Clothes,* 83.

95. Martin Williams, "Recording Limits and Blues Form," in *The Art of Jazz: Essays on the Nature and Development of Jazz,* ed. Williams (New York: Grove, 1959), 91–94.

96. Hughes, "Baby," "Shout," in *Fine Clothes,* 61, 49.

97. Jahan Ramazani, *Poetry of Mourning: The Modern Elegy from Hardy to Heaney* (Chicago: University of Chicago Press, 1994), 153.

98. Hughes, "Hey" and "Hey! Hey!" in *Fine Clothes,* 17, 89. Indeed, Hughes would republish these poems as a single two-stanza poem, "Night and Morn," in his book *The Dream Keeper* (New York: Knopf, 1932).

99. Ramazani, *Poetry of Mourning,* 140–143.

100. Hughes, *The Big Sea,* 264.

101. Hughes, "Songs Called the Blues," *Phylon* 2 (second quarter 1941): 143.

102. Hughes, "Magnolia Flowers," "Mulatto," "Red Silk Stockings," *Fine Clothes,* 70, 71–72, 73.

103. Langston Hughes, "Jazz Band in a Parisian Cabaret," in *Fine Clothes,* 74.

104. Hughes, *The Big Sea,* 162.

105. See Hughes, *The Big Sea,* 158–163, 171–183; Craig Lloyd, *Eugene Bullard: Black Expatriate in Jazz-Age Paris* (Athens: University of Georgia Press, 2000), 90–100; William A. Shack, *Harlem in Montmartre: A Paris Jazz Story between the Great Wars* (Berkeley: University of California Press, 2001), 33; Bricktop [Ada Smith Ducongé] with James Haskins, *Bricktop* (New York: Atheneum, 1983), 84–103; Rampersad, *The Life of Langston Hughes, vol. 1,* 85.

106. Hughes, *The Big Sea,* 162.

107. I have adopted the phrase "amphibious spaces" from Stepto, *From behind the Veil,* 102.

108. Hughes, "The Cat and the Saxophone (2 A.M.)," *The Weary Blues* (1926), collected in *The Collected Poems,* 89. Rampersad gives the source of the lyric in his endnote, 624.

109. Hughes, "Jazz as Communication," in *The Langston Hughes Reader* (New York: G. Braziller, 1958), 492.

110. Significantly, the poem was originally titled "To a Negro Jazz Band in a Parisian Cabaret" when published in the *Crisis* in 1925; the revised title in *Fine Clothes* allows the phrase to be read both as an apostrophe and as a descriptive. Hughes, "Jazz Band in a Parisian Cabaret," *Crisis* (December 1925): 67. See Rampersad's note in *The Collected Poems,* 620.

111. Duke Ellington, "The Encyclopedia of Jazz," foreword to Leonard Feather, *The Encyclopedia of Jazz* (New York: Bonanza Books, 1960), 15.

112. Hughes, "Songs Called the Blues," 145.

113. See Jacques Derrida, "Schibboleth, pour Paul Celan," in *Midrash and Literature,* ed. Geoffrey Hartman and S. Budick (New Haven: Yale University Press, 1986), 324–325.

CHAPTER 9
PERIODIZING MODERNISM
POSTCOLONIAL MODERNITIES AND THE SPACE/TIME
BORDERS OF MODERNIST STUDIES
*Susan Stanford Friedman**

By the mid-2000s, many scholars felt that modernism was everywhere. No longer confined to a subset of formal experimentation by a small coterie of men, modernism now reached across cultures, genders, races, and—most important for Susan Stanford Friedman—borders. Borders of both space and time. What did this expansion mean for the notion of "modernism" that seemed to hold together the long-standing canon of the field, though? Expanding the canon of a field defined by aesthetic criteria is not like expanding the canon of a century or a nation's literary past. On the contrary, Friedman notes, expanding the canon of modernist studies to include postcolonial works poses a serious challenge to the internal coherence of the field—a challenge that she embraces, and that she wants the field of modernist studies to reckon with.

Friedman returns to the founding statements of Modernism/modernity, which located modernism with substantial precision between 1890 and 1945 in an Anglo-American and European core. For all the nods to postcolonial literatures, multiculturalism, and non-European epistemologies, Friedman notes, the foundation of the field is still bound up with a now-obsolete formulation of "modernism" itself. What's more, this version of "modernism" is itself tied to a distinct sense of "modernity" largely created to privilege rapid change and large-scale ruptures—as experienced by metropolitan subjects more than by colonial ones. Here, Friedman has in mind the work of Fredric Jameson—the two have been at odds on a number of core issues—and his understandings of modernism and modernity in articles such as "Modernism and Imperialism" (1988) and books such as *A Singular Modernity* (2002), both of which have been have provided crucial narratives for debate in the New Modernist Studies. Along with Edward Said and Simon Gikandi, Jameson helped place imperialist and colonial systems at the center of formal analyses of modernism, and Friedman has spent decades wrestling with and revising the implications of their insights.

This brings Friedman to a question that has preoccupied much of her work since the early 2000s: How do we position a field called "modernism" in relation to theories of multiple modernities? If modernity was not and is not a singular event, but a diffuse set of occurrences across various points in human history, why could modernism not have arisen in, say, twelfth-century China? How can a field like modernist studies tie itself to any sense of modernism that is both broadly inclusive and yet delimited enough to be legible? Conversely, Friedman herself has faced questions implicit in her work: If modernism could be anywhere

*From *Modernism/modernity*, v. 13, no. 3, pp. 425–43. Johns Hopkins University Press, ©2006. Reproduced here with permission.

and everywhere, hasn't the West just re-imposed its sense of modernity all over the world once again? And is there any historical epoch that was not characterized by rupture and change, and thus, would any period of time not be modernist?

Friedman's essay, along with its two connected *Modernism/modernity* articles and an MSA keynote she gave on the topic, continue to generate much discussion. They tie together several conceptual threads from the redefinitions of modernism that postcolonialism, comparative literature, world literature, and Global South studies have proposed. The answer cannot simply be to endlessly expand the tent, nor can it be to scour the globe searching for poems that look like local versions of *The Waste Land* and deem them "modernist." What we can do—ethically as well—remains unresolved, and that lack of resolution has been one of the great prompts for creativity and synthetic thinking in the New Modernist Studies.

Periods are entities we love to hate. Yet we cannot do without them. . . . Consequently, the uses to which we put periods depend crucially on how we delimit them. . . . The art lies in the cutting.

Marshall Brown[1]

Coloniality, in other words, is the hidden face of modernity and its very condition of possibility.

Walter D. Mignolo[2]

. . . to announce the general end of modernity even as an epoch, much less as an attitude or an ethos, seems premature, if not patently ethnocentric, at a time when non-Western people everywhere begin to engage critically their own hybrid modernities.

Dilip Parameshwar Gaonkar[3]

Einstein's theory of relativity forged a major paradigm shift in theorizing the relationship between time and space, one that systematized what some in the arts and philosophy of modernism were already beginning to articulate early in the century. More recently, cultural studies theorist Lawrence Grossberg has advocated what he calls "the timing of space and the spacing of time" as a precondition for a new "geography of beginnings."[4] Regarding space and time not as absolutes but rather as cognitive categories of human thinking, I want to build on these theories of relativity to examine the spatial politics of historical periodization—the way that generalizations about historical periods typically contain covert assumptions about space that privilege one location over others. Fredric Jameson's imperative—"Always historicize!"—leads unthinkingly into binaries of center/periphery unless it is supplemented with the countervailing imperative—Always spatialize![5] Jameson's widely influential essay, "Modernism and Imperialism," introduces the spatiality of global imperialism into his discussion of literary history and argues for imperialism as constitutive of modernist aesthetics in the West. But for him, modernism was over and done with by the end of World War II, to be followed by postmodernism characterized by a shift into the multinational corporate flows of late capitalism and new forms of imperialism.[6] Many others, including Walter Mignolo as evident in the epigraph, would agree with Jameson's insistence that Western modernity is inextricably tied to Western colonialism in Asia, Latin America, and Africa. However, I consider Jameson's spatialization of modernism incomplete.

A full spatialization of modernism changes the map, the canon, and the periodization of modernism dramatically. Moreover, rethinking the periodization of modernism requires abandoning what I have called the "nominal" definition of modernity, a noun-based designation that names

modernity as a specific moment in history with a particular societal configuration that just happens to be the conditions that characterize Europe from about 1,500 to the early twentieth century. The "relational" mode of definition, an adjectivally-based approach that regards modernity as a major rupture from what came before, opens up the possibility for polycentric modernities and modernisms at different points of time and in different locations.[7] Examining the spatial politics of the conventional periodization of modernism fosters a move from singularities to pluralities of space and time, from exclusivist formulations of modernity and modernism to ones based in global linkages, and from nominal modes of definition to relational ones.

The Spatial Politics of Periodizing Modernism

Modernism is conventionally understood as a loose affiliation of aesthetic movements that unfolded in the first half of the twentieth century. This view is accurately reflected in the founding statement of the Modernist Studies Association, still listed on the website, although its parameters are considerably more limited than the wide-ranging work presented at the Modernist Studies Association annual conferences:

> The Modernist Studies Association is devoted to the study of the arts in their social, political, cultural, and intellectual contexts from *the later nineteenth- through the mid-twentieth century*. The organization aims to develop an international and interdisciplinary forum to promote exchange among scholars in this revitalized and rapidly changing field.[8]

There is a spatial politics embedded in the Modernist Studies Association's temporal borders for modernism, roughly the 1890s–1940s, one that picks up on the prevailing assumptions about temporality in the field more generally. Even within the European context, this dating privileges Anglo-American modernism, that is, modernism in English produced in Britain and the United States and by expatriates living abroad. However, a quick glance through such field-defining critics of modernism as Malcolm Bradbury and James McFarlane, Marshall Berman, Astradur Eysteinsson, and Peter Nicholls makes evident that the modernism they delineate is itself polycentric and plural, with different nodal points of high energy and interconnection in the culture capitals of Europe, Britain, and the U.S.—albeit with a limited continental scope. For many, the proper genealogy of this European modernism goes back to the Baudelaire of *Les Fleurs du Mal* in the 1840s–1850s and the cosmopolitan flaneur of his essay "The Painter of Modern Life" (1863).[9] The temporal boundaries of modernism promoted by the Modernist Studies Association on its website reflect an Anglo-American and English language bias and thus do not even work for Western modernism.

The Modernist Studies Association's end date for modernism has an even more pernicious effect on modernisms outside the West. This periodization cuts off the agencies of writers, artists, philosophers, and other cultural producers in the emergent postcolonial world just as their new modernities are being formed. India's independence from Britain and the wrenching murder and displacement of millions in Partition that gave birth to two postcolonial nation-states happen in 1947–1948. One after another of the colonies in the Caribbean and in Africa acquire liberation from official colonial rule in the 1950s and 1960s. The 1950s are the period of Frantz Fanon's brilliant indigenizations of European psychoanalysis to dissect the psychopathologies of colonial racism for both whites and blacks. *Black Skins, White Masks* is yet another manifestation of the phenomenology of the new and the now that defines a modern sensibility.[10] To cite Dilip Parameshwar Gaonkar from the epigraph once again, "to announce the general end of modernity even as an epoch . . . seems premature, if not patently ethnocentric, at a time when non-Western people everywhere begin to engage critically their own hybrid modernities."

Declaring the end of modernism by 1950 is like trying to hear one hand clapping. The modernisms of emergent modernities are that other hand that enables us to hear any clapping at all. As Walter Mignolo argues in the article from which the epigraph was taken, colonialism is constitutive of Western modernity, essential to its formation from the sixteenth through the twentieth centuries. As a consequence, we must not close the curtain on modernism before the creative agencies in the colonies and newly emergent nations have their chance to perform. Their nationalist movements and liberations from the political dimensions of colonial rule are central to the story of their modernities. Therefore, the creative forces within those modernities—the writers, the artists, the musicians, the dancers, the philosophers, the critics, and so forth—are engaged in producing modernisms that accompany their own particular modernities. To call their postliberation arts "postmodern"—as they often are—is to miss the point entirely. Multiple modernities create multiple modernisms. Multiple modernisms require respatializing and thus reperiodizing modernism.

The centrality of colonialism and postcolonialism for the nineteenth and twentieth centuries requires a new geography of modernity and modernism, one based on an understanding of what the Caribbean poet and theorist Édouard Glissant calls a "poetics of relation" that produces "*creolité*" or "the immeasurable intermixing of cultures."[11] Rather than positing a mosaic of different modernisms, each separated from all others by the fixed barriers of geopolitical and cultural borders around the world, I regard the boundaries between multiple modernisms as porous and permeable, fostering self/other confrontations and minglings as mutually constitutive, both *between* different societies and *within* them. This geography of mobility and interculturality is not a utopian fantasy of peaceful integration, but rather recognizes that the contact zones between cultures often involve violence and conquest as well as reciprocal exchange, inequality and exploitation as well as mutual benefits, and abjection and humiliation as well as pride and dignity. But the geography I advocate refuses victimology and assumes agency on all sides in the zones of encounter—not autonomy, or the freedom to act unimpeded by others, but rather agency, the drive to name one's collective and individual identity and to negotiate the conditions of history, no matter how harsh.

In aesthetic terms, this new geography involves a radical rewriting of what critics have called modernism's internationalism: its polylingualism and polyculturalism, its resistance to national culture, and its primitivist embrace of the non-Western Other as a means for revitalizing the various sterilities of the West. From Picasso to Stravinsky, from Pound to Eliot and Joyce, from the Dadaists to the Surrealists, the icons of modernism embody what many have regarded as "a supranational movement called International Modernism," to cite Hugh Kenner's well-known formulation in "The Making of the Modernist Canon."[12] Few would agree with Kenner's more outlandish statements in this essay that International Modernism is created solely by expatriate Americans and Irishmen writing in English or that writers like Virginia Woolf, William Carlos Williams, and William Faulkner are "provincial," not modernist. Indeed, the international modernism of critics like Bradbury and McFarlane or Berman is far more European-centered than Anglo-American. But however much the concepts of modernist internationalism differ from each other, they nonetheless typically operate within an unexamined center/periphery framework that locates the creative agency of modernity in the West.

Whether acknowledged or not, prevailing concepts of modernist internationalism stage Western artists as the innovators and the cultures of the rest as tribal and traditional, as the raw material for creative appropriation and transmutation into modern art. With some notable exceptions— the work of Simon Gikandi's *Writing in Limbo: Modernism and Caribbean Literature*, Charles W. Pollard's *New World Modernisms*, and Laura Doyle and Laura Winkiel's *Geomodernisms* come preeminently to mind—the creative agencies of colonial and postcolonial subjects as producers of modernism have been largely ignored. The exclusion of these agencies deeply affects the definitional projects of modernist studies, producing circular overviews of modernism that reflect the absence of the very texts that would transform an understanding of the field in general.[13]

The geographical blind spot of prevailing concepts of modernist internationalism is, in my view, a particular instance of what geographer J. M. Blaut more generally calls the ideology of European diffusionism. He defines this ideology as a narrative of modernity:

> Europeans are seen as the "makers of history." Europe eternally advances, progresses, modernizes. The rest of the world advances more sluggishly, or stagnates: it is "traditional society." Therefore, the world has a permanent geographical center and a permanent periphery: an Inside and an Outside. Inside leads, Outside lags. Inside innovates, Outside imitates.[14]

Blaut suggests that this storyline assumes a center/periphery model of modernity that arose in conjunction with Western imperialism as one of its major rationalizations for colonial rule. He details the evolution of this ideological formation from the beginning of the European conquests to its late twentieth-century formations. He argues that European diffusionism remains powerful today across the disciplines and the political spectrum, from the Marxist world-systems theory of Immanuel Wallerstein and his disciples to the neo-conservatives like Samuel Huntington and his followers bemoaning the "clash of civilizations." For Wallerstein, modernity is a Western virus whose spread infects the rest of the world; for Huntington, the Other is a pollutant that threatens the West. For both, however, modernity is an autonomous Western invention. Whether condemned or lionized, modernization is for both camps synonymous with Westernization.[15]

The conventional periodization of modernism is, I believe, an instance of this Eurocentric diffusionist ideology—whether found among those critics committed to a notion of Western aesthetic exceptionalism, or those who see emergent national literatures outside the West as either derivative of or entirely separate from modernism. As I argued in a plenary address for the inaugural MSA conference in 1999, the new geography of modernism needs to locate many centers of modernity across the globe, to focus on the cultural traffic linking them, and to interpret the circuits of reciprocal influence and transformation that take place within highly unequal state relations.[16] More recently, Pollard theorizes what he calls "New World modernisms" that are neither purely European nor purely indigenous. Featuring Glissant's concepts of creolization and a poetics of relation, Pollard theorizes nomadic trajectories for various modernisms that dismantle the notion of European centers and colonial peripheries:

> Glissant subsequently extends this idea of creolization to a "new global level" in developing his "poetics of relation." . . . Glissant defines this term by offering a simple historical narrative of the trajectories of cultural exchange, first a trajectory from the center to the peripheries, then a movement from the peripheries to the center, and finally, in the "poetics of relation," the "trajectory is abolished" and the "poet's word" reproduces a "circular nomadism; that is, it makes every periphery into a center; . . . it abolishes the very notion of center and periphery."[17]

Pollard's contribution is to link Glissant's poetics of relation directly to issues of modernism, positing the existence of a "discrepant cosmopolitan modernism" that refuses the common linkages between postcolonialism and postmodernism. By juxtaposing T. S. Eliot with Derek Walcott and Kamau Braithwaite, Pollard illustrates more generally "how modernism has migrated as a cultural ideal and how it has changed through this migration."[18]

Geomodernisms: Race, Modernism, Modernity, edited by Laura Doyle and Laura Winkiel, goes even further than Pollard in theorizing a departure from conventional periodizations and the resultant locations of modernism. Doyle and Winkiel call for a global approach to modernism and modernity that goes well beyond the linked trajectories of colonizing metropole and colonized peripheries:

To emplace modernism in this way—to think . . . in terms of interconnected modernisms—requires a rethinking of periodization, genealogies, affiliations, and forms. To some degree, this rethinking estranges the category of modernism itself. The term *modernism* breaks open, into something we call geomodernisms, which signals a locational approach to modernisms' engagement with cultural and political discourses of global modernity. The revelation of such an approach is double. It unveils both unsuspected "modernist" experiments in "marginal" texts and unsuspected correlations between those texts and others that appear either more conventional or more postmodern.[19]

Recognizing modernisms on a planetary landscape involves identification of intensified and proliferating contact zones that set in motion often radical juxtapositions of difference and consequent intermixing of cultural forms that can be alternately embraced, violently imposed, or imperceptibly evolved. Traveling and intermixing cultures are not unidirectional, but multidirectional; not linear influences, but reciprocal ones; not passive assimilations, but actively transformative ones, based in a blending of adaptation and resistance. All modernisms develop as a form of cultural translation or transplantation produced through intercultural encounters. As Edward Said puts it in reference to traveling theory, "Such movement into a new environment is never unimpeded. It necessarily involves processes of representation and institutionalization different from those at the point of origin. This complicates any account of the transplantation, transference, circulation, and commerce of theories and ideas."[20] Over time, Said concludes, "the now full (or partly) accommodated (or incorporated) idea is to some extent transformed by its new uses, its new position in a new time and place."[21] In "Traveling Theory Revisited," Said goes even further to argue that in traveling and transplanting elsewhere, theory—particularly Western theory traveling to the colonies—often becomes stronger and more radical, based on "an affiliation in the deepest and most interesting sense of the word." Instead of being derivative or diluted, this theory can have "its fiery core . . . reignited" and invigorated.[22]

Terms for cultural translation and adaptation abound, and I have been collecting, sorting, and analyzing them as keywords that convey different resonances for the complexities of global interculturality.[23] But for my purposes in this essay, I want to highlight *indigenization*—a form of making *native* or *indigenous* something from elsewhere. Indigenization presumes an affinity of some sort between the cultural practices from elsewhere and those in the indigenizing location. Hostile soil does not allow transplantation to take hold; conversely, the practices that take hold in their new location are changed in the process. Anthropologist Anna Tsing likens this paradoxical relationship to the "friction" that allows movement: the earth's resistance to the wheel that allows the wheel to turn. "I stress the importance of cross-cultural and long-distance encounters in everything we know as culture," she writes. "Cultures are continually co-produced in the interactions I call 'friction': the awkward, unequal, unstable, and creative quality of interconnection across difference."[24] *Friction* carries with it the connotations of conflict and serves as an apt metaphor for interculturality in colonial and postcolonial contexts.

The terms *indigenization* and *nativization* additionally suggest a kind of cultural cannibalism, if you will, an ingestion of the other which transforms both the cannibal and the cannibalized. This association of modernity with indigenization, nativization, and cannibalism appears to fly in the face of the conventional association of these terms with the traditional and primitive. But because I regard tradition as the invention of modernity, as part of modernity's fashioning of its own rupture from the past, I like the contradictions these terms suggest. Indigenization reminds us that modernity involves a forgetting of origins, a claiming of cultural practices from elsewhere as so much one's own that the history of their travels is often lost. Moreover, I echo here deliberately the modernist manifesto of Brazilian writer Oswald de Andrade, whose 1928 "Manifesto Antropófago" ("Anthropophagist Manifesto") invokes his cannibal ancestors the Tupinamba Indians, who ate the

early European explorers, to develop his metaphor of the New World modernism in its relation to European modernism. As John King puts it, "For Oswald de Andrade, Brazilian artists should similarly take on the powers of the colonizers, through ingestion, producing in this way an artistic practice that was very much their own."[25]

Like Western modernities, colonialism greatly enabled the development of Western modernisms formed through the indigenization of cultural practices from elsewhere. Conversely, colonized subjects indigenized Western modernity and modernism in forming their own modernities within the inequitable framework of colonial power and resistance.[26] The inflow and outflow of cultural forms was constitutive of modernity and modernism for both the imperial and colonized centers, though with significant differences. The inflow of non-Western art into the West as foundational for European modernism has been much studied, especially in relation to European primitivism—as in the case of Picasso's borrowings of African art in the formation of Cubism, which art historian William Rubin described as a "cannibalization" that served as a "countercultural battering ram" enabling his "attack on European bourgeois aesthetic sensibility."[27]

But because of the prevailing periodization of modernism, the indigenizations of Western aesthetics into colonial and post-colonial settings engaged in their own emergent modernities have not typically been considered modernist. For some, modernism is a purely Western aesthetic and as a category has no explanatory power for postcolonial writing. Why bother, Barbara Harlow once asked me, to consider Tayeb Salih, the Sudan's leading novelist and author of the 1967 novel *Season of Migration to the North*, a modernist? Leave modernism to the Europeans and Anglo-Americans, she insisted; literatures of newly emergent postcolonial nation-states have everything to do with the ongoing effects of colonialism and little or nothing to do with modernism. For others, committed to the project of what Dipesh Chakrabarty calls "provincializing Europe," the modernity of colonial and post-colonial sites is irremediably "derivative" or "belated," a form of "colonial mimicry" which at best denaturalizes Western modernity by highlighting the artifice of its construction.[28] In his otherwise splendid introduction to *Alternative Modernities*, Gaonkar begins his genealogy of modernism—which he defines as the cultural dimension of modernity—with none other than Baudelaire as an originary point, thus setting himself up for yet another version of the diffusionist story and the post-colonial lament of being caught in the reactive position of belatedness.[29]

In contrast to these views, R. Radhakrishnan insists that the task for postcoloniality is "to find a way out of the curse of 'derivativeness.'" He does so first by pointing out that "there is nothing that is not derivative," including the West's modernity, and secondly by advocating the recognition of "alternative, alterior, heterogeneous, hybrid, and polycentric modernities."[30] To Radhakrishnan's argument about modernity, I would add the necessity for finding a way out of the curse of presumed derivativeness for non-Western modernisms. These modernisms are different, not derivative. Like the modernisms of the West, they are hybrid, evidencing signs of traveling modernisms that have transplanted and become native.

A planetary approach to modernism requires, in my view, jettisoning the ahistorical designation of modernism as a collection of identifiable aesthetic styles, and abandoning as well the notion of modernism as an aesthetic period whose singular temporal beginning and endpoints are determinable, however interminable the debates might be about them. Instead, I regard modernism as the *expressive dimension of modernity*, one that encompasses a range of styles among creative forms that share family resemblances based on an engagement with the historical conditions of modernity in a particular location. Multiple modernisms emergent in the context of modernities located across a global landscape has a profound effect on historical periodization. Instead of looking for the *single* period of modernism, with its (always debatable) beginning and end points, we need to locate the *plural* periods of modernisms, some of which overlap with each other and others of which have a different time period altogether.

Modernism as the Expressive Dimension of Modernity

Defining modernism as the expressive dimension of modernity, wherever it occurs on the planet and in whatever particular form, appears to beg the question, to be a tautological statement with little explanatory power. What, after all, *is* modernity? Does the term *modernity* lose specificity in being broadened beyond its conventional meaning of what happened in the West after 1500 (for example, capitalism, nation-state formation, imperialism, Enlightenment, Industrialization, et cetera)?[31] Does every period in history lay claim to being *modern*, and if so, doesn't the term become meaningless? If *modernity* lacks particularity as a concept, then the claim that *modernism* is modernity's expressive domain is necessarily emptied of specificity as well. If all periods are *modern*, then all aesthetic expression must be *modernist*. A definitional category has meaning only on the basis of the inclusion of some phenomena and the exclusion of others. Without some principle of inside/outside, the category *qua* category collapses into uselessness. In "Definitional Excursions: The Meanings of *Modern/Modernity/Modernism*," I resisted definition, instead advocating an interrogation of the definitional dissonances of the debate itself as well as the radical disjuncture between how these terms are used across the disciplines. But for my claim here about modernism to have any explanatory significance, I recognize that some provisional definition of modernity is necessary. In tune with the earlier essay's critique of nominal definitions of modernity as perniciously Eurocentric and singular, my strategic definition of modernity here is relational, emphasizing the temporal rupture of before/after wherever and whenever such ruptures might occur in time and space.

Let me be clear: I do not regard every historical period as "modern"; nor do I regard every creative expression produced in the context of modernity to be "modernist." In defining modernism as the expressive dimension of modernity, I mean to suggest a range of creative meaning-making forms and cultural practices that engage in substantial and different ways with the historical conditions of a particular modernity. That said, I still need to provide some definition of modernity, no matter how provisional and porous the conceptual boundaries. I advocate a polycentric, planetary concept of modernity that can be both precise enough to be useful and yet capacious enough to encompass the divergent articulations of modernity in various geohistorical locations. I suggest that modernity involves a powerful vortex of historical conditions that coalesce to produce sharp ruptures from the past that range widely across various sectors of a given society. The velocity, acceleration, and dynamism of shattering change across a wide spectrum of societal institutions are key components of modernity as I see it—change that interweaves the cultural, economic, political, religious, familial, sexual, aesthetic, technological, and so forth, and can move in both utopic and dystopic directions. Across the vast reaches of civilizational history, eruptions of different modernities often occur in the context of empires and conquest. This definitional approach recognizes the modernities that have formed not only after the rise of the West but also before the West's post-1500 period of rapid change—the earlier modernities of the Tang Dynasty in China, the Abbasid Dynasty of the Muslim empire, and the Mongol Empire, to cite just a few.[32]

Moreover, modernity is often associated with the intensification of intercultural contact zones, whether produced through conquest, vast migrations of people (voluntary or forced), or relatively peaceful commercial traffic and technological or cultural exchange. Indeed, heightened hybridizations, jarring juxtapositions, and increasingly porous borders both characterize modernity and help bring it into being. The speed and scope of widespread transformation often leads to what Marshall Berman calls (citing Marx) the sensation that "all that is solid melts into air," and what I call the phenomenology of the new and the now.[33] Modernity has a self-reflexive, experiential dimension that includes a gamut of sensations from displacement, despair, and nostalgia to exhilaration, hope, and embrace of the new—a range that depends in part on the configurations of power and the utopic versus dystopic directions of change.

Understood as an umbrella term, modernity has a complex and contradictory relationship to its seeming opposite—"tradition" or "history." Modernity and tradition are relational concepts that modernity produces to cut itself off from the past, to distinguish the "now" from the "then." Modernity invents tradition, suppresses its own continuities with the past, and often produces nostalgia for what has been seemingly lost. Tradition forms at the moment those who perceive it regard themselves as cut off from it.[34] Modernity's dislocating break with the past also engenders a radical reaction in the opposite direction. As a result, periods of modernity often contain tremendous battles between "modernizers" and "traditionalists," those who promote the modern and those who want to restore an imagined and often idealized past. Indeed, in my view, the struggle between modernizing and traditionalizing forces within a given society is itself a defining characteristic of modernity. In this sense, past-oriented traditionalism is as much a feature of modernity as modernization. Moreover, modernity also produces what Paul de Man calls (citing Nietzsche) "a ruthless forgetting" of the past: "Modernity exists in the form of a desire to wipe out whatever came earlier."[35] The past that is repressed, that will not be remembered, comes back to haunt and trouble the present. Buried within the radical ruptures from the past are hidden continuities—all the things that refuse to change or cannot change, often having to do with the uneven distributions of power and violent histories.

In this context, the notion of derivative postcolonial modernities contains an implicit and misleading binary that sets up the West as modern and the Rest as traditional, struggling to reject its traditionalism in favor of becoming modern, which by a subtle metonymic slide is the equivalent of becoming Western. While there is no doubt that many colonial subjects experience the humiliations and ambivalence of this modernity/tradition opposition, this phenomenological dimension of modernity reflects the ideological force of the diffusionist myth and obscures both the traditionalisms within the West and the indigenous modernities outside the West. Instead, we need to look for the interplay of modernity and tradition *within* each location, that is, within both the West and the regions outside the West.

Broadening the provisional definition in these ways presumes a pluralization of modernity. As Gaonkar puts it, "modernity is not one, but many." He challenges what he calls the "acultural theory" of modernity which posits "the inexorable march of modernity [that] will end up making all cultures look alike." He promotes instead what he calls a "cultural theory," one that "holds that modernity always unfolds within a specific culture or civilizational context."[36] Gaonkar is one among a growing number of theorists and historians who are calling for a new discourse about modernity, one based on an acknowledgement of "multiple modernities," "early modernities," "alternate modernities," "polycentric modernities" or "conjunctural modernities"—to cite some of the current terms in use.[37] This approach typically assumes that each manifestation of modernity is distinctive and yet affiliated through global linkages to other modernities or societal formations. Sanjay Subrahmanyam terms this concept of global linkages "conjunctural." Countering Wallerstein's metaphor of modernity as the "virus" of capitalism spreading from the exploitative West to the Rest, Subrahmanyam writes that "modernity is a global and *conjunctural* phenomenon, not a virus that spreads from one place to another. It is located in a series of historical processes that brought relatively isolated societies into contact."[38] Multiple modernities, in short, involve global weblike formations, with many multidirectional links, affiliations, and often brutal inequities of power. They are not mosaics, each modernity separate and isolated from all others, evolving autonomously and equally. And yet they are not the same either, as each reflects the particular indigenizations of its own location.

This provisional approach to modernity engenders a parallel approach to modernism as the expressive dimension of any given modernity. Polycentric modernities produce polycentric modernisms, ones which are simultaneously distinctive and yet produced through indigenizations of traveling modernities that take place within frequently extreme differences of power. This

dynamic is particularly true for the modernisms developing out of colonialism and its demise throughout the century. Theorizing modernism in this way fundamentally alters the conventional end points of twentieth-century modernism.

Season of Migration to the North as a Modernist Novel

Spatializing modernism across a polycentric landscape allows us to include Tayeb Salih's postcolonial novel *Season of Migration to the North* within the canon of twentieth-century modernisms. One of the best known contemporary novels in Arabic, completed by the Sudan's leading writer during his exile in Beirut, *Season of Migration to the North* appeared in 1967 and then in English translation in 1969.[39] As a novel that echoes, reverses, and affiliates with Conrad's *Heart of Darkness*, *Season of Migration to the North* thematizes the enmeshing of both European and African modernities with colonialism and the seeming ruptures brought about by the demise of European imperialism and the rise of new African nation-states like the Sudan. But Salih's novel challenges both the modernity of the West and the postcolonialism of the Sudan by deconstructing the familiar binaries of West/ Rest, modern/traditional, and innovative/imitative. Instead, he shows each location as imitative of the other; each, in other words, is engaged in mimetic encounters that intermix the modern and traditional as constitutive of modernity itself in its different locations. Women—specifically, attraction to them, violence against them, and women's own engagements with modernity—figure centrally in his complex staging of intercultural encounters.

As echo to *Heart of Darkness*, *Season of Migration to the North* reverses the journey of Kurtz from Europe to Africa. Mustafa Saʿeed is a brilliant Sudanese prodigy who journeys from the South to the North, early in the century, into the heart of the colonial metropolis—first to Khartoum, then to Cairo, and finally to London and Oxford. Like *Heart of Darkness*, Mustafa's tale is mostly told by one main narrator, who, like Marlow, becomes ever more clearly unreliable and heavily ironized. Even more than Conrad's novel, *Season of Migration to the North* is a narrative of indeterminacy; of mysteries, lies, and truths; of mediating events through the perspectives of multiple embedded narrators; of complex tapestries of interlocking motifs and symbols; and of pervasive irony.[40] Stylistically speaking, Salih's novel is "high modernist," having moved even further than Conrad from the conventions of realism.[41]

Just as Kurtz exceeded expectations as a colonial agent, Mustafa is a great success in Britain. There, he acquires degrees and becomes the darling of the British left, writing books and advising ministers on economics and development in the Empire. In a love/hate relationship with the culture that exoticizes him, he turns into "the black Englishman," infected with the disease of those he lives among, much as Kurtz had "gone native" in the Congo. He seduces scores of white women, "modern" women whose Orientalist fantasies he exploits and exposes as a form of modern longing for pre-modern desert Arab or black primitive prince. He hunts them like prey, driving two to suicide and murdering the last, his wife, the one he loves, in a sadomasochistic orgy.[42] In a fit of liberal guilt, the English court lets him off with a light sentence, buying into the myth of the colonized victim and denying him the dignity of free will and moral responsibility for his actions. In disgust, Mustafa migrates back to the Sudan, selecting a village at the bend of the Nile, where he appears out of nowhere one day to buy land, farm, marry a local woman, and find partial acceptance as the stranger with a hidden past he shares with no one, until he tells a part of his story to the nameless narrator. One day, after making sure his affairs are in order, he mysteriously disappears. The villagers assume he drowned in the seasonal flooding of the Nile, either by accident or suicide, but a tale also surfaces in Khartoum that he secretly returned to Britain. In the penultimate chapter of the novel, the narrator opens the secret room Mustafa had kept hidden from everyone. The room is a replica in the desert of a British gentleman's library, complete with hundreds of books and a

fireplace over which hangs a portrait of his dead white wife. In shock and despair, the narrator goes swimming in the Nile, heading for the northern shore; and although he chooses to live rather than drown, the novel leaves us hanging, as unsure of his final fate as we are of Mustafa's.

In an interview, Salih explains Mustafa's state of mind in terms of sexualized postcolonial revenge. "In Europe," Salih notes, "there is the idea of dominating us."

> That domination is associated with sex. Figuratively speaking, Europe raped Africa in a violent fashion. Mustafa Sa'eed, the hero of the novel, used to react to that domination with an opposite reaction, which had an element of revenge seeking. In his violent female conquests he wants to inflict on Europe the degradation which it had imposed upon his people. He wants to rape Europe in a metaphorical fashion.[43]

Many have assumed that Mustafa's views are Salih's own. But the novel ultimately refuses such simple binaries of North/South, colonizer/colonized, and modernity/tradition. Instead, Salih unveils the interplay of oppositions in both Britain and the Sudan, exploding in particular the association of modernity with the West and tradition with Africa. Establishing an ironic distance between himself and both the narrator and Mustafa, Salih exposes the way "tradition" is always in a process of change and "modernity" is never as complete a rejection of the past as it seems. North and South are not so much opposites as they are mutually constitutive, existing in conjunctural relationship, both *between* nations and *within* nations. Gender and sexuality are the forces that explode the illusion of absolute difference. Salih indigenizes Conrad's trope of journey to the heart of otherness as a means of exposing the darkness at home. The steamer's progress up the Congo river in Conrad's tale exposes the hypocrisy of European (or at least Belgian) imperialism in the Congo; the journey north in Salih's novel uncovers not only the diseased traditionalism of the North but also the brutalizing tradition in the Sudanese village on the Nile. To understand the novel in this way, we must be attuned to the novel's pervasive modernist irony and its subtle undermining of illusion in both North and South.

The novel's village is not what the narrator and Mustafa imagine it to be—a changeless, simple, gracious place.[44] There are signs of change everywhere, represented symptomatically in the novel by the steady beat of the "puttering pumps" that have replaced the older water-wheels. Moreover, Mustafa's "rape" through seduction of white women in the North has its counterpart in a terrifying rape in the village which is sanctioned by tradition. Mustafa's widow Hosna, a thoroughly "modern" woman in the context of the village, has refused to accept any suitors for her hand and instead makes known her desire for the narrator. She even approaches the narrator's father and tells him to instruct his son to marry her. The narrator's mother is scandalized: "What an impudent hussy! That's modern women for you!" (*SMN*, 123). Afraid of his own desire for Hosna, the narrator agrees to do what he profoundly disapproves of: approach Hosna on behalf of the old village lecher and close friend of his grandfather, Wad Rayyes, who is determined to marry Hosna. As the narrator's friend later tells him, "The world hasn't changed as much as you think. . . . Some things have changed—pumps instead of water-wheels, iron ploughs instead of wooden ones, sending our daughters to school, radios, cars, learning to drink whisky and beer instead of arak and millet wine—yet even so everything's as it was. . . . Women belong to men and a man's a man even if he's decrepit" (*SMN*, 99–101).

Modernization of water-wheels is one thing, but modern women must be resisted. The result is catastrophic, ripping apart the seemingly placid and changeless surface of the village to reveal the brutality within. Hosna is forcibly married and manages to fend off the attacks of her new husband until one night when villagers hear her screams and do nothing to interfere, only to discover the pair dead and covered in blood. Hosna does what she tells the narrator she will do—kill Wad Rayyes if she is forced to marry him. Then she kills herself. The village, Salih reveals, is a site of partial

modernization, a growing modernity that does not incorporate its girls and women, its family institutions. Rape is not just a metaphor for colonial exploitation and postcolonial revenge. Rape is also what happens when "women belong to men." Hosna's city ways—her modernity— arouse not only the narrator, who is afraid to act, but also the old man whose desire to possess her seems to be an allegory for the resistance to modernity itself. Lest one think of Hosna's action as a simple importation of Western ways into the village, the reaction of Wad Rayyes's elder wife to the story of his death is a chilling warning: "Good riddance!," she says, and at his funeral she "gave trilling cries of joy" (*SMN*, 128). The roots of gender modernization in the village lie in the suffering of its women and their own longing for freedom from tyranny in the family.

Salih further deconstructs the binary of (European) North and (African) South by using the issue of gender relations to expose the North/South power divide *within* the Sudan itself, a long-standing ethnic and religious divide that led to decades of civil war between the dominant Arab and Muslim North and the dominated non-Arab and Christian/animist South. Salih highlights the North's enslavement of women from the South in particular to break open North/South binaries based solely on colonialism. Mustafa's mother, we learn, was a slave from the South, a fact that might explain her striking coldness toward her son. Moreover, Wad Rayyes regales the narrator's grandfather and his friends in the village with the story of his kidnapping "a young slave girl from down-river" whom he delights in raping over and over again (*SMN*, 74). That friends laugh in pleasure at his bawdy tale just days before he rapes Hosna heightens the novel's ironic exposure of violence within the seemingly placid surface of village life and allegorizes the North/South divisions within the Sudan.

In so doing, Salih indigenizes Conrad's project in *Heart of Darkness* to expose the hypocrisy of European imperialism's so-called civilizing mission in Africa and the reality of its greed and bestiality. Salih, like Conrad, exposes the heart of darkness at home, centered in the Sudan's gender and ethnic/religious differences. Beneath the hypocrisy of serene village life in Salih's novel lies the hidden brutality of the village's ambivalent relationship to modernity and its refusal to incorporate the security and freedom of its women in its future. The traditionalism of Salih's "modern" narrator, the postcolonial government agent from Khartoum who is too timid to support Hosna's bid for freedom, has its parallel in Marlow's gender traditionalism at the end of *Heart of Darkness* when he refuses to tell the Intended the truth about Kurtz's last words. In maintaining her illusions about Kurtz's idealism, Marlow performs the traditional role of the man who protects the delicate woman from the harsh realities of life and thus sustains his own need for masculine mastery. Irony in both novels unravels the overlapping oppositions between modernity/tradition, north/south, and man/woman.

The juxtaposition of *Heart of Darkness* and *Season of Migration to the North* breaks down the conventional narrative of modernism as the invention of the West imitated by the Rest. It shows how a polycentric approach to modernity and modernism reveals the way that each site—in Britain and in Africa—is constructed through engagement with the other. Further, each site also exhibits a key feature of modernity: the struggle between modernizing and traditionalizing forces for which women and particularly the violence done to them exposes, indeed explodes the cultural narratives of both rational progress and nostalgic tradition. Like Said's notion of the colonial intensification of the colonizer's traveling theory in "Traveling Theory Reconsidered," Salih's modernist exposure of the violent traditionalisms at the heart of both North and South is not so much derivative of Conrad as it is a sharper and more focused attack on the gender systems of both the colonizer and the colonized. Salih's affiliation with Conrad leads to an indigenization of his tale in which "its fiery core" (to echo Said again) has been reignited with a vengeance.

Moreover, reading *Heart of Darkness* and *Season of Migration to the North* in conjunction as the expressive dimensions of colonial and postcolonial modernities suggests that cutting off modernism

in the 1940s does a violence to the postcolonial text and postcolonial modernisms that reproduces in the symbolic domain the broader violence of colonialism itself. The 1940s end date for modernism in effect refuses to hear what the later modernisms have to say about the modernities that have shaped and been shaped by colonialism and its aftermath throughout the twentieth century.

Conclusion

Whether conceived as a loose affiliation of aesthetic styles or as a literary/artistic historical "period" with at least debatable beginning and end points, modernism contains an unacknowledged spatial politics that suppresses the global dimensions of modernism through time, and the interplay of space and time in all modernisms. As Marshall Brown writes about the problematics of literary periodization, "the art lies in the cutting." Cutting off the end of modernism in the 1940s is an "art" that is also a "politics." It obscures the central role that colonialism played in the formation of modernism in both colonizing and colonized cultures, and it completely suppresses the agencies of those writers and artists who engage with postcolonial modernities after the 1940s. We do not, I believe, reduce the concepts of modernity and modernism to categories that are so inclusive as to be meaningless by theorizing the geohistory of twentieth-century modernism as I have been doing. Instead, we gain a greater sense of the possible modernist particularities that develop in different locations and times in history.

To spatialize the literary history of modernism requires the abandonment of diffusionist ideologies of innovative centers and imitative peripheries. It requires as well the recognition that the "periods" of modernism are multiple and that modernism is alive and thriving wherever the historical convergence of radical rupture takes place. Always spatialize! But remember: spatialization means reperiodizations. Recognizing the "emplacement" of modernisms, to echo Laura Doyle and Laura Winkiel in their introduction to *Geomoderisms*, expands the planetary landscape of modernism at the same time that it retains attention to the creative forms of engagement with modernities whenever and wherever they occur.

Hurry up, please.

It's time for the Modernist Studies Association to change the organization's periodization of modernism in its official description if it wants to reflect the work actually being done under its umbrella. More broadly speaking, it's time as well for modernist studies to expand the horizons of time.

Notes

1. Marshall Brown, "Periods and Resistances," Special Issue on Periodization: Cutting Up the Past. *Modern Language Quarterly* 62, no. 4 (December 2001): 309, 315. For their challenges to portions of this essay, I am indebted to audiences at the Modernist Studies Association Conference (1999, 2005); University of Texas, Austin (2004); Lebanese American University, Lebanon (2004); and University of Coimbra, Portugal (2005); and to the anonymous reader for *Modernism/Modernity*. I owe special thanks to Brian Richardson, who organized the 2005 MSA panel entitled Re-Figuring the Boundaries of Modernism for which I read the short version of this essay; Richardson's paper, "Modernism: Period or Style?," also argues for extending the end points of modernism through the contemporary period.

2. Walter Mignolo, "The Many Faces of Cosmo-polis: Border Thinking and Critical Cosmopolitanism," *Cosmopolitanism*, ed. Carol A. Breckenridge, Sheldon Pollock, Homi K. Bhabha, and Dipesh Chakrabarty (Durham, N. C.: Duke University Press, 2002), 158.

3. Dilip Parameshwar Gaonkar, "On Alternative Modernities," *Alternative Modernities* (Durham, N.C.: Duke University Press, 2001), 14.

4. Lawrence Grossberg, "The Space of Culture, the Power of Space," *The Post-Colonial Question: Common Skies, Divided Horizons*, ed. Iain Chambers and Lidia Curti (London: Routledge, 1996), 180.

5. Fredric Jameson, *The Political Unconscious: Narrative as a Socially Symbolic Act* (Ithaca, NY: Cornell University Press, 1981), 9. See my counterimperative, "Always spatialize," in a discussion of "geopolitical literacy" in *Mappings: Feminism and the Cultural Geographies of Encounter* (Princeton, N. J.: Princeton University Press, 1998), 130–1. See also Christopher Bush's advocacy of a "location-oriented modernist studies" and suggestion that we "imagine a Fredric Jameson of space extolling: 'Always localize'" in "The Other Side of the Other?: Cultural Studies, Theory, and the Location of the Modernist Signifier," *Comparative Literature Studies* 24, no. 2 (2005), 176. Harry Harootunian attacks the spatial turn in modernity studies as a reinstitution of a European colonial paradigm of center/periphery in "Some Thoughts on Comparability and the Space-Time Problem," *boundary 2* 32, no. 2 (Summer 2005), 23–52.

6. Fredric Jameson, "Modernism and Imperialism," *Nationalism, Colonialism and Literature*, ed. Terry Eagleton, Fredric Jameson, and Edward W. Said (Minneapolis: University of Minnesota Press, 1990). For discussion of the necessity for and problems of periodization in literary history, see the special issue on Periodization: Cutting Up the Past of *Modern Language Quarterly* 62, no. 4 (December 2001). None of the contributors give serious consideration to the spatial boundaries implicit in historical—that is, temporal—periodization.

7. Susan Stanford Friedman, "Definitional Excursions: The Meanings of *Modern/Modernity/Modernism*." *Modernism/Modernity* 8, no. 3 (September 2001), 493–514.

8. http://msa.press.jhu.edu/ (emphasis added).

9. Marshall Berman, *All That Is Solid Melts into Air: The Experience of Modernity* (1982; rev. ed. New York: Penguin, 1988); Malcolm Bradbury and James McFarlane, ed. *Modernism* (New York: Penguin, 1976); Astradur Eysteinsson, *The Concept of Modernism* (Ithaca, N. Y.: Cornell University Press, 1990); Peter Nicholls, *Modernism: A Literary Guide* (Berkeley: University of California Press, 1995); and Charles Baudelaire, "The Painter of Modern Life," *Selected Writings on Art and Literature*, trans. R. E. Charvet (New York: Penguin, 1973), 403–5. Modernism in Spanish has yet another periodization, as Cathy L. Jrade explores in *Modernismo Modernity and the Development of Spanish American Literature* (Austin: University of Texas Press, 1998). Houston A. Baker Jr.'s pathbreaking book *Modernism and the Harlem Renaissance* (Chicago, Ill.: University of Chicago Press, 1987) was an early positing of a distinctive and differently periodized modernity for African Americans and thus for their particular modernism.

10. Frantz Fanon, *Black Skins, White Masks: The Experiences of a Black Man in a White World* (1952), trans. Charles Lam Markmann (New York: Grove Press, 1967).

11. Edouard Glissant, *Poetics of Relation* (1990), trans. Betsy Wing (Ann Arbor: University of Michigan, 1997), 138.

12. Hugh Kenner. "The Making of the Modernist Canon." *Chicago Review* 34, no. 2 (spring 1984), 53–57. On modernist primitivism, see especially Marianna Torgovnick, *Gone Primitive: Savage Intellects, Modern Lives* (Chicago, Ill.: University of Chicago Press, 1990); William Rubin, "Modernist Primitivism: An Introduction," *"Primitivism" in 20th Century Art: Affinity of the Tribal and the Modern*. Vol. 1 (Boston, Mass.: Little, Brown, 1984), 1–84. For discussion of philosophical primitivism in the development of Western modernity, see Fuyuki Kurasawa, *The Ethnological Imagination: A Cross-Cultural Critique of Modernity* (Minneapolis: University of Minnesota Press, 2004).

13. Simon Gikandi, *Writing in Limbo: Modernism and Caribbean Literature* (Ithaca, N. Y.: Cornell University Press, 1992); Charles W. Pollard, *New World Modernisms: T. S. Eliot, Derek Walcott, and Kamau Brathwaite* (Charlottesville: University of Virginia Press, 2004); Laura Doyle and Laura Winkiel, ed. *Geomodernisms: Race, Modernism, Modernity* (Bloomington: Indiana University Press, 2005). See also the growing body of criticism of non-Western writers as modernist with a concomitant reconceptualization of modernist internationalism in Anthony L. Geist and José B. Monléon, ed. *Modernism and Its Margins: Reinscribing Modernity from Spain and Latin America* (New York: Garland, 1999); Priya Joshi, *In Another Country: Colonialism, Culture, and the English Novel* (New York: Columbia University Press, 2002); Jrade, *Modernismo Modernity and the Development of Spanish American Literature*; Chana Kronfeld, *On the Margins of Modernism: Decentering Literary Dynamics (Controversions: Critical Studies in Jewish Literature, Culture, and Society)* (Berkeley: University of California Press, 1996); Michael Valdez Moses, *The Novel & The Globalization of Culture* (New York: Oxford University Press, 1995); Fernando J. Rosenberg, *The Avant-Garde and Geopolitics in Latin America* (Pittsburgh: University of Pittsburgh, 2006); Vicky Unruh, *Latin American Vanguards: The Art of Contentious Encounters* (Berkeley: University of California Press, 1994); and Susan Stanford Friedman, "Modernism in a Transnational Landscape:

Spatial Poetics, Postcolonialism, and Gender in Cesaire's *Cahier/Notebook* and Cha's *Dictee*," *Paideuma* 32.1/2/3 (spring, fall, winter 2003), 39–74.

14. J. M. Blaut, *The Colonizer's Model of the World: Geographical Diffusionism and Eurocentric History* (New York: Guilford Press, 1993).

15. Samuel P. Huntington, *The Clash of Civilizations and the Remaking of the World Order* (New York: Simon and Schuster, 1996); Immanuel Wallerstein, "Eurocentrism and Its Avatars: The Dilemmas of Social Science," *New Left Review* no. 226 (November/December 1997), 105. See also Wallerstein's summary of his influential world-systems theory in *World-Systems Analysis: An Introduction* (Durham, N. C.: Duke University Press, 2004) and my extended analysis of what Wallerstein and Huntington share in "Unthinking Manifest Destiny: Muslim Modernities on Three Continents," *Shades of the Planet: American Literature as World Literature*, ed. Wai Chee Dimock (Princeton, N. J.: Princeton University Press, 2007).

16. Susan Stanford Friedman, "Cultural Parataxis and Transnational Landscapes of Reading: Toward a Locational Modernist Studies"; an extended version of this paper is forthcoming in *Modernism*, ed. Vivian Liska and Astradur Eysteinsson (Amsterdam: John Benjamins, 2007).

17. Pollard, *New World Modernisms*, 5; he cites Glissant, *Poetics of Relation*, 29.

18. Pollard, *New World Modernisms*, 9.

19. Doyle and Winkiel, Introduction, *Geomodernisms*, 3.

20. Edward W. Said, "Traveling Theory," *The World, the Text, and the Critic* (Cambridge, Mass.: Harvard University Press, 1983), 226.

21. ibid., 227.

22. Edward W. Said, "Traveling Theory Reconsidered" (1994), *Reflections on Exile and Other Essays* (Cambridge, Mass.: Harvard University Press), 452.

23. In my book in progress, *Planetary Modernism and the Modernities of Empire, Nation, and Diaspora*, I adapt Raymond Williams' concept of keywords, identify over seventy terms for various forms of cultural translation, and sort them by rhetorical categories such as linguistic, organic, economic, cultural, aesthetic, and so forth.

24. Anna Tsing, *Friction: An Ethnography of Global Connection* (Princeton, N. J.: Princeton University Press, 2005), 3.

25. John King, ed. Introduction, *The Cambridge Companion to Modern Latin American Culture* (Cambridge, U.K.: Cambridge University Press, 2004), 2. See also Unruh, *Latin American Vanguards*.

26. For Western literary modernism's formation through engagement with the colonies, see especially Simon Gikandi, *Maps of Englishes: Writing Identity in the Culture of Colonialism* (New York: Columbia University Press, 1996); Elleke Boehmer's discussion of "the globalized interface of modernism" in *Empire, the National, and the Postcolonial, 1890–1920* (Oxford, U.K.: Oxford University Press, 2002), 175 (see especially "Towards a Theory of Modernism in the Imperial World," 169–83).

27. Rubin, "Modernist Primitivism: An Introduction," 7. See also Simon Gikandi's discussion of Picasso's borrowings from African art and the Western suppression of African intellectual and aesthetic thought in "Picasso, Africa, and the Schemata of Difference," *Modernism/Modernity* 10, no. 3 (September 2003), 455–80.

28. See Dipesh Chakrabarty, *Provincializing Europe: Postcolonial Thought and Historical Difference* (Princeton, N. J.: Princeton University, 2000) and *Habitations of Modernity: Essays in the Wake of Subaltern Studies* (Chicago, Ill.: University of Chicago Press, 2002); Homi K. Bhabha's concept of colonial mimicry in *The Location of Culture* (London: Routledge, 1993). For the notion of colonial and postcolonial modernities as "derivative," Partha Chatterjee's *Nationalist Thought and the Colonial World: A Derivative Discourse?* (1986) has been particularly influential. *The Partha Chatterjee Omnibus* (New Delhi: Oxford University Press, 1999), 1–282.

29. Goankar, "On Alternative Modernities," 4–6.

30. R. Radhakrishnan, "Derivative Discourses and the Problem of Signification," *The European Legacy* 7, no. 6 (2002), 790, 788.

31. For conventional Eurocentric definitions of modernity, see for example, Anthony Giddens, *The Consequences of Modernity* (Stanford, Calif.: Stanford University Press, 1990) and the textbook by Stuart Hall and Bram Gieben, *Formations of Modernity* (Cambridge, U.K.: Polity Press, 1992), especially 1–16;

Wallerstein; Huntington. For a counterexample, see Arjun Appadurai's deployment of the term *modernity* to describe late twentieth-century culture in *Modernity at Large: Cultural Dimensions of Globalization* (Minneapolis: University of Minnesota Press, 1996).

32. See especially Janet L. Abu-Lughod, *Before European Hegemony: The World System A.D. 1250–1350* (Oxford, U.K.: Oxford University Press, 1989); Blaut; Shmuel N. Eisenstadt and Wolfgang Schluchter, eds., Special Issue on Early Modernities, *Daedalus* 127, no. 3 (summer 1998); S. N. Eisenstadt, ed., Special Issue on Multiple Modernities, *Daedalus* 129, no.1 (winter 2000); André Gunder Frank, *ReOrient: Global Economy in the Asian Age* (Berkeley: University of California Press, 1998); Stephen K. Sanderson, ed., *Civilizations and World Systems: Studying World-Historical Change* (London: Sage, 1995); Jack Weatherford, *Ghengis Kahn and the Making of the Modern World* (New York: Three Rivers Press, 2004); and Friedman, *Planetary Modernism*.

33. Berman's title, *All That Is Solid Melts into Air*, alludes to Marx's phrase and discussion of modernity in *The Marx-Engels Reader*, ed. Robert C. Tucker (2nd. ed., New York: Norton, 1978), 577–78 (Berman, 21).

34. See also James Clifford's dialectical understanding of tradition/modernity in "Traditional Futures," *Questions of Tradition*, ed. Mark Salber Phillips and Gordon Schochet (Toronto: University of Toronto Press, 2004), 152. For a different view, see Moses, *The Novel & The Globalization of Culture*; although he brings attention to the modernisms produced in the postcolonies, Moses finds in these texts a critique of Western modernity based in the authors' pre-modern and traditional cultural contexts (especially xiv–xvi, 24–25, 107–92). Like many social theorists, Moses argues that modernization causes global homogenization, and he regards the pre-modern and the traditional in the Third World as forces of resistance to modernity's homogenizing. Others, like Clifford in "Traditional Futures," Gaonkar in "On Alternative Modernities," and Victor Roudeometof in "Globalization or Modernity?" (*Comparative Literature Review* no. 31 [1994], 18–45) argue against this view, suggesting instead that globalization heightens the indigenizations of traveling cultures and the ensuing hybrid heterogeneity of local cultures.

35. Paul de Man, "Literary History and Literary Modernity," *Blindness and Insight* (Minneapolis: University of Minnesota Press, 1983), 147–8.

36. Gaonkar, "On Alternative Modernities," 17.

37. See for example Radhakrishnan; Gaonkar; Friedman, "Definitional Excursions"; Abbas Milani, *Lost Wisdom: Rethinking Modernity in Iran* (Washington, D.C.: Mage Publishers, 2004); Eisenstadt and Schluchter; Eisenstadt; Julios Ramos, *Divergent Modernities: Culture and Politics in Nineteenth-Century Latin America*, trans. John D. Blanco (Durham, N. C.: Duke University Press, 2001); Sanjay Subrahmanyam, "Hearing Voices: Vignettes of Early Modernity in South Asia, 1400–1750," *Daedalus* 127, no. 3 (1998), 75–104.

38. Subrahmanyam, "Hearing Voices," 99–100; for virus and toxin imagery for modernity, see Wallerstein's "Eurocentrism and Its Avatars."

39. Tayeb Salih, *Season of Migration to the North* (1967), trans. Denys Johnson-Davies (Boulder, Colo.: Three Continents Books, 1970); hereafter abbreviated *SMN*. Criticism on the novel is proliferating rapidly; although references to Salih's echoing of *Heart of Darkness* abound, no one (with the exception of Saree Makdisi) considers *Season* within the context of modernism. For discussion of Saleh's community of exiles and writers in Beirut, see Mona Takieddine Amyuni, Introduction, *Season of Migration to the North, by Tayeb Salih: A Casebook*, (Beirut: American University of Beirut, 1985); Philip Sadgrove, "Al-Tayyib Salih," *African Writers*, Vol. 2, ed. Brian C. Cox. (New York: Charles Scribner's, 1997), 733–44. For selected discussions of the novel, see especially Amyuni's *Casebook*, produced in Beirut; Ali Abdalla Abbas, "Notes on Tayeb Salih: *Season of Migration to the North* and *The Wedding of Zein*," *Sudan Notes and Records* 55 (1974): 46–60; John E. Davidson, "In Search of a Middle Point: The Origins of Oppression in Tayeb Salih's *Season of Migration to the North*," *Research in African Literatures* 20, no. 3 (fall 1989): 385–400; Patricia Geesey, "Cultural Hybridity and Contamination in Tayeb Salih's *Mawsim al-hijira ila al-Shamal (Season of Migration to the North)*, *Research in African Literatures* 28 (fall 1997): 128–40; Brian Gibson, "An Island unto Himself? Masculinity in *Season of Migration to the North*," *Jouvert* 7, no. 1 (autumn 2002); Barbara Harlow, "Othello's Season of Migration," *Edebiyat* 4, no. 2 (1979): 157–75; Wail S. Hassan, "Gender (and) Imperialism: Structures of Masculinity in Tayeb Salih's *Season of Migration to the North*," *Men and Masculinities* 5, no. 3 (2003): 309–24; R. S. Krishnan, "Reinscribing Conrad: Tayeb Salih's *Season of Migration to the North*," *International Fiction Review* 23, nos. 1–2 (1996): 7–15; Saree S. Makdisi, "The Empire Renarrated: *Season of Migration to the North* and the Reinvention of the Present," *Critical Inquiry* 18 (summer 1992): 804–20; Mohammad Shaheen, "Tayeb Salih and Conrad." *Comparative Literature* 22, no.1 (spring 1985): 156–71; Muhammed Siddiq, "The Process of Individuation

in Al-Tayyeb Salih's Novel *Season of Migration to the North*, *Journal of Arabic Literature* 9 (1978): 67–104; Gayatri Chakravorty Spivak, *Death of a Discipline* (New York: Columbia University Press, 2003), 54–66.

40. For the relation of the novel to *Heart of Darkness*, see especially Shaheen, "Tayeb Salih and Conrad"; Krishnan, "Reinscribing Conrad"; and Spivak, *Death*, 54–66.

41. For discussion of *Season* and other contemporary Arab novels (especially by Lebanese writers) as part of an "Arab modernism," see Makdisi, "'Postcolonial' Literature in a Neocolonial World: Modern Arabic Culture and the End of Modernity," *boundary 2* 22, no. 1 (1995): 104–5.

42. On Mustafa's "hyper-masculinity" and its relationship to colonialism, see Gibson; Hassan. Spivak also briefly discusses gender, modernity, and tradition in *Season*, noting Salih's displacements of the familiar binary.

43. Constance E. Berkley and Osman Hassan Ahmed, ed. *Tayeb Salih Speaks: Four Interviews with the Sudanese Novelist*, trans. Berkley and Ahmed (Washington, D.C.: Embassy of the Democratic Republic of the Sudan, 1982), 15–6.

44. In *Habitations of Modernity*, Chakrabarty notes a parallel phenomenon that helps illuminate Salih's treatment of the Sudanese village. Bengali men working in Calcutta often spent their summers in their village homes, which they represented in stories as sites of nostalgic longing and changeless-ness; after Partition, they were cut off from those villages, a rupture that only increased their desire and idealization of village life ("Memories of Displacement: The Poetry and Prejudice of Dwelling," 115–37). Salih's narrator, educated in England and working in Khartoum for the new nation-state, exhibits many of these same "modern" traits, exoticizing (indeed, Orientalizing) the Bedouin women he sees dancing in the desert in the much-discussed desert caravan sequence (*MSN*, 108–15) and romanticizing what he sees as the stability of the village.

CHAPTER 10
FORCED EXILE
WALTER PATER'S QUEER MODERNISM
*Heather K. Love**

Walter Pater may not seem like the kind of queer icon that contemporary scholars seek out, especially in light of the centrality of figures like Woolf, Stein, Proust, and Wilde to the work of the New Modernist Studies. By the time of Heather K. Love's writing, queer modernist studies had indeed been flourishing for some time, and Pater had received mostly muted attention. But this is precisely why Love finds him so valuable. The late Victorian writer lived on the cusp between the "older, private forms of sub-cultural homosexual life" that he participated in and "the birth of homosexuality as a modern category of identity," but he did not produce "heroic" statements of modernist ideals vis-à-vis queer arts and politics. Nor was he a martyr for a queer cause. Rather, he was "withdrawn," quiet, perhaps even ashamed; he refused explicit politics and embraced a mode of "apostasy," and thus, "Pater's failure to approximate the norms of modernist political subjectivity" might make him look like a figure who remained silent in the face of a great cultural opportunity.

But Love—picking up a line of thought that Jack Halberstam would soon call "the queer art of failure"—repurposes and rereads Pater's purported failures and his queerness in general in order to rethink some of our core narratives of modernist aesthetics and cultural politics. Her first object of study is experimentation: some modernists, she notes, experimented because they wanted to transgress aesthetic norms, but many others had no choice but to transgress in their works. That is because experimentation was the only natural articulation of marginal subjectivity itself. Pater himself was variously a central and a marginal figure, and Love sees value in his protomodernism as "bad" writing and thought, where his transgressions do not seem as radical or even rebellious as contemporary scholars typically study. But what Love calls his "politics of refusal" actually is a mode of politics—one with a rich history in queer subcultural and academic life alike.

Here, Pater becomes a figure somewhat like the version of Joyce that the French sociologist Pascale Casanova takes up at length in her *World Republic of Letters* (1999), a book that itself has had considerable influence on the New Modernist Studies. Casanova studies the ways in which writers from marginal, outsider positions—especially geopolitical margins, like colonies and remote, provincial cultures—became dominant figures through the prestige circuit in Paris that was thriving during the modernist period. Pater had a profound influence in his time, too, yet remained (often by choice) on the fringes of several movements around him, and in this way, Love sees that he enacted a mode of queer subjectivity guided by "shrinking resistance" that points us to a broader history of "those who drew back and those whose names were forgotten." The task for contemporary scholars, she implies, is to recover

these queer histories as silences, refusals, and withdrawals, rather than attempting to rewrite and glorify past figures who shunned the potential limelight of queer existence in the early moments of public homosexual identity-formation.

Love's essay points to the shifting categories for thinking about modernism that had emerged over the previous decade and a half: seeing modernism as intentionally "bad," as failed, and as invested in various politics of visibility and silence. We see more such lines of criticism in the final essay collected here—Paul Saint-Amour's "Weak Theory, Weak Modernism"—but at this juncture, Love captures a way of replotting modernism's story around new concepts and configurations. If we don't simply lionize transgression, and instead look through the fine grains of its diffuse historical dialectics, we find in figures like Pater a refreshingly different sense of modernism and a different set of coordinates through which modernism's emergence could be mapped.

to be weak is miserable,
Doing or suffering . . .

Paradise Lost (1.157–58)

In thinking about *bad modernism*, it may be useful to recall that it was modernism itself that gave *bad* a good name. Being bad has always meant crossing the line, turning away from what is accepted and familiar, heading out for the unknown; but it was only with modernism that the value of such transgression underwent a sharp reversal. Certainly, we may say that the Romantics inaugurated the possibility that bad could be good, that revolt could be a moral duty rather than a moral failing. But it was modernism that gave currency to the idea that going to the limits might be essential to the recreation of the world. From Baudelaire's Satanism to Marx's "poetry of the future" to Nietzsche's "transvaluation of all values," modernists sought to wreck the old world in order to make room for the new. They viewed the world of their predecessors as so corrupt and oppressive that it practically begged for destruction; they prescribed, in the words of D. H. Lawrence, "surgery—or a bomb." Although it made up only a fraction of the aesthetic production in the period, this "heroic" version of modernism has been most consistently identified with modernism itself. The academy has welcomed many of modernism's most notorious bombsquads, making a place not only for the Men of 1914, but also for Futurists, Dadaists, and Surrealists. Over the course of the twentieth century, this version of modernism has prevailed to such an extent that innovation and the break with authority now look like core values.

It is a mark of modernism's profound success, in other words, that "we moderns" tend to think that making good depends on a willingness to do bad. As a result, it is difficult to say what we might mean by *bad modernism*. If we are considering making a break with the orthodoxies of modernism, resistance may be futile: iconoclasm is what modernism is all about. If we hope, instead, to identify and claim a subaltern current or deviant strain of modernism, we are once again in trouble. Such modernism would not really be bad modernism: it would just be modernism. Again, we might interpret *bad modernism* as a dissident form of modernist scholarship; however, in an academic context that values transgression or, at the very least, novelty, modernism that is not a little bit bad does not get much play. Given the modernist transvaluation of values, it is difficult to imagine a bad modernism that would not seem anything but just fine.

In his book on the modernist work of art, *Untwisting the Serpent*, Daniel Albright characterizes modernism as an art of extremity. He writes, "Much of the strangeness, the stridency, the exhilaration of Modernist art can be explained by [its] strong thrust toward the verges of aesthetic experience:

after certain nineteenth-century artists had established a remarkably safe, intimate center where the artist and audience could dwell, the twentieth century reaches out to the freakish circumference of art."[1] Albright describes the extremist impulse in modernism as a desire to cross boundaries, to set off from the center of culture toward its outer limits. What is crucial in such a definition, however, is the different valence of exile for those escaping from the center and for those who find themselves already positioned on the "freakish circumference." The meaning of modernist transgression—of crossing the line—depends to a great extent on which way you are headed: it is one thing to light out for the Territory, and something different, after all, to live there.

Recently, critics have begun to rethink this image of modernism as a "drive to the margins" by situating aesthetic modernism within a broader geographical and cultural framework. The ascendancy of American and European high modernism has been challenged by recent work that explores black and white modernism, non-elite cultural production in the period, the gender of modernism, and the global dimensions of modernity.[2] While it is possible to understand the transgressive aspect of modernism as an escape from the crumbling center of culture (the "white flight" model), the early twentieth century was also an era of new social possibilities for a range of marginal or dominated subjects. If the prevailing image of modernism remains the drive to the margins, it is in part because modernism itself is still defined from the center; recent work on alternative cultures of modernity has not been integrated into an understanding of the period as marked by traffic *between* the center and the margins. The exemplary modernist gesture of self-exile is at some distance from the experience of "forced exile"—whether through migration or marginalization—which is one of the most widespread and characteristic effects of modernization. If one has not departed under one's own steam, being on the margins looks less like heroic sacrifice and more like *amor fati*. Such a modernism cannot easily be recuperated as good: in recording the experience of forced exile, it undermines the heroism of modernist transgression, revealing the uneven terrain of twentieth-century modernity.

As important as it is to attend to the real differences between "dominant" and "marginal" modernisms, it is also important to remember how difficult it can be, in any given case, to tell the difference. Consider the example of James Joyce, who in a certain light looks to be a perfect representative of dominant modernism. Joyce's position is significantly complicated by his status as a subject of British colonial rule. In the case of Joyce's decision to leave Ireland, it would be difficult to say whether this exile was forced or chosen. Stephen Dedalus's embrace of Lucifer as his role model in *A Portrait of the Artist as a Young Man* is perhaps the most iconic gesture of modernist transgression. Stephen is modernism's proudest exile: he takes the rebel angel's motto— "*non serviam:* I will not serve"—as the cornerstone of his aesthetic and moral program. "I will not serve that in which I no longer believe, whether it call itself my home, my fatherland, or my church: and I will try to express myself in some mode of life or art as freely as I can and as wholly as I can, using for my defense the only arms I allow myself to use, silence, exile, and cunning."[3] In the conventional account of divine history, voiced in the novel by the pastor at a school retreat, exile is figured as the punishment for Lucifer's rebellion; in following Lucifer, Stephen embraces exile as the very means of his rebellion. Stephen's decision to betray the sacred trinity of family, God, and nation is one of the defining moments of modernism. In this by-now familiar narrative, the proud exiles of Joyce's generation abandoned the bankrupt certainty of their fathers' world in order to construct new modes of life and art: they betrayed the old world in order to forge a new one.

While modernism may have destroyed the old world, it's not clear that it successfully created a new one. In this sense, Lucifer is an apt emblem of high modernism: his stand against God is both courageous and doomed from the start. Milton offers the paradigmatic account of the tragic rebellion of the most beautiful of angels. He draws attention to the intimate link between defiance and abjection at the beginning of *Paradise Lost*, when we find Satan "vanquish'd, rolling in the fiery gulf" (1.52). In these opening lines, Milton constantly juxtaposes Satan's continued defiance with

his utter misery, as he describes him "prone on the flood" (1.195), raising his head above the waves to speechify against God. This constant underlining of the contrast between Satan's condition and his rhetoric is to emphasize the continuity between them: Milton suggests that it is because Satan is feeling so bad that he is talking so big.

We hear a similar quaver in Stephen's voice when he tells his friend Cranly that he is willing to bear damnation. The irony of Stephen's pledging himself to eternal solitude as he "thrills" to Cranly's touch is not lost on the reader (269), who hears the imminent disappointment in this oath of defiance. Stephen's namesake Daedalus captures the ambivalence of modernist transgression: he is at once heroic artificer—the architect of the labyrinth—and at the same time a failed creator and an involuntary exile. I think we can trace the underside of modern Satanism in the word "apostasy," derived from the Greek *apostasia*: "to stand off, withdraw" (OED). Given God's absolute power, the angels can do nothing but "stand back" from Him. As a form of aesthetic and moral apostasy, modernism joins the image of revolt to the image of abject failure. While Stephen claims to fly in the face of God, his act of apostasy is an act of refusal, a step backward rather than a lurch forward.

In his article "Salt Peanuts: Sound and Sense in African/American Oral/Musical Creativity," Clyde Taylor offers a version of modernism that resonates with this Satanic version of rebellion. Treating the relation between black and white modernism, Taylor suggests that we think of all modernism as a response to the experience of alienation and exclusion.

> [A]ll people in extreme situations are either experimenters or passive victims. African experimenters in America differ from the experimenters of Western creativity only in having less choice whether or not to try something new. The displaced Africans shared the same motivations for experimentation and for indifference to faithful representation of the world ordered by Western rationalist intelligence as those which drove Picasso, Stravinksy, and Ezra Pound. In both the African American oral tradition and the art movements we call modernist, we find a driving search for forms of spiritual and human expression that could withstand the alienation of modern industrial culture and its inclination to transform human relations into commodity relations.[4]

Taylor traces modernist innovation as a response to victimization and sees continuity between the kinds of experiments undertaken in dominant cultures and those undertaken in vernacular ones. The only difference is that "African experimenters in America" have had less choice than "the experimenters of Western creativity [about] whether or not to try something new." Drawing a link between the experience of black Americans and of high modernists, he suggests that in the early twentieth century both groups found themselves on the margins; setting the heroics of modernist innovation side-by-side with the experience of victimization, he draws out the strain of failure that runs through all modernism. Such a framework offers a usefully rich account of "dominant" modernism, of "marginal" modernism, and of the many modernisms ranged along this spectrum. Yet there are crucial differences between a generalized sense of alienation and structural forms of domination.[5] A rethinking of bad modernism—of modernism gone bad—along Taylor's lines also demands a new attention to the specific forms of exclusion faced by early-twentieth-century subjects.

We might begin to think through such exclusions by considering the history of the word *bad*. According to the OED, *bad* originally derives from the Middle English *bad-de*, a variation on the Old English term *bæddel* ("homo utriusque generis, hermaphrodita") and its "derivative *bædling* 'effeminate fellow, womanish man,' applied contemptuously." Webster's Unabridged Dictionary links the term further to *bædan*, to defile. This term finds its origin in an experience of social domination, in the stigmatizing force of the insult ("*bædling* . . . applied contemptuously"). With

the performative force of any slur, *bad* constitutes the other as abject, marginal, and degraded simply through the act of naming. It is possible to trace the aftereffects of this origin in a range of meanings over the last several centuries: these meanings range from more neutral definitions of *bad* as "lacking good qualities" to stronger characterizations such as unpleasant, unhealthy, deficient, downcast, corrupt, decayed, false, pernicious, morally depraved, and evil.

This longer etymological history of bad runs parallel to the history of the word *queer*, which also has its origin as a term of abuse for sexual and gender outsiders. This playground slur underwent a change in its fortunes when in the late 1980s it was recuperated as the name for a rebel strand of lesbian and gay politics. At the end of *Bodies That Matter*, Judith Butler discusses the history of the term *queer*, asking "How is it that a term that signaled degradation has been turned . . . to signify a new and affirmative set of meanings? . . . Is this a reversal that retains and reiterates the abjected history of the term? When the term has been used as a paralyzing slur, as the mundane interpellation of pathologized sexuality, it has produced the user of the term as the emblem and vehicle of normalization. . . . If the term is now subject to a reappropriation, what are the conditions and limits of that significant reversal?" Butler considers the challenges of turning *queer* to good effect, given its "constitutive history of injury."[6] Butler's reflections here are indebted to Michel Foucault's discussion of "'reverse' discourse" in *The History of Sexuality*, in which he traces the origins of modern homosexual identity to the legal and medical literature of the late nineteenth century. Foucault's account of this history is marked by ambivalence, as he points out that the claim for the "legitimacy" of homosexuality was made "in the same vocabulary, using the same categories by which it was medically disqualified."[7] Both Foucault and Butler suggest that turning a negative category into a positive one cannot be done cleanly: modern homosexuality is bound up with modern regimes of categorization, discipline, and stigma.[8] In the context of *bad modernism*, we might ask whether the reclaiming of *bad* is a reversal "that retains and reiterates the abjected history of the term." As in the case of *queer*, the modernist affirmation of this term is haunted by its history as an instrument of shame.

If modernism in general can be said to have deployed a certain inversion of good and evil, the specific turn in the meaning of the word *bad* seems to have been an invention of black American vernacular speech. While the OED names a whole range of bad meanings of *bad*, from deficient to corrupt to evil, its one positive meaning ("Possessing an abundance of favourable qualities; of a musical performance or player: going to the limits of free improvisation; of a lover: extravagantly loving") is traced to "*Jazz* and *Black English*." The OED locates the first positive use *of bad* in the Harlem novel *The Walls of Jericho* (1928) ("This crack army o' Joshua's . . . walk around, blowin' horns. . . . The way they blow on them is too bad."). *The Random House Historical Dictionary of American Slang* traces a slightly earlier usage ("Ellington's jazzique is just too bad," 1927) and a much earlier black dialect usage in the work of the American humorist George Ade ("a pohk chop 'at's bad to eat," 1897). Geneva Smitherman traces this use of "good" bad to the Mandinka language, to the phrase "*a ka nyi kojugu*" ("It is good badly"), suggesting that the black dialect inversion of *bad* was an African retention.[9] This outtake from the history of *bad* points toward a bad modernism speaking in the vernacular, and speaking back to a history of victimization. The reversal of bad in an African American context is perhaps most visible as an example of reverse discourse in the reclaiming of the term "bad nigger," which originated as strictly a term of abuse but emerged later as a name for proud resistance. Classic figures of the "bad nigger" such as Jack Johnson and Stagolee embody the ambivalence of the Satanic ideal; their good badness is marked by a long history of social exile.[10]

It is striking that "bad" seems, from the beginning, to have been caught up with the fate of social exiles.[11] And while I would not want to conflate the situation of medieval hermaphrodites with that of black Americans at the turn of the twentieth century, it is nonetheless true that the word *bad* is

haunted by a history of social domination. This bad or ruined history of *bad* may help us to rethink the image of modernist rebellion as heroic resistance and to bring out the strain of failure in all modernism.

In this essay I consider the bad modernism of the late-nineteenth-century critic and novelist Walter Pater, exploring his aesthetics of failure specifically in relation to his experience of bearing a marginalized sexual identity. Pater has proved difficult to classify in several ways. Understood alternately as a late Victorian, a decadent aesthete, and an early modernist, Pater resists easy situating within traditional literary periods. His most significant work, *Studies in the History of the Renaissance* (1873), looks backward to exemplary moments in the history of Western culture, celebrating the coming together of the Greek and the Christian spirit in the Renaissance. Pater's turn toward the past aims to transform the present and the future; he explored these moments in an effort to ignite a similar moment of cultural revolution in the present. He drew on the past in part to break with it; his thoroughgoing critique of religious, moral, and social tradition is legible as modernist. Pater's social position is equally difficult to classify. In one sense, we can see him as situated within the inner sanctum of traditional English culture, especially if we understand Oxford's Brasenose College (where Pater was a don) as answering to that description. However, he was also positioned at the "freakish circumference" of culture. Pater's distance from norms of gender and sexual behavior meant for him a kind of internal exile; his position of educational and national privilege could be maintained only by fending off the constant threat of exposure. While Pater avoided the fate of the most famous martyr to homosexual persecution (he died in 1894, less than a year before Oscar Wilde's trial), his position at Oxford was seriously undermined by rumors of an affair with an undergraduate, William Money Hardinge.[12]

A "queer" Pater has emerged in recent criticism, as several critics have explored the relation between his status as a sexual outsider and his aesthetics. While these critics have attended most fully to the effects of secrecy and concealment in Pater's work, here I am interested in particular in drawing out Pater's investment in failure and in victimization. We might read all of Pater's writings as dedicated to the figure of the victim: in this sense, he cultivates a modernist aesthetic based not on violent transgression but rather on refusal and passivity. Such a form of shrinking resistance may seem at odds with the protocols of modernist rebellion, and it has often been read as a sign of Pater's aestheticist withdrawal from the field of the social. I suggest recasting his aesthetics of failure as a complex response to a particular historical experience of exclusion. Pater's own situation was paradoxical; he participated in older, private forms of homosexual sub-cultural life at the same time that he witnessed the birth of homosexuality as a modern category of identity. In this sense, I think it is possible to understand Pater as doubly displaced, inhabiting a threatened position as someone with secrets to keep and as someone whose particular form of secrecy was fast becoming superannuated. Living through this moment of profound historical transformation and of displacement, Pater imagined a world in which time was suspended.

Pater's break with the future and with the hard and fast revolutionism of the modernists has made him the cause of some embarrassment. He has been closely linked to the ills of aestheticism: political quietism, withdrawal from the world, hermeticism, nostalgia, a slack relativism, and the elevation of beauty above justice. I want to suggest that what has been seen as a lack of political commitment might be better understood as Pater's failure to approximate the norms of modernist political subjectivity. I read withdrawal in Pater not as a refusal of politics but rather as a politics of refusal; I propose that we understand his shrinking politics as a specifically queer response to the experience of social exclusion. The key practices of such a politics—secrecy, the vaporization of the self, ascesis, and temporal delay—depart significantly from the modernist protocols of political intervention. Nonetheless, I argue that we should understand such practices as constituting an alternative form of politics—one consonant with the experience of marginalized subjects.

Pater begins the famous conclusion to *The Renaissance* with an epigraph from Heraclitus ("All things are in motion and nothing at rest") and a gloss on this citation. He writes, "To regard all things and principles of things as inconstant modes of fashion has more and more become the tendency of modern thought. Let us begin with that which is without—our physical life. Fix upon it in one of its more exquisite intervals, the moment, for instance, of delicious recoil from the flood of water in summer heat."[13] The profound anonymity of Pater's writing is in evidence here as he moves from an infinitive construction ("To regard . . .") to a generalizing use of the first-person plural ("Let us begin . . .") to a moment of narration that is introduced by an invocation to the reader ("Fix upon . . .") and then moves to a complete vaporization of the subject.

The agentless action that Pater describes ("the moment of delicious recoil from the flood of water in summer heat") recalls the dynamic that Eve Kosofsky Sedgwick identifies, in her work on Henry James, as "queer performativity." For Sedgwick, this term describes a combination of reticence and virtuosic stylistic performance; she traces this dynamic to the experience of queer childhood, with its combination of alienation, extreme self-consciousness, and lots of time for reading. Sedgwick draws on Silvan Tomkins's description of shame as "interrupted interest" in order to describe queer performativity as a gesture of approach followed by a blushing withdrawal. This dual movement of solicitation and self-effacement occurs throughout Pater's writing. In his approach to the reader, Pater somehow manages to be both forward and shrinking, both suggestive and withdrawn. What is striking in the passage quoted above in particular is the way that Pater identifies the movement of recoil as the most delicious moment: this investment in recoil is matched rhetorically by the delicious secreting of the subject in the text.

Throughout his writing, Pater evinces a fascination with the disappearing subject. In his first published essay, "Diaphaneitè," delivered as a lecture to the "Old Mortality Society" at Oxford in July 1864, Pater offers a breathtakingly abstract account of a particular "type of character," that "crosses rather than follows the main currents of the world's life."[14] He writes,

> There are some unworldly types of character which the world is able to estimate. It recognizes certain moral types, or categories, and regards whatever falls within them as having a right to exist. The saint, the artist, even the speculative thinker, out of the world's order as they are, yet work, so far as they work at all, in and by means of the main current of the world's energy. Often it gives them late, or scanty, or mistaken acknowledgement; still it has room for them in its scheme of life, a place made ready for them in its affections. . . . There is another type of character, which is not broad and general, precious above all to the artist. . . . It crosses rather than follows the main current of the world's life. The world has no sense fine enough for those evanescent shades, which fill up the blanks between contrasted types of character. . . . For this nature there is no place ready in its affections. This colourless, unclassified purity of life it can neither use for its service, nor contemplate as an ideal. (154)

In his description of this crystal character, Pater describes a figure even less welcome in the world than unworldly, yet recognizable, historical actors like the saint, the artist, and the speculative thinker. Pater sketches a character without characteristics; nothing positive attaches to this figure, who is defined solely by his imperceptibility and his state of permanent exile. This figure occupies the blanks between recognizable social forms and between other people. This colorless character is not solid enough to be the object of antipathy or aggression; so complete is the world's refusal of him that his only response is to evanesce, to become transparent.

Such diaphanous types appear throughout Pater's work. They populate in particular the world of *The Renaissance*. Pater imagines the Renaissance through a series of extended reveries on the lives of a range of historical and fictional characters. The book spans a period that extends from

the twelfth to the eighteenth centuries and includes nearly all major movements in Western aesthetics and philosophy. This world is populated by characters or types who are indecisive, shrinking, transparent.[15] The beautiful passivity of these figures is enabled by the quality of suspended animation that characterizes this era. As Pater describes it, the Renaissance is a realm free from surveillance and from the necessity of taking sides: "Within the enchanted region of the Renaissance, one need not be forever on one's guard. Here there are no fixed parties, no exclusions" (17). In a world without warfare, warriors are not needed: one is freed up to imagine a realm populated exclusively by crystal characters. In *The Renaissance*, Pater creates a world that appears as the "counterimage" of the paranoid world of the late nineteenth century. Many of the central descriptions of this world are taken from a lexicon of homosexual secrecy: this language of suggestion indexes the diffuseness and suggestibility of male homoerotic subcultures on the eve of the invention of the homosexual.

In his article "Pater's Sadness," Jacques Khalip suggests that transparency in Pater is "allied . . . to a need for defensiveness," and he explicitly links Pater's embrace of anonymity to his experience bearing a marginalized sexual subjectivity. In a discussion of ascesis in Pater's work, Khalip writes, "We suffer because of our lack of knowing, but for Pater, the willful suffering that accompanies ascesis, or his kind of renunciation, is a far better gesture than the arrogant effort to extend and insinuate oneself over other persons and things."[16] Khalip understands Pater's withdrawal as a way of diminishing his epistemological hold over the world, a refusal to dominate. In Pater's case, such a willed act of self-overcoming can often have the air of a forced march. Khalip writes, "That sadness characterizes and vivifies a sense of absence is made clear in the way that certain habitual failures to attend both in and to the social world register the effect of various coercive routines of concealment" (147). Out of this experience of marginalization, Pater imagines an ideal type or character "whose first act of descent is a death, a self depleted by the simultaneous disappearance of the fields of sociality which are available for its self-realization" (141). In this sense, we may understand the moment of ascesis in Pater not only as a withdrawal of the subject from the world but also as a withdrawal of the world from the subject.

In her account of Pater's historical romance *Marius the Epicurean*, Maureen Moran writes that Pater draws attention to "the value of the excluded and the victimized."[17] This emphasis on the "heroic importance of the marginalized" is legible not only as a strategy for redefining Victorian manliness but also a way of registering a particular experience of exclusion. In "Diaphaneitè" Pater describes the redemptive significance of his basement type:

> Over and over again the world has been surprised by the heroism, the insight, the passion, of this clear crystal nature. Poetry and poetical history have dreamed of a crisis, where it must needs be that some human victim be sent down into the grave. These are they whom in its profound emotion humanity might choose to send. (157–58)

Pater's "clear crystal character" is defined not only by his transparency but also by his status as victim. Heroism, insight, and passion are here all bound up in an experience of martyrdom, even scapegoating, as this figure is sent to the grave by all humanity.

Pater offers a specific image of the victim as hero in a story borrowed from Heine's *Gods in Exile*, reproduced in a chapter on Pico della Mirandola in *The Renaissance*. Heine's tale recounts the twilight existence of the Greek gods after the triumph of Christianity: rather than disappearing with the coming of Christianity, the pagan gods go into hiding, live their lives out in disguise, drinking beer instead of nectar. Pater cites Heine: "Let me briefly remind the reader . . . how the gods of the older world, at the time of the definite triumph of Christianity, that is, in the third century, fell into painful embarrassments, which greatly resembled certain tragical situations in their earlier life. They now found themselves beset by the same troublesome necessities to which they had once

before been exposed during the primitive ages. . . . Unfortunate gods! They had then to take flight ignominiously, and hide themselves among us here on earth, under all sorts of disguises" (21).

Pater is particularly concerned with the fate of Apollo, the god of light, who fell under suspicion "on account of his beautiful singing." A spiritual tribunal ensues, during which Apollo confesses his true identity "on the rack." Condemned to death, Apollo makes a last request: "[B]efore his execution he begged that he might be suffered to play once more upon the lyre, and to sing a song. And he played so touchingly, and sang with such magic, and was withal so beautiful in form and feature, that all the women wept and many of them were so deeply impressed that they shortly afterwards fell sick" (21).

On the one hand this is a story of the triumph of the villagers, who force Apollo's confession before executing him. The story narrates the victory of the confessors, who not only discover Apollo but torture and bury him.[18] Still, the villagers are not content to let him lie in the grave but dig him up to make sure that he is dead. The narrative continues: "Some time afterwards the people wished to drag him from the grave again, that a stake might be driven through his body, in the belief that he had been a vampire, and that the sick women would by this means recover. But they found the grave empty" (21).

Heine's story demonstrates the strategic value of disappearance under a regime in which vigilance takes the form of identification and surveillance. The gods in Heine's story are already in disguise, but this strategy of camouflage (or "fitting in") does not prove to be adequate. Apollo's most effective form of resistance is through sacrifice—his death at the hands of his torturers. It is only when he is dead that he is finally able to disappear completely, absenting himself from the grave they have made for him. Before disappearing completely, Apollo reveals himself in a performance that infects the locals with its beauty. We might understand Pater's own aestheticist practice in a similar vein; like Apollo, he "kills us softly" with his gorgeous prose before fading out altogether.

In his conclusion to *The Renaissance*, Pater writes: "Well, we are all condamnés, as Victor Hugo says: we are all under sentence of death, but with a sort of indefinite reprieve." In this vision of a universal death sentence, we can read an allegory of Pater's historical position. His experience of displacement seems to lead not only to a politics of camouflage and disappearance but also to a politics of deferral. His investment in this story of the gods lingering on after they have been dispossessed is legible in terms of the lingering on of queer figures as the new era of homosexual identity approached. According to Khalip, Pater's crystal figures indicate the possibility of a transformed future without ever moving toward that future. In describing this figure in Pater's work, Khalip writes, "The crystal character is imbued with a type of visionary beauty specific to his (or its) diaphanous description, but this transparent, recuperative alien, most himself when he is not himself, can only remind us of the process of liberation he is meant to perform, without ever actually accomplishing it" (148).

The power of this figure for Pater is represented in terms of latency, potential, and delay. He writes, "Those who prosecute revolution have to violate again and again the instinct of reverence. That is inevitable, since after all progress is a kind of violence. But in this nature revolutionism is softened, harmonized, subdued as by a distance. It is the revolutionism of one who has slept a hundred years" (158). In such passages, Pater gestures toward an underworld politics that draws on the potential that gathers beneath and behind the visible social world. Rather than violent revolution, Pater recommends sleep. He does not rise up against the onset of modernity. Instead, he responds to it with a weak refusal: he quails at its approach.

In his chapter on Botticelli in *The Renaissance*, Pater traces a "middle world" in which "men take no side in great conflicts, and decide no great conflicts, and make great refusals" (36). Pater specifically contrasts Botticelli's attitude toward these melancholy figures to Dante's: "what Dante scorns alike of heaven and hell, Botticelli accepts." The explicit reference here, as Paul Tucker notes, is to Dante's

consigning of "the neutral angels, together with the historical figures guilty of futility and indecision," to the Vestibule of Hell.[19] These indecisive, neutral angels are the subject of Pater's luminous essay on Botticelli. Taking his cue from a poem by Matteo Palmieri, Pater describes a "fantasy" that "represented the human race as an incarnation of those angels who, in the revolt of Lucifer, were neither for Jehovah nor for His enemies" (35). In this alternative genealogy, Pater suggests that humanity itself is the residue or trace of a failed or weak apostasy. Like their heavenly forebears, these human figures "take no side in great conflicts, and decide no great causes, and make great refusals" (36). Their gesture of apostasy is not an act of heroic revolution; rather, they take an almost imperceptible step back from God. They are marked by loss of an indeterminate nature, a sweet melancholy that infuses each gesture and look. This melancholy is intimately tied to their refusal to act, as Pater writes that these figures are "saddened perpetually by the great things from which they shrink" (36).

Pater never names these "great things" from which Botticelli's sad angels shrink, but we might read his description of the world they inhabit as an allegory for spaces for male-male intimacy before the advent of modern homosexuality. The "queerness" of Botticelli's figures is suggested by several of the "traits" that Pater ascribes to them—wistfulness, a peculiar beauty, the air of victimization and underground existence that marks them—but also by the particular quality of their exile, which is described here as both a spatial and a temporal displacement. In tracing the celestial genealogy of these figures, Pater writes,

> True or false, the story interprets much of the peculiar sentiment with which he infuses his profane and sacred subjects, comely, and in a certain sense like angels, but with a sense of displacement or loss about them—the wistfulness of exiles, conscious of a passion and energy greater than any known issue of them explains, which runs through all his varied work with a sentiment of ineffable melancholy. (36)

The sense of loss about these figures seems to be a result of their alienation from dominant social structures: with only vaporous, insubstantial parents and no "known issue," these figures fall outside structures of kinship. Their place is not in the home; but they don't seem to belong in the closet either. Rather, Pater seems to propose here an epistemology of the vestibule, as he imagines a community of subjects defined through indecision and delay. This liminal, semi-public space allows for a beautiful deferral, and, one assumes, for the emergence of alternative forms of sociability. As attractive as this world is, the air of melancholy that infuses it serves as a reminder that this dwelling place is not freely chosen. One ends up there by failing to choose.

The spatial displacement of these figures is matched by a temporal displacement: they fall outside the home, but also outside of the linear narratives and ordered temporalities of blood kinship. These figures are outside time, suspended in an endless present of indecision. While we might think of the strange beauty of these figures as an effect of their resistance to age, they are also beautiful because they are "out of it," at a distance from the pulsions of anticipation. Pater explicitly describes the refusal of the future as beautiful in a passage on Greek sculpture in his essay on Winkelmann:

> [I]n the best Greek sculpture, the archaic immobility has been stirred, its forms are in motion; but it is a motion ever kept in reserve, and very seldom committed to any definite action. Endless are the attitudes of Greek sculpture, exquisite as is the intervention of the Greeks in this direction, the actions or situations it permits are simple and few. There is no Greek Madonna; the goddesses are always childless. The actions selected are those which would be without significance, except in a divine person—binding on a sandal, or preparing for the bath. When a more complex and significant action is permitted, it is most often represented as just finished, so that eager expectancy is excluded. (139)

The beauty of these figures is specifically tied for Pater to their lack of expectancy and to their timeless embodiment of "motion in repose." The minute gestures of the statues invoke a timeless present, imaging forth a heaven in which nothing—or nothing of significance—ever happens. To be beautiful in Pater's view is to expect nothing, least of all a child. It is significant that reproduction itself is signaled as the culprit for linear history itself: the birth of a child is defined as the "great event" which demands the breaking up of immobility into a grasping expectancy.[20]

Despite Pater's equation of beauty with childlessness, he focuses on a mother in his chapter on Botticelli: the essay centers on that shy and shrinking figure, the Madonna of the Magnificat. For Pater, however, this figure is compelling precisely for the "great refusals" of which she is capable. Not only does this peevish mother seem the victim of an unwanted pregnancy, she also refuses the historical facts of the coming of Christ and of her own deification. Through her impassivity and melancholy Botticelli's Madonna signals her weak protest; in the end, like Apollo, she is subject to a forced confession. Pater writes,

> For with Botticelli she too, though she holds in her hands the "Desire of all nations," is one of those who are neither for Jehovah nor for His enemies; and her choice is on her face. The white light on it is cast up hard and cheerless from below, as when snow lies upon the ground, and the children look up with surprise at the strange whiteness of the ceiling. Her trouble is in the very caress of the mysterious child, whose gaze is always far from her, and who has already that sweet look of devotion which men have never been able altogether to love, and which still makes the born saint an object almost of suspicion to his earthly brethren. Once, indeed, he guides her hand to transcribe in a book the words of her exaltation, the *Ave*, and the *Magnificat*, and the *Gaude Maria*, and the young angels, glad to rouse her for a moment from her dejection, are eager to hold the inkhorn and to support the book. But the pen almost drops from her hand, and the high cold words have no meaning for her, and her true children are those others, among whom, in her rude home, the intolerable honor came to her. (37)

The great event that Pater describes in his account of this painting is the birth of Christ, whose divinity casts a shadow over those who receive him. I understand this passage as a melancholic meditation on the inevitability of historical change. Pater's Madonna seems burdened by her knowledge of the profound difference that Christ's birth will make. Pater suggests that Mary is saddened in particular by the inevitability of her own deification as a result of having borne the Son of God. As he describes the infant Christ guiding his mother's hand to trace out the words of the Marian Liturgy, Pater imagines that the Virgin was exalted against her will.

I want to suggest that we might read this passage as an allegory of Pater's resistance to his own future exaltation. The "intolerable honor" that came to him was the onset of late-nineteenth-century modernity, and with it the birth of homosexuality as a newly public and newly recognizable social identity. Pater was situated on the verge of a new era of possibility for queer subjects, and his ambivalence about this historical development is palpable: his choice is on his face. In this image of the Madonna, Pater produces another image of the forced confession, reminiscent of Apollo's singing before his execution. As in Heine's account of Apollo's final moments, being identified or named is described as tragic but it is at the same time a moment of glorification.

What is lost in such a moment of transformation is suggested by the opening words of the *Magnificat*, one of the prayers Pater's Madonna is forced to copy out. The words of the prayer record Mary's response to her cousin Elizabeth's praise ("Blest are you among women and blest is the fruit of your womb . . ."). The passage from Luke begins: "And Mary said: My soul proclaims the greatness of the Lord, and my spirit rejoices in God my Savior; because He has looked upon the humiliation of His servant. Yes, from now onwards, all generations will call me blessed." Mary embodies a

profound contradiction: she is both God's humble servant and the Blessed Virgin, a kind of deity in her own right. What is unsettling to Pater about the moment of her glorification is that it entails the forgetting of her life of servitude. Once God looks on her humiliation, it is transformed into glory: as if magically, her shame is transmuted into pride. Pater seems to suggest that if such a deification means erasing the record of one's life on earth, it might be better to resist it. This passage resonates in surprising ways for those future generations, queer subjects forced to copy out the *Ave* and the *Magnificat* of contemporary gay and lesbian identity.

> *Tout s'efforce vers sa forme perdue . . .*
>
> André Gide, *Le traité du Narcisse*

Critics continue to disagree about the specific meaning of the Great Refusal in Dante's *Inferno*, arguing about whether the unnamed figure in the Vestibule of Hell is Celestine V, Boniface XIII, or Pontius Pilate. At the same time, the notion of the great refusal has been linked to a queer tradition of the refusal of reproduction and of the future. We might think, for instance, of the reworking of this passage from Dante in "*Che fece . . . il gran refuto*," by the Greek poet C. P. Cavafy:

> For some people the day comes
> when they have to declare the great Yes
> or the great No. It's clear at once who has the Yes
> ready within him, and saying it,
> he goes from honor to honor, strong in his conviction.
> He who refuses does not repent. Asked again,
> he'd still say no. Yet that no—the right no—
> drags him down all his life.[21]

Cavafy's poem suggests a model of queer subjectivity based on the experience of refusal, and on the failure to find the "great Yes" within. Cavafy suggests that this affirmation might be replaced by "the great No"—a form of refusal that, while linked to degradation, is nonetheless "right." Eve Sedgwick alludes to this poem in her introduction to *Performance and Performativity*, when she argues that performatives can work negatively as well as positively.[22] Recent work on queer performativity has focused on the importance in J. L. Austin's work of positive performatives; Sedgwick and Judith Butler have both drawn attention to the importance for Austin of the example of "I do," the great Yes of the wedding ceremony. In this context, we might understand Cavafy's refusal, his No, as the inverse of "I Do," a queer performative that is articulated in resistance to the heterosexual order.

Herbert Marcuse also takes up the idea of the great refusal in *Eros and Civilization*, when he contrasts the rational, reproductive order of sexuality (identified with the figure of Prometheus) with an alternative tradition of sexuality as pleasure and affirmation. Marcuse identifies this alternative tradition with two figures long associated with perverse desire, Orpheus and Narcissus. Prometheus, for Marcuse, defines the dominant image of the "culture-hero": "the trickster and (suffering) rebel against the gods, who creates culture at the price of perpetual pain. He symbolizes productiveness, the unceasing effort to master life; but, in his productivity, blessing and curse, progress and toil are inextricably intertwined."[23] The culture-making revolt of Prometheus is contrasted with the Orphic/Narcissistic revolt "against culture based on toil, domination, and renunciation" (164). While Prometheus is marked by suffering, his suffering is in the service of a higher aim: out of his rebellion and his work, he makes the future. Against the background of these dialectical struggles and reversals, Marcuse describes the powers of Orpheus and Narcissus as "the

redemption of pleasure, the halt of time, the absorption of death; silence, sleep, night, paradise—the Nirvana pleasure not as death but as life" (164).

While Marcuse sees a great potential for liberation in the figures of Orpheus and Narcissus, he also describes the difficulty in translating these figures out of art and into politics. Describing the "order of gratification"—both aesthetic and sensual—that defines the Orphic/Narcissistic realm, he writes: "Static triumphs over dynamic; but it is a static that moves in its own fullness—a productivity that is sensuousness, play, and song. Any attempt to elaborate the images thus conveyed must be self-defeating, because outside the language of art they change their meaning and merge with the connotations they received under the repressive reality principle" (164–65). In Marcuse's description of a dynamic stillness and a static productivity realized in song, we hear echoes of Pater's aesthetic ideal. But as in the case of Pater's basement types, his drowsy revolutionaries, one gets the feeling that Orpheus and Narcissus don't travel well. These are figures that are at home in the realm of art, but their interventions remain "isolated" and "unique" (209). In describing the contrast between the Promethean world and the Orphic/Narcissistic world, Marcuse recapitulates the contrast between a heroic bad modernism and a failed bad modernism:

> In contrast to the images of the Promethean culture-heroes, those of the Orphic and Narcissistic world are essentially unreal and unrealistic. They designate an "impossible" attitude and existence. The deeds of the culture-heroes also are "impossible," in that they are miraculous, incredible, superhuman. However, their objective and their "meaning" are not alien to the reality, on the contrary, they are useful. They promote and strengthen this reality; they do not explode it. But the Orphic-Narcissistic images do explode it; they do not convey a "mode of living"; they are committed to the underworld and to death. At best, they are poetic, something for the soul and the heart. But they do not teach any "message"—except perhaps the negative one that one cannot defeat death or forget and reject the call of life in the admiration of beauty. (165)

In contrast to the heroic, active rebellion of Prometheus, Orpheus and Narcissus are defined by their withdrawal from the world of the real—by their refusal to "participate." These queer figures protest "against the repressive order of procreative sexuality. The Orphic and Narcissistic Eros," writes Marcuse, "is the end to the negation of this order—the Great Refusal" (171). The problem, according to Marcuse, is how to make refusal count as anything more than refusal—or, how to make a revolt against productivity productive rather than simply negative. Like Pater's victim-heroes, Orpheus and Narcissus are pledged to the underworld: whatever their designs on the world, they do not see the light of day.

Pater himself has been understood entirely through the terms of the Orphic/Narcissistic tradition: his drowsy, shrinking form of revolution has been understood at once as a model of aesthetic subjectivity and as a political embarrassment. It is almost as if Cavafy were telling Pater's fortune in "*Che fece . . . il gran refuto*": Pater found his No—the right No, the most beautiful No—and it dragged him down all his life. In rethinking this legacy, however, I want to suggest that we might understand the Orphic/Narcissistic world not only as an aesthetic mode but also as a "mode of living"—as an alternative form of political subjectivity.

In his essay "The Commitment to Theory," Homi Bhabha writes:

> The language of critique is effective not because it forever keeps separate the terms of the master and the slave, the mercantilist and the Marxist, but to the extent to which it overcomes the given grounds of opposition and opens up a space of translation: a place of hybridity, figuratively speaking, where the construction of a political object that is new, neither the one

nor the other, properly alienates our political expectations, and changes, as it must, the very forms of our recognition of the moment of politics.[24]

If we are to discover new political objects, I would argue, we need to rethink the structures and affects of political subjectivity and political expectation. Ordinarily, we are interested in a politics that would respond to the experience of the powerless, but we construct a model of politics that has nothing in common with the experience of powerlessness. The dominant model of political agency commits itself to activity and to strength and so seeks to distance itself from this legacy of weakness. The fear, of course, is that political consciousness that incorporates the "damage done" by social violence will be ineffectual and isolating. However, the streamlining of the political—of "proper" political subjectivities and affects—excludes many potential political subjects. In particular, it excludes those "unrecognizable" types who "cross rather than follow the main currents of the world's life."

We might think of the first volume of Foucault's *History of Sexuality* as another queer site for the articulation of a politics of refusal. In this project, Foucault aims to recast power as something other than a stark confrontation between the powerful and the powerless. Foucault's reframing of power is legible as an attempt to rethink strategies of resistance in response to shifting modes of domination. At the same time, we might understand Foucault's rethinking of power as clearing the way for alternative forms of political subjectivity. He writes, "Where there is power, there is resistance. . . . These points of resistance are present everywhere in the power network. Hence there is no single locus of great Refusal, no soul of revolt, source of all rebellions, or pure law of the revolutionary" (95–96). Foucault denies the concept that there is one great Refusal, suggesting instead that resistance is made up of an endless number of refusals, a "plurality of resistances, each of them a special case" (96). Given the history of queer refusal, we might read Foucault's theory of power as an attempt to make room for "special cases"—to create a politics for subjects who do not credibly embody the "pure law of the revolutionary."

The historical experience of shame and secrecy has left its imprint on queer subjectivity. The effects of this history are often understood simply as historical waste products, the shaming traces of internalized homophobia. However, instead of denying or trying to "get over" this past, queer subjects might begin to forge a politics that keeps faith with those who drew back and those whose names were forgotten. Those subjects don't wake up after a century haunting the underworld ready to plunge ahead into a glorious future. Engaging with and using the experience of ruination, failure, or badness as a resource is crucial to the construction of a model of political subjectivity that does not create a new set of exclusions. The example of Pater's shrinking resistance suggests that we need to rethink the heroics of rebellion and to begin to imagine a politics that incorporates a history of forced exile. Such a "homeopathic" approach to political subjectivity would incorporate rather than disavow the causes of social inequality. Given the "ruination" to which history's others are subject, we need to recognize and even affirm forms of ruined political subjectivity. We need a politics forged in the image of exile, of refusal, even of failure. Such a politics might offer, to quote that beautiful loser Nick Drake, "a troubled cure for a troubled mind."[25]

Notes

Thanks to Douglas Mao and Rebecca Walkowitz for their sensitive and engaged readings of this piece. I am also grateful to Andrew Gaedtke, David Kurnick, Mara Mills, Keja Valens, Michael Vazquez, and the Mods Group at the University of Pennsylvania for their feedback and support.

1. Daniel Albright, *Untwisting the Serpent: Modernism in Music, Literature, and Other Arts* (Chicago: University of Chicago Press, 2000), 30. Thanks to Doug Mao for this reference.

2. For a good general account of such recent work, see Rita Felski, "New Cultural Theories of Modernity," *Doing Time: Feminist Theory and Postmodern Culture* (New York: New York University Press, 2000), 55–76. A brief list of work in "alternative modernities" might include Arjun Appadurai, *Modernity at Large: Cultural Dimensions of Globalization* (Minneapolis: University of Minnesota Press, 1996); Homi Bhabha, *The Location of Culture* (London: Routledge, 1994); Dipesh Chakrabarty, *Provincializing Europe: Postcolonial Thought and Historical Difference* (Princeton, N.J.: Princeton University Press, 2000); Paul Gilroy, *The Black Atlantic: Modernity and Double Consciousness* (Cambridge, Mass.: Harvard University Press, 1993); Rita Felski, *The Gender of Modernity* (Cambridge, Mass.: Harvard University Press, 1995); Dilip Parameshwar Gaonkar, *Alternative Modernities* (Durham, N.C.: Duke University Press, 2001); Ranajit Guha, *History at the Limit of World-History* (New York: Columbia University Press, 2002); Timothy Mitchell, ed., *Questions of Modernity* (Minneapolis: University of Minnesota Press, 2000); Michael North, *The Dialectic of Modernism: Race, Language, and Twentieth-Century Literature* (New York: Oxford University Press, 1994); Gayatri Spivak, *A Critique of Postcolonial Reason: Toward a History of the Vanishing Present* (Cambridge, Mass.: Harvard University Press, 1999).

3. James Joyce, *A Portrait of the Artist as a Young Man* (New York: Penguin, 2003), 268–69.

4. Clyde Taylor, "'Salt Peanuts': Sound and Sense in African/American Oral/Musical Creativity," *Callaloo* 5 (1982): 3.

5. If Taylor seems to minimize the difference between dominant and marginal modernisms, it is perhaps because he makes the criterion of activity so central. For Taylor, extreme situations make people into *either* active experimenters *or* into passive victims. In practice, however, it is often the case that extreme situations turn people into both experimenters *and* victims: being on the receiving end of social domination can make you bad and it can make you *bad*.

6. Judith Butler, "Critically Queer," *Bodies that Matter: On the Discursive Limits of "Sex"* (New York: Routledge, 1993), 223.

7. Michel Foucault, *The History of Sexuality*, vol. 1, trans. Robert Hurley (New York: Vintage, 1978), 101.

8. Such a confrontation with the mixed origin of homosexual identity has the status of a trauma in the discipline of lesbian, gay, and queer studies; the process of working through the fact of homosexuality's origin in social marginalization and modern disciplinary structures can never be finished, since homosexuality has no origin outside of this troubled history.

9. Geneva Smitherman, *Black Talk: Words and Phrases from the Hood to the Amen Corner* (Boston: Houghton Mifflin, 1994). The tracing of such early-twentieth-century "inventions" to African sources also significantly complicates the traditional means for "dating" modernity.

10. Cecil Brown discusses the Satanic legacy of the folk anti-hero Stagolee in his recent book *Stagolee Shot Billy* (Cambridge, Mass.: Harvard University Press, 2003). Tracing Stagolee's appearance in the art and literature of the twentieth century, Brown describes this figure as a "fallen angel" whose criminality and coldness register as social protest. For the "bad nigger," disregard for danger and death, extravagant displays of virility, and the ability to control women constitute a form of social protest; folk traditions such as the dozens "sum up," in Brown's words, "the mood of despairing rebellion" (202). While such swaggering masculine protest might seem miles away from the shuddering withdrawals discussed below, we might consider a link between Pater's crystal character and Stagolee's cool; both might be understood as alternative forms of masculinity that negotiate the loss of social power.

11. The difficulty of reading this history of "bad" is amplified by the politics of etymology at the turn of the century. The period from 1880 to 1920 is defined by systematic attempts to standardize the English language (the founding of the OED itself being the prime example of such a project) in order to rid it of elements of what George Bernard Shaw referred to as "quaint slavey lingo." George Bernard Shaw, "A Plea for Speech Nationalisation," cited in Michael North, *The Dialect of Modernism: Race, Language, and Twentieth-Century Literature* (Oxford: Oxford University Press, 1994), 12.

12. See Linda Dowling's discussion of the affair and its aftermath in *Hellenism and Homosexuality in Victorian England* (Ithaca, N.Y.: Cornell University Press, 1994). esp. 92–103. Dowling offers an account of the extreme swings of Pater's career in a reading of his violent allegory of suspicion and violence, "Apollo in Picardy." She writes: "All the painful burden of Pater's experience at Oxford presses into view here—the intoxicating education, the fiery friendship, the hopes for cultural regeneration and a more liberal way of life, followed by the cold incomprehension, the hatred, the stony exile" (140).

13. Walter Pater, *The Renaissance: Studies in Art and Poetry* (Oxford: Oxford University Press, 1998), 150.

14. Included in the Oxford edition *of The Renaissance, 150.*

15. The book is also addressed to such a number, "the few . . . the elect and peculiar people of the kingdom of sentiment" (10). For later twentieth-century examples of queer texts in search of kindred readers, see Christopher Nealon, *Foundlings: Lesbian and Gay Historical Emotion before Stonewall* (Durham, N.C.: Duke University Press, 2001).

16. Jacques Khalip, "Pater's Sadness," *Raritan 20*, no. 2 (Fall 2000): 5, 138.

17. Maureen Moran, "Pater's 'Great Change': Marius the Epicurean as Historical Conversion Romance" in *Walter Pater: Transparencies of Desire*, ed. Laurel Brake, Lesley Higgins, and Carolyn Williams (Greensboro, N.C.: Macmillan Heinemann ELT, 2002), 170–88.

18. It is significant that the onset of this new historical era in Heine's story is characterized by the technology of forced confession. Christian confession is crucial in the genealogy of modern sexual identity that Foucault traces in *The History of* Sexuality, vol. 1.

19. Paul Tucker, "'Reanimate Greek': Pater and Ruskin on Botticelli," in Brake et al, eds., *Walter Pater*, 123. The passage from Dante reads:

> And some I knew among them; last of all
> I recognized the shadow of that soul
> who, in his cowardice, made the Great Denial.
>
> At once I understood for certain: these
> were of that retrograde and faithless crew
> hateful to God and to His enemies. (3.55–60)
> *The Inferno*, trans. John Ciardi (New York: Penguin, 1954).

20. We might compare this image of a woman "expecting" to Pater's more positive image of expectation, invoked earlier in the Winckelmann essay—the image of "Memnon waiting for the day" (135). In the image of this stone Egyptian tower, Pater offers an image of pregnancy that is aesthetic rather than biological: the first rays of the sun draw from Memnon a song rather than a child.

21. The translation is by Edmund Keeley and Philip Sherrard, in *The Dark Crystal: An Anthology of Modern Greek Poetry* (Athens: Denise Harvey, 1981).

22. Eve Sedgwick and Andrew Parker, eds., *Performance and Performativity* (New York: Routledge, 1995). Thanks to David Kurnick for this reference.

23. Herbert Marcuse, *Eros and Civilization: A Philosophical Inquiry into Freud* (Boston: Beacon Press, 1966), 161.

24. Homi Bhabha, "The Commitment to Theory," *The Location of Culture* (London: Routledge, 1994), 25.

25. Nick Drake, "Time Has Told Me," from *Five Leaves Left* (London: Island Records, 1969).

CHAPTER 11
THE NEW MODERNIST STUDIES
*Douglas Mao and Rebecca L. Walkowitz**

Expansion. That's the word that Douglas Mao and Rebecca L. Walkowitz use to describe the changes in the field of modernist studies since the early 1990s. In particular, three types of expansion have characterized the New Modernist Studies: temporal (across new period boundaries), vertical (across high and low cultures), and horizontal (across the globe). Mao and Walkowitz use these movements as a means to give structure and shape to a massive and still-growing bibliography of publications that, at the time of their writing, had been growing in many directions for some fifteen years at least. Expansion enlivened the field, but as Jennifer Wicke had noted already in 2001 (see "Appreciation, Depreciation: Modernism's Speculative Bubble"), it also threatened to render it so diffuse and capacious that it was unintelligible.

Mao and Walkowitz's coauthored introduction to their edited collection *Bad Modernisms* (2006) laid the groundwork for this longer, synoptic essay that takes stock of the field with both depth and breadth. Such an account hadn't been attempted—at least, not so broadly—since the early 1990s, when Marjorie Perloff registered what were then recent changes in the field. Mao and Walkowitz note from the start, however, that the field has expanded beyond what any one account could capture, and instead they offer narratives of the developments that have occurred along two specific axes: the "transnational turn" and the focus on "mass media rhetorics."

The transnational turn—as Susan Stanford Friedman's essay (Chapter 9) showed—had been quite exhilarating for modernist scholars. They "discovered," so to speak, that modernism had existed all along in most every corner of the world, from the Caribbean to China, and that the scholarly focus on American and Western European texts in dominant languages had obscured all sorts of creative, energetic linkages across the globe. Of course, they imply, these connections were no surprise to the figures that fostered them in the early twentieth century, but they had been obscured by decades of scholarship in which multilingualism and exile were themes that re-centered Joyce, Eliot, and Pound's collective importance. The risk of this belated insight and emergent field of inquiry, though, is one that Laura Doyle and Laura Winkiel spelled out in their influential collection *Geomodernisms* (2005): it simply re-maps the very networks of empire itself and presents them as destabilizing, when in actuality, they were often the creations and means of colonial dominance itself. The transnational turn, then, was a welcome recalculation, but one that must proceed with caution.

The focus on mass media, by contrast, aimed to account for technological developments in the late nineteenth and early twentieth century through which modernism—long viewed as contained within the genres of high arts—was vitally articulated. These included radio, telephony, cinema, and mass-circulation newspapers and periodicals. Modernists not only

*From *PMLA*, v. 123, no. 3, pp. 737–48. The Modern Language Association of America, ©2006. Reproduced here with permission.

reached new audiences through these media, but also shifted their aesthetics in order to account for the materiality and forms of these media themselves. In doing so, they sometimes aligned themselves dangerously with campaigns of partisan propaganda and state-run mass persuasion, while at other times they re-engineered the nature of their difficult, often abstruse works in order to translate them for popular consumption. Here, Mao and Walkowitz note, modernism is not what postmodernists attacked it for being; rather, as scholars such as Kevin Dettmar argued, it preempted those attacks with its own deep investments in new media.

Over a decade later, Mao and Walkowitz's essay is still cited for the way it captures the energies of at least two successive waves of New Modernist Studies scholarship. And though they were not the first to use "New Modernist Studies" as a catch-all term for this movement, they did so in a highly visible forum: in an essay commissioned for *PMLA*'s "The Changing Profession" series. This made the term readily available to literary scholars of all fields, and this essay has likely been the most influential in consolidating what the name has meant. It has prompted a number of responses, some of them quite pointed (such as Charles Altieri's and Max Brzezinski's). And it remains an invaluable document of a field in transition some 15 years after its emergence.

Expanding Modernism

In our introduction to *Bad Modernisms*, we traced the emergence of the new modernist studies, which was born on or about 1999 with the invention of the Modernist Studies Association (MSA) and its annual conferences; with the provision of exciting new forums for exchange in the journals *Modernism/Modernity* and (later) *Modernist Cultures*; and with the publication of books, anthologies, and articles that took modernist scholarship in new methodological directions. When we offered that survey, one of our principal interests was to situate these events in a longer critical history of modernism in the arts. In the present report, we want to attend more closely to one or two recent developments that may be suggestive about the present and the immediate future of the study of modernist literature. Part of the empirical, though certainly far from scientific, basis of our considerations lies in our recent service on the MSA Book Prize committee (Walkowitz in 2005, Mao in 2006), through which we became acquainted with dozens of recent contributions to the field.

Were one seeking a single word to sum up transformations in modernist literary scholarship over the past decade or two, one could do worse than light on *expansion*. In its expansive tendency, the field is hardly unique: all period-centered areas of literary scholarship have broadened in scope, and this in what we might think of as temporal, spatial, and vertical directions. As scholars demonstrate the fertility of questioning rigid temporal delimitations, periods seem inevitably to get bigger (one might think of "the long eighteenth century" or "the age of empire"). Meanwhile, interrogations of the politics, historical validity, and aesthetic value of exclusive focus on the literatures of Europe and North America have spurred the study (in the North American academy) of texts produced in other quarters of the world or by hitherto little-recognized enclaves in the privileged areas. In addition to these temporal and spatial expansions, there has been what we are calling here a vertical one, in which once quite sharp boundaries between high art and popular forms of culture have been reconsidered; in which canons have been critiqued and reconfigured; in which works by members of marginalized social groups have been encountered with fresh eyes and ears; and in which scholarly inquiry has increasingly extended to matters of production, dissemination, and reception.

Temporal expansion has certainly been important in the study of literary modernism: the purview of modernist scholarship now encompasses, sometimes tendentiously but often illuminatingly, artifacts from the middle of the nineteenth century and the years after the middle of the twentieth as well as works from the core period of about 1890 to 1945. But the spatial and vertical expansions have been more momentous. Spatial broadening has meant not only that scholars now attend to works produced in, say, Asia and Australia but also that they investigate complex intellectual and economic transactions among, for example, Europe, Africa, the United States, and the Caribbean. In concert with the temporal enlargement, this spatial one has led to an extremely fruitful rethinking of relations among the key terms *modernism*, *modernization*, and *modernity*. Meanwhile, the vertical reconfiguration exerts a kind or degree of disruptive force on modernist studies that it may not on any other period-based field, since for many years modernism was understood as, precisely, a movement by and for a certain kind of high (cultured mandarins) as against a certain kind of low (the masses, variously regarded as duped by the "culture industry," admirably free of elitist self-absorption, or simply awaiting the education that would make the community of cognoscenti a universal one).

To be sure, these three strands of expansion—temporal, spatial, and vertical—often overlap. Scholars argue that modernism reveals itself to be a more global practice once we extend the historical period to the late twentieth century or even as far back as the early seventeenth. Those who believe that getting to know a work of literature means becoming acquainted with its editions and translations will more readily conceive of it as belonging to more than one moment and more than one place. Literary historians are revealing how attention to continuities or discontinuities of time and space transform our conceptions of what counts as literary production and of the actors, collaborators, and media involved in it. In the sections that follow, we focus on two developments in the study of modernist literature, one associated preeminently with the spatial axis of change, the other with the vertical, but it should be clear that these developments by their nature do not restrict themselves to a single axis.

The two currents we have chosen to spotlight are by no means to be understood as the future of the field. On the contrary, questions pertaining to literary form, intraliterary influence, narratology, affect, gender, sexuality, racial dynamics, psychoanalysis, science, and more continue to propel important scholarly endeavors, and we might reasonably have chosen other directions to dwell on here. We also want to make clear, especially for the benefit of readers outside the field, that the two developments considered here are by no means equal in scale or in recognition by modernist scholars. The increasing emphasis on transnational exchange is widely seen as crucially transformative and will certainly remain so for many years, whereas the concentration of work around mass media rhetorics pertains to a smaller body of publication, has been little remarked so far, and may turn out to be not the leading edge of a major trend but only a momentary convergence—albeit a highly instructive one—of individual scholarly projects.

The Transnational Turn

There can be no doubt that modernist studies is undergoing a transnational turn. This has produced at least three kinds of new work in the field: scholarship that widens the modernist archive by arguing for the inclusion of a variety of alternative traditions (Brooker and Thacker; Chang; Doyle and Winkiel, "Global Horizons"; Friedman, "Periodizing"; Gaonkar; Joshi); scholarship that argues for the centrality of transnational circulation and translation in the production of modernist art (Edwards; Hayot, "Modernism's Chinas"; Lewis, *Modernism*; Puchner; Santos; Schoenbach; Yao); and scholarship that examines how modernists responded to imperialism, engaged in projects

of anticolonialism, and designed new models of transnational community (Begam and Moses; Berman, *Modernism*; Boehmer; Booth and Rigby; Brown; Cuddy-Keane; Gikandi; Pollard; Ramazani, "Modernist Bricolage"; Walkowitz).

Of course, it is not new to associate modernism with the milieu of "exiles and émigrés," to recall the title of Terry Eagleton's influential book from 1970. But while scholars working today under the umbrella of transnational modernism share the antiparochialism of an earlier scholarly tradition, they veer away from the old international modernism in several notable ways. For one thing, their work often aims to make modernism less Eurocentric by including or focusing on literary production outside Western Europe and the United States. For another, it engages with postcolonial theory and concerns itself with the interrelation of cultural, political, and economic transactions. And it emphasizes a variety of affiliations within and across national spaces rather than, as Jahan Ramazani puts it, "an ambient universe of denationalized, deracialized forms and discourses" ("Transnational Poetics" 350).

Many examples of the diversification of modernism's places can be found in the September 2006 special issue of *Modernism/Modernity*, entitled *Modernism and Transnationalisms*; in the anthology *Crowds* (Schnapp and Tiews), which includes Sanskrit, Japanese, Hebrew, Chinese, and Hungarian (along with English, Italian, French, and German) in its semantic histories of the modern crowd; and in Laura Doyle and Laura Winkiel's collection *Geomodernisms*, where modernist art is culled from Brazil, Lebanon, India, and Taiwan as well as the townships of Dublin and Native American communities in the United States. These volumes globalize modernism both by identifying new local strains in parts of the world not always associated with modernist production and by situating well-known modernist artifacts in a broader transnational past. This past is the primary subject of Doyle's own *Geomodernisms* essay, which argues that the "key English-language *vocabularies* of Atlantic modernity" have their origin in the rhetoric of the English Civil War and the liberty narratives of the New World ("Liberty" 51). Situating Nella Larsen's early-twentieth-century writing in a long "Atlantic story" that connects the modernism of Harlem to earlier political writing in New England, Britain, Africa, and the Caribbean (64), Doyle extends the time and place of modernism's prehistory while holding the main narrative of modernism to familiar parameters. Her "Atlantic modernity" reaches back to the 1640s, but the literary production that forms the major analytic object of her essay comes from Larsen, Virginia Woolf, Jean Rhys, Claude McKay, and other anglophone writers of the early twentieth century.

Doyle's long genealogy may be contrasted with Susan Stanford Friedman's emphasis on modernism's ongoing emergence—her view that modernism's spaces can be expanded properly only if we extend its temporality farther forward. In the opening essay of the special issue *Modernism and Transnationalisms*, Friedman asserts wittily that "declaring the end of modernism by 1950 is like trying to hear one hand clapping" and calls for the Modernist Studies Association "to expand the horizons of time" ("Periodizing" 427, 439). Her recent essays, in both *Geomodernisms* and *Modernism/Modernity*, have deployed a strategy she calls "cultural parataxis," which has involved pairing late-nineteenth- and early-twentieth-century literary texts from Britain with later texts from India and the Sudan. Friedman regards E. M. Forster's *A Passage to India* (1924) and Arundhati Roy's *The God of Small Things* (1997), to take one such pairing, "each as a modernist text in its own right, reflecting the modernity of its time and place, as well as the textual and political unconscious of its distinctive geomodernism" ("Paranoia" 246–47).

Some critics now speak of postcolonial literature as a form of modernist literature, whereas others have been eager to hold the two traditions apart. With Friedman, Ramazani describes late-twentieth-century writers as modernists, though he distinguishes between "Euromodernists" and "postcolonial poets" who articulate "a cross-culturalism still more plural and polyphonic than Euromodernism" ("Modernist Bricolage" 449). By contrast, Urmila Seshagiri dates postcolonial literature from the death of modernist aesthetics: in her eloquent "Modernist Ashes, Postcolonial Phoenix," she

analyzes Jean Rhys's 1934 *Voyage in the Dark* as a telling "fulcrum between experimental modernism and postcolonial literature" (489). Likewise, Simon Gikandi sees postcolonial literature as one of modernism's heirs. He argues "that it was primarily—I am tempted to say solely—in the language and structure of modernism that a postcolonial experience came to be articulated and imagined in literary form" (420). Gikandi's contention may not sit comfortably with those who define postcolonial literature by its independence from European political and cultural projects, as he himself acknowledges (421), but it complements arguments such as Friedman's and Eric Hayot's, which have emphasized the complex interrelation between so-called European and non-European literary production.

In a special issue of the journal *Modern Chinese Literature and Culture*, Hayot presents a two-pronged attack on the notion that modernism began in the West, arguing first that "at the so-called origin of European modernism, the foreign has already inserted itself" and second that "it ought to be possible to reconceive a definition of modernism itself that . . . would consider the entire global output that has occurred under the name 'modernism.'" This consideration, Hayot argues, "would permit an understanding of 'modernism' from a much larger historical and cultural perspective" ("Bertrand Russell's Chinese Eyes" 131). Making room both for the expansion of modernism's locations and for the recalculation of European modernism's Europeanness, Hayot's work is part of a rich seam of scholarship that has focused on what he has called "modernisms' Chinas"—on how Anglo-American modernists "took China as the national or cultural ground for their aesthetic labor" and how artists in China created modernist traditions of their own ("Modernisms' Chinas" 3; see also Chang; Hayot, *Chinese Dreams*; Laurence).

Other challenges to reifications of the divide between European modernism and literary production originating beyond Europe appear in Nicholas Brown's *Utopian Generations*, Charles Pollard's *New World Modernisms*, and Jessica Berman's work on "comparative colonialisms." Brown argues vigorously that "every discussion that isolates a 'modernist tradition' or an 'African tradition' . . . carries with it an inherent falseness" (3), while Pollard sees a dynamic exchange between fields: "as Caribbean writers have transformed the methods of modernism, modernism itself has become a more discrepant cosmopolitan literary movement" (9). Berman, for her part, offers an innovative twist on the comparative model, bringing modernism and postcolonial literature together by analyzing the intellectual encounter between two colonial subjects, James Joyce and Mulk Raj Anand. Instead of choosing writers from different generations, Berman treats the Irish Joyce and the Indian Anand, both of whom published important works in the 1920s and 1930s, as central players in a modernist anticolonial tradition.

Scholars are understandably concerned that the globalization of modernism will involve the erasure of countertraditions or the folding of those countertraditions into a normative Anglo-American model. Doyle and Winkiel articulate this concern at some length in the introduction to their volume, but they also offer helpful replies in later essays. In "Transnational History at Our Backs," Doyle points out that transnationalism is not a new phenomenon, that it has not simply or recently replaced national models of literary culture. Rather, she argues, transnational cultures, including the Atlantic transnationalism that began in the sixteenth century, have helped generate the imaginary construction of the nation (532–33). For her part, Winkiel aims for a "manner of reading transnationally" that brings local histories together while emphasizing and exposing their "gaps and contradictions" (508). Winkiel considers as an example the complex placements of Nancy Cunard's 1935 anthology *Negro*, which was produced transnationally (in Paris, London, and New York), which assembled contributors from the African and African American diaspora, and which used the anthology form to create a discontinuous transnational collage (526).

Winkiel's analysis of Cunard's anthology is not the only work to offer a model for thinking about twentieth-century literary texts that operated on both a local and a transnational scale. Her analysis builds on Brent Hayes Edwards's *Practice of Diaspora: Literature, Translation, and the Rise*

of Black Internationalism, which presents the Harlem Renaissance as a transnational movement, "molded through attempts to appropriate and transform the discourses of internationalism" (3). *The Practice of Diaspora* does not have an entry for modernism in its index, but it makes a major contribution to the field by presenting an elegant solution to the tension between recognizing local movements and drawing connections across borders. Edwards proposes that internationalism "necessarily involves a process of linking or connecting across gaps," because transnational solidarities need national discrepancies (11). Gaps and differences, he asserts, provide the friction that animates art (15).

Our own field of expertise is anglophone modernism, and for that reason much of the work we have discussed here reflects changes in scholarship on English-language literature. But it must be said that one of the key recent developments in anglophone modernist studies has been a greater acknowledgment of the role of translation and multilingual circulation in the development of national and micronational literary histories. For example, Irene Ramalho Santos has called for the inclusion of the Portuguese modernist Fernando Pessoa (who was educated in South African English-language schools, felt himself deeply influenced by literature in English, and sometimes wrote in English) in the canon of Anglo American literature, arguing that we need to reorganize the intellectual divisions in modernist studies from nation and language based traditions to categories such as Atlantic modernism. In *Atlantic Poets*, she cautions that comparative work needs to be careful not to intensify the separations between distinct traditions: "The very disciplines that recently emerged for building bridges and establishing comparisons among literatures continue, in general, to assume that such bridges and comparisons occur between integral, preconstituted entities" (4). On the contrary, Santos insists, "the heteroreferentiality of national literatures and cultures constitutes their original proper mode" (4–5).

Martin Puchner makes a similar point about original multilingualism, arguing in *Poetry of the Revolution* that the *Communist Manifesto*, composed in German but first published in England and translated quickly into many other languages, was designed to be a work of world literature. He then undertakes a global analysis of modernist art that pivots on the production, translation, and circulation of the *Communist Manifesto* and its influence on art manifestos throughout the world. Other recent scholarship also follows the migration of modernist art across national borders and argues for the significance of translation to modernist production. In "Le Pragmatisme," Lisi Schoenbach looks at the social and state institutions that enabled transactions between American and French versions of pragmatism; Pericles Lewis, reading Woolf reading Marcel Proust, argues that the influence of nonanglophone precursors on British modernism has been underestimated ("Proust").[1]

Scholarship such as Edwards's, Santos's, Puchner's, Schoenbach's, and Lewis's should change the way we talk about Anglo American modernism. It asks us to consider how early-twentieth-century texts circulated in the world and how this dissemination affected modernist production; it suggests that even those of us who think of ourselves as scholars of British or United States modernism can no longer exclude nonanglophone works from our teaching and research. This point has been made not only by specialists in modernism but also by other kinds of theorists of world literature, who over the past few years have been nudging that field from the study of masterpieces to the study of circulation and consumption in the global marketplace.[2] Meanwhile, scholars such as Edwards, Puchner, Ramazani, Melba Cuddy-Keane, and Rebecca L. Walkowitz have been analyzing how modernist works developed new paradigms of transnational solidarity that were then appropriated by later artists. Tracking various examples of "cultural globalization," Cuddy-Keane argues that "global connectivity entered into literary, and hence public, discourse" during the early twentieth century (545). Ramazani, focused on poetry, and Walkowitz, focused on the novel, have examined the ways that late-twentieth-century migrant writers refashioned modernist strategies to suit new transnational designs.

Leah Price has remarked that nothing proves the existence of a field so much as the publication of a reader (36–37). If this is true, the field will be here soon: *The Oxford Handbook of Global Modernisms*, edited by Mark Wollaeger, is scheduled for production in 2009.

Media in an Age of Mass Persuasion

One element of early-twentieth-century transnationalism that bore heavily on literary modernism was the development of novel technologies for transmitting information: telegraph, radio, cinema, and new forms of journalism not only reconfigured culture's audiences but also helped speed manifestos, works of art, and often artists across national and continental borders. As Anthony L. Geist and José B. Monléon note, "[T]he invention of new communication technologies and the increasing globalization of capital following World War I" meant that "the avant-garde movements appeared simultaneously in the margins and the center. No longer can one speak of culture 'arriving late' to the far-flung removes of the empire" (xxx). Clearly, attention to such technologies contributes to both spatial and vertical expansion of the field, as in Fernando Rosenberg's *Avant-Garde and Geopolitics in Latin America*, which shows how questions of transnational simultaneity and connection inform the work of writers like the Argentinean Roberto Arlt. In 1937, Rosenberg observes, Arlt altered the name of one of his newspaper columns to "Al margen del cable" ("On the Margins of the Newswire"); in 1929 and 1931, Arlt published a pair of novels, *Los siete locos and Los lanzallamas*, that in Rosenberg's view represent a "critique of media consumption" yet also suggest how social change might be supported by a "permanent, open-ended strategic action from within streams of information that become sites of contestation," a "decentering of stagnant notions of producers and consumers along a geographic divide" (131, 63, 66, 72).

Rosenberg's book is only one of several recent studies to locate literary modernism in a rhetorical arena transformed by media's capacity to disseminate words and images in less time, across bigger distances, and to greater numbers of people than ever before. In *Recovering the New*, Edward S. Cutler argues, in a rather different transnational vein, that the "scene of modern writing is . . . the recursive print exchange between urban nodes throughout the United States and Western Europe" beginning in the nineteenth century (11–12); in *Front-Page Girls*, Jean Marie Lutes attends to the influence of turn-of-the-century American newspaperwomen on American fiction. In *Modernism on Fleet Street*, Patrick Collier treats the difficult relation to the press felt by early-twentieth-century British literati, who found newspapers and magazines a handy source of income (from the writing of reviews, for example) but also saw in them a stimulus to an accelerated and superficial reading likely to have baleful social consequences. The ethical and political imperatives driving BBC radio, and the authors who contributed to its programming in the 1920s and 1930s, are the subject of Todd Avery's *Radio Modernism, while in Wireless Writing in the Age of Marconi*. Timothy Campbell argues that fascism exploited not only the capacity of radio to reach mass audiences but also the kind of machine-body relay emblematized in the marconista, or wireless operator. In this quintet of books alone one can find sustained discussions of media transformation in relation to Edgar Allan Poe, Charles Baudelaire, Willa Cather, Djuna Barnes, Virginia Woolf, James Joyce, Rebecca West, T. S. Eliot, H. G. Wells, F. T. Marinetti, Vicente Huidobro, Gabriele D'Annunzio, Ezra Pound, and other now canonical writers.

Some recent studies, such as Michael North's *Camera Works* and Keith Williams's *British Writers and the Media*, 1930–45, have illuminated the social hope engendered among writers by what were, in the early twentieth century, new or relatively new media, but many have stressed more heavily the anxieties spawned by such channels' evident handiness for implanting particular beliefs in a docile populace. Collier, for example, notes how period commentators worried about newspapers' tendency to offer only fragments of political debates, "selected not for their rational soundness but for their likelihood of selling papers," and about their ability to "exercise a mysterious, extra-

rational, *mass* influence, transforming readers into a dehumanized conglomerate, liable in the direst projections to becoming agents of anarchy or an easily manipulated mob" (19, 15). In *Modernism, Media, and Propaganda*, Wollaeger argues that the "propagation of too much information by the media created a need for propagandistic simplifications" disseminated by those same media, yet at the same time created "a receptive audience for modernism's deep structures of significance. . . . [B]oth modernism and propaganda provided mechanisms for coping with information flows" (xiii). In *Sex Drives*, Laura Frost tracks erotic fantasy's now familiar incorporation of fascist iconography back to the propaganda, especially the anti-German propaganda, produced during the heyday of high modernism. And a number of scholars (Buitenhuis; Cohen; Sherry; Tate; as well as Wollaeger) have explored how the propaganda machine was partly served by literati or, on the other side, inspired new modes of political dissent.

It is hardly a secret that the materializing of a new world of information was one of the crucial historical developments of the early twentieth century, nor has modernist criticism over the decades completely neglected the phenomenon. But it does seem that this transformation is currently attracting unusually focused scholarly attention, and we may want to ask why. What does this upsurge tell us about the recent past and immediate future of modernist literary study?

One key context for this turn, unquestionably, is modernist scholars' ongoing exploration of the networks of publications in which high modernist artifacts saw print and of the movements and agendas such publications served. Scholars have been examining closely the little magazines and other periodicals that famously sponsored the first appearance of so many modernist masterpieces (Churchill; McKible; Morrisson; Rainey, Institutions and Revisiting), and this effort has been assisted by the growth of the Modernist Journals Project, which provides online access to seminal periodicals such as *Blast*, the *English Review*, and the *New Age*. Among the most significant revelations to emerge so far from work on the larger culture of print has been that of modernism's entanglement, in the pages of early-twentieth-century periodicals, with what may seem at first quite unliterary promotions of feminism, socialism, nationalism, and other programs of social change (Ardis; Lyon; Nelson; Scott). To study the media of modernism, it seems, is to encounter ambitions for literary art that might otherwise be lost to historical memory.

No less significant, as a context for the recent inquiry into propaganda and new media, is the now substantial body of work on what we may call the marketing of modernism—a topic that has engaged some of the finest scholars in the field for over a decade and whose partial genealogy is worth sketching here. For the mid-twentieth-century commentators who helped solidify modernism as an object of analysis—Clement Greenberg, Theodor W. Adorno, the New Critics, and others—it was evident that a common denominator in the vast welter of modernist formal innovations was the property of being hard to sell to large numbers of people, at least in the short term. From this observation it was but a step to the view that an essential component of modernism lay in disdain for the easy consumability of mass cultural forms. And for some, Adorno most notably, this conclusion in turn led to the conviction that at the very heart of modernism lay an intricate resistance to the course of the world as advanced capitalism was fashioning it.

This broad understanding began to suffer revision in the last quarter of the twentieth century, with interventions such as Fredric Jameson's 1979 "Reification and Utopia," which preserved the central opposition but insisted that modernism could have absolutely no conceptual coherence apart from the reviled other of mass culture, and Andreas Huyssen's 1986 *After the Great Divide*, which disclosed a host of convergences between mass cultural elements and modernist art. In the wake of Huyssen's influential work, scholars have complicated the high-low or art-versus-commodity story in countless ways, noting how modernist ambitions were entangled with the language of advertising and the commodification of the bohemian (Bowlby; Cooper; Wicke), how modernist writers absorbed and remade forms of mass culture rather than merely disparaging them (Chinitz; Herr; Naremore and Brantlinger; Strychacz), and how modernists created an audience

for their art by associating it with qualities such as seriousness, modernness, or prestige (Dettmar and Watt; Jaffe; Latham; Morrisson; Rainey, *Institutions*; Strychacz; Wexler). Predictably, such work has drawn the fire of critics (within and without the academy) who see it as abetting a general devaluation of the specifically literary qualities of literature or as an assault on aesthetic value. But it might be rejoined that this work's truer import lies in showing in new ways how the imaginative exhilaration we draw from literary texts can be rooted in the nonimaginary world.

Recent considerations of modernism in relation to mass media and the manipulation of public opinion can certainly be viewed as part of this larger inquiry into how modernism built its audiences. But it is also possible to understand the turn toward media and persuasion in another manner—as a veering away from rather than an extension of the kind of scholarship that puts the opposition between art and commodity at its center. After all, even the most surprising elucidations of modernism's promotional strategies, even those readings that most vigorously unsettle the dichotomy of high and low, can be said to remain under the sway of the anticommodification paradigm inasmuch as they keep its terms in the foreground instead of asking what other questions it has tended to overshadow. The recent work on publics and persuasion, however, suggests how the long-standing focus on commodification has sometimes led to a sidelining of communication and dissemination, a privileging of the element of entertainment over that of information, and a dwelling on the new products issuing from the culture industry at the expense of attention to new techniques of public rhetoric. Whether the harbinger of a longrunning trend or a brief convergence around a particular literary-historical problem, in other words, work on modernism in an age of mass persuasion demonstrates that we may enrich significantly the vertical expansion of modernist studies when we take as the other of modernist art not popular culture qua commodity but something else—in this case, the avalanche of reportage, the shaping of fact in propaganda, the phenomenon of news.

Politics as Itself

If this recent line of inquiry suggests the productivity of getting out from under the commodity form (at least temporarily) when assaying literature's relation to modern social life, it also suggests the utility of recalling that modern subjects have been not only consumers but also citizens and voters and resident aliens—members of masses capable of being organized and harangued in countless ways yet in varying degrees conscious of themselves as embedded in political situations that they may in some way affect. This kind of turn is, again, far from unique to modernist studies. In literary scholarship generally, there has for some time been growing interest in the conduct of politics in relatively naked rather than veiled forms. Indeed, if one of the exhilarating trends since the late 1970s has been literary-critical engagement with thick textures of history (the structures and vicissitudes of ordinary life, the experiences of the silenced or obscure as well as the eminent and articulate, the ways questions of power inform discourse apparently removed from the political sphere), such analysis has recently been complemented with intensified awareness of what was once taken to be historiography's fundamental business: acts of leaders and governments, mobilizations of national and international sentiments, transformations of partisan institutions. With a boost from new or old theorists like Giorgio Agamben, Hannah Arendt, and Carl Schmitt, literary scholars seem more and more to be augmenting broadly. Foucauldian approaches to the subject's fashioning by putatively apolitical institutions, experts, and norms with attention to the dissemination of overtly political rhetoric, to perplexities of sovereignty as such, and to writers' confrontations with immediate apparitions of the state.

Matters of the state and state building have always been central to the literature and metaliterature of colonial and postcolonial struggles, which is to say that this issue of politics as itself marks a point of intersection between the transnational turn in modernist studies and the turn toward the

repercussions of mass media—that is, between evidently spatial and implicitly vertical expansions of the field. The new transnational scholarship has not been slow to consider how arms of states and other overtly political bodies have helped bring ideas across national boundaries or at times worked to prevent such crossings, but some critics have argued that the new transnationalism, if it is to be new at all, must probe much further the effects of the state on modernist production. In an exchange with Jahan Ramazani in a recent number of *American Literary History*, William Maxwell focuses on the case of Claude McKay to point out that border crossing was not always the result of new solidarities or an act of individual assertion; rather, "the modernist state's disciplinary mechanisms compelled the elaboration of some literary internationalisms." One can hear the echo of Foucault in Maxwell's argument, but his riposte notably focuses on specific governmental actions of the early twentieth century (by the FBI and the Foreign Office) and uses these deliberate maneuvers to distinguish an "obligatory Black Atlanticism" from a liberatory experience of "unfettered discursive commerce" (363). Meanwhile, issues of nation and mass politics have increasingly come to the fore in studies of European and North American literary modernism (Chu; Lewis, *Modernism*; Peppis; Tratner), even where imperialism has not been a dominant concern.

Finally, it seems imperative to place recent work on transnational currents and technologies of persuasion in the context of a general feeling that we are today enduring a crisis of information—a feeling as old as modernity itself, perhaps, but especially acute in recent years, thanks not only to the cognitive unsettlement attending the rhetoric of globalization but also to changes in the regulation and organization of mass media. In his conclusion to *Modernism on Fleet Street*, Collier echoes many before him in observing that contemporary problems of access, mediation, and information overload in political participation are well addressed neither by our political structures nor by dominant theories of political communication. Wollaeger draws his recent book to a close by noting how the problem of distinguishing between propaganda and information vividly persists, as in the 2005 Stop Government Propaganda Act, prompted by the second Bush administration's payments to news analysts (to promote an education initiative) and a public relations firm (to produce fake television news stories endorsing a new Medicare law [261]). To this eloquent example, we might add phenomena such as the cheeky partisanship of the Fox News Channel, the failure of United States journalists to interrogate adequately the case for the invasion of Iraq, and the immediate entry into the lexicon of the term *truthiness*, coined in the first days of Comedy Central's *Colbert Report* to denote an air of truthfulness that holds more affective power than fidelity to facts. Clearly, one challenge for twenty-first-century intellectuals is to understand why and how new domestic and transnational debates about media intersect with fierce resurrections of old ones. It would be surprising if modernist studies, centered as it is on times and places marked by especially dramatic changes in the politics of information, ignored this pressing challenge.

Notes

1. Ramazani, "Transnational Poetics," is a model of "cross-national literary citizenship."
2. See, for example, Moretti, "Conjectures" and "More Conjectures"; Damrosch; Dimock; and Buell and Dimock.

Works Cited

Ardis, Ann. *Modernism and Cultural Conflict, 1880–1922*. Cambridge: Cambridge UP, 2002.
Avery, Todd. *Radio Modernism: Literature, Ethics, and the BBC, 1922–1938*. Aldershot, Eng.: Ashgate, 2006.

Begam, Richard, and Michael Moses. *Modernism and Colonialism: British and Irish Literature, 1899–1939.* Durham: Duke UP, 2007.

Berman, Jessica. "Comparative Colonialisms: Joyce, Anand, and the Question of Engagement." *Modernism/Modernity* 13 (2006): 465–85.

——. *Modernism, Cosmopolitanism, and the Politics of Community.* Cambridge: Cambridge UP, 2001.

Boehmer, Elleke. *Empire, the National, and the Postcolonial, 1890–1920: Resistance in Interaction.* Oxford: Oxford UP, 2002.

Booth, Howard J., and Nigel Rigby, eds. *Modernism and Empire.* Manchester: Manchester UP, 2000.

Bowlby, Rachel. *Just Looking: Consumer Culture in Dreiser, Gissing, and Zola.* New York: Methuen, 1985.

Brooker, Peter, and Andrew Thacker. *Geographies of Modernism: Literatures, Cultures, Spaces.* London: Routledge, 2005.

Brown, Nicholas. *Utopian Generations.* Princeton: Princeton UP, 2005.

Buell, Lawrence, and Wai Chee Dimock. *Shades of the Planet: American Literature as World Literature.* Princeton: Princeton UP, 2007.

Buitenhuis, Peter. *The Great War of Words: British, American, and Canadian Propaganda and Fiction, 1914–33.* Vancouver: U of British Columbia P, 1987.

Campbell, Timothy. *Wireless Writing in the Age of Marconi.* Minneapolis: U of Minnesota P, 2006.

Chang, Sung-sheng Yvonne. "Twentieth-Century Chinese Modernism and Globalizing Modernity: Three Auteur Directors of Taiwan New Cinema." Doyle and Winkiel, *Geomodernisms* 133–50.

Chinitz, David. *T. S. Eliot and the Cultural Divide.* Chicago: U of Chicago P, 2003.

Chu, Patricia. *Race, Nationalism, and the State in British and American Modernism.* Cambridge: Cambridge UP, 2006.

Churchill, Suzanne. *The Little Magazine* Others *and the Renovation of Modern American Poetry.* Aldershot, Eng.: Ashgate, 2006.

Cohen, Debra Rae. "Citizenship in the Salon: The Public Private War of Violet Hunt." *Challenging Modernism: New Readings in Literature and Culture, 1914–45.* Ed. Stella Deen. Aldershot, Eng.: Ashgate, 2002.

Colbert Report: Truthiness. Comedy Central. 17 Oct. 2005. 11 Feb. 2008 <http://www.comedycentral.com/sitewide/media_player/play.jhtml?itemId=24039>.

Collier, Patrick. *Modernism on Fleet Street.* Aldershot, Eng.: Ashgate, 2006.

Cooper, John Xiros. *Modernism and the Culture of Market Society.* Cambridge: Cambridge UP, 2004.

Cuddy-Keane, Melba. "Modernism, Geopolitics, Globalization." *Modernism/Modernity* 10 (2003): 539–58.

Cutler, Edward S. *Recovering the New: Transatlantic Roots of Modernism.* Hanover: U of New Hampshire P; UP of New England, 2003.

Damrosch, David. *What Is World Literature?* Princeton: Princeton UP, 2003.

Dettmar, Kevin, and Stephen Watt. *Marketing Modernisms: Self-Promotion, Canonization, Rereading.* Ann Arbor: U of Michigan P, 1996.

Dimock, Wai Chee. *Through Other Continents: American Literature across Deep Time.* Princeton: Princeton UP, 2006.

Doyle, Laura. "Liberty, Race, and Larsen in Atlantic Modernity: A New World Genealogy." Doyle and Winkiel, *Geomodernisms* 51–76.

——. "Transnational History at Our Backs: A Long View of Larsen, Woolf, and Queer Racial Subjectivity in Atlantic Modernism." *Modernism/Modernity* 13.3 (2006): 531–60.

Doyle, Laura, and Laura Winkiel, eds. *Geomodernisms: Race, Modernism, Modernity.* Bloomington: Indiana UP, 2005.

——. "The Global Horizons of Modernism." Introduction. Doyle and Winkiel, *Geomodernisms* 1–16.

Eagleton, Terry. *Exiles and Émigrés: Studies in Modern Literature.* London: Chatto, 1970.

Edwards, Brent Hayes. *The Practice of Diaspora: Literature, Translation, and the Rise of Black Internationalism.* Cambridge: Harvard UP, 2003.

Friedman, Susan Stanford. "Paranoia, Pollution, and Sexuality: Affiliations between E. M. Forster's *A Passage to India* and Arundhati Roy's *The God of Small Things*." Doyle and Winkiel, *Geomodernisms* 245–61.

"Periodizing Modernism: Postcolonial Modernities and the Space/Time Borders of Modernist Studies." *Modernism/Modernity* 13 (2006): 425–44.

Frost, Laura. *Sex Drives: Fantasies of Fascism in Literary Modernism.* Ithaca: Cornell UP, 2002.

Gaonkar, Dilip Parameshwar, ed. *Alternative Modernities.* Durham: Duke UP, 2001.

Geist, Anthony L., and José B. Monléon. "Modernism and Its Margins: Rescripting Hispanic Modernism." Introduction. *Modernism and Its Margins: Reinscribing Cultural Modernity from Spain and Latin America.* Ed. Geist and Monléon. New York: Garland, 1999. xvii–xxxv.

Gikandi, Simon. "Modernism in the World." Preface. *Modernism/Modernity* 13 (2006): 419–24.

Hayot, Eric. "Bertrand Russell's Chinese Eyes." *Modern Chinese Literature and Culture* 18.1 (2006): 120–54.

——. *Chinese Dreams: Pound, Brecht, Tel quel*. Ann Arbor: U of Michigan P, 2003.

——. "Modernisms' Chinas." *Modern Chinese Literature and Culture* 18.1 (2006): 1–7.

Herr, Cheryl. *Joyce's Anatomy of Culture*. Urbana: U of Illinois P, 1986.

Howes, Marjorie. *Yeats's Nations: Gender, Class, and Irishness*. New York: Cambridge UP, 1996.

Huyssen, Andreas. *After the Great Divide: Modernism, Mass Culture, Postmodernism*. Bloomington: Indiana UP, 1986.

Jaffe, Aaron. *Modernism and the Culture of Celebrity*. Cambridge: Cambridge UP, 2005.

Jameson, Fredric. "Reification and Utopia in Mass Culture." *Social Text* 1 (1979): 130–48.

Joshi, Priya. *In Another Country: Colonialism, Culture, and the English Novel in India*. New York: Columbia UP, 2002.

Latham, Sean. *"Am I a Snob?": Modernism and the Novel*. Ithaca: Cornell UP, 2003.

Laurence, Patricia. *Lily Briscoe's Chinese Eyes: Bloomsbury, Modernism, and China*. Columbia: U of South Carolina P, 2003.

Lewis, Pericles. *Modernism, Nationalism, and the Novel*. Cambridge: Cambridge UP, 2000.

——. "Proust, Woolf, and Modern Fiction." *Romantic Review* 99 (2008): 77–86.

Lutes, Jean Marie. *Front-Page Girls: Women Journalists in American Culture and Fiction, 1880–1930*. Ithaca: Cornell UP, 2006.

Lyon, Janet. *Manifestoes: Provocations of the Modern*. Ithaca: Cornell UP, 1999.

Mao, Douglas, and Rebecca L. Walkowitz. "Modernisms Bad and New." Introduction. *Bad Modernisms*. Ed. Mao and Walkowitz. Durham: Duke UP, 2006. 1–18.

Maxwell, William J. "Global Poetics and State-Sponsored Transnationalism: A Reply to Jahan Ramazani." *American Literary History* 18 (2006): 360–64.

McKible, Adam. *The Space and Place of Modernism: The Russian Revolution, Little Magazines, and New York*. New York: Routledge, 2002.

Moretti, Franco. "Conjectures on World Literature." *New Left Review* 1 (2000): 54–68.

——. "More Conjectures." *New Left Review* 20 (2003): 73–81.

Morrisson, Mark S. *The Public Face of Modernism: Little Magazines, Audiences, and Reception, 1905–1920*. Madison: U of Wisconsin P, 2001.

Naremore, James, and Patrick Brantlinger, eds. *Modernity and Mass Culture*. Bloomington: Indiana UP, 1991.

Nelson, Cary. Repression and Recovery: *Modern American Poetry and the Politics of Cultural Memory, 1910–1945*. Madison: U of Wisconsin P, 1989.

North, Michael. *Camera Works: Photography and the Twentieth-Century Word*. New York: Oxford UP, 2005.

Peppis, Paul. *Literature, Politics, and the English Avant-Garde: Nation and Empire, 1901–1918*. Cambridge: Cambridge UP, 2000.

Pollard, Charles W. *New World Modernisms: T. S. Eliot, Derek Walcott, and Kamau Brathwaite*. Charlottesville: U of Virginia P, 2004.

Price, Leah. "The Tangible Page." *London Review of Books* 31 Oct. 2002: 36–39.

Puchner, Martin. *Poetry of the Revolution: Marx, Manifestos, and the Avant-Gardes*. Princeton: Princeton UP, 2006.

Rainey, Lawrence. *Institutions of Modernism: Literary Elites and Public Culture*. New Haven: Yale UP, 1998.

——. *Revisiting* The Waste Land. New Haven: Yale UP, 2005.

Ramazani, Jahan. "Modernist Bricolage, Postcolonial Hybridity." *Modernism/Modernity* 13 (2006): 445–64.

——. "A Transnational Poetics." *American Literary History* 18 (2006): 332–59.

Rosenberg, Fernando. *The Avant-Garde and Geopolitics in Latin America*. Pittsburgh: U of Pittsburgh P, 2006.

Santos, Irene Ramalho. *Atlantic Poets: Fernando Pessoa's Turn in Anglo-American Modernism*. Hanover: UP of New England, 2003.

Schnapp, Jeffrey T., and Matthew Tiews, eds. *Crowds*. Stanford: Stanford UP, 2006.

Schoenbach, Lisi. "Le Pragmatisme." Conf. of the Soc. for the Study of Narrative Lit. Washington, 2006.

Scott, Bonnie Kime. *Refiguring Modernism*. 2 vols. Bloomington: Indiana UP, 1995.

Seshagiri, Urmila. "Modernist Ashes, Postcolonial Phoenix: Jean Rhys and the Evolution of the English Novel in the Twentieth Century." *Modernism/Modernity* 13 (2006): 487–506.

Sherry, Vincent. *The Great War and the Language of Modernism*. New York: Oxford UP, 2003.

Strychacz, Thomas. *Modernism, Mass Culture, and Professionalism*. Cambridge: Cambridge UP, 1993.

Tate, Trudi. *Modernism, History, and the First World War*. Manchester: Manchester UP, 1998.

Tratner, Michael. *Modernism and Mass Politics: Joyce, Woolf, Eliot, Yeats*. Stanford: Stanford UP, 1995.

Walkowitz, Rebecca L. *Cosmopolitan Style: Modernism beyond the Nation*. New York: Columbia UP, 2006.

Wexler, Joyce. *Who Paid for Modernism? Art, Money, and the Fiction of Conrad, Joyce, and Lawrence.* Fayetteville: U of Arkansas P, 1997.

Wicke, Jennifer. *Advertising Fictions: Literature, Advertisement, and Social Reading.* New York: Columbia UP, 1988.

Williams, Keith. *British Writers and the Media, 1930–45.* Basingstoke, Eng.: Macmillan, 1996.

Winkiel, Laura. "Nancy Cunard's Negro and the Transnational Politics of Race." *Modernism/Modernity* 13 (2006): 507–30.

Wollaeger, Mark. *Modernism, Media, and Propaganda.* Princeton: Princeton UP, 2006.

Yao, Steven G. *Translation and the Languages of Modernism: Gender, Politics, Language.* New York: Palgrave-Macmillan, 2002.

CHAPTER 12
LOVE AND NOISE
*Mark Goble**

The initial expansionist waves of the New Modernist Studies sought to treat a whole range of new materials—from advertisements to fashion to pulp magazines—as important aspects of an underlying modernity. Such an approach also offered a way to break down some of the intellectual and disciplinary boundaries that had grown up between literature, film, theatre, and art, as well as the deeply ideological practice of isolating art within national domains. Postcolonial criticism sought to resist such practices by invoking new spaces of analysis—such as Paul Gilroy's "Black Atlantic"—and the Modernist Studies Association deliberately cultivated transnational and transdisciplinary approaches. In fact, its policies for conference panels intentionally barred work that was too narrowly focused on canonical authors and the kind of formalism that had helped ground what Hugh Kenner famously called "The Pound Era."

This initial suspicion of national and formalist approaches to modernist works, however, created an unintentional blind spot as critics focused on the deep structure of modernity rather than on the broad reach of media technologies. Inspired by a renewed interest in the work of theorists like Friedrich Kittler, Marshall McLuhan, and Lewis Mumford, a new wave of critics began to treat modernism as a media formation. Novels, poems, and plays, in other words, could no longer be treated as exceptional forms of human creative expression, but instead became one form of media among others—merely nodes in what Marshall McLuhan called a global "media ecology." The initial origins of the New Modernist Studies in literary criticism thus gave way to the newly booming fields of media and communication studies.

Mark Goble's *Beautiful Circuits: Modernism and the Mediated Life* offers a particularly powerful example of such work. Goble argues for a more broadly conceived modernism that self-consciously sought to explore the pleasures, powers, and limits of rapidly expanding communication technologies. Like Miriam Hansen, he rejects the formalism of critics who sought to make modernism nothing more than experiments with individual media, whether a canvas, a book, or a screen. Instead, he explores "what it meant for so many writers and artists to surrender to their medium at a moment when new practices of communication were making the experience of technology itself an occasion for aesthetic experiment and historical reflection."

In the chapter included here, Goble ranges broadly across film theory, popular illustration, experimental prose, and recording technologies to explore strategies of resistance to a technologized communication that had become globally ubiquitous. By focusing in particular on the rise of stardom, he contends that media transformed the idea of subjectivity and thus the traditional forms of literary and visual practices used to construct and sustain it. Weaving together texts as diverse as a Norman Rockwell painting, a scene from the

1932 film *Grand Hotel*, and the opening pages of Stein's *Everybody's Autobiography* (1937), he suggests that communication has actually displaced the idea of the private or enclosed self. Communication, that is, "no longer exists to bear our representational burdens so as much as we exist for its perpetuation—at whatever cost, and on terms we need not understand." This powerful argument shifts both modernism and modernity away from their traditional roots in aesthetics, economics, and ideology toward a media-centric definition in which we find ourselves trapped within the "beautiful circuits" of our now pervasive communication technologies.

Besides, when every body has his portrait published, true distinction lies in not having yours published at all. For if you are published along with Tom, Dick, and Harry, and wear a coat of their cut, how then are you distinct from Tom, Dick, and Harry?

Herman Melville, *Pierre*

In America everybody is, but some are more than others.

Gertrude Stein, *Everybody's Autobiography*

When Gertrude Stein Checks in to Grand Hotel

The travesty of literary celebrity that Melville undertakes when the action of *Pierre* moves from the country to the city is as savage as it is, from young Mr. Glendinning's perspective, uncalled for. Disinherited, estranged from family and fiancée, impoverished, incestuously in love with either his mother or his sister, or both—becoming famous would seem to be the least of Pierre's problems. Then again, as he is molested from the start by the uncanny likeness of his father's image and the "ineffable correlativeness" it suggests, it is perhaps not out of character for Pierre to be worried, above all, about anything that might render him just a version of someone else.[1] For Pierre, to sit for a daguerreotype, to be "dayalized a dunce"—where once a "faithful portrait" marked the "immortalizing [of] a genius"—is to lose oneself within a democracy of mercenary and formulaic distinction; so we might say that for Melville, the mediating discourses and material emanations of fame work contrary to their own clamor, permitting not the apotheosis of the singular individual but rather the replication of a standardized type of celebrity, famous like most people are not, but also famous exactly like other famous people already are.[2] Melville thus assaults an American culture of celebrity in a highly precocious way, identifying at this early moment that what is most compelling about stardom has less to do with its scarcity and considerably more to do with its proliferation and promiscuity: as Leo Braudy writes in his comprehensive history of fame in Western culture, "America pioneered in the implicit democratic and modern assumption that everyone could and should be looked at. This it seemed was one of the privileges for which the American Revolution was fought."[3] The overstatement here is only partly rhetorical. Stars do, after all, represent exemplary instances of the mediated life in America; they constitute a whole category of extravagantly mediated personhood, a whole species that is at home in the simulated, artificial worlds of publicity that have come to surround those technologies, film most of all, that have amplified fame and its effects out of all historical proportion. The logical extension of Melville's corrosive irony toward fame, a point that Braudy approaches more gingerly but just as surely, treats being a star as the same thing as being American, only more so: we are all looked at, we are all mediated, we are all spectacularly reproduced, and the lifestyles of the rich and famous are nothing more than variations on modern

life in general, pitched at the level of allegory and dressed up to show a little, or sometimes a lot, of class.

No such concerns for Gertrude Stein, or so my other epigraph on American celebrity would have us think. Stardom here assumes an ontological status; it is a difference that makes a difference: a star is a star is a star is a star. She makes this remark in *Everybody's Autobiography*, the 1937 sequel to her astonishing best seller of 1932, *The Autobiography of Alice B. Toklas*, and these two texts will be my primary concern in this chapter, which is about the mediated life of celebrity in the 1930s and the particular iconography of fame found in Stein's popular writings. I am interested in what might be called the content of the form of Stein's fame. I will not be treating Stein's fame as a biographical footnote, nor as a catastrophe from which her writing failed to recover, nor as an extended performance of cultural subversion from within.[4] I would like instead to reconsider her stardom as an essential aspect of her literary production in the 1930s, a period in which Stein— all her otherness notwithstanding—finds herself strangely and belatedly embraced by American culture, perhaps in part because she describes the experience of celebrity in ways that constellate a distinctively modernist fascination with medium aesthetics within a broader sense of cultural response to a modernity distinguished by the pervasiveness of its media. That is to say, the life of fame she narrates, and which is pictured in the iconography that surrounds her, takes its particular shape within a world that depends on technologies of communication and representation whose influences are felt on a pervasive scale. "I of course did not think of it in terms of the cinema," Stein writes of her own modernity, "in fact I doubt whether at the time I had ever seen a cinema but, I cannot repeat this too often any one is of one's period and this our period was undoubtedly of the cinema and series production."[5] The joke being, of course, that Stein for once does not repeat herself, though evidence of a world doing things cinematically is abundant in the texts to which I will be turning shortly.

Stein's willingness to admit to cinema's influence—without ever having seen a movie—testifies with uncanny elegance to the profound importance of film for literary modernism as a whole, and for the unique "crossing and interplay of the life of media forms" that McLuhan observed in the languages of Eliot, Proust, and Joyce.[6] In this respect, Garret Stewart is just the latest to argue that literary modernism must be understood, as Stein would say, in terms of the cinema. Writing of the non-semantic noise and "stray signification" that so many early-twentieth-century texts indulge and reproduce, Stewart proposes that "literary modernism begins, is always beginning, with such incursions of linguistic eccentricity in our habituation to lexical and syntactic code," and this patterns an entire network of "filiation" between "literary and filmic textuality."[7] Modernist writing, for Stewart, wants to face, and at the same time to contain, the materiality of words that may not always mean what authors say, nor even mean at all; and the "rough equivalent in film," he suggests, "is a surrender, induced by the text itself, to the optically unthought of the moving image" (266). Though voiced in the idiom of deconstruction, Stewart's modernism—predicated on the "surrender" to an unmeaning, technical constraint—is evocative of Clement Greenberg and the "instinctive accommodation to the medium" he celebrates in "Towards a Newer Laocoön" and elsewhere.[8] Phonemes and photographs constitute the "oscillating materiality" that show what modernism really is for Stewart, "beneath the shows of representation," and so we arrive again at a sense of modernism where the sensuous and visceral take precedent, and eventually win out against the text's intended content (266). "What thus glimmers into possibility," according to Stewart, "is a decisively new view of the convergence between the filmic apparatus and a whole stratum of literary writing tapped and maximized by modernism: namely, a technology not just of inscription or writing, but of 'style' itself" (286). Though not a figure that Stewart mentions, Stein would seem a perfect case of such "convergence." Hugh Kenner glances at this dimension of Stein's work in *The Pound Era*—in which he just barely glances at her anyway—when he describes her devotion to "a mystique of the word" that structures a literary enterprise "not related to a reader's understanding."[9] In Stein, "the

words turn toward one another in a mathematic of mutual connection" that affirms "the aim and morality of style." If modernist writing, to return to Stewart, "vibrates with the undulant undoing of continuous signification"—the phrase already sounds like it was made for Stein—her texts aspire to this condition of play and excess with a forthright determination that is almost artless in its evasion of everyday semantics. Indeed, I can think of no better way to describe the vertigo of reading Stein than Stewart's summary judgment on what finally makes for modernism on the page: "Words don't make it through to you from a strictly communicating consciousness *that* way" (266).

And so Stein exemplifies the new mode of writing that Friedrich Kittler calls "the discourse network of 1900," which understands the medium of words as powerfully challenged by the ability of film and other "technological media" to record and store experience of every kind.[10] Stein's early experiments in automatic writing, which she pursued with Leon Solomon while both were students at Johns Hopkins, are one of several cases that Kittler uses to explain how film's capture of motion and human physicality, and the phonograph's capture of sound and human speech, result in the familiar modernist condition in which the "most radical extrapolation" of what writing can do is to "write writing" itself. "The ordinary, purposeful use of language—so-called communication with others—is excluded."[11] For many of Stein's best feminist critics, her turn away from the conventions of everyday grammar, syntax, and punctuation indicates her commitment to a language unwilling to suffer the rules of "Patriarchal Poetry," to invoke one very strenuous, though handily titled, example of her refusal to communicate.[12] Without attributing Stein's style to any politics, Peter Nicholls speaks effectively on behalf of a consensus that almost no one wants to contradict: "Stein's focus of attention travels consistently away from meaning to the texture of writing. Language begins to assume a new opacity" as it becomes less a medium of reference and more "a medium of consciousness."[13] Thus it seems only appropriate that when Stein is discussed explicitly with respect to film, she is situated alongside works of the cinematic avant-garde that similarly confound the limits and assumptions of classical Hollywood. For Susan McCabe, experimental films such as Man Ray's *Emak Bakia* can help illuminate Stein's "strategies of representation and embodiment," because their emphasis on "fragmented, repetitive bodies" and "decentered plots" parallels the "bodily disjunction" that Stein wants her reader to experience not as a thematic *in* her writing but *as* her writing. Stein aspires to reproduce techniques of cinematic modernism that are "otherwise unnoticeable in conventional narrative film."[14]

This chapter, however, argues that there is much that we can learn from thinking about Stein and Hollywood cinema in its most conventional and formulaic forms, and that her fascination with the medium of film takes on an unexpected shape in her popular writings of the 1930s—writings that demonstrate not only what happens when Stein tries to communicate with a wider audience but also the effects of such communication on her particular style of modernism. I am interested, in other words, in what Stein wants to communicate by self-consciously situating her popular writing—with its still palpable difficulty and opacity and aspiration to materiality and noise—in a world that she describes as cinematic for all the ways in which it permits Stein herself to register the effects of stardom and celebrity. If "the task of the modernist artist," as Stanley Cavell famously writes in 1969, when Greenberg's modernism still held sway, "is to find what it is his art finally depends upon," I want to suggest that Stein discovers that *hers* depends on Hollywood.[15]

I should also confess that the account of Stein that I will be developing itself depends on that flimsiest and most popular of narrative conventions, the coincidence. Stein's unlikely celebrity begins with the publication of *The Autobiography of Alice B. Toklas* in the summer of 1933, along with its concurrent monthly serialization in the *Atlantic*, which began in May of that same year. Written almost entirely in the fall of 1932, Stein's obscured autobiography and history of modernism is thus completed at the very moment when *Grand Hotel* (MGM, 1932) is commanding first place at box offices all over the nation that Stein had left, but never really left behind. Starring Greta Garbo, John Barrymore, Joan Crawford, Lionel Barrymore, and Wallace Beery—each among the

most prominent and profitable stars of the period—*Grand Hotel* went on to earn more than $2.5 million (against just over $700,000 spent on production and distribution), as well as the Oscar for Best Picture of 1932. There is no evidence that Stein read Vicki Baum's best-selling novel from which the movie was adapted, nor is it at all likely that she saw *Grand Hotel* in Paris before starting work on her own narrative of cosmopolitan sociability amid the visual culture of modernism. It is this coincidence that I hope to make as historically meaningful as possible.

With this same film almost certainly in mind, Rem Koolhaas writes that "the 'Hotel' becomes Hollywood's favorite subject" in the 1930s because it functions not just as a space of visual possibility but also as a narrative readymade, "a cybernetic universe with its own laws generating random but fortuitous collisions between human beings who would never have met elsewhere."[16] The cameo appearance—defined without elaboration in *The Dictionary of Film Terms* as "a screen role of short but memorable duration," often by an actor "who is usually a major film star or entertainment figure"—is the technology of characterization that responds most directly to this new fantasy of communicating interiors, thickly saturated yet eloquent with information, splendor, and human beings as visual surfaces in constant motion. For in addition to representing the perhaps prototypical film version of the "cybernetic universe" that Koolhaas describes, *Grand Hotel*, as I will soon argue, must also be accorded a special place in any history of the formal device at issue here, because what Irving Thalberg and the production team at MGM devised, for the first time, was a narrative film where even the biggest stars—because they were too many—made little more than cameo appearances. Yet *Grand Hotel* seems positively vacant by comparison if we consider the dazzling assembly of cameo appearances that practically choke the narrative of *The Autobiography of Alice B. Toklas*—in which four hundred different individuals are mentioned by name—and relent hardly at all in *Everybody's Autobiography*—in which another three hundred, that is, three hundred *more* names are deployed, referenced, and otherwise dropped as indirect but nevertheless telling evidence of just how well received, from Mary Pickford to Eleanor Roosevelt, Gertrude Stein was upon her return to America. Sheer numbers, though, tell only part of the story. I am finally interested in an elaborate iconography of modernity that locates the cameo appearance at an intersection of private lives and public spheres in American media culture, an imagined space that encompasses hotel and home alike, a world of cameo appearances that brings Gertrude Stein and Greta Garbo into an electrifying proximity too noisy and too mediated by far to be called contact in any traditional sense of the term. Though this was, unless biographers discover something to the contrary, as close as the two ever were.

The World of Cameo Appearances

In the 1990s especially, cameo appearances became so widespread as almost to command a genre of their own. "You Ought to Be in Pictures," announced a headline from the *New York Times*, "Everyone Else Is These Days."[17] And if not "everyone," then at least a tremendous parade of the marginally famous: Mort Zuckerman, Calvin Trillin, Ivana Trump, the late George Plimpton (the *Times*'s "king of cameos"), Erica Jong, and Ed Koch are among those mentioned in the story; off the top of my head, and I say this with a degree of embarrassment, I can think of cameo appearances by Brooke Shields, Mel Brooks, Carol Burnet, George Segal, Don Rickles, Keith Hernandez, Jean Claude Van Damme, Yoko Ono, Billy Crystal, Robin Williams, Maureen Stapleton, Carroll O'Connor, Jerry Seinfeld, Beau Bridges, and Dick Gephardt—and these just on NBC sitcoms. Rosie O'Donnell, Joan Rivers, and Brooke Shields (again) on *Nip/Tuck*; Jennifer Aniston on *Dirt*; Britney Spears on *How I Met Your Mother*: seemingly every sweeps week and fight for higher ratings inaugurate an unceasing promotional hum of "special guest stars," suggesting that P. T. Barnum's "operational aesthetic" continues to function as the compulsory logic of "Must-See TV,"

for it is clear that a significant aspect of the attraction in such cases is all the apparatus at work in simply announcing the attraction itself.[18] This is not to say that the cameo appearance is nothing but a gimmick or a marketing ploy; it is, however, never *not* a gimmick, no matter its other semiotic ambitions. And so a film like Robert Altman's *The Player* (1992) or a series like *The Larry Sanders Show* or *Extras* depends on both a constant stream of cameo appearances and our pleasurable complicity with the very Hollywood star system that is being mocked; an aura of the "culture industry" at its most recursive and claustrophobic is always the point, and the cameo appearance seems the ideal formal device to signal an appropriately high self-consciousness without conscience. In this regard, Billy Wilder's *Sunset Boulevard* (1950)—with Gloria Swanson's captivatingly historicized performance as Norma Desmond, Eric von Stroheim's gothic turn as her butler, Cecil B. DeMille, Hedda Hopper, and all the "wax-works," including Buster Keaton and his one word of deliciously morbid, stone-faced dialogue—and Jean-Luc Godard's *Contempt* (1963)—featuring Fritz Lang as the director of the fictional version of Homer that is being filmed within the fiction of the film itself—must be accorded their ambiguous status as classically postmodern (with either term, or both, in scare quotes) examples of the skillful manipulation of cameo appearances. And it is no accident that both films are obsessed with the mortality of their medium, with the death of cinema at the hands of either television (Wilder) or Hollywood (Godard); the cameo appearances in each embody and allegorize fragments of a film history that is always about to be, or perhaps already has been, lost. As if stars in a world of cameo appearances don't die—they just get smaller parts.

Or put another way, the cameo appearance reproduces stardom in miniature, and I say this with more than just wordplay in mind.[19] In *The Savage Mind*'s famous discussion of *bricolage*, Lévi-Strauss observes that it is not simply the fact of representation, but rather the reduction in scale upon which almost all representation depends, that conditions our response to cultural artifacts and, more to the point, diversifies "our power over a homologue of the thing [represented]"—as smallness itself provides a "means" by which the object "can be grasped, assessed and apprehended at a glance."[20] This account of the miniature has a particular bearing on the cameo appearance. For as an eminently small phenomenon of celebrity, it trades on a mode of identification that remains somewhat removed from the totalizing engrossment in narrative that has long been the bottom line for classical Hollywood cinema. The cameo appearance might even be considered among the least of "attractions," to use Tom Gunning's famous term for any number of direct solicitations of the spectator that "rupture a self-enclosed fiction world"—but still, an attraction nonetheless.[21] The vast majority of cameo appearances effectively trivialize or "tame," as Gunning would say, the same moments of narrative limbo that they exploit; a walk-on by Marlo Thomas, Wayne Newton as "Wayne Newton"—these are not avant-garde gestures, any more than simply knowing the players in *The Player* without a scorecard is evidence of some superior distance from the film's domain.[22] The cameo appearance cannot help but be clever in every sense of the word; it is often precious or smug, but it also has the sly potential to allow us to borrow ownership of the means of pop cultural production, for it is finally *our* knowledge of the lesser-knowns and has-beens of film and TV history upon which the cameo appearance ultimately depends. Has there even been a cameo appearance if we do not recognize that guy from *Dexter* or what's-her-name, the one from that movie? The cameo appearance draws a charmed circle of self-congratulatory viewership, as if we too were part of this little family business that is the culture industry, where everybody knows everybody else in one giant network of relations that connects us not just to the star system but to the larger economy of entertainment and spectacle that it implies. Here, I suggest, is the most important aspect of the cameo appearance as stardom writ small: it offers, as Susan Stewart has observed of miniatures in general, "a diminutive, and thereby manipulable, version of experience, a version which is domesticated and protected from contamination."[23] A charm against the very system that proliferates it, the cameo appearance, like the dollhouse and other microscopic domains, creates

"a tension or dialectic between the inside and the outside, between private and public property, between the space of the subject and the space of the social."[24]

At issue, then, is how we understand our strange yet familiar place in a world of celebrity that seems to enclose and isolate us simultaneously. The cameo appearance communicates, endlessly and without decision, between these two ways of describing just where we belong—outside or in?—in reference to the star system as a way of life, as a way of imagining the effects of a media culture that may well surround us all, but surrounds some more than others. The cameo appearance does not resolve, but rather puts on display the contradictory accounts of stardom with which this chapter began. It is a figure that refers to celebrity in both the dubious aggregate and the splendid particular, to celebrity as both a product of the assembly line and incandescent personality, spectacular and available for the rest of us to see, but probably never be. This is all much, much less than it was invented to accomplish.

* * *

In December 1932 *Fortune* published a company profile of Metro-Goldwyn-Mayer, the largest and most successful enterprise in the world "devoted exclusively to the business and art of producing moving pictures."[25] What immediately follows this straightforward enough remark is a startling account, or perhaps I should say accounting, of all that adds up to compose the "business" side of the movie equation. From MGM's physical plant—"fifty-three acres valued at a trifling $2,000,000"—to its "twenty-two sound stages," "sixteen company limousines," "room for the practice of 117 professions," and "colored shoe-shine boy outside the commissary [who] considers himself an actor because he frequently earns a day's pay in an African mob scene," no asset, it would seem, no matter how trifling or disagreeable, goes unrecorded; *Fortune* cites just over thirty-five figures on the story's first page alone, from the "50¢" oysters at the M-G-M dining hall to the "billion pairs of eyes" that watch M-G-M films. The company's sublime mathematics of scale are exhaustively detailed in a tone of dry sophistication, as if to remind the reader that big numbers are business as usual in the pages of *Fortune*, even if the movies are not; but at other moments, the outlandishness of the studio's bottom line appears to beggar both *Fortune*'s sense of irony and its prose, as if to suggest that any complication of style or syntax would only interfere with the narrative adding machine:

> M-G-M's weekly payroll is roughly $250,000. On it are such celebrities as Marion Davies ($6,000), Norma Shearer, the three Barrymores, who get about $2,500 a week each, Clark Gable, Jean Harlow, Joan Crawford, Buster Keaton, Robert Montgomery, Marie Dressler (whose pictures take in more than any of the others'), Helen Hayes, Jimmy Durante, Conrad Nagel, Ramon Novarro, Wallace Beery, small Jackie Cooper, who makes $1,000 a week, John Gilbert, and until very recently, Greta Garbo. Miss Garbo is likely soon to return from Sweden where she recently retired after amassing a fortune of $1,000,000. If she does return, she will doubtless have a chance to make another million. Actors' salaries are only a small part of M-G-M's outlay. The biggest and most expensive writing staff in Hollywood costs $40,000 a week. Directors cost $25,000. Executives cost slightly less. Budget for equipment is $100,000 a week. M-G-M makes about forty pictures in a year, every one a feature picture or a special picture. Average cost of Metro-Goldwyn-Mayer pictures runs slightly under $500,000. This is at least $150,000 more per picture than other companies spend. Thus Metro-Goldwyn-Mayer provides $20,000,000 worth of entertainment a year at cost of production, to see which something like a billion people of all races will pay more than $100,000,000 at the box office. *Motion Picture Almanac*, studying gross receipts, guesses at a yearly world total movie audience of 9,000,000,000. (51)

Some of these numbers no longer supply quite the same shock value now that a single film regularly costs more to produce than the year's global box office gross, and the scandalous salaries of the

Barrymores and Norma Shearer, and even Marion Davies, are probably less than what Matthew McConaughey spends on his personal chef and trainer. But this is 1932, the worst year of the Great Depression in America and, of special importance, the worst year of the Great Depression in Hollywood. *Fortune* only hints at the story we could tell with the following figures: between 1930 and 1932, the domestic film audience erodes from 80 million to less than 55 million per week; the combined payrolls of the five major studios plummet from $156 million to less than $55 million, the "Polish immigrant who sometimes makes $500,000 a year" at MGM not withstanding; these same five studios see their stock value decrease by almost 80 percent and their profits simply vanish, with net losses totaling $26 million by 1932 and only one major studio not in some sort of receivership. That studio, needless to say, is MGM, which will single-handedly generate an astonishing 75 percent of the industry's profits for the decade.[26]

Grand Hotel figures prominently in *Fortune*'s attempt to understand how MGM has done more than just survive the same economic crisis that has swamped its competitors. This being *Fortune*, due mention is made of the company's flexible debt structure and "conservatively amortized" inventory; but this also being Hollywood, the explanation that is ultimately provided for MGM's prodigious bottom line is, strictly speaking, no explanation at all but rather a striking concession to the irrational alchemy of movie stardom, senseless and occult, and thus easy to deprecate even when it represents nothing less than the secret magic of the market itself. The "real clue" to M-G-M's preeminence, we learn near the article's close, is "the exuding of personality" by all those stars whose salaries are registered with such precision in the passage above, for "while there may be some dispute about M-G-M's acting, no one will deny that the M-G-M roster exudes more personality than any other in Holly wood" (122). All this "exuding" is performed by "a dozen of those hypnotic ladies who are asked to send their height, weight, bust dimensions and autograph to dreamy admirers all over the country," and though *Fortune* doesn't say what's asked of the men, we are still informed that MGM claims "a half-dozen male performers of equally mesmeric power" (122). In an example of the studio's promotional genius that *Fortune* reproduces, *Grand Hotel* appears as a virtual reification of MGM's commercial aesthetic on-screen. Setting a lobby poster for the film alongside a bombardment of come-ons to distributors—colloquial, ecstatic, cliché, and Yiddish, no less—the language reads like nothing so much as a premature Donald Barthelme pastiche of the very ad-speak it exemplifies.

Fortune later argues that films like *Grand Hotel* represent an altogether necessary modernization of the star system. "It is true that there are a diminishing number of pictures in the old movie tradition," the article notes of a "tradition" not yet twenty, with studios no longer churning out "pieces of utter whiffle for the display of some jerkwater matinee idol" (122). Instead, "what Mr. Thalberg substitutes for the 'star' system is a galactic arrangement whereby two or more 'stars' appear in one film . . . and so long as M-G-M keeps as much personality on tap as it has at present, so long can M-G-M hope to be well up in the Holly wood van" (122). The mixed metaphors here—from the cosmos to the bottling plant—might indicate just how unprecedented MGM's emphasis on the star system in "multiple" was at the time, though in retrospect the film seems a patent example of classical Hollywood. But Rudolph Arnheim, writing of *Grand Hotel* in his "Film Report" for 1933, after briefly rehearsing *Fortune*'s narrative of the film industry in crisis, uncorks a figurative reading of the movie that captures its strangeness with considerably more flavor: "*Grand Hotel* is a truly astonishing example of the culture of the American society film," he writes, adding that it offers evidence that Hollywood feels "forced, by the catastrophic failure of all proven attractions, to the desperate measure of collecting a whole bunch of stars in one single film, according to the principle that chocolate is good and herring is good, hence Garbo plus Beery must be really good!"[27]

The combination of Stein plus celebrity could have seemed no less strange at the time. And that Stein imagines a world of cameo appearances that matches the formal and thematic design of *Grand Hotel* almost exactly is the oddest of several "fortuitous collisions," recalling Koolhaas, between

high modernism and Hollywood that we will witness in this chapter. I am particularly interested in how the cameo appearance structures a kind of space in which people and technology are placed in communication. The cameo appearance is the most resplendent icon of Stein's experience of celebrity, which is itself an experience of the mediated life in America and abroad. "The thing is like this," Stein writes in *Everybody's Autobiography* as she attempts to reckon her new status as celebrity, "it is all a question of identity. It is all a question of the outside being outside and the inside being inside. As long as the outside does not put a value on you it remains outside but when it puts a value on you then it gets inside or rather if the outside puts a value on you then all your inside gets to be outside" (48). The star, in other words, is someone who has been turned inside out by the market and by media culture—which makes her just like the rest of us, especially in familiar accounts of the market and its effects on, or against, subjectivity.[28] Both Stein's writings in the wake of celebrity and *Grand Hotel* assume a self that is constituted in its very mediation, lost to all traditional notions of the private, and banished from the types of space historically constructed to house privacy in all its forms. Yet this mediated life of fame—visible, overheard, and thoroughly publicized—is not necessarily a life about which all is disclosed and in which nothing remains incommunicable to a world of others. It is a life of cameo appearances, where we experience everything in passing, in abbreviated gestures of familiarity and recognition that put precious little on display in showing us just what we want to see.

Celebrity from the Inside Out

"She always was, she always is," Stein writes of herself from the narrative remove of Toklas's impersonated voice, "tormented by the problem of the external and the internal" (112). *The Autobiography of Alice B. Toklas* registers this particular torment in a variety of ways, including, obviously enough, in the text's narration, performed as if "internal" to Alice B. Toklas when it in fact originates outside her in the person of Gertrude Stein. And though the language here is one of psychological disturbance, suggesting that Stein suffers the irreconcilable difficulties of inside and outside with the greatest sensitivity, the immediate frame of reference for this remark concerns aesthetic form more than emotional pain. While traveling in Spain, Stein's "style gradually changed," and where before her interests had been focused "only in the insides of people, their character and what went on inside them," she subsequently writes in response solely to "a desire to express the rhythm of the visible world" (111–112). To avoid all representations of interiority, to restrict language to details of sense and surface, is a "struggle" that Stein admits is ongoing, even as the surrounding narrative offers strong evidence that some sort of victory has been achieved. *The Autobiography of Alice B. Toklas* is an autobiography almost wholly void of psychological reflection, an autobiography that confesses to almost nothing that cannot be observed with the eye or ear.

This fact, however, hardly detracted from its popular success as a record of Stein and Toklas's life in the cosmopolitan city of Paris during "the heroic age of cubism." Looking back on *The Autobiography* from the vantage point of its sequel, Stein admits that Toklas thought that the book "was not sentimental enough" to be a best seller, though "later on when it was a best seller she said well after all it was sentimental enough" (47). We might take this remark as showing that Stein was well aware of the terms on which women's writing—and especially writing that achieved a measure of wide acclaim—tended to circulate; we might also wonder to what degree *The Autobiography's* involvement with the language of domesticity, certainly a dialect of the sentimental, represented a canny strategy on Stein's part, an attempt, recalling Stewart's discussion of the miniature, to offer a "diminutive" or "manipulatable" account of modernism and modernity. Sara Blair suggests that Stein's work demonstrates that the private home provided "a dense site of distinctly modern" social

experience in the years after World War I, and she argues persuasively that in such texts as "If You Had Three Husbands," we see that avant-garde literary production was often situated in a "changing form of domesticity."[29] That said, there is little sense that *The Autobiography* even counts as avant-garde. Bob Perelman describes Stein's best seller as deeply committed to the "domestication of modernist art and writing."[30] He means no great slight with this remark, but it is difficult to avoid the insinuation that *The Autobiography* represents a diminished achievement in light of other Stein texts, a view shared by many of her best critics.[31] Near the end of Toklas's story, just pages before the book's ruse of authorship is confirmed, we read the following attempt to isolate the narrative's retrograde domestic situation from its avant-garde aura: "She finds it difficult," Toklas muses, "to understand why we are not more modern. Gertrude Stein says that if you are way ahead with your head you are naturally old fashioned and regular in your daily life" (232). To come to this conclusion, however, one must first agree that a life lived amid a constant press of cameo appearances is, by any standard, "regular." And what we find inside the strangely domestic spaces of publicity at 27 Rue de Fleurus is a social world whose visible rhythm, paraphrasing Stein a bit, is both supremely frantic yet oddly without resonance. Stein imagines a space where interiority has given way to a version of what Blair terms "metropolitan sociality," and it is exactly this feature of Stein and Toklas's home that makes it the ideal environment for recognizing the modernity of Stein's writing.[32]

I want to begin with the fifth chapter of *The Autobiography of Alice B. Toklas*, "1907–1914," which records, and explicitly thematizes, the greatest proliferation of cameo appearances. "And so life in Paris began," we read, "and as all roads lead to Paris, all of us are now there, and I can begin to tell what happened when I was of it" (81). This gesture of inclusiveness toward all, of opening up a private space to any who might stop by, either physically or through the mediation of language itself, is a central trope of this, the text's longest chapter. Yet this promise that history will be simulated as if "you are there," as a newsreel might put it, is almost immediately revised and contained, its force lessened by Toklas's admission that the sheer proliferation of visitors to the Stein salon dampens the magnitude of their individual significance:

> The geniuses came and talked to Gertrude Stein and the wives sat with me. How they unroll, an endless vista through the years. I began with Fernande and then there were Madame Matisse and Marcelle Braque and Josette Gris and Eve Picasso and Bridget Gibb and Marjory Gibb and Hadley and Pauline Hemingway and Mrs. Sherwood Anderson and Mrs. Bravig Imbs and the Mrs. Ford Madox Ford and endless others, geniuses, near geniuses and might be geniuses, all having wives, and I have sat and talked with them all all the wives and later on, well later on too, I have sat and talked with all. (81–82)

While this series of interchangeable wives parades through 27 Rue de Fleurus, Toklas remains a constant around which a social comedy of broken marriages and mistresses swirls, the functional equivalent of Stein's spouse—for the purposes of domestic entertaining at the very least. The text is invitingly silent on the next step in a syllogistic logic that follows from the fact that Stein sits with "the geniuses" and Toklas with their wives. I will return to this silence, but for now I want to attend to the display of sociability that surrounds this telling moment of private life revealed for public view. Given that a dozen other "wives" are mentioned in the space of a sentence, what interests me about this passage is not so much the status of Toklas as the "wife of a genius," but the status of *any* self-representation under conditions demanding such rapid, superficial referencing.

At the risk of putting it too strongly, Stein dissociates interiority from privacy, from solitude, and most importantly, from meaningful perception in general. This is to say that *The Autobiography* pursues a range of representational strategies that try not to devolve into a conventional metaphorics opposing surface to depth, "external" to "internal." A surprisingly useful account of how such

strategies might shape a poetics of self-display is offered by Bakhtin's description of Greek "rhetorical autobiography" from the essay "Forms of Time and Chronotope in the Novel," written sometime in the late 1930s, and certainly without any reference to Gertrude Stein. In this genre's particular "chronotope," as Bakhtin maps it, "there was not, nor could there be, anything intimate or private, secret or personal, anything relating solely to the individual himself, anything that was, in principal, solitary. Here the individual is open on all sides, he is all surface, there is in him nothing that exists 'for his sake alone.'"[33] This is not, for Bakhtin, a condition of clinical, existential isolation; on the contrary, the sense of a surrounding public is so intimate and enveloping that "this 'surface' on which a man existed and was laid bare, was not something alien and cold" (135). Instead, Bakhtin writes, "a man was utterly exteriorized but within a human element, in the human medium of his own people" (135). It is an ennobling, if not utopian, state of affairs for Bakhtin, gloriously prior to a life "drenched in muteness and visibility," before both "loneliness" itself and a loss of "the unity and wholeness that had been a product of [man's] public origin" (135). But for Stein, this "human medium" figures as an interminable series of cameo appearances—a public, so to speak, in two dimensions only. She represents life at 27 Rue de Fleurus so as to match Bakhtin's paradise of the public self in almost every regard save the most important—that is to say, the ultimate effect of all this living for public view. Stein and Toklas actually seem to imagine themselves as "exteriorized" for no good reason whatsoever. "It was an endless variety," Toklas says later in the chapter, "and everybody came and no one made any difference. There were friends who sat around the stove and talked and there were the endless strangers who came and went" (116). She describes a strange wasteland of publicity; and the terrain is more evocative of Eliot and his melancholic affectations than might be expected. The Stein salon functions like Bakhtin's chronotope of the classical public square, a void of privacy and interiority, but visible only in the form of fittingly modernist ruins. "Who else came. There were so many." "And no one made any difference."

Of the more than four hundred cameo appearances that preoccupy *The Autobiography of Alice B. Toklas*, a sizable percentage are found in the immediate vicinity of this remark, lending it an iconic status within the exhausting swells of social life at the Stein salon. Braudy describes the historical world of fame as one in which "names inundate us," and this is certainly true of Stein's world in Paris. In the ten pages surrounding Toklas's elegy for the less significant masses of friends and strangers at 27 Rue de Fleurus, the reader is treated to the following cacophony of proper names: Mildred Aldrich (who "adored cablegrams"), Henry McBride, Roger Fry, Clive Bell, Mrs. Clive Bell, and "many others" from the Bloomsbury circle, Wyndham Lewis, Augustus John, Lamb, and "throngs of englishmen," "Pritchard of the Museum of Fine Arts, Boston," "the Infanta Eulalia," Lady Cunard and her daughter Nancy, Jacques-Emile Blanche, Alphonse Kahn, Lady Ottoline Morrell "looking like the feminine version of Disraeli," "a roumanian princess" and her "cabman," William Cook and "a great many from Chicago," Raventos, Sabartes, "the futurists all of them led by Severini," Marinetti, Epstein "the sculptor," Dr. Claribel Cone, Etta Cone, Emily Chadbourne, Myra Edgerly, (Arnold) Genthe ("the well known photographer"), John Lane, Colonel and Mrs. Rogers, John Lane, Mabel Dodge, Edwin Dodge, Constance Fletcher, Jo and Yvonne Davidson, Florence Bradley, Mary Foote "and a number of others quite mad with fear," Siegfried Sassoon, Edith Sitwell, André Gide, Muriel Draper, Paul Draper, Haweis, Mina Loy, Harry and Bridget Gibb, Florence Bradley, Charles Demuth, Picabia "dark and lively," Marcel Duchamp "looking like a young norman crusader," Carl Van Vechten, Robert Jones, John Reed. . . . And while the reproduction of such a list may seem excessive on my part, I should point out that even this taking of attendance leaves us far short of the total population Stein registers in these years, for not only are countless individuals abstracted within cryptic references to "everybody" and "others," but names continue to drop from the pages of *The Autobiography* at nearly the same relentless pace until the chapter ends with the eruption of war—the only event capable of checking this prodigious output of cameo appearances.

But this extravagant record of the "human medium" within which Stein and Toklas live is weirdly without a message. If we are told in advance that "no one made any difference," why provide us with this elaborate social registry in the first place, why subject us to this detailing of empty particulars? Thinking first in formal terms, there is a sort of musicality to all these proper nouns, a sensual experience of odd-sounding syllables and exotic pronunciations; yet given Stein's antipathy toward the noun as a part of speech—"things once they are named the name does not go on doing anything to them and so why write in nouns"—it is unlikely that she would have been after these particular non-representational effects of language (*LA*, 210). Indeed, as Jennifer Ashton points out, Stein insists in many of her writings that names can do nothing but refer; "the liveliness of proper names," as Ashton puts it, is a "way of negating the very possibility" that reference will ever be lost.[34] For Stein, then, each of the four hundred proper names included in *The Autobiography* must denote a specific individual, even if the vast majority of these references have no connotative value for her reader. Thus the exhaustive accumulation of all these names, we might say, serves as an object lesson in what communications theory would describe as the difference between an utterance and information, which finally does not depend upon a logic of linguistic reference, as it does upon a felicitous match of code to context. And since information, to borrow from Gregory Bateson, is a difference that makes a difference, we should already know that none of the countless visitors who pass through *The Autobiography* can fully register in the end as individuals.

Rather, Stein seems intent on exploiting a phenomenon of social poetics, and what comes to matter about all these names is not their singularity as references to people but their accretion within space and time. Lecturing on "The Gradual Making of *The Making of Americans*," Stein observes that "it is something strictly American to conceive a space that is filled with moving, a space of time that is filled always filled with moving" (161). The cameo appearances of "1907–1914" indicate the workings of an American system of social production, a system that seeks to maximize the sheer numbers of social contact, to exaggerate out of all traditional proportion the ratio between public exposure and private remove, while at the same time minimizing the significance of any single event of personality. The figuring of the social as a dense network of comings and goings, without end or effect, recalls no one text so much as *The Great Gatsby*, where Nick Carraway tabulates "in the empty spaces of a [rail way] time-table" the profligacy of names that circulate through an East Egg summer.[35] Fitzgerald's set piece articulates, perhaps as scathingly as one can, the relationship between a social life of extreme publicity and a deeper sense of space and time as produced by technology and its networks, whether material or metaphoric. Stein is not nearly so determined to render the technological mediation of her social space, though there is a possibility that Fitzgerald looms as an influence here.[36] To map Gatsby's glittering parties onto a rationalized grid of commuter transport requires a commitment to realist irony that Stein, for the most part, lacks. What results, however, is much the same: a disorienting democracy of attention is all but forced upon us, a vortex of characters in constant motion, some of whom are perhaps crucial, many of whom are clearly trivial, yet all of whom occupy the stage for the identical fleeting moment. Thus a strict representational economy is emphasized, an implacable distribution of mimetic resources that accords equal time to both the terminally obscure and the historically famous, the Infanta Eulaila on the one hand and John Reed on the other; in a world of cameo appearances it is incumbent upon the audience of readers to know the difference, to read *against* the reduction in scale and fashion their own highly personal surplus of meaning. Yet this distribution of attention is, by the same token, a flagrant travesty of narrative and historical logic; these cameo appearances leave little space for the protocols of standard autobiographical representation, for perceptible divisions between foreground and background, between major and minor characters, between Lady Cunard and Mina Loy. "Everybody brought somebody," Toklas notes, and while this is certainly hyperbole and readily explained by reference to Stein's fondness for both indeterminate pronouns

and aggrandizing generalizations, this technically meaningless and oddly affecting sentence also represents, in the only way possible, the upper limit of social reference itself, a way of marking a superlative degree of intimate publicity beyond which there is nothing but more "endless strangers," more visits from more people looking at more pictures, more points of passing interest along an "endless vista through the years." There is an exhaustive redundancy to the feats of memory in *The Autobiography of Alice B. Toklas*, exhaustive not only of some readers' patience but of the notion of historical significance as well. "And everybody came and no one made any difference."

That is, almost no one. For despite the sheer speed at which this social scene moves past the reader, and despite the sheer number of names the narrative accumulates, it is still possible to trace different paths of reference through the thicket of cameo appearances. Toklas's passing remark that "everybody found the futurists very dull," as Marjorie Perloff has argued, refers not only to Stein's personal antipathy toward futurism and its violent, promotional ideology of the avant-garde but also to a larger network of her texts in which the language practices of Marinetti and others are subjected to political scrutiny and poetic play (or vice versa).[37] It is also possible to imagine a, strictly speaking, *historicist* attempt to locate Stein's dazzling swirl of social reference within what Stephen Greenblatt would call a "cultural poetics" that puts small denominations of "mimetic capital" into circulation.[38] That John Reed makes a brief and somewhat unpleasant appearance at 27 Rue de Fleurus momentarily places the aesthetic radicalism of modern culture in communication with the political radicalism with which Reed is famously associated, and such networks of intertextual meaning might well be pursued. And as theoretically "everybody" possesses some degree of historical resonance, from the Infanta Eulalia to the Princesse de Polignac, the intertextual horzons of *The Autobiography of Alice B. Toklas* are all but limitless, offering an infinitely extensive system of cultural reference and surface particularity, with each obscure dignitary or minor painter leading finally to some domain of signification outside the text itself. The cameo appearance thus represents a dream of potentially endless historicizing, a historicizing rendered trivial, marginal, and haphazard by the very form of utterance that instigates it. If you recognize the name Gertrude Atherton, you crack a portion of Stein's code, and if you do not, the text gives no indication whatsoever that you have missed something, no more than Stein seems concerned if the name Marcel Duchamps carries any more significance than Alphonse Kahn, each of which is subject to the same economy of the cameo appearance. A name is a name is a name is a name. The text all but aspires to a condition that David Shenk, writing at the height of dot-com culture in the late 1990s, called "data smog" in hopes of capturing the feel of living in an environment where information is too abundant for our own good.[39] Thus a familiar modernist aesthetics of difficulty—"opacity" as Nicholls might say, or for Stewart "continuous signification"—operates not because the text resists definitive interpretation but because it encourages endless annotation.

But as I said, there is at least one way to qualify the text's conceivably interminable historical "irreference," and that qualification is this: to say that every cameo appearance is formally the equal of any other is not to say that every cameo appearance is experienced equally by any reader. Different readers approach *The Autobiography* with different degrees of competence in the arcana of its period-specific acts of memory. For every reader who skims over "Lady Ottoline Morrell" without a thought—her name just noise on the page—there is another who knows a bit of her biography, and so has reason, however trivial, to link Stein and D. H. Lawrence, who had based a character in *Women in Love* on Morrell in 1920. All this name-dropping has the effect of producing different readers: some who find the text a richly nodal document of modernism's culture and some who find the text a useless show of social capital. The contingency of the cameo appearance lets it beg with equal authority to be taken for granted, missed entirely, or doggedly pursued; but in any case, the cameo appearances in Stein make a spectacle out of information. We might even say that Stein's name-dropping revels in the "theatricality" of information, a term I am borrowing from

Michael Fried. This is to stress the potential "obtrusiveness" and "aggressiveness"—two especially disparaging aesthetics that Fried associates with 1960s minimalism—that are risked by any work of art whose effect depends on "the special complicity that that work of art extorts from the beholder."[40] Or put differently, to the degree that cameo appearances in Stein refer only to names that no reader, I think, is supposed to know in full—this is why the narrative is structured as a show of "inside" information from the early days of modernism—the text must also acknowledge that these names need not communicate at all, that they constitute a medium where "the materials do not represent, signify, or allude to anything; they are what they are and nothing more" (165). And it is against the presence of this noise, and the theater of sociality that constantly intrudes on Stein and Toklas at 27 Rue de Fleurus, that *The Autobiography* employs one of the final cameo appearances of "1907–1914" to confirm that while we have been watching names come and go, Stein has been absorbed in her writing all along.

The most important drama of recognition played out over the course of *The Autobiography of Alice B. Toklas* concerns none of the text's cameo appearances so much as it does Gertrude Stein herself. At the beginning of the narrative, Toklas is introduced as an uncanny appraiser of greatness, a person who has encountered genius "only three times . . . and each time a bell within me rang," well in advance, she informs us, of any "general recognition" by the public (5). That she and she alone recognized Stein's genius "on sight" is the initial rationale for the fiction of her narration, as we learn from such provisional titles for her faux autobiography as, "My Life With The Great," or "Wives of Geniuses I Have Sat With"—trotted out just before Stein's hand as author is finally revealed. This revelation, as critics of the text's first illustrated edition have noted, is quite literally literal; facing opposite to the final paragraphs of the text we find a photograph captioned, "First page of the manuscript of this book," a gesture that graphically returns us to the start of the text, now visible in its author's hand, and yet does so with some irony, for just how, in the end, are we supposed to identify this writing as belonging to Gertrude Stein? How is this "hand" any more conclusive as evidence of authorship than the fictive "voice" of the narrative itself? And why, for that matter, the first page of the manuscript?

This illustration turns Joseph Frank's famous aesthetic of "spatial form"—in which modernist literature aspires to "rival the spatial apprehension of the plastic arts in a moment of time"—into a kind of joke, a showy unveiling of the obvious that directs us back to the beginning of the book as if *now* we know to read it all differently.[41] It is also, of course, a joke about the meaningless materiality of the text, which is to say, that its deictic gesture—"first page of manuscript of this book"—does not denote "this book" at all, nor can it possibly confirm its author. The picture functions as what Katherine Hayles would term a "material metaphor," a figurative exploitation of the text's physical apparatus "that foregrounds the traffic between words" and books as technologies, mediums, or objects.[42] And in this respect, by including a picture of Stein's original manuscript, the text oddly enough recalls its own performance of displaced or distributed authority. "I always say," Stein writes, "that you cannot tell what a picture really is or what an object really is until you dust it every day and you cannot tell what a book is until you type it or proof read it. It then does something to you that only reading never can do" (106). Of course, Stein here writes about what Toklas does: experience the text as it communicates from one medium to another in a process that is perfect, strictly speaking, to the degree that it makes no difference. The typewriting of Stein's manuscripts gives Toklas a claim to textual intimacy with Stein that we as readers can never have, and that Stein, perhaps, cannot have herself. Kittler insists, echoing Jacques Lacan, that in the discourse network of 1900, where relays with and through technology have replaced communication between men and women, "there is no sexual relation between the sexes."[43] But Kittler also takes for granted that male authors and their female secretaries or, as they were objectified, their "typewriters," are the only players in this modern drama of mediation and textuality. The "genius" of *The Autobiography of*

Alice B. Toklas, on the contrary, is to put these circuits of technology to work so that sexual relations within the sexes become, if not exactly possible, at least legible within the media environment that makes Gertrude Stein so famous.

That 27 Rue de Fleurus is the scene of Stein's writing is a fact of which we are continually reminded, beginning with the first edition's frontispiece illustration, a Man Ray photograph of Stein in silhouette at her desk, pen in hand, while Toklas occupies the background in a brightly lit doorway, her relationship to Stein's writing, as well as to the book before us, indeterminate—the title page of the first edition does not feature the name of an author.[44] These pictures, as James Breslin argues, make visible the displacement of authority that the narrative embodies in both its formal texture and its dominant thematics. The cameo appearance of Alvin Langdon Coburn, however, represents a moment of visibility, one that unexpectedly brings Stein into focus, not just as an author but, more importantly, as a star. "It was about nineteen twelve that Alvin Langdon Coburn turned up in Paris," Toklas tells us near the end of "1907-1914," making this the chapters penultimate cameo. She continues:

> He was a queer american who brought with him a queer english woman, his adopted mother. Alvin Langdon Coburn had just finished a series of photographs that he had done for Henry James. He had published a book of photographs of prominent men and he wished now to do a companion volume of prominent women. I imagine it was Roger Fry who had told him about Gertrude Stein. At any rate he was the first photographer to come and photograph her as a celebrity and she was nicely gratified. He did make some very good photographs of her and gave them to her and then he disappeared and though Gertrude Stein has often asked about him nobody seems ever to have heard of him since. (131–132)

This is one of the few cameo appearances that produces a specific narrative affect, a feeling that aspires to pathos but is perhaps more accurately described as the exhaustion of pathos, the weary realization that almost no one who has been mentioned in the preceding pages will ever be heard of again. To hark back to the critical vocabulary of Henry James, whose presence here quietly hints at a literary genealogy from the culmination of his career to the origin of Stein's, there is a certain tone to Coburn's visit, and this tone encompasses much of what the cameo appearance has to say about the emotional life of modernity: there are simply too many people to keep track of, too many events to register, too much history to write into the permanent record, even when that record is reduced in scale—thus extending the capacity of its memory—to a parade of cameo appearances.[45] This passage also makes clear that "celebrity" is one of the names designating this condition of extreme yet attenuated sociability, this blur of personality mediating between the intimate spaces of the home and a public sphere that lacks both limit and resonance, being both "endless" and making "no difference." But this is not at all what we see pictured in Coburn's photographs of Stein, images remembered as the first documents of her "celebrity," which represent a scene of writing almost entirely disconnected from the outside world. Thus even though Coburn's brief cameo is little more than "the appearance of a disappearance," to borrow a particularly resonant phrase from Alex Woloch's work on the function of minor characters, it makes a difference to Stein in that it christens the phenomenon of her celebrity and pays tribute to the materiality of the medium that distinguishes her literary status.[46]

In one Coburn photograph the page over which Stein works glows as a field of absolute whiteness matched visually to the extreme illumination of her forehead. The incandescence of the page recalls something of the ectoplasmic manifestations pictured in so much Victorian spiritualist photography, though in this case, there is no "other" erupting into our own world save that of Stein's own mental energies, the supreme consciousness that distinguishes the circuit between mind and

page. Another of the Coburn pictures similarly fixates on the apparent dissolution of Stein's body into writing itself, as again Stein's rapt attention directs the viewer to the place in the image where it becomes impossible to determine just where the writer ends and the materials of writing begin. I should also add that writing is figured as anything but "automatic" in the Coburn series; in fact, the visual emphasis on Stein's powers of intention could hardly be stronger. But the profound modernity of Stein's writing is banished from the iconography of Coburn's pictures, where velvet robes, antique furniture, and an ostentatiously situated candle suggest that the technology of writing remains unaltered, despite the haunting presences of a modern visual culture that remains just slightly out of focus in the background, with its fuzzy mirror image of Gertrude Stein as already represented—Picasso's famous portrait dominates the deep center of the photograph—barely registering behind a foreground wholly dominated by Steins absorption in the act of writing. Stein and her painted figure subtly mirror one another—the color of clothing is similarly dark, her face and forehead are likewise bright and focal, she is seated in both portraits, with her hands visible—but the author dwarfs her image. Indeed, Coburn's photograph almost renders Picasso's painting as the product of Stein's imagination; it floats above her head as if filling up a thought bubble. In this photograph, the act of writing radiates with a materiality that seems at once to "draw" on the visibility of modernist painting—the pun seems unavoidable since Stein could be seen as sketching here—even as the image quietly asserts the priority and specific inwardness of textuality.

So if this is what Stein looks like as a nascent "celebrity," neither fame nor recognition would seem to pose much of a distraction to the modern writer. Celebrity finally registers as no interference at all; the social noise at 27 Rue de Fleurus does not interrupt the ideal network of communication that relays the contents of the writer's mind to the page as if that page were as intimately connected to the body as the writer's own hand. The closed circuit of writing is impenetrable, and its technological apparatus is no apparatus at all but rather a perfect and seamless extension of the author and her identity. These photographs from 1914—fondly recalled by Stein in 1932 as the first images of her "celebrity"—depict a domestic scene of writing still isolated from the restless mobilizations of publicity, a space that remains "old fashioned and regular" despite the crowded assembly of endless cameo appearances and the pressures they apply to any stable notions of inside and outside.

Other accounts of the modern home at this same time imagine a radically different sort of domestic space: "In all its essentials," writes Norman Bel Geddes in *Horizons*, his 1932 fantasia of a streamlined lifeworld, "a house should be organized as a factory is. For it *is* a factory of a kind; and it is the most difficult kind of factory to run."[47] The writing factory at 27 Rue de Fleurus runs smoothly enough, according to *The Autobiography*, with Stein producing texts in great abundance while still managing to entertain a nostalgia for domesticity in the total absence of the solitude that is its defining condition. Some hint of this contradiction is visible even in 1914, for the old-fashioned candle is quite obviously not providing the brilliant illumination for the scene of writing the Coburn photograph depicts. The imaginary space of celebrity has a much different look—and sound—to Stein after she has actually achieved it, and this scene of writing gives way to a dizzying profusion of what we might call scenes of communication.

Ecstasies of Communication

There are limits to the modernity of Stein's Paris, and within the space of time narrated by *The Autobiography of Alice B. Toklas*, one such frontier is marked by the absence of the telephone.

As Gertrude Stein and I came into the café there seemed to be a great many people present and in the midst was a tall thin girl who with her long thin arms extended was swaying

forward and back. I did not know what she was doing it was evidently not gymnastics, it was bewildering and looked very enticing. What is that, I whispered to Gertrude Stein. Oh that is Marie Laurencin, I am afraid she has been taking too many preliminary apéritifs. Is she the old lady that Fernande told me about who makes noises like animals and annoys Pablo. She annoys Pablo alright but she is a very young lady and she has had too much, said Gertrude Stein going in. Just then there was a violent noise at the door of the café and Fernande appeared very large, very excited and very angry. Félix Potin, said she, has not sent the dinner. Everybody seemed overcome at these awful tidings but I, in my american way said to Fernande, come quickly, let us telephone. In those days in Paris one did not telephone and never went to a provision store. But Fernande consented and off we went. Everywhere we went there was either no telephone or it was not working, finally we got one that worked but Félix Potin was closed or closing and it was deaf to our appeals. (97–98)

The basic units of narrative action in this passage are events of communication. The indecipherable bodily gestures of Marie Laurencin, the whispered exchange between Alice and Gertrude, the reports of animal verbalizations that annoy Picasso, and finally Fernande's striking entrance and grand distress over an eminently bourgeois catastrophe, which is as much to say no catastrophe at all. "One would like to ask," Freud writes in *Civilization and Its Discontents*, published just two years before, in 1930, "is there, then, no positive gain in pleasure, no unequivocal increase in my feeling of happiness, if I can, as often as I please, hear the voice of a child of mine who is living hundreds of miles away or if I can learn in the shortest possible time after a friend has reached his destination that he has come through the long and difficult voyage unharmed?"[48] To these zero-sum games of pleasure forced upon us by modern life, we might add Fernande's somewhat less dreadful dilemma: is there no positive gain in domestic comfort if the technology that spares me the labor of shopping cannot bring me my undelivered dinner? The "american way" to resolve this crisis, a solution about which Toklas seems somewhat ashamed, automatically involves an engagement with whatever means of technology are at hand, and even, if necessary, an actual trip to the grocery store, no matter how unaesthetic the hard facts of consumer life may be. Thus overlapping networks for the exchange of language and money are here designated as uniquely American priorities, the special province of the nation which, "having begun the creation of the twentieth century in the sixties of the nineteenth century is now the oldest country in the world" (73). This famous remark is readily confirmed, at least in terms of America's disposition toward the telephone, by an AT&T ad of 1935. "America leads in telephone service," it reads. "In relation to population there are six times as many telephones in this country as in Europe and the telephone is used nine times as much."[49]

The second chapter of *Everybody's Autobiography*, plainly titled "What Was the Effect Upon Me of The Autobiography," begins with a description of a new economy that conditions writing after Stein's surprising best seller. An indiscriminate theory of value that accorded every word the same dear status gives way to an inescapable "money value" that spectacularly commercializes some language while declaring other language worthless (40). Several critics and biographers have pointed to a prolonged and, for Stein, entirely uncharacteristic period of writer's block as one result of her success.[50] But I am interested in another way that Stein's late celebrity and financial viability materialized themselves in her daily life. Now able to sell even her earlier, unpublished works with some regularity, Stein acquires an agent, William Aspinwall Bradley, and takes dramatic steps to ensure that she and Toklas aren't quite so old-fashioned:

So he was excited and I had to have a telephone put in first at twenty-seven rue de Fleurus and then here at Bilignin. I had always before that not had a telephone but now that I was going to be an author whose agent could place something I had of course to have a telephone. We are just now putting in an electric stove but that is because it is difficult if not impossible to

get coal that will burn and besides the coal stove does not heat the oven and anyway France is getting so that French cooks do not like to cook on a coal stove. To be sure cooking with coal is like lighting with gas it is an intermediate stage which is a mistake. It would seem that cooking should be done with wood, charcoal or electricity and I guess they are right, just as lighting should be done by candles or electricity, coal and gas are a mistake, like railroad trains, it should be horses or automobiles or airplanes, coal, gas and railroads are a mistake and that has perhaps a great deal to do with politics and government and the nineteenth century and everything however to come back to my agent and to my success.

It is funny about money. (45)

There is no accommodating the categorical modernity that this passage implies: the gradual progress of domestic technology in the background of *The Autobiography* is pointedly revisited here, not as a source of nostalgia but rather as a series of errors, an extended misrecognition of history's direction. Modernity, in short, is an all or nothing proposition; like the bumper sticker version of "America, Love It or Leave It"—horses or airplanes—but no straddling between then and now. "Everything" changes irrevocably with the modern, and though there is no way to know exactly what "everything" involves, I think it safe to say that "money" is at the root of it, and the telephone is among its most visible and audible signs. "And so Mr. Bradley telephoned every morning and they gradually decided about everything and slowly everything changed inside me," Stein writes just a paragraph later, "yes of course it did because suddenly it was all different, what I did had a value that made people ready to pay" (45–46). The telephone represents this larger network of communication that is identical to a larger network of exchange, making each transmission of mediated language a commercial transaction as well, an accumulation of economic determinants that "gradually" penetrates both home and self, rendering any vestiges of domestic individualism as backward as gaslight. Thus the telephone is a symbolic technology in several senses of the word, for it is not only a means of communication but also a metonymic figure for deeper historical and economic transformations. And though Stein appears to define with little difficulty just what the telephone is a symbol of, we should not ignore another aspect of the telephone in *Everybody's Autobiography*, an aspect featured prominently in *Grand Hotel* as well, in which phone calls are the very symbol of all that is modern because they symbolize nothing in particular, a telling background noise that consumes as much meaning as it transmits.

* * *

One does not step inside the spatial and narrative world of *Grand Hotel* by walking through its massive revolving door and crossing its breathtaking lobby; one enters by way of the telephone. The ostentatious display of stardom in the film's opening credits, where each major actor, beginning with Garbo, of course, is treated to a premature curtain call, fades to black, and then fades in on what I want to call an establishing shot of the hotel's interior, but which really isn't, because the space it establishes is entirely *too* interior: the film's first images are of the hotel's switchboard, with the camera tracking over the heads of a series of nearly identical telephone operators, connecting and disconnecting a Babel of calls, a chattering polyphony of unspecified language, recognizable as English only in that the words "Grand Hotel" keep emerging audibly above the noise. And while we return to this space several times in the film's narrative, the switchboard remains totally "disconnected," architecturally speaking, from the interior of the Grand Hotel itself, within whose confines the entire narrative of the film takes place. We know only that these invisible channels of communication lead to narrative—a lot of narrative.

Fade to a man on the telephone. First Senf, the hotel porter played by Jean Hersholt, places a call to the hospital, begging to know if his wife has given birth yet, though he isn't permitted to leave

his work even if she has. Then Otto Kringelein, the terminally ill petit bourgeoisie played to the hilt by Lionel Barrymore, calls home to let someone know he is staying at the "most expensive hotel in Berlin," where even this phone call costs "2 marks 90" every minute. Then Wallace Beery's archly German Herr General Director Preysing calls home to let them know he has safely arrived for his important meeting with a company from Manchester, a meeting upon which "everything depends." A woman named Suzette, the assistant to the famous ballerina Grusinskaya, calls the theater to warn them that "Madame will not dance tonight." Then Baron von Geigern, a jewel thief with the most impeccable class status of any of the film's characters, calls some anonymous criminal boss. "I need more money," he demands, "or I can't stay at this hotel much longer." We witness these calls from a position directly in front of each speaker, as if the movie screen was nothing more than the transparent wall of the telephone booth. The background remains largely out of focus, with just enough visual detail to let us know that there is motion and activity here, but not so much detail that our attention is drawn away from these intensely differentiated monologues—Hollywood character acting of the highest polish.

And then the sequence repeats itself. We return to each conversation a few seconds later, now in tight close-ups lasting only a few seconds, from which we cut away right in the middle of sentences, right in the middle of words. Thus Kringelein again: "I've taken all my savings and I'm going to enjoy spending it, all of it." Senf: "I can't, I'll lose my job. It's like being in jail." Preysing: "The deal with Manchester must go through." Suzette: "I'm afraid she will." And finally Kringelein: "Music all the time. Dancing. It's wonderful." These three minutes epitomize a narrative economy of montage, compressing almost all the information we need to make sense of the film's extensive plot: so much melodrama, so little time. The accelerating pace of the editing even invites a loose analogy between the general scarcity of money in the narrative and the special scarcity of screen time in the film, for the essence of *Grand Hotel* is that even its stars, because they are too many, make little more than cameo appearances, with Garbo around for only a scandalously brief twenty-some minutes.[51] The first line of dialogue in the film that is not spoken into a telephone is spoken directly to the viewer—or to nobody in particular—by Dr. Otternschlag, a scarred veteran of World War I played by Lewis Stone. His flat delivery and affected weariness exaggerate the resonance of the film's perverse moral—perverse, that is, because it evacuates meaning instead of condensing it: "Grand Hotel. People coming . . . going. Nothing ever happens." And the echo of Stein—or Stein's echo of Dr. Otternschlag, as the case may be—is unmistakable: "It was an endless variety, and everybody came and no one made any difference."

But something does happen that radically alters the film's visual logic, punctuating this opening scene of communication with a moment of spectacle that mutes, at least momentarily, Dr. Otternschlag's ironic commentary. The close-up of Lewis Stone fades, and we now see the crowded lobby of Grand Hotel from a vantage that is more or less at eye level, a true establishing shot in that the narrative space of the film is now immediately characterized: a world of gleaming surfaces, fancy dress clothes, a profusion of faces, constant movement. The "Blue Danube Waltz" begins, implying a social scene that operates with Viennese precision and splendid grace, though perhaps tending to the banal. The lobby of the Grand Hotel bears a resemblance in this sequence to that of the Hotel Atlantic in F. W. Murnau's 1924 film *Der Letze Mann*, at one time the most successful foreign film in U.S. history and almost certainly a point of reference here. Yet for all that these two films share at the level of locale and thematic emphasis, their particular visual techniques articulate radically different conceptions of space.[52] At the beginning of *Der Letze Mann*, we are already inside the hotel, descending toward the lobby in an elevator through whose grilled gate we see a scene of people in motion; the camera's point of view simulates the visual field of an unspecified yet embodied observer, a person with whom we walk out of the elevator and then across the lobby in a legendary and, for its time, technologically miraculous tracking shot.[53] And while the first

shot of the full lobby in *Grand Hotel* depicts a similar interior design, its perspective could not be farther removed from the intimately subjective position in which Murnau situates us. *Grand Hotel* fades without warning to an overhead view of the lobby. This image gives some sense of the giddy perspective the viewer experiences, for while the sudden remove of our visual perspective from a crowded space, practically clogged with narrative, suggests a kind of surveillance and power over the microscopic scene below, this unexpected moment of visual abstraction—recalling a Busby Berkeley musical perhaps, and warped as if filmed in a convex mirror—also suggests a moment of harrowing weightlessness, as if all that was solid about social observation itself was about to melt into air.[54] Intricacies of character and plot are no longer visible from this celestial point of view, and though we soon return to "earth" and its noises, melodramas, and chattering dialogue, there is something about this brief respite from the narrative claustrophobia of the telephone booths that continues to haunt the opening sequence as it unfolds. This moment of pure visual display brings a whole architecture of modern life into focus. We see that there is an absolute dichotomy between the interior workings of the social machine and its reflection in the world of spectacle, between the switchboard's exposed bowels of tangled wires and faceless female labor and the shining spaces of circulation in the hotel's lobby. Like Gertrude Stein, to put it bluntly, *Grand Hotel* is tormented by the problem of the external and the internal, both in the melodramatics of its plot—a jewel thief hides behind the Baron's aristocratic veneer, a murderous villain lurks inside the stolid industrialist, without substance, and of course, inside the call girl and/or secretary played by Joan Crawford there beats a heart of gold—and also at the level of cinematic form. At no time in the film do we step outside the Grand Hotel itself; it is telling that the only glimpse we get of a space not contained within this interior is when we follow a hearse carrying the Baron's coffin out into the street; to check out of *Grand Hotel* is to move inevitably toward death.[55]

Nowhere after the opening sequence in *Grand Hotel* is so much accomplished with so much visual economy. The plot tangles forward, and characters meet and couple in almost every conceivable combination, as if the narrative was driven by some algorithm seeking to maximize each of its stars' screen time. Any description of the plot in detail is beggared by a rococo structure of interrelated events. The Baron meets Kringelein and then Flaemmchen (Joan Crawford) meets the Baron; then Kringelein meets Flaemmchen; then Preysing meets Flaemmchen, and later Kringelein and the Baron as well; once everyone has met everyone, the Baron makes his attempt to steal Grusinskaya's jewels but falls in love with her instead; Preysing makes his fraudulent business deal, and Flaemmchen becomes his sexual employee; Kringelein meanwhile tries desperately to seize what pleasures his dying body is capable of withstanding, a mission of petty hedonism that leads him first into conflict with his former boss, who happens to be Preysing, and then the Baron, who nobly refuses to steal from Kringelein despite his pressing need for money, and tries instead to rob Preysing, who kills him in the attempt. Thus Grusinskaya leaves for her next destination, unaware that her lover is dead; Preysing leaves for home financially ruined and under arrest; Kringelein leaves with Flaemmchen, planning to spend on her whatever time and money he has left; Senf the porter learns that his wife has given birth safely; Dr. Otternschlag, with the film's last line of dialogue, returns us to where we started in the first place: "Grand Hotel. People coming . . . going. Nothing ever happens." The film ends with nothing of the visual flourish that distinguishes its opening. In fact, after those first few minutes described above, it settles into a relatively workaday mode of narrative cinema, perpetually crowded and quickly paced, but never again approaching the speed of its opening montage of telephone calls, and never again indulging in a moment of pure visuality that matches the strangeness of the spectacular overhead shot that occurs soon after.

In many ways, the opening sequence of *Grand Hotel* serves as the perfect illustration for the "amazing hotel-world" that is the Waldorf-Astoria in 1905, when Henry James visits it in *The American Scene*. As soon as he enters the lobby, James writes, the thickly mediated space of the

hotel's interior "quickly closes round him," and the observer is "transported to conditions of extraordinary complexity and brilliancy. The air swarms, to intensity, with the *characteristic*, the characteristic condensed and accumulated as he rarely elsewhere has had the luck to find it."[56] This well-known section of *The American Scene* has been read from a variety of critical perspectives, and to these I would add my own observation that what James seems to stumble into here is the world of cameo appearances, where a traditional poetics of character has given way to one based on speed and scale.[57] "That effect of violence in the whole communication," James argues, "results from the inordinate mass, the quantity of presence, as it were, of the testimony heaped together for emphasis of the wondrous moral" (78). The "moral" that he derives from his visit to the grand hotel is, not surprisingly, sharper than that of Dr. Otternschlag, for James at least tries to isolate a cultural logic within the bewildering confusion of the Waldorf-Astoria's lobby, concluding that the "general truth" of this space lies in the "practically imperturbable" relation between "form and medium": "here was a conception of publicity *as* the vital medium organized with the authority with which the American genius for organization, put on its mettle, alone could organize it" (81). The conditions of supreme publicity that James describes at the Waldorf-Astoria result only in part from the brute facts of population and motion, and depend as much, if not more, on the complex arrangement of aesthetic display and economic imperative that becomes, so to speak, the very air one breathes.[58] These are not, however, conditions conducive to narrative; there is no "story" to tell about the "hotel-word," there is only a special effect and dream-vision to be described, "a gorgeous golden blur, a paradise peopled with unmistakable American shapes" (81). Perhaps it is this "paradise" we see from our fleeting vantage point suspended above the Grand Hotel's lobby, a lobby whose floor, as Donald Albrecht notes, bears a striking resemblance to a chessboard, an image that would no doubt appeal to Henry James as well, who witnesses in the hotel lobby "the sharpest dazzle of the eyes as precisely the play of the genius for organization."[59]

More surprising by far is that *Grand Hotel* serves as the perfect illustration for Gertrude Stein's *Everybody's Autobiography*, a text that features several scenes of communication that reproduce the film's opening sequence with uncanny fidelity. We left Stein having just had telephones installed at both 27 Rue de Fleurus and her summer home at Bilignin. But the telephone is ringing in *Everybody's Autobiography* long before Stein narrates the how and why of its relatively belated installation in her domestic world. The text begins with a short introduction that promises all the pleasures of a sequel—"Alice B. Toklas did hers and now anybody will do theirs"—yet the paragraphs that follow appear determined to provide as little continuity as possible from *The Autobiography of Alice B. Toklas*. We learn right of that Alice Toklas objected to the "B"; that Stein has been thinking a lot about Dashiell Hammett; that someone named Miss Hennessy carries a wooden umbrella. And while it is possible to pursue a phantom narrative logic to these distractions—Toklas's discomfort with how Stein named her might index larger questions of her "voice" in *The Autobiography*; Hammett's presence at the beginning suggests a connection between this book and the detective fiction that Stein was both reading and, in a highly experimental mode, writing—I am more interested in how this introduction seeks to represent a state of distraction as such, that is to say, a state of distraction that Stein equates with her newly earned status as star. "It is very nice being a celebrity," Stein writes, "a real celebrity who can decide who they want to meet and say so and they come or do not come as you want them" (2). Stein wants "celebrity" to name an experience of sovereign social power, a new order of agency in the public world. The actual workings of this power, however, involve a network of telephone calls and social contingencies that matches anything we see and, as importantly, hear in *Grand Hotel*:

> So Alice Toklas rang up Mrs. Ehrman and said we wanted to meet Dashiell Hammett.
> She said yes what is his name. Dashiell Hammett said Miss Toklas. And how do you spell it. Alice Toklas spelt it. Yes and where does he live. Ah that said Alice Toklas we do not know,

we asked in New York and Knopf editor said he could not give his address. Ah yes said Mrs. Ehrman now what is he. Dashiell Hammett you know The Thin Man said Alice Toklas. Oh yes said Mrs. Ehrman yes and they both hung up.

We went to dinner that evening and there was Dashiell Hammett and we had an interesting talk about autobiography, but first how did he get there I mean at Mrs. Ehrman's for dinner. Between them they told it.

Mrs. Ehrman called up an office he had at Hollywood and asked for his address, she was told he was in San Francisco, then she called up the producer of The Thin Man he said Hammett was in New York. So said Mrs. Ehrman to herself he must be in Hollywood. So she called up the man who wanted to produce The Thin Man and had failed to get it and he had Hammett's address. Mrs. Ehrman telegraphed to Hammett saying would he come that evening to dine with her to meet Gertrude Stein. It was April Fool's Day and he did nothing and then he looked up Ehrman and it was a furrier and no Mrs. Ehrman and then he asked everybody and heard that it was all true and telegraphed and said if he might bring who was to be his hostess he could come and Mrs. Ehrman said of course come and they came. His hostess but all that will come when the dinner happens later. (2–3)

There is a confusing tedium to this story's iteration of phone calls and telegrams, and it is obviously this tedium upon which its comedic ambition is based, as this anecdote amuses only insofar as it demonstrates to excess its own lack of narrative interest. Yet we might also notice a preciousness to the story's pursuit of redundancy, for while it details an acceleration of social media I'm sure we believe we already know too well, I think Stein treasures each event of communication required to bring Hammett to the dinner table. The flat syntax and hurried rush of noun and verb suggest there is nothing really to hold the reader's attention, and it is almost maddening to work through the particulars of exactly the kind of story we might expect to have condensed into some far less cumbersome form. But what's perversely interesting about this story is the illogic that looms behind its tedium: why does Mrs. Ehrman know to call Hollywood once she is told that Hammett is in New York? And what exactly does that last sentence mean? What tense are we left in? What temporality is being narrated? This story is, after all, comedic in the grand sense as well: "The theme of the comic is the integration of society," Northrop Frye reminds us, but just what sort of society is integrated by this extravagance of phone calls breeding ever more phone calls, and increasingly unmanageable amounts of mediated language adding up to ever decreasing amounts of meaning?[60]

A high society is certainly one answer. We do not, after all, look to the world of celebrity for economic representations of poverty and lack. And in historical terms especially, this comedy of communication is marked with signs of class and cosmopolitan privilege that had not yet lost their novelty in 1930s America. The number of telephones actually declined slightly in the first years of the Depression, this according to *Communication Agencies and Social Life*, a 1933 report produced by the President's Research Committee on Social Trends, which also documents for the "average" American an interval of roughly one and a half days (four for long distance) between phone calls, and more than six months between telegrams.[61] Stein thus accounts for several months of communication in just a few minutes, and though I do not want to make too much of this sociological contrast, I think it safe to say that *Everybody's Autobiography* relishes its own peculiar class decadence. "Every class has its charm and that can do no harm as long as class has its charm," Stein writes later in the text; neither the sound of nursery rhyme nor the metaphysical caveat that follows, "and anybody is occupied with their own being," salvages such a statement, whose inconsiderate politics are mitigated only by their glibness (173).

When Stein returns to America in 1934–35, at a time when Depression-era iconography routinely equated impoverishment with technological antiquity, her complete fascination with a world where

telegrams are dispatched without a second thought and the telephone rings constantly places her, as we shall see, in closer communication with Hollywood cinema than with any other cultural discourse of the period. The telephone was an essential emblem of class status and modernity, as Donald Albright has observed, whether on the desk of Jon Fredersen in Fritz Lang's *Metropolis* (1927) or on that of Larry Day, the absurdly wealthy stockbroker played by Douglas Fairbanks, Sr., in Edmund Goulding's previous film, *Reaching for the Moon* (1931)—his desk has sixteen phones on it, more than the entire lobby of Grand Hotel; and there are moments in the film when he "needs" each and every one, making deals with London and the Bourse, buying low and selling high, a manic vision of the economy that had been, until recently, doing big business. While it was certainly possible by the 1930s to treat the telephone as just another appliance in the standard American home, or as scenery around the office, it was also possible to make the telephone seem like a superlative necessity for those who make deals and live high—or must have dinner with Dashiell Hammett on a day's notice.[62]

Or, we might pursue another line of argument. That such scenes reference an iconography of class is still to insist on *reference* itself as a possibility under these conditions of rampant communication. As the camera cuts from phone booth to phone booth in *Grand Hotel*'s lobby, as Stein details the obscure signifying chain that finally brings her and Dashiell Hammett into actual contact, are we not witness to systems of media that serve no end so much as their own immense elaboration? Baudrillard makes what has become a common enough postmodern observation when he writes, "There is no longer any transcendence or depth, but only the immanent surface of operations unfolding, the smooth and functional surface of communication."[63] This seems to diagnose what we see in *Grand Hotel* and *Everybody's Autobiography*, because for all the noise of telephone calls and cameo appearances, there is also something relentlessly "functional" about these excesses of mediation itself, and even as we find ourselves increasingly unable to translate all these media events into a narrative or structure of reference, we also marvel at their uncanny fertility, the way each call breeds another call, each telegram breeds another telegram, and yet somehow the circuits of social life still manage to get closed, and thus Hammett shows up for dinner without ever knowing who invited him or why. What matters most, after all, about the telephone calls at the beginning of *Grand Hotel* is not who the characters are talking to on the other end of the line, but rather how their individual conversations talk to one another, establishing purely discursive relationships between these characters in advance of their later interactions in the real world. The film's two hours play out a game whose rules are established five minutes into the narrative, with all its subsequent combinations of star and plot already accounted for.[64]

In this regard, the scenes of communication I am describing look much like that depicted in an unlikely illustration of Baudrillard's point: Norman Rockwell's 1948 painting *The Gossips*. For all of Rockwell's obvious skill at representing physiognomy and affect, the fact remains that what this painting is about cannot be represented at all. The circuit of communication is perfectly and justly closed; "what goes around comes around" is no doubt this painting's homiletic teaching. Just *what* goes around, however, is irrelevant to the image. Rockwell's America has no shortage of juicy improprieties—perhaps a little drinking problem, some out-of-wedlock flirting at the ice cream social—and any of them might be captured in this image of transmission. That this image takes the form of a series of cameo portraits, disembodied pro files assembled in a montage of communicative action, suggests yet another aspect of its relevance to my discussion here. It is as if the very speed of the imaginary message demands that Rockwell start drawing the next figure before finishing the previous one, just as the pace of *Grand Hotel*'s editing finally overtakes the film's dialogue. And like the opening sequences of both *Grand Hotel* and *Everybody's Autobiography*, Rockwell's *Gossips* captures a network of total publicity that is both intimate and empty, a circuit that finally closes around nothing at all. More radically than Goulding or Stein, Rockwell presents

us with an image of pure communication—pure, that is, because it is completely uncompromised by reference and takes place nowhere in the real world. Familiar as we all are with countless Rockwell images of small-town America, it is easy to imagine the shady streets, barbershops, coffee shops, and quaint kitchens where all these exchanges are happening, but it is precisely the absence of these spaces that makes this image so compelling. "The simulation of distance . . . between the two poles of the communication process is," Baudrillard writes, "just a tactical hallucination 'Reality' has been analyzed into simple elements and recomposed into scenarios of regulated opposition" (142). Nothing could be "simpler" than a Norman Rockwell painting, especially one that depicts what is, after all, only the children's game of "telephone" at work in the world of adults. Yet this painting crystallizes one of the most radical conclusions we might draw from the scenes of communication that open both *Grand Hotel* and *Everybody's Autobiography*: that "communication" itself no longer exists to bear our representational burdens so much as we exist for its perpetuation—at whatever cost, and on terms we need not understand.

The Static of Sex

Stein concludes the introduction to *Everybody's Autobiography* by relating another anecdote of her newfound celebrity, though this second story aims at teaching a much different lesson about American fame and its consequences. Also different is the particular technology of fame at the heart of the matter. Stein's dinner with Hammett is the product of what we would now call "net working," a late-modern verb that was still almost exclusively a noun in the 1930s.[65] The introduction closes, however, with Stein offering one of literature's first accounts of the photo opportunity, a practice of celebrity that indexes fame's iconic dimensions just as surely as the noise of telephoning captures something of fame's extreme discursivity. What Stein makes clear at the beginning of *Everybody's Autobiography* is that being a celebrity demands a great deal of communication—both verbal and visual.

While in New York during the first weeks of her U.S. visit, Stein and Toklas are asked to a tea at which "a short little woman with a large head" is present, and also a woman to whom Stein pays little attention until someone informs her that she is Mary Pickford, "America's Sweetheart." "We were asked to meet each other, Mary Pickford and I," Stein writes, ". . . and then, I do not quite know how it happened, she said suppose we should be photographed together. Wonderful idea I said" (5). But as the story continues, Stein begins to understand that celebrity involves a subtle calibration of competing interests and desires for publicity. There is an economy of fame, a logic of supply and demand that keeps some stars apart even as it brings others together. Mary Pickford's cameo appearance becomes crucial for *Everybody's Autobiography* because it hints at this underlying economy, and also suggests that not "everybody" might want to have their picture taken with Gertrude Stein:

It is funny about meeting and not meeting not that it makes any difference if you don't you don't if you do you do. Nathalie Barney was just telling me that her mother often asked her to come in and meet Whistler. Even if you do not care about his pictures he will amuse you, she said, but Nathalie Barney was always busy writing a letter whenever her mother happened to ask her and so she never met him. Mary Pickford said it would be easy to get the Journal photographer to come over, yes I will telephone said some one rushing of, yes I said it would be wonderful we might be taken shaking hands. You are not going to do it, said Belle Greene excitedly behind me, of course I am going to I said, nothing would please me better of course we are said I turning to Mary Pickford, Mary Pickford said perhaps I will not be able to stay and she began to back away, Oh yes you must I said I will not be long now, no no she said I

think I had better not and she melted away. I knew you would not do it, said Belle Greene behind me. And then I asked every one because I was interested just what it was that went on inside Mary Pickford. It was her idea and then when I was enthusiastic she melted away. They all said that what she thought was if I were enthusiastic it meant that I thought it would do me more good than it would do her and so she melted away or others said perhaps after all it would not be good for her audience that we should be photographed together, anyway I was very much interested to know just what they know about what is good publicity and what is not. (5–6)

There is of course no way to know just what's happening "inside" Mary Pickford as she decides against a photograph with Gertrude Stein. The collective wisdom of those at the scene articulates a sort of second law of thermo dynamics for the rich and famous, making any net gain for Stein necessarily a net loss from whatever publicity Pickford might garner. We might also pursue another explanation, one that takes special notice of Nathalie Barney's mention here and questions whether something about the sexuality of Stein's modernity contributes to Pickford's concerns that the association "would not be good for her audience." Barney, after all, was a significantly more notorious lesbian than Stein, having been memorialized in a 1914 book entitled *Letters to an Amazon* and having long presided over a Parisian salon that easily rivaled the artistic and literary glamour of 27 Rue de Fleurus. That Barney's lone cameo appearance in *Everybody's Autobiography* occurs in such close proximity to Pickford's vague discomfort is hardly conclusive, but it is certainly curious, which is how Stein's sexuality seems to figure for many while she is on tour in the United States. The indirect communication—or better, direct miscommunication—of her homosexuality is very much the point of a headline like "Gertrude Stein, Not a Freak, Limits Her Audiences to Five Hundred," an announcement made by the *New York Herald Tribune* on October 29, 1934, about a sold-out lecture. As Terry Castle notes, "freak" was one of several words used from the eighteenth century forward to disclose lesbian identity without saying it out loud, and while references to Stein's linguistic eccentricity often trafficked in a vocabulary of the weird ("the babblings of the insane," according to one article in the *New York Times*), the play of sexual innuendo strikes me as highly intentional here, especially in relation to other press coverage from the period.[66] "'Yes, I Am Married,' Says Gertrude Stein," according to a *New York Herald Tribune* story on May 13, 1935. Perhaps playing of Stein's own teasing approach toward Toklas's de facto married status in *The Autobiography—Wives of Geniuses I Have Sat With* reads one alternate title weighed at the end of the narrative—Stein's immediate qualification, "I mean I am married to America, it is so beautiful," only accentuates the sexual indeterminacy that surrounds the relationship between Stein and Toklas in the public imagination of the period. "Has Gertrude Stein a Secret?" asks B. F. Skinner in the pages of the *Atlantic* in 1934. The ostensible subject of his investigation into what he calls her "true second personality" is not her sexual identity but rather her early exposure to automatic writing while a psychology student at Harvard. Gertrude Stein most definitely has a secret: that she authored, along with Leon M. Solomon, a scientific paper titled "Normal Motor Automatism." This is hardly the stuff of which pornography is made, and there is little titillation to be had from exposing Stein as—what else?—a former medical student; but on another level, what matters more is that something about Stein encouraged this flirtation with her homosexuality even as it remained ostentatiously undisclosed by the abundant references to her "mannish" attire and her affection for her secretary and "traveling companion," whom Stein sometimes calls "Pussy," according to one newspaper article.[67] Has Gertrude Stein a secret? The answer is of course "yes" and by the way, it's not about sex.

The question in which I am interested, however, does not concern our knowledge about Stein's sexuality—what did Mary Pickford know and when did she know it?—so much as it concerns the means by which knowing sex is transposed into a question concerning communication itself. I

could pursue this line of argument on largely theoretical grounds, revisiting "the epistemology of the closet" and the "open secret" of homosexuality in modern culture, or Castle's departure from each.[68] But what continues to surprise me is that I don't have to: the communication of sexuality and desire is in fact an explicit concern of both *Everybody's Autobiography* and *Grand Hotel*, and both texts are determined to make the noises of sex as loudly as possible while demurring from any representations of sex as such, a strategy of oddly carnal reticence that depends, somewhat perversely, on telephones on the one hand and dogs on the other. This is not to say that either telephones or dogs function as mere indexes of lesbian sexuality; the circuits of suggestion and intimation that link dogs, telephones, and sex are rather far from direct, and it is the excessive verbosity of such a mimetic circuitry that seems finally to make it so appealing to all involved.

Consider the following sequence of events concerning Stein's servant, an "Indo-Chinaman" named Trac. By this point in *Everybody's Autobiography* Stein has made a kind of Orientalism into a repeated motif, around which various attitudes toward race and identity coalesce, though this is a matter that warrants a full discussion at some later time.[69] I want to focus instead on the way Stein suspends the sex of Trac's object of desire within a flurry of media and communication (in its older sense as well, signifying physical transit and not just the exchange of information):

> Trac did not go out in the evening, that is to say he did not like to go out in the evening because if he did it might be frightening and he began to talk about everything. . . . And then he began to talk about having a comrade with him. Yes we said. But will he come, well no said Trac he will not not when I tell him how it is about not going out, yes but when there are two of you you can go out we said well anyway said Trac it is very distracting and I do not work well when I am distracted, yes we said but you said you would, yes he said well I will write to my comrade again.
>
> Three days after he announced the comrade was coming. That is fine we said to tell him to telegraph the train by which he is leaving and we will go and call for him we said. Yes said Trac here is the letter. Yes we said but this is written by a Frenchwoman she is writing for him, no said Trac that is the comrade, what said we, yes said Trac that is the comrade, what said we, yes said Trac that is the comrade. Oh no we said not at all, and I said, if I want a Frenchwoman I will choose her, not for me said Trac, no I said no you have to telegraph her of I said, it is too late said Trac she has her ticket, well telegraph it of we said, I have no address says Trac besides she has started. Well I said come on we will meet her and Trac and I went to meet her. We met her. She was the largest fattest Bretonne I have ever seen and dear me. Well there we were. (164–165)

To say that this is all "very distracting" is, I think, to speak directly to what matters most here. Earlier in *Everybody's Autobiography* Stein writes, "A distraction is to avoid the consciousness of the passage of time" (61), but clearly what is avoided in this passage is the gender of Trac's "comrade," and among the letters, telegrams, and arriving trains, it is difficult to know just who wants a French woman and who, if anyone, will pick her out. The reader, like Stein herself, expects Trac to be bringing a man home: the heterosexual option here is the altogether perverse one. But Stein's characteristic parataxis allows for, and perhaps actively demands, a great deal of misinterpretation, as ever more information is relayed by syntactic inversions and the same pronouns are repeated without regard for their antecedents. While some sense of the normal order of things—in terms of sex, if not exactly ethnicity—returns when all this communication comes to an end, we are still left with the impression that the speed at which modern life is lived can breed a certain promiscuity, a sexual energy that cannot be fully contained because it is always in communication, somewhere in the wires and all the mediated language that they carry back and forth. The mediated character of modernity, simply put, makes for strange bedfellows—never mind sexuality.[70] I want to make

an explicit comparison between this moment in *Everybody's Autobiography* and one of the most memorable sequences in *Grand Hotel*, again not because any direct influence is likely, but rather because the sheer coincidence of certain devices, technically speaking, illuminates something crucial about the mediated life that both texts describe. I am thinking of a sequence near the end of the film that brings several plot lines to a dark culmination by connecting them to one another by means of the telephone. Garbo's last scene in *Grand Hotel* (save a few seconds that show her final departure from the hotel) takes place immediately after Preysing has killed Baron von Geigern, having caught the genteel thief in the act of stealing from his suite. This scene is morbidly concerned with the telephone as well: Preysing beats von Geigern to death with a telephone, and the reaction to the crime is registered immediately by the hotel's switchboard operator, herself a witness to the crime over the open phone line. When the film then cuts to Grusinskaya's suite for Garbo's last scene, the telephone remains an overdetermined presence in the narrative. The essence of the scene is that Grusinskaya is completely ignorant of her lover's death by telephone, and this point is made clear with truly melodramatic redundancy. Garbo first notes, "The music has stopped." She pauses, then adds, "How quiet it is tonight! It was never so quiet in the Grand Hotel." Still determined to communicate its irony, the film next has Garbo turn to a large bouquet and observe, "Those flowers . . . make me think of funerals." It is now that she picks up the phone and asks to be connected with Baron von Geigern. The next shot cuts to a dimly lit interior, a ringing phone, and the Baron's dachshund alone on the bed, craning its neck toward the phone, which will, alas, never be answered. We cut back to Garbo as she responds to the voice of the operator (though we do not hear it ourselves): "Well, keep ringing. He must be asleep." What is striking about Garbo's monologue from this moment until its conclusion is that it is not, technically speaking, the soliloquy it sets out to be. Garbo hums. She pleads to the telephone, "Come and fetch me, *mon cheri*, I'm longing for you. I haven't been asleep." She takes the phone from her face and cradles it like a baby, like her lover's head, like an object that has been invested by cathexis with a wild surplus of longing and desire. "I kept thinking that you, that you might come to me," she says. All this lover's discourse pours out to the lover who can no longer hear it, which is not at all to say that no one is listening. For Garbo's next line is another answer to the silent interruption of the operator: "But he must answer. Ring . . . ring . . . ring! Oh *cheri*, why don't you answer the phone please?" And after another short pause, Garbo again instructs the operator, "Yes, yes, yes. Ring, ring." Twice then, we are reminded that Garbo's monologue is also dialogue, surreptitious and overheard by the operator, whose vantage is both quietly instrumental and deeply voyeuristic, and in this latter regard, whoever she is, she listens in much the same way we do in the audience—not just hearing Garbo as she makes love through—and to—the telephone, but *overhearing* her.

The caption beneath this image of Garbo on the phone, taken from an "official" 1980 MGM biography, reads more suggestively than anything I would dare invent to describe this scene's implications for *Everybody's Autobiography*: "She related to objects so magically that leading men were often not missed. In *Grand Hotel*, Garbo's best love scene was played to a telephone."[71] It would be surprising to find any reactions from the actual time of the film's release that were so forthright with their innuendo, but this should not cause us to discount the possibility that at least some in the audience took note that Garbo was, however vicariously, making love to a woman on-screen for one of the few times in her career. That this erotic exchange also depends entirely upon the technology that keeps this other woman of-screen is the aspect of this sequence I want most to emphasize: the telephone represents a whole matrix of sexual possibility that any contact in the flesh must necessarily terminate, and so in a very strange way, the hint of something lesbian here is perhaps less troublesome than what is offered by the joke that gets this hint across, namely the possibility that no one person might be as desirable as the elaborate network of devices and discourse that takes his—or her or their or our—place. "I want to be alone," Garbo's signature declaration of erotic inaccessibility, takes on a different meaning altogether in the age of the telephone, when isolation

itself becomes a state of intense arousal and promiscuous connectedness.[72] What informs a great many narratives of mediated desire—whether concerning the telephone, or as we have seen, the telegraph—is the stubborn indeterminacy of that "you" who is wanted on the other end of the line. There is an exquisite degree of communicational malfunction at work in both the low comedy of Trac's surprising romance and the high melodrama of Madame Grusinskaya's misdirected wooing; one might even say that "perverted" is just the right word for how these messages are interrupted, rendered somehow wayward, left unanswered, and ultimately relayed to "wrong numbers." At the same time, to speak as Ellis Hanson does of "the telephone and its queerness" is to imagine a sexualization of technology that is considerably too precise for either *Grand Hotel* or *Everybody's Autobiography*, at least so far as the story of Trac's long distance, and then troublesomely present, "comrade" is concerned. Sex of any kind—between men, women, or men and women—would close the circuit, threatening the very field of sexual possibility that remains open so long as sex itself remains an impossibility. The price of the medium, to return to McLuhan, is the massage—the embodied, the sensual, the physically material.

Yet something of the carnal does inhere in these frantically mediated sexual encounters, and I think it might best be pinned down by recalling for a moment the performance of the only other actor to appear on-screen during this sequence of *Grand Hotel*, and that's the Barons dog, Adolphus. Simply put, there is a direct connection between the carnal and the canine at this point in the film, and this emblematic relationship emerges with even greater force in *Every body's Autobiography*. For the dog's symbolic function throughout *Grand Hotel*, as a conventional sign of the Baron's deep goodness despite his compromising choice of profession, also indexes, albeit fleetingly, one of the most pervasive icons of the period. Why a dog here? And why a dog in *Grand Hotel*, where any and all relations are subject to the deadly interference of speed, money, and technology? Perhaps there is a more than distant relation between Adolphus and Nipper, the famous "Victor Dog" of Francis Barraud's 1899 painting, which subsequently became the trademark image of the Gramophone Company and later the exclusive property of RCA. As Michael Taussig has argued, this image seeks to codify and memorialize a notion of "fidelity" in several senses of the term, both as a characteristic of the phonograph and its "mimetic superpower" and as a moral sentiment, an encompassing "loyalty" that will persist no matter how confounded by new technologies of the virtual and the simulated.[73] The sentimentality of this picture, alternatively known by the title "His Master's Voice," is more than matched by its modernity; for even as Nipper provides a deeply comforting image of technology's new subject, the phonograph at which he puzzles is the occasion for a series of questions that the image itself does not answer, not the least of which concerns the fate of the master whose "voice" the picture names but of course cannot make visible. Whether a record of the dead, or of the merely absent, the voice of the phonograph speaks from a position of great loss: the original Nipper belonged to the artist's dead brother. It is in this regard especially that Adolphus shares a curious and melancholic kinship with the "Victor Dog." Nipper answers to a machine as if it were its master; Adolphus turns to the phone as if it were the Baron; and on the other end of the line, Garbo seduces the phone as if it were her lover. All three look to the "magic" of technology to compensate for the man they miss, which is not the same thing at all as the man they *need*. Whatever consummation—of heterosexual desire, of marriage plot—this dachshund's cameo appearance marks as impossible, Adolphus also signals a new series of erotic possibilities, of connections that Grusinskaya might not have chosen for herself but that, as Garbo's performance makes memorably clear (one must simply hear her plead with the telephone, "Ring . . . Ring . . . Ring!"), are exploited with considerable emotive hyperbole. A bizarre love triangle indeed emerges between Garbo, a telephone, and a dachshund: human, machine, and animal in a single, inoperable circuit of sexualized communication, each imparting a fetishized functionality upon the next point in the relay—Adolphus in place of narrative and sexual closure, the telephone in place of the absent male lover, the operator's voice in place of the audience, and the whole complicated network of

desire and displacement beggaring by comparison any "love scene" between Garbo and Barrymore that a different ending would allow. There is, to put the matter simply, a lot more desire to go around when all it *can* do is go around.

A constant refrain throughout Stein's writings of the later 1930s, in both *Everybody's Autobiography* and *The Geographical History of America* (1936), is the crisis of identity she registers with every repetition of the sentence "I am because my little dog knows me."[74] The accumulated force of this oddly sentimental, ontological declaration as it resonates through Stein's writing suggests another unexpected coincidence with *Grand Hotel*. And accumulate it does: "I am I because my little dog knows me" begins the play "The Question of Identity" in *The Geographical History of America* (99); later in the play, the relationship is complicated—"I am I because my little dog knows me, even if the little dog is a big one"—but the basic terms that relate identity remain unchanged; and near the end of *The Geographical History* , Stein borrows the language of a children's song, as if to stress the dramatic simplicity of her dilemma: "The person and the dog are there and the dog is there and the person is there," Stein writes, "and where oh where is their identity" (234). The very popularity she enjoys after the publication of *The Autobiography* is widely considered to have initiated Stein's identity troubles, and while recent critics, such as Charles Bernstein, have looked elsewhere, to "Stein's triple distance from the ascendant culture (gender, sexual orientation, ethnicity)," in search of ways to understand "I am because my little dog knows me," *Everybody's Autobiography* offers strong evidence that this sentence and its many variations address more particular problems of fame, publicity, and a new economy of writing.[75]

Recall that Stein's first act of popular, and thus financial, success is to purchase a coat and two collars for Basket (a white poodle named for a similar dog in James's *The Princess Casamassima*) (41). Stein's first moment of anxiety about success is similarly triangulated by reference to her poodle; thus just a few pages later, she writes, "It is funny about money. And it is funny about identity. You are because your little dog knows you, but when your public knows you and does want to pay for you and when your public knows you and does not want to pay for you, you are not the same you" (46). There is an instant of hesitation when the hint of chiasmus suspends her identity, along with "you" her reader, amid dog and public, money and no money. This grammatical travesty of cause-and-effect logic—who exactly is it that pays for "I" the reader? What public knows "me" in the privacy I share only with the book itself?—is pursued with even more gusto later. "I had always been I because I had words that had to be written inside me," Stein insists, "and now any word I had inside could be spoken it did not need to be written. I am I because my little dog knows me. But was I I when I had no written word inside me" (66). The spoken—a category that Stein extends to include the newspaper—is language without resistance, "and so writing naturally needs more refusing" (48). But was Stein Stein without writing, with reporters hanging on her every spoken word? Such grammar provides an excess of "refusing," performing the writerly resistance to too easy representation that Stein worries over in the aftermath of her fame. What such a performance does not provide, however, is an answer to the very question it poses, for this kind of language, as Bernstein rightly concludes, is more concerned with "holding of naming to see what otherwise emerges" than with making some stable determination of what "identity" is and what dogs have to do with it.[76] The dog in all these formulations is a figure of indeterminate yet absolutely essential feedback, placing one effect of identity—"I am"—in communication with a cause that causes nothing, even as it displaces questions of identity onto questions of relation—"because my little dog knows me." It is not so much *what* the little dog knows—who can know, after all?—but *that* it knows, that allows Stein to change the rules of the game. "But we we in America are not displaced by a dog," Stein writes in *The Geographical History*, "no no not at all not at all displaced by a dog" (100). But "displaced by a dog" is exactly what Stein is in America, her hesitating disavowals notwithstanding, and it is this way of being displaced that gives Stein a language capable of simultaneously deferring from, and referring to, the phenomenon of celebrity, as an experience of language, of class, of

publicity, and eminently one of mediation. Like Adolphus in *Grand Hotel*, Stein's "little dog" also has some bearing on knowledge of a more intimate sort.

"Everything changes," Stein notes soon after the telephone is installed at 27 Rue de Fleurus and the summer house in Bilingnin. "I had never had any life with dogs and now I had more life with dogs than with any one" (49). This is, on the one hand, a simple statement of biographical fact: having purchased Basket in 1929, Francis Picabia gives Toklas and Stein a chihuahua, which they name Pépé (a perhaps impolitic nod to its imagined ethnicity). But on the other hand, Stein and Toklas's "life with dogs" is a sly suggestion of the domestic itself, a way of acknowledging "community property" and putting on display an erotic relationship that was otherwise unrepresentable. I confess that I am taking some license here, and perhaps reading too much into the accompanying details of Stein and Toklas's daily existence. Yet isn't there a difference between an image like the Man Ray photograph that serves as the frontispiece to the first edition of *The Autobiography* and this Cecil Beaton photograph from 1938? and isn't it the dog that makes this difference especially telling? Around 1934 we see a marked shift toward pictures of Stein, Toklas, and their dog(s); a 1994 visual biography of Stein features half a dozen such images, none of which date from the period between 1929 and 1934, even though Basket was an available prop during those years as well.[77] As oblique family portraits, images like these evidence, at the very least, a willingness to play with an iconography of domestic intimacy that seems not to have been so appealing just a few years earlier. As suggestively as any buzz of innuendo surrounding Stein and Toklas in U.S. press coverage of their lives and travels, a "life with dogs" discloses their mediated partnership and shared affection; that these are not particularly brazen aspects of homosexuality in no way delimits their sly refashioning of the utterly normative—a "life with dogs"—as the potentially curious. As critics have been pointing out, Stein did pursue a variety of strategies for the representation of sexuality throughout her career, most notably in texts such as the early novel (later published as) *Q.E.D.* or in poems such as "Lifting Belly." What we see in images like this Beaton photograph and read in Steins constant references to the dog's life, testifies to a much different representational strategy that falls just short of reference to a space of privacy that may or just as well may not, hold sexuality as its defining secret. In this regard, the sense of a formal interiority that one gets from Beaton's photograph is revealing in exactly the degree to which it is the opposite of risqué. Framed on its left edge by one opened door, with Stein standing before another in the right middle ground and Toklas sitting in the far depths of the image past still one more threshold, the photograph establishes both a thematics of entrance into closed interiors and an overwhelming formal insistence on classical perspective, enforcing a strict geometry toward the vanishing point of Toklas herself, strikingly illuminated and captured with great depth of field. Stein offers more resistance to our inward scrutiny than does Basket, who seems not so much a Cerberus in lamb's wool, on guard against deeper penetration, but rather on par with Toklas, matched in their shared diminution in respect to Gertrude Stein. What might Stein's gesture of discipline be preventing? Is Basket about to leap up with affection, obscuring Toklas from view entirely and thus ruining the picture? Or is he instead being kept in place, ensuring that the whole "family" is arranged just so for the camera? This captured moment of drama between Stein and Basket, whatever its irrecoverable meaning, also has the effect of keeping us, as viewers, in our place: we enter the recesses of the image solely on Stein's own authority, though to what end that authority is directed only her little dog knows. Toklas is demurely situated in anticipation of some "wives of genius" to sit with, while Stein commands not only the family dog but also the viewer's access to the private confines of the home. Yet even this rather conservative reading of the image (of somewhat limited biographical accuracy, too) unleashes, as I ruefully might put it, the possibility of a domesticity entirely between women, and an equivalent of marriage in which the "man of the house" is a strictly performative role, a fiction of gender that anybody, or better still, "everybody," can effect.

Given the utter impossibility of any physical intimacy between Stein and Toklas as they are represented in this picture—indeed, Toklas is so thoroughly distanced here that at first glance she could be mistaken for a child—I am tempted to argue that the price to be paid for any imagining of same-sex domesticity is the comprehensive repression of the sexual. That Basket is so sternly kept down suggests that there is little chance of opening the door and catching sight of some unexpected show of compromising, carnal animality. But I would not want to go so far as to accuse this image of telling what Catharine R. Stimpson calls the "lesbian lie," the politically fraught untruth "that no lesbians lie abed here," which Stimpson insists must be read *through* before any sense can be made of Stein's more popular writings of the 1930s.[78] The semiotic function of dogs in and around *Everybody's Autobiography* is no more or less sexually misleading than a remarkable bit of euphemism we find at the end of *The Thin Man* (1934), the very film, coincidentally enough, that is being made from Dashiell Hammet's best-selling detective fiction when he makes his crucial cameo appearance in Stein's narrative of her American tour. For not only does the film version of *The Thin Man* employ the telephone throughout as the only visible sign of the eponymous figure at the center of all the mystery, intrigue, martinis, and *entendre*; it also concludes with a scene of considerable interest in light of Stein's life of publicity as a "life with dogs." Nick and Nora Charles, played by William Powell and Myrna Loy, retire to their sleeping compartment aboard the cross-country train on which they're bound for California. Nora instructs Nick to put their terrier, Asta, in bed with her; Nick has different arrangements in mind, and with a caddish "Oh yeah?" throws Asta on the top bunk, where he paces back and forth for a few frames before he lies down and covers his eyes with his paws in a gesture of effectively pornographic propriety. (Cut to a shot of the speeding train as the music swells for the closing cred its: "California, Here I Come.") In the aftermath of the Hollywood Production Code, sex of any kind was subject to new protocols for on-screen representation, and even the hint of a wholly normative coupling between man and wife thus demanded a circuitous symbology, decorous and yet transparently suggestive of exactly the sex that so insistently was not being shown.

It is guesswork on my part to wonder if *The Thin Man* actually informed *Everybody's Autobiography*, though Stein does carry on a running discussion of detective fiction and Dashiell Hammett throughout the book, and she had just completed *Blood on the Dining Room Floor*, her own peculiar contribution to the genre. That said, the connection is worth pursuing a bit further. Because there is clearly no "heterosexual lie" upon which *The Thin Man* depends; the dog does not represent the obliteration of sex so much as its translation into a more arcane symbolic language, one more mediated but hardly bent on the epistemological denial of what's going on in the bunk below. Asta chastely covers his eyes precisely because he knows, which is as much for the text to admit that we know too as we watch from our considerably less intimate vantage point. What Basket knows is a problem of considerably greater elusiveness, and I am not suggesting that Stein's repeated references to dogs in and around *Everybody's Autobiography* indicate a simple structure of displacement undone with a single interpretive gesture. "I am because my little dog knows me" neither announces out loud nor secretes away the truth of Stein's sexual identity, but rather communicates that identity in much the same way that the telephone communicates her social identity as a celebrity or her economic identity as a best-selling author: with a great deal of interference.

There is just one instant of raw, unmediated connection in *Everybody's Autobiography*, and Stein's representation of this encounter says much about the strange publicity of sex in a culture that is saturated with media. Stein describes an incident between two dogs that seems to beg the question of just what must be repressed in the making of a public "Gertrude Stein," but as this question shades almost imperceptibly into one about technologies of representation, it becomes clear that a "life with dogs" is no alternative to the mediated life of fame and celebrity. The unknowable interiorities that are signified by all these little dogs are always in communication with the outside world. As early as 1913, in *A Long Gay Book* (published in 1933), Stein had

claimed that "a life which is private is not what there is."[79] But even if private life *isn't*, perhaps the exposure of one's privacy may still be limited to nothing more than the occasional and fleeting cameo appearance, such as that which punctuates the passage below. To prevent the thread of the narrative from becoming lost—a situation practically guaranteed by Stein's narration—let me say up front that the story involves Stein and Toklas trying to get to Chicago in time to see an opera. "If things do not take long," Stein begins aphoristically, "it makes life too short." She continues in the next paragraph:

> They telephoned there is plenty of time if you come by airplane. Of course we could not do that we telephoned back, why not, they said, because we never have we said, we will pay for your trip the two of you forward and back they said, we want to see the opera we said but we are afraid. Carl Van Vechten was there while all this was going on, what is it, we explained, oh nonsense he said of course you will fly, we telephoned back we will pay for the three of you. All right we said and we had to do it. Everybody is afraid but some are more afraid then others. Everything can scare me but most of the things that are frightening are things that I can do without and really mostly useless unless they happen to come unexpectedly do not frighten me. . . . I told all this to Carl and he said I am coming and so we did not think about it again. We went on doing what we were doing and then one day we were to meet Carl and fly and we did very high. It was nice. I know of nothing more pleasing more soothing more beguiling than the slow hum of the mounting. I had never even seen an airplane near before not near enough to know how one got in and there we were in. That is one of the nice things about never going to the movies there are so many surprises. Of course you remember something, two little terriers that belong to Georges Maratier began fighting their servant had been visiting her uncle who is our concierge and the two of them a wire-haired and a black Scottie both females they should not but they do were holding each other in a terrifying embrace. The girl came and called me, people always think that I can do something, anyway as I went out I always go out when I am called I remembered I had never been near a dog fight before I remembered in the books you pour water on them so I called for cold water in a basin and poured it on them and it separated them. The white one was terribly bitten. Reading does not destroy surprise it is all a surprise that it happens as they say it will happen. But about the airplane . . . we liked it and whenever we could we did it. They are now beginning to suppress the noise and that is a pity, it will be too bad if they can have a conversation, it will be a pity. (195–196)

Here we witness a still more perverse coupling of dogs and telephones. This highly impacted sequence of narrative, which begins with a now familiar scene of communication, is all but overwhelmed by whatever it is that takes place between those two female dogs, "holding each other in a terrifying embrace": "they should not but they do." To remark, blandly and without affect, that "of course you remember something," and then to illustrate the axiom by remembering *this* of all things, suggests the manifestation of a sexual unconscious that has been all but banished from the surface of the text itself, as if only by means of this seemingly random act of memory can Stein let us know what all the text's "little dogs" have known from the beginning; that even the young girl on the scene assumes Stein's familiarity with such erotic violence further adds to the sense of overdetermination, to the sense that here is something startling and revelatory about Stein and sex—much has been made, after all, from moments in Henry James and others that are altogether less "bestial" and pornographic than this.[80] Yet there is also a deliberateness to the choreography of this passage's shock effects that brings to mind a different mediating context for the significance of this sexualized outburst, which strikes me as having more to do with the throwaway reference to cinema than might be guessed. For Stein's passing comment about never "going to the movies" and the "nice things" that result does manage to imply a sort of reverse phenomenology of surprise as

a basic provision of film experience. What Stein in effect describes is a particular susceptibility to being astonished that survives only so long as the movies are avoided, or phrased another way, a mental conditioning provided for by film that accommodates us to modern life, circumscribing our psychic exposure to a new concentration of traumas, spectacles, and violent stimuli.

The "two little terriers" whose frenzy of bodily contact Stein so inexplicably remembers are, I admit, about the last things that would seem to "correspond to profound changes" in the modern subject's sensory field; but there they are, making a tremendous spectacle of themselves, and right in the middle of a passage where such notable icons of the modern as airplanes and telephones barely register in comparison.[81] The exchange of telephone calls about the trip to Chicago, for instance, marks the twelfth or thirteenth appearance of this very set piece, with each recapitulation further quieting the noisy strangeness of the new communicative environment of celebrity that Stein enters at the beginning of the text. The possibilities of electrical media are treated here as simple conventions for the representation of reported dialogue, as if "we telephoned" carried the exact semantic weight of "we said." And of course it shouldn't: the whole point of the passage is that time and space have, in fact, been annihilated according to program, that *now* "there is plenty of time" in America, because communication by telephone and airplane indicate a new temporality that might not make sense, but doesn't appear too disturbing for all the disjuncture it involves. The bland, all-purpose adjective "nice" defines the three-word sentence that encapsulates Stein's first experience of flight. This suggests an amenable modernity, at least until the movies are mentioned and the narrative abandons its own "slow hum" for a violent memory.

Stein has almost nothing kind to say about the movies in her account of the very tour on which she repeatedly proclaimed their historical significance. Thus, in "Portraits and Repetition," one of her public talks from 1934–35, Stein says that "funnily enough the cinema has offered a solution" to the demands of a modernist portraiture by combining seriality and singularity in the same technology of representation; but in *Everybody's Autobiography*, the cinema figures more as problem than "solution," and the trouble involves what Stein describes as a new kind of publicity to everyday life in the cinematic America she observes. Writing of "the wooden houses of America," Stein notes that "less and less there are curtain and shutters on the windows . . . and that worried me"; she then goes on to draw a much larger conclusion about how open windows make good neighbors in America, whether you want them or not, since "as everybody is a public something and anybody can know anything about any one and can know anyone then why shut the shutters and the curtains and keep any one from seeing, they all know what they are going to see so why look" (189). Stein's logic here seems to assume a social network of universal surveillance, with the power to look so democratically distributed that nobody, as Stein might say, needs to exercise it because "everybody" else, in their transparent homes, has already made sure that there will be nothing to see. Yet Stein also evokes something of the relational identity she formulates around the little dog who knows her, except in this case, the other one who knows who makes us what we are implies a self of maximum publicity, not indeterminate privacy. And when Stein returns to the subject of domestic space in America just a few pages later, she argues that this social visibility is a patently cinematic condition: "In America they want to make everything something anybody can see by looking. That is very interesting, that is the reason there are no fences in between no walls to hide anything no curtains to cover anything and the cinema that can make anything be anything anybody can see by looking" (202). And when confronted with her own spectacular image on-screen, Stein retreats with just the slightest hint of an anti-modernism that we rather might expect of Henry James or Henry Adams: "I saw myself almost as large and moving around and talking I did not like it particularly the talking, it gave me a very funny feeling and I did not like that funny feeling. I suppose if I had seen it often it would have been like anything you can get used to anything if it happens often but that time I certainly did not like it and so when the Warners asked us to come and lunch we did not go" (288–299).

Stein's discomfort here with what she was simultaneously declaring to be the representative medium of her period indicates an inconsistency in her position, a blind spot, quite literally, where the cinematic modernity that she imagines is finally reckoned against her having almost no firsthand experience of the movies. We might well expect this moment to ratify the fantasy of celebrity that Stein indulged in *Photograph*, a 1920 play that also considers the question of a mechanically reproduced self, but at a moment of relative obscurity in Stein's career. "For a photograph we need a wall," the text begins, "Star gazing. / Photographs are small. They reproduce well. / I enlarge better."[82] But perhaps by the time of *Everybody's Autobiography*, Stein has learned that publicity is governed by a different genius, and so she tells Charlie Chaplin, of all people, that "having a small audience not a big one" is what has produced, perversely enough, her amazing popularity in America (292). Thus the very magnitude of cinematic exposure threatens to violate this principle of the market, potentially delivering to Stein an audience so sizable that it could leave her without "publicity" altogether.

Or, what finally gives Stein a "funny feeling" about the movies might be the threat of exposure of a wholly different kind. For there is still that inexplicable cut in the narrative from the shock effects of film to the little terriers of Georges Maratier; the conceit of a syntactic connection between the two ("of course you remember something . . .) resolves nothing, and though the dialectical image of "the movies" juxtaposed with the erotic is certainly suggestive, I hesitate to call it decodable, much less transparent—like the houses of America—in making visible a sexuality that Stein wants to keep inside but that film itself somehow forces out. The representations of mediated sexuality in Stein's texts of the 1930s defy such gothic alternatives, such logics of *either* repression *or* unconscious revelation. "I am because my little dog knows me" implies nothing so much as a zone of privacy within the language of identity, a way of showing who you are without saying what you are. Language, simply put, is the technology that allows Stein and Toklas to make little more than cameo appearances in the very texts in which they star. Bennet Cerf, Stein's chief promoter at Random House, didn't know how much he was saying when he called her "the publicity hound of the world."

Gertrude Stein Superstar

The cultural circuitry that this chapter has described can be closed, at least for the time being, thanks to a last series of coincidences that occasion a cameo appearance by Garbo herself in the larger drama of celebrity that surrounds Gertrude Stein for the rest of her career, and continues to affect her reputation right down to the present day. Writing to Carl Van Vechten in the winter of 1940, with the German occupation of Paris a little more than three months away, Stein confesses that she would like to make another trip to America, though not for just any reason, and certainly not to escape the threat of war. What looms between Stein and America is the prospect of a second lecture tour, both an absolute necessity if she and Toklas are to pay their own way and also the less desirable by far when weighed against Stein's "dream that Hollywood might do the Autobiography of Alice Toklas [*sic*]":

> I would like to go over but to lecture three or four times a week for a number of weeks does not really seem to me as if I would like it, of course we cannot go over without making money and there it is, . . . they could make a very good film out of [*The Autobiography*] and then they would pay us large moneys to go out and sit and consult and that would be all new and I would like that.[83]

The dream of "large moneys" for small labors in Hollywood is hardly Stein's invention. It is, however, a fantasy that rarely plays out in the mythology of the movie business, sometimes carrying a lucky

actor to stardom, but often involving the author who risks Hollywood—in *What Makes Sammy Run?* (1941) and *The Last Tycoon* (1941), in *Sunset Boulevard* (1950) and *In a Lonely Place* (1950), in *The Player* and *Barton Fink* (1991)—in rather more harrowing and even fatal plots; "the death of the author" is a worn-out conceit in Hollywood, just another slightly stale "high concept" long before it takes the academy (ours, as opposed to the one that gives out Oscars) by storm. But this has nothing to do with what worries Van Vechten when he answers Stein a few weeks later. His enthusiasm, as it was regarding almost anything Stein proposed, was flamboyantly whole hearted. "I talked to Bennett [Cerf] about the motion picture possibilities of The Autobiography," he writes, "which are ENORMOUS, but motion picture people are peculiar. You can't approach *them*. They must approach *you*. I think the time to take this up is when you are lecturing in Hollywood" (670). Thus Van Vechten assumes the rhetoric of both adoring fan and Hollywood insider, relating the rules of the game and the "peculiar" anthropology of the deal, what Stein should and shouldn't expect along the way to seeing a film version of *The Autobiography of Alice B. Toklas* become a reality. "Of course you would have to appear in the picture," Van Vechten adds, as if offering just another piece of knowing advice. "Even Greta Garbo and Lillian Gish couldn't be you and Alice" (670).

In a tremendous reversal of her prior uneasiness over seeing herself on screen, Stein replies with a measured endorsement of the general plan, writing back to Van Vechten in April 1940 that several lecture-bureau agents "seem to think that Alice B. might be done in Hollywood," and moreover, that she is willing to go him one better in casting a film version of *The Autobiography* that consists solely of cameo appearances, not just by Stein and Toklas but by everybody, all the "endless strangers" and passing social presences. "Perhaps we all could go out and act in it," Stein ventures, "all that are spoken of in the book I think it would be fun" (671). She unfortunately says nothing in particular about Van Vechten's hyperbole that even Garbo would be insufficient in the role of "Gertrude Stein," which might not have sounded like hyperbole at all given Stein's profound sense of her own significance, captured best in her instruction to the reader of *The Geographical History* to "Think of the Bible and Homer think of Shakespeare and think of me" (109). Nor can we know from her reply whether Stein perceived—or for that matter, whether Van Vechten intended—a deeper play of allusion in referencing Garbo, the star of *Queen Christina* (1933), among the most famous de facto lesbian films of all time, and the subject of sexual gossip and Hollywood innuendo of which, I've no doubt, the magnificently well-connected Van Vechten was aware. But such historical intrigue takes place *inside* a moment of communication that is knowable to us only along the gleaming surface of its language. Garbo's cameo appearance in the Stein–Van Vechten letters seems to me a perfect example of its kind: because of the speed at which it moves and the dimension it does not have, we are left with both more and less information than we are due, as everything would make sense without a passing reference to Greta Garbo, yet once this reference it made, we can't help but feel like there could be more to it, more explanation, more context, more "referent" to the reference itself, which is exactly what the cameo appearance is designed to avoid in the first place, for it is finally a sign that stays a sign no matter how many networks of signification we may assemble around it. All we can be sure of, in other words, is that Garbo is treated as an icon, and not as an icon *for* anything, save perhaps the condition of being an icon. Still, the reference seems anything but empty, and so we keep looking at the opaque interior, at the blankness inside the figure's outlines, and we keep thinking there is something we might have missed, something momentary, in passing, fading into the background.

In April 1940, though, all such concerns were soon to be rendered, in a word, academic. "Well anyway spring does come," Stein writes after expressing her hopes for "Alice B." in Hollywood, "and things do happen" (671). "Things" did: Paris was occupied in June; and Stein and Toklas remained in Bilignin for the duration of the war, where they were left more or less unmolested by both the Nazis and the Vichy regime, owing perhaps to the very extent of Stein's fame and her connections to the United States, or, less appealingly, to her friendship with Bernard Faÿ, later convicted of

collaboration and for more, it is safe to assume, than the influence he peddled with the Germans to save Stein's art collection.[84] So while it is easy enough to condemn as escapist this whole discussion of the film version that wasn't of *The Autobiography of Alice B. Toklas*, we might also remember that any avenue of potential escape was, on the contrary, an eminently practical concern, and that beneath all this fantasy and flattery about Stein trumping Garbo and an all-star cast of hundreds reproducing the salad days of modernism, Hollywood might represent not just Stein's "dream" of stardom and of money without labor, but of safety as well, of a security in being visible and exposed on film and in America, conditions she dreaded in 1935 but that we can hardly fault her for finding more enticing by comparison a few years later. When the war was over, Stein did in fact find herself once more before the movie cameras, the featured interview in a U.S. Army newsreel entitled *A G.I. Sees Paris*, proving that she surpassed Garbo on at least one front, that of endurance—to put it bluntly—in the courting of publicity. Thus a historical turn of events that would have seemed truly astonishing to anyone in America in 1940, and more improbable than any dream of Hollywood loosed in the correspondence of Gertrude Stein: that Stein would be making another film appearance some five years after the most famous star in the world had, without warning, forever vanished from the screen. I hesitate to suggest for even a moment that Stein managed to outshine Garbo, especially since there was such a profound incandescence to Garbo's resistance to fame in the last fifty years of her life. Technically speaking, however—and this is, of course, a phrase I take seriously—Stein did manage to outlast Garbo in the eye of public visibility, and that should count for something. A final image should bring this rather vague sense of significance I am evoking into sharper resolution.

We see Gertrude Stein seated in her home, and the nation's camera is rolling. Alice B. Toklas is nowhere to be seen, nor is there much evidence of the idiosyncratic, "mannish" wardrobe that was noted so compulsively by the press a decade before. Even the decor of the apartment, when compared to that pictured in the Coburn photographs of 1913, or those of Beaton in the late 1930s, seems almost tacitly to have mutated into a new kind of space, to have domesticated itself into a "grandmother's house," complete with flower baskets, candy dishes, and bric-a-brac atop all available surfaces. In short, almost every detail of the photograph conspires to convince us that we are witness to a scene of capitulation that was expected all along: the avant-garde, after all, is born to acquiesce in most classical accounts of its history; it fights the good fight for as long as it can, but every story then ends the same way, necessarily and programmatically, with a drama of co-optation that shows just how grave, now that it's gone, this last threat to the order of things has been. But the series of cameo appearances I've described in these pages, should, I hope, upset any feelings of nostalgia we might have for a radical poetics of identity that was lost when Stein "went Hollywood," and prevent just as surely any feelings of reflexive condemnation we might have about a "culture industry" that produces only ideology and unpleasure. What Gertrude Stein's last star turn shows is that being thoroughly mediated—by the nation, by capitalism, by technology, by language—is not always the same thing as being exploited, turned inside out, left empty of that which made you you, as Stein herself might put it. Or we can at least hope, so long as there is that little dog in the picture, staring right back through the camera that everybody else has agreed to ignore, as if knowing what no one else knows, and what no one else could say even if they did, not the Army, not Gertrude Stein, and certainly not me.

Notes

1. Herman Melville, *Pierre, Or, The Ambiguities*, in *Herman Melville: Pierre, Israel Potter, The Piazza Tales*, . . . , ed. G. Thomas Tanselle (New York: Library of America, 1984), 103. The quotation I use in my first epigraph appears on pp. 297–298 of this edition. Subsequent citations to this text will be internal. My second epigraph is found on p. 173 of *Everybody's Autobiography* (Cambridge, Mass.: Exact Change, 1993; originally published by Random House in 1937). Subsequent internal citations to this text

will be abbreviated as *EA*. I will also be making frequent reference to the following Stein texts: *The Autobiography of Alice B. Toklas*, in *The Selected Writings of Gertrude Stein*, ed. Carl Van Vechten (New York: Vintage Books, 1962), 1–237, internal citations abbreviated as *ABT*; *Lectures in America* (Boston: Beacon Press, 1985; originally published by Random House in 1935), internal citations abbreviated as *LA*.

2. Melville, *Pierre, Or, The Ambiguities*, 297.

3. Leo Braudy, *The Frenzy of Renown: Fame and its History* (New York: Oxford University Press, 1986), 506. Braudy describes the whole period of modernity, from the seventeenth century to the present, as participating in "the democratization of fame," a phrase with a special relevance for Melville in that his satire on celebrity is tied closely to his *political* satire at the expense of "Young America," a loose affiliation of expansionists and nationalists centered around the Democratic Party and active in the 1840s and 1850s. Melville thus excoriates a certain mode of the (print) culture industry by way of attacking a mode of radical democracy that also fell short of its advertising.

4. For more on how Stein's fame has engendered a fundamentally split critical response, see Catherine R. Stimpson, "Humanism and Its Freaks," *boundary* 2, nos. 12/3–13/1 (Spring/Fall 1984): 301–319. Stimpson argues that most critics have focused on Stein's output either before *The Autobiography* or after; and more importantly, they have articulated absolute preferences for either an avant-garde or a popular Stein, with a popular Stein coming in a distant second.

5. Gertrude Stein. *Lectures in America* (Boston: Beacon Press, 1985; reprint of 1935 Modern Library edition), 177. A number of critics have done valuable work on the problem of "series production" in Stein, which is in part why I have slighted this topic here. See especially Friedrich A. Kittler, *Discourse Networks, 1800/1900*, trans. Michael Metteer with Chris Cullens (Stanford, Calif.: Stanford University Press, 1990), 225–229, and also Mark Seltzer, *Bodies and Machines* (New York: Routledge, 1992), for a general discussion of writing and its psycho-mechanics in American culture. From a much different perspective on Stein and mechanical reproduction, see Michael Davidson, "The Romance of Materiality: Gertrude Stein and the Aesthetic," in *Ghostlier Demarcations: Modern Poetry and the Material Word* (Berkeley, Calif.: University of California Press, 1997), 35–63. Davidson's account draws on classic discussions in Benjamin; Kittler and Seltzer both at end from a theoretical matrix of Lacan and Foucault, among others, and so push toward conclusions far removed from the latent (albeit negative) romanticism of the Frankfurt School. For a perspective on these issues that operates within a more traditional literary-historical framework, see Cecelia Tichi, *Shifting Gears: Technology, Literature, Culture in Modernist America* (Chapel Hill: University of North Carolina Press, 1987).

6. Marshall McLuhan, *Understanding Media*, 2nd ed. (New York: Signet, 1964), 259.

7. Garrett Stewart, *Between Film and Screen: Modernism's Photo Synthesis* (Chicago: University of Chicago Press, 1999), 266.

8. Clement Greenberg, "Towards a Newer Laocoön," in John O'Brien, ed., *The Collected Essays and Criticism*, vol. 1, *Perceptions and Judgements, 1939–1944)*, 86 (Chicago: University of Chicago Press, 1988). While Stewart does not refer to Greenberg, his engagement with Stanley Cavell's *The World Viewed* provides one possible explanation for how this particular strain of modernist medium specificity comes to reverberate in his work on film and photography.

9. Hugh Kenner, *The Pound Era* (Berkeley: University of California Press, 1971), 385.

10. Kittler, *Discourse Networks*, 229.

11. Ibid.

12. Important discussions that address the interrelation of form and gender in Gertrude Stein include Marianne DeKoven, *A Different Language: Gertrude Stein's Experimental Writing* (Madison: University of Wisconsin Press, 1983), and Lisa Ruddick, *Reading Gertrude Stein: Body, Text, Gnosis* (Ithaca, N.Y.: Cornell University Press, 1990). Recent work by Priscilla Wald reads Gertrude Stein against the discourse and ideology of "Americanization" and marks a significant turn in Stein criticism, sustaining a concern for form and language within a self-consciously "new" historicist project and politics. See especially her "A 'Losing-Self Sense': *The Making of Americans* and the Anxiety of Identity," in *Constituting Americans: Cultural Anxiety and Narrative Form* (Durham, N.C.: Duke University Press, 1995), 237–298. A special issue *of Modern Fiction Studies* devoted to Gertrude Stein (vol. 42, no. 3, Fall 1996) also features a number of articles that offer revisionist interpretations of Stein and her cultural status; the category of "race" in Stein's work merits the most attention in this issue, which includes striking pieces from Charles Bernstein, Julie Abraham, and others.

13. Peter Nicholls, *Modernisms: A Literary Guide* (Berkeley: University of California Press, 1995), 202.

14. Susan McCabe, "'Delight in Dislocation': The Cinematic Modernism of Stein, Chaplin, and Man Ray," *Modernism/Modernity* 8, no. 3 (Fall 2001): 429, 430, 442.

15. Stanley Cavell, "A Matter of Meaning It," in *Must We Mean What We Say?* 1969; updated ed. Cambridge, Eng.: Cambridge University Press, 2002), 219.

16. Rem Koolhaas, *Delirious New York: A Retroactive Manifesto for Manhattan* New York: Moacelli Press, 1994), 148.

17. Peter Applebome, "You Ought to Be in Pictures. Everyone Else Is These Days," *New York Times*, February 2, 1999.

18. I owe the phrase "operational aesthetic" to Neil Harris, from his classic discussion of P. T. Barnum in *Humbug: The Art of P.T Barnum* (Boston: Little, Brown, 1973). And I use the term "attraction" here with particular reference to the work of Tom Gunning. In the most general sense, a "cinema of attractions" represents the sheer "harnessing of visibility" that narrative cinema modifies, represses, and otherwise enlists in the service of its various agendas—articulated most forcefully in film studies by psychoanalytic and feminist accounts of voyeurship. Two articles provide an excellent introduction to Gunning's groundbreaking work: "The Cinema of Attraction: Early Film, Its Spectator and the Avant-Garde," *Wide Angle* 8, no. 3–4 (1986): 63–70, and "'Now You See It, Now You Don't': The Temporality of the Cinema of Attractions," *Velvet Light Trap* 32 (Fall 1993): 3–12. Writing in the earlier piece, Gunning describes the cinema of attraction as a historical mode that savors "its ability to *show* something": "This is a cinema that displays its visibility, willing to rupture a self-enclosed fictional world for a chance to solicit the attention of the spectator" (64). And while cameo appearances are rarely put to avant-garde ends, they certainly represent what Gunning would call a "tamed attraction," a moment that recalls the sheer visuality of early film within the containment of narrative structure. See also Richard deCordova, *Picture Personalities: The Emergence of the Star System in America* (Urbana: University of Illinois Press, 1990), 1–21, 98–116; see also Miriam Hansen, *Babel and Babylon: Spectatorship in American Silent Film* (Cambridge, Mass.: Harvard University Press, 1991), 245–294.

19. Cameos date back to antiquity as a form of portraiture and visual representation. By the nineteenth century, however, the hand carving of cameos from precious or semiprecious stones had largely vanished, replaced in popularity by miniatures and then, of course, by photography. Generic cameos remained fashionable as jewelry throughout the nineteenth century, however, and to some extent, remain so to this very day. *The Oxford English Dictionary* dates the first use of "cameo" in the context of the theater to the middle of the nineteenth century, and it is this sense that expands in the twentieth to cover similar brief performances in film and on television.

20. Claude Lévi-Strauss, *The Savage Mind* (Chicago: University of Chicago Press, 1966), 23–24.

21. Tom Gunning, "The Cinema of Attraction: Early Film, Its Spectator and the Avant-Garde," *Wide Angle* 8, no. 3–4 (1986): 65. I discuss Gunning's notion of a "tamed" attraction in a previous footnote.

22. I am indebted to Scot Bukatman for pointing out that special subcategory of personality that seems to exist only to star as who they in fact are: Zsa Zsa Gabor, Charles Nelson Riley, etc. It is at this tawdriest level of celebrity that the strange "reality effect" of the cameo appearance becomes most apparent.

23. Susan Stewart, *On Longing: Narratives of the Miniature, the Gigantic, the Souvenir, the Collection* (Durham, N.C.: Duke University Press, 1993), 69.

24. Ibid., 68.

25. "Metro-Goldwyn-Mayer," *Fortune*, December 1932, 51.

26. Ibid., 114; Tino Ballio, *Grand Design: Hollywood as a Modern Business Enterprise, 1930–1939*, vol. 5 of *History of the American Cinema* , general ed. Charles Harpole (New York: Charles Scribner's Sons, 1993), 13–15; Thomas Schatz, *The Genius of the System: Hollywood Filmmaking in the Studio Era* (New York: Pantheon Books, 1988), 159.

27. Rudolph Arnheim, "Film Report (1933)," in *Film Essays and Criticism*, trans. Brenda Benthien (Madison: University of Wisconsin Press, 1997), 194.

28. See Walter Benn Michaels, *The Gold Standard and the Logic of Naturalism: American Literature at the Turn of the Century* (Berkeley: University of California Press), 1–28, 115–139, and Seltzer, *Bodies and Machines*, 80–90, and esp. 198–201.

29. Sara Blair, "Home Truths: Gertrude Stein, 27 Rue de Fleurus, and the Place of the Avant-Garde," *American Literary History* 12, no. 3 (Fall 2000): 420.

30. Bob Perelman, "Seeing What Gertrude Stein Means," in *The Trouble with Genius: Reading Pound, Joyce, Stein, and Zukofsky* (Berkeley: University of California Press, 1994), 45.

31. I am thinking in particular of the critical debates discussed by Stimpson in the aforementioned article on shifts in Stein's reputation. When, for example, a writer like Marianne DeKoven, in *A Different Language*, suggests that Stein's productions of the thirties and forties were "conventionally written," a much larger dialectic between avant-garde and popular representation is invoked, and in the case of Stein, this dialectic has often been phrased as a narrative of declension—from experimentalist to co-opted "modern" author. Some of the best work on *The Autobiography* has concentrated on the matter of the genre itself as reformulated by Stein. See especially James Breslin, "Gertrude Stein and the Problems of Autobiography," in Michael J. Hoffman, ed., *Critical Essays on Gertrude Stein*, 149–159 (Boston: G. K. Hall). I am greatly indebted to Breslin's work on the text's first edition, as well as to his effort to engage with questions of what might be called the social poetics of Stein's writing and her perpetual inventiveness at the level of social representation, even when the linguistic surface of her late texts takes on a more comfortably conforming look.

32. Blair, "Home Truths," 433.

33. Mikhail Bakhtin, "Forms of Time and of the Chronotope in the Novel: Notes Toward a Historical Poetics," in *The Dialogic Imagination*, ed. Michael Holquist, trans. Caryl Emerson and Michael Holquist (Austin: University of Texas Press, 1981), 135.

34. Jennifer Ashton, "'Rose Is a Rose': Gertrude Stein and the Critique of Indeterminacy," *Modernism/Modernity* 9, no. 4 (Winter 2002): 582. Ashton makes a strong case against critics of Stein who argue that her poetics pave the way for contemporary Language writing; for Ashton, Stein's emphasis on intentionality and meaning is finally at odds with a poststructuralist understanding of language that stresses materiality as a limiting condition upon interpretation itself.

35. F. Scott Fitzgerald, *The Great Gatsby* (New York: Collier Books, 1991), 65–68.

36. For more on the relationship between Fitzgerald and Stein, see James R. Mellow, *Charmed Circle: Gertrude Stein and Company* (New York: Praeger), 275–276.

37. Marjorie Perloff, "'Grammar in Use': Wittgenstein/Gertrude Stein/Marinetti," in *Wittgenstein's Ladder: Poetic Language and the Strangeness of the Ordinary* (Chicago: University of Chicago Press, 1996), 98–99.

38. See Stephen Greenbla, *Marvellous Possessions: The Wonder of the New World* (Chicago: University of Chicago Press, 1991), 5–7. See also his essay "Towards a Poetics of Culture," in H. Aram Veeser, ed., *The New Historicism*, 1–14 (New York: Routledge, 1989). For a useful discussion of these now "classical" statements of historicist method, see Alan Liu, "Local Transcendence: Cultural Criticism, Postmodernism, and the Romanticism of Detail," *Representations* 32 (Fall 1990): 75–113. Liu employs a language that is highly suggestive in considering the implicitly "technological" status of the text and of the archive in current critical theory.

39. David Shenk, *Data Smog: Surviving the Information Glut* (San Francisco: HarperSanFrancisco, 1998).

40. Michael Fried, "Art and Objecthood," in *Art and Objecthood: Essays and Reviews* (Chicago: University of Chicago Press, 1998), 155.

41. Joseph Frank, *The Widening Gyre: Crisis and Mastery in Modern Literature* (New Brunswick, N.J.: Rutgers University Press, 1963), 57.

42. Katherine Hayles, *Writing Machines* (Cambridge, Mass.: MIT Press, 2002), 22.

43. Kittler, *Discourse Networks*, 357.

44. See Breslin, "Gertrude Stein and the Problems of Autobiography," for a powerful explication of *The Autobiography*'s authorial gamesmanship and how the first edition's photographs are enlisted in this deep play. But to what extent this play was "real"—i.e., designed to convince a reader of Toklas's authorship—is another matter. Excerpts of *The Autobiography* appeared under Stein's name in the *Atlantic*, for example. It seems safe to say that the text was no *Primary Colors*, and that Stein's displaced authorship was often presented as just another performative dimension of her public personality, another way her "eccentricity" manifested itself.

45. Coburn had recently completed his work with Henry James on the photographic frontispieces for the complete "New York Edition" of James's writings. Coburn also made famous photographs of George Bernard Shaw and Ezra Pound, among others. His presence here marks a strategic insistence on Stein's part that her true status was visible long before the mere accident of a breakthrough public success.

46. Alex Woloch, *The One vs. the Many: Minor Characters and the Space of the Protagonist in the Novel* (Princeton, N.J.: Princeton University Press, 2003), 42. For calling this phrase to my attention, I am indebted to Alexander Nemerov's *Icons of Grief: Val Lewton's Home Front Pictures* (Berkeley: University of California Press, 2005).

47. Norman Bel Geddes, *Horizons* (New York: Little, Brown, 1932), 126–127. These remarks recall the famous declarations of Le Corbusier, "A house is a machine for living in," made in *Towards a New Architecture* (New York: Payson and Clarke, 1927).

48. Sigmund Freud. *Civilization and Its Discontents,* trans. James Strachey (New York: W. W. Norton, 1961), 38. I am indebted to Avital Ronell's *The Telephone Books* for bringing this passage to my attention.

49. Bell Telephone System advertisement, *Saturday Evening Post*, January 19, 1935, 43.

50. Stein herself gives an account of her unexpected writer's block in *Everybody's Autobiography*, 65–67. Many Stein biographies, including Mellow's, make reference to this period as a time of crisis in her writing; some critics, such as those Stimpson describes in aforementioned articles, believe this to be a crisis from which her writing never recovers, especially as an experimental project.

51. Upon the film's release, John Mosher in the *New Yorker* writes, "In spite of the brevity of her appearance, against what many a star would call ground odds, Garbo dominates the picture entirely." Quoted in Michael Conway, Dion McGregor, and Mark Ricci, *The Complete Films of Greta Garbo* (New York: Citadel Press, 1991), 112.

52. The plot of *Der Letze Mann* involves an aging doorman (Emil Jennings) who is removed from his position of prominence when a manager comes to the mistaken conclusion that he can no longer manage the physical demands of the job. The loss of the stature associated with such an important role in the workings of a "grand hotel," here called the Atlantic, signals a widespread crisis in the man's family life as well. But in a staggering and arbitrary reversal—mandated by UFA—the doorman, now working in the washroom, is left a small fortune in return for a gesture of kindness, and at the end of the film he is seen enjoying a life of almost decadent privilege and indulgence.

53. *Der Letze Mann*, dirrected by F. W. Murnau. UFA, 1924.

54. The famous phrase from Marx is the starting point for Marshall Berman's *All That Is Solid Melts Into Air* (London: Verso, 1983).

55. The film ends with all of its main characters, with the exception of Crawford's Flaemmchen, facing some sort of implicit or explicit mortality: Preysing leaves under arrest for murder, perhaps to be executed for killing the Baron; Kringelein accompanies Flaemmchen for one last whirl of pleasure and spending before his illness takes its inevitable course; and though Grusinskaya remains unaware of the Baron's death at the film's conclusion, the viewer might well recall her earlier talk of suicide and wonder just what awaits her when she learns the truth. Thus the film's melodramatic architecture is securely structured.

56. Henry James. *The American Scene* (New York: Penguin, 1994), 78–81. Originally published in 1907, James's account of the Waldorf-Astoria remains of interest, especially in light of Koolhaas's cybernetic account of the "grand hotel." For James as well, the hotel offers a scene of information-in-motion, a representational environment in which the spectators' attempt to make sense is implicated in the space's attempt to make its impression.

57. James's experience of the Waldorf-Astoria is powerfully discussed by Ross Posnock in *The Trial of Curiosity: Henry James, William James, and the Challenge of Modernity* New York: Oxford University Press, 1991), 250–284.

58. For a compelling discussion of *The American Scene*, see Mark Seltzer. *Henry James and the Art of Power* (Ithaca, NY: Cornell University Press, 1984).

59. Donald Albrecht, *Designing Dreams: Modern Architecture in the Movies* (New York: Harper and Row in collaboration with the Museum of Modern Art, 1986), 138–142.

60. Northrop Frye, *Anatomy of Criticism* (Princeton, N.J.: Princeton University Press, 1957), 43. I should add that the aforementioned critical discussions of the telephone—Hanson, Gunning, Ronell—tend to emphasize the more "tragic" or "ironic" aspects of the technology.

61. Malcolm Willey and Stuart Rice, *Communication Agencies and Social Life* New York: McGraw-Hill, 1933), 153.

62. For more on the role of the telephone in modernist Hollywood set design, see Albrecht's discussion of "Offices" on film in *Designing Dreams*, 123–133. I am indebted to this discussion for bringing this image from *Reaching for the Moon* to my attention.

63. Jean Baudrillard, *The Ecstasy of Communication*, trans. Bernard Schutze and Caroline Schutze (New York: Semiotext(e), 1987), 12.

64. The opening sequence of telephone calls establishes not just an array of character types but also a balance sheet of who has money and who needs money and who has money but needs something else, i.e., Grusinskaya, represented by her secretary in this sequence. The various alignments between characters we witness as the narrative proceeds always refer back to the underlying economics established at the beginning of the film. But I would not enforce upon the film a strict materialist reading. Rather, I would say that the film imagines a particular zero-sum game of human pleasure and happiness, and tropes this game by constant references to the having and spending of money.

65. The *Oxford English Dictionary* entry for "network" acknowledges no use of this word as a verb until its 2nd edition; it there traces "network" as a verb back to the 1880s.

66. Terry Castle, *The Apparitional Lesbian: Female Homosexuality and Modern Culture* (New York: Columbia University Press, 1993), 9. The etymological evidence for this usage is somewhat slight; in the larger context of Stein's depiction in U.S. newspapers in 1934 and 1935, amid constant references to her "mannish" attire and to her "companion," Toklas, whom one reporter notes she calls "Pussy," I do think it more than possible that inciting curiosity about Stein's sexuality was accomplished by such reporting, whether intentional or not. In this, the press still lagged far behind *The Autobiography* itself. See also "Gertrude Stein Arrives and Baffles Reporters by Making Herself Clear," *New York Times*, October 25, 1934, and "Gertrude Stein, Home, Upholds Her Simplicity," *New York Herald Tribune*, October 25, 1934.

67. B. F. Skinner, "Has Gertrude Stein a Secret?" *Atlantic*, January 1934, 50–57. My favorite instance of a sexual suggestion about Stein in the press, however, is a sheer coincidence from 1969. On the same page as a *New York Times* article concerning the MOMA's acquisition of Stein's art collection (January 10, 1969), there is also an ad for Radley Metzger's *Therese and Isabelle*: "The Most Whispered About, The Most Talked About Motion Picture Of The Year." A blurb from *Cosmo* reads: "When the two girls get down to business, it is riveting." The ad makes explicit—in a classic soft-core sort of way—everything that isn't said when Toklas is referred to as Stein's "longtime companion" just a column to the left.

68. The conversation I'm imagining would involve the aforementioned texts by Terry Castle, D. A. Miller, and Eve Sedgwick, among others.

69. Stein elsewhere writes of the "peaceful penetration of the 'Oriental,'" signaling a shift to a modernity marked by the "Oriental mixing with the European" (22).

70. See my discussion of Ella Wilcox's *Wired Love* in chapter 1.

71. Alexander Walker, *Garbo: A Portrait, Authorized by Metro-Goldwyn-Mayer* (New York: Macmillan, 1980), 129.

72. For more on the sometimes odd sexuality of the telephone, see Ellis Hanson, "The Telephone and Its Queerness," in Sue-Ellen Case, Philip Bret, and Susan Leigh Foster, eds., *Cruising the Performative: Interventions Into the Representation of Ethnicity, Nationality, and Sexuality*, 34–58 (Bloomington: Indiana University Press, 1995), and also Avital Ronell, *The Telephone Book: Technology, Schizophrenia, Electric Speech* (Lincoln: University of Nebraska Press, 1989).

73. Michael Taussig, *Mimesis and Alterity: A Particular History of the Senses* (New York: Routledge, 1993), 213.

74. This formulation also patterns the text "Identity a Poem," which is constructed from different passages of *The Geographical History*. This text may be found in *A Stein Reader*, ed. Ulla E. Dydo (Evanston, Ill.: Northwestern University Press, 1993), 588–595. For more on this piece, see Charles Bernstein, "Stein's Identity," *Modern Fiction Studies* 42, no. 3 (Fall 1993) 485–488. For more on Stein and the way she uses the dog as a figure to express the paradox of identity, see Michael Trask, *Cruising Modernism: Class and Sexuality in American Literature and Social Thought* (Ithaca, N.Y.: Cornell University Press, 2003).

75. Bernstein. "Stein's Identity." 485.

76. Ibid., 488.

77. This is not a claim that I can make with full certainty, but it is a verifiable impression one gets from a recent pictorial biography of Stein assembled from various archival sources by Renate Stendhal (*Gertrude Stein in Words and Pictures* [London: Thames and Hudson, 1995]). For more on an American iconography of dogs, see Marjorie Garber, *Dog Love* (New York: Simon and Schuster, 1996).

78. See Catharine Stimpson, "Gertrude Stein and the Lesbian Lie," in Margo Culley, ed., *American Women's Autobiography: Fea(s)ts of Memory*, 152–166 (Madison, University of Wisconsin Press, 1992).

79. This passage from *A Long Gay Book* is found in Stein's lecture "The Gradual Making of *The Making of Americans*," (*LA*, 155–157).

80. I am thinking of the aforementioned essay "The Beast in the Jungle," by Eve Sedgwick, as well as a later essay, mainly on James's *The Wings of the Dove* , where she argues for a much more explicit reading of several passages in James as allegories of anal sex (see *Tendencies* (Durham, N.C.: Duke University Press, 1993). I say "allegories" in the technical sense: Sedgwick insists on a direct correspondence between a manner of syntax and an imagined bodily act.

81. Walter Benjamin, "The Work of Art in the Age of Mechanical Reproduction," in *Illuminations*, trans. Harry Zohn (New York: Schocken Books, 1968), 250. See also "On Some Motifs in Baudelaire," 163–165. One might also compare this passage in Stein to related moments in George Simmel's famous essay "The Metropolis and Mental Life," in *On Individuality and Social Forms*, ed. Donald N. Levine (Chicago: University of Chicago Press, 1971), 324–339, for while Stein makes few remarks that address urban experience as such, she describes a modern psychology that has much in common with that posited by Simmel.

82. "Photograph, A Play in Five Acts," in *A Stein Reader*, 344.

83. *The Letters of Gertrude Stein and Carl Van Vechten, 1913–1946*, vol. 2, ed. Edward Burns (New York: Columbia University Press, 1986), 667.

84. The wartime activities of Faÿ continue to be a subject of debate, and while there is evidence, discussed in Mellow, *Charmed Circle*, of his intervention on behalf of Stein throughout the war, there is less evidence about what Stein herself knew of her protector's actions on her behalf.

CHAPTER 13
HER OWN SKIN
*Anne Anlin Cheng**

Drawing on the fields of ethnic studies, feminism, and performance studies—to name only a few—Anne Anlin Cheng's *Second Skin* exemplifies the kind of interdisciplinary approaches to modernism that many scholars have sought in the past three decades. She takes as her subject the multi-layered life of Josephine Baker, an emblem of so many things in the early twentieth century: Black performance, the convergence of high and low cultures, the female body (clothed and unclothed in public), European primitivism, and the histories of empire that modern dance has continually encoded and recoded. Cheng peels back these layers and analyzes them through an optic that emerges from Baker's own life: the notion of a "surface." From here, we start to see how and why surfaces mattered so much to modernism—for incredibly fraught reasons.

"All art is at once surface and symbol," Oscar Wilde famously proclaimed. The Wildean mode of representation resists models of *depth* as the predominant mode of epistemology: why are the interpretations and answers we create from the act of consuming art not *themselves* the point? Such a question recasts how we imagine Baker as a performer. On the one hand, she has been celebrated as a figure who harnessed and redirected the voyeuristic desires of white audiences and turned them against themselves in her Danse Sauvage (audaciously wearing fake bananas as a skirt). On the other hand, she herself was conscious of how deeply imbricated her performances were in a racially charged culture of exploitation.

One way of seeing Baker's legacy, Cheng then suggests, is to think of how she manipulated the sense of a surface in the modernist moment. The rejection of ornamentation and decoration in much modernist theory was no purely aesthetic matter: it had racial implications, too. Baker, by "wearing nakedness like a sheath," as Cheng puts it, pushed modernist primitivism and, in particular, its visual components to the brink of conceptual failure. And she did so in ways that registered vital and progressive politics: Baker, like many famed modernist artists, exiled herself in Paris and became a French citizen, then became a prominent figure in both the French Resistance and the American civil rights movement. Baker was teaching audiences the lesson that Conrad had wished to impart: she was teaching them how "*to see*" through "racial difference," Cheng writes, and was thereby reorienting "the political expectations of the black female body" as a central perceptive element of high modernist style.

Cheng unfolds a broad reconsideration of "skins" in modernism, from architectural styles to novelistic description, with Baker's body—rather than idealized notions of a deracinated, ungendered "style"—at the core of her narrative. Cheng traces the "denuded modern surface" across an array of cultural productions, through theorists like Frantz Fanon and Adolf Loos, and through the discrete movements of Baker's alternately witty, serious, affirmative,

*From Anne Anlin Cheng, *Second Skin: Josephine Baker and the Modern Surface.* Oxford University Press, ©2011. Reproduced here with permission.

and unsettling performances. Baker employed both high and low forms in her art, and the sense of spectacle that she created and constantly refashioned even to the brink of censure refocuses the sense of "modernism" that, by the time of Cheng's writing, had still not given full consideration to the centrality of racialized layers in its key aesthetic articulations.

Why should modern architects who abhor ornamentation, tattoos, and other erotic markings choose to think about the surfaces of their buildings as "skins"? Why do the first modern bathing suits bear a graphic resemblance to nineteenth-century prison uniforms? What do museum displays have to do with burlesque performances? Is the twentieth-century fascination for transparency a pleasure about seeing *into* or *through* things?

This book turns our attention to the mysteries of the visible, and how those mysteries dwell on the surfaces that we think we know all too well. The above, seemingly unrelated questions of style— and really of desire—are all part of what I call Modernism's dream of a second skin. And our entry into this story will be the surprising figure of Josephine Baker, a woman who achieves international fame overnight for wearing her nakedness like a sheath.

With three memoirs, over twenty biographies in English and French alone, and a wealth of images preserved and replicated, Baker's story appears to be as well excavated as her nudity was widely publicized. One has only to invoke her name (no, even just hint at the barest gestural outline of her figure) and all that she stands for—the racist and sexist history of objectification and of desire that makes up the phenomenon of European Primitivism or, conversely, the idealization of black female agency—immediately materializes. Yet what would it mean to see Baker not as an example of but as a fracture in the representational history of the black female body? Why is it unimaginable to reflect on the ways in which her performance style—even her body type—might not fit into established tropes such as the Venus Hottentot? Although the history of racialized femininity would seem to insist on a relentless story about the coercions of the visible, we might want to ask: how is it we know we are seeing what we think we are seeing? What are the conditions under which we see?

The givenness of Baker's race and gender and what those categories mean for a European audience at the turn of the twentieth century has led almost all critics of Baker to position her in a well-established tradition of colonial black female representation. For a large segment of feminist critics, Baker indubitably and specifically references the figure of the Venus Hottentot.[1] This critical certitude, however, has unwittingly limited the context in which we can consider Baker. One *sympathetic* critic goes as far as to suggest that there is not much there to be studied: "Looking at Josephine . . . —that endearing but not-precisely-pretty face, the honey-sweet smile, her tangible craving for love and acceptance—it is hard to see what all the fuss was about."[2] Thus, with one gesture, Baker is both fully explicated (a phenomenon that is attributable only to the standing history of eroticizing black women for white male gaze) and dismissed.

With the centennial of her birth in 2006, there has been a resurgence of interest in Baker, including a touring museum exhibit and an academic conference at Columbia University and Barnard College in New York City in the same year, and a new United States postal stamp in 2008. But views of Baker remain tethered to the vexed poles of vilification and veneration. At the Columbia/Barnard conference, for instance, there was almost unanimous agreement, even if with different intonations, that Baker epitomizes the European history of ethnographic representations. And the issue of Baker's agency invariably becomes mythologized in order to rescue her from the denigrating history that she is seen to unavoidably represent. While that history provides a central background for Baker's career, this book traces an alternative, though equally fervent and enduring, context for understanding Baker's iconography and impact.

The phenomenon of Baker is also a phenomenon of Modernism and the entwined crises of race, style, and subject-hood. Indeed, how would our understanding of the political expectations surrounding the black female body be altered were we to consider Baker as a dynamic fulcrum through which the very idea of a "Modernist style" is wrought? This study does not claim Baker's modernity as a means of refuting the charges of atavism so frequently leveled at her image. Rather it takes as a given that Modernism and Primitivism are intertwined, at times even identical, phenomena.[3] To take this imbrication seriously means that we must expand the contexts and terms through which we approach a figure like Baker.

From its inception, the Baker myth has always generated more visual and categorical conundrum than accepted accounts can accommodate. On the night of October 2, 1925, at the Théâtre des Champs-Elysées, a woman entered the stage on all fours, bottom up, head down, wearing a tattered shirt and cut off pants, a strange doll among bales of cotton and bandanaed "bucks" and "black mammies." With her hair slicked back in a shining armor and her mouth painted in minstrel style, this figure started to dance—and danced like nothing anyone has seen before. With eyes crossed, buttocks quivering, legs going every which way that slim pulsating body on stage appeared part child, part simian, part puppet on neurotic strings; then she retreated. But she came back, this time, clad in nothing but copper skin, bright pink feathers around her thighs, ankles, and neck, doing a full split while hanging upside down on the well-oiled shoulders of a black giant: one moment, dead weight; the next, pure kinetic eruption.

That woman was, of course, Baker. And the show was taking place off stage as well. Records tell us that the audience both sat back and stood, screamed and clapped, shouted at the performer in adoration and disgust; some rushed the stage while others quit the theater. The next morning, the Parisian papers puzzled over what exactly was seen: "Was she horrible, delicious? Black, white? . . . Woman, other? Dancer, fugitive?"[4] And the mystery did not abate. A year later, *Vanity Fair* continued the fascinating puzzle with a meditation by E. E. Cummings, who revived the performer through a series of rhetorical negations: "a creature neither infrahuman nor superhuman but somehow both: a mysterious unkillable Something, equally nonprimitive and uncivilized, or beyond time in the sense that emotion is beyond arithmetic."[5]

We might take this reception to testify to secret pleasures and their disavowals or chalk it up to the unconscious ambivalence of colonial desire. While these explanations account for the ardor and the contradictions, they cannot quite address the particular terms of this incoherence or why this kind of bewilderment is taking place at this particular time. After almost three centuries of European incursion into the "Dark Continent"; over six decades since the Emancipation Proclamation in the US; and a quarter of a century into the birth of artistic and literary Modernism, which had made much of its attractions for so-called African imports, what we find at this theatrical enactment of two of the most rehearsed sites of European conquest—the plantation and the jungle—is a moment of profound consternation.[6] More intriguingly, it seems worth asking why this consternation, even if disingenuous or exaggerated, should narrate itself specifically as a categorical confusion—that is, over categories of race, gender, and the human that the legacy of imperial history ought to have secured, or at least lent the fantasy of certitude. Thus at the moment *la Baker* was invented on stage we see not the affirmation or the denial of Modernist Primitivism but the failure of its terms to inscribe its own passions.

And, indeed, why Baker? History tells us that chorus girls of every make and model had been strutting up and down the stages of Montmartre for more than a decade by the time she hit the scene in 1925; African American musicians had been arriving in droves since the war; and the Théâtre des Champs-Elysées, unlike its more conservative competitor the Paris Opera, had been catering to the taste for the exotic for years.[7] Still, nothing struck Paris like Baker. The avant-garde's appetite for Baker is the stuff of which legends are made: Jean Cocteau and José Miguel Covarrubias designed

stage sets and costumes for her; Fernand Léger introduced her to the elite coterie of the surrealists; Le Corbusier wrote a ballet for her; Henri Matisse made a life-size cutout of her that he hung in his bedroom; Alexander Calder made a wire sculpture of her; Alice B. Toklas invented a pudding recipe named after her, just to cite a few. Beyond designating Baker as the muse, few have been able to articulate what it is about Baker that made her *the* object of such intense and extensive Modernist investment.[8] Nor has anyone considered the active interplay (both material and theoretical) between Modernist aesthetic practices and the manifest terms of Baker iconography.

So did those audiences see something different—or were they seeing differently? What interests me about revisiting the intimacy between Modernism and Primitivism is not what it can tell us about how we see racial difference, but about how racial difference teaches us *to see*. This line of inquiry is especially important at a time when techniques of seeing were so rapidly changing, for not only do new visual technologies affect how we see racial difference but, as I will suggest, racial difference itself influences how these technologies are conceived, practiced, and perceived. When we move Baker outside of the well-rehearsed framework of Primitivism and juxtapose her celebrated naked skin (as theater and as fabrication) next to other surfaces and other techniques of display in the first quarter of the twentieth century, what we find is a radically different account of what constitutes the Baker phenomenon. What follows then is a story of the modern skin and its distractions.

Through the work of Frantz Fanon [especially *Black Skin, White Masks* (1952)], we have come to understand race as an "epidermal schema," as something ineluctably tied to the modality of the visible. Hence, critics like Mary Ann Doane would describe racial difference's "constant visibility" as "inescapable" and as "a disabling overvisibility," and Homi Bhabha would call the indisputable nature of this epidermal scheme colonialism's "open secret," reminding us that "skin, as the key signifier of cultural and racial difference in the stereotype, is the most visible of fetishes."[9] But *is* skin—and its visibility—so available? When we turn to an over-exposed and over-determined figure like Baker, are we in fact seeing what we think we are seeing? What might be some other "schemas" through which skin acquires its legibility? By situating Baker in relation to various modes of Modernist display—the stage, photography, film, and architecture—we will trace alternative stories about racialized skin, narratives that compel a reconceptualization of the notions of racialized corporeality, as well as of idealized, Modernist facades. It is on the surface of this most organic, sensual, and corporeal of icons that we will find the most unexpected and intense residue of modern synthetics and the imagination that accompanied them.

From the very beginning Baker's "own skin" offers a highly peculiar business. Although her nakedness has been understood to be a key to her theatrical success and the material evidence of her racial embodiment, it is in fact a remarkably layered construct. In popular cultural memory, her skin is often discursively associated with, at times even rhetorically replaced by, other corporeal habits: banana skins, feathers, drapery. In her films, during the very moments of literal and symbolic exposure, she is also often curiously and immediately covered over by everything from dirt to coal to flour. Arguably one of the most visually remembered entertainers of the twentieth century, Baker frequently appeared in photographs, posters, lithographs, caricatures, and on postcards partially or wholly nude, but her nakedness never stands alone and instead frequently exercises an eccentric communion with other epidermises, both natural and inorganic. In short, with Baker, *being unveiled often also means being covered over.*

I want to turn our attention not to what Baker's visibility hides but how it is that we have failed to see certain things on its surface. Before we can broach Baker's skin as a discursive construct and a corporeal agent, we have to grasp the sediment of signification that "human skin" has accrued by the dawn of the twentieth century. The very substance and contours of the human body were undergoing renovations, a process precipitated by the Industrial Revolution and intensified by

the age of mechanical reproduction. Medical advancement, visual technological innovations such as film and photography, industrial-philosophical discourses such as Taylorism, among other developments, converge to forge a fantasy about a modern, renewed, and disciplined body. At the same time, through discourses such as psychoanalysis, the boundary of the human body is simultaneously multiplied and restricted; the mind/body split gets both literalized and distorted. (Readers of Sigmund Freud will know that his revolutionary discovery of "psychical reality" and the importance of fantasy life itself entails a vexed history of struggle with the tenacious pull of biologism and "fact.")[10] It may not be too much of an overstatement to say that the material and metaphysical boundary of the human body—and, by implication, what constitutes the human— forms one of the central philosophical concerns of the twentieth century.

Perhaps this is why Modernism is so obsessed with "skin," its perfection and reproduction in a wide range of discursive and practical spheres and in a startling array of materials. In one of the most whimsical but striking images of Modernism, Elie Nadelman's sculpture *Man in the Open Air* (c. 1915, bronze), we find precisely this dream of perfection.

Our gentleman in the open air is luckily impervious to all atmospheres. He is hermetically sealed in a flawless skin that pours down from his bowler hat through his lithe figure down to his toes sinking comfortably into the metallic ground: body, vestment, environment as one. Even the tree branch going through his fingers is not enough to pierce his insouciance but is assimilated instead as an elegant extension of the body. This sculpture offers a comment about masculinity, dandyism perhaps, in the fray of modernity. But it also signals the Modernist immersion in the primacy of surface as the perfect corollary to and replacement of human skin. (Did the skin absorb the bronze or did the alloy absorb the skin?)

The philosophic preoccupation with surface serves as a cornerstone for a host of Modernist innovations in a variety of disciplines and forms: in literature, think of Virginia Woolf's description of life as "a semi-transparent envelope" and Oscar Wilde's claim that "only superficial people pay no attention to appearances"; in art, the trajectory from Cézanne's planar surfaces to Cubism to Andy Warhol's quip, "If you want to know all about Andy Warhol, just look at the surface"; in architecture, the move from the Modernist celebration of blank walls to the "surface talk" that still dominates architectural debates today; in medicine, the new focus on epidermal functions and its semiotics; in science, the accelerated development of scopic technology and the birth of what Hugh Kenner calls "transparent technology."[11] Even in psychoanalysis there is Freud's reputed methodological shift from what might be called "excavating archaeology" to so-called "surface analysis" or, in the context of conceptualizing the nature of the ego and its ontology, his evocative description of the ego as a "projection of the surface" and, later, Jean Laplanche's depiction of the ego as a "sack of skin."[12] There is, of course, also Didier Anzieu's provocative *The Skin Ego (Moipeau)*. The trope of skin/surface thus occupies a central place in the making of modern aesthetic and philosophic theory.

To this day, from aerodynamic tears to the glass wall, modern design and aesthetic philosophy remain absorbed in the idea of "pure surface." Contemporary designers continually manipulate the relationship between the inside and outside of objects, garments, and buildings, creating skins that both reveal and conceal, skins that have depth, complexity, and their own behaviors and identities.[13] Of course it can be said that all these moves to the surface are not really moves to the surface and in the end reconfirm the surface-depth binary (by, for instance, reproducing the surface as essence). Yet I want to suggest that, for a brief period in the early twentieth century, before cultural values collapsed back once again into a (shallow) surface and (authentic) interior divide, there was this tensile and delicate moment when these flirtations with the surface led to profound engagements with and reimagings of the relationship between interiority and exteriority, between essence and covering.

So what *can* the surface be or do if it is not just a cover? This question impacts not only Modernist, formalist experimentations but also how the modern history of racialized skin gets seen,

read, and written. For we cannot address the history of modern surfaces without also asking after the *other* history of skin, the violent, dysphoric one—the one about racialized nakedness inherited from the Enlightenment so necessary to Western constructions of humanity and the one that speaks of the objectification, commodification, and fetishization of racialized skin, especially black female skin.[14] While the gendered aspects of Modernism's skin preoccupation have been addressed by scholars (Schor, Wigley), what has been less studied or observed is the element of race in this aesthetic history.[15] In architectural theory, for example, the topic of race rarely arises; yet the skin trope underlying modern architectural conceptions of (white or pure) surface demands a critical engagement with ideas of racial difference. Indeed, as we will see, the question of modern surface itself bears a deeply intimate relationship to the visualization of racialized skin in the twentieth century. The European Modernist, aesthetic history of "surface" (that which covers and houses bodies) and the philosophic discourse about "interiority" (that which has been privileged as recessed and essential) provide the very terms on which modern racial legibility in the West, what Fanon calls the "epidermalization of inferiority" (112), is limned.

The relationship between the dress of civilization and the primitive "fact of blackness" (Fanon), moreover, may signal something other than antagonism or disavowal. When aesthetic history meets the history of human bodies made inhuman, what we will confront may not be an account of how modern surface represses or makes a spectacle of racialized skin but, instead, an intricate and inchoative narrative about how the inorganic dreams itself out of the organic and how the organic fabricates its essence through the body of the inanimate. This reciprocal narrative in turn will radically implode the distinction of surface versus essence so central to both racist and progressive narratives about the jeopardized black body. That is, the perennial opposition between what is open and naked versus what is veiled and hidden has been as important to the racist imagination as it is to the critical intervention designed to decode it. For the racist, nakedness signals rawness, animality, dumb flesh and is repeatedly invoked, socially and legally, as the sign of the inhuman and the other. For the critical race theorist, that nakedness is deconstructed as an entirely socialized and juridicized concept yet nonetheless reproduced as that which irreducibly indexes skin's visual legibility: "Look, a Negro!" (Fanon, 109). But what happens when we contest the terms of that visibility?

This is where we find Baker, gleaming at the threshold where human skin morphs into modern surface. By actively engaging with the synthetic and covered status of skin, Baker's body as text and performance requires that we reread how we read race. Her reputedly primitive nakedness must be understood within a larger philosophic and aesthetic debate about, and desire for, the "pure surface" that crystallized in the early twentieth century. And that pure surface in turn looks to black skin, not for disavowal but for articulation. What I am calling the dream of a second skin—of remaking one's self in the skin of the other—is a *mutual* fantasy, one shared by both Modernists seeking to be outside of their own skins and by racialized subjects looking to escape the burdens of epidermal inscription. To follow this reciprocal narrative between black skin and pure surface is to rewrite the story of skin in critical race discourse, for reading modern aesthetic style and black skin as interrelated and mutually referential holds profound consequences for understanding race as a visual, corporeal phenomenon. By decoupling skin from flesh, the notion of a second skin revises the basic assumptions of a racial discourse that aligns skin with the corporeal and the intractable. The racist interpellation "See the Negro!" is thrown into crisis when we attend to the contours of what is seen, and when we challenge the most readily available terms of describing the body fixed by that injunction.

What is this thing called race? It is both more and less than biology or ideology. It wields its claim most forcefully and destructively in the realm of the visible, yet it designates and relies on the unseen. Baker, precisely as an apparent racial symbol, counter intuitively and significantly reveals

the ellipses and the suspensions preconditioning the stability of that sign. From the inception of early ethnic studies to contemporary critical race theory, so much has been written about skin color in African-American literature that other aspects of skin have been neglected. This study revisits the visceral possibilities of raced skin, not in order to recuperate notions of corporeal authenticity, but to attend to the curious interface between that skin and inorganic surfaces emerging out of the first quarter of the twentieth century. It tries to understand raced skin as itself a *modern material fascination*, one that speaks not just to a history of objectification but paradoxically also to an emerging concept of matter as mutability, thereby redefining raced skin as "dumb flesh."

For me, the challenge of writing the story of Baker rests in learning how to delineate a material history of race that forgos the facticity of race. This study is thus not a biography of Baker, nor a historiography of her performances. Instead, it offers a series of associative and cumulative meditations about the intimacy between the philosophical origins of the "denuded modern surface" and the theatricalization of "naked skin" at the dawn of the twentieth century, with Baker as a pivotal figure. In these essays, Baker appears, disappears, and reappears to allow into view the enigmas of visual experience that are rarely extended to racialized bodies which remain tied to ideas of visual certitude and readability. We will allow ourselves the gift of itinerancy as we travel through unlikely regions—real stages and imagined houses, banana plantations and ocean liners, metallic bodies and radiant cities—in an effort to track the protean yet ardently persistent conversation between modern surface and black skin.

The early Modernists were in many ways more frank than we are about the seductions and efficacies of otherness in the acts of self-making. Speaking of Baker and the negrophilia sweeping Europe, the poet and novelist Ivan Goll observed in 1926: "But is the Negro in need of us, or are we not sooner in need of her?" There can hardly be a more clear articulation or more succinct self-diagnosis of European Primitivism's need for and projection about the racial other. When it comes to a phenomenon like Modernist Primitivism, what continues to invite reading is therefore not colonial ideology's repressed content but its *expressiveness*. What continues to hold our gazes and captivate our minds are those disquieting moments of contamination when reification and recognition fuse, when conditions of subjecthood and objecthood merge, when the fetishist savors his or her own vertiginous intimacy with the dreamed object, and vice versa.

Notes

1. See bell hooks, "Selling Hot Pussy," from *Black Looks*, 61–79; Suzan-Lori Parks, "The Rear End Exists"; T. Denean Sharpley-Whiting, "Cinematic Venus in the Africanist Orient," from *Black Venus*, 105–118.

2. Andrea Stuart, "Looking at Josephine Baker," 142.

3. This book is indebted to the insights of critics who have revealed the deep imbrications, if not downright identicalness, between "Modernism" and "Primitivism": Ann Douglas, *Terrible Honesty: Mongrel Manhattan in the 1920s*; Brent Hayes Edwards, *The Practice of Diaspora: Literature, Translation, and the Rise of Black Internationalism*; Paul Gilroy, *The Black Atlantic: Modernity and Double Consciousness*; and Sieglinde Lemke, *Primitivist Modernism: Black Culture and the Origins of Transatlantic Modernism*. Lemke, for one, demonstrates that even as fantasies of black art were instrumental in forming white Modernism, white European culture was also instrumental in shaping black artistic expressions, arguing that, when it comes to racial fantasies, the boundaries of ownership and objecthood cannot be disciplined or controlled no matter how much ideology might wish them to be. The story of Modernist Primitivism is thus a tale about appropriation and reappropriation, about imagined origins and reimagined futures. At the same time, it is noticeable that even Lemke, who has written one of the most astute treatises on Modernist Primitivism that steps outside of binary terms, nonetheless falls back on a binaristic discourse when it comes to Josephine Baker, observing that "Josephine Baker appealed to colonialist fantasies of the exotic" (97) and that Baker "adapted the racist stereotypes by which black people had been oppressed and exploited them for her own commercial success" (103).

4. Pierre de Régnier, review for *Candide* (25 Nov. 25 1925), quoted by Marcel Sauvage, *Les Mémoires de Joséphine Baker*, 11–12. Also quoted without documentation by biographers Jean-Claude Baker and Chris Chase, *Josephine Baker: The Hungry Heart*, 5; Phyllis Rose, *Jazz Cleopatra: Josephine Baker in Her Time*, 19; Lynn Haney, *Naked at the Feast: A Biography of Josephine Baker*, 20. Nancy Cunard also registers similar confusions about Baker's race and gender in her contribution "Negro Stars" to her edited collection *Negro Anthology*: "is it a youth, is it a girl? . . . she seems to whiten as we gaze at her" (329).

5. E. E. Cummings, "Vive la Folie!" 20.

6. When Virginia Woolf made her famously unequivocal claim that "on or about December, 1910, human character changed," she tied this sea change directly to Roger Fry's influential exhibition "Manet and the Post-Impressionists" of the same year. This exhibition not only introduced French avant garde art to England some thirty years after its initial appearance in France but also established "primitive objects" as foundational tropes for Modernist aesthetic theories. That exhibition along with Fry's essays "The Art of the Bushman" (1910) and "Negro Sculpture" (1920) made primitive objects the occasion for an emerging modern aesthetic. For an account of this history, see Marianna Torgovnick, *Gone Primitive: Savage Intellects, Modern Lives*, 85–104. For quote from Woolf, see Virginia Woolf, "Mr. Bennett and Mrs. Brown," 388.

7. Kaiama L. Glover, "Postmodern Homegirl." See also Tyler Edward Stovall, *Paris Noir: African American life in the City of Light* for a definitive study of the cosmopolitan community of black American expatriate writers, artists, musicians, and intellectuals in Paris from 1914 to the present. Bennetta Jules-Rosette's *Black Paris: The African Writer's Landscape* offers another important study of African writers in Paris, from the early negritude movement to the mid-1990s. The Parisian cabaret clientele racing Baker were therefore hardly strangers to so-called exotic imports. Baker's debut itself also saw seasoned viewers such as the poet e. e. cummings, the filmmaker Jean Cocteau, the painter Fernand Leger, and the American expatriate New Yorker writer Janet Flannel.

8. Although there is no existing monograph on Baker's art as a serious engagement with Modernist aesthetics, there is a group of key essays that have treated Baker's art with critical patience to which this book is indebted. I am thinking of Elizabeth Ann Coffman, "Uncanny Performances in Colonial Narratives: Josephine Baker in *Princess Tam Tam*"; Mae Henderson, "Josephine Baker and La Revue Nègre: From Ethnography to Performance"; Sianne Ngai, "Black Venus, Blonde Venus"; and Jeanne Scheper, "'Of la Baker, I Am a Disciple': The Diva Politics of Reception." Bennetta Jules-Rosette's exceptional biography of Baker, *Josephine Baker in Art and Life* also provided much-needed resources. This critical biography is especially instructive in its keen attention to the constructed nature of Baker's self-representation. Finally, as I was completing this book, Jayna Brown's study, *Babylon Girls: Black Women Performers and the Shaping of the Modern*, was published. Although I would argue that Baker exceeds the assessment offered by Brown that she was finally a symptom of "the masculinist European fantasies of the female colonial subject imported to the city" (251), I found Browns study to be extremely helpful in providing contexts for understanding Baker in relation to the larger history of early modern black female performers.

9. Fanon, *Black Skin, White Masks*, 112; Mary Ann Doane, *Femmes Fatales*, 223; Homi K. Bhabha, *The Location of Culture*, 78.

10. I am thinking, for example, of Freud's work on hysteria and the case of Dora and how his development of the concepts of trauma and psychical reality struggled with the impulse to posit a "real" rather than "imagined" scene of seduction. It is the psychoanalysts Jean Laplanche and J. B. Pontalis who point out rather shrewdly that the moment Freud discovers "psychical reality" is also the moment when he submits it to the law of the real. That is, the psyche is freed only to be irrevocably tethered to the biological. See Freud, "Fragment of an Analysis of a Case of Hysteria" (1905/1901), SE 7:3, and Jean Laplanche and J. B. Pontalis, "Fantasy and the Origins of Sexuality." in *Formations of Fantasy*.

11. Virginia Woolf, "Modern Fiction"; Oscar Wilde, *The Picture of Dorian Grey*; Andy Warhol in a 1966 interview with *The East Village Other*, collected in *I'll Be Your Mirror: The Selected Andy Warhol Interviews, 1962—1987*; Hugh Kenner, *The Mechanic Muse*.

12. Sigmund Freud, "The Ego and the Id" (1923), SE 19:19; Jean Laplanche, *Life and Death in Psychoanalysis*, 81. For a thought-provoking treatment of Freud's "archaeology metaphor," see Matthew C. Altman's essay "Freud among the Ruins: Re-visions of Psychoanalytic Method."

13. In recent years, with the advent of new materials and digital technologies the lure of the surface has drawn architectural theorists and practitioners alike to explore concepts such as "sentient," "performative," or "intelligent" surfaces. The "Skin Show" at the Cooper-Hewitt National Design Museum

(2002), organized by Ellen Lupton, and Toshiko Mori's "Immaterial/Ultramaterial" exhibition at Material Connexion (2002) attest to the millennial attraction of developments in material science and fabrication technology and underscore broader interests in the fraught relations among bodies, structures, and appearances. Recently, the Cooper-Hewitt hosted a sequel to its "Skin Show," which presents examples of new products, furniture, fashion, architecture, and media that are expanding the limits of the outer surface. Reflecting the convergence of natural and artificial life, this exhibition highlights how enhanced and simulated skins appear throughout the contemporary environment.

14. For the larger history of the role of racial difference in the philosophic making of European Enlightenment, see Emmanuel Chukudi Eze, ed., *Race and the Enlightenment: A Reader*. For a more specific history about the role of skin collecting in British Victorian culture, see Lisa Z. Sigel, *Governing Pleasures: Pornography and Social Change in England, 1813–1914*—especially the chapter on "Sexuality Raw and Cooked, 50–80. For an intriguing look at British museum culture and morbidity, see Nicholas Daly's essay "That Obscure Object of Desire: Victorian Commodity Culture and the Fictions of the Mummy."

15. In *Reading in Detail: Aesthetics and the Feminine*, Naomi Schor addresses the feminization and rejection of the ornamental detail on the modern surface in the making of aesthetic idealism. Indeed, she names Adolf Loos, whom we will meet in this study, as a prime example of the modern philosophic rejection of the feminized ornamental detail. In *White Walls, Designer Dresses*, Mark Wigley highlights the critical and fraught conversation with femininity in the history of the making of the modern white wall. I build on these scholars' insights to suggest that race, too, has written its indelible traces on those modern surfaces. The history of idealist aesthetics, exemplified by the nonornamental, clean, white surface, is a history not only of sexual difference, as Schor and Wigley so beautifully demonstrate, but also of racial difference. It is also, I believe, a history that foregrounds the failure, not the triumph, of these differences.

CHAPTER 14
INTRODUCTION TO *DIGITAL MODERNISM*
*Jessica Pressman**

The media-centric approach to modernism evident in earlier entries from Hansen and Goble largely remain rooted in the art, literature, and film of the fifty year span from 1890 to 1940. Despite the radical attempts they represent to expand the field, in other words, they nevertheless operate with an essentially temporal definition of modernism as a historical period that runs from the rise of Oscar Wilde to the ruin of World War II. Reframing modernity around media technologies, however, requires that we rethink such tidy boundaries. After all, we continue to live, invent, and suffer through an ongoing media revolution that can be traced from Thomas Edison's phonograph through Norbert Wiener's cybernetic theory to early computer networks and the rise of social media. The chronology of a modernism that ends in the midcentury simply does not align with the fact that Vannevar Bush—arguably the inventor of the hyperlink—worked in the heart of the modernist era; or with the knowledge that Claude Shannon's influential theory of communication owes something to his encounter with Joyce's *Finnegans Wake* (1939). In fact, if we understand modernism through Pound's insistence that artists "make it new," then we see a steady stream of such experimentation in the endless array of new media that shape and reshape our everyday lives.

When located in this alternative historical model where technology and aesthetics intertwine, modernist studies becomes radiant, expansive, and pervasive. In fact, the field's center of gravity has plainly shifted away from literature and toward newer disciplines like Film, Media Studies, and Mass Communication. Seen from this vantage, the aesthetic arguments that produced the strongest academic articulations of "modernism" are weak attractors at best. Indeed, influential media theorists like N. Katherine Hayles, Rita Raley, and Matthew Kirschenbaum have developed alternative approaches to modernist works derived from the history of communication technologies, theories of interactive media, and even new methods of composition like the typewriter and the word processor.

In *Digital Modernism: Making It New in New Media*, Jessica Pressman argues that the same impulses that drove the literary modernism of writers like Joyce and Stein persist across the twentieth and twenty-first centuries. Digital technologies, in other words, are not as radically new as we think and have themselves been subject to the same kind of radical experiments with form and representation that energized the great writers of the 1920s. In coining the concept of "digital modernism," Pressman seeks specifically to activate these avant-garde energies and to trace the work they continue to do in the cultural and technological networks we now inhabit. "Digital modernism," she argues, "allows us to reconsider how and why media is (and always has been) a central aspect of experimental literature and the strategy

of making it new." This excerpt, taken from the book's introduction, provides an overview of the method and theory behind her attempts to draw out these connections. It thus realizes the way in which so much of our art—whether in a video game or a piece of avant-garde electronic literature—remains within the horizon of a modernism whose contours and consequences we have still not been able to fully grasp.

Tching prayed on the mountain and
 wrote MAKE IT NEW
on his bath tub
 Day by day make it new
cut the underbrush,
pile the logs
keep it growing.

 —Ezra Pound, excerpt from "Canto LIII" (264–5)

Making it new may be the oldest trick in the book, but it has newfound urgency in contemporary digital literature. Ours is an age increasingly denned by engagement with new media and obsessed with newness. This is particularly true in regard to creative and technological innovation. But this book argues that digital literature—literature made and accessed in and through digital computing—offers a surprising counterstance to this privileging of newness.[1] A recent trend in electronic literature makes it new in ways that make visible the tradition of making it new and thus, I claim, illuminates and refreshes our sense of literary history. As Ezra Pound suggests in the excerpt I selected as an epigraph, making it new means razing the underbrush of the recent past in order to seek out the older, taller trees that can serve as a foundation for new poetic structures. This strategy implies an ability and willingness to shift between seeing the trees and the forest, between focusing on individual literary works and on the larger network, field, or dataset they comprise.

Electronic literature is born-digital. It is computational and processual, dependent upon the operations of the machine for its aesthetic effects. Electronic literature emerges through a series of translations across machine codes, platforms, and networks; its resulting onscreen content depends upon algorithmic procedures, software, hardware, and (often) Internet compatibility. I use the terms "electronic literature" and "digital literature" interchangeably, for they both describe a diverse array of creative works that employ computational processing to produce text-based art. Electronic literature has been celebrated as a postmodern literary form that grows out of technologies, subjectivities, and poetics from the middle of the twentieth century, but this book provides an alternative genealogy. Across diverse genres and programming platforms, I examine a subset of contemporary online electronic literature that remixes literary modernism. These works adapt seminal texts from the modernist canon (e.g., Pound's *Cantos*, Joyce's *Ulysses*), remediate specific formal techniques (e.g., stream of consciousness, super-position), and engage with cornerstone cultural issues (e.g., the relationship between poetics, translation, and global politics). They employ a strategy of renovation that purchases cultural capital from the literary canon in order to validate their newness and demand critical attention in the form of close reading.

All of the works of electronic literature examined in this study are web-based and published on or after 2000, but what binds them is what makes them distinct from the majority of born-digital art—a commitment to literariness and a literary past. These works challenge assumptions about electronic literature that have become commonplace, such as expectations for reader-controlled interactivity or the assumption that electronic literature forfeits substantive content to formal experimentation.

The works that sustain my attention are text based, aesthetically difficult, and ambivalent in their relationship to mass media and popular culture. They support immanent critiques of a society that privileges images, navigation, and interactivity over complex narrative and close reading. Instead of celebrating all that's new in new media, these works challenge contemporary culture and its reigning aesthetic values.

They do so by adopting a modernist practice of seeking inspiration and validation in a literary past. I call this strategy of renovating modernist aesthetic practices, principles, and texts into new media "digital modernism." Writers involved in digital modernism assess the state of electronic literature, and of literature in general in our digital age, and they decide to raze and rebuild. To do so, they cut the recently grown underbrush of digital literature and seek out the older, taller trees— modernist strategies of conceptualizing, crafting, and presenting literary art. They reframe literary tradition in ways that complicate simple designations of "new" even as they faithfully uphold and reconsider Pound's mantra.

Exemplary of this strategy is Young-hae Chang Heavy Industries (YHCHI), the collaborative duo that anchors Chapter 3 and inspired the inception of this book. YHCHI creates web-based animations that flash lengthy narratives onscreen one word or phrase at a time at heightened speeds. The text is rendered nearly illegible by the speed at which it flashes, and the result is an aesthetic of difficulty exacerbated by the fact that readers cannot stop or slow the animation. YHCHI revel in the challenge their work poses. "We can't and won't help readers to 'locate' us," they coyly state; "Distance, homelessness, anonymity, and insignificance are all part of the Internet literary voice, and we welcome them."[2] And yet, as I explore in detail in Chapter 3, YHCHI *do* locate their most acclaimed work in a particular cultural context. In interviews and artist statements, they repeatedly claim that *Dakota* (2002) "is based on a close reading of Ezra Pound's *Cantos* part I and part II." What is at stake for YHCHI, and other contemporary writers like them, in claiming association with the experimental-made-canonical movement of modernism? What does this *use* of modernism tell us about our current moment, its reading practices and the role of literature within it? These questions motivate the chapters that follow. For, rather than an instance of idiosyncratic cultural remixing, I see YHCHI's use of Pound and of modernism more generally as exemplary of a larger contemporary movement—digital modernism—in which twenty-first century writers purchase cultural capital from the literary canon in order to validate new aesthetics, promote traditional reading practices, and demand that their work be taken seriously.

My study of digital modernism makes the case for considering these digital creations as "literature" and argues for the value of reading them carefully, closely, and within the tradition of literary history. Analyzing these digital adaptations also provides a fresh perspective on modernism, specifically an opportunity to assess how modernist literature engaged with the new media of its own moment. This book thus pursues a dual purpose: it situates contemporary digital literature in a genealogy that rewrites literary history, and it reflects back on literature's past, and on modernism in particular, to illuminate the crucial role that media played in shaping the ambitions and poetics of that period. *Digital Modernism* thus conjoins literary studies and media studies to illuminate their shared past and necessarily entwined future.

Part I. Defining My Terms

Modernism

By "modernism" and its inclusion in the term "digital modernism" I mean a creative strategy rather than a temporal period or movement organized around certain key figures. I understand modernism to be a strategy of innovation that employs the media of its time to reform and refashion older

literary practices in ways that produce new art. In other words, I will argue, using works of digital modernism to guide me, that modernism is centrally about media.

"A Return to Origins Invigorates,"[3] Ezra Pound claims, and the digital writers I examine in this study concur. They employ a deliberate anachronism that marks the form and content of their works in ways that express a larger, shared ambition. Pound is a central figure in this book. His poetry and criticism, but also his influence on other writers to explore the relationship between literature and media, permeates the pages that follow. Pound describes making it new as an act of recovery and renovation, not an assertion of novelty. That is why he defines literature as "news that STAYS news," and he begins *The Cantos* by renovating the news of ancient Greece: "Canto I" begins with Odysseus diving into the underworld in an adaptation of Book XI of Homer's *The Odyssey*. James Joyce's *Ulysses* is an example of this approach, as T. S. Eliot claims. In the essay "*Ulysses*, Order, and Myth" (1923), Eliot validates *Ulysses* by describing how it updates much older "news." "In using the myth" Eliot writes, "in manipulating a continuous parallel between contemporaneity and antiquity, Mr. Joyce is pursuing a method which others must pursue after him."[4] Eliot sees Joyce's renovation of a classical past as forever altering the foundation upon which future writers will build. But making it new is not just about reinventing the past. It is also about using new media to do so. In "Canto LIII," from which my epigraph is taken, Pound locates efforts to make it new in specific sites of medial inscription—on the interface of the bathtub's walls and the sliced logs piled high to make new structures. Making is building, building requires material, and this material matters. Thus, making it new, I insist, is about renovating the past *through* media.

Whatever ambiguous qualifications are used to define "modernism," the late decades of the nineteenth century and the early decades of the twentieth century is certainly the classical period of our contemporary technological age. Our modern mediatized consciousness emerged during this first electric age. In his seminal *The Culture of Time and Space 1880-1918*, Stephen Kern shows that new conceptions of time and space accompanied new technologies of communication and, in turn, so too did new artistic methods of representing this experience also emerge. More recently, Enda Duffy's *The Speed Handbook: Velocity, Pleasure, Modernism* presents an "epistemology of speed in the specific historical period . . . [that] corresponded to the culture termed 'modernist'" by exploring the causal connection between new technologies and modern(ist) aesthetics.[5] Literary scholars have studiously detailed the relationships between modern technologized life and experimental art movements such as Futurism, which particularly informed modernism. The narrative of this period's technoliterary history is well rehearsed indeed.[6] Media scholars, too, have recognized this period as transformative for laying the foundation for modern media culture. Friedrich Kittler's *Discourse Networks 1800/1900* identifies a decisive epistemic shift in the period that gave birth to modernism; this rupture is represented as a forward-slash in the book's title. Kittler claims that Western culture at the end of the nineteenth century experienced a monumental change in "the network of technologies and institutions that allow a given culture to select, store, and produce relevant data."[7] The governing cultural "discourse network" of the previous epoch, he argues, was based in oral and analog modes of communication that supported a sense of embodied connection between human beings through such media as handwriting, whose flow of letters directly inscribes the enacted movements of one person for another. But the "continuous connection of writing" that exemplified the earlier discourse network of analog communication media was then disrupted by the emergence of new media.[8] "The historical synchronicity of cinema, phonography, and typewriting," Kittler writes, "separated optical, acoustic, and written data flows, thereby rendering them autonomous."[9] This new media epoch initiated the transition to discourse network 1900.

New media critic Lev Manovich also identifies the modernist period as a decisive moment of medial shift that paves the way for the digital. In *The Language of New Media* he argues that innovations in cinema, and in montage in particular, foregrounded modularity and interchangeability

in ways that produced a new cultural perspective. "A hundred years after cinema's birth," Manovich writes, "cinematic ways of seeing the world, of structuring time, of narrating a story, of linking one experience to the next, have become the basic means by which computer users access and interact with all cultural data."[10] But before Kittler, Kern, and Manovich, Marshall McLuhan, the father of media studies, identified modernism as the foundation for modern electric age. As I show in Chapter 1, McLuhan established media studies by reading the contemporary period through the lens of modernism and by adapting New Critical reading practices to approach and analyze electronic media.

If modernism is, as McLuhan and more recent media critics claim, the first electronic age, and if making it new is the cornerstone of literary modernism, and if this mantra implies, as I argue, a focus on media, then literary modernism invites media studies. The implications of this fact are evident in works of digital literature that remix modernism and refocus attention on the role of media within earlier modernist works. Digital modernism thus allows us to reconsider how and why media is (and always has been) a central aspect of experimental literature and the strategy of making it new.

Electronic Literature

Electronic literature is still in its nascent stages, but in just over two decades of existence it has already witnessed the passage of at least two generations, the development of a small but certain canon, and the rarefaction of expectations about what electronic literature is and does, Electronic literature emerged and gained critical interest in the late 1980s and early '90s. This "first generation of electronic literature," as Katherine Hayles calls it, was comprised primarily of hypertexts, a genre of text-based narrative that promotes nonlinear, or more accurately multilinear, reading paths.[11] Electronic hypertexts have print predecessors in experimental novels like Vladimir Nabokov's *Pale Fire*, David Foster Wallace's *Infinite Jest*, Julio Cortazar's *Hopsotch*, and the *Choose Your Own Adventure* young adult book series, all of which use footnotes or other textual devices to connect chunks of text and enable navigation of the narrative as a network rather than a linear path. Most electronic hypertexts were either uploaded to the Internet by individual authors or published by Eastgate Systems (founded by Mark Bernstein in 1986), a small publisher dedicated to electronic literature, on discs or CD-Roms.[12] Eastgate's tagline, "serious hypertext," described not only individual works but also an ambition shared by the publisher, writers, and readers alike—to gain serious attention for the emerging field of electronic literature. Eastgate's tagline also had the effect of aligning all electronic literature that took itself seriously with hypertext. Academic advocates supported this endeavor by taking hypertexts very seriously and strenuously vocalizing this claim. Victorian scholar George P. Landow hailed hypertext as the culmination of poststructuralism's decentered and writerly text.[13] Postmodern fiction writer Robert Coover's infamous article "The End of Books" (*New York Times Book Review*, 1992) brought hypertext to the public eye with death threats to a favorite reading technology. A few of the first generation hypertexts so vociferously lauded comprise the emerging canon of electronic literature, including Shelley Jackson's *Patchwork Girl* (Eastgate, Storyspace version, 1995) Michael Joyce's *afternoon: a story* (Eastgate, Storyspace 1990 [1987]), and J. Yellowlees Douglas's "I Have Said Nothing" (Eastgate, 1994); excerpts from the latter two were included in the Norton print literary anthology *Postmodern American Fiction* (1997) and thereby ensconced in the literary canon where they are assured to be taken seriously.

In the mid-1990s innovations in graphical interfaces transformed the text-based Internet into the image-laden web, exponentially expanding its users and possibilities. The nature of electronic literature changed dramatically. First generation electronic literature, the lengthy text-based

hypertexts built in Storyspace or HTML (like Adrienne Eisen's web-based "Six Sex Scenes" [1996]) gave way to a second generation of dynamic, visual, and animated works. Second generation works explore and exploit the features of new authoring software packages. Most dominant among them was Flash (formerly Macromedia Flash), which enables the production of multimedia, multimodal, and interactive aesthetics. First generation text-based narratives quickly looked outdated in comparison to the flashy facades of new, Flash-based works. For example, the online literary journal *Poems That Go* (www.poemsthatgo.com) exhibits exemplary works of second-generation, Flash-based electronic literature.[14] Although it has ceased publishing new issues, *Poems That Go* (thankfully) still maintains an archive of its past issues. The works I study here and designate as "digital modernist" were created after the emergence of the second generation of electronic literature, but they resist the characteristics of that classification in decisive ways.

Instead of exploiting the possibilities of Flash to pursue ever-new aesthetics through combinations of complex animations, detailed graphics, and immersive interactivity, digital modernism is characterized by an aesthetic of restraint. YHCHI remains the exemplary case, for they proudly claim to employ "a simple technique that *shuns* interactivity, graphics, photos, illustrations, banners, colors, and all but the Monaco font" (emphasis added).[15] The fact that these writers, and others like them, pursue minimalism as a conscious act of rebellion is, I contend, significant. The intentional rejection of fashionable trends and expectations serves as a strategy uniting contemporary digital writers. It also connects this movement to a longer tradition of similar rebellion, specifically, the modernist avant-garde.

To quote the oft-quoted modernist art critic, Clement Greenberg, "What singles Modernism out and gives it its place and identity more than anything else is its response to a heightened sense of threats to aesthetic value."[16] This statement expresses the standard story of modernism: that the popular, lowbrow culture spurred serious writers toward reactionary and decidedly highbrow aesthetics. According to this narrative, modernist literature is intentionally antipopular.[17] Digital modernism responds to a similar sense of threat in similar ways, but the fact that these artistic works are built in corporate software and displayed online alongside all forms of popular, lowbrow, consumer entertainment complicates any simple designations of high/low, modernism/ postmodernism, counterculture/status quo, and so forth. Exploring the relationship between modernism and digital modernism exposes the central role of media and of mass culture in both periods' artistic endeavors. Approaching modernism via digital modernism thus shows how literary history is, at least in part, media history.

Digital modernist works share a revolutionary sensibility and a desire for confrontation with their modernist predecessors. This spirit is, in part, due to the shifting status of electronic literature in the early years of the twenty-first century. This shift is evidenced in the tale told by the publishing history of the literary journals dedicated to showcasing and distributing electronic literature in the 1990s. Like modernism in the early decades of the twentieth century, electronic literature emerged in and through a subculture of small literary journals. The late 1990s saw the proliferation of online magazines dedicated to publishing electronic literature and the critical discourse about this new field, including interviews with authors, book reviews, and scholarly articles. Some of the journals that came online in the last years of the twentieth century include *Beehive* (Talan Memmott, ed.) in 1998, *The Iowa Review Web* (Thorn Swiss, ed.) in 1999, *Riding the Meridian* (Jennifer Ley, ed.) in 1999, *Cauldron.net* (Claire Dinsmore, ed.) in 1999, *Drunken Boat* (Michael Mills and Ravi Shankar, eds.) in 2000, and *poemsthatgo.com* (Megan Sapnar and Ingrid Ankerson, eds.) also in 2000. Such webzines flourished and brought attention to the second generation of electronic literature, but they did not last long. Creative and critical energy shifted, on the whole, from a focus on literary studies to media studies more broadly construed. Websites and blogs about emergent digital formats proliferated, particularly those focused on games and their scholarly study, then known as

"Ludology."[18] Literary journals ceased operations and faded into the static of cyberspace. In the first few years of the twenty-first century, many of the mainstays of the electronic literature community stalled production: *Drunken Boat* in 2001, *Cauldron.net* in 2002, *Beehive* with its 2002-3 issue, and *Riding the Meridian* in 2003. *The Iowa Review Web* continued publication longer (stalling out in 2007), but whereas its first issues (1999-2001) were devoted to showcasing electronic literature, its later issues shifted to interviews with authors and critical essays about new media. Similarly, as of October 2012, Eastgate.com's home page showcases tools rather than just literary texts, and the majority of the literature it offers is over a decade old. There are, of course, exceptions to the broad-stoke narrative I present here, but the context serves as a relevant backdrop for understanding digital modernism.

Despite the situation implied by this quick survey of the early digital literary journals, electronic literature is neither dead nor static. It is alive and well, and it has a score to settle. There is a countermovement underway, this book argues, a serious effort to encourage digital literature to be taken seriously. This response is not limited to digital literature. The impact of digital literature and the reach of digital modernism also affect print, and my coda explores the influence of digital modernism on an exemplary bookbound novel. But the majority of this book focuses on Internet-based literature in order to show how and why one of the most maligned of literary spaces, the web—one accused of fostering reading habits that destroy deep attention and devalue hermeneutic analysis—is actually the place where serious literature stages its rebellion and renaissance.

"Digital Modernism"

The title of this project invokes decades of debate distinguishing modernism and postmodernism, the details of which have been thoroughly rehashed and do not need repeating here. However, a brief explanation of my chosen terminology might prove helpful. By titling this project "Digital Modernism" I conjoin electronic literature to the modernist period rather than its immediate predecessor, postmodernism, because I see points of connection between modernism, postmodernism, and digital modernism that would be lost by focusing only on the latter period.[19] There are two central reasons why the title of this book is not "Digital Postmodernism." First, the grand narratives distinguishing modernism from postmodernism based on "the great divide," as Andreas Huyssen famously described the relationship between high art and mass culture, now seem outdated.[20] Scholars have shown that instead of being opposed to popular culture, modernism was in fact deeply permeated by the lowbrow and mass media. Second, ours is no longer the same cultural epoch as that described by Jean-Francois Lyotard, Fredric Jameson, Linda Hutcheon, and others theorists of postmodernism writing in the 1980s. Personal computing, the Internet, and the technologies of global capitalism have altered cultural composition, capitalist economies, and systems of signification, let alone theories about them. Works of digital modernism are accessed online, within the infrastructure of e-commerce and popular technoculture, and this embeddedness is essential to their practice and immanent critique. These works represent and respond to the networked age and what Henry Jenkins calls "convergence culture," wherein content flows across media platforms and cultural communities.[21] If inter activity ("participatory culture" as Jenkins calls it) is the primary affect and aspect of convergence culture, games might be considered its central cultural artifact. As we will see, digital modernism rebels against this cultural situation and the affective mode exemplary of it—interactivity—by returning to an older aesthetic of difficulty and the avant-garde stance it invokes.[22]

It makes sense, then, that the only previous use of the term "digital modernism" I have been able to locate is as a substitute for "avant-gardism." Lev Manovich uses the term just once in an early nettime.com correspondence (from 1998) with fellow media theorist Geert Lovink in a thread titled

"Digital Constructivism."[23] It is not coincidental that the term should come from Manovich, for his work deeply influences my own. We both analyze digital media and its aesthetic effects by exploring connections to modernist art. However, our goals lead to different arguments, methodologies, and outcomes. As I mentioned earlier, Manovich's *The Language of New Media* charts a genealogy that connects digital media to cinema, and his text serves as bedrock for the field of new media studies. However, his argument about the absorption of modernism into new media technology is one that I seek to complicate. "One general effect of the digital revolution," Manovich writes, "is that avant-garde aesthetic strategies came to be embedded in the commands and interface metaphors of computer software. In short, the avant-garde became materialized in a computer."[24] Specifically, he means that the "avant-garde strategy of collage reemerged as the 'cut-and-paste' command, the most basic operation one can perform on digital data."[25] Such a claim is intriguing but problematic because it reduces a cultural movement with a message into a medium. The title and argument of his essay "Avant-Garde as Software" (1999) unabashedly identifies the avant-garde by the formal techniques it uses rather than the manner or goals to which they are employed.[26] Manovich sees modernism as "materialized" in a computer and thus as an involuntary, media-determined effect of digital art-making. The effect of this argument assigns avant-garde strategies to the machine rather than the human artist. This collapse of the avant-garde into the computer can be read as the ultimate fulfillment of Fredric Jameson's claim about postmodernism, wherein the capitalist system consumes all possibilities of critiquing it.[27] This is a conclusion that digital modernism resists, and, following the works, I do too. Instead of reading the computer as an avant-garde technology, I examine the conscious adaptation of modernist techniques as a formal practice and strategic alignment in specific digital works. I read literary objects produced through computing technologies whose techniques express an avant-garde strategy that is revised from the modernist period and repurposed for contemporary culture.

Digital modernism is aligned with strategies of the avant-garde: it challenges traditional expectations about what art is and does. It illuminates and interrogates the cultural infrastructures, technological networks, and critical practices that support and enable these judgments. Digital modernism thus remakes the category of the avant-garde in new media. My goal in making such statements is not to resuscitate tired cultural categories or to simply identify a new avant-garde movement. Instead, I seek to remind us of the transformative effects literature can have when we dedicate our attention to it and, specifically, to close reading it. This book pursues close reading as both subject and method. It models how close reading can be adapted to serve as media-specific analysis of digital literature and argues that such critical, formal, and analytical endeavors are vital to the current, digital moment.

Close Reading

"Close reading" describes a variety of methods for approaching a literary text in order to understand *how* it means, but the term focuses on the formal techniques used to produce a particular effect and affect. In other words, close reading explores the artistry and craft of literature. As the term implies, "close reading" asserts a relationship of closeness to the text. More than anything, it describes the careful application of focused attention to the formal operations in a literary text. Close reading thus entails slow, careful, and repeated reading.

Close reading became a central activity of literary criticism in a very hyper-moment, a period—modernism—that is, I suggest, similar to our own. It emerged as an affront to the speeding up of modern life due to new technologies of speed and automation such as the automobile, the telegraph, cinema, and ticker tape.[28] John Guillory reminds us that when I. A. Richards was laying the foundation for literary criticism in the early 1920s, he "notoriously offered no positive methodology of reading,

only a set of tactics for removing the sources of misreading."[29] These "sources" were deeply related to the mediatized moment of the modernist period. "Richards was already confronting a media generation," Guillory writes; Richards saw "his generation as already overwhelmed by a saturated media environment, buffeted by stimuli that produce conditioned responses."[30] Richards sought a means of combating these stimuli by focusing attention on the details of an individual literary text. The speeding up of life in the early decades of the twentieth century had the ironic and significant effect of introducing new efforts to slow things down. Close reading was one such effort. Jeffrey Schnapp describes the modernist moment as one in which speed and "a sense of urgency" produced a "tempo and complexity [that] give rise to distinctive forms of slowness: distractions, bureaucratic delays, traffic jams"[31] I would add close reading to this list. Close reading tunes out the distractions of the speeding, technological world in order to focus, concentrate, and read slowly.[32] "The crucial thing is to slow down," Jonathan Culler writes in his description of close reading.[33] Close reading is slow and disciplined reading. As we will see, the New Critics codified close reading into a disciplined practice that became the primary professional and pedagogical practice of literary studies for much of the twentieth-century. But before we get to the New Critics, let me pause for a moment to consider the central tenet upon which the reading practice of close reading is founded.

Close reading depends upon the belief that a text is worthy of sustained attention. The idea that a text could and should be studied for its content, aesthetics, and formal attributes (rather than, say, because of who wrote it or what moral lesson it imparts) was a radical one. It is hard for us—particularly those of us who learned to close read as part of learning to study literature—to consider disassociating literature from close reading or to recognize just how revolutionary the ambitions undergirding close reading really were. But it's worth recalling this historical context in order to understand why I ground my argument about digital literature in the history of modernism, the New Criticism, and close reading.

The New Criticism

Like "close reading," "The New Criticism" is also an uncertain term. It shares with "new media" and "modernism" an identification of presentness and suggests confrontation with (or rejection of) the recent past. "The New Criticism" describes a critical movement that emerged in the 1930s and remained a staple of literary studies until the 1970s, when New Historicism and other critical movements of the postwar, postmodernist, and poststructuralist period arose to challenge the ideologies upon which the New Criticism was based (and which I will soon discuss). John Crowe Ransom's book *The New Criticism* (1941) gave a title to the movement, but the definition and boundaries of that movement remained diverse and ambiguous, even among its members. In an interview near the end of his life, Cleanth Brooks, who, by all accounts was a central member of the New Criticism, said, "What is it exactly that a New Critic does? Ransom never says."[34] But Brooks does posit a suggestion. "As far as some sort of common pursuit is concerned, I think it is safe to say that these people [the New Critics] generally took the text very seriously"[35] Frank Lentricchia agrees. "The common ground," he writes, "is a commitment to close attention to literary texture and what is embodied there."[36] Focusing on what *is* there—that is, the words on the page—may seem like a simple and obvious pursuit to us now, but in the 1920s and '30s it was radical. It might prove challenging—in the wake of New Historicism, multiculturalism, and other critical movements invested in deconstructing the ideological stakes of the New Criticism as formalism—to appreciate just how diverse and avant-garde the New Criticism really was.[37] But, before literary criticism became central to English departments and before the term "literary criticism" became interchangeable with "literary scholarship," literary studies meant philology, literary history, and the passing down of *belle-lettrist* sensibilities.

The sea change in the Anglo-American academy began across the pond, at Cambridge University, with I. A. Richards. Richards was a pioneer in literary criticism and a great influence on the New Criticism. (In Chapter 1, I discuss his influence on Marshall McLuhan.) Richards's *The Principles of Literary Criticism* (1924) laid the foundation for literary criticism to emerge as a discipline. In the preface to this book, Richards writes, "This book might be compared to a loom on which it is supposed to re-weave some raveled parts of our civilization "[38] The specific part of our civilization Richards seeks to unravel and reweave is the way of practicing literary studies; and since the word "text" has its etymological root in the Latin word for "to weave," he urges a focus on analyzing a text's formal arrangement rather than just its linguistic content. Untangling the mess that constituted literary studies meant redefining the practice of critical reading and the type of writing it produced. Richards writes, "the reader, as opposed to the biographer, is not concerned with what as historical fact was going on in the authors mind when he penned the sentence, but with what the words— given the rest of the language-may return."[39] Reading for what the words "may return" demands that a reader "go deeper."[40] Deep reading implies a sustained focus on the words themselves and how they operate to produce a particular effect. Such a critical practice asks the reader to approach the text with the purpose of excavating it and bringing to light its internal functions.

For Richards, deep reading also implied attention to how a text affects the reader. More than the students he inspired, either directly (like F. R. Leavis and William Empson) or indirectly (like the American New Critics), Richards was interested in the psychological and neurological process of reading.[41] He was far more interested in the reader's mind than in the authors, and his advice to the reader to pursue slow, close reading is based in an understanding of how the brain operates. Richards writes, "a *very slow* private reading gives a better chance for the necessary interaction of form and meaning to develop than any number of rapid perusals" (emphasis in original).[42] "This simple neurological fact," he continues, "if it could be generally recognized and respected, would probably more than anything else help to make poetry understood."[43] Richards's insistence on reading with slow, focused attention and rigorous consideration of the "interaction of form and meaning" demands that critics study the work itself rather than just research around it. This shift in critical focus inspired a new generation of critics.

The New Criticism was, Andrew DuBois explains, "a *radical* response to arcane Indo-European philology on the one hand, and on the other to a body of historical scholarship that seemed more deeply interest in sociology and biography than in literature" (emphasis added).[44] The New Critics were "academic radicals," Gerald Graff states, for they "challenged the supremacy of the philologists, the literary and intellectual historians, and the literary biographers."[45] They did so, Miranda Hickman explains, by "treat[ing] literary texts as art, rather than texts documenting history, social developments, ethics, or philosophy."[46] The New Critics sought to legitimate literary criticism and defend humanistic inquiry. As Graff writes, "The New Criticism stands squarely in the romantic tradition of the defense of the humanities as an antidote to science and positivism."[47] Close reading was the critical method they developed to serve this pursuit. "The methodology of 'close reading,'" Graff explains, "was an attempt not to imitate science but to refute its devaluation of literature: by demonstrating the rich complexity of meaning within even the simplest poem."[48] Rather than seeking to explain what a text means, to provide one "true" meaning or utilitarian purpose for a work, close reading reveals complexity and multiplicity. "The tendency of science is necessarily to stabilize terms," Cleanth Brooks writes in the *Well-Wrought Urn*, "to freeze them into strict denotations; the poet's tendency is by contrast disruptive."[49] This is why the New Critics favor poetry and difficult texts, works that traffic in disruption and disorientation. This is also why their criticism and pedagogy focus on terms like "ambiguity" (William Empson's *Seven Types of Ambiguity* [1930]), "paradox" (Brooks's essay "The Language of Paradox" [1947]), "tension," and "irony." These formal techniques and patterns reward explication.[50] The New Critical close readings

often rise to the level of creative acts themselves. For anyone who has read a good close reading, one that takes you through a journey in a text you've read before and teaches you to see it anew, you know how transformative that experience can be. A good close reading can change your mind. It can make you reread and reconsider. Close reading can be not only about art but can become art, and for the New Critics, this was part of the point.

The New Critics were great close readers, and many of them were poets themselves, including William Empson, John Crowe Ransom, Robert Penn Warren, and Allen Tate. They took inspiration from modernists like Eliot and Pound, who fused the roles of poet and critic. They understood poetry to be a discipline and craft; consider Eliot's dedication to Pound, *il miglior fabbro* or "the better craftsman." They understood this craft as requiring dedicated study; consider Pound's *The Guide to Kulchur* (1938). Following Pound and Eliot, the New Critics thought poetry and criticism should strive for the precise and objective rather than emotive, experiential, or sentimental. As T.S. Eliot famously states, poetry "is not a turning loose of emotion, but an escape from emotion; it is not the expression of personality."[51] Similarly, in language that echoes Eliot's, Richards calls for criticism that approaches the aesthetic experience "in terms of distinterestedness, detachment, distance, impersonality, subjective universality, and so forth."[52] The New Criticism that emerged thereafter valued an objective stance toward the aesthetic and a focus on form.[53]

This disinterestedness is often interpreted as disinterest with anything other than form, and the New Critics are routinely criticized as formalists who cared nothing for history, culture, and so forth. "No idea of the New Critics inspired more protests" writes Graff, "than their assumption of the 'objective' nature of the literary text, their view that a poem is an object whose meaning can be analyzed by a detached, ideally disinterested critic."[54] But as Robert Archambeau argues, such protest often "involves a fundamental misunderstanding of what is meant by disinterest."[55] Pursuing the philosophical threads that influence Richards (and, through him, the New Criticism more broadly), Archambeau argues that disinterestedness implied a balanced and open perspective, rather than the opposite; "The disinterested mind, as Richards defines it, *is* the dialogic mind" (emphasis in original).[56] The larger point here is that the primary critique leveled against the New Critics—that they isolated their object of study from its historical context—is in fact true of their critics. But I am getting ahead of myself.

The New Criticism emerged in the years immediately following the period of high modernism. Many of the theorists known as New Critics built their reputations reading and teaching these difficult works. Close reading provided a method of appreciating the experiments of literary modernism, and the New Criticism, in turn, served to canonize modernism. "New Criticism grew up partly to justify modernist literature," William Logan writes.[57] Indeed, the codification of close reading was essential to establishing literary criticism as a field with a modern literary canon, and modernist literature was central to that canon. "The most significant achievement of the New Criticism" Graff argues, "was not its dissemination of a new technique of reading (though this was certainly significant), but its popularization of the modernist idea of literature and along with it modernist assumptions about language, knowledge, and experience."[58] Close reading was a central part of this endeavor.

Close reading was never just a means of understanding literary works but also of discerning and assigning value to them. Evaluation and judgment was inscribed into the practice from its inception. As Richards writes, the critical "endeavor [is] to discriminate between experiences and to evaluate them."[59] Codifying a practice of critical reading instituted a value-system for literature and established a class of professional readers capable of assigning and describing these values. The professional literary critic emerged as a manager of readerly taste as literary criticism became an academic discipline. Such was the goal, as John Crowe Ransom stated it in "Criticism, Inc." (1938): "Criticism must become more scientific, or precise and systematic, and this means that it

must be developed by the collective and sustained effort of learned persons—which means that its proper seat is in the universities."[60] Close reading became a skill-set taught in English departments, and particular types of texts best served this reading practice. As a result, certain texts were deemed worthy of close reading while others were not. For example, the New Critics privileged poetry over prose, imagistic, cerebral, and difficult works over those with a direct, colloquial, or sentimental tone.[61] One result of this hierarchy was a relegation of the majority of female and minority writers to the margins. Guillory reminds us, "Canonicity is not a property of the work itself but of its transmission."[62] The transmission of the New Criticism through pedagogy (in classrooms and textbooks) and critical publications helped to codify a canon that included modernist literature.[63] It also established literary criticism as a profession, extended the prestige of English departments within the American academy, and confirmed close reading as the central skill taught within.

From a media studies perspective, one might claim that one of the reasons close reading remained a staple of American English departments and literary pedagogy more broadly is that it required little technological support. The New Critical practice of close reading presupposes that literature is print based. It approaches a text with the assumption that the text is read in a printed form—a page, a book, a handout, and so forth—and this assumption encodes certain ideologies. Namely, the object of study is thought to lack dependency upon its material characteristics; its words, and not the material properties of the textual medium (ink, paper, binding, edition, etc.), are considered relevant.[64] Many criticize the New Criticism for not expressing interest in media, materiality, or other more tangible aspects of a work's context (history, politics, publishing history, etc.). Indeed, the New Criticism, and the critical methodology for close reading that it promoted, has been simplified, caricatured, and even rejected outright. Formal analysis has been deemed outdated or, even, associated with a different cognitive epoch.[65] I challenge these conclusions and the assumptions about New Criticism upon which they are built by excavating their history. Contemporary digital poetics demands such efforts, for such literature requires the skills associated with close reading. As I will repeatedly argue throughout this book, this new literature promotes renovation of older critical practices, and invites reconsideration of how close reading is a technique that itself has a history deserving of excavation and analysis.

I am not alone in desiring to reassess the New Criticism. A recent wave has scholars excavating the New Criticism, its influence, and the way its history has been written. One finding is that misconceptions about the New Criticism proliferate because the same essays by the same people get anthologized over and over again. The larger, more diverse spectrum of New Critical work remains largely unread, at least until recently. In *Praising It New: The Best of the New Criticism* (2008) Garrick Davis collects and republishes essays by modernist and New Critical writers in "the first anthology of New Criticism to be printed in fifty years," as the blurb on the book's back cover proclaims. Frank Lentricchia and Andrew DuBois's *Close Reading: The Reader* (2003) focuses not only on known New Critics but also on more contemporary efforts at close reading. This valuable volume includes essays by Helen Vendler, Franco Moretti, and Eve Kosofsky Sedgwick, which collectively show how close reading extends beyond the expected dates and political perspectives of those who first honed the craft. Lentricchia describes the collection as "intended to represent and undercut what we take to be the major clash in the practice of literary criticism in the past century: that between so-called formalist and so-called nonformalist (especially 'political') modes of reading" by exploring their "common ground": "a commitment to close attention to literary texture and what is embodied there."[66]

In addition to the republication of New Critical texts, scholarly volumes that reconsider the New Criticism are also emerging. Miranda Hickman and John McIntyre's recent collection *Rereading the New Criticism* (2012) is exemplary in its effort to "reevaluat[e] the significance and legacy of the New Criticism" by collecting contemporary scholarly essays that closely analyze the texts and contexts of

the New Criticism in ways that rebuke misconceptions about that founding movement in literary criticism.[67] In this respect, this collection follows other important critical acts of reconsideration, including William J. Spurlin and Michael Fischer's collection *The New Criticism and Contemporary Literary Theory: Connections and Continuities* (1995) and Mark Jancovich's *The Cultural Politics of the New Criticism* (1993). These efforts begin with the recognition, in Miranda Hickman words, that "New Critical work is still widely misrepresented as ahistorical, apolitical, and acontextual."[68] The recent surge of interest in reconsidering the New Criticism provides welcome company and context for my own ambitions.

Mine is not a book about the New Criticism. Close reading is my arrow not my target. But my purpose and practice have certain key points of intersection with the New Critics. Most significantly, I make the case for the continued importance of literature and literary criticism in an increasingly digital, visual, and networked culture. Moreover, I do so by close reading specific works of literature. This book is structured around acts of close reading that endeavor to expose the aesthetic value of digital literature and the literary more broadly.

Part II. The Stakes of My Argument

Renovating Close Reading

"These days," Jane Gallop writes, "I worry about the fate of close reading."[69] For Gallop, close reading is "the most valuable thing English ever had to offer" and, moreover, "the very thing that made us a discipline."[70] Lamenting the current state of literary studies, wherein archival research has upended textual explication and literary history seems more important than analysis, Gallop states, "If practiced here and there, it [close reading] is seldom theorized, much less defended."[71] Jonathan Culler echoes Gallop's sentiments. In a recent article for the *ADE Bulletin* titled "The Closeness of Close Reading" (2010), he claims, "we cannot just take close reading for granted, especially as we welcome into the university a generation of students raised in instant messaging" and "in an age where new electronic resources make it possible to do literary research without reading at all."[72] The fact that reading (and close reading) cannot to be taken for granted as standard skills no more is an opportunity to deliberately reassess and refashion these practices to suit our modern age and its born-digital artworks. We need to recognize how close reading is a historical and media-specific technique that, like other critical practices, demands renovation as we embrace our modern age and its digital literature.[73]

This book is part of a recent movement in literary criticism that seeks to recall the benefits of close reading in order to facilitate its adaptation. A handful of new media critics have recently asserted the value of close reading digital art and literature. Roberto Simanowski's *Digital Art and Meaning: Reading Kinetic Poetry, Text Machines, Mapping Art, and Interactive Installations* (2011) shows how digital art promotes interpretation; Jan Van Looy and Jan Baetens's *Close Reading New Media* (2003) collects essays that close read individual digital art objects; Alice Bell and Astrid Ensslin's special issue of the online journal *Dichtung-Digital*, titled "New Perspectives on Digital Literature: Criticism and Analysis" (2007), highlighted "second-wave theory" of digital literature that "focuses on close readings and semiotic textuality"[74] In a recent essay in *Digital Humanities Quarterly* titled "The Materialities of Close Reading: 1942, 1959, 2009," David Ciccoricco critiques this "second-wave theory" or what he calls "second generation digital-literary criticism" (of which the aforementioned texts would be part) for their "celebration of both the practice and the very possibility of close reading works of digital literature, while at the same time failing to adequately articulate what 'close reading' means, or must come to mean, in digital environments."[75] I hope that my book participates in the effort to advocate for close reading approaches to digital literature, and

thus also for the value of digital literature, even as it sympathizes with Ciccoricco's critique. What distinguishes the chapters that follow from other, earlier attempts at approaching digital literature through close reading (of the likes that earn Circcoricco's scorn) is an effort to demonstrate the relevance of this approach while also theorizing and historicizing it.

After the boom and bust cycle of contentious claims about either the newness or sameness of digital media and either the rupture or continuation that digital literature poses to literary studies, we are left with the need to analyze the specific effects of the symbiosis between literature and media as it bears itself out in particular works. I contend that literary scholars need to pay more attention to the media aspects of literature and that media critics need to pay more attention to the literariness of electronic literature. I close read digital literature because the works deserve it. Indeed, you might not know it from reading most criticism about electronic literature, but these works are of interest not only because of their technological properties and programmatical innovations but also because of their narrative content and formal aesthetics. The medium is not the only message, but it is a popular one among critics. The works that sustain my study invite and reward close reading. They are rich and complex, filled with intertextual allusions and complicated poetics that reward careful reading and rereading.

But how do we close read works that are multimedia and multimodal, comprised of "flickering signifiers" (rather than static and stable ones) and of multiple layers of semiotic processes, including hidden programming text and computer code?[76] Different answers to these questions have led to a crisis of sorts in the field of electronic literary criticism or, at least, to proliferation of critical subspecializations. Because digital literature challenges our ability to locate "the text," it invites diverse critical methods and sparks debates about what counts as literature and as literary criticism. In the field of electronic literature, scholarly attention has recently shifted from the content displayed onscreen to the technological platforms and programming code producing it, and this has stimulated a debate over what and how to read.

Early in the study of digital poetics, Loss Pequeño Glazier (2002) identified source code as a vital component of the digital text that deserved critical analysis, and today more critics are pursuing such examination. Mark C. Marino proposes a method of analysis that he calls Critical Code Studies which reads programmable code *as* text to "analyze and explicate code as a text, as a sign system with its own rhetoric, as verbal communication that possesses significance in excess of its functional utility."[77] Other critics, like Florian Cramer and John Cayley, warn against reading code as text. Arguing that because code is an executable process, programmable text becomes code only when it runs. They conclude, code is not code when it is extracted for study.[78] Or as Cayley pithily titles his essay, "The Code Is not the Text (unless It Is the Text)."[79] Even with such precautions, however, a shift is underway in contemporary digital criticism—a turn away from reading onscreen aesthetics toward analysis of the technical mechanics of digitality. This trend is exemplified by MIT Press's two new book series: Platform Studies (edited by Ian Bogost and Nick Montfort), which "investigates the relationships between the hardware and software design of computing systems and the creative works produced on those systems," and Software Studies (edited by Matthew Fuller, Lev Manovich, and Noah Wardrip-Fruin) which "uses and develops cultural, theoretical, and practice-oriented approaches to make critical, historical, and experimental accounts of (and interventions via) the objects and processes of software."[80] These critical strategies are valid and valuable, particularly when they serve to promote a fuller understanding of digital textuality and the reading practices it promotes; but they should not replace rigorous analysis of the aesthetic ambitions and results of technopoetic pursuits.

I approach electronic literature by close reading its onscreen aesthetics, both its textual and nontextual elements. For this reason, *Digital Modernism* might be considered a kind of apologia for "screen essentialism" in digital literature.[81] Through this apologia, I argue that close reading digital

literature is valuable training for twenty-first century media literacy. As I will suggest throughout, this book is not just about electronic literature or even about literature more generally; it is also about the value our culture places on critical thinking and analysis. I hope to show how studying the formal poetics of born-digital literature promotes reflective consideration of the practices we use to read, analyze, and judge.

Literary Analysis as Media Literacy for a Digital World

Digital Modernism positions literary analysis at the center of our technological culture. It shares this ambition with the New Critics. As I mentioned earlier, those critics sought to recuperate literary analysis from an increasingly devalued position in relation to the sciences in the early part of the twentieth-century, and they used close reading to do so. In the early part of the twenty-first century, we find ourselves in a similar situation. In a culture that seems to favor facts over critique, data over interpretation, positivism over poetics, we might draw some points of parallel to that period which inspired the New Critics to turn to the text and close read. An economic crisis has made a liberal arts education increasingly untenable for the majority of Americans, and the study of literature and the humanities seems particularly out of reach. But we should remember that New Critics saw close reading as a pedagogical means of training students to read not only specific literary texts but also to learn to evaluate and judge culture more broadly. The pedagogical goal of the New Critics, Tara Lockhart writes, was for students to "become more capable of pursuing their own inquiries and more competent at generating critical responses to complex textual questions."[82] The goal remains the same today, although the complex textual questions are now just as likely to be written in lines of programming code as in poetic stanzas. In whatever form or medial format the text appears, however, close reading of it supports and enables critical thinking. This point, more than anything, is my polemic and purpose.

In our culture of technophilia, most people are users of ever-more complex media products containing ever-more sophisticated interfaces that hide the interworking of the technologies and the ideologies behind their design. Most users lack the skills to think critically about these objects and, moreover, about how these objects formally operate. How do we understand the interface of the Google home page? How does it formally produce meaning? When I ask my students this question, I am usually met with silence and confusion. The response is not because they don't know what the Google home page looks like but because they have never been asked to think critically about it. When I follow up with more specific questions about the formal properties of the interface, things begin to change. Students begin to notice the typography used to depict the company's name and recognize it as a deliberate choice employed for particular purposes: to present a playful poetic that imagistically enables a single word to become a corporation's name (a pronoun), a space and thing (a noun), and a mode of action for using the search engine (a verb). They start to explicate how the stark white background of the Google home page produces its central poetic effect—ambiguity (that poetic property that so fascinated the New Critics). Students begin to see this web page, which they have encountered hundreds of times before, as a *text* with complicated poetics—one which deserves to be analyzed.

If we want to train critical thinkers for a digital era, we need to teach them to close read new media objects and artworks. We can do so by teaching them to read and close read digital literature. The question of how to read digital literature is thus not only of interest to a sub-set of academics but part of a much wider cultural discussion about literacy in a digital age. In an earlier age, the New Critics turned to close reading individual works of literary art as a means of bridging the emergent divide between science and the humanities. We can learn from their example because now, more than ever before, close reading can serve to bridge this divide. When it comes to digital literature,

there is no separation between science and literary art. Digital literature is algorithmically driven and technologically enabled; its content cannot be separated from its form or format.[83] Web-based digital literature exacerbates this point because it exists as part of a network (the Internet) and thus challenges the ability to identify the piece's perimeters or proclaim its autonomy. What we learn by close reading digital literature is that one cannot simply focus on textual formal devices but must consider how they are formatted and in which contextual networks they are produced, distributed, and accessed. This means a merger of formalism and textual studies, aesthetics and media studies. We *can* retain the productive and illuminative pleasures of formalist close reading while simultaneously recognizing and examining the material and historical contexts in which a literary work operates. We can also complicate simplistic distinctions between science and art, poetics and technology.

Electronic literature demands that we do so.

Part IV. Critical Influences

Digital Modernism seeks to builds bridges between modernism and digital literature, print textuality and computational technologies, literary criticism and media studies. This attempt to illuminate the recursive relationship between modernism and new media is inspired by revaluations of modernism by such scholars as Michael North, Garrett Stewart, Johanna Drucker, and Marjorie Perloff as well as the textual criticism of Jerome McGann, George Bornstein, Lawrence Rainey, and others who remind us that literature is always created, distributed, accessed, and archived in material contexts and media-specific conditions. Whether we realize it or not, these conditions inform the ways in which we read and study literature. In the field of new media studies, *Digital Modernism* stakes a claim for the importance of literature and literary analysis. Here I build upon the work of Katherine Hayles, Alan Liu, and Rita Raley, all of whom pursue media-specific analysis with scholarly vigor and historical breadth while remaining acutely attuned to literary poetics. Hayles, in particular, is a central and powerful node in the network of influences that inform my approach for, in many recent publications, she has drawn critical attention to the "intermediation" (her term) of natural language and computing code and to the need to reassess the implications of this situation, particularly as it informs literary studies.[84]

My decidedly literary approach participates in and benefits from cross-disciplinary conversations in media studies and media archaeology lead by the likes of Wendy Chun, Lisa Gitelman, Matthew Kirschenbaum, Lev Manovich, Terry Harpold, and others who work to reconceive the ways in which we theorize the relationships between old and new media. My commitment to caring about emergent literary aesthetics is informed by another strain of recent scholarly work—efforts by theorists such as Sianne Ngai and Rita Felski—who forcefully and gracefully assert the need to rethink aesthetics. In her treatise *On Beauty*, Elaine Scarry pens an apologia for aesthetics in a postmodern world that seems to reject it as a serious field of study. Wouldn't it be ironic if the post-postmodern period heralds the return of aesthetic theory *through* digital literature? In my effort to read aesthetics by renovating close reading, I am inspired by critics like Franco Moretti who strive to find creative methods of reassessing and reinvigorating the practices we lump together under the title "literary criticism." If I achieve my goals, this project will contribute to ongoing efforts by a diverse group of scholars who all seek to adapt traditional humanities criticism to illuminate, historicize, and contextualize the contemporary and the new. My particular intervention is to provide a framework for locating diverse points of connection across a century of literary history and across more recent but distributed conversations about the relationship between media and literary studies. In what follows, I read the literary aspects of individual digital works in ways that extend traditional literary criticism to digital objects and digital culture more broadly.

Part V. Chapter Summaries

Each chapter of this book examines a different aspect of digital modernism's relationship to modernism and shows how reading carefully between these literary acts provides an opportunity to reconsider literature and literary history through perspectives made possible by new media. Chapter 1, "Close Reading: Marshall McLuhan, from Modernism to Media Studies," introduces the father of media studies, Marshall McLuhan, as a modernist New Critic and argues for the importance of understanding how close reading serves his foundational writing. McLuhan studied at Cambridge under such eminent New Critics as I. A. Richards and F. R. Leavis, and this training provided the scaffolding for his later theories about media evolution. I examine how McLuhan adapted the New Critical practice of close reading and applied it to objects that the New Critics did not consider literary. In so doing, he built media studies from literary studies. Recognition of this fact places the literary at the heart of our medial moment. Taking seriously McLuhan's training in literature as well as his writerly prose is, I claim, crucial to understanding his theories of media but also the larger field of media studies that grew out of them. Although many people cite or refer to McLuhan, few close read his writings. Yet close reading his prose illuminates the ways in which he adapted modernist literature to serve his contemporary medial context. Sustained attention to how he refashioned the New Criticism illuminates central convergences between literary and media studies and reminds us how creative and versatile the critical activity of close reading can be.

My second chapter turns McLuhan's famous insight that the medium is the message into a strategy for close reading. "Reading Machines: Machine Poetry and Excavatory Reading" performs close reading as media archaeology and argues that the machines involved in producing a reading experience are crucial aspects of a literary work's aesthetics. I read William Poundstone's digital work *Project for the Tachistoscope: {Bottomless Pit}* (2005) as it flashes a stream of speeding text and icons onscreen in an act of poetically remediating a now-obsolete technology, the tachistoscope. In his digital work, Poundstone presents a tachistoscopic reading experience that archives the older technology and promotes excavation of it. This chapter pairs Poundstone's digital work with an earlier experiment in machine poetics that dates from the modernist period: Bob Brown's Readies machine (circa 1930). American avant-garde poet Bob Brown introduced his plan to build a reading machine that would speed up the way we read and thereby fundamentally change the kind of literature we write. He called his machine "The Readies." "The word 'readies' suggests to me a moving type spectacle," Brown writes, "reading at the speed rate of the day with the aid of a machine, a method of enjoying literature in a manner as up-to-date as the lively talkies."[85] The Readies was never built, but Brown's writing about the machine and his anthology of poetry for it (which includes out-of-print poems by Gertrude Stein, E. X. Marinetti, and Ezra Pound) serves as a crucial link between experimental writers of modernist and contemporary periods imagining literary revolution *through* innovations in the speed-reading machines of their own times.

Having established that digital modernism exposes media to be part of the poetic practice and thus deserving of critical analysis, the next two chapters consider specific literary techniques enabled by digital technologies and employed by digital modernism. Chapter 3, "Speed Reading: Simultaneity and Super-position," examines Young-hae Chang Heavy Industries's claim that their "*Dakota* is based on a close reading of Ezra Pound's *Cantos* part I and part II." I close read the digital work in relation to its proclaimed source material despite the fact that the speed at which *Dakota* flashes challenges efforts to do so. I show how YHCHI brilliantly adapt Pound's poetry at the level of content and form. For, not only do YHCHI remix the language of the first cantos but they also use Flash to renovate Pound's poetic technique of "super-position" or textual montage. This chapter

examines the transformation of Pound's formal technique into Flash to show how the poetic result illuminates connections between the modernist and digital modernist texts as well as the literary periods they represent.

Chapter 4, "Reading the Database: Narrative, Database, and Stream of Consciousness," traces a constellation of digital modernist works that adapt stream of consciousness in ways that illuminate literature's effort to represent cognition with and through media. James Joyce's *Ulysses* is the central node in this network, the inspiration for a variety of digital modernist works: a Twitter-based performance of "Wandering Rocks" (by Ian Bogost and Ian McCarthy), a generative, database-driven work of performance art (Talan Memmott's *Twittering: a novel)*, and a deeply complex narrative inspired by a section of Joyce's "Ithaca" chapter (Judd Morrissey and Lori Talley's *The Jew's Daughter)*. Considering these diverse works together and in relation to their source of inspiration, *Ulysses* shows how stream of consciousness—that central literary technique for representing consciousness in twentieth-century literature, which came to the fore through modernism—is, at its heart, decidedly about media. This chapter shows how contemporary literature updates modernist techniques for depicting human consciousness to reflect changes as its subject becomes posthuman and its medium becomes digital.

I also explore a conceptual and technological parallel between stream of consciousness and electronic hypertext, the latter of which is often identified as a technological format that models the mental processes of associative cognition. *The Jew's Daughter* pursues an allusion to hypertext as it adapts "The Jew's Daughter" section of *Ulysses*, a decidedly nonhypertextual and non-stream of consciousness narrative section. I compare how these literary works represent cognition as a mediated process, and I focus on two points of connection. First, the juxtaposition between digital and modernist works shows how *Ulysses* employs a database aesthetic to depict cognition. Examining this point complicates contemporary critical debates about the difference between database and narrative. Second, and subsequently, literary fiction is seen to be a vital space for testing out theories about how media informs and affects cognition.

The fifth chapter, "Reading Code: The Hallucination of Universal Language from Modernism to Cyberspace," intervenes in a different topic of contemporary debate in media studies: discourse about the readability of computer code. I trace a prehistory of this discussion about code-as-text back to, yes, modernism. I draw a parallel between the idea that computer code enables universal communication and the idea that the Chinese ideogram is a universal medium for poetics, an idea most famously propagated by Ezra Pound via Ernest Fenollosa. Chinese has been a central part of Western discourse about universal language for centuries, from Leibniz's binary logic through to Norbert Wiener's computer-based machine translation and debates about Global English via the World Wide Web. This chapter traces this thread across the intertwined histories of poetics and computing. I read a work of electronic literature that incorporates ideograms into its interface design (Young-hae Chang Heavy Industries's *Nippon*) and a digital novel that confronts and rejects the idea that cyberspace enables universal translation (Erik Loyer's *Chroma*). These works, I claim, resist the ideological underpinnings that turn code into a universal language—either through the conceit that code is capable of universal machine translation or that code is an autonomous, unreadable entity on par with a natural language. These works, I argue, critique computational ideologies *through* literature. In so doing, they remind us that literature and its study are essential to understanding and critiquing digital culture and discourse.

Digital Modernism concludes with a coda, "Rereading: Digital Modernism in Print, Mark Z. Danielewski's *Only Revolutions*" that demonstrates how the strategy of digital modernism informs contemporary print literature. Danielewski's experimental print novel *Only Revolutions* (2006) employs the central modernist and digital modernist practice of adapting the past to pursue literary innovation and, even, revolution. The novel contains 360 pages with 360 words per page, and its

design demands that readers turn the book around, literally *revolve* it (to use the language of the novel's title), in order to read the narratives of its two protagonists, which are printed at opposite ends of each page. *Only Revolutions* illuminates and exploits the possibilities of the codex as a medium for experimental literature even as it depicts this traditional reading machine referencing and relying upon the Internet for its bookishness. This novel displays print literature as part of, not separate from, the digital network. In so doing, it proclaims the vitality of print textuality in the digital age. Moreover, *Only Revolutions* enacts a digital modernist strategy by showing how the older medium (the book) and the literature it contains (whose poetic is, I will show, decisively modernist) are renovated through interaction with digitality. With this conclusion, I show how digital modernism extends beyond the screen and, thus, I hope, extends the relevance of my efforts to analyze it.

Collectively, the chapters in this book illustrate how literature adapts to a new age and its new media. And, as the texts we study evolve, so too must our practices of critical analysis continue to change. The challenges posed to traditional modes of analysis offer opportunities to update our critical practices and to see afresh the recursive relationship between technologies and textual expression. The chapters that follow strive situate electronic literature within literary history and push literary studies to evolve with our new media age. What is at stake is nothing short of a better understanding of the significance of literary art, critical reading practices, and humanistic culture in our networked age.

Notes

1. Wendy Hui Kyong Chun discusses the role of "new" in "new media," insightfully pointing out that the focus on "'making new' reveals the importance of interrogating the forces behind any emergence, the importance of shifting from 'what is new' to analyzing what work the new does." "Introduction: Did Somebody Say New Media?" in *New Media, Old Media*, eds. Wendy Hui Kyong Chun and Thomas Keenan (New York and London: Routledge, 2006), 3.

2. Qtd. in Thorn Swiss, "'Distance, Homelessness, Anonymity, and Insignificance': An Interview with Young-Hae Chang Heavy Industries," *The Iowa Review Web* (2002), accessed October 17, 2012, http://iowareview.uiowa.edu/TIRW/TIRW_Archive/tirweb/feature/younghae/interview.html.

3. "The Tradition" in *Literary Essays of Ezra Pound*, ed. T. S. Eliot (New York: New Directions, 1954), 92.

4. T. S. Eliot, "*Ulysses*, Order, and Myth" in *James Joyce: Two Decades of Criticism*, ed. Seon Givens (New York: The Vanguard Press, 1963), 198–202. Originally published in *The Dial*, November 1923. For a thoughtful meditation on how Eliot's myth-based reading of *Ulysses* has served literary criticism, see Kevin Dettmar's "'Working in Accord with Obstacles': A Postmodern Perspective on Joyce's 'Mythical Method'" in *Rereading the New: A Backward Glance at Modernism*, ed. Kevin J. H. Dettmar (Ann Arbor: University of Michigan Press), 277–296.

5. Enda Duffy, *The Speed Handbook: Velocity, Pleasure, Modernism* (Duke University Press, 2009), 42.

6. See Michael Levenson's *A Genealogy of Modernism: A Study of English Literary Doctrine 1908–1922*, (Cambridge: Cambridge University Press, 1984), Lawrence Rainey's *Institutions of Modernism: Literary Elites and Public Culture* (New Haven: Yale University Press, 1998, particularly Chapter 1), and Marjorie Perloff's *The Futurist Moment: Avant-Garde, Avant Guerre, and the Language of Rupture* (Chicago: University of Chicago Press, 1986).

7. Friedrich Kittler, *Discourse Networks, 1800/1900*, trans. Michael Metteer with Chris Cullens (Stanford: Stanford University Press, 1990), 369.

8. Friedrich Kittler, *Discourse Networks*, 83.

9. Friedrich Kittler, *Gramophone, Film, Typewriter*, trans. Geoffrey Winthrop-Young and Micahel Wutz (Stanford: Stanford University Press, 1999), 14.

10. Lev Manovich, *The Language of New Media* (Cambridge: MIT University Press, 2001), xv. I discuss the ways in which my project differs from Manovich's later in this introduction; for, although Manovich and

I both pursue a connection between digital media and modernism, our approaches and arguments differ in methodology and purpose.

11. N. Katherine Hayles's "Deeper into the Machine: The Future of Electronic Literature," *Culture Machine*, vol. 5 (2003), accessed October 17, 2012, http://svr91.edns1.com/~culturem/ index.php/cm/article/view Article/245/241.

12. Eastgate published these titles in a proprietary format, disc and CD-Rom. Eastgate also produced (through the efforts of Jay David Bolter, John B. Smith, and Michael Joyce) Storyspace, an authoring program specifically designed for producing hypertexts. Many of the important early works of electronic literature were built in Storyspace. For more on Storyspace software, see http://www.eastgate.com/storyspace/index.html or The Electronic Labyrinth at http://www3.iath.virginia.edu/elab/hfl0o23.html.

13. See George P. Landow's *Hypertext 2.0: The Convergence of Contemporary Critical Theory and Technology*, 2nd ed. (Baltimore: Johns Hopkins University Press, 1997) and also "Hypertext, Hypermedia, and Literary Studies: The State of the Art" with Paul Delany, which is an introduction *Hypermedia and Literary Studies*, eds. Landow and Delany (MIT Press, 1991).

14. *Poems That Go* was edited by Megan Sapnar and Ingrid Ankerson, accessed October 17, 2012, http://www.poemsthatgo.com.

15. Qtd. in Swiss, "'Distance, Homelessness, Anonymity, and Insignificance': An Interview with Young-Hae Chang Heavy Industries."

16. Clement Greenberg, "The Notion of 'Postmodern'" in *Zeitgeist in Babel: The Postmodernist Controversy*, ed. Ingeborg Hoesterey (Indiana UP), 46. The essay was previously published in *Arts 54*, No. 6 (February 1980).

17. For example, in *After the Great Divide: Modernism, Mass Culture, Postmodernism* (Indianapolis: Indiana University Press, 1986), Andreas Huyssen argues, "Modernism constituted itself through a conscious strategy of exclusions, an anxiety of contamination by its other: an increasingly consuming and engulfing mass culture" (vii). Huyssen distinguishes between modernism and postmodernism, by claiming that contrary to modernism, "postmodernism rejects the theories of the Great Divide" (viii).

18. In May 2001 Gonzalo Frasca founded Ludology.org, "an online resource for videogame researchers"; in July 2001, the first issue of *Game Studies.org* appeared and scholarly print publications about games studies proliferated.

19. In *21st Century Modernism: The "New" Poetics* (Oxford: Blackwell Publishers, 2002), Marjorie Perloff asks, "what if . . . there were a powerful avant-garde that takes up, once again, the experimentation of the early twentieth century?" (3–4). It should already be obvious that I argue that an avant-garde is doing just that and doing it online. Whereas Perloff charts a continuum between modernist poetry and "the unfulfilled promise of the revolutionary poetic impulse in so much of what passes for poetry today" (5–6), I am interested in recognizing a new wave of applied practice in a new media format. Despite the title of her book, Perloff does not engage with the poetics of the new century in their new media formats.

20. See Andreas Huyssen, *After the Great Divide: Modernism, Mass Culture, Postmodernism* (Indianapolis: Indiana University Press, 1986).

21. See Henry Jenkins, *Convergence Culture: Where Old and New Media Collide* (New York University Press, 2006). I discuss this book and its central concept of convergence culture in more detail in the Coda.

22. A *New York Times* article describing the emergence of video games in the Academy, Michael Erard's "The Ivy-Covered Console" (February 26, 2004), pits games against modernism as a means of describing their cultural position and possibility. The article ends by quoting author and English Ph.D., Dexter Palmer, positioning games in relation to literary modernism: "'Maybe,' he said, 'game critics can someday explicate Arc the Lad, bringing it to a larger market in the same way that the literary entrepreneur Sylvia Beach supported Joyce and published *Ulysses*. But I don't want to draw the comparison between Arc the Lad and *Ulysses*,' Dr. Palmer said, 'because that would be very, very wrong.'" Although the works in this study are not games, they do complicate the simple conclusion that digital narratives occupy such different ends of the cultural spectrum and that to read them as you would *Ulysses*—i.e., to close read or "explicate"—would be "very, very wrong." Indeed, this book strives to complicate, if not outrightly reject, the assumption that games and other objects of digital culture should not be read with the dedication and critical reading practice one would turn to highbrow literature.

23. In "Digital Constructivism: What Is European Software? An exchange between Lev Manovich and Geert Lovink" (November 11, 1998), Lev Manovich writes, "Like you, I also believe in digital modernism or avant-gardism" (http://www.nettime.org/Lists-Archives/nettime-l-9812/msg00063.html). As far as I can

tell, Manovich does not use the term again, either in that conversation or in his published work. Instead, in the rest of this net-time correspondence and in his larger body of work on new media, Manovich uses the terms "modernism" and "avant-garde," often interchangeably. For Manovich, "modernism" is a flexible category with historical dates ranging "approximately from 1860s to 1960s; or from Manet to Warhol; or from Baudelaire to McLuhan" ("Avant-Garde as Software," *Ostranenie*, ed. Stephen Kovats [Frankfurt: Campus Vertag, 1999]). In contrast, I use the term "modernism" to refer to a specific strategy employed by writers in the early decades of the early-twentieth century and adapted by writers of contemporary digital literature.

24. Lev Manovich, *The Language of New Media*, xxxi.

25. Lev Manovich, *The Language of New Media*, xxxi.

26. Lev Manovich, "Avant-Garde as Software." http://www.manovich.net/articles.php

27. See Fredric Jameson's *Postmodernism: Or, The Cultural Logic of Late Capitalism*, (Durham: Duke University Press, 1991), chapter 1 in particular. This is neither Manovich's conclusion nor his tone. He does not see the absorption of the avant-garde into the computer as a bad thing but rather as an effect of the technology: "what was a radical aesthetic vision in the 1920s became a standard computer technology by the 1990s" ("Avant-Garde as Software").

28. See Enda Duffy, *The Speed Handbook: Velocity, Pleasure, Modernism* for brilliant explorations of the role of speed in modernist culture and art.

29. John Guillory, "Close Reading: Prologue and Epilogue," *ADE Bulletin*, no. 149 (2010), 13.

30. John Guillory, "Close Reading: Prologue and Epilogue." In this way, Guillory argues that Richards's "prologue" to close reading has much in common with close reading's "epilogue" as exemplified, Guillory argues, by N. Katherine Hayles's argument about hyper-attention (in Hayles, "Hyper and Deep Attention: The Generational Divide in Cognitive Modes," *Profession* [2007], pp. 187–199).

31. Jeffery T. Schnapp, "Fast (slow) modern" in *Speed Limits*, ed. Jeffery T. Schnapp (Milan: Skira, 2009), 27.

32. Much has been written about the value judgments implicit in the distinction between slow and fast reading. "Good Reading Is Slow Reading," J. Hillis Miller claims in a section tide of *On Literature: Thinking in Action* (New York: Routledge, 2002).

33. Jonathan Culler, "The Closeness of Close Reading," *ADE Bulletin*, no. 149 (2010), 3. Culler continues, "though 'slow reading' is doubtless a less useful slogan than either 'slow food' or 'close reading,' since slow reading may be inattentive, distracted, lethargic" (23).

34. Qtd. in William J. Spurlin's "Afterword: An Interview with Cleanth Brooks" in *The New Criticism and Contemporary Literary Theory: Connections and Continuities*, eds. William J. Spurlin and Michael Fischer (New York: Garland, 1995), 366. In this interview, Brooks also states that the term "The New Criticism" "was not a name we used to describe ourselves" (367).

35. Qtd. in William J. Spurlin's "Afterword: An Interview with Cleanth Brooks," 367.

36. Frank Lentricchia, "Preface," *Close Reading: The Reader*, eds. Frank Lentricchia and Andrew DuBois (Durham: Duke, 2003), viv.

37. The New Critics were not alone in pursuing commitment to form and formalism. The Russian Formalists were hugely influential in and around the same period.

38. I. A. Richards, *Principles of Literary Criticism* (New York: Routledge [1924], 2001), vii.

39. I. A. Richards, *How to Read a Page: A Course in Efficient Reading with an Introduction to 100 Great Words* (Boston: Beacon Press, 1942), 14–15. Or consider Cleanth Brooks's statement in a later essay, "The Formalist Critic" (1951), "the formalist critic is concerned primarily with the work itself. Speculation on the mental processes on the author takes the critic away from the word into biography and psychology" (reprinted in *Praising it New: The Best of the New Criticism*, ed. Garrick Davis [Swallow Press/Ohio UP, 2008]), 86.

40. I. A. Richards, *How to Read a Page*, 15.

41. See John Guillory, "Close Reading: Prologue and Epilogue."

42. I. A. Richards, *Practical Criticism: A Study of Literary Judgment* (Myers Press reprint, 2008 [1929]), 234.

43. I. A. Richards, *Practical Criticism*, 234.

44. Andrew DuBois, "Close Reading: An Introduction" in *Close Reading: The Reader*, eds. Frank Lentricchia and Andrew DuBois (Durham: Duke, 2003), 4.

45. Gerald Graff, Literature Against Itself: Literary Ideas in Modern Society (Ivan R. Dee, 1979), 129.

46. Miranda Hickman, "Rereading the New Criticism," in *Rereading the New Criticism*, eds. Miranda Hickman and John D. McIntyre (Columbus: Ohio State UP, 2012), 9.

47. Gerald Graff, Literature Against Itself, 133.

48. Gerald Graff, Literature Against Itself, 133.

49. Cleanth Brooks, *The Well-Wrought Urn: Studies in the Structure of Poetry* (New York: Reynal & Hitchcock, 1947), 8.

50. For a cogent critique of the results of this formalist focus, see Robert Scholes, *The Crafty Reader* (New Haven: Yale UP, 2001). Scholes rails against the heritage of the New Criticism: "we have lost the craft of reading poetry—lost sight of poetry's private pleasure and of its public powers—and that our methods of studying and teaching poetry for the past half-century are very much to blame for this condition" (6). The New Critical "preference for subtlety and complexity, which went hand in hand with a sustained critique of the obvious and sentimental," he writes, "had the effect of cutting off poetry they liked from the more popular poems that had functions to get many young people interested in poetry in the first place" (13).

51. T. S. Eliot, "Tradition and Individual Talent" in *The Sacred Wood: Essays on Poetry and Criticism* (London: Methuen, 1920).

52. I. A. Richards, *Principles of Literary Criticism*, 11.

53. For more on how close reading has a "scientific or perhaps quasi-scientific origin" due to how Richards "constructed a psychology of reading on the foundation of the stimulus-response model" used in contemporary scientific discourse, see Guillory's "Close Reading: Prologue and Epilogue" (11).

54. Gerald Graff, *Literature Against Itself*, 129.

55. Robert Archambeau, "Aesthetics as Ethics: One and One Half Theses on the New Criticism" in *Rereading the New Criticism*, eds. Miranda Hickman and John D. McIntyre (Columbus: Ohio State UP, 2012), 45.

56. Robert Archambeau, "Aesthetics as Ethics: One and One Half Theses on the New Criticism," 45.

57. William Logan, "Forward into the Past: Reading the New Critics" in *Praising it New: The Best of the New Criticism*, xii.

58. Gerald Graff, *Literature Against Itself*, 5.

59. I. A. Richards, *Principles of Literary Criticism*, viii. For more on how the universities served as the seat of New Criticism, see Davis's editorial notes to "Part 4: Appraising Poets and Periods" (45–46).

60. John Crowe Ransom, "Criticism, Inc," in *Praising it New: The Best of the New Criticism*, 50.

61. T. S. Eliot explains why this value system matters in "The Metaphysical Poets" (1921). He writes, "poets of our civilization, as it exists at present, must be difficult. Our civilization comprehends great variety and complexity, and this variety and complexity, playing upon a refined sensibility, must produce various and complex results. The poet must become more and more comprehensive, more allusive, more indirect, in order to force, to dislocate if necessary" (reprinted in *Praising it New: The Best of the New Criticism*, 149).

62. John Guillory, *Cultural Capital: The Problem of Literary Canon Formation* (Chicago: University of Chicago Press, 1993), 56.

63. For more on the importance of the New Critical textbooks, primarily those by Brooks and Warren, see Tara Lockhart's "Teaching with Style: Brooks and Warren's Literary Pedagogy" in *Rereading the New Criticism*, 195–217. Lockhart quotes Mark Jancovich's statement, "More than any other New Critical activity, these text-books were responsible for redefining the object of literary study. They directed attention to the linguistic forms of the text, and defined the terms of reference within which literary studies largely continues to operate" (214).

64. The field of textual studies and work by scholars such as Jerome McGann, George Bornstein, and Lawrence Rainey, in particular, seeks to rectify this myopic view by showing how medium, material context (including the format and the venue in which a poem was first published), and bibliographic history crucially inform the text and its interpretation. My own thinking is deeply shaped by this line of scholarship.

65. I am thinking here of Katherine Hayles's claim for a generational distinction between hyper and deep attention, which map onto multi-talking and close reading, in "Hyper and Deep Attention: The Generational Divide in Cognitive Modes," *Profession* (2007).

66. Frank Lentricchia, "Preface," *Close Reading: The Reader*, ix.

67. Miranda Hickman and John D. McIntyre, "Acknowledgements," *Rereading the New Criticism*, vii.

68. Miranda Hickman, "Introduction; Rereading the New Criticism" in *Rereading the New Criticism*, 4.

69. Jane Gallop, "The Historicization of Literary Studies and the Fate of Close Reading," *Profession* (2007), 182.

70. Jane Gallop, "The Historicization of Literary Studies and the Fate of Close Reading," 182.

71. Jane Gallop, "The Historicization of Literary Studies and the Fate of Close Reading," 183. Gallop identifies the current state of literary studies thus, "We have become amateur, or rather wannabe, cultural historians" (183).

72. Jonathan Culler, "The Closeness of Close Reading," 21 and 24, respectively. Culler colorfully describes the indefinable role of close reading, "Close reading, like motherhood and apple pie is something we are all in favor of, even if what we do when we think we are doing close reading is very different" (21).

73. N. Katherine Hayles has been forcefully and persuasively making this claim for some time now. In *My Mother Was a Computer: Digital Subjects and Literary Texts* (Chicago: University of Chicago Press, 2005), she writes, "literary and cultural critics steeped in the print tradition cannot simply continue with business as usual. Needed are new theoretical frameworks for understanding the relation of language and code; new strategies for making, reading, and interpreting texts; new modes of thinking about the material instantiation of texts" (11).

74. Astrid Ensslin and Alice Bell, "New Perspectives on Digital Literature: Criticism and Analysis," in *Dichtung-Digital*, no. 37 (2007), accessed October 17, 2012, http://dichtungdigital.de/editorial/2007.htm.

75. David Ciccoricco, "The Materialities of Close Reading: 1942, 1959, 2009," *Digital Humanities Quarterly*, 6, 1 (2012), para. 1.

76. On flickering signifiers, see chapter 2 of Hayles's *How We Became Posthuman: Virtual Bodies in Cybernetics, Literature, and Informatics* (Chicago: Chicago UP, 1999), titled "Virtual Bodies and Flickering Signifiers."

77. Mark C. Marino, "Critical Code Studies," *Electronic book review* (December 4, 2006), accessed October 17, 2012, http://www.electronicbookreview.com/thread/electropoetics/codology.

78. In "Digital Code and Literary Text," Florian Cramer explains that code "is solely dependent on how another piece of code—a compiler, a runtime interpreter or the embedded logic of a microprocessor—processes it" (*Beehive*, [2002], http://beehive.temporalimage. com/conten_apps43/cramer/0000.html).

79. In "The Code Is not the Text (Unless It Is the Text)," John Cayley highlights the fact that "composed code is addressed to a processor" and "complexities of [this] address should not be bracketed" (*Electronic book review*, 2002), http://www.electronicbookreview.com/thread/electropoetics/literal.

80. "Platform Studies" book series description, MIT UP website, accessed October 17, 2012, http://platformstudies.com/ and "Software Studies Book Series" description, accessed March 8, 2011, http://mit press.mit.edu/catalog/browse/browse.asp?btype=6&serid=179.

81. Matthew Kirschenbaum uses the term "screen essentialism" to describe critical analysis focused solely on the screen rather than in the modes of storage and processing involved in producing the onscreen aesthetic; see *Mechanisms: New Media and the Forensic Imagination* (MIT Press, 2008), see chapter 1. Nick Montfort used the term earlier in a presentation titled "Continuous Paper: The Early Materiality and Workings of Electronic Literature," MLA conference, Philadelphia (December 28, 2004).

82. Tara Lockhart writes, "The New Critical method of textual analysis, though often perceived in retrospect as isolationalist, was intended to result in precisely the opposite phenomenon: it sought to restore to literature a central place in the culture at large" ("Teaching with Style," 201).

83. From this we can extrapolate that literary analysis is vital to explaining *how* meaning is produced through our digital interfaces and devices, operating systems, search engines, and communication platforms. Steven Johnson, *Interface Culture: How New Technology Transforms the Way We Create and Communicate* (Basic Books, 1997), 213; italics in original, Media critic Steven Johnson identifies "interface design" as "a kind of art form—perhaps *the* art form of the next century" (from his vantage point at the end of the twentieth century) and explains that metaphors are central to interface design.

84. Hayles writes, "Language alone is no longer the distinctive characteristic of technologically developed societies; rather, it is language plus code" (*My Mother Was a Computer*, 16).

85. Bob Brown, *The Readies* (Roving Eye Press, Bad Ems, 1930), 1. In 2009 Rice University Press (Literature by Design Series) reprinted a new edition of *The Readies*, which contains a substantial afterword by Craig Saper. This edition is an important step toward procuring renewed appreciation of Brown.

CHAPTER 15
METAMODERNISM
NARRATIVES OF CONTINUITY AND REVOLUTION
*David James and Urmila Seshagiri**

Is modernism over? And if it is, how do we know? If it's not, then what *is* modernism in the present day? These questions, which had preoccupied scholars of modernist studies as least since Harry Levin, Raymond Williams, and Frank Kermode argued over whether an end to "the modern" was even philosophically possible, are the points of entry for David James and Urmila Seshagiri's "Metamodernism." This essay, appearing like Mao and Walkowitz's in *PMLA*, notes that some of the most highly regarded authors of the present day—Zadie Smith, J. M. Coetzee, Ian McEwan, and others—have consistently placed "a conception of modernism as revolution at the heart of their fictions, styling their twenty-first century literary innovations as explicit engagements with the innovations of early-twentieth-century writing." This observation cuts in several directions, James and Seshagiri argue: we must ask not only why they have written in such a way, but also why they are highly regarded for doing so over a century after the height of modernist aesthetics. In other words, why does modernism seem to be so alive long after its purported death, and why are modernist forms celebrated in contemporary literature, whereas baroque or naturalist styles (for example) seem not to be?

The legacies of modernism are something that James and Seshagiri make a powerful case for addressing, not as an unconscious agent in the background of all writing since the 1910s, but rather, as a product of contemporary writers' "inventive, self-conscious relationships with modernist literature." If modernism is, as these writers suggest, "inherently positive, transportable across time, and transferable" to the present, then we must rethink the way we periodize the movement. Perhaps it was *not*, after all, so distinctly produced by and tied to the shocking mass violence of the First World War; or perhaps all of the work in the New Modernist Studies to expand the periodization of modernism had both planted and uprooted the historical contingencies of the movement. Or, on the contrary, perhaps modernism was something like a period-specific response to early-twentieth-century conditions that created forms and aesthetics that were—unbeknownst to their creators—as universalizable and adaptable as modes like realist narration have proven to be.

James and Seshagiri identify a number of contemporary novels that "reassess and remobilize narratives of modernism." That is, these novels don't simply employ modernist forms; they do so in manners that force readers to grapple more broadly with how modernism is framed in relation to present aesthetics. But we shouldn't simply label them "modernist" or "neo-modernist" (and certainly not "postmodernist," given its different valences). In fact, James and Seshagiri push back against the rapid expansion of the idea of modernism

*From *PMLA*, v. 129, no. 1, pp. 87–100. The Modern Language Association of America, ©2014. Reproduced here with permission.

identified with the scholarship of Susan Stanford Friedman, for one. They argue that "once modernist becomes an epithet for evaluating expressive reactions to modernity, whether at the beginning of the seventeenth century or the dawn of the twenty-first, whether in Berlin or Bombay, it loses a degree of traction and threatens to betray its own need to be replaced." Instead, they push for a return to periodization through which phenomenon like (in their terms) "metamodernism" are more visible.

Metamodernism itself shoots off in multiple directions in its project of moving "the novel forward by looking back at the aspirational energies of modernism"—somewhat like a generation of postwar postmodernist writers (John Barth, for instance) aimed to do, but with a surprisingly positive and affirmative vision of modernism at its core. Its results are unpredictable and difficult to characterize in one fell swoop, but James and Seshagiri contend that metamodernist works demonstrate that "modernism's formal promises for narrative fiction will make political, ethical, and aesthetic sense in the future only if modernism denotes a historically precise activity instead of connoting radical artistic responses to every modernity's upheavals." That is, modernism's purported defining features—its signature aesthetic responses to dramatic historical rupture—will now be narrowed down to something more precise, more historically bound, and yet more open and adaptable than many critics had yet acknowledged. And here, modernism paradoxically will find more life in literary and scholarly commentary alike.

The task for contemporary literature is to deal with the legacy of modernism.

—Tom McCarthy (2010)

1914/2014: Narratives of Modernism

A century separates us from an iconic moment of aesthetic metamorphosis: 1914 witnessed the appearance of James Joyce's *Dubliners*, Gertrude Stein's *Tender Buttons*, Mina Loy's "Parturition," and the vorticist journal *Blast*. It was the year Dora Marsden and Harriet Shaw Weaver, aided by Ezra Pound, started the literary review the *Egoist* in London and Condé Nast and Frank Crowninshield launched *Vanity Fair* in New York. Arnold Schoenberg's atonal symphonic works assaulted classical sonorities; Wassily Kandinsky elevated the purity of geometric form above the functional work of visual representation. Most crucially, 1914 saw the assassination of Archduke Ferdinand in Sarajevo and the subsequent outbreak of the First World War. Cutting a bloody, four-year swath across Europe, the war took almost forty million lives and rendered all subsequent formal innovation inseparable from cultural devastation: thus the intricate, ruptured literary architectures of *The Waste Land* (1922), *Ulysses* (1922), and *To the Lighthouse* (1927).

So runs a mythos of Western metropolitan modernism that has in recent years been supplanted by a more nuanced, historically balanced, and demographically diverse understanding of cultural production in the early twentieth century. Yet what occasions our essay is the surprisingly persistent legacy of this very mythos in twenty-first-century arts and letters. A growing number of contemporary novelists—among them Julian Barnes, J. M. Coetzee, Ian McEwan, Cynthia Ozick, Will Self, and Zadie Smith—place a conception of modernism as revolution at the heart of their fictions, styling their twenty-first-century literary innovations as explicit engagements with the

innovations of early-twentieth-century writing.[1] At a moment when postmodern disenchantment no longer dominates critical discourse or creative practice, the central experiments and debates of twentieth-century modernist culture have acquired new relevance to the moving horizon of contemporary literature.

What artistic issues emerge when innovators today open up alternative futures for fiction through engagements with their modernist past? In turn, what fresh light does today's writing cast on modernism's own generative moment, its always vexed beginnings, middles, and ends? In 2010 the English novelist Tom McCarthy declared, "The task for contemporary literature is to deal with the legacy of modernism" ("Avant-Garde" 38), and burgeoning dialogues between literary present and literary past reveal twentieth-century modernism's complex—but still undertheorized—appeal for the ambitions of twenty-first-century novelists.

We call attention to modernism's legacies at a time when the field of modernist studies is characterized by intense self-scrutiny as well as unprecedented geographical, temporal, and cultural diffuseness. The term *modernism*—pluralized into *modernisms*, preceded by wide-ranging adjectives—is now connotative rather than denotative. Our essay by no means marks the first investigation into the increasing breadth attributed to modernism, but what distinguishes our approach is its defense of returning to the logic of periodization.[2] Such an approach not only offers a rubric for reading contemporary literature's relationship to modernism but also generates a retrospective understanding of modernism as a moment as well as a movement. That moment, we contend, should still be understood in historically conditioned and culturally specific clusters of artistic achievements between the late nineteenth and mid–twentieth centuries. Although stubbornly in conflict with the critical rhetoric of transhistorical extension, our contention offers a clear premise for tracing how a significant body of late-twentieth- and twenty-first-century literature consciously responds to modernist impulses, methods, and commitments.

Our approach is thus both methodological and literary-historical, insofar as we examine what contemporary fiction can tell us about current reconstructions of modernism as a period and as a paradigm. Without a temporally bounded and formally precise understanding of what modernism does and means in any cultural moment, the ability to make other aesthetic and historical claims about its contemporary reactivation suffers. Further, our conception of the contemporary itself deserves a rigorous periodization of any modern instance from which it follows.[3] Fading one domain into the other, we run the risk of assuming modernism to be inherently positive, transportable across time, and transferable to the work of contemporary writers. And the self-conscious designation of a modernist period works against the reductive, presentist conception of contemporary literature as a mere branch of modernist studies rather than a domain whose aesthetic, historical, and political particulars merit their own forms of intellectual inquiry.

We focus on contemporary fictions distinguished by inventive, self-conscious relationships with modernist literature. The legacy inscribed in these relationships is an important but little-charted twenty-first-century aesthetic that we call metamodernism. Metamodernism regards modernism as an era, an aesthetic, and an archive that originated in the late nineteenth and early twentieth centuries. The dominant postures of this literary corpus, therefore, clash with the current academic understanding of modernism as a temporally and spatially complex global impulse. Philosophers and political theorists have supplanted the idea of modernity as a monodirectional, post-1500 secular Western phenomenon with a more fluid conception of modernity as a collection of asynchronous historical moments in discontiguous locales.[4] Accordingly, the already multifaceted and factionalized study of modernism casts its net across centuries and continents to demonstrate, in Susan Stanford Friedman's words, that "polycentric modernities produce polycentric modernisms" ("Periodizing" 435). How, then, do we respond to the proliferation of contemporary literature that transcribes modernist aesthetics pioneered in the early twentieth century? Do such fictions merely compound the false historical consciousness of their modernist antecedents?

On the contrary, metamodernism's value for scholars of contemporary and modernist literature alike lies in the ambition that unifies its otherwise varied artistic and historical positions: to reassess and remobilize narratives of modernism. We use the phrase "narratives of modernism" in a dual sense. It refers, on one hand, to experimental fiction shaped by an aesthetics of discontinuity, nonlinearity, interiority, and chronological play (consider the self-reflexive perspectivism of Barnes's *The Sense of an Ending* [2011], Zadie Smith's *NW* [2012], and Taiye Selasi's *Ghana Must Go* [2013]). On the other hand, "narratives of modernism" describes fictions—overtly experimental or otherwise—plotted around the very creation and reception of modern art and letters (witness the reimagined stories of modernism's emergence in John Berger's *G.* [1972], McEwan's *Atonement* [2001], and Coetzee's *Youth* [2002]). The metamodernist novelists we group together extend, reanimate, and repudiate twentieth-century modernist literature. In turn, their stylistic affiliations and derivations, as well as their reimagined tableaux of modernism's origins, demand a critical practice balanced between an attention to the textures of narrative form and an alertness to the contingencies of historical reception. And if modernist studies has in recent years partly marginalized formalism while privileging historicism, the advent of metamodernist fiction offers a welcome opportunity to revisit the field's current methodological preoccupations. In what follows, we explicate how the formal commitments of twenty-first-century metamodernist fiction inform current debates about transnational literatures, the challenges of periodization, and the disciplinary constitution of the study of contemporary writing.

Expansion and Contraction

In 2008, Douglas Mao and Rebecca L. Walkowitz's "The New Modernist Studies" identified for readers of this journal "expansion" as the guiding principle of modernist scholarship (737). Mao and Walkowitz astutely predicted that vertical and horizontal approaches to modernism would reveal the movement's hitherto obscured layers and contours, dissolving once-entrenched boundaries between high and low culture. Indeed, such expansions have invigorated numerous scholarly domains, including modern periodical studies, modernist feminism, visual culture, disability studies, critical race theory, the study of everyday life, and the reassessment of "middlebrow" literary production.[5] But it is the transnational turn, as Mao and Walkowitz, among others, have termed it, that has expanded the field most dramatically. Rooted in modernist studies' belated encounter with postcolonial theory in the early 1990s—when Fredric Jameson and Edward Said demonstrated that imperial praxis played a central role in British modernism's formal and material development—recent theories of transnational literature have widened modernism's ambit beyond the asymmetrical dyads of innovative Western imperial center and emulative non-Western colonial periphery.[6] Coinciding with the ascent of global literary studies in the profession more generally, imperial-era modernism has been refined and reconceptualized, its current incarnations a collocation of cosmopolitan, transatlantic, diasporic, regional, and planetary modernisms.[7]

Jessica Berman's 2011 *Modernist Commitments: Ethics, Politics, and Transnational Modernism*, which ranges deftly across Indian, Caribbean, Irish, Spanish, and English modernisms, exemplifies how transnational criticism can enact a much needed historicist corrective to the assumptions about canonicity, aesthetic innovation, and cultural production that have long governed the study of modernism. In Berman's eloquent characterization, modernism is "a mode that arises in conjunction with impending modernity in many places, guises, attitudes, and temporalities," as well as a mode that is continually "demonstrating the continuum of political engagement that helps to motivate it" (32–33). Berman captures the scholarly temperament that has enabled the breadth of recent work, ranging from pathbreaking collections such as Laura Doyle and Laura Winkiel's *Geomodernisms: Race, Modernism, Modernity* (2005) to monographs like Matthew Hart's *Nations*

of Nothing but Poetry: Modernism, Transnationalism, and Synthetic Vernacular Writing (2010), Christopher GoGwilt's *The Passage of Literature: Genealogies of Modernism in Conrad, Rhys, and Pramoedya* (2011), Gayle Rogers's *Modernism and the New Spain: Britain, Cosmopolitan Europe, and Literary History* (2012), and Saikat Majumdar's *Prose of the World: Modernism and the Banality of Empire* (2013).[8] Crowned by the publication in 2012 of *The Oxford Handbook of Global Modernisms*, the enormous, conceptually daring taxonomic effort of the transnational turn has persuasively overwritten modernism's Eurocentrism. The narrative of modernism we presented at the opening of our essay has been, if not discredited, at least thoroughly reterritorialized, its Anglo-European axis decentered and situated among a wide range of non-Western histories and cultural art forms. (Indeed, modernist studies has so comprehensively pluralized its object of study that we counted no fewer than forty geographically distinct subcategories of modernism in the course of writing our article.)

Wings unfurling across the globe, modernism's new critical cartography also disrupts a long-standing Eurochronology. Consequently, the transnational turn poses methodological questions about the movement's reperiodization. Does a geographical imperative correspond to a temporal imperative, one that would establish modernism's occurrence at markedly different times? More simply, must we revise modernism's when because we have changed its where? In fact, the geospatial liberation of modernism has by no means supplied a model for addressing modernism's travels across time. Daunting interpretive hurdles face advocates of transhistorical enlargement such as Gabriel Josipovici, whose sweeping *What Ever Happened to Modernism?* (2010) traces modernism back to the publication of *Don Quixote*, or Susan Stanford Friedman, who reads modernism as an expressive facet of multiple modernities, implying that we might therefore date modernism as far back as to sixth-century China ("Periodizing" 433 and "Definitional Excursions" 507). Expanding modernism's historical moment has attractive critical upshots: a purely modal conception of modernism releases it from essential ties to any one modernity, allowing us to readopt modernism as a flexible posture rather than a fixed period. But once modernist becomes an epithet for evaluating expressive reactions to modernity, whether at the beginning of the seventeenth century or the dawn of the twenty-first, whether in Berlin or Bombay, it loses a degree of traction and threatens to betray its own need to be replaced. Retaining modernism across deep time can dehistoricize it as a movement but repoliticize it as a global practice, a practice that serves instrumental ends in the context of cultural circumstances with which modernist writing has yet to be associated.

Temporal contraction, or periodization, helpfully counterbalances the spatial expansiveness of the new modernist studies. Indeed, giving precision to modernism's place in time facilitates a more historically robust understanding of how it has moved across cultures. What might be the advantages of retaining the first half of the twentieth century as the most aesthetically meaningful time frame for the modernist arts? This apparently unfashionable move finds three immediate justifications. First, to periodize literature is no more arbitrary than to dissolve periodicity; both gestures impose artificial temporal boundaries on a cultural field.[9] Second, and more directly relevant to our argument, redefining modernism merely through its transhistorical proliferation blurs the technical achievements and affective character of early-twentieth-century art. Finally, we fail to do justice to contemporary literature if we approach it as either a belated iteration of modernism or the outgrowth of a movement that never receded. Periodization, therefore, amplifies, rather than constrains, scholarly discourse about modernism, its several legacies, and the moment of contemporary literature.

Questions of periodization have always played an immanent role in modernist studies.[10] In the wake of the transnational turn, however, debates about the exact moments of Anglo-European modernism's arrival and departure (debates that absorbed the movement's original practitioners in the early twentieth century)[11] have been reoriented to conceive of modernism in relation to

centuries rather than decades. The narrow window between 1890 and 1940 has been disputed on the grounds of elitism, bad faith, and historical myopia. Raymond Williams, for example, whose theories of cultural production paved the way for the historicizing work of the new modernist studies, argued in 1987 that what we call modernism is in fact a "highly selected version of the modern" whose aesthetic postulates were comprehensively anticipated by Romanticism (33). More recently, Friedman called for "modernist studies to expand the horizons of time" by "jettisoning the ahistorical designation of modernism as a collection of identifiable aesthetic styles, and abandoning as well the notion of modernism as an aesthetic period whose singular temporal beginning and endpoints are determinable" ("Periodizing" 432). In 2012, Eric Hayot interrogated the extant foundations of literary study in *On Literary Worlds*, declaring, "Period is the untheorized ground of the possibility of literary scholarship" (154). Expanding the stakes of this debate to real-world ethics, Hayot warns that our passive acceptance of traditional literary periods "reinforces a presentist and dissociative form of historical thinking that makes the world a less good, more stupid place to live in" (168). This audacious claim finds kinship with the self-explanatory title of Ted Underwood's *Why Literary Periods Mattered: Historical Contrast and the Prestige of English Studies* (2013).

And yet, despite these and numerous other, varied efforts to repudiate modernism's early-twentieth-century genesis, the decades between 1890 and 1940 repeatedly emerge as the chrysalis for modern literature's form-breaking work. Each of the scholars cited above eventually concedes, implicitly or explicitly, that the early twentieth century witnessed the burgeoning of a new kind of artistry. Williams, for example, after arguing that periodization straitjackets modernism, admits that "there is unquestionably a series of breaks in all arts in the late nineteenth century" (33). Friedman advocates a temporal logic through which the Indian poet Kabir is a modernist because his fifteenth-century verses conjure the rhythms of twentieth-century jazz.[12] Hayot tries to defeat periodizing logics by treating realism, Romanticism, and modernism as historically portable modes rather than as fixed literary eras; however, he defines each mode through a conspicuously embedded, unwittingly traditional chronology of the arts. Modernism, ostensibly present across centuries of modernity, tends still to be recognized through its affinities with the twentieth-century arts.[13] We now appear to be caught in a scholarly loop: plural or singular, national or transnational, ahistorical or transhistorical, *modernism* consistently returns its scrutinizers to the early twentieth century. Why?

If we look to nonliterary arts, the answer is readily apparent. Stravinsky and Schoenberg, Duchamp and Klee, and Duncan and Nijinsky fundamentally shifted the aural, visual, and kinesthetic quality of the arts. This shift had no pre-twentieth-century equivalent: Beethoven's dramatic, form-altering symphonic feats, for example, upheld classical tradition with far greater fidelity than Stravinsky's, so that even the Ninth Symphony, with its dissonant "terror fanfare" and unprecedented vocal chorus, bears little relation to *The Rite of Spring*'s notoriously distorted play of meter and melody. Why not acknowledge that twentieth-century narrative fiction, too, was foundationally altered by the innovative arrangements of modernist literary form? To make such a claim is not to return to an outmoded insistence that modernism consisted solely of self-willed aesthetic shock, initiated exclusively by privileged factions of urban innovators.[14] Nor does periodization aim to elevate modernism's affective powers above prior or subsequent aesthetic developments. Rather, in straightforward terms, it assures a temporal correspondence between the category of modernism and the early twentieth century's investment in form as a register of creative expression.

A single moment in Virginia Woolf's *To the Lighthouse* might help to illustrate such a claim. Here, drawn from the middle section, "Time Passes"—itself a dazzling tumult of natural, imperial, and psychological temporalities—is the novel's violent, oblique climax, a narrative turning point outside the interpretive reach of transhistorical or geospatial literary paradigms:

[Mr. Ramsay, stumbling along a passage one dark morning, stretched his arms out, but Mrs. Ramsay having died rather suddenly the night before, his arms, though stretched out, remained empty.] (132)

Woolf's toneless sentence denies the world-making power of her own psychological realism and violates the radical coherence of the novel's opening section. This narrative parataxis, its brutality made graphic through square brackets, leaves the reader, too, bereft and "stumbling along a passage": Woolf defamiliarizes novelistic logic about plot, character, and time, endowing her self-referential sentence with an artistic autonomy that resists demystification. Mrs. Ramsay's death, unexplained and inexplicable, opens a literary wound that no biographical detail about Julia Stephen or historical fact about Queen Victoria can stanch. We dull modernism's particular brilliance when we dissolve it into a collective of techniques comparable with what other writers have practiced at other points in history, and to characterize modernism as a feature common to centuries of interlocking modernities is to risk depriving works such as To the Lighthouse of the formal and temporal inventiveness unique to their era.

This early-twentieth-century inventiveness lies at the heart of twenty-first-century metamodernism, which assesses how modernists enlarged the scope of literary possibility by capsizing long-held assumptions about narrative integrity. Our defense of a period for modernist literature, accordingly, signals not a retreat into an "interminably repeated comfort zone," as Friedman warns ("Planetarity" 474), but a valuable and self-reflexive strategy that endows literary history with clarity even as it encourages ongoing debate about when modernism waxed and waned. And we need to retain periodicity not to shore up a canonical sense of when modernism began, the moment from which it cast its influence, but to establish a literary-cultural basis for charting the myriad ways that much twenty-first-century fiction consciously engages modernism through the inheritance of formal principles and ethicopolitical imperatives that are recalibrated in the context of new social or philosophical concerns. Contemporary literary fiction responds to modernism as an aesthetic venture that can certainly occur globally, in different cultures. For such writing, however, modernism also belongs in a temporally localizable moment that we should not overwrite in our eagerness—however politically well-intentioned—to impart a democratic sensibility to art long perceived as Eurocentric, metropolitan, and elite.

Metamodernism

Part of the challenge we face in reading modernism's legacy lies in finding key words to particularize contemporary writers' active responses to their modernist inheritance. The growing body of twenty-first-century metamodernist fiction does not only (or even principally) redeploy familiar traits like rupture, irony, and fragmentation as benchmarks of newness or arbiters of compositional value and esteem. If we map metamodernism's dominant strains, we find that a more ambitious aesthetic-historical pursuit characterizes an otherwise disjunctive collection of writers and novels: to move the novel forward by looking back to the aspirational energies of modernism. And while robust literary legacies abound—Romantic and realist after-lives, for instance, flourish in the new century (e.g., Kaplan; Larmore; Green)—modernism's continuance is intimately bound up in the evolution of the novel itself and, therefore, comprises more than so many lines of flight into the present. The cultural work and artistic innovations of some of the most daring and original contemporary novels are enacted under the rubrics—implicit or explicit—of early-twentieth-century modernism.

Metamodernist practice redistributes the innovative energies of its predecessors. It pays tribute to modernist style (as in the writing of Allan Hollinghurst, Kazuo Ishiguro, Michael Ondaatje,

Zadie Smith, Jeanette Winterson); it inhabits the consciousness of individual modernist writers (Virginia Woolf in Michael Cunningham's *The Hours* [1998], Henry James in Colm Tóibín's *The Master* [2004], Henry James and Joseph Conrad in Cynthia Ozick's Dictation: *A Quartet* [2008]); and it details modernism's sociopolitical, historical, and philosophical contexts (Bruce Duffy's *The World As I Found It* [1987], Monique Truong's *The Book of Salt* [2004], Pat Barker's *Life Class* [2007]). And if early-twentieth-century modernism takes center stage in fiction that aggressively examines the very idea and ethos of modernist artistry (McEwan's *Atonement* and Coetzee's *Youth*), it plays an equally formative role as an absent or vanishing referent in novels where overt influences are less visible (Barnes's *The Sense of an Ending* [2011], Ali Smith's *There but for The* [2011], Self's *Umbrella* [2012]). Across vastly divergent transnational literary registers, as even these partial catalogs reveal, metamodernist writing incorporates and adapts, reactivates and complicates the aesthetic prerogatives of an earlier cultural moment. As a historical antecedent, a cultural trope, and an archive of stylistic and technical possibilities, twentieth-century experimental modernism exerts considerable force on the vision and voice of such contemporary novels.

This is not to imply that fiction's most striking advances today occur solely under the mantle of modernism, but rather to highlight the stakes of modernism's presence for contemporary writers as both a moment and a movement, as an era with which they imaginatively reconnect and as an ethos that they formally refine. Without attempting to unify a disparate body of creative priorities, we can observe how such novelists collectively perpetuate a notion of modernist art's capacity for dissenting unfamiliarity, for resisting the whole phenomenology of recognition by which readers apprehend and assimilate a new work within existing frames of generic reference and evaluation. Metamodernist narratives thus distinguish themselves from an earlier postmodernism through self-conscious, consistent visions of dissent and defamiliarization as novelistic inventions specific to the early twentieth century. On one hand, twenty-first-century metamodernism demonstrates that the impulse to reform the very medium of narrative fiction reached a zenith a century ago; contemporary writers variously acknowledge that the manipulation of form was a litmus test for modernist accomplishment. On the other hand, some metamodernist fictions actually perform historicizing acts, dynamically reflecting on modernism's aesthetic prerogatives in order to mobilize innovations of their own.

To alight in more detail on a writer today whose fiction captures this logic of innovation through retrospection—reassessing modernism as a seismic event for narrative form as well as an epochal episode for modern culture—we turn to the work of Tom McCarthy. McCarthy has drawn on a modernist lineage different from the legacy of literary impressionism that we can trace in the metamodernist work both of established figures like McEwan and Hollinghurst and of such emerging voices as Jon McGregor (*If Nobody Speaks of Remarkable Things* [2002]) and Kamila Shamsie (*Burnt Shadows* [2009]). Looking not to the interiority, obliquity, and density of James or Faulkner, McCarthy has advanced the kind of uncomfortable externalism advocated by Wyndham Lewis, who resisted psychological fiction by employing narrative modes that pay "more attention," in Lewis's terms, "to the outside of people," so that characters' "shells, or pelts, or the language of their bodily movements, come first, not last" (*Satire* 46). McCarthy's externalized fiction challenges the critical privileging of the novel's capacity to reveal people's inward ethical behaviors, to delve into inner moral capacities rather than show us external "shells."

McCarthy's striking intervention in the contemporary scene therefore seems all the more pointed and disruptive at a time when a sizable proportion of literary fiction, as Jesse Matz has argued, is dominated by impressionism—by writing that we expect to elaborate, rather than eviscerate, psychological depth.[15] The impressionist interiority that has begun to seem orthodox today appeared so at its origin to Lewis, who opposed what he viewed as a widespread tendency among his modernist contemporaries toward subjectivism. It was a tendency he described

as "the approved 'mental method,'" one that would ultimately lead, he feared, to the novel's "physical disintegration and formal confusion" (*Time* 112). Moving away from lush simulations of mentation, McCarthy's fiction emphasizes hard surfaces over streams of consciousness, compulsive repetition over sensory refection. This anti-impressionist style animates McCarthy's debut novel, *Remainder* (2006)—famously lauded by Zadie Smith as "one of the great English novels of the last 10 years" (93)—and in his Booker Prize–shortlisted *C* (2010).

Holding much in common with the hybrid of romance and *Künstlerroman* in Lewis's *Tarr* (1918), *C* charts the fortunes of Serge Carrefax to his premature death. Born in 1898 on a prestigious estate in southern England, Serge signs up as a wireless operator at the start of the First World War, serving in spotter planes over the front line. After witnessing the horrors of bombardment firsthand, he is all but desensitized, and his dehumanization is reciprocated as a rhetorical strategy. What ensues in *C* revolves around an impersonal attention to bodies as matter, a mode not without ethical implications as a descriptive vehicle for scenes of violence. In one particularly disturbing episode, we encounter in a glade the fresh remains of a shelled contingent of soldiers. By this point, we have become accustomed to the way inner feelings are superseded by Serge's fascination with matter rather than emotion, for McCarthy prevents Serge throughout from becoming the kind of central, focalizing intelligence whose subjective responses evoke pathos:

> They're all dead. They slump against the trunks like over-ripened fruit that's lost its shape, begun to rot. Their faces all wear grimaces, as though frozen in a grotesque laughter bordering on the insane. Serge looks at their mouths: some of the jaws are dislocated and hang loose; two of them have been ripped open by shrapnel wounds extending from the chest, or neck, or cheek; one has been blown of entirely, leaving a hole through which broken shards of jawbone poke.
>
> The sound's loud here. The men's deformed mouths seem to be either transmitting it or, if not, then at least shaping it, their twisted surfaces and turned-out membranes forming receptacles in which its frequencies and timbres are unravelled, recombined, then sent back out into the air both transformed and augmented, relayed onwards. Their eyes, despite being empty of perception or reaction, seem electrified, shot through with a current that, being too strong for them, has shattered them and left them with a burnt-out, hungry look. (177)

One could invoke, as a kind of epigraph of this sequence, Lewis's insistence, ventriloquized through his protagonist in *Tarr*, that "deadness is the first condition of art" and that "good art" in turn "must have no inside" (265). In this scene, disconcertingly, McCarthy seems to adopt that condition literally, invoking deadness for its own sake as a premise for experimental flair. An unsettling division emerges between character and commentator through the elegant variation, clause by clause: notice the cascade of related verbs (*unravelled, recombined, transformed, augmented*), which do not appear to stem from Serge's center of consciousness. Such rhetorical elaborations signal McCarthy's switch from free indirect discourse to a more externally stylized portrait of the corporeal reality of death—a portrait now synonymous with subjective vitality, for eyes are seemingly "electrified" yet "empty of perception." We find ourselves pinned as readers between two competing affective responses: the pleasure of appreciating the dexterity with which McCarthy's style ambushes us and the disarming acknowledgment that any appreciation of that style is inseparable from the macabre focus of its linguistic energy. Thus, McCarthy's impulse to simultaneously disarm and defamiliarize finds common currency with Lewis but also with Woolf: writers who, despite their mutual antagonisms in their own time, provide equally generative antecedents to the dissenting effect produced by a novel like *C*.

But defamiliarizing strategies of resistance and discomfiture are not merely a stylistic or hermeneutic matter. As expressive registers of aesthetic dissent, they can also present an index of the political and ethical efficacy that contemporary writing attains by remobilizing modernist

procedures. How we might apprehend and encompass the multiple modalities and social import of modernist reformations in contemporary fiction is a task that Laura Marcus has persuasively addressed. Marcus pinpoints dynamics of "homage" and "reinscription" in a range of novelists who might otherwise appear unrelated: B. S. Johnson, Saul Bellow, Salman Rushdie, and Winterson. Marcus alerts us to the political consequences that can ensue when contemporary writers transcend "the formal limitations of the modernist text," arguing that Rushdie, for one, shows that the "coexistence of a multiplicity of styles and languages in Joyce's fiction has also been engaged, in diverse and complex ways, by post-colonial writing up to the present" (89).

For Neil Lazarus, this point has apparently been lost on critics who have refused "[t]o situate modernism in relation to modernity in the context of a discussion of 'post-colonial' literature." Lazarus attributes this scholarly resistance to the fact that "while colonialism is commonly taken as intrinsic to the socio-historical project of *modernity*, *modernism* is not typically viewed—for all its 'dissidence'—as featuring an anticolonial dimension" (28). Complementing recent correctives to this tendency by, for instance, Laura Winkiel, Simon Gikandi ("Modernism"), Michael Valdez Moses, Urmila Seshagiri ("Modernist Ashes"), and Tim Woods, Lazarus surveys a range of figures (some prominent in accounts of contemporary postcolonial fiction, others neglected) including Claribel Alegría, Timothy Mo, Nissim Ezekiel, Phanisvaranatha Renu, and Arundhati Roy. Against the backdrop of such a diverse corpus, he argues "that there might be a *modernist writing after the canonization of modernism*—a writing, that is to say, that resists the accommodationism of what has been canonised as modernism and that does what at least some modernist work has done from the outset—namely, says 'no'; refuses integration, resolution, consolation, comfort; protests and criticises" (31).

Rebecca Walkowitz redirects questions of postcolonial modernism toward the contexts of world literature and translation. In a recent essay, "Close Reading in an Age of Global Writing," Walkowitz broaches the prospect of whether "an aesthetics of translatability [can] find a place for the historical, political, and cultural texture that we value in literature and especially in literature produced in languages that are not our own" (173). How, Walkowitz asks, do modernist values infect the compatibility of literary innovation and translatability? Building on her bracing account of the political afterlives of modernism's engagement with cultural difference and transnational attachment in *Cosmopolitan Style* (2006), Walkowitz considers how world literature today—not only by novelists such as Ishiguro and Coetzee but also by the Web artists Young-Hae Chang and Marc Voge—responds to modernism while also reconfiguring the values we associate with it.

The methodologies proffered by Marcus, Lazarus, and Walkowitz bridge a perceived gap between aesthetic analysis and cultural critique, opening the way for rich discussion about political and ethical facets of modernist narrative technique.[16] The scholarship of Aarthi Vadde and Timothy Bewes, for example, investigates the ties between formal strategies and the political aspirations of transnational thought. Alternative genealogies of modernist practices and their influence are being traced across the twentieth century by Andrzej Gasiorek, Madelyn Detloff, and Jesse Matz.[17] And the representational challenges of finding in modernism modes for evoking the embodied actualities of catastrophe, atrocity, and poverty have been tested in recent work by Susan Andrade, Derek Attridge (J. M. Coetzee), and Russell Samolsky. Such interventions advance conversations about what David James calls "the promise of modernism," encompassing modernism's institutional afterlives and its ethical trajectory in postwar and recent world anglophone writing (*Modernist Futures* 5).

The range of potential optics through which to view modernism's continuing relevance and provocation for contemporary novelists is expanding. Our seminar for the 2013 conference of the Modernist Studies Association, for instance, exemplified the variety that now characterizes approaches to questions of modernism's legacy.[18] It included contributions on Berger's multigeneric historiographies of cubism, on McEwan's recuperation of modernist structures of irony after postmodernism, on Ozick's splicing together of Jamesian and Conradian idioms in ways that raise

the issue of style's transferability across time, and on Ali Smith's resolute defense of the ethos of renewal, formal adventure, and versatility that, for her, modernism bequeaths to writers now. An expanding body of scholarship attends to how and why writers from the late twentieth century onward have consciously reassessed modernist impulses and reactivated the movement's strategies. Consequently, the new modernist studies has a fresh set of resources with which to unmask the ongoing implications of modernism's original cultural ruptures and revolutions.

We should note here that fiction is not alone in playing host to metamodernism. Beyond McCarthy's revival of Lewis and Zadie Smith's homage to Forster, beyond Coetzee's debts to Kafka and Beckett or McEwan's intolerance of Woolf, metamodernist dialogues thrive in publishing houses and the performing arts, in museums and movies. Consider, for example, the London-based independent publisher Persephone Books, a recuperative feminist press that generates a vivid, unusual legacy for modernism by reprinting long-obscured writing by women. At the University of North Carolina, a 2011–12 arts season titled "*The Rite of Spring* at One Hundred" commissioned international artistic collaborations that engaged the ballet's "enduring legacy as a modern masterpiece" ("*Rite*"), including Vijay Iyer's *Radhe Radhe* (a Stravinsky-derived jazz composition about Holi, the Hindu "rite of spring") and Bill T. Jones's A Rite (a dizzyingly choreographed work combining Stravinsky's original score with enactments of the riotous outrage that greeted the ballet's premiere). At the Metropolitan Museum of Art's Costume Institute, an innovative 2012 multimedia creation called *Schiaparelli and Prada: Impossible Conversations* featured the iconic modernist fashion designer and her contemporary successor "conversing" about their artistic affinities and disparities. The international 2011 blockbuster exhibit *The Steins Collect*, which illuminated Gertrude and Leo Stein's roles as enablers of the Paris avant-garde, finds a whimsical analogue in Woody Allen's 2010 film *Midnight in Paris*, in which a frustrated novelist travels back to the fabled Paris of the 1920s, enthralled by the maverick authenticity of modernists such as Hemingway, Stein, Fitzgerald, Picasso, Matisse, and Dalí. In each of these instances, the convergence of modernist forms and modernist histories enables artistic innovation. Modernism's opening moves—narrated from myriad perspectives, filtered through diverse media—provide the spur and measure of contemporary culture's own moves into an aesthetic future.

Surrounded by the lives and half-lives of modernism, we should assimilate the movement's still-powerful presence into our understanding of its origins and ambitions. The growing body of scholarship on metamodernism thus provides new points of entry into the twin questions that constitute the core of modernist critique and historiography: "What was modernism?" as Harry Levin demanded in 1960 (609), and "When was modernism?" as Williams asked in 1987. Modernism's *what* is perpetually traveling across a spectrum from history to aesthetics; modernism's *when* has stretched backward and forward from its implicit and contested starting point in the early twentieth century. But the twenty-first-century novelists surveyed here remind us that modernism's formal promises for narrative fiction will make political, ethical, and aesthetic sense in the future only if modernism denotes a historically precise activity instead of connoting radical artistic responses to every modernity's upheavals. As modernist practices continue to cross literary-historical and cultural frontiers, our conversations about the movement's twentieth-century genesis will enrich our conversations about its twenty-first-century regenerations.

Notes

1. As these writers' names suggest, we limit ourselves here to narrative fiction, because the development of postwar experimental poetry carries a story of discrete avant-garde renaissances that raise a separate set of literary-historical and interpretive questions about the relation between (poetic) innovation and the modernist tradition, a set that merits an account of its own (Perloff).

2. Doyle offers an excellent sequence of methodological engagements with the new modernist studies. See also the essays in Caughie, esp. Ross, as well as Friedman's response to Ross ("World Modernisms").

3. The study of contemporary literature and arts has only recently begun to acquire an institutional presence. See Punday and the mission statement of the Association for the Study of the Arts of the Present, the first professional society dedicated to contemporary arts and culture, founded in 2008 ("A.S.A.P. Mission Statement"). See also Attridge, *Singularity*, and Dubreuil.

4. Appadurai, Chakrabarty, and Gaonkar have identified alternative, hybrid, provincial, and postcolonial modernities that challenge Eurocentric theories of modernity formalized by scholars such as Immanuel Wallerstein and Anthony Giddens.

5. Scholes and Wulffman; Ziarek; Randall; Cheng; Thaggert; Seshagiri, *Race*; Lyon; Brown and Grover.

6. Jameson's 1990 essay "Modernism and Imperialism" and Said's 1993 *Culture and Imperialism* heralded the postcolonial critique of modernism, ushering in important studies such as Boehmer; Gikandi, *Maps*; Doyle; Baucom; Esty; Marx; and Begam and Moses.

7. Friedman, "Planetarity"; Walkowitz, *Cosmopolitan Style*; Abravanel; Tacker; Alexander and Moran.

8. The new spatial orientation is also a dominant presence in handbooks and anthologies on modernism, shaping volumes such as *Geographies of Modernism* (2005), *Gender in Modernism: Complex Intersections, New Geographies* (2007), and The *Oxford Handbook of Modernisms* (2010). Similarly, note the multinational scope of recent special issues like *Modernism/Modernity's Mediamorphosis: Print Culture and Transatlantic/Transnational Public Sphere(s)* (2012) and *Modern Fiction Studies's Modernism, Feminism, and Women Writers* (2013).

9. Jameson makes this point in *The Political Unconscious* (1981), characterizing literary periods as conceptual constructions that are "as indispensable as they are unsatisfactory" (28).

10. As Shiach points out, modernism's ambiguous origins and end points have typically been moved back and forth across the fin de siècle, the outbreak of the First World War, and the end of the Second World War. Studies whose goal is to establish clear time lines for modernism's rise include Butler; Miller; Rabaté; Bluemel; Levenson; and Jackson. Professional societies such as Post-1945 and The Space Between: Literature and Culture, 1914–1945 identify the First and Second World Wars as boundaries for modernism; the Modernist Studies Association concentrates on arts from "the later nineteenth-through the mid-twentieth century" (*Modernist Studies Association*).

11. Anglo-European modernists and their contemporaries were as vigorous in their pronouncements of modernism's demise or irrelevance as they were in the manifestos that announced its arrival. Consider, e.g., Woolf's "The Leaning Tower" (1941), Lewis's "The End of Abstract Art" (1940), and Orwell's "Inside the Whale" (1940).

12. Remarks made during the question-and-answer period at the roundtable session "The Time and Origin of Repetition: Modernism after Modernism," 128th MLA Annual Convention (2013).

13. Berman incisively argues against this tendency, rethinking assumptions about the intercultural transaction of modernist influences between Europe and its former colonies ("Neither Mirror").

14. Mao and Walkowitz's introduction to *Bad Modernisms* (2006) historicizes theories of modernism as rupture ("Introduction"). Schoenbach offers a brilliant counterhistory, arguing that modernism emerged as profoundly through continuity and habit as it did through rupture and shock.

15. "Most fiction now," contends Matz, "shifts perspectives, withholds judgement and conjures immediacy, mainstreaming an Impressionism free of its original scepticism, alienation and anxiety" ("Pseudo-Impressionism?" 123–24).

16. McGurl maps another institutional legacy of modernism in *The Program Era* (2009), in which the North American creative writing curriculum emerges as the mise-en-scène for postwar revaluations of modernist technique.

17. Gasiorek, "'A Renewed Sense of Difficulty'"; Matz, *Lasting Impressions*; Detloff. See also Gasiorek's engagement with debates about the aftermath of modernism amid the resurgence of social realism in the 1950s and 1960s in Postwar British Fiction (1995).

18. Participants in the seminar, which was called Modernist Reformations and Reactivations, included Derek Attridge, Michaela Bornstein, Vicki Mahaffey, Laura Marcus, Omri Moses, Christopher Mourant, Michael LeMahieu, Amanda Golden, Kevin Brazil, and Matthew Oches.

Works Cited

Abravanel, Genevieve. *Americanizing Britain: The Rise of Modernism in the Age of the Entertainment Empire.* New York: Oxford UP, 2012. Print.

Alexander, Neal, and James Moran. *Regional Modernisms.* Edinburgh: Edinburgh UP, 2013. Print.

Andrade, Susan Z. "Representing Slums and Home: Chris Abani's *GraceLand*." James, *Legacies* 225–42.

Appadurai, Arjun. *Modernity at Large: Cultural Dimensions of Globalization.* Minneapolis: U of Minnesota P, 1996. Print.

"A.S.A.P. Mission Statement. " *ASAP.* Assn. for the Study of the Arts of the Present, n.d. Web. 31 Oct. 2013.

Attridge, Derek. *J. M. Coetzee and the Ethics of Reading: Literature in the Event.* Chicago: U of Chicago P, 2005. Print.

——. *The Singularity of Literature.* London: Routledge, 2004. Print.

Baucom, Ian. *Out of Place: Englishness, Empire, and the Locations of Identity.* Princeton: Princeton UP, 1999. Print.

Begam, Richard, and Michael Valdez Moses, eds. *Modernism and Colonialism: British and Irish Literature, 1899–1939.* Durham: Duke UP, 2007. Print.

Berman, Jessica. *Modernist Commitments: Ethics, Politics, and Transnational Modernism.* New York: Columbia UP, 2011. Print.

——. "Neither Mirror nor Mimic: Transnational Reading and Indian Narratives in English." *The Oxford Handbook of Global Modernisms.* Ed. Mark Wollaeger with Matt Eatough. New York: Oxford UP, 2012. 205–27. Print.

Bewes, Timothy. *The Event of Postcolonial Shame.* Princeton: Princeton UP, 2010. Print.

Bluemel, Kristin, ed. *Intermodernism: Literary Culture in Mid-Twentieth-Century Britain.* Edinburgh: Edinburgh UP, 2009. Print.

Boehmer, Elleke. *Empire, the National, and the Postcolonial, 1890–1920.* Oxford: Oxford UP, 2005. Print.

Brown, Erica, and Mary Grover, eds. *Middlebrow Literary Culture: The Battle of the Brows, 1920–1960.* Basingstoke: Palgrave, 2011. Print.

Butler, Christopher. *Early Modernism: Literature, Music, and Painting in Europe, 1900–1916.* Oxford: Oxford UP, 1994. Print.

Caughie, Pamela L., ed. *Disciplining Modernism.* Basingstoke: Palgrave, 2009. Print.

Chakrabarty, Dipesh. *Provincializing Europe: Postcolonial Thought and Historical Difference.* Princeton: Princeton UP, 2000. Print.

Cheng, Anne Anlin. *Second Skin: Josephine Baker and the Modern Surface.* Oxford: Oxford UP, 2011. Print.

Detloff, Madelyn. *The Persistence of Modernism: Loss and Mourning in the Twentieth Century.* Cambridge: Cambridge UP, 2009. Print.

Doyle, Laura. *Bordering on the Body: The Racial Matrix of Modern Fiction.* New York: Oxford UP, 1995. Print.

Doyle, Laura, and Laura Winkiel, eds. *Geomodernisms: Race, Modernism, Modernity.* Bloomington: Indiana UP, 2005. Print.

Dubreuil, Laurent. "What Is Literature's Now?" *New Literary History* 38.1 (2007): 43–70. Print.

Esty, Jed. *The Shrinking Island: Modernism and National Culture in England.* Princeton: Princeton UP, 2003. Print.

Friedman, Susan Stanford. "Definitional Excursions: The Meanings of Modern/Modernity/Modernism." *Modernism/Modernity* 8.3 (2001): 493–513. Print.

——. "Periodizing Modernism : Postcolonial Modernities and the Space/Time Borders of Modernist Studies." *Modernism/Modernity* 13.3 (2006): 425–43. Print.

——. "Planetarity: Musing Modernist Studies." *Modernism/Modernity* 17.3 (2010): 471–99. Print.

——. "World Modernisms, World Literature, and Comparativity." *The Oxford Handbook of Global Modernisms.* Ed. Mark Wollaeger with Matt Eatough. New York: Oxford UP, 2012. 499–525. Print.

Gaonkar, Dilip Parameshwar, ed. *Alternative Modernities.* Durham: Duke UP, 2001. Print.

Gasiorek, Andrzej. *Postwar British Fiction: Realism and After.* London: Arnold, 1995. Print.

——. "'A Renewed Sense of Difficulty': E. M. Forster, Iris Murdoch, and Zadie Smith on Ethics and Form." James, Legacies 170–86.

Gikandi, Simon. *Maps of Englishness: Writing Identity in the Culture of Colonialism.* New York: Columbia UP, 1996. Print.

——. "Modernism in the World" *Modernism/Modernity* 13.3 (2006): 419–24. Print.

GoGwilt, Christopher, *The Passage of Literature: Genealogies of Modernism in Conrad, Rhys, and Pramoedya.* New York: Oxford UP, 2010. Print.

Green, Matthew. "Dreams of Freedom: Magical Realism and Visionary Materialism in Okri and Blake." *Romanticism* 15.1 (2009): 18–32. Print.

Hart, Matthew. *Nations of Nothing but Poetry: Modernism, Transnationalism, and Synthetic Vernacular Writing*. New York: Oxford UP, 2010. Print.

Hayot, Eric. *On Literary Worlds*. New York: Oxford UP, 2012. Print.

Jackson, Kevin. *Constellation of Genius: 1922: Modernism Year One*. London: Hutchinson, 2012. Print.

James, David, ed. *The Legacies of Modernism: Historicizing Postwar and Contemporary Fiction*. Cambridge: Cambridge UP, 2012. Print.

——. *Modernist Futures: Innovation and Inheritance in the Contemporary Novel*. New York: Cambridge UP, 2012. Print.

Jameson, Fredric. "Modernism and Imperialism." *Nationalism, Colonialism, and Literature*. By Terry Eagleton, Jameson, and Edward Said. Minneapolis: U of Minnesota P, 1990. 43–66. Print.

——. *The Political Unconscious: Narrative as a Socially Symbolic Act*. Ithaca: Cornell UP, 1981. Print.

Josipovici, Gabriel. *What Ever Happened to Modernism?* New Haven: Yale UP, 2010. Print.

Kaplan, Cora. *Victoriana: Histories, Fictions, Criticism*. New York: Columbia UP, 2007. Print.

Larmore, Charles E. *Romantic Legacies*. New York: Columbia UP, 1996. Print.

Lazarus, Neil. *The Postcolonial Unconscious*. Cambridge: Cambridge UP, 2011. Print.

Levenson, Michael. *Modernism*. New Haven: Yale UP, 2011. Print.

Levin, Harry. "What Was Modernism?" *Massachusetts Review* 1.4 (1960): 609–30. Print.

Lewis, Wyndham. "The End of Abstract Art." *New Republic* 31 Mar. 1940: n. pag. Web. 1 Aug. 2012.

——. *Satire and Fiction*. London: Arthur, 1930. Print. Enemy Pamphlets 1.

——. *Tarr*. Ed. Scott Klein. Oxford: Oxford UP, 2010. Print.

——. *Time and Western Man*. Ed. Paul Edwards. Santa Barbara: Black Sparrow, 1993. Print.

Lyon, Janet. "On the Asylum Road with Woolf and Mew." *Modernism/Modernity* 18.3 (2011): 551–74. Print.

Majumdar, Saikat. *Prose of the World: Modernism and the Banality of Empire*. New York: Columbia UP, 2013. Print.

Mao, Douglas, and Rebecca L. Walkowitz. "Introduction: Modernisms Bad and New." *Bad Modernisms*. Ed. Mao and Walkowitz. Durham: Duke UP, 2006. 1–18. Print.

——. "The New Modernist Studies." *PMLA* 123.3 (2008): 737–48. Print.

Marcus, Laura. "The Legacies of Modernism." *The Cambridge Companion to the Modernist Novel*. Ed. Morag Shiach. Cambridge: Cambridge UP, 2007. 82–97. Print.

Marx, John. *The Modernist Novel and the Decline of Empire*. Cambridge: Cambridge UP, 2005. Print.

Matz, Jesse. *Lasting Impressions: Impressionism Now*. New York: Columbia UP, forthcoming.

——. "Pseudo-Impressionism?" James, *Legacies* 114–32.

McCarthy, Tom. *C*. London: Cape, 2010. Print.

——. "To Ignore the Avant Garde Is Akin to Ignoring Darwin." Interview by James Purdon. *Observer* 31 July 2010: n. pag. Web. 19 Nov. 2013.

McGurl, Mark. *The Program Era: Postwar Fiction and the Rise of Creative Writing*. Cambridge: Harvard UP, 2009. Print.

Miller, Tyrus. *Late Modernism: Politics, Fiction, and the Arts between the World Wars*. Berkeley: U of California P, 1999. Print.

Modernist Studies Association. Modernist Studies Assn., n.d. Web. 1 Oct. 2013.

Moses, Michael Valdez. "Disorientalism: Conrad and the Imperial Origins of Modernist Aesthetics." Begam and Moses 43–69. Print.

Orwell, George. "Inside the Whale." *"Inside the Whale" and Other Essays*. London: Penguin, 1957. 9–50. Print.

Perloff, Marjorie. *Twenty-First-Century Modernism: The "New" Poetics*. Oxford: Blackwell, 2002. Print.

Punday, Daniel. *Five Strands of Fictionality: The Institutional Construction of Contemporary American Fiction*. Columbus: Ohio State UP, 2010. Print.

Rabaté, Jean-Michel. *1913: The Cradle of the Modern*. Oxford: Wiley, 2007. Print.

Randall, Bryony. *Modernism, Daily Life, and the Everyday*. Cambridge: Cambridge UP, 2008. Print.

"*The Rite of Spring* at One Hundred." *Carolina Performing Arts*. Carolina Performing Arts, n.d. Web. 1 Nov. 2013.

Rogers, Gayle. *Modernism and the New Spain: Britain, Cosmopolitan Europe, and Literary History*. New York: Oxford UP, 2012. Print.

Ross, Stephen. "Uncanny Modernism; or, Analysis Interminable." Caughie 32–52.

Said, Edward. *Culture and Imperialism*. New York: Vintage, 1993. Print.

Samolsky, Russell. *Apocalyptic Futures: Marked Bodies and the Violence of the Text in Kafka, Conrad, and Coetzee*. New York: Fordham UP, 2011. Print.

Schoenbach, Lisi. *Pragmatic Modernism*. Oxford: Oxford UP, 2012. Print.

Scholes, Robert, and Cliford Wulfman. *Modernism in the Magazines: An Introduction*. New Haven: Yale UP, 2010. Print.

Seshagiri, Urmila. "Modernist Ashes, Postcolonial Phoenix: Jean Rhys and the Evolution of the English Novel in the Twentieth Century." *Modernism/Modernity* 13.3 (2006): 487–505. Print.

——. *Race and the Modernist Imagination*. Ithaca: Cornell UP, 2010. Print.

Shiach, Morag. "Periodizing Modernism." *The Oxford Handbook of Modernisms*. Ed. Peter Brooker et al. Oxford: Oxford UP, 2010. 17–30. Print.

Smith, Zadie. "Two Directions for the Novel." *Changing My Mind: Occasional Essays*. London: Hamilton, 2009. 71–96. Print.

Thacker, Andrew. *Moving through Modernity: Space and Geography in Modernism*. Manchester: Manchester UP, 2003. Print.

Thaggert, Miriam. *Images of Black Modernism*. Amherst: U of Massachusetts P, 2010. Print.

Underwood, Ted. *Why Literary Periods Mattered: Historical Contrast and the Prestige of English Studies*. Stanford: Stanford UP, 2013. Print.

Vadde, Aarthi. "National Myth, Transnational Memory: Ondaatje's Archival Method." *The Contemporary Novel: Imagining the Twenty-First Century*. Ed. Timothy Bewes. Spec. issue of *Novel: A Forum on Fiction* 45.2 (2012): 257–75. Print.

Walkowitz, Rebecca L. "Close Reading in an Age of Global Writing." *Modern Language Quarterly* 74.2 (2013): 171–95. Print.

——. *Cosmopolitan Style: Modernism beyond the Nation*. New York: Columbia UP, 2006. Print.

Williams, Raymond. "When Was Modernism?" *The Politics of Modernism: Against the New Conformists*. Ed. Tony Pinkney. London: Verso, 1987. 31–35. Print.

Winkiel, Laura. "Postcolonial Avant-Gardes." *Decentering the Avant-Garde: Towards a New Topography of the International Avant-Garde*. Ed. Per Backstrom and Hubert van der Berg. Atlanta: Rodopi, 2013. 89–108. Print.

Woods, Tim. "A Complex Legacy: Modernism's Uneasy Discourse of Ethics and Responsibility." *James, Legacies* 153–69.

Woolf, Virginia. "The Leaning Tower." *The Moment and Other Essays*. New York: Harcourt, 1948. 128–54. Print.

——. *To the Lighthouse*. 1927. New York: Harcourt, 2005. Print.

Ziarek, Ewa. *Feminist Aesthetics and the Politics of Modernism*. New York: Columbia UP, 2012. Print.

CHAPTER 16
OSCAR WILDE, MAN OF LAW
Robert Spoo[1]

Almost from the start, modernism (both old and new), found itself entangled with the law. Oscar Wilde, who is still considered one of the movement's foundational figures, began his life as a brilliant playwright only to end his career in the dock, where the British courts judged him guilty of indecency for sleeping with other men. Two of the era's landmark works— Joyce's *Ulysses* and Lawrence's *Lady Chatterley's Lover*—were ruled indecent, and even when the bans on them were finally lifted, they were published with the legal rulings as prefaces. Modernism simply could not be understood apart from its encounters with the law. Indeed, its most energetic impresario, Ezra Pound, also found himself arrested (and narrowly escaped execution for treason) because of his fascist radio broadcasts. His reputation survived, in part, thanks to a series of poems called *The Pisan Cantos* (1948) that he wrote while detained by American forces in an open-air cage.

These narratives about law, oppression, book banning, and imprisonment formed an important part of modernism's mythology, helping to associate it from the start with a kind of revolutionary or outsider status. Such narratives extend back even farther to Baudelaire's and Flaubert's encounters with censorship, through Radclyffe Hall's banned lesbian novel, and forward to the wild provocations of Henry Miller and William S. Burroughs. As the New Modernist Studies took shape, however, such narratives had begun to lose their power as scholars found themselves confronting a challenging set of legal issues revolving around copyright. The attempt to expand what could count as modernism or to rethink some of the early twentieth century's core works ran headlong into recalcitrant heirs who controlled access to the archives and could regulate what could be seen, published, and quoted. At the same time, countries throughout the world were also aligning and lengthening copyright laws, making it even more difficult to expand the modernist archive by introducing obstacles that those writing about Shakespeare or Austen did not face.

No critic has done more to clarify these challenges, to articulate clearly the rights of scholars, or to illuminate modernism's complicated legal landscape than Robert Spoo. An accomplished editor and critic, he served for a decade as the editor of the *James Joyce Quarterly*, where he found himself consistently entangled with the author's estate and began to learn how copyright law, in particular, was silently but powerfully shaping scholarly practice. He left his tenured position as a professor of English to enroll in Yale Law School, where he gained new expertise in intellectual property law and began to practice in the field. During this time, he joined a team that brought a suit against the Joyce estate in defense of a biographer who found herself stymied as she tried to write a book about the author's daughter, Lucia Joyce. Although the case was settled before it could to trial, it nevertheless helped create a new understanding about the limits of copyright law.

[1]From Robert Spoo, *Modernism and the Law*. Bloomsbury Academic, ©2018. Reproduced here with permission.

Spoo's legal work has intersected consistently with his scholarly writing and he has become an expert on the many different ways in which law shapes the creation and reception of literature. Here we have excerpted a chapter from *Modernism and the Law* (2018), a volume in the New Modernisms series that surveys key legal principles like copyright, obscenity, and privacy that helped fashion the idea of modernism. This piece focuses in particular on the complicated figure of Oscar Wilde, whose work is shot through with legal issues and questions that extend far beyond his infamous trials. Wilde, Spoo argues, can best be understood not simply as an author but as a "complete man of law" who helped create a series of "judicial gaps" that became both as sites of radical aesthetic innovation as well as hazards for the writers who ventured into them.

More than a decade after Oscar Wilde's death, his friend and literary executor Robert Ross wrote an introductory note for Stuart Mason's *Bibliography of Oscar Wilde* (1914). By turns satirical and admiring, amused by the obsessive archeology that underlay the hundreds of entries, Ross began his cameo appearance by playfully suggesting that he might sue Mason:

> Pius the Ninth, when invited to assist the sale of a certain writer's book, promised to put it on the Index Librorum Prohibitorum. The kindest act which I could do for Mr. Stuart Mason would be to injunct the result of his toil on the ground that he or his publishers had committed some breach of the Copyright Laws. This would have tempted the dealer in unauthorised literature, who would, I am sure, have invested at once in what might promise to become "curious" and "scarce." But Mr. Mason has pedantically observed all the principles of the Berne and Berlin Conventions and those other conventions which have no other authority than courtesy. (Mason, *Bibliography* v)

The sardonic faux-legalism of this endorsement suggests that Ross, mired at the time in litigation arising from his friendship with Wilde (Murray 182–8), could scarcely think of the disgraced wit as a subject distinct from the law. Ross figures himself here as the plaintiff in a lawsuit against the bibliographer, seeking an injunction for infringements of Wilde's copyrights—even though forced sales and bankruptcy had stripped Wilde of many of his copyrights in the aftermath of his trials and burdened Ross with the ongoing task of recovering the alienated rights for Wilde's children (Ellmann, *Oscar* 588). Bitter and court-weary, Ross cannot resist pointing to other features of the legal landscape of the early twentieth century. He notes that books tainted by legal scandal—whether from charges of obscenity, blasphemy, or piracy—often acquired value in the underground markets that exploited law-induced scarcity. And he casts a skeptical eye on international copyright conventions that had been adopted in previous decades for combatting cross-border piracies but that, lacking the signature of the United States, often did little to inhibit transatlantic exploitation of European writers. Only "courtesy"—informal norms of respect for authorship, discussed below and in Chapter 3—might persuade American publishers to treat foreign authors and their executors as if they were entitled to control the printing of books and the collecting of royalties.

The primary target of Ross's imaginary legal action is the book itself, "the result of [Mason's] toil," which he playfully threatens to "injunct" and so consign to a booklegger's heaven of forbidden wares. He does not suggest, as some executors might, that he will seek damages to compensate beneficiaries. His litigation scenario is mostly *in rem*, directed against the offending thing, rather than *in personam*, against the actors—Mason and his publisher—who are responsible for the imaginary infringement. Ross thus models his friendly suit on one of the period's chief legal strategies: to assail books themselves as the source of harm to morality, property, or reputation.

Ross evokes in his brief fantasia the law-saturated culture in which Wilde lived and wrote—a culture of authorial regulation, moral didacticism, banned books and performances, infringed copyrights and lawful piracies, and informal and sporadic courtesies extended to vulnerable authors. Wilde himself had come to recognize that he was a product or precipitate of the law. Writing in his prison cell at Reading in 1897, he observed that "[t]o be entirely free, and at the same time entirely dominated by law, is the eternal paradox of human life that we realise at every moment" (*De Profundis* 704). This melancholy philosophy—confided in a letter to his friend and lover, Lord Alfred Douglas—figured the law almost as an erotic force, imposing its will on consciously free subjects just as Dorian Gray's personality "dominates" the artist Basil Hallward in *The Picture of Dorian Gray* (1891:25), and as Wilde "dominated" various young men, according to the barrister who cross-examined him at trial (Holland 268, 270, 273). As a convict, Wilde at times thought of himself as a victim and plaything of the law; at other times, he imagined the law as a retributive fury exacting a righteous toll for his private conduct. But mostly he lamented "the unintelligent violence of the Law" as a thing that crowded and consumed his postlapsarian life (*Complete Letters* 819, 1142; *De Profundis* 758).

Yet law's pervasive force had been there all the time, even if Wilde only became fully aware of it as he looked back on his road to Reading. In *De Profundis* he observed, "I am a born antinomian. I am one of those who are made for exceptions, not for laws" (732). He returned to the figure of the exception later in the same letter while discussing Christ as the supreme example of individualism: "Christ had no patience with the dull lifeless mechanical systems that treat people as if they were things. . . . For him there were no laws: there were exceptions merely" (750–1). Wilde imagined himself to be, like Christ, an exception shining in the darkness of homogenizing laws, a figure whom norms and normative systems could never assimilate or fully comprehend.

When he characterized himself as an exception among laws, did he mean that he was an exception in the conventional legal sense? If this was his meaning, then he thought of himself as occupying law's ambit of grace, a person whose individualism merited a special juridical accommodation. If, on the other hand, he meant that his exceptionalism was outside law's framework altogether, something unaccounted for by the law, then he was imagining himself and his predicament as constituting a state of exception analogous in some ways to the condition described by the political theorist Carl Schmitt: an emergency or extreme peril that troubles the shared legal order and cannot be reconciled with known facts or made to conform to preexisting legal codes (Schmitt 6). The exception in this sense—and it seems to be Wilde's sense—is charged with dangerous novelty, with "the power of real life [that] breaks through the crust of a mechanism that has become torpid by repetition" (15). In this respect, Wilde was a solvent of norms, a human emergency that dared the Victorian legal order to regulate and remedy him. His personal state of exception implied "a suspension of the judicial order itself" (Agamben 4).

But Wilde was not the only sociolegal emergency. The very laws that he challenged were in a state of perilous flux. The legal regimes that regulated literary piracy, obscenity, privacy, sexuality, and other aspects of British life at the *fin de siècle* contained gaps, negative spaces, undeveloped rationales, and ambiguous standards—legal black holes and grey holes that either defied the law to fill them or invited the law to act arbitrarily and capriciously in regulating deviant subjects (Vermeule). Even before an English court sentenced him to two years at hard labor for the statutory offense of gross indecency, Wilde's life had become defined by the laws of late nineteenth-century Britain and its combative, legalistic culture. His immersion in law, forced and voluntary, makes him both a representative and an exceptional figure within his legal culture and a precursor of literary modernism's complex interactions with law in the decades that followed. Just as Wilde's state of exception collided with the regulatory forces of Victorian law, so modernist writing would be a challenging emergency within the transitional normative systems that sought to regulate it.

Honor and Libel

In Britain in the late nineteenth and early twentieth centuries, there was a fierce culture of honor among writers and artists, often manifested in real or threatened litigation or in public accusations and recriminations. Men who felt that their professional or personal reputations had been impugned instituted civil or criminal libel proceedings, seeking damages for themselves or prison terms for their opponents. In 1878, James McNeill Whistler sued the art critic John Ruskin for publishing a critique that assailed one of Whistler's paintings as the work of a "coxcomb ask[ing] two hundred guineas for flinging a pot of paint in the public's face" (qtd. in Whistler 1). Whistler prevailed in the libel action, but the jury awarded him only contemptuous damages of a farthing, and the judge denied him the costs of his suit (Pennell 242). In *The Gentle Art of Making Enemies* (1890), Whistler revisited the Ruskin litigation and other artistic and literary quarrels, including his public feud with Wilde for allegedly plagiarizing his ideas (236–43). In the decades following Wilde's death, Lord Alfred Douglas was the plaintiff or the defendant in several libel proceedings involving books about his relationship with Wilde, accusations of homosexuality, and his work as an author and editor. Even Douglas's father-in-law prosecuted him for criminal libel in the course of a family dispute (Murray 168–9).

In this culture of honor, the combatants spoke the language of law as if it were a sturdy vernacular. When Douglas's father, the Marquess of Queensberry, confronted Wilde at his London home to warn him to stay away from his son, Wilde went on the offensive: "I suppose you have come to apologise for the statements you made about my wife and myself in letters you wrote to your son. I should have the right any day I chose to prosecute you for writing such a letter." To this threat of a libel prosecution, Queensberry retorted, "The letter was privileged, as it was written to my son" (qtd. in Ellmann, *Oscar* 447). Queensberry's reply alluded to the law's qualified privilege for communications made to protect the interests of family members (Odgers, *Outline* 124–5). Less menacingly, George Bernard Shaw wrote to the author and journalist Frank Harris in 1921 to discourage the making of a film about Wilde's life. He lectured Harris colorfully if pedantically on the application of libel law to living and deceased persons and on the distinction between copyrighted expression and unprotected ideas. If the "film people" attempted to use Shaw's name, he warned, he would "be down on them instantly with all the legal thunderbolts [he could] throw" (qtd. in Harris 209–11).

These honor feuds were sometimes not far from physical violence. In the quarrel leading up to Wilde's attempt to prosecute Queensberry for criminal libel, the principals threatened each other with beatings and shootings. In response to an insulting telegram, Queensberry wrote his son that he would give him the "thrashing" he deserved. In return, Douglas informed his father that, in addition to a possible libel action, he had armed himself with a "loaded revolver" with which he or Wilde would be "completely justified" in defending themselves against "a violent and dangerous rough" (qtd. in Murray 58, 64). Queensberry himself claimed that he would be justified in shooting the "monster" Wilde in the street, and he showed up at restaurants armed with a horsewhip, vowing to administer a public lashing if he found Wilde and his son together. A concerned friend made Wilde a present of a sword stick with which to protect himself (73–4), and Wilde warned the Scarlet Marquess during a heated interview that, whatever the Queensberry boxing rules might say, "the Oscar Wilde rule [was] to shoot at sight" (qtd. in Ellmann, *Oscar* 447). These mutual menacings blended legalism and mayhem in a potent antisocial brew. (Fascinated by the romance of wounded honor, Wilde included duel motifs in at least two unproduced dramas [411–12].)

Turbulent quarrels over reputation were the chief reason for the historical growth of criminal libel law (Latham 75–6). A remedy in the criminal courts was meant to take the place of duels, public brawling, and other breaches of the peace (Odgers, *Outline* 177–8). Lord Alfred Douglas

referred to his own libel actions as attempts to obtain "satisfaction," a transfer of the duel from the field of honor to the courtroom, with attorneys playing the role of seconds and the jury's verdict replacing the épée and the pistol (Murray 187). Aesthetes and decadents who resorted to honorable violence were imitating the habits of the hereditary leisure class, for whom dueling, according to Thorstein Veblen, was the survival of an archaic predatory instinct (Veblen 249). Queensberry and Wilde—the one a blood aristocrat, the other a dandy mimicking the dress and airs of the upper class—might have traded threats of violence, but in the end they submitted their honor-based aggressions to the criminal courts, which had long before assumed jurisdiction over public violence committed in the name of wounded honor.

Wilde's formal indictment against Queensberry recited the dual rationale underlying the law of criminal libel as it existed in 1895. Wilde alleged that the calling card left by Queensberry at Wilde's club, bearing the message "For Oscar Wilde posing as somdomite [sic]," was maliciously intended "to deprive [Wilde] of his good name fame credit and reputation" and "to excite him to commit a breach of the peace" (Holland 285–6). Wilde in effect charged that Queensberry should be held accountable for both a private wrong and a public harm because he had sought to injure Wilde's reputation and to incite him to violent retaliation. Although harm to reputation had long been recognized as the basis for civil libel actions, and breach of the peace as the basis for prosecuting criminal libels, jurists in the nineteenth century were coming to view criminal libel as protecting against private and public harms equally (*Report from the Select Committee* 35; Veeder 41–7). Criminal libel's threat to the public peace had given rise to several traditional rules. First, unlike a libel in a civil action, a criminal libel need not have been published to a third party to be punishable; a libel communicated solely to the injured party was sufficient to provoke violence (Odgers, *Outline* 187–8). Second, although only statements about living persons could be the subject of civil actions for libel, a libel aimed at the dead was a punishable crime because it could lead to family feuding or other public mischief (184). Third, while the truth of an injurious statement was a complete defense in a civil action, truth alone could not justify a libel in the common-law criminal courts, because telling an inflammatory truth might provoke retaliation just as easily as stating a falsehood. Hence, the old maxim, "The greater the truth, the greater the libel" (188).

Because Wilde was prosecuting him for criminal libel, Queensberry could not defend himself simply by proving the truth of his statement that Wilde had been posing as a sodomite. Instead, Queensberry had the twofold statutory burden of showing that his words were true and that he had published them for the public benefit (Libel Act 1843 S 6; Latham 76). Publishing a truth for the public benefit was deemed to justify a libel because it offered a "countervailing advantage to compensate the public for the risk of a breach of the peace" (Odgers, *Outline* 188). In other words, publishing an unsettling truth for a broadly beneficial purpose was thought to balance out any threat to the public safety. The law of criminal libel, while it shared elements with its civil counterpart, in this respect remained rooted in the public interest. Throughout the trial, Queensberry— although his public-spiritedness had previously shown itself in threats to beat and disinherit his son—maintained, through his counsel, that he had sought to "save" Douglas and to expose Wilde's corrupting influence on other young men, for the public benefit (Holland 249).

Posing

The "hideous words" written on Queensberry's calling card read, "For Oscar Wilde posing as somdomite" (Ellmann, *Oscar* 438). Or did they? At least three different readings of the crabbed scrawl have seemed possible. Some scholars contend that what Queensberry wrote was "For [or To] Oscar Wilde posing Somdomite" (438; Holland 300 n41). At Queensberry's committal hearing in

March 1895, the hall porter of Wilde's club, to whom the Marquess had handed the card, testified that the message was "For Oscar Wilde ponce and somdomite," but Queensberry interrupted and insisted that the words were "posing as sodomite" (Holland 4). Queensberry's self-serving version— "posing as" was easier to defend than other possibilities—was the one that came to dominate the proceedings, but what did it mean to pose as a sodomite? Wilde's indictment itself seemed undecided. His first count alleged that the words accused him of "commit[ting] and [being] in the habit of committing the abominable crime of buggery with mankind" (285). The second count offered no interpretation at all, suggesting, probably, that the words meant just what they said: "*posing* as a sodomite." Queensberry's plea of justification mirrored this dual reading by claiming, first, that "the natural meaning of the words" was that Wilde "did solicit and incite" more than a dozen young men "to commit sodomy and other acts of gross indecency and immorality with him"; and, second, that certain writings by Wilde described or were related to "sodomitical and unnatural habits tastes and practices" (286–91). These allegations all converged in the notion that Wilde had "created a public persona for himself as a 'sodomite'" (Latham 65), yet the litigation never quite settled on a single meaning for Queensberry's cryptic slur. Was Wilde accused of *posing* or of *being*, and did it really matter which?

In fact, the meaning of "posing" multiplied throughout the libel trial, overtaking Queensberry's simple dichotomous equivalency: "to pose as a thing is as bad as to be it" (Holland 214). Wilde himself introduced the first variation when defense counsel Edward Carson caught him in a flattering miscalculation of his age. Wilde flared, "I have no intention of posing for a younger man at all" (64). This flippant parody of the Marquess's calling card glanced, unconsciously perhaps, at *The Picture of Dorian Gray*, which Carson would shortly adduce as evidence of Wilde's immoral posing. In the novel's second chapter, Dorian literally poses for the painter Basil Hallward and grows jealous of the portrait that will "remain always young" while Dorian himself will become "old, and horrible, and dreadful" (1890:19). After his prayer for perpetual youth is answered, Dorian lives a life that enables him, as the years pass, to pose as a young man about London, while his portrait, shut away in the attic, registers the reality of his moral corruption and physical aging. Worship of youth is at the center of the story's bizarre moral alchemy. Dorian is his own living portrait, perpetually posed and posing. His unchanging body circulates in society, as Jonathan Goldman has shown (19–54), while the changing canvas keeps a secret tally of his sins. Basil Hallward also fears that the picture reveals a secret, but it is "the secret of [his] own soul," the "extraordinary romance" and "idolatry" that he has felt for Dorian (1890:6, 10, 57). Dorian and Basil both worry that the canvas will betray a shameful truth that has its roots in worship of male youth and beauty. Wilde once remarked that Basil was the character he felt he most resembled but that "Dorian [was] what [he] would like to be—in other ages, perhaps" (*Complete Letters* 585). The faint quibble on "ages" foreshadowed Wilde's chronological posing in the witness box.

In *Dorian Gray*, posing is mostly characterized as a false or feigned attitude. When Basil chides him for his cynical "pose," the dandy Lord Henry Wotton retorts that "[b]eing natural is simply a pose" (1890:5). Confronted by Basil about scandalous rumors, Dorian attacks the hypocrisy of the middle classes "who pose as being moral" (1891:118). Later, when Dorian hints that he has murdered Basil, Lord Henry chaffs him for "posing for a character that doesn't suit [him]" (160). These are poses that seek to conceal the truth. Queensberry, in contrast, seemed to charge Wilde with a pose that revealed the truth. At trial, Carson sought to collapse the distinction between posing and being, appearance and reality, by showing that Wilde's poses were simply a performance of his sexual being (Danson 107; Novak 82). When Wilde refused to condemn a homoerotic story, "The Priest and the Acolyte," which had appeared in the same magazine that printed some of his epigrams, Carson pressed him: "I want to see what position you pose in." Wilde objected to this taunt, but Carson had scored his point, implying that Wilde's poses were actually antisocial positions

that could be unveiled by aggressive questioning. Wilde's writings, Carson argued, showed him "pos[ing] as not being concerned about morality or immorality" (Holland 70, 74). Under the stress of cross-examination, the meaning of posing was changing from public persona to private belief, from exteriority to interiority, just as the trial as a whole, according to Alan Sinfield and Ed Cohen, helped to establish homosexuality as an intrinsic type of sexual identity. Seeking leave from the court to read from Joris-Karl Huysmans' *À Rebours*, which had suggested some incidents in *Dorian Gray*, Carson contended that establishing what was "in [Wilde's] mind" when he wrote the novel would help the jury to determine whether he was "posing as a sodomite" (Holland 100). Wilde's "writings and [his] course of life," Carson argued, permitted the jury to infer that he "was either in sympathy with, or addicted to, immoral and sodomitic habits" (255). Posing was no longer simply a form of public display. It was the essence of Wilde.

In the course of the trial, Carson developed a further specialized meaning of "posing" with which he mocked Wilde's artistic pretensions. When Wilde stated that only "brutes and the illiterate" would think that *Dorian Gray* was "a sodomitical book," Carson sprang to the defense of unsophisticated readers and asked Wilde if he thought "the majority of people live up to the pose that you are giving us . . . or are educated up to that" (Holland 81). Wilde took the bait. When Carson belittled the artistic merits of one of his letters to Douglas, Wilde retorted, "I think everything I write extraordinary. . . . I don't pose as being ordinary—good heavens!—I don't pose as being ordinary" (110). Carson had cleverly driven a wedge between Wilde and the jury, making the playwright out to be an elitist snob whose very art was a pose. This made it all the easier for the barrister to argue that in consorting with unemployed male prostitutes (or "renters"), Wilde was not nobly disregarding class distinctions as he pretended, but simply using the young men for his indecent needs. As we will see in Chapter 2, the pitting of aesthetic cliques against the moral masses, the posing artist against the ordinary reader, was a common ploy of judges, prosecutors, and social purity groups in the early decades of the twentieth century.

Blackmail

The three trials of Oscar Wilde indelibly linked blackmail and defamation law as mechanisms for preserving reputation in the modern world—and as platforms for the ritual sacrifice of reputation. Wilde's initial libel prosecution featured his letters to Lord Alfred Douglas, which had fallen into the hands of blackmailers and were read out in court to establish Queensberry's plea of justification. After the libel action ended abruptly in a conceded jury verdict for Queensberry, the government prosecuted Wilde over the course of two trials for committing the crime of gross indecency. Section 11 of the Criminal Law Amendment Act of 1885, known as the Labouchere Amendment, made it a misdemeanor, punishable by up to two years' imprisonment at hard labor, for any male, in public or in private, to commit, procure, or attempt to procure "any act of gross indecency with another male person." The conduct proscribed by the statute was notoriously indeterminate, and it could occur anywhere, in public or in private, whereas older British law had imposed liability only if a grossly indecent act occurred in "an open and public place" (Mead and Bodkin 68–9). Acts of sodomy would certainly fall within the scope of the Labouchere Amendment, but so would less overt kinds of intimate contact. Replying to a journalist's charges that *Dorian Gray* was an indecent work, Wilde in 1890 declared that he had tried to surround Dorian "with an atmosphere of moral corruption [that was] vague and indeterminate and wonderful." "What Dorian Gray's sins are no one knows," Wilde contended. "He who finds them has brought them" (*Complete Letters* 439). The nebulous language of the Labouchere Amendment similarly invited subjective reader response on the part of fact-finders. It posed scandalous riddles that prosecutors and juries might solve as they pleased, vindictively or sanctimoniously.

During Wilde's second and last criminal trial, his attorney Edward Clarke argued that the proceedings seemed to be "operating as an act of indemnity for all the blackmailers in London" (qtd. in Ellmann, *Oscar* 476). He meant that some of the young men who had appeared as witnesses were notorious for blackmailing and other rogueries. In 1893, a group of blackmailers had subjected Wilde to what was known as the badger game, tag-teaming him as they attempted to extract serial payments for an amorous letter he had written to Douglas. Blackmail in this pre-digital era often took the form of payment demanded for the return of an embarrassing physical document. In Wilde's play *An Ideal Husband* (1895), the action turns on two incriminating documents—a letter written by Sir Robert Chiltern early in his career and a recent note penned by his wife—that threaten professional and marital ruin, respectively. Only Sir Robert's letter is actual evidence of wrongdoing, but both writings serve the purpose of the blackmailer, Mrs. Cheveley, for whom extortion is "the game of life as we all have to play it" (*Ideal* 495). In a twist on the Wildean motif of intangible honor being menaced by a tangible object, Lord Goring at one point turns the tables on Mrs. Cheveley by confronting her with a diamond brooch she once stole and threatening to have her prosecuted if she doesn't hand over Sir Robert's letter (488, 535–7).

Wilde's plays are filled with ingenious variations on blackmail's coercions, as when Mrs. Cheveley agrees to surrender Sir Robert's letter if Lord Goring will marry her (*Ideal* 532–3), or when Mrs. Erlynne, who has been extorting money from Lord Windermere by threats that she will reveal that she is Lady Windermere's mother, repents and vows that she will ruin her daughter's life if he now tells Lady Windermere the truth (*Lady Windermere's* 425–7). Mrs. Erlynne's maternal change of heart takes the form of counter-blackmail. Whereas she formerly promised silence in exchange for Lord Windermere's cash payments, she now obtains his silence by threatening to behave in ways that will cause her daughter pain. The theme of blackmail floats playfully over *The Importance of Being Earnest* (1895) without ever settling into real menace. The first act opens with Algernon refusing to hand over Jack's "private" cigarette case until Jack agrees to explain its mysterious inscription from "little Cecily" (324–6). From innocuous coercions like this to Dorian Gray's cruel threat to disgrace a former friend unless he agrees to dispose of Basil Hallward's body (1890:89–92), motifs of extortion pervade Wilde's mature writings. Sometimes blackmail is figured as a slow-gathering retribution. "Sooner or later we all have to pay for what we do," declares Mrs. Cheveley (*Ideal* 496). In most cases, however, it is rooted in the pose of excessive morality—the "monstrous pedestals" erected by Victorian ideals (521)—which Angus McLaren associates with the rise of sexual respectability and of privacy as a proprietary good (McLaren 3–4, 11, 278).

In the nineteenth century, blackmail often appeared as a revolt of the lower orders. Servants, gamekeepers, coachmen, and other employees became dangerous when they decided to use the intimate knowledge they had acquired during their service to coerce their employers, thus turning the household *heimlich* into the criminal *unheimlich* (McLaren 43). The crime of blackmail, seen in this light, was a vehicle for protecting the moneyed and privileged classes from a knowledge-empowered proletariat (Alldridge 373). Wilde complained from prison about Douglas's careless treatment of his letters, left "lying about for blackmailing companions to steal, for hotel servants to pilfer, for housemaids to sell" (*De Profundis* 716). *The Importance of Being Earnest* opens with a comic glance at the danger of the all-hearing domestic when Lane, the manservant, remarks that he "didn't think it polite to listen" while his master, Algernon Moncrieff, was playing the piano (321). Dorian Gray, who cultivates the power of knowing other men's secrets, worries that his servant, under a "placid mask of servility," might become a "spy" in the house, using his access to Dorian's altered portrait to blackmail him for the rest of his life (1890:59, 63). Dorian takes pains to cover the picture with a heavy fabric before asking a frame-maker and his "somewhat rough-looking young assistant" to carry it up to the attic (60–2). His great fear is that servants and workmen, paid to do the living for their masters, will thereby acquire forbidden knowledge and become as gods, turning old transgressions into a source of endless tribute.

One of Wilde's letters to Douglas, in which he compared the young man to Apollo's lover Hyacinthus, fell into the hands of opportunists who attempted to "rent," or blackmail, Wilde. Somehow—probably through the renters—a copy of the letter found its way to the theater manager Herbert Beerbohm Tree; and when the badgers set upon Wilde, the latter shook them off by saying that he would have paid a large sum for the letter as a "work of art," but that Tree's copy made buying it back unnecessary. He also informed them that the letter would shortly be published "in sonnet form in a delightful magazine"—a reference to *The Spirit Lamp*, an Oxford undergraduate magazine that in 1893 printed Pierre Louÿs' free French translation of the letter (a ruse, argued Queensberry's attorney, for laundering the letter's indecency) (Holland 50–5, 111–33). The existence of copies of the Hyacinthus letter foiled the blackmail plot, which depended on a unique tangible document passing from renter back to rented after payment. The multiplication of copies in effect introduced the logic of copyright into the mechanics of blackmail, substituting the benign prospect of authorized dissemination of a public good for the danger of a unique incriminating artifact. With the aura of blackmail dissipated by the reality of mechanical reproduction, the asking price for the original document fell sharply (50–5).

Affirmative Defenses

Wilde's encounter with blackmailers revealed a characteristic feature of his art and legal imagination. When one of the renters claimed, to start the bargaining, that a man had offered him £60 for the Hyacinthus letter, Wilde facetiously urged him to accept that offer, as he himself had never "received so large a sum for any prose work of that very small length" (Holland 53). Wilde's retort was typical: an epigrammatic parry that converted a black market for secrets into a white market for literature, and a dangerous love letter into a work of art. When Lord Henry, whom Dorian Gray calls the "Prince of Paradox," attacks realism in literature by announcing that "[t]he man who could call a spade a spade should be compelled to use one" (1891:147), he is engaging in a similar gesture of transvaluing values, equating intellectual effort with manual labor and treating literary taste as a mark of social class. Throughout his trials, Wilde deflected adversarial questioning—whether about the purported immorality of his writings or of his friendships—by shifting the context to artistic meanings and values. He insisted in the witness box, "I cannot answer any question apart from art," in effect positing a transvalued aesthetic morality at odds with the discourse of law and legal proceedings (Holland 105).

Wilde's instinct, both in his heterodox maxims and in his answers on cross-examination, was to assert a form of what the law calls an affirmative defense, a pleading strategy whereby a defendant does not deny the truth of the complainant's factual claims but instead attacks her legal right to assert them (*Black's* 60). For example, a person charged with murder might raise the affirmative defense of insanity, without actually denying that he had killed the victim; or the defendant in a copyright action might concede that she had copied from the plaintiff's work but argue that her copying was privileged as a fair use. The rhetorical posture of the affirmative defense is "yes but," just as Wilde's paradoxes and epigrams quip, "yes but." His aphoristic art—described by critics as "a perverted mimicry of public speech" and a practice of "inverting Victorian truisms" (Gagnier 7; Goldman 25)—was a form of affirmative defense, prefiguring his law-for-art's-sake posture during the legal proceedings: "What is abnormal in Life stands in normal relations to Art" ("A Few Maxims" 1203). Wilde consistently exploited the logic of the affirmative defense, wearily acknowledging a state of facts but wittily pointing to a larger moral or aesthetic dimension ignored by his adversaries. One of the least witty things he ever did was to cave to external and internal pressures in prosecuting the Marquess of Queensberry for libel. But once he found himself in the dock, he regained his levity

and elevated the affirmative defense to an art form. The great speech during his first criminal trial in which he discoursed movingly on "the love that dare not speak its name" translated the fact of male–male desire to the moral plane of noble love, and allowed Wilde, for a Platonic moment, to dominate the Old Bailey as he had formerly ruled dinner tables in society (Ellmann, *Oscar* 463).

Privacy, Publicity, and Name Appropriation

In attempting to prosecute Queensberry for libel, Wilde pursued a remedy that was plainly ill-adapted to the real outrage. The insult scribbled on Queensberry's card served Wilde as a pretext for invoking the law to free himself from the Marquess's escalating menace. Wilde brought the libel action, in part, to reclaim his threatened privacy, to draw a line between his public poses and his private actions. The trial did the opposite, of course, turning his private conduct into public notoriety and collapsing his cherished distinction between surface and secret. By the late nineteenth century, privacy had come to seem a proprietary entitlement of the middle and upper classes, as McLaren notes (4, 11, 61–2). Blackmailers recognized this property as a monetizable good, just as commercial journalism created a mass market for artistic celebrity and saleable image. Wilde lived in a time when privacy and publicity as yet enjoyed few recognized legal protections (North). Privacy was a juridical exception, a lacuna that the clumsy mechanisms of defamation law, copyright law, and even extralegal dueling sometimes sought to fill. Wilde typified the contradictory subject of modernity—the self that seeks to enjoy the benefits of selective public display while fiercely asserting the right to be let alone.

For Wilde, individualism meant freedom from external compulsions. Individual goodness flourishes "when [people] are let alone," he wrote in "The Soul of Man under Socialism" (1891) (1100). His feeling for privacy was intense and genuine. In 1885, he was outraged over a public sale of John Keats's love letters and responded with a sonnet that lamented the dead poet's loss of privacy to "the brawlers of the auction mart." The poem, of which Wilde was especially proud, decried the "small and sickly eyes" that pored over Keats's letters, and compared the auction to the dividing of Christ's garments by dicing Roman soldiers who had failed to perceive "the God's wonder, or His woe" ("On the Sale" 815). The public sale struck Wilde as a further invasion of Keats's privacy—the letters had already been published several years before—and as a sullying of art by bourgeois market values. In particular, Wilde deplored the hawking of Keats's "poor blotted note[s]," the tangible remains of his private passion; and he managed to purchase several of the letters himself, almost as if he were paying a blackmailer's price to retrieve his own intimate confessions (Wilde, *Complete Letters* 254 n2).

Wilde himself would know the shame of merchandised privacy ten years later when, following his failed libel action, his creditors forced a sale of his books, manuscripts, and other effects, including the original manuscript of a Keats sonnet, which the poet's niece had given him (Wilde, *Complete Letters* 157–8). James Joyce, writing in 1909, proposed a line from Psalms as a fitting motto for Wilde's tombstone: "They part my garments among them, and cast lots upon my vesture" ("Oscar" 205). Although Joyce was primarily referring to Wilde's tragically divided legacy as a man and writer, the words also echo the sonnet on the sale of Keats's letters and mark Wilde as a celebrity dandy whose defiant posing could not in the end prevent the public sacrifice of his personal privacy.

Wilde was as protective of his family's privacy as of his own. In 1889, the journalist and author Herbert Vivian published some humorous details concerning Wilde's children, claiming that the wit had offered to stand as "fairy-godfather" of the book (154–8). Wilde objected to this "extremely vulgar and offensive" publication and denied that Vivian had "the right to make one godfather to a dirty baby against one's will," especially when Vivian added the insult of reproducing the text of one

of Wilde's letters without his permission. Wilde was even more disturbed that the story had upset his wife Constance, who, he said, did not "wish to see her children paraded for the amusement of the uncouth." He accused Vivian of combining "the inaccuracy of the eavesdropper with the method of the blackmailer"—an invasion of domestic space coupled with an exploitative use of private correspondence (*Complete Letters* 426–7). Vivian's journalistic predation had put Wilde in mind of the close proximity between invaded privacy and blackmailed reputation as comparably intractable legal problems.

Wilde complained that Vivian had published a book "with which no gentleman would wish to have his name associated" (426). Vivian had appropriated his name for the purpose of spreading gossip "in the public press," in effect violating two rights that Wilde held dear: the right to privacy and the right to control the publicity of his name (427). Yet Vivian's perceived wrongs were largely immune from legal retaliation in 1890. Wilde might have sued him for infringing a copyright in his letter, but such an action would not have gone to the essence of Wilde's grievance: the assault on his domestic seclusion and the exploitation of his marketable name.

In 1890, privacy and publicity occupied a negative space in the law, a gap for which English courts offered little satisfactory redress apart from the unwieldy law of defamation and the limited tort of confidentiality. That same year in the *Harvard Law Review*, Samuel D. Warren and Louis D. Brandeis famously called on the common law to protect "the right to be let alone," but the law's full response was decades away, as we will see in Chapter 4. Without clear causes of action for privacy invasion and name appropriation, authors often resorted to homemade remedies. Wilde's self-help took the form of shaming Vivian for his "wilful surrender of that position you hold as a gentleman" and a "Cambridge man" (*Complete Letters* 426). Vivian had not acted properly from "a gentleman's point of view, or from the point of view of literary honour" (427). Wilde was appealing to an extralegal concept of class-based honor, decrying a breach of propriety that in a more dangerous setting might have led to violence on the field of honor. In the absence of a legal remedy, he invoked informal norms of courtesy to fill the juridical void that Warren and Brandeis were urging American common-law courts to address.

Wilde's writings foreground privacy as a primary desideratum, whether in Dorian Gray's "terrible pleasure of a double life" (1891:134) or in the comedy of Algernon Moncrieff's theory of Bunburying (*Importance* 325–6). The Picture of Dorian Gray is, in one respect, the story of a compulsively public man who wishes to keep his personal life private, and who secretes the record of that life—his portrait—in the attic room where as a boy he often hid himself in a *cassone*, an ornate marriage chest where brides traditionally stored their personal effects (1890:61–2). Fearing the kind of public gossip that led Warren and Brandeis to call for a right to privacy, Basil Hallward admits that he loves "secrecy . . . the only thing that can make modern life wonderful or mysterious to us" (1890:5). Even after his public disgrace, Wilde insisted on a modicum of privacy, refusing Douglas permission to quote in print from the intimate letters he had written him from Holloway Prison after his arrest. Although the forced sale had stripped him of many of his literary and performance rights, he could still invoke the undivested "legal copyright" in his private correspondence (*De Profundis* 722). He was shocked that his lover would consider disseminating letters that he should have guarded as "sacred and secret beyond anything in the whole world," and he reminded Douglas of the sonnet he had written to express his "sorrow and scorn" over the sale of Keats's letters (717).

In *De Profundis*, Wilde also rebuked Douglas for planning to use his name without permission on the dedication page of a volume of poems (684, 721–2). Wilde knew that his name had lost its power and respectability; after his arrest, his name had been pulled down from theater hoardings where his comedies were playing, and he acknowledged in prison that his children would no longer bear his name (654; Ellmann, *Oscar* 458). Yet he clung to the remnants of dignity and refused to allow Douglas to appropriate his name for a dedicatory paratext, just as he had upbraided Herbert Vivian for using

his family to boost a journalistic effort. Wilde could no longer feel, as Basil Hallward and Lord Henry Wotton do in *Dorian Gray*, that names were powerful and talismanic (1890:5; 1891:147), but he could deny Douglas the use of his name to play keeper of the Wildean flame. Douglas was the love that dare not publish Wilde's name without permission. Honor, courtesy, and friendship demanded at least that.

Piracy, Copyright, and Courtesy

In "The Soul of Man under Socialism," Wilde wrote that private property had "crushed true Individualism" and that only with the abolition of property could healthy individualism flourish. The "perfect personality" would not "admit any laws but its own laws; nor any authority but its own authority" (1083, 1084–5). As attractive as this hedonic anarchism may have seemed to Wilde the essayist, Wilde the man of property was far from relinquishing his copyrights. He took pains to secure rights for his plays in copyright-unfriendly America and made special arrangements to reserve the book rights to "The Portrait of Mr. W.H." (1889) and *The Picture of Dorian Gray* after their magazine appearances (*Complete Letters* 150, 400, 425). He was deeply distressed when forced sales and bankruptcy took away "my copyright in my published works, my copyright in my plays, everything in fact . . . down to the staircarpets and door-scraper of my house," as if the law had compounded tragedy by erasing any distinction between his intellectual creations and his gross chattels (*De Profundis* 774). Even after his release from prison, Wilde hoped to buy back some of his copyrights, and he schemed to secure rights for *The Ballad of Reading Gaol* (1898) in the United States, where copyright protection for foreign authors depended, after 1891, on simultaneous transatlantic publication and other stringent conditions (*Complete Letters* 970; Chace International Copyright Act S 4956; see also Chapter 3).

When Wilde made his celebrated lecture tour of the United States in 1882, American copyright law offered virtually no protection for foreign authors. He was indignant when he learned that his *Poems*, published the year before in London, was being hawked on American trains for ten cents in the unauthorized Seaside Library edition published in New York. In addition to his poems, the flimsy volume contained his lecture on the English Renaissance, the centerpiece of his cross-country tour. He complained about this "hellish infringement on the right of an English author" and told the train newsboys that such piracies "must have a disastrous effect on poetical aspirants," espousing the theory, as Wordsworth had done a half-century before, that creative incentives would dry up unless authors could legally control their writings ("The Poet" 1; Wilde, "Impressions" 178). Wilde claimed that the pirated version of his lecture was thinning attendance at his appearances—"people think they know it, and stay away"—so he hurried together two new readings for the remainder of his tour (*Complete Letters* 147; Ellmann, *Oscar* 193). Piracy no less than copyright could sometimes spur creativity.

Wilde also made efforts to secure US copyright for his play *Vera; or, the Nihilists* (1880), which he wanted to see produced in New York, but when asked by a reporter if copyright had been his reason for coming to America, he loftily ignored the impertinence (Hofer and Scharnhorst, eds. 14). Fantasizing with a friend years later about producing a deluxe volume containing his unwritten thoughts, Wilde quipped that there should be "five hundred signed copies for particular friends, six for the general public, and one for America" (qtd. in Ellmann, *Oscar* 392). The remark was only partly a sneer at American culture; given the rapidity with which unauthorized publishers reprinted British writings, a single imported copy would have sufficed to supply bookstores in all major American cities within a week or two. As with Dickens before him, Wilde's celebrity in America soared, and his lectures filled up, in part because his writings were reprinted so freely and cheaply.

Lawful piracy was an aggressive, often volatile business in America in the 1880s, but not all publishers exploited the letter of the discriminatory copyright law. For decades, certain established

publishers had agreed among themselves to divide up the commons of foreign works and to respect each other's claims to certain authors and books. This informal cartel was known as the courtesy of the trade, or trade courtesy; its participants, which included the Harpers, Scribner's, Henry Holt, and other major houses, even paid honoraria or royalties to foreign authors when they could. As a response to the law's creation of a teeming public domain and legalized piracy, trade courtesy brought a fragile order to American publishing by improvising a facsimile of copyright law and enabling publishers and authors to benefit from informal norms of neighborly self-restraint (Spoo, *Without* 13–64). Foreign authors were so grateful to be treated courteously that they sometimes wrote statements or letters of authorization, which their American publishers reproduced in the front matter of their editions. These courtesy paratexts extolled the virtues of honest publishing and served to legitimize the authorized text (Spoo, "Courtesy"). The US copyright vacuum for foreign authors was a kind of juridical void, yet this void was not filled by a sovereign or executive power but rather by informal, voluntary trade norms. Trade courtesy was to the copyright gap what Wilde's appeal to honor and gentlemanliness was to the privacy-law gap.

Although distressed by the piratical Seaside Library, Wilde took consolation in Roberts Brothers of Boston, which had published an authorized courtesy reprint of *Poems* in 1881. It is not known whether Roberts Brothers made payments to Wilde, but he was pleased to have a "genuine" American edition and remarked scornfully of the pirate houses that "a country gets small good from the literature it steals" (Hofer and Scharnhorst, eds. 121, 123 n7). On one occasion when he was traveling by train, Wilde scolded a newsboy for selling the pirated *Poems* for the "beastly figure" of twenty-five cents for three copies. The plucky boy laughed at him and refused to believe that he was the author of the volume. Later, after being assured that Wilde was indeed who he said he was, the boy returned and offered him half a dozen oranges "to call it square" ("The Poet" 1). Here was a rude, spontaneous pantomime of what courtesy publishers were doing on a larger scale: offering legally uncompelled honoraria for the exploitation of foreign authors' unprotected writings.

Wilde came to America under contract. The producer Richard D'Oyly Carte had agreed to pay his expenses and half-profits from his lectures if he would go about the country as a living advertisement for the authorized American production of Gilbert and Sullivan's *Patience, or Bunthorne's Bride* (1881), a comic opera satirizing the aesthetic movement and based in part on Wilde himself. The contract required Wilde to lecture in aesthetic garb, complete with knee-breeches, black hose, and satin coat (Goldman 25; Rose, *Authors in Court* 71), and it was in such a costume that he posed for a series of photographs taken by the celebrity photographer, Napoleon Sarony, shortly after he arrived in New York. Sarony insisted on an exclusive agreement that made him the sole photographer of Wilde during his American tour, an arrangement that Wilde later regretted when he saw the high quality of professional photography in other cities (Hofer and Scharnhorst, eds. 127). Sarony's exclusive contract was responsible for the dearth of other photographs of Wilde in America and for the compensatory profusion of cartoons and caricatures that followed the aesthete from city to city. When a company marketed unauthorized lithographs based on his photograph "Oscar Wilde No. 18," Sarony sued for copyright infringement and took the case all the way to the US Supreme Court (*Burrow-Giles Lithographic Co. v. Sarony*). In this era before celebrities enjoyed rights of publicity, Wilde, the posing subject of the infringed image, had no standing to claim his own damages in litigation (North 187).

Wilde's role as "advance poster" or "sandwich man" for *Patience* has been much discussed (Lewis and Smith 22–5; Gaines 80–1). Less well understood is the copyright dimension of his arrangement with Carte. *Patience*, like other Gilbert and Sullivan productions, enjoyed doubtful copyright protection in the United States, and pirate productions sprang up in various American cities to exploit the English team's popularity. Wilde's appearances were intended to impress on the public that only Carte's was the authorized version (Lewis and Smith 7; North 189; Rose, *Authors in Court* 71, 73). In this respect, Wilde played a role analogous to the courtesy paratexts printed

in the opening pages of authorized American editions of British authors' works, guaranteeing the quality and authenticity of the approved Carte production. Wilde's relationship to *Patience* was also trademark-like, a sort of official Bunthorne brand, prefiguring the efforts of today's content industries to use trademark and branding to reinforce questionable or expiring copyrights in movies, cartoons, and other media (Foley; Rosenblatt).

Wilde publicly posed as the original of the fleshly poet Reginald Bunthorne of the opera, yet he was also a copy of Bunthorne, contractually required to model a parody of aestheticism that had already been popularized by Gilbert and Sullivan and, before them, the cartoonist George du Maurier in *Punch*. The fundamental distinction in copyright law between original works and copies became perversely transposed in Wilde's life and art. In "The Decay of Lying" (1891), he grounded the theory that "Life imitates Art," or that the original copies the copy, in references to mechanical reproduction and copyrighted dissemination: "Life tries to copy [Art], to reproduce it in a popular form, like an enterprising publisher" (982). Wilde was the original of Sarony's photographs, but his popularity grew through mass reproduction of those posed images, both in authorized copies bearing Sarony's signature and in thousands of infringing copies for which Sarony collected damages, as well as in countless cartoons and illustrations that copied Wilde as he toured America. The humorist Eugene Field turned himself into a human copy of Wilde by driving about Denver in a carriage, got up in a wig and fur-trimmed overcoat, imitating the languid gestures of the Bunthorne lookalike (Ellmann, *Oscar* 191).

Whether Dorian Gray is the original or the copy of the hidden portrait that does the changing and suffering for him is a question that haunts the novel. As he circulates in London society, unaltered for decades, he is more like a photograph than a person. Scholars have probed motifs of the commodified self, mass reproduction, and photography in the novel (Gaines 43–52; Novak 84–8; Rose, *Authors in Court* 88–9). One measure of Lord Henry's worship of Dorian is the twenty-seven photographs of the young man that he keeps in his house (1890:22–3). Sarony is known to have photographed Wilde in twenty-seven different poses (Rose, *Authors in Court* 72). When Wilde revised the novel for its book appearance, he altered the number to eighteen (1891:47), perhaps an allusion to Sarony's copyright lawsuit over his photograph, "Oscar Wilde No. 18." (In Wilde's story "The Canterville Ghost" [1887], the brash Americans who purchase a haunted English estate replace its ancient portraits with "large Saroni [sic] photographs" of themselves [204].) Dorian may be an infringing photograph, a copy that has illicitly traded places with the original and is passing itself off as authentic to a public enamored of mass-reproduced experience. The ambiguity of "picture" in the novel's title opens the text to visual possibilities beyond a painted portrait (Novak 82–3). Challenged to defend the novel in the libel proceedings, Wilde described it as "a picture of changes" (Holland 103).

After his release from prison, Wilde lived abroad, spending freely when he could, often hard up, supported largely by an allowance from his wife and gifts from friends. He had learned the humiliation of bankruptcy while incarcerated—an experience, Paul Saint-Amour suggests, that prepared him for a new understanding of intellectual property as a basis for intersubjective community. Wilde had challenged the "privatizing of imaginative expression" in earlier counterdiscourses, notably his plagiarized lecture on the literary forger Thomas Chatterton and in "The Portrait of Mr. W.H.," where belief in a theory about Shakespeare's sonnets circulates "exactly like alienable material property"—a chattelizing of intangible thought (Saint-Amour, *Copywrights* 96, 109). In prison, Wilde transformed bankruptcy and dispossession into "the renunciatory grace of a public domain" by writing *De Profundis*, an intertextual *cri de coeur* that was "post-property, post-copyright, post-genius" (97, 118).

Wilde had one more subversion in store for the idea of property. In his last years, he sold the scenario of an unwritten drama for £100 to several persons, each apparently believing that he or she was the sole purchaser. Frank Harris also paid £100 for the scenario. After expanding the

sketch, Harris staged the play in London as *Mr. and Mrs. Daventry* (1900), but not before the other purchasers—at least five—threatened legal action unless they were paid. Wilde was unmoved by Harris's predicament and only complained that "Frank has deprived me of my only source of income by taking a play on which I could always have raised £100" (*Complete Letters* 1211–2). Wilde had turned his investors into something like blackmail victims, uncertain that their payments would ever really buy peace.

By selling the same scenario to multiple buyers, Wilde created what Michael Heller calls a tragedy of the anticommons—a resource endangered by underuse and stagnation because of the difficulty of coordinating conflicting ownership claims. Whereas a commons is sometimes threatened with overuse—too many exploiters of a single unowned resource, such as overgrazed land—an anticommons is threatened with underuse: too many owners of a single proprietary resource. This was Wilde's final drama—not the scenario itself, but the anticommons tragedy he blithely created as he seduced investors. The gesture summed up all his witty contempt, and passion, for property. The renunciatory commons he had imagined in prison now became a lucrative anticommons, serially sold and forever saleable, Keatsian in its passionate permanence, a golden alms bowl for collecting tributes to his genius. There was a certain famboyance in Wilde's repeated sale, a wish to live in the memory of his investors. Perhaps tragedy is not the right word, since Harris managed in the end to pay off all the indignant purchasers. Rather, this was Wilde's tragicomedy of the anticommons.

Obscenity and Blasphemy

Wilde viewed censorship as a bullying blend of psychic repression and poor reader response. He held that all efforts of governments to suppress "imaginative literature" were "monstrous," and that "Public Opinion" was "monstrous and ignorant" when it tried to "control Thought or Art" (*Complete Letters* 431; "Soul" 1094). Lord Henry Wotton sketches a parallel theory when he tells Dorian Gray that denial of desire sickens the soul by enacting "monstrous laws" that render desire "monstrous and unlawful" (1890:14). Desire becomes monstrous because social taboo and self-denial make it so, not because the mind itself, apart from action, can do any evil. Wilde argued that the true moral of *Dorian Gray* was that "all excess, as well as all renunciation, brings its punishment," and that Dorian suffers from "an exaggerated sense of conscience" that leads in the end to self-mutilation and suicide (*Complete Letters* 435–6). When challenged to explain why he opposed censorship, Wilde asserted that "[t]he rights of literature . . . are the rights of intellect" (434). He was not referring to intellectual property rights but rather to the notion that the mind possesses inalienable rights of self-expression that the world has a correlative duty to respect. This was the basis of the aphorism he added to *Dorian Gray*: "[t]here is no such thing as a moral or an immoral book" (1891:17). In court, he similarly insisted that "[t]here are no views in a work of art" (Holland 80). Ethical demands confused literature with life. Governments had no competency, and courts no jurisdiction, to dictate morality to authors.

Wilde's libel trial doubled as an inquisition into the morality of his writings. Queensberry's plea of justification accused *Dorian Gray* of being "an immoral and obscene work . . . calculated to subvert morality and to encourage unnatural vice" (Holland 290–1). Carson's cross-examination articulated a didacticism that would haunt modernism for the next fifty years. He insisted that literature had a duty to offer moral instruction to "the majority of people." Wilde countered that literature had a duty only to itself: to make a "beautiful thing" (81, 105). With his eye on the jury, Carson divided the world into those who candidly placed the "ordinary meaning" on *Dorian Gray*—by which he meant the true, immoral meaning, put there by the sodomitical poser—and those who boasted of reading an "artistic meaning" into the work; and he argued that Wilde's offense in publishing the

novel could be excused only if the book "came into the hands" of a small artistic elite rather than the ordinary masses (261).

Carson's words echoed the test of obscenity that had been formulated in the 1868 case of *Regina v. Hicklin*: "whether the tendency of the matter charged as obscenity is to deprave and corrupt those whose minds are open to such immoral influences, and into whose hands a publication of this sort may fall" (369). The formula had a powerful effect on authors' conceptions of their readerships. When Walter Pater in 1888 published the second edition of his *Studies in the History of the Renaissance*—the work Wilde reverently called his "golden book" (Ellmann, *Oscar* 47)—he omitted its controversially hedonistic conclusion out of fear, he confessed, that "it might possibly mislead some of those young men into whose hands it might fall" (Pater 246 n). This *Hicklin*-inspired concern for a hypothetically corruptible class implied that a market for indecent literature, if allowed to exist at all, should be confined to a small group of professionals and connoisseurs whose morals the law need not bother to superintend. As we will see in Chapter 2, the dream of a divisible market insulated from obscenity prosecutions inspired the printing of deluxe and limited editions of transgressive modernist works.

If the impulse to censor derived from repression of desire, the search for the obscene was a crude kind of reader response that always revealed the limitations of the reader. "The books that the world calls immoral," Lord Henry remarks in *Dorian Gray*, "are books that show the world its own shame" (1891:163). In "The Soul of Man under Socialism," Wilde went further to say that when ordinary people find a work of art to be unintelligible, it is because the work is "a beautiful thing that is new"; and when they find a work to be immoral, it is because the work "is a beautiful thing that is true" (1092). It was this autotelic imperturbability of art, as much as the unspecified nature of Dorian Gray's corruption, that prompted Wilde to assert that readers who thought they had discovered Dorian's sins had actually "brought them" (*Complete Letters* 439). The self-righteous search for obscenity was, according to Wilde, an opportunistic prurience (a word he liked to half-rhyme with "Puritan") ("Critic" 1048), a form of projection that often revealed a lustful mind and always revealed a Philistine. He had long been familiar with the prude and the censor from his study of the trials of Gustave Flaubert and Charles Baudelaire for obscenity and immorality (Holland xxxv).

Several of Wilde's works were informally accused of immorality. His early *Poems*, which contained the narrative "Charmides" with its scandalous suggestions of fetishism and necrophilia, was requested for the library of the Oxford Union Society and then, by a divided vote of the members, rejected for supposed obscenity and plagiarism (Ellmann, *Oscar* 146–8). When Wilde was touring America, the minister Thomas Wentworth Higginson assailed *Poems* as reeking of "immorality" and "insulted innocence" (Lewis and Smith 118–19). Wilde repelled these attacks with his customary distinction between art and morality, but the charges continued to follow him about the country (Hofer and Scharnhorst, eds. 103). *Dorian Gray*, especially in its initial appearance in *Lippincott's Monthly Magazine* (1890), was attacked in the press as indecent, and the newsdealer W. H. Smith & Son pulled the issue from its bookstalls (Holland 310 n113).

Wilde also encountered accusations of blasphemy. In the 1880s, a "timorous editor" insisted that Wilde's sonnet on Keats's love letters be removed from a poetry anthology because of the perceived blasphemy of the sestet, which implies a comparison between the dead poet and the crucified Christ (Wilde, *Complete Letters* 445). When Edward Carson, cross-examining Wilde at the libel trial, assailed "The Priest and the Acolyte" as blasphemous, Wilde seemed for a moment to agree (he might actually have been disturbed by the story's irreverence), but he quickly recovered his poise and asserted that the story was aesthetically "disgusting" as distinct from "blasphemous" ("not my word") (Holland 70–1). In 1892, his drama *Salome* had been banned from the British stage, not ostensibly for its cruel, decadent eroticism, but because the Lord Chamberlain, the official licensor

of plays, refused to allow the public representation of Biblical figures, although Wilde succeeded in printing the play in French and English (Ellmann, *Oscar* 372–4). He objected when his publisher mentioned the Lord Chamberlain's prohibition in advertisements for the book. The value of the drama, he said, lay in its "tragic beauty . . . not a gross act of ignorance and impertinence on the part of the censor" (*Complete Letters* 547). As late as 1909, the Lord Chamberlain refused to license George Bernard Shaw's *The Shewing-Up of Blanco Posnet* because the protagonist makes irreverent statements about God (Marshik, *British* 61).

The Picture of Dorian Gray, one of Wilde's most transgressive works, escaped official prosecution for obscenity during his lifetime, but for years following his trials, the novel lay under unofficial ban in Britain. Carson had powerfully denounced the work as immoral and sodomitical in the libel trial, and Charles Gill, the prosecutor in Wilde's first criminal trial, had attempted to sway the jury by reading Carson's remarks into the court record. As Simon Stern has shown, Carson's dogged cross-examination concerning *Dorian Gray* essentially served the purpose of an obscenity prosecution and deterred republication of an authorized edition in England for nearly twenty years.

Yet many of Wilde's works, including *Dorian Gray*, continued to circulate in furtive pirated editions in Britain and France (Mason, *Bibliography* 543). Unauthorized American editions of *Dorian Gray* appeared for years after Wilde's death (Mason, *Oscar* 154–6). In 1910, guttermen in Fleet Street and the Strand sold crude reprints of *De Profundis* until these pirates, consisting of booksellers, printers, caterers, and hawkers, were arrested and sentenced to several months' imprisonment for criminal copyright infringement (Mason, *Bibliography* 532–3). (The prosecutor was C. F. Gill, presumably Charles Gill, who had been the prosecutor in Wilde's first criminal trial fifteen years before.) A structural antagonism existed between obscenity and copyright laws from the late nineteenth century through the rise of modernism. In banning controversial writings, censorship functioned as a sort of super-copyright, vesting the government or powerful purity groups with exclusive power to control publication, and making it diff cult for anyone else, even authors, to print and disseminate suspect works. Copyright law, in perverse contrast, sometimes failed to protect allegedly immoral works at all. As we will see in Chapter 3, writings thought to be indecent could be poor candidates for copyright in Britain and the United States, chiefly because authors and publishers faced legal and practical obstacles to enforcing property rights in such writings. The mutually defeating ends of censorship and copyright produced an interactive emergency within the law—a juridical gap that spurred an underground market for unauthorized, experimental, and transgressive works.

* * *

The decade and a half that witnessed Wilde's celebrity also saw changes in the law that would trouble modernism well into the next century. Social transition and turbulence were making the law a difficult passage for what Wilde called the "new" and the "true" in literature: changing tests of obscenity; incipient but uncertain rights of privacy and publicity; the transatlantic copyright vacuum filling, slowly and unevenly, with onerous rules for protection. Wilde himself was an exception for whom legal rules were an alien alphabet; his "nemesis of character," he wrote, made him a "problem for which there was no solution"; he was a "perverse and impossible person," the "pariah-dog of the nineteenth century" (*Complete Letters* 995, 1006, 1079). It was not just the erasure of Wilde during his imprisonment that created his exceptional status. He had always embodied a kind of juridical void, a standstill or suspension of law (Agamben 48–9), which he expressed in the figure of the anomic, unassimilable dandy, the norm-dissolving individualist who represented "a disturbing and disintegrating force," and as a proud, homosexual Irishman who crossed class boundaries as a man and writer (Wilde, "Soul" 1091).

Law's passion for property amused and intrigued Wilde. He wrote paradoxically of serially held ideas and promoted an impossible commons owned separately by multiple investors. In his post-carceral vagabondage, he found new meanings for intellectual property, inventing stories, promising friends that he would write them down, but mostly keeping them to himself, fully formed "in [his] own mind," as a private public domain (qtd. in Ellmann, *Oscar* 571). Such mental hoarding allowed him to be a spendthrift of promises, an unselfish giant who had broken down the wall of his garden to let in his few remaining worshippers. In prison, he had observed the treatment of convicted children and noticed their bewilderment at the law's "strange abstract force," so unlike the comprehensible punishments administered by parents (Wilde, "Case" 960). Mourning and mourned as an outcast, he mocked and wept at the law's abstract force, fully inhabited by its past, present, and future—a complete man of law.

Works Cited

Agamben, Giorgio. *State of Exception*. Trans. Kevin Attell. Chicago: U of Chicago P, 2005.

Alldridge, Peter. "'Attempted Murder of the Soul': Blackmail, Privacy and Secrets." *Oxford Journal of Legal Studies* 13.3 (Autumn 1993): 368–87.

Black's Law Dictionary. 6th ed. St. Paul, MN: West, 1990.

Cohen, Ed. *Talk on the Wilde Side: Towards a Genealogy of a Discourse on Male Sexualities*. New York: Routledge, 1993.

Danson, Lawrence. *Wilde's Intentions: The Artist in His Criticism*. Oxford: Clarendon, 1997.

Ellmann, Richard. *Oscar Wilde*. New York: Alfred A. Knopf, 1988.

Foley, Kathryn M. "Protecting Fictional Characters: Defining the Elusive Trademark-Copyright Divide." *Connecticut Law Review* 41.3 (February 2009): 921–61 .

Gagnier, Regenia. *Idylls of the Marketplace: Oscar Wilde and the Victorian Public*. Stanford, CA: Stanford UP, 1986.

Gaines, Jane M. *Contested Culture: The Image, the Voice, and the Law*. Chapel Hill: U of North Carolina P, 1991.

Goldman, Jonathan. *Modernism Is the Literature of Celebrity*. Austin: U of Texas P, 2009.

Harris, Frank. *George Bernard Shaw: An Unauthorised Biography*. Ware, UK: Wordsworth, 2008.

Hofer, Matthew, and Gary Scharnhorst, eds. *Oscar Wilde in America: The Interviews*. Urbana: U of Illinois P, 2010.

Holland, Merlin. *The Real Trial of Oscar Wilde*. New York: Fourth. Estate, 2003.

Joyce, James. "Oscar Wilde: The Poet of 'Salomé.'" *Critical Writings*. Ed. Ellsworth Mason and Richard Ellmann. New York: Viking, 1959. 201–5.

Latham, Sean. *Art of Scandal: Modernism, Libel Law, and the Roman à Clef*. New York: Oxford UP, 2009.

Lewis, Lloyd, and Henry Justin Smith. *Oscar Wilde Discovers America*. New York: Benjamin Blom, 1936.

Marshik, Celia. *British Modernism and Censorship*. Cambridge, UK: Cambridge UP, 2006.

Mason, Stuart. *Bibliography of Oscar Wilde*. Intro. Robert Ross. London: T. Werner Laurie, 1914.

McLaren, Angus. *Sexual Blackmail: A Modern History*. Cambridge, MA: Harvard UP, 2002.

Mead, Frederick, and A. H. Bodkin. *Criminal Law Amendment Act, 1885, with Introduction, Notes, and Index*. London: Shaw and Sons, 1885.

Murray, Douglas. *Bosie: A Biography of Lord Alfred Douglas*. New York: Hyperion, 2000.

North, Michael. "The Picture of Oscar Wilde." *PMLA* 125.1 (January 2010): 185–91.

Novak, Daniel A. "Sexuality in the Age of Technological Reproducibility: Oscar Wilde, Photography, and Identity." *Oscar Wilde and Modern Culture: The Making of a Legend*. Ed. Joseph Bristow. Athens: Ohio UP, 2008. 63–95.

Odgers, W. Blake. *Outline of the Law of Libel*. London: Macmillan, 1897.

"The Poet and the Peanut Boy." *Fort Collins Courier* (May 4, 1882): 1. Posner, Richard A. *Law and Literature: A Misunderstood Relation*. Cambridge, MA: Harvard UP, 1988.

Report from the Select Committee of the House of Lords Appointed to Consider the Law of Defamation and Libel. N.p., 1843.

Rose, Mark. *Authors in Court: Scenes from the Theater of Copyright*. Cambridge, MA: Harvard UP, 2016.

Rosenblatt, Elizabeth L. "Adventure of the Shrinking Public Domain." *University of Colorado Law Review* 86 (Spring 2015): 561–630.

Saint-Amour, Paul K. *The Copywrights: Intellectual Property and the Literary Imagination.* Ithaca, NY: Cornell UP, 2003.

Schmitt, Carl. *Political Theology: Four Chapters on the Concept of Sovereignty.* Trans. George Schwab. Cambridge, MA: MIT P, 1985.

Sinfield, Alan. *Wilde Century: Effeminacy, Oscar Wilde, and the Queer Moment.* London: Cassell, 1994.

Spoo, Robert. "Courtesy Paratexts, Informal Publishing Norms and the Copyright Vacuum in Nineteenth-Century America." *Stanford Law Review* 693 (March 2017): 637–710.

Spoo, Robert. *Without Copyrights: Piracy, Publishing, and the Public Domain.* New York: Oxford UP, 2013.

Veblen, Thorstein. *Theory of the Leisure Class.* 1899. New York: Penguin, 1979.

Veeder, Van Vechten. "History and Theory of the Law of Defamation. II." *Columbia Law Review* 4.1 (January 1904): 33–56.

Vermeule, Adrian. "Our Schmittian Administrative Law." *Harvard Law Review* 122.4 (February 2009): 1095–1149.

Vivian, Herbert. "Reminiscences of a Short Life." *Oscar Wilde: Interviews and Recollections.* Vol. 1. Ed. E.H. Mikhail. London: Macmillan, 1979. 154–8.

Warren, Samuel D., and Louis. D. Brandeis. "The Right to Privacy." *Harvard Law Review* 4.5 (December 15, 1890): 193–220.

Whistler, James McNeill. *Gentle Art of Making Enemies.* London: William Heinemann, 1904.

Wilde, Oscar. "A Few Maxims for the Instruction of the Over-Educated." *Complete Works of Oscar Wilde.* New York: Perennial, 1989. 1203–4.

Wilde, Oscar. *An Ideal Husband. Complete Works of Oscar Wilde.* New York: Perennial, 1989. 482–551.

Wilde, Oscar. "The Canterville Ghost." *Complete Works of Oscar Wilde.* New York: Perennial, 1989. 193–214.

Wilde, Oscar. "The Case of Warder Martin: Some Cruelties of Prison Life." *Complete Works of Oscar Wilde.* New York: Perennial, 1989. 958–64.

Wilde, Oscar. *Complete Letters of Oscar Wilde.* Ed. Merlin Holland and Rupert Hart-Davis. New York: Henry Holt, 2000.

Wilde, Oscar. "The Critic as Artist." *Complete Works of Oscar Wilde.* New York: Perennial, 1989. 1009–59.

Wilde, Oscar. "The Decay of Lying." *Complete Works of Oscar Wilde.* New York: Perennial, 1989. 970–92.

Wilde, Oscar. *De Profundis. Complete Letters of Oscar Wilde.* Ed. Merlin Holland and Rupert Hart-Davis. New York: Henry Holt, 2000. 683–780.

Wilde, Oscar. *Importance of Being Earnest. Complete Works of Oscar Wilde.* New York: Perennial, 1989. 321–84.

Wilde, Oscar. "Impressions of America." *Oscar Wilde in America: The Interviews.* Ed. Matthew Hofer and Gary Scharnhorst. Urbana: U of Illinois P, 2010. 177–82.

Wilde, Oscar. *Lady Windermere's Fan. Complete Works of Oscar Wilde.* New York: Perennial, 1989. 385–430.

Wilde, Oscar. "On the Sale by Auction of Keats' Love Letters." *Complete Works of Oscar Wilde.* New York: Perennial, 1989. 815.

Wilde, Oscar. *The Picture of Dorian Gray. Lippincott's Monthly Magazine* 46 (July 1890): 1–100. Cited as "1890."

Wilde, Oscar. *The Picture of Dorian Gray.* 1891. *Complete Works of Oscar Wilde.* New York: Perennial, 1989. Cited as "1891."

Wilde, Oscar. "Soul of Man under Socialism." *Complete Works of Oscar Wilde.* New York: Perennial, 1989. 1079–1104.

CHAPTER 17
WEAK THEORY, WEAK MODERNISM
*Paul K. Saint-Amour**

An inventive and synthetic essay, Paul Saint-Amour's "Weak Theory, Weak Modernism" also appeared in the scholarly world rather inventively: it was published simultaneously as the introduction to a special issue of *Modernism/modernity* and in its online peer-reviewed platform Print Plus. Within a few months, it generated no less than twenty-eight response essays released in five groups on the journal's extended website. This robust response—and surely these twenty-eight essays only scratched the surface—attests to both the liveliness and the thorniness of the issues that Saint-Amour hits upon in his essay.

Saint-Amour reclaims the (ironic) power of weakness to reformulate some of the key paradigms of modernism and questions of modernist studies. His sense of weakness comes largely from queer theory and disability studies, both of which have pushed back against the various claims of "strength" in argumentation, aesthetics, and logic. We tend to devalue weakness, just as a generation of modernist writers often did for misogynistic, sometimes homophobic reasons. Figures like Pound, Hulme, and Marinetti equated hardness, strength, and tough masculinity with formal innovation; Pound praised Joyce's "clear" and "hard prose," for one. Women, the logic went, produced flabby, weak, insipid writing, the opposite of what Saint-Amour characterizes as the "muscular idol smashing" of modernism's self-proclaimed revolt.

But if we have so fully moved beyond such valuations a century later, Saint-Amour asks, why do we then buy into that "superseded" logic, even implicitly, when thinking theoretically and writing critically about modernism? Might the collective "embrace of weakness" of recent movements like "post-critique, surface reading, distant reading, thin description, the sociological turn, and new formalism" offer an alternative approach to modernist studies that rejects the imperative of strong narratives about modernism's ontological, epistemological, and historical nature? Indeed, Saint-Amour argues, the emergence of modernism *as a field* was conditioned by the gradual *weakening* of the term, not its philosophical hardening around tightly policed borders. ("Having shed its drive to coherentism, the field could cohere," he claims.) In other words, we ought to stop making strong claims about what, when, and where modernism was, and instead learn from the movement's rise in the wake of post-Nietzschean philosophy's fall from its idealized transcendent language and concepts.

Saint-Amour moves through Gianni Vattimo to Eve Kosofsky Sedgwick to a host of other thinkers in a tour de force account of the field that is meant to feel anything but forceful. In asking scholars to be less the "decoder[s]" of modernism's fine grains and more the participants in its unlikely disavowal of the omnipotence of critical insight, Saint-Amour also asks us to rethink how modernism is formulated in spheres like the academic job market and the nonacademic intellectual field. The many responses to "Weak Theory, Weak Modernism"

*From *Modernism/modernity*, v. 25, no. 3, pp. 437–59. Johns Hopkins University Press, ©2018. Reproduced here with permission.

lodged a variety of disagreements, including the idea that Saint-Amour had made a straw man or monolith of a field that had already diversified itself beyond the limitations he still sees. We conclude this volume with this essay precisely because it has been so generative—in agreement and in disagreement—and thus acts as a new turn in the continual courses of the New Modernist Studies.

Weakness: not a word that would seem, at first blush, to have anything to say to modernism. Modernism doesn't blush; it blasts. Its reputation is for strength *in extremis*—for steep critiques of modernity, energetic convention busting, the breaking of vessels. In the words of its early theorists, modernism is "rebellion against authority," a "revolution of the word," "kicking over old walls" and "breaking of 'Do Nots.'"[1] Nothing small-bore about revolt, nothing weak about making it new. Surely weakness is modernism's obverse—injured, low-energy, and acquiescent—all the cloying orthodoxy that modernism would shock its way out of. Modernism is the production of aesthetic strength through iconoclasm and strenuous innovation. It is strong people exhibiting strength.

Or so the story used to go. From the perspective of the present, that story sounds enthralled with the self-mythologizing of a handful of male writers, germane to only a narrow bandwidth of the cultural production we have come to call modernist, and then only to its self-understanding. It verges on cartoon vitalism. Equating modernism with this kind of muscular idol smashing and warrior masculinity misses both the traditionalism of the strong and the dissidence of the weak. It favors metropolitan spaces hospitable to consensus about what counts as convention and what as rebellion. It skews away from generations who understood themselves as extending rather than negating the work of modernist forebears. And it rules out whole areas of study that have lately become important in our field, including the everyday, the domestic, the affective, the middlebrow, the infrastructural, the doctrinal. "Strong" modernism belongs to a largely superseded moment in modernist studies.

Yet with modernism as with so much else, it's one thing to let go of strength and quite another to embrace weakness. Weakness comes with a lot of baggage. It sits at the center of a dense array of slurs by which marginal subjects have been kept marginal. The word *weak* can function in an ableist heteropatriarchy as a synonym, variously, for *woman*, *queer*, and *disabled*. A feminist, anti-homophobic, disability-oriented practice encounters weakness first as a charge to disprove, only secondarily as part of a logic to dismantle. In what follows, some meanings of weakness will present themselves as normative (i.e., evaluative or judgmental) and others as non-normative (i.e., non-evaluative or descriptive). Some will plainly participate in the semantic fields of gender, sexuality, or ability while others will not. But even the ostensibly non-normative meanings of *weak*—including its earliest sense as "pliant, flexible, readily bending"— are tinged with its normative ones, as even the non-gendered meanings (for example) bear some memory of, or association with, the gendered ones.[2] In considering what weakness might afford us theoretically or methodologically, we are still and always confronting a term of subjection. Rather than pretend we can simply hive off this history by thickening a few semantic firewalls, we do better to keep in mind the tendency of descriptive and dismissive senses of weakness to interfere with one another. This would be to remember that in taking up non-normative forms of weakness we are also reclaiming a term of derogation—even as no theoretical embrace of weakness is reducible to such a reclamation.

If weakness is such a loaded concept, why not find some other way to characterize our theorizing and field-construction? One answer is that the various loads borne by weakness can productively decenter what they encounter. Baggage unbalances. To the extent that the terms *theory* and *modernism* are still masculine-gendered, conjoining them with weakness further discomfits that

gendering. The same conjuncture may vex what remains of both terms' association with normative modes of sexuality, mindedness, and embodiment. Weakness, that is, helps us continue to make theory and modernism strange to themselves. It does so not just in its capacity to unsettle by association but, more and more, through paradigms of weak thought—paradigms that have largely emerged in fields that address difference, stigma, and inequity. This has been especially true of queer theory, whose dissident relationship to strong ideologies of sex and gender prepared it to play a central role in developing models of weak thought. Out of scholarship in queer, gender, and disability studies have come alternatives not just to normative accounts of identity and expression, capacity and desire, but also to methodologies rooted in those normative accounts.[3] These emergent, alternative methods explore, among other things, what would happen if strength were no longer the presumptive master-criterion for art, thought, research, argument, and teaching. They prompt us to revisit, in both our critical practices and our pedagogy, the gendered politics of yielding and force, of all-or-nothing arguments with their forgotten middles and superseded alternatives, of agency and its relinquishment. They draw attention to obsolete epistemologies, to actions unpremised on self-possession, to creative practices unendorsed by the portrait of the author as lone master builder. And they issue an invitation that scholars of modernism, including the contributors to this special issue, are taking up: to leave off theorizing weakness as a failure, absence, or function of strength and instead to theorize *from* weakness as a condition endowed with traits and possibilities of its own.

A second answer to "why weakness?"—related to the first insofar as many of its key figures have commitments in feminism, queer theory, and disability studies—also begins with a set of recent methodological initiatives. These have proposed lower-pitched alternatives to certain "strong" theoretical habits of thought in literary studies. Dubbed "the new modesty in literary criticism" by Jeffrey Williams, this array of overlapping but distinct approaches includes post-critique, surface reading, distant reading, thin description, the sociological turn, and new formalism.[4] The critics associated with these approaches call for alternatives to "symptomatic reading"—that is, to interpretive modes whose primary aim is to expose the ruses of ideology, decode the encryptions wrought by the unconscious, or otherwise penetrate the surfaces of texts to get at their truer, occulted depths. Many of these critics call as well for literary studies to retire two more portraits familiar to students of strong modernism: the portrait of the artwork as locus of autonomy from ideology and the portrait of the critic as heroic demystifier of ideology. In place of these, proponents of the new modesty have offered alternative portraits of the critic ranging from "minimal critical agency" to "canny formalism" and alternative methods running from descriptive microanalyses of individual texts' manifest content to quantitative analyses of large literary databases.[5] And they've provoked strong reactions: accusations of quietism, recommitments to critique, and attempts to bend the new modesty to explicitly political ends.

These developments and provocations have been slow to impact modernist studies, in part because their initial epicenter was in nineteenth-century studies. Sharon Marcus, whose meditation on "just reading" in *Between Women* (2007) helped touch off the post-critical turn, is a Victorianist.[6] Stephen Best, who with Marcus co-edited the special issue of *Representations* on "The Way We Read Now," is a scholar of legal hermeneutics, race, and nineteenth-century American literature.[7] Nicholas Dames and Leah Price have drawn attention, respectively, to how nineteenth-century readers read without interpreting and how they used books without reading them.[8] Their fellow Victorianist, Caroline Levine, has written one of the central statements of the new or strategic formalism.[9] And Franco Moretti's turn toward quantitative methods has happened primarily in relation to the corpus of nineteenth-century fiction.[10] Yet modernist studies and its practitioners have also played a role, if an often underappreciated one, in the turn away from symptomatic reading. Moretti has been crucially engaged with modernism since his *Signs Taken for Wonders*

(1983), and modernist works have remained a part of his recent data sets. Rita Felski, a Latourian advocate of post-critique, is a scholar of gender and modernism; her *Uses of Literature* (2008), one of the opening salvos of post-critique, is partly staged as an attempt to take modernism back from Jameson's strong historicism.[11] Heather Love, a scholar of gender, sexuality, affect, and modernism, has played a key role in bringing microsociological methods to literary study.[12] Other examples abound.

One aim of this special issue, then, is to bring together work that explores the ramifications of the new modesty and a certain subset of queer methods in and for modernist studies in particular. Another is to advance debates about post-critique by moving past some of the brittler binarisms— paranoid versus reparative, depth versus surface, close versus distant, critique versus description— on which those debates run aground. We do so by shifting the focus of the debate to *weak theory*, a loose parcel of concepts and heuristics that mostly antedate post-critique, and only some of which have since become associated with it. Several articles in this issue, especially Benjamin Kahan's, take up Eve Sedgwick's work on reparative reading, which itself draws on midcentury psychologist Silvan Tomkins's notion of weak affect theories as attempting to account for "near" phenomena rather than to unify a wide range of disparate objects. Grace Lavery draws partly alongside Felski while also re-entangling affect, criticism, and critique, terms that tend to remain discrete in Felski's recent work. Contributors also engage with figures less easily assimilable to the post-critical turn, in the process asking how weak theory might abet or reshape critique rather than supersede it. Sara Crangle draws on "weak thought" (*pensiero debole*), the name that postmodern philosopher Gianni Vattimo gives to what survives Nietzsche's discrediting of strong thought's metanarratives (foundational metaphysics; a singular, progressive model of modernity; Hegelo-Marxian models of totality). She builds, too, on Emmanuel Levinas's use of weakness as a central metaphor in the critique of philosophical transcendence. Melanie Micir and Aarthi Vadde extend Sianne Ngai's work on the aesthetics of negative emotions characterized by "weak intentionality" and "the politically charged predicament of suspended agency."[13] Sociologist Mark Granovetter's work on the strength of weak interpersonal ties is invoked in this issue by Wai Chee Dimock, who has elsewhere called for theory that "does not aspire to full occupancy in the analytic field, that settles for a low threshold in plausibility and admissibility . . . that does not even try to clinch the case."[14] Dimock's work, in turn, informs Gabriel Hankins's account of a weak conjunction between digital method and the field of modernist studies. What these theorists of weakness, Sedgwick included, share is not a vehement, dialectical negation of either strength or critique but an interest in the work accomplished by the proximate, the provisional, and the probabilistic.

Our special issue pursues two main ways of reacquainting modernist studies with weakness. First, it takes the view that a post-Nietzschean weakening in the philosophies of history and aesthetics was a condition of modernism's emergence, at least in the European context, as a cultural phenomenon. Modernism, by these lights, is made both necessary and possible in the west by theory's weakening. Yet as a condition of modernist possibility, that theoretical weakening was partially written over by the energetic masculinism attributed to the figures and works first canonized by the field. This heroic "men of 1914" script likely compounded baseline cultural and institutional prejudices in effacing writers who were women, sexual dissidents, disabled subjects, and racial others, or who identified with those minoritized subjects in their work, leaving it to later generations of scholars to attempt to undo that erasure through recovery projects. Another result of the overwriting at issue here was that modernism got misrecognized for several generations as the zenith of myth or of its future-oriented counterpart, metanarrative, whereas modernism was in fact inextricable from the loss of metanarrative, attending to myth as a lost or impossible object of desire—a virtual, ruined, or compensatory thing. This is to say that the "incredulity toward metanarratives" Jean-François Lyotard ascribed to postmodernism was already a feature of modernism, indeed one of its originary

conditions.[15] Several of our contributors pursue the upshot of this revision: that epistemological humility and weakness-in-theory did not happen *to* modernism after the fact but happened *as* and *through* modernism.

Second, the issue makes the case that modernist studies's emergence as a field has been concomitant with a steady weakening of its key term, *modernism*. Ours has become a strong field—populous, varied, generative, self-transforming—in proportion as it has relaxed its definitions of modernism and learned to ask other questions of a work than "But is it really modernist?"—questions that sometimes permit other strong terms, commitments, and analytics to come to the fore. True, a certain bent for gatekeeping and canon building remains a phantom reflex. But that same tendency has been an object of mounting skepticism for decades. Michael Levenson's *A Genealogy of Modernism* (1984), whose title seems to promise a bright-line, in-or-out account of modernism, instead describes the term as "at once vague and unavoidable," a "blunt instrument" to be used only "as a rough way of locating our attention."[16] According to Bonnie Kime Scott, the contributing editors of her field-changing critical anthology *The Gender of Modernism* (1990) "worked restively" with the term, manipulating it rather than attempting to fit neglected figures into then-current masculinist defnitions.[17] By the time the field was emerging fully in the 1990s, the "men of 1914" portrait and the straw-man modernism created by theorists and practitioners of postmodernism were being discredited. With an immanent theory of modernism weak enough to permit the horizontal frictions and attachments necessary for field formation, modernist studies could be imagined as a capacious and self-reflexive problem space. Having shed its drive to coherentism, the field could cohere.

And *expand*, you might be thinking, recalling Douglas Mao and Rebecca Walkowitz's one-word summation of the changes in the field since about 1990.[18] It could expand chronologically, beyond its old 1890–1940 period boundaries; expand in the cultural strata, media, and methodologies it compasses; expand, perhaps above all, spatially, through a turn described variously as transnational, global, and planetary. When a field expands so dramatically, and along so many axes at once, it rightly raises the question of *expansionism*—of the extent to which by opening up it might encroach on adjacent fields, or at least compel them to accept the terms of the expanding field's recognition. When Christopher Bush, reviewing Susan Stanford Friedman's *Planetary Modernisms* (2015), writes that her claim of a medieval Mongol modernity "vividly captures the shock if not awe of [the book's] agenda to liberate the world and its pasts for 'modernism' and 'modernity,'" he analogizes the planetary turn advocated by Friedman to US imperialism's forcible export of democracy.[19] Friedman herself anticipates the charge, concluding that it is "better to risk expansionism than to perpetuate the Eurocentric box" drawn by narrowly periodized conceptions of modernism and modernity.[20] These charges and countercharges, all of them strong claims about strength, should nonetheless prompt a series of questions among practitioners of a weak modernist studies—questions about weakness's implication in, even its predication on, forms of strength. When does the weakening of a field's central term participate, deliberately or not, in a "lose to win" strategy, a performatively submissive showing of the belly that draws attention away from a territorial dominance-bid? Does weak theory have a role to play in balancing, on the one hand, the obligation to broaden narrow canons and, on the other, the dangers of overreach and appropriation? Is there a weak theoretical alternative to treating fields of study as scarce, excludable resources or embattled territories? What does weakness offer in the way of a new vantage from which to theorize power, including power's way of working through weakness and weakness-claims? And under what conditions is the embrace of weakness in theory, method, rhetoric, or field-construction a luxury only available to the strong?

I'll take up some of these questions below; others will bubble up in contributors' articles. For the moment, let me acknowledge that not all of this journal's readers will recognize, in the foregoing descriptions, the global field of modernist studies, or even the wedge of that field—studies of mostly

Anglophone modernism by scholars based in British and North American universities—represented by this special issue. Nor will everyone find weak theoretical approaches worth the sacrifice of analytical certitude, reach, force, and occupancy that they often entail. If the two Modernist Studies Association roundtables at which most of its contributors first shared their work are any indication, this special issue will occasion lively, even heated debate. Surely this is one of the most valuable services such an issue can tender its field of study: rather than "brand" a scholarly method or territorialize an object of study, to irritate a field into a state of self-scrutiny—or even a crisis of self-recognition—that generates fresh methods and collaborations, needed forms of humility and responsibility, unforeseen kinds of projects, and renewed or new reasons for undertaking them.

Some Weak Theorists

Strong theory, weak theory: this is not, of course, a distinction invented here but one that emerges from several sources that we can loosely bundle. Nor is the "weak theory" at issue anything as recent as the vaunted waning of post-structuralism (as in "the death of theory"). Its earliest strand might be said to be roughly co-emergent, and perhaps causally entangled, with Anglo-European modernism. This strand would include both Marx's subjection of ideology to the dialectic and the later founderings of Hegelo-Marxian certainties and models of totality in the moment of their actualization. It would include Nietzsche's dissolution of metaphysics—his assault, in the name of the will to power, on systematic philosophy's god-terms and its assumption of progress. And it would include Freud's understanding of analysis not as a way to reveal being as a structure, condition, or given, but rather as a way to construct being as an event. Here, I'm paraphrasing the aforementioned Gianni Vattimo, for whom a society with "supreme and exclusive values," in effect a pantheon of god-terms, is no longer tenable thanks to the contributions of Marx, Nietzsche, and Freud. In their wake, says Vattimo, the philosopher's duty is not to demonstrate transcendental or objective truths but to edify by showing that truth is produced through interpretation and conversation; no longer to be "humanity's guide to understanding the Eternal" but to "redirect humanity toward history."[21] For literary critics steeped in the new modesty, such claims can be usefully disorienting in the way they turn critique's sponsorial giants (again, Marx, Nietzsche, and Freud) to ends distinct from the "critique" portrayed and opposed by advocates of the post-critical turn. For Vattimo, critique is precisely not the confident exposure of surface phenomena as manifestations of a single self-concealing code, structure, or hierarchy. It is closer to the recognition that such exposures would require sovereign metaphysical notions of being and truth that are no longer tenable; that what remains to philosophy is a practical accounting of how truth is constituted by interpretation within particular historical horizons. What's more, such a praxis aims to go on weakening whatever transhistorical claims to being and truth persist. Far from reducing all objects to proof of a strong theory, critique, for Vattimo, weakens its objects without reciprocally strengthening the critic's thought.

Along these lines, Vattimo has since the 1980s been advocating what he calls *pen-siero debole* or "weak thought," a philosophy that would reduce the "peremptoriness of reality" and address reality "as a set of shared images—a discourse." Asked in 2002 what a strong theory of weakness would look like, Vattimo responded:

> In a strong theory of weakness, the philosopher's role would not derive from the world "as it is," but from the world viewed as the product of a history of interpretation throughout the history of human cultures. This philosophical effort would focus on interpretation as a process of weakening, a process in which the weight of objective structures is reduced. Philosophy

can consider itself neither as knowledge of the external, universal structures of being, nor as knowledge of the external, universal structures of *episteme*, for both of these are undone by the philosophical process of weakening. That is, after the critique of ideology, after the Nietzschean critique of the notion of "things as they are." ("Weak Thought," 453)

The key phrase here is "interpretation as a process of weakening, a process in which the weight of objective structures is reduced." For Vattimo, thought is weak not only when it avoids "strong" or transcendental truth-claims but also when it actively *weakens* the monopolistic hold of such claims on our understanding of history and possibility. By a similar token, law becomes, "by means of interpretation . . . an instrument for weakening the original violence of justice" (454). Again, weak thought *weakens* the peremptoriness of what passes for the inarguable; it beholds the edifice of the given and says (with apologies to Cheng Tang and Ezra Pound), "Make it weak." However, to relinquish metaphysics along with teleological models of history is not, for Vattimo, to give up on the possibility of social transformation. To the contrary, he writes, compassion [*pietà*] for those "elements that have not become world: the ruins accumulated by the history of victors at the feet of Klee's angel . . . is the only real fuel of revolution—not some project legitimized in the name of a natural right or an inevitable course of history."[22] Weak thought would be the means by which those so far unworlded ruins might gain our compassion and charge us to make radically new social formations become world. Weakness would be the strait gate through which newness would enter.

Whereas for Vattimo weak thought is the sequel to Marx, Nietzsche, and Freud, for Eve Sedgwick weak theory is an alternative to the strong theory she sees as exemplified by their work. Building on psychologist and cybernetician Silvan Tomkins's 1963 book, *Affect-Imagery-Consciousness*, Sedgwick takes strong theory as shorthand for strong *affect* theory. In fact, all theories, as she understands Tomkins, are affect theories in that they seek to maximize positive and minimize negative affect on the part of the theorist, who could be Freud or one of his analysands, a tenured Marxist or a member of the global precariat. But then comes the counterintuitive part: affect theories that fail to minimize negative affect tend to become stronger, compensating for their failure by attempting to unify a wider and wider range of disparate phenomena. A failed affect theory, that is, hopes to ward off further refutation and humiliation by securing a larger territory against bad surprises. If we go along with Sedgwick in seeing orthodox Marxism as a strong theory, we might say that it tends to become increasingly totalizing, coherentist, and teleological in proportion as it fails to prevent Marxists from feeling shitty about the persistence of capitalism.

Whereas strong theories get stronger after failing to minimize negative affect, weak affect theories, says Tomkins, must be effective to remain weak. Their effectiveness tends to inhere in their attempts not to unify far-flung objects but to "account only for 'near' phenomena," venturing "little better than a description of the phenomena which [they purport] to explain."[23] Strong theory is *decryptive*, bent on decoding or unmasking a vast array of phenomena in order to avoid bad surprises. Weak theory is *descriptive*, seeking to know but not necessarily to know better than its object. Insofar as it omits to defend itself at every moment against refutation, weak theory finds the risk of bad surprises an acceptable price to pay for the prospect of good ones—for the hope "that the future may be different from the present," in Sedgwick's words, even if that opening of the future means entertaining "such profoundly painful, profoundly relieving, ethically crucial possibilities as that the past, in turn, could have happened differently from the way it actually did" (*Touching Feeling*, 146). As against the indicative moods of strong theory, weak theory welcomes the subjunctive, the speculative, and the counterfactual.

Sedgwick's work has sparked a lively series of exchanges, particularly among queer theorists and students of affect, about how a "reparative" criticism might supersede the "paranoid" criticism powered by the hermeneutic of suspicion. As stimulating as these exchanges have been, they often

produce a caricature of all "critique" as addicted to binary decipherment and the dodgy rabbit-out-of-a-hat stagecraft of revelation. Having fixated on Sedgwick's Kleinian menu of reparative versus paranoid positions, critics of the hermeneutic of suspicion have paid scant attention to the variety of weak-theoretical projects that shelter under the ostensibly strong-theoretical big-top of critique. (As just one example, think of the ever-growing importance and varied legacies of Benjamin's work, with its site-specificity and weak messianism, in contrast to the long stall of orthodox Marxism.) This has been to miss one of the more suggestive elements of Sedgwick's work via Tomkins—the counterintuitive dynamics that distinguish weak from strong affect theories—as a result of attending too doggedly to one of her project's more inflexible trajectories, the critique of critique.

This embrace of the reparative energies in Sedgwick over her advocacy of weak theory should prompt us to ask whether our tendency to turn toward what is considered strong—our *dynamotropism*, if you will—prevents even those who practice weak theory, even those whose fields are constituted around weakly theorized terms, from proudly declaring themselves weak theorists. It may be that practicing weak theorists who avoid the handle have intuited something like weak theory's double-bind: that to avow oneself a weak theorist in a dynamotropic profession is to invite attack for being unrigorous, quietist, anti-theory, anti-intellectual; that the negative affect consequent on that attack would cause one's theory of weakness to grow stronger in response, until it aimed to be the key to all mythologies; that the only way to keep one's theory weak and effective is to practice it with a furtiveness that looks an awful lot like *paranoia*, that signal trait of the strong theorist. Or, alternatively, to practice it under cover of big terms (worldedness, globality, planetarity) or sweeping moves (transperiodization, say, or transtemporalization) whose apparently vast scale camouflages the theoretical weakening one is actually seeking to produce. We might well hesitate before following Sedgwick in reading all theory, particularly critical theories of ideology, as affect theory. But if modernist studies has indeed, for a while now, been weakening its immanent theory of modernism without saying so, it would be worth our considering the role affect might have played in that disavowed weakening, and might still have to play in its avowal.

One of the few theorists in the field to explicitly avow and advocate weakness is Wai Chee Dimock. In her 2013 essay on Henry James, Colm Tóibín, and W. B. Yeats, Dimock uses genre to road test a weak-theoretical approach. As against strong theoretical projects in which "there is a curious resemblance . . . between the totalizing zeal of the theorist and the totalizing claim being made on behalf of its object," the weak theory Dimock advocates

> cannot support a system of sovereign axioms. Instead, the frequency, diversity, and centrifugal nature of the spin-offs [i.e., threads in laterally propagated, long Latourian networks] suggest not only that the points of contact will change from moment to moment but that the field itself might not even be governed by a single morphology, an ordering principle generalizable across the board and presetting its hierarchies. Local circumstances can do a lot to change the operating baseline and the various claims to primacy resting upon it. ("Weak Theory," 733, 737)

As for Sedgwick and Vattimo, weak theory in Dimock's sketch conceives of the future other than as the time in which one's theory will be either refuted or vindicated. It imagines there are other things to do with weakness than to triumph over it, other responses to constraint than its redemption as strength. Where strong theory attempts to ride its sovereign axioms to "a future never for a moment in doubt," weak theory tries to see just a little way ahead, behind, and to the sides, conceiving even of its field in partial and provisional terms that will neither impede nor shatter on the arrival of the unforeseen (733).

Weakening Modernism

Dimock's piece has the advantage, for some readers, of not sitting on the pediment of Cold War affect theory or presupposing a particular reading of Marx, Nietzsche, and Freud in whose wake the duty of the philosopher or the work of the critic must undergo a sea change. Her aims are thus not epochal but practical and incremental— "that literary history," she says "might be more easily conceived as a nonsovereign field, with site-specific input generating a variable morphology, a variable ordering principle, so that what appears primary in one locale can indeed lapse into secondariness in another" (738). That's not a bad description of the field of modernist studies today: not quite a Sedgwickian venture, where one does little more than describe what one purports to explain, but something closer to Vattimo's practice of weakening the monopolistic or sovereign hold of particular terms by rotating through them, according one a local primacy in one place, then relegating it to an ancillary, latent, or even fallow role in another. Although the transnational (global, planetary) turn has contributed to the field's becoming nonsovereign, I'd suggest that this process has been under way underway for several decades—and, more, that the field's early weakening (as it were) is bound up with its tardy formation. As I understand it, what Mao and Walkowitz christened the new modernist studies in 2008 was never preceded by an old modernist studies. Yes, there were scholars of modernist works and authors before the launching of this journal in 1994 and of the Modernist Studies Association in 1998, but they were working predominantly in single-author fields. The broader field-making energies of those who thought about modernism were pouring mainly down two other channels. First, post-structuralist theory, which became a principal field for a generation of scholars trained to work on early twentieth-century writers and who might, in post-structuralism's absence, have been establishing a modernist studies during the 1970s and 1980s. And second, the establishment of *postmodernism* as a term and field of study—the journal *Postmodern Culture* was founded in 1990, four years before *Modernism/modernity*—whose canonical works were championed by scholars who wrote first books on modernist writers and sought to canonize later works through analogies to modernism.[24]

What kind of theory of modernism has been animating modernist studies since its belated formation in the 1990s? How would we characterize that theory's density, intensity, extensiveness, and maybe above all its investment in making claims declarative enough to be refutable? I want to suggest that the field's immanent theory of modernism is a weak theory, growing weaker. Here, I mean weak in the descriptive rather than the normative sense. For all our efforts to attend less exclusively to strong people exhibiting strength, scholars in the humanities have stayed pretty devoted to normative senses of strength and weakness, whether in our scholarly and theoretical terms, in the rhetoric of the recommendation letter, or in the terms we use to evaluate student work. ("This is a strongly motivated argument, but weakly supported by textual evidence," for example.) Yet if we look to other disciplines we encounter all kinds of weakness in the non-normative or descriptive sense, often to do with questions of range. Consider the weak nuclear force in physics, whose weakness indexes the super-close range of particle interactions. Or sociologist Mark Granovetter's work on the strength of weak interpersonal ties, whose weakness he conceived by analogy with the weak hydrogen bonds that bind water molecules to one another, in contrast to the strong covalent or ionic bonds that hold water together at the intramolecular level.

Granovetter's classic 1973 article "The Strength of Weak Ties" is worth tarrying over here for its descriptive (and, one might add, theoretically strong) account of how one kind of weakness can produce another kind of strength.[25] Granovetter's central claim is a simple and powerful one: that weak social ties enable information to travel farther and more rapidly than strong ones do. If I communicate news to someone to whom I'm strongly tied—say, to a sibling, partner, or close friend—that bit of news will simply have gained access to a social network that overlaps largely with

my own. But if I tell my dental hygienist, an elevator acquaintance from the building where I work, or a stranger ahead of me in the post office line—someone whose quotidian social universe overlaps with mine slightly or not at all—the news jumps networks as a spark leaps a firebreak to touch off dry new fuel. As nineteenth-centuryists are beginning to discover, Granovetter's piece is especially useful to read beside literary works that attempt to model, in their diegetic worlds, the social itineraries of information.[26] It helps us think about why, in George Eliot's *Middlemarch*, the news about Edward Casaubon's diabolical codicil reaches Will Ladislaw through a long series of weak social ties, jumping gaps between households, employment relations, classes, and communities, moving eventually from the country estates to the well-to-do townsfolk who make up Will's main social circle. All this because Dorothea, the codicil's subject and Will's would-be lover, holds him too dear to tell him news that casts him in a shameful light—the news that her dying husband made her inheritance of his fortune conditional on her never marrying Will once she was widowed. Strong ties, at best a slow mode of dissemination, can actually kill the transmission of news altogether when shame arises between intimates.

One can imagine tracing the relationship between weak social ties and the circulation of information in modernist works, especially in the more capacious and populous fictions we study. But so far scholars of modernism haven't taken up Granovetterian readings of diegetic social networks, perhaps on the assumption that modernist works reject the kind of realist mimesis or modeling that would give such readings traction. While shying away from weak social ties in our diegetic analyses, however, we have for a while now been giving them pride of place in tracing the social networks in which modernist cultural producers were embedded. For contrast's sake, consider as a baseline two consecrated images from the study of coterie modernism—images that use the idiom of the family portrait to give us a modernism among intimates.[27]

These two portraits (and similar ones of Bloomsbury, the Stein circle, and other tightly clustered coteries) were among the fetish images of modernist studies in its early years. They were largely portraits of strong social ties: siblings, partners, lovers, close friends, classmates, clubmates, patrons, protégés, and impresarios. Now consider this well-known image from the introduction to Scott's *The Gender of Modernism*, an anthology that built on two decades of recovery work and canon-expansion by feminist critics and scholars of African American literature.

As significant as the content of the "Tangled Mesh of Modernists" is the critical impulse to which it testifies: an impulse to look beyond families and coteries to a broader variety of farther ramifying connections. To be sure, some of Scott's lines indicate strong ties. But the majority trace weaker ones, often between individuals who never met in person and were connected through print—through the writing of appreciative reviews, introductions, critiques, parodies, even diatribes. The ties here are both one-way and two-way. And they include a wide range of dispositions, from approbation (Rebecca West of Virginia Woolf) to antipathy (Woolf of Arnold Bennett, Nancy Cunard of Pound). Recalling Vattimo's notion of interpretation as a process of weakening the monopolistic hold of putatively objective structures, we can see Scott's "Tangled Mesh of Modernists" as one way this weakening looked at a crucial infection point in modernist studies's self-understanding.

For a more recent example of the drift in modernist studies toward a field conception based on weaker social ties, consider this image of ten writers and producers affiliated with the BBC Eastern Service. It's an image that has appeared during the last few years as both an object of analysis and a kind of methodological touchstone or escutcheon in work by Daniel Morse, Peter Kalliney, and others.[28]

Where the sage-like Strachey centers, above, here the microphone supplants him as the strong hub of the image, concretizing at least three more diffuse if undeniably powerful structures—the crown-chartered monopoly of the BBC, the Indian wing of its Empire Service during wartime, and the medium of radio itself. The group clustered around that centripetal

object, however, is not just more varied in terms of race, culture, and social class than the other two portraits, or more mixed in the cultural prestige of those it depicts. It's not just more global or transnational in its itineraries. It's also a portrait of the weaker social ties that facilitate more diverse and attenuated clusters. And it metonymizes still weaker-tie social networks made up of individuals never photographed together by dint of their never having met—far-flung networks of writers, editors, and translators of the sort lately traced by Kalliney, Gayle Rogers, Eric Bulson, and others, joined only by one another's writings, and by post, telegraph, and radio.[29] In addition, the multilingual networks traced by comparatists such as Rogers and Bulson suggest an axiom about the field-conception they helped displace: that strong-tie portraits of modernism tend toward monolingualism.

This interest in dispersive cultural networks and exchanges could have served a one-way, Eurocentric diffusionist view of modernism as starting among a handful of metropolitan elites and coteries and spreading, radially and belatedly, to peripheral sites. That it has largely helped delimit or discredit such a view results from the growing recognition that modernism is not a property of some self-identical cultural "content" that gets sent out through networks; that it is, rather, a temper or mode that arises largely by way of multi-directional networked exchanges, whether these take the shape of collaboration, translation, misprision, imitation, provocation, appropriation, or counter-appropriation. Recognizing this takes us back, in turn, to the distinction between theory and field. Apropos of this distinction, I suggest that a field's strength (in the normative sense)—its vitality, generativity, and populousness—may increase as the immanent theory of its central term weakens (in the descriptive sense). What I mean is that the less sovereign a hold the central term has upon the field it frames, the more ferment and recombination can occur within that field, and among more elements. This seems to have been the case with modernist studies, which has flourished in proportion as the term *modernism* has softened its definitional gaze and relinquished its gatekeeping function—in proportion, again, as we have learned to focus on questions other than, "But is such-and-such a work really modernist?" In fact, as I suggested earlier, the field's formation qua field appears to have required a weaker theory of modernism than that Harry Levin-era question permits. I value the strong field that resulted from this weakening-in-theory and mostly celebrate that weakening and the chances it affords us. At the same time, I would urge that the more varied and dispersive networks we now study demand renewed attention to how the differentials of power played out historically across those networks and continue to structure how we study and teach them. But my aims here are finally descriptive rather than laudatory, hortatory, or polemical. Indeed, part of what I'm attempting to describe is the emergence of a certain descriptive turn in our field.[30] This would be to recognize the current of weakness in modernist studies's immanent field-theory and the kinds of projects, including certain strong theoretical ones, such weakness licenses.

Let me offer some examples of weak-theoretical formulations of modernism by scholars, particularly those working in the global frame. Here is Jessica Berman's way of framing modernism in *Modernist Commitments: Ethics, Politics, and Transnational Modernism*:

> Modernism, I will claim, stands for a dynamic set of relationships, practices, problematics, and cultural engagements with modernity rather than a static canon of works, a given set of formal devices, or a specific range of beliefs. . . . [M]odernist narrative might best be seen as a constellation of rhetorical actions, attitudes, or aesthetic occasions, motivated by the particular and varied situations of economic, social, and cultural modernity worldwide and shaped by the ethical and political demands of those situations. Its rhetorical activity exists in constant and perpetual relationship to the complex, various, and often vexing demands of the social practices, political discourses, and historical circumstances of modernity and the

challenges they pose to systems of representation—even as its forms and attitudes sometimes hide this fact.[31]

What I'd most like to note here is the language of the flexible set or constellation. Modernism, for Berman, isn't a trait whose presence we can certify by ticking certain boxes or by showing that a work fulfills some master-criterion. It's diffused, rather, through a lattice of nodes and traits, detectable as site-specific subsets of an unnamed set of "relationships, practices, problematics, and cultural engagements" that may take place in a range of locations—aesthetic, rhetorical, cultural, economic, social, ethical, philosophical, historical. A stronger theory of modernism might at least specify some threshold or minimum number of qualifying "relationships, practices, problematics, and cultural engagements," or of signal "rhetorical actions, attitudes, or aesthetic occasions," below which a given work might be said to fall short of the designation *modernist*. But Berman's definition is unvexed by this classical paradox of the heap—the difficulty of saying when a heap of rice (say) ceases, through the deduction of one grain after another, to be a heap. It is content to let modernism be definitionally and constitutively vague.[32] We find a similar emphasis on the flexible and the conjunctural in Tsitsi Jaji's *Africa in Stereo: Modernism, Music, and Pan-African Solidarity*, although Jaji focuses, albeit nonexcludingly, on modernism as an aesthetic category. "I use modernism," she writes, "as a simple heuristic device for indexing aesthetic choices that reflect self-conscious performances of 'being modern.'"[33] Notice that Jaji's locution, "I use modernism as," treats modernism not as a category endowed with a stable—to say nothing of transcendental— ontology, but rather as a function of the scholar's self-conscious performance, and implicitly as one use in an unspecified set of credible uses. I'd submit that this is more and more the case with our formulations of modernism; we're less apt to find the word *modernist* as a predicate adjective ("Such-and-such a work or figure is modernist") than as the object of the preposition *as* in sentences in the subjunctive mood ("Were we to read such-and-such a work or figure as modernist," and so on). Although both Jaji's and Berman's formulations use the indicative mood (Jaji: "I use modernism as"; Berman: "Modernism stands for"), there's an implied subjunctive to both, an element of the provisional, the probabilistic, or the thought-experimental, as becomes clear in Berman's passage when she goes on to say that "Modernist narrative *might* best be seen as a constellation."

Here's a final example, from Mark Wollaeger's introduction to *The Oxford Handbook of Global Modernisms*:

> What is needed, then, is not a static definition that attempts to specify the *sine qua non* of modernism, but something more like . . . Wittgenstein's family resemblance, a polythetic form of classification in which the aim is to specify a set of criteria, subsets of which are enough to constitute a sense of decentered resemblance. While some criteria undoubtedly will be formal—fragmentation as a marker of modernism is not likely to go away anytime soon—others will be more conceptual or historical. . . . Relying solely on received criteria will not work, but that doesn't mean that all the older criteria were wrongheaded.[34]

Wollaeger's word *polythetic*, meaning a class of things with many but not all properties in common, dovetails with Berman's notion of flexible sets and subsets. Although Wollaeger differs from Berman and Jaji in actually calling for a set of criteria, we should observe that these criteria are not then declaratively provided but rather addressed in an implied subjunctive mood, under the sign of what they would be certain or likely or unlikely to be, were they to emerge. And the sense of resemblance such modernist criteria would convey, in their subsets, would anyway be "decentered." Despite his wish for a taxonomy, Wollaeger leads us to a modernism configured much like Berman's and Jaji's: laterally associative instead of vertically definitional; probabilistic instead of binary; subjunctive

rather than indicative; and, to borrow a distinction from David James and Urmila Seshagiri's article on metamodernism, "connotative rather than denotative."[35]

Unlike the critics I've been discussing, James and Seshagiri distinguish between connotative and denotative approaches to modernism in the course of calling for a return to the latter—a return, as they put it, to "a temporally bounded and formally precise understanding of what modernism does and means," and presumably to a sense, too, of what is not modernist ("Metamodernism," 88). Yet even as they ask us to go back to a strongly theorized and periodized modernism, they underscore modernism's auxiliary or instrumental function as a term in the field of study that bears its name. For their main motivation in advocating a return to the denotative approach is not to mount an argument that is conceptually or historically intrinsic to modernism but simply to facilitate the historical speciation and study of contemporary literature that, in novelist Tom McCarthy's words, "deals with the legacy of modernism" (87). In other words, even the rationale for reverting to the *sine qua non* model rejected by the likes of Berman, Jaji, and Wollaeger is relational; a strong theory of modernism is to be reactivated, but only to serve weak theoretical ends. I take this to be an exception that proves the rule: that instead of anchoring a strong, all-or-nothing, unified theory of its field, modernism now functions in local and provisional ways, as an auxiliary term that supports other lines of argument not endogenous to its problem-space. In the house of modernist studies, *modernism* has left off playing bouncer and started playing host.

Yet even in saying so, we should bear in mind how such a host remains tied to older senses and cognates—to the warlike gathering, to the stranger or enemy (*hostis*), to the victim (*hostia*). When it comes to fields of study, there can be a disquietingly short distance from hospitality to hostile takeover, from "all are welcome here" to "all are incorporated here," even "all are appropriated here." Modernist studies seems likely to keep expanding in the near term, as scholars working in the field draw more figures, works, media, languages, regions, traditions, and historical moments into the field, or into some relation to it. It would be a terrible irony—and, worse, both intellectually and ethically noxious—if a field expansion made possible by a certain weakness-in-theory were to result in a homogenizing triumphalism fed by the annexation of others' intellectual resources, spaces, voices, and rights-of-way. Even as scholars of modernism seek, with good reason, to make the field more inclusive, we need to be vigilant lest inclusivity become a byword for instrumentalizing the work or presence of others. Cultivating such vigilance would mean creating room for scholars in other fields to traverse and even transform modernist studies for their own reasons, not for the sake of "our" portrait of the field. It would also mean attending to the complex interactions between two kinds of field expansion: one motivated by a sense of *responsibility* to reach beyond what historically has been a small, Eurocentric, predominantly white male canon; the other exercised as an *entitlement* to claim expertise in anything, anywhere, at any time. In what cases, we would want to ask ourselves, does the claim of responsibility function as a warrant for the exercise of entitlement? What role might weak theory play in vitiating such warrants? And how might an ethics of humility help us to responsibly weak ways of engaging works, persons, subjects, and areas that we aren't entitled to engage strongly?

Embers

I'd like to step back a little now to air some of my own ambivalences about weak theory. I was trained in the late 1980s and early 1990s and remain committed to much of the project of neo-Marxist cultural materialism and political formalism, and thus to some of the very moves that advocates of post-critique literary studies would abandon as over-chewed, flavorless gum. These include the swerve from appearances to structures; the attempt to trace occulted or non-obvious relations among apparently disparate things; the belief that there is some correlation between exposing the

ruses of ideology and, if not neutralizing them, at least defecting or opposing them more mindfully while imagining alternative ways of being in the world. And although I'm not given to scaled-up theoretical claims, when made well by others they've been among the claims that have most inspired me as a critic. I suppose it's because of that receptivity that I've struggled, while writing this introduction, not to pluck strength from the jaws of weakness by claiming, for instance, that modernism in a global frame should be understood not just as an *object* of weak theory but as weak thought *par excellence*—as a set of disparate sites and conversations unified by the aim of weakening the monopolistic hold of transcendental truth claims upon us. (Luckily, the paranoid reader in me immediately began to list humiliating exceptions to such a claim, though I then had to resist the temptation to respond by inflating my claims further.) In a less personal vein, I wonder whether the weakening drift of modernist studies means giving up on totality as a category, either normatively or descriptively, and if so whether we've thought sufficiently about the analytical and political costs of doing so.[36] Relatedly, some of the largest-scale attempts to weaken modernism—especially Susan Stanford Friedman's essays defining it as any aesthetic rupture engaged with rapid change in any historical period—entirely decouple modernity, and consequently modernism, from capitalism.[37] Even if your aim in addressing a particular work's modernism is to produce a low-level description (in Dimock's phrase) rather than to plumb the political unconscious of its form, just taking capitalism off the table as a necessary *descriptor* is a game changer.

Max Brzezinski aired such a concern in his 2011 piece called "The New Modernist Studies: What's Left of Political Formalism?" Brzezinski criticized work done by junior and mid-career scholars of modernism during the preceding decade, singling out Martin Puchner's *Poetry of the Revolution* as a case study, for celebrating an incoherent range of "weak utopian impulses" in various writers while evacuating truly committed left-wing writing of its oppositional politics.[38] The essay, with its bent for sloganeering ("Is the *Neo* in Neoliberalism the *New* in New Modernist Studies?"), is mostly a lesson in the pitfalls to which strong theory is prone, its way of permitting the hammer-wielding critic to see everything as a nail (Brzezinski, "New Modernist Studies," 120). But I'm haunted by one accusation of Brzezinski's, which is that the new modernist studies emptied modernism of its political content in order to consolidate it as a brand, to turn it into a "marketable intellectual commodity" (109).[39] It haunts me not because "modernism" can be allotted the kind of monovalent political content one could easily evacuate, or because I accept Brzezinski's premise that "the new modernist studies" is anything like a unitary movement. But a brand's function, after all, is to guarantee a level of quality and identity across multiple product lines. Brands assert a unity where there is none, conferring discrete narrative lines on marketplace expansion and diversification. There's a risk, at least, that what I have here called the theoretical weakening of modernism is a byword for its transformation into a semantically empty trademark; that *modernism*, denuded of declarative, definitional, or analytical sharpness, becomes the licensed swoosh, bird, or ghost under which we all do various kinds of globalizing business. And accompanying that risk, another: that the centripetal power of even a weak modernism keeps us in a field-formation that it might be time to think about dissolving and reconstituting around some other term or concept; that we're travelers trying to warm our hands at a fire that's gone out, as fires do, and that we'd all be better off moving on.

Because the concerns I've named here about weak theory are real ones for me, I won't dispatch or dismiss them lightly. But if I were to frame a response from a weak theory perspective, I might begin by saying that capitalism, not least in its neoliberal morphology, is the ultimate strong theory without a theorist, the ultimate sovereign field without a sovereign. When we oppose it with an equally totalizing theory of anti-capitalism, we often mass-produce the same findings and refusals we've been cranking out for decades, multiplying these across the landscape in a strange parody of the thing we wish to challenge. Yes, there are oppositions that bear repeating and disseminating. But when what you oppose has a death-grip on repetition and dissemination, you may need to shift registers: you may need not only different ways of speaking your opposition, but different scales

and intensities at which to speak it. One thing that we encounter in scaling down or tailing off is the degree to which the ostensibly strong ideologies and phenomena that we study and oppose have their own local infections, subjunctive moods, and lateral assemblages, their own weak theoretical incarnations. The weak theorist would be ideally suited to describe these and, in coordination with others, to describe how our most pernicious strong theories emerge from dubiously scaled-up weak ones. This is to venture that there are specific, non-totalizing ways in which weak theory can get to grips with bad totalities. The challenge here, of course, would be keeping one's own theory weak rather than permitting it to drift toward doctrine, coherentism, triumphalism, and sovereign self-understanding.

Or toward sovereign models of the subject. Here we do well to remember the field's past and lingering attachments to strong models of subjectivity—to the artist as autochthonous genius, curse-hurler, puzzle-maker, or remote, impersonal god; to the critic as master decoder and defender of culture. Yet the humanities have lately tended toward countervailing models of the subject as distributed, precarious, dependent on and even co-constituted with other beings, objects, environments. Modernist studies, for its part, has begun attending to objects that exceed the commodity form or exhibit agency and social standing; to subjects that partake, without being objectified, in the uncertain or unactualized being of objects; to subject-object relations that offer alternatives to extractivism and anthropo-narcissism.[40] Should the politics of the strongman continue to surge on a global scale as they have lately done, those of us who work in weakly theorized disciplines such as the humanities will need to test our models of subjects, objects, and their relations under this intensifying pressure. It's possible we'll return to bright-line portraits of heroic individual agency, including the strongman modernism I described above as superseded, on the dialectical basis that we get to the future precisely through what appears obsolete. To go this route in modernist studies would mean considering what that old-fashioned modernism might yet have to say to our oppositional moment, particularly to agential ways of opposing aesthetics to capitalism by way of totality. But as I've suggested throughout this article, weakness-in-theory is also an undialecticized part of modernism's past and of its historical emergence as a field of study. Weakness, too, has unfinished work to do. As we go forward, then, we may also—or alternatively—meet the strongman's recrudescence with an ethics and politics of shared debility, a condition all the more demanding of our engagement as it is unevenly distributed among beings and environments. To take this path would be to root collective work and action in broad, loosely tied coalitions without ideological purity tests and in the entangled differentials of our vulnerability. This need not entail relinquishing the prospect of every kind of strength in every context. And it shouldn't make us heedless of the differences between kinds of weakness—physical, political, rhetorical, aesthetic, epistemological—or of the limits of their fungibility. But it would mean letting go of strength, including strength-in-theory, as perforce a good. Meanwhile, *pensiero debole* might be just what guides us to those forms of description, repair, critique, and resistance that are particular to subjects conversant with their own varieties of weakness.

To return to my image of the field as a group of travelers gathered around dwindling embers, maybe the fire was never the point, the dwindling having been the real occasion for the gathering. Where at a hotter, less populous moment the guests would have chanted Pound's maxim, "Literature is news that stays news," we may be ready to say other words to one another: modernism is weakness that stays weak.[41]

Notes

I'd like to express my gratitude to Chris Holmes and Jennifer Spitzer for organizing the 2014 Global Modernism Symposium at Ithaca College for which an early draft of this piece was written. I'm also indebted

to the participants in a New York–New Jersey Modernism Seminar at which a later draft was discussed—particularly to the hosts, Sarah Cole and Rebecca Walkowitz, and to Emily Bloom, Matt Eatough, Anne Fernald, Michael Golston, Matthew Hart, Jeffrey Lawrence, David Kurnick, Celia Marshik, Václav Paris, Victoria Rosner, Michael Rubenstein, Stefanie Sobelle, and Marianna Torgovnick. Thanks, too, to Jed Esty, Heather Love, Gayle Rogers, Avery Slater, Joseph Valente, and other interlocutors at Penn's Modernist and Twentieth-Century Studies Working Group and to those who attended a session of Yale's 20/21st Century Colloquium at which I presented this work, especially Seo Hee Im, Carlos Nugent, and Palmer Rampell.

An earlier version of some of this discussion also appears in the last section of the introduction to my book, *Tense Future: Modernism, Total War, Encyclopedic Form* (New York: Oxford University Press, 2015).

1. R. A. Scott-James, *Modernism and Romance* (London: John Lane, 1908), 266; Eugene Jolas, "The Revolution of the Word Proclamation," *transition* 16–17 (1929): 13; Lucia Trent and Ralph Cheyney, "What Is This Modernism?," in *More Power to Poets!: A Plea for More Poetry in Life, More Life in Poetry* (New York: Henry Harrison, 1934), 106–10, 106.

2. *OED Online*, March 2018, s.v., "weak, adj. and n."

3. For a small sample of such works, see Eve Kosofsky Sedgwick, *Touching Feeling: Affect, Pedagogy, Performativity* (Durham, NC: Duke University Press, 2003); Heather Love, *Feeling Backward: Loss and the Politics of Queer History* (Cambridge, MA: Harvard University Press, 2007); Benjamin Kahan, *Celibacies: American Modernism and Sexual Life* (Durham, NC: Duke University Press, 2013); Alison Kafer, *Feminist, Queer, Crip* (Bloomington: Indiana University Press, 2013). Kafer does not invoke weak theory as such, but her critique of bimodal distributions of futurity (between those who do and those who do not "have a future"), her mobile, ambivalent handling of identification, and her dedication to questions as "keep[ing] me focused on the inconclusiveness of my conclusion" may be understood as weak-theoretical elements of her project (*Feminist, Queer, Crip*, 18).

4. Jeffrey J. Williams, "The New Modesty in Literary Studies," *Chronicle of Higher Education* 61, no. 17 (2015): B6–B9, chronicle.com/article/The-New-Modesty-in-Literary/150993/. For a recent skeptical response to post-critique à la Rita Felski and Bruno Latour, including a reading of the new modesty as "not really new and . . . not really modest," see Bruce Robbins, "Not So Well Attached," *PMLA* 132, no. 2 (2017): 371–76, 373.

5. Stephen Best and Sharon Marcus, "Surface Reading: An Introduction," *Representations* 108, no. 1 (2009): 1–21, 17; Caroline Levine, *Forms: Whole, Rhythm, Hierarchy, Network* (Princeton, NJ: Princeton University Press, 2015), 150.

6. See Sharon Marcus, *Between Women: Friendship, Desire, and Marriage in Victorian England* (Princeton, NJ: Princeton University Press, 2007).

7. See *Representations* 108, no. 1, especially Best and Marcus's introduction.

8. See Nicholas Dames, *The Physiology of the Novel: Reading, Neural Science, and the Form of Victorian Fiction* (New York: Oxford University Press, 2007); and Leah Price, *How to Do Things with Books in Victorian Britain* (Princeton, NJ: Princeton University Press, 2012).

9. See Levine, *Forms*.

10. See Franco Moretti, *Atlas of the European Novel 1800–1900* (London: Verso, 1998); Franco Moretti, *Graphs, Maps, Trees: Abstract Models for a Literary History* (London: Verso, 2005); and Franco Moretti, *Distant Reading* (London: Verso, 2013).

11. See Rita Felski, *Uses of Literature* (Oxford: Blackwell, 2008); also Rita Felski, *The Limits of Critique* (Chicago, IL: University of Chicago Press, 2015).

12. See, especially, Heather Love, "Close but not Deep: Literary Ethics and the Descriptive Turn," *New Literary History* 41, no. 2 (2010): 371–91; Heather Love, "Close Reading and Thin Description," *Public Culture* 25, no. 3 (2013): 401–34; and Love's forthcoming *Practices of Description*.

13. Sianne Ngai, *Ugly Feelings* (Cambridge, MA: Harvard University Press, 2005), 22, 12.

14. Wai Chee Dimock, "Weak Theory: Henry James, Colm Tóibín, and W. B. Yeats," *Critical Inquiry* 39, no. 4 (2013): 732–53, 736.

15. Jean-François Lyotard, *The Postmodern Condition: A Report on Knowledge*, trans. Geoff Bennington and Brian Massumi (Minneapolis: University of Minnesota Press, 1984), xxiv. Another way to put the point I'm making here: postmodernism was theorized in relation to a modernism misrecognized as theoretically strong. As that misrecognition lifted, postmodernism as an analytic proved brittle and quick to oxidize.

16. Michael Levenson, *A Genealogy of Modernism: A Study of English Literary Doctrine 1908–1922* (Cambridge: Cambridge University Press, 1984), vii.

17. Bonnie Kime Scott, introduction to *The Gender of Modernism: A Critical Anthology*, ed. Bonnie Kime Scott (Bloomington: Indiana University Press, 1990), 4.

18. Mao and Walkowitz write, "Were one seeking a single word to sum up transformations in modernist literary scholarship over the past decade or two, one could do worse than light on *expansion*. In its expansive tendency, the feld is hardly unique: all period-centered areas of literary scholarship have broadened in scope, and this in what we might think of as temporal, spatial, and vertical directions" (Douglas Mao and Rebecca L. Walkowitz, "The New Modernist Studies," *PMLA* 123, no. 3 [2008]: 737–48, 737).

19. Christopher Bush, review of *Planetary Modernisms: Provocations on Modernity Across Time*, by Susan Stanford Friedman, *Modernism/modernity* 23, no. 3 (2016): 686–88, 686.

20. Susan Stanford Friedman, *Planetary Modernisms: Provocations on Modernity Across Time* (New York: Columbia University Press, 2015), 317.

21. Gianni Vattimo, *The Vocation and Responsibility of the Philosopher*, quoted in Gianni Vattimo and Santiago Zabala, "'Weak Thought' and the Reduction of Violence: A Dialogue with Gianni Vattimo," trans. Yaakov Mascetti, *Common Knowledge* 8, no. 3 (2002): 452–63, 452. Vattimo's central statement on weak thought is *La Fine della modernità* (1985), published in English as *The End of Modernity*, trans. Jon R. Snyder (Baltimore, MD: Johns Hopkins University Press, 1988).

22. Gianni Vattimo, "Dialectics, Difference, Weak Thought," in *Weak Thought*, ed. Gianni Vattimo and Pier Aldo Rovatti, trans. Peter Carravetta (Albany: SUNY Press, 2012), 51.

23. Silvan Tomkins, *Affect Imagery Consciousness*, vol. 2, *The Negative Affects* (New York: Springer, 1963), 433. Tomkins is also quoted in Sedgwick, *Touching Feeling*, 134.

24. In an ideal world, this narrative about how ideas have transformed the field of modernist studies would be entangled in something I have not undertaken here: a longitudinal sociology of the field's institutionalization as seen, both qualitatively and quantitatively, through changes in curricula, hiring practices, conferences, academic publishing trends, etc.

25. See Mark S. Granovetter, "The Strength of Weak Ties," *American Journal of Sociology* 78, no. 6 (1973): 1360–80.

26. For excellent readings of Victorian works by way of weak social ties, see Gage McWeeny, *The Comfort of Strangers: Social Life and Literary Form* (New York: Oxford University Press, 2016).

27. Editor's note: Please consult the original essay for figures.

28. See Daniel Morse, "An 'Impatient Modernist': Mulk Raj Anand at the BBC" (paper presented at the University of Pennsylvania's Modernist and Twentieth-Century Studies Working Group, Philadelphia, PA, 2011); and Morse's article by the same name in *Modernist Cultures* 10, no. 1 (2015): 83–98, which discusses but does not reproduce the photo; Peter J. Kalliney, *Commonwealth of Letters: British Literary Culture and the Emergence of Postcolonial Aesthetics* (New York: Oxford University Press, 2013). Jessica Berman has also discussed the photograph in unpublished talks.

29. See, e.g., Gayle Rogers, *Modernism and the New Spain: Britain, Cosmopolitan Europe, and Literary History* (New York: Oxford University Press, 2012); Gayle Rogers, *Incomparable Empires: Modernism and the Translation of Spanish and American Literature* (New York: Columbia University Press, 2016); Eric Bulson, *Little Magazine, World Form* (New York: Columbia University Press, 2017).

30. For a recent characterization of and contribution to the descriptive turn, see "Description Across Disciplines," ed. Stephen Best, Heather Love, and Sharon Marcus, special issue, *Representations* 135, no. 1 (2016).

31. Jessica Berman, *Modernist Commitments: Ethics, Politics, and Transnational Modernism* (New York: Columbia University Press, 2011), 7–8.

32. Megan Quigley argues in *Modernist Fiction and Vagueness* (Cambridge: Cambridge University Press, 2015) that the heap or *sorites* paradox and the epistemic and semantic problems of vagueness it indexes are at once key subjects and key qualities of modernist fiction. Quigley's book is also, by my reading, a monograph-à-clef about its field; we might think of it as bearing the secret title *Modernist Studies and Vagueness*.

33. Tsitsi Jaji, *Africa in Stereo: Modernism, Music, and Pan-African Solidarity* (New York: Oxford University Press, 2014), 15.

34. Mark Wollaeger, introduction to *The Oxford Handbook of Global Modernisms*, ed. Mark Wollaeger with Matt Eatough (New York: Oxford University Press, 2012), 12.

35. David James and Urmila Seshagiri, "Metamodernism: Narratives of Continuity and Revolution," *PMLA* 129, no. 1 (2014): 87–100, 88.

36. For a compelling recent defense of totalization as the contemporary negation of universalization, see Jed Esty and Colleen Lye, "Peripheral Realisms Now," *MLQ* 73, no. 3 (2012): 269–88.

37. See Susan Stanford Friedman, "Definitional Excursions: The Meanings of *Modern/Modernity/ Modernism*," *Modernism/modernity* 8, no. 3 (2001): 493–513; Susan Stanford Friedman, "Periodizing Modernism: Postcolonial Modernities and the Space/Time Borders of Modernist Studies," *Modernism/ modernity* 13, no. 3 (2006): 425–43; and Susan Stanford Friedman, "Planetarity: Musing Modernist Studies," *Modernism/modernity* 17, no. 3 (2010): 471–99.

38. Max Brzezinski, "The New Modernist Studies: What's Left of Political Formalism?," *Minnesota Review* 76 (2011): 109–25, 111.

39. See also Martin Puchner's "The New Modernist Studies: A Response," *Minnesota Review* 79 (2012): 91–96. Jennifer Wicke has, like Brzezinski, written about modernism as a brand but engages more than he does with the historical and ideological complexities of brands and branding; see Wicke's "Appreciation, Depreciation: Modernism's Speculative Bubble," *Modernism/modernity* 8, no. 3 (2001): 389–403.

40. See, for example, Joshua Schuster, *The Ecology of Modernism: American Environments and Avant-Garde Poetics* (Tuscaloosa: University of Alabama Press, 2015); Michelle Ty, "On Self-Forgetting: Receptivity and the Inhuman Encounter in the Modernist Moment" (PhD diss., University of California, Berkeley, 2016).

41. Ezra Pound, *ABC of Reading* (1934; rpt., London: Faber and Faber, 1991), 29.

INDEX

African American modernism. *See* Black modernism; New Negro

autonomy 7, 15, 20–2, 24, 77, 111, 137, 202, 325, 355

avant-garde 3–4, 6, 9, 11–12, 16, 21, 23–4, 40, 46, 61, 62, 78, 82–3, 86, 88, 111–12, 138–9, 143, 148, 150, 158, 238, 248, 254, 280–3, 289, 294, 296–7, 301–3, 329

Baker, Josephine 287–90, 292–3

Beach, Sylvia 31–2, 36, 112, 114, 315

Benjamin, Walter 4, 8, 22, 40, 82

Black modernism 121, 162–3, 167, 170, 172, 175, 178–80, 187–91, 196, 208, 212–14, 218–20. *See also* New Negro

celebrity 190, 246–8, 251–3, 259–60, 265, 268, 278, 343, 345–6, 350

censorship 129, 138, 153, 155, 157, 334, 348, 350

cinema 3, 102–3, 121–36, 144, 232, 238, 247, 250, 277–8, 299–300, 303

Dada 7–9, 11, 23–4, 61, 62, 86, 111, 132–3, 144, 202, 217

dialect 37, 41, 42, 46–51, 53–60, 63–4, 84, 123, 180, 217, 220, 227, 253, 367

digital modernism/digitality 309, 314, 356

disability studies 322, 353–5

Eliot, T. S. 16, 22, 30, 32–6, 38, 41, 45–7, 58, 59, 64, 113, 115–16, 121–2, 202–3, 232, 238, 247, 255, 299, 306

elitism 4, 94, 108, 114, 324

Fanon, Frantz 166–7, 169, 183, 197, 201, 287, 290, 292

feminism 16, 23–5, 28, 34, 40, 79, 86, 121, 143, 199, 207, 239, 290–1, 322, 355

film 31, 36, 121–36, 245–52, 262–4, 277–8, 280, 296, 337. *See also* cinema

Flaubert, Gustave 3, 13–15, 19–20, 75, 334, 349

form (and formalism) 3, 22, 28, 30, 32–4, 36, 38, 41, 57, 60, 94, 121–2, 124–8, 130–1, 134, 175, 177–9, 186–8, 192, 199–200, 204–7, 239, 245, 249–50, 252, 256–7, 259, 274, 291, 304, 311, 316, 319–20, 322, 324–6, 328–9, 353, 355, 365. *See also* New Criticism

Frankfurt school 3, 16, 121–2

Freud, Sigmund 18, 20, 30, 39, 86, 261, 288–9, 291, 292, 294, 358–9, 361

futurism 7, 9, 30, 35, 86, 123, 144, 217, 257, 299

gender and sex/sexuality 3–4, 14–17, 19–20, 22, 24–5, 28–35, 37–40, 75, 80–4, 86–90, 123, 125–6, 129–31, 136, 140, 150, 152–7, 161, 162, 199, 206, 209–10, 216–17, 220–1, 223–31, 269–70, 273–4, 278, 336–7, 340, 354–6

global modernism 123, 128–9, 131, 200–1, 203–5, 207, 211–14, 218, 238, 323, 364

Greenberg, Clement 21–2, 41, 122, 137, 239, 245, 247–8, 301

H.D. 31, 34–9, 95

high/low culture 9, 15, 24, 41, 94, 96, 102, 108–9, 114, 121–2, 125–35, 137–45, 150, 153–8, 161, 162, 232, 287, 301–2, 322

Hurston, Zora Neale 28, 32–3, 36–8

Jameson, Fredric 199–200, 239, 302–3, 322, 330, 356

jazz 24, 44–7, 59, 63, 164, 190, 191, 220, 324, 329

Joyce, James 3, 16, 28, 32–9, 41, 46, 63, 84, 94–103, 105, 107, 109–11, 114–20, 122, 137, 154–7, 161, 202, 216, 218, 236, 238, 247, 296–7, 299, 313, 320, 328, 334, 343, 353

Kenner, Hugh 33, 41, 48, 122, 202, 245, 247, 291

Kracauer, Siegfried 16, 121, 130, 136

little magazines 137–40, 146, 158–9, 239

Marinetti, F. T. 20, 24, 30, 35, 40, 160, 238, 255, 257, 312, 353

markets/commodities 6, 11–12, 94–6, 99–102, 110–14, 124, 128–9, 135, 137–40, 142, 150, 153–4, 157–8, 239–40, 335, 366–7

Marxism 5–6, 40, 125, 130, 203, 206, 214, 356, 358–60, 365

masculinity 14, 16, 20, 33, 37, 79–80, 82, 86, 210, 214–15, 230, 291, 353–4

mass media 12, 79, 82, 127, 131, 136, 150, 298, 302

modernism/modernity 3–4, 13–25, 42, 45–8, 54, 58–61, 63–4, 75–7, 83–7, 132, 162, 163, 199–200, 201, 211, 216, 353, 361

Modernist Studies Association (MSA) 138, 201, 211, 233, 235, 245, 328, 330, 358, 361

modernity 14, 21–2, 32, 43, 45–6, 63, 75–83, 85–90, 108, 121–4, 126–33, 136, 141, 145, 149, 159, 176, 178–9, 199–215, 218, 224, 226, 230, 245–7, 253, 259–60, 262, 270, 277–8, 281, 289, 291, 319–24, 328–30, 343, 354, 356–7, 363, 366

New Criticism 84, 101, 304–8, 312

New Negro 31, 47, 163, 165, 168, 178, 181–2, 192

Index